The Wallace Collection
Catalogue of Pictures
I

The Wallace Collection
Catalogue of Pictures

I

British, German, Italian, Spanish

by John Ingamells

The Trustees of the Wallace Collection, Manchester Square,
London W1M 6BN
1985

The cover shows a detail from
P116 *The Cumaean Sibyl* by Salvator Rosa

© Copyright The Trustees of the Wallace Collection

British Library Cataloguing in Publication Data
Wallace Collection
The Wallace Collection: Catalogue of Pictures.
I: British, German, Italian, Spanish
1. Painting, European – Catalogs
I. Title II. Ingamells, John
759'.94'074 ND450
ISBN 0 900785 16 0 (softback)
ISBN 0 900785 17 9 (hardback)

Catalogue designed by Graham Johnson
and printed by The Westerham Press

Contents

Foreword

This volume is the first of three which together will replace the sixteenth edition of the *Catalogue of Pictures and Drawings* of 1968. Volume two will deal with the French pictures and volume three with the Dutch and Flemish. The contents of the present volume may be tabulated thus:

School	Paintings	Drawings	Totals
British	55	55	110
German	7	1	8
Italian	67	4	71
Spanish	22	0	22
Totals	151	60	211

In compiling this catalogue I have inevitably incurred considerable debts to other scholars. Numerous questions have been answered with unfailing kindness, and acknowledgments of private and printed sources will generally be found within the relevant catalogue entries. Here I must emphasise a particular debt to the work of my predecessors in earlier editions of this catalogue, and acknowledge generous assistance received from Mrs. Enriqueta Frankfort, Mr. Herbert Lank, Mr. J. G. Links, Sir Oliver Millar, Mr. Philip Pouncey, Sir Ellis Waterhouse and Professor Federico Zeri. Dr. Marion Spencer's notes on the Boningtons, deposited in 1964 and previously used for the 1968 catalogue, again provided an invaluable starting point for that section of the catalogue. I would like to thank the Directors of the National Gallery, London, the National Portrait Gallery, London, and the Courtauld Institute of Art for permission to consult their libraries and archives, where I received much kind help. Likewise the staffs of the London Library, the Royal Academy Library and the British Museum Print Room have been of great assistance. Christie's and Sotheby's generously allowed access to their archives.

Of my colleagues within the Wallace Collection I want particularly to thank Miss Ruth Cowell for her relentless pursuit of sale references and articles, Mr. John McKee for his constant assistance, and Mr. Richard Beresford for a perceptive reading of the typescript.

The catalogue appears in a more elegant format than its predecessors. This is wholly due to The Monument Trust, who have contributed towards the cost of the paper-back edition and entirely financed the production of a limited, cloth-bound edition containing a number of colour plates.

All the pictures have been carefully examined and remeasured. The various woods used for panel paintings have been identified by Mr. Peter Mactaggart of

Mac & Me Ltd. Many of the photographs, and the majority of the colour plates in the cloth-bound edition, have been specially taken by Mr. Gordon H. Roberton of A. C. Cooper Ltd.

Material from the Royal Archives at Windsor Castle has been used by gracious permission of Her Majesty The Queen, and from the archives of the National Portrait Gallery, London, by permission of the Director and Trustees.

John Ingamells

Introduction

(This note may be supplemented by reference to the Genealogical Table on page 11, Appendices I–V and to 'Inventories' in the Abbreviations which follow.)

The majority of the pictures catalogued in this volume were acquired by Richard, fourth Marquess of Hertford. He had already settled in Paris when he began to collect seriously on his accession in 1842, and he continued buying up to his death in 1870. He bought mostly in the sale rooms of London and Paris, employing a number of agents of whom Samuel Mawson in London was particularly influential, often persuading his noble client to buy a picture he may not have seen for himself. Pictures bought in Paris or on the Continent were kept in Lord Hertford's apartment at 2 rue Laffitte (only two of the pictures here catalogued seem to have been in his country residence, Bagatelle in the Bois de Boulogne), with the exception of three which were sent to England in 1857 for the *Art Treasures* exhibition in Manchester (Murillo P68, del Sarto P9 and Velázquez P88). Pictures acquired in London were generally kept at 13 Berkeley Square (leased between 1846 and 1858) or Hertford House (where the Berkeley Square pictures were eventually transferred). The principal exceptions to this pattern were the thirty pictures bought at the Bicknell sale in 1863 which were sent to the rue Laffitte.

The fourth Marquess had also inherited some pictures which he kept at Hertford House. Twenty-seven are catalogued here; six Canalettos and some family portraits from his great-grandfather, the first Marquess: four English portraits from his grandfather, the second Marquess, and more portraits together with Titian's *Perseus and Andromeda* from his father, the third Marquess, whose various London residences had included 105 Piccadilly, Dorchester House and St. Dunstan's Villa. There was also a collection, formed principally by the first Marquess, at Ragley Hall, the family's English country seat, which was neglected by the third Marquess (who preferred Sudbourne Hall in Suffolk) and ignored by the fourth.

By bequeathing his collections to his illegitimate son, Richard Wallace, the fourth Marquess separated them from the Hertford title. Wallace had lived in Paris with his father, but moved to Hertford House following the siege of Paris and the Commune of 1870–1. He brought over much of his new inheritance to add to the collection already in Hertford House, which had to be enlarged accordingly. While it was being extended Wallace resided at 105 Piccadilly, and his collections were exhibited at the new Bethnal Green Museum in the East End of London (a branch of the South Kensington Museum, now the Victoria and Albert Museum) between 1872 and 1875. The two editions of that perfunctory catalogue compiled by Charles C. Black provide the first printed

account of the Wallace Collection. Wallace himself went on to acquire a number of pictures, often of secondary quality; thirty-seven are catalogued here, the majority bought *en bloc* from the vicomte Both de Tauzia in 1872.

Lady Wallace bequeathed those works of art on the ground and first floors of Hertford House to the Nation in 1897 as The Wallace Collection. The remainder of the Wallace collection, still in Paris in the rue Laffitte or Bagatelle, passed to Lady Wallace's residuary legatee, Sir John Murray Scott. The collection at Ragley had already been entailed with the Marquisate.

The first picture catalogue of the Wallace Collection was compiled by (Sir) Claude Phillips (Keeper 1898–1911) in 1900. By 1911 it had run through twelve editions, each containing amendments and additions. D. S. MacColl (Keeper 1911–24) then rewrote the catalogue, and his 13th and 14th editions of 1913 and 1920 contained much new information, particularly concerning provenances. The 15th edition of 1928 was revised by (Sir) Philip Hendy (Assistant 1923–7) who reattributed several pictures. His text was revised by (Sir) Francis Watson (Assistant 1938–62, Director 1963–74) for the 16th edition of 1968.

The Seymour-Conway Family
Earls and Marquesses of Hertford

FOUNDERS OF THE WALLACE COLLECTION

Francis Seymour-Conway (1719–1794; Earl of Hertford & Viscount Beauchamp 1750; Earl of Yarmouth & *Marquess of Hertford* 1793)

m. 1741 Lady Isabella Fitzroy (1726–1782) d. of 2nd Duke of Grafton

seven sons and six daughters, of whom

Francis Ingram Seymour-Conway (1743–1822; Viscount Beauchamp 1750; Earl of Yarmouth 1793; *2nd Marquess of Hertford* 1794)

m. 1. 1768 Alice Elizabeth (d. 1772) d. of Viscount Windsor

m. 2. 1776 Isabella Anne Ingram Shepheard (1760–1834) d. of 9th Viscount Irwin

only surviving child

Francis Charles Seymour-Conway (1777–1842; Viscount Beauchamp 1793; Earl of Yarmouth 1794; *3rd Marquess of Hertford* 1822)

m. 1798 Maria Fagnani (1771–1856)

two sons and a daughter, of whom

Richard Seymour-Conway (1800–1870; Viscount Beauchamp 1800; Earl of Yarmouth 1822; *4th Marquess of Hertford* 1842)

one illegitimate son
(by Mrs. Agnes Jackson, *née* Wallace, 1789–1864)

Richard (Jackson) Wallace (1818–1890; name changed to Wallace 1842; Baronet 1871)

m. 1871 Amélie Julie Castelnau (1819–1897)

Lady Wallace bequeathed the major part
of the family's collection of works of art to
the Nation as The Wallace Collection

Explanation

Pictures are catalogued within schools alphabetically by artist; for each artist pictures are described in order of their inventory numbers.

Artists' biographies are essentially brief, but length may vary according to the importance of the artist's work within the Collection.

Attributions	*After:* derived from an identified work by the named artist
	Ascribed to: there remains an element of doubt concerning the traditional attribution
	Attributed to: now thought to be by, but there remains an element of doubt
	Follower of: contemporary with, and near the style of, the named artist
	Manner of: a general stylistic relationship with the work of the named artist, but not contemporary with him
	Studio/Workshop of: produced in the named artist's studio/workshop, probably under his direction and after his design
Right and left	normally indicate the spectator's right and left, unless otherwise indicated (e.g. a sitter's left hand in a portrait)
Medium	assumed to be oil, unless otherwise stated
Measurements	have all been retaken. The area of the painted surface is normally given, in centimetres, height before width. For panels the depth is also given.
Condition	notes list previous restorations as recorded in archives, and are otherwise generally confined to a description of visible imperfections, e.g. repaired damages, retouchings and *pentimenti*
Drawings	preliminary and/or related graphic works by the named artist
Versions	replicas and closely related compositions, generally attributable to the named artist; the support is canvas unless otherwise stated
Provenance	prices: as a comparative guide for nineteenth-century prices, the pound was worth approximately 25 French francs, and the guinea (gn.) 26 francs

Abbreviations

See also following artists' biographies

ARA	Associate Royal Academician
Bagatelle	See Inventories
Bartsch	J. Adam von Bartsch, *Le Peintre graveur*, 21 vols., 1803–21
Belfast 1876	Industrial Exhibition and Bazaar, Ulster Hall, Belfast, opened 23 May 1876; Sir Richard Wallace lent 50 water-colours (nos.54–103) and one oil (no.5)
Berenson, *Lists* 1897	B. Berenson, *Central Italian Painters of the Renaissance*, 1897
Berenson, *Lists* 1907	B. Berenson, *North Italian Painters of the Renaissance*, 1907
Berenson, *Lists* 1909	B. Berenson, *Florentine Painters of the Renaissance*, 1909
Berenson, *Lists* 1932	B. Berenson, *Italian Pictures of the Renaissance*, 1932
Berenson, *Lists* 1957	B. Berenson, *Italian Pictures of the Renaissance, Venetian School*, 1957
Berenson, *Lists* 1963	B. Berenson, *Italian Pictures of the Renaissance, Florentine School*, 1963
Berenson, *Lists* 1968	B. Berenson, *Italian Pictures of the Renaissance, Central Italian and North Italian Schools*, 1968
Bethnal Green 1872–5	Paintings, Decorative Furniture and other works of Art lent by Sir Richard Wallace to the Bethnal Green Museum; the exhibition was opened on 24 June 1872 and closed in April 1875. Catalogued by C. C. Black, 1872 and 1874, the second edition showing that Wallace added material after the exhibition opened.
BFAC	Burlington Fine Arts Club, London
BI	British Institution, London
Dorchester House	See Inventories
Evans invoice	Two invoices in the Wallace Collection archives from W. & P. Evans, 18 Silver Street, London, to the fourth Marquess of Hertford for work on pictures in Hertford House – restoration of pictures and frames and 92 new frames; the first dated April 1857 (in connection with the *Art Treasures* exhibition at Manchester), the second February 1859.
FS	Free Society of Artists, London; annual exhibitions 1762–83
Hertford House	See Inventories
Ingamells 1983	J. Ingamells, *The 3rd Marquess of Hertford as a Collector*, 1983
Inventories	preserved in Wallace Collection archives, unless otherwise stated: *Bagatelle*, Bois de Boulogne, Paris, residence of the fourth Marquess of Hertford 1835–70; bequeathed to Richard Wallace; inventory 1871, objects removed from Bagatelle on death of the fourth Marquess and stored at 3 rue Taitbout, Paris (Archives de Paris, D48 E³ 62).[1]

[1] 3 rue Taitbout had been the residence of the third Marchioness of Hertford c. 1824–56, Lord Henry Seymour (d. 1859) and Wallace. I am very grateful to Mme. Françoise Arquié for indicating the existence of the 1871 inventories (see also rue Laffitte).

Inventories (continued)	*Dorchester House*, Park Lane (demolished 1848), leased by the third Marquess of Hertford 1829–42; inventory 1842, on his death.
	Hertford House, now the Wallace Collection, acquired by the second Marquess of Hertford in 1797; leased as French Embassy 1835–50; rarely visited by the fourth Marquess who kept works of art there; residence of Sir Richard and Lady Wallace 1875–97; inventory 1834, following death of second Marchioness; 1843, following death of third Marquess; 1846 (List of Paintings left for the use of the French Ambassador); 1870, on death of the fourth Marquess, and 1890, on death of Wallace.
	Rue Laffitte, no.2, Paris, residence of the fourth Marquess of Hertford 1829–70; bequeathed to Richard Wallace; inventory 1871 following death of fourth Marquess (Archives de Paris, D48 E³ 62). See also Appendix v.
	105 Piccadilly, London, given to the third Marchioness by the Duke of Queensberry; used by the third Marquess 1824–30, occasionally by the fourth Marquess before 1842, and by Wallace 1872–5; sold 1876; schedule of part contents insured by the Sun Insurance Co. (no.2498155) 23 April 1874–25 March 1875.
	St. Dunstan's Villa, Regent's Park, London (demolished 1937); built 1826 for the third Marquess who bequeathed it to the Countess Zichy who sold it 1855; inventory 1842, on death of third Marquess.
	Sudbourne Hall, Suffolk (demolished 1950); a Hertford country seat, used by the first, second and third Marquesses; purchased by Wallace 1874 and sold 1884; inventory 1842, on death of third Marquess, 1871, following death of fourth Marquess, and 1874.
Ipswich 1880	Exhibition of paintings, Ipswich Art Gallery, High Street, Ipswich, opened 30 June 1880; Sir Richard Wallace lent 57 pictures (nos.11–67) 'from the Sudbourn Hall Collection of Modern Paintings'.
Letters	*The Hertford Mawson Letters*, ed. J. Ingamells, 1981
Manchester, *Art Treasures*, 1857	*Art Treasures of the United Kingdom*, Old Trafford, Manchester, 5 May–7 October 1857; the fourth Marquess of Hertford lent 44 paintings which were housed in a special room (saloon H) with their own numbers
Millar	O. Millar, *The Tudor, Stuart and early Georgian Pictures in the collection of Her Majesty The Queen*, 1963, nos. 1–649, and *The later Georgian Pictures in the collection of Her Majesty The Queen*, 1969, nos.650–1238
OWS	Old Water-Colour Society, London
105 Piccadilly	See Inventories
RA	Royal Academician/Royal Academy, London
SA	Society of Arts 1760, Society of Artists 1761, Incorporated Society of Artists, 1765; annual exhibitions in London 1760–91
SBA	Society of British Artists
St. Dunstan's	See Inventories
Sudbourne	See Inventories

Thieme-Becker	U. Thieme and F. Becker, *Allgemeines Lexikon der Bildenden Künstler*, 37 vols. 1908–49
Vasari-Milanesi	G. Vasari. *Le Vite de' più Eccellenti Pittori Scultori ed Architettori*, ed. G. Milanesi, 9 vols., 1906 ed.
Waagen 1838	G. F. Waagen, *Works of Art & Artists in England*, 1838
Waagen, I–III	G. F. Waagen, *Treasures of Art in Great Britain*, 3 vols., 1854
Waagen, IV	G. F. Waagen, *Galleries and Cabinets of Art in Great Britain*, 1857 (published as a supplement to the *Treasures of Art*)
Wallace Collection catalogues	previous editions of this catalogue (see Introduction) are referred to as 'catalogue' with date
Walpole *Correspondence*	Horace Walpole, *Correspondence*, Yale edition, ed. W. S. Lewis, 43 vols. + 5 vols. index, 1937–83

British School

Richard Parkes Bonington (1802–1828)

Born on 25 October 1802 in Arnold, Nottingham, his mother a teacher, his father successively a gaoler, a drawing master and a lace-maker. In 1817 he moved with his parents to Calais where F. L. T. Francia encouraged him to paint coast scenes in water-colour. In 1818 the family moved to Paris where Bonington made water-colour copies of Dutch and Flemish landscapes in the Louvre. In 1820 he became a pupil of Baron Gros in the Ecole des Beaux-Arts; he was then remembered as talking ceaselessly of Turner and reading medieval histories. Academic figure-studies by him are preserved at Nottingham and in the British Museum. From 1821 he undertook regular sketching tours in Normandy and he reached Bruges and Ghent in 1823. In 1821 he exhibited water-colours with the Paris dealers Hulin and Schroth and they were admired by contemporaries such as Delacroix and Corot. His anglicised picturesque views ran counter to *le goût davidien* and Bonington left Gros, amicably, late in 1822. He began to paint in oil c.1822 by which time he had also taken up lithography. He published 15 lithographs in 1824 as the *Restes et Fragmens d'Architecture du Moyen Age*; some of his stones were used by Baron Taylor in 1825 for the second *Normandie* and the *Franche-Comté* volumes of his *Voyage pittoresque de l'ancienne France*, and he published his own *Cahier de six sujets* in 1826. Bonington showed two water-colours in the 1822 Salon, and in 1824, when his exhibits included three oil seascapes, he was awarded a gold medal. He spent most of 1824 in Dunkirk. In the summer of 1825, with his friend Armand Colin, he came to London where he met up with Delacroix. Together they sketched armour in the collection of Sir Samuel Meyrick (much of which is now in the Wallace Collection). On their return they shared a studio in Paris between September 1825 and January 1826, a period stimulating for them both. Delacroix was then working on the *Execution of Marino Faliero* (Wallace Collection P282) which reflects something of Bonington's narrative restraint and delicacy of colour, while Bonington turned increasingly to exotic and historical subjects, undoubtedly encouraged by Delacroix's example. He took his sources from the old masters in the Louvre, engravings in the Bibliothèque Nationale and from the oriental collection of Delacroix's friend, J.-R. Auguste. At the same time he developed the small-scale water-colour using body-colour and gum varnish to rival the effect of oil. In January 1826 Bonington exhibited for the first time in London, two coast scenes in oil at the BI. From April to June 1826 he was in Italy with his friend Baron Rivet. Venice profoundly affected him, but they also saw Milan, Verona, Bologna, Padua and Florence. He exhibited a *Vue du palais ducal à Venise* in the 1827 Salon (it is now in the Louvre), two more (both now in the Tate Gallery) at the BI in January 1828, and another at the RA in May. In the same year he showed three ambitious histories; *Henri IV et l'ambassadeur d'Espagne* (P351 below) and *François Ier et la reine de Navarre* (a version of P322 below) at the February 1828 *supplément* to the Salon, and *Henry III of France* at the RA (P323 below). Bonington visited London in 1827 and the

spring of 1828. Since 1826 he had shown signs of consumption, and in September 1828 his parents brought him to London for treatment. He died at 29 Tottenham Street on 23 September 1828.

Abbreviations

Curtis	A. Curtis, *Catalogue de l'oeuvre lithographié et gravé de R. P. Bonington*, 1939
Dubuisson	A. Dubuisson, *Richard Parkes Bonington*, trans. and annotated by C. E. Hughes, 1924
Ingamells	J. Ingamells, *Richard Parkes Bonington*, 1979
Nottingham, 1965	M. Spencer, *R. P. Bonington*, catalogue of an exhibition at the Castle Museum and Art Gallery, Nottingham, 1965
Shirley	The Hon. A. Shirley, *Bonington*, 1940, with unnumbered catalogue of Bonington's works

P270 *Child at Prayer*

In the costume of c.1630–40; the lady in black[1] in a yellow chair; the child in salmon red with a green sash; a lily in the vase on the red table-cloth.

Millboard 35.9 × 27.9 painted area 34.3 × 24.5
the paint extends in parts beyond these measurements

There is a fine craquelure on the background pillar.

The child's dress, the lily, the woman's markedly fair complexion and the catholic appurtenances, suggest a particular circumstance rather than a genre scene. Although a historical subject has not previously been proposed, it is possible that P270 may be intended to represent Anne of Austria and the young Louis XIV.[2]

Probably painted in 1826, see Drawings below. The composition is comparable with water-colours of that date (cf. P668 and P732), and the execution and colour are bolder than in P333.

Drawings

EDINBURGH National Gallery of Scotland (D22911); a sheet of closely related figure studies, also including a view of Venice, implying a date of 1826 (Nottingham 1965, no.182).[3]
A closely related drawing was in the Brown sale, Paris, 7 March 1843 (22).[4]

Provenance

Bonington sale, Sotheby's, 2nd day, 30 June 1829 (221, 'A Cabinet Picture, Mother and Child at Prayer'), bt. Seguier, 100 gn.; Gen. the Hon. Edmund Phipps (1760–1837); the Hon. Edmund Phipps (1808–57); his sale, Christie's, 25 June 1859 (91, 'The Widow and Child, an interior...'), bt. Mawson for the 4th Marquess of Hertford, 180 gn.;[5] Hertford House inventory 1870.

Exhibitions

BI 1843 (130, *Child Praying*); Bethnal Green 1872–5 (52).

References General

Shirley, p.95, as 1824–5; Ingamells, pp.33, 46.

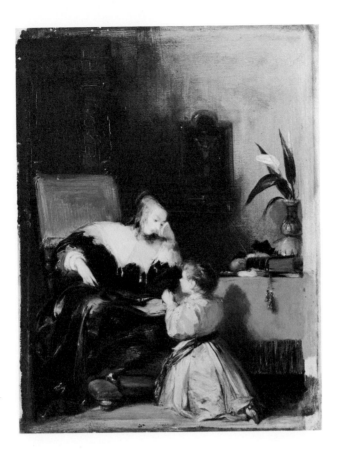

1 She is dressed formally, not necessarily as a widow (see Provenance), cf. C. Piton, *Le costume civil en France*, n.d., pp.196, 199, 205.

2 Anne of Austria (1601–66) m.1615 Louis XIII (1601–43); their eldest son Louis XIV (1638–1715). The lily would be an obvious emblem for the French Crown. Bonington could have consulted Mme. de Motteville's *Mémoires* which tell how '*la Reine . . . prenoit un grand soin d'entretenir dans l'âme de ce jeune prince . . . les sentiments de vertu, de sagesse et de piété qu'elle lui avoit inspirés dès son enfance*'; she described Anne as having '*les plus beaux cheveux du monde, de couleur châtain clair . . . ses belles mains . . . faisoient admirer toutes leurs perfections*', and her complexion was remarkable for its '*blancheur et . . . netteté*' (1886 ed., I, pp.171, 265). Bonington's *Anne of Austria and Mazarin* in the Louvre (Nottingham 1965, no.297) shows the Queen Regent similarly dressed and fair of complexion. Two pencil drawings of Anne by Bonington are in the Castle Museum and Art Gallery, Nottingham (Nottingham 1965, nos. 118–19). It must be said that the figure in P270 is more elegant than Anne, either in fact (cf. s379 in the Wallace Collection) or in Bonington's Louvre oil.

3 Illus. *Master Drawings*, III, 1965, pl.40.

4 '*La Prière. Une jeune Femme, vêtue de noir et assise dans un fauteuil, la tête appuyée sur une de ses mains, écoute avec attention son jeune enfant qui, à genoux près d'elle et les mains jointes, lui récite sa prière. Une belle et large lumière qui éclaire cette jolie scène pleine de sentiment, des draperies riches et brillantes, des chairs fines et transparentes et une entente parfaite du clair-obscur, font de ce dessin, qui est d'une composition simple et vraie, une des productions les plus remarquables de son auteur*', 330 fr.

5 Hertford was particularly anxious to have it: 'The Bonnington we must also have as it must be very pretty & we have none at Manchester house' (*Letters*, no.91, p.116). In fact P341 had been seen by Waagen at Hertford House in 1854–6 (IV, p.92).

P273 *A Sea Piece*

Canvas, relined 54.9 × 84.5

Cleaned in 1978 by Hargrave. Two large tears, one in the lower left quarter, the other parallel with the right-hand edge, were repaired by relining before 1900. There are *pentimenti* on the centre sails.

Probably painted 1824–5.[1] Bonington exhibited two *Marines* in the Salon of 1824. The composition recalls both Francia and Turner,[2] and the execution and cool tonality is matched by *Near Boulogne* (Tate Gallery, no.5790)[3] which has been dated 1823–4.

Copy

LONDON Adamson sale, Christie's, 10 May 1875 (83, 'Replica of the... picture in... Wallace's collection'), 32 × 51; probably the panel 35.5 × 54 in an English private collection 1983.

Versions

Two related water-colours are recorded.
BUDAPEST Museum of Fine Arts (no.1935–2627), 14.1 × 23.1, dated 1824, ex-Majorszky collection, exh. Munich, *Das Aquarell 1400–1950*, 1972–3 (273).
NEW HAVEN Yale Center for British Art, 13.8 × 20.3, ex-Bowood (Shirley, pl.135 in reverse; Nottingham 1965, no.206).

Provenance

Probably Mainnemare sale, Paris, 21 February 1843 (I, '*Marine et Falaises; sur le devant une barque de pêcheurs remplie de personnages, et dans le fond plusieurs embarcations sous voiles. Tableau d'un ton brillant et éclatant de lumière; les vagues y sont d'une grande transparence et vraies de mouvement, et les nuages parfaitement rendus*'), 2,300 fr.[4] The 4th Marquess of Hertford; reframed in Hertford House 1859 ('*Modern, a Sea Piece. 5 in. wide Measure 12 ft. 6 in.*');[5] Hertford House inventory 1870.

Exhibition

Bethnal Green 1872–5 (44, *Sea piece: a Cutter getting under way*).

References General

Shirley, p.104, as 1826; Ingamells, pp.14, 34.

[1] This date was also proposed by Spencer (Nottingham 1965, no.206).
[2] Cf. Francia's seascape in the British Museum, no.1877–10–13–952. Bonington would have known Turner's works only through engravings prior to 1825, but cf. the *Egremont* and *Leader* sea-pieces in the *Liber Studiorum* (R.10, R.20). In Mr. Bonington's sale, Christie's, 23–4 May 1834, lots 8 and 11 were 'Turner's marine views, india proofs' and 'Turner & Girtin's River Scenery'. See also M. Cormack, *Master Drawings*, III, 1965, p.287.
[3] Shirley, p.90, pl.24, as 1823.
[4] Lord Hertford acquired other pictures from this sale, by Delaroche (lots 7 and 8) and Horace Vernet (lot 33).
[5] Evans invoice.

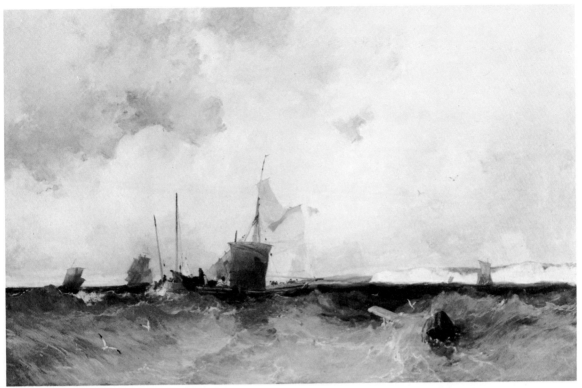

P273

P322 *François Ier and Marguerite de Navarre*

The King in red with a black hat, fingering a gold medal; Marguerite in green; a rust-red curtain. On the window pane is inscribed: *Souvent/femme Varie/Bien fol est/qui s'y fie.*

Canvas 45.7 × 34.5

The surface is very uneven and marked by a fine craquelure,[1] more pronounced in the darker passages. The varnish is discoloured.

François Ier (1494–1547), King of France from 1515, and his devoted sister, Marguerite d'Angoulême (1492–1549), author of the *Heptameron*, who m. 1st Charles, duc d'Alençon, and 2nd Henri, King of Navarre. The subject is founded on the discovery, recorded in 1724, of the verse *'Souvent femme varie/Mal habil qui s'y fie'*, *'écrit avec un diamant de la propre main de François Ier'*, on a window of the château de Chambord.[2] The scene was painted by F. Richard in 1804 (Arenenberg, musée Napoléon)[3] and there is at least one other interpretation by Bonington, see below.

Probably painted in 1826–7. Another version was exhibited in the 1827–8 Salon, see below. A related water-colour by Delacroix, *François Ier et sa maîtresse*, in the Fogg Art Museum,[4] may imply that Bonington was considering the composition in 1825–6. Both the Bonington and the Delacroix relate, in reverse, to Richard's composition of 1804. The head of the King in P322 is based on Titian's portrait of François Ier in the Louvre;[5] the head and costume of Marguerite have been described as deriving from her portrait by Clouet, or from a portrait of Eléonore d'Autriche;[6] the hound might derive from Veronese's *Supper in the House of Simon the Pharisee* (Turin, Galleria Sabauda).[7] P322 was much admired in the nineteenth century: in 1868 Blanc claimed he found *'tout le romantisme contemporain... renfermé dans ce tableau'.*[8]

Engraving

L. Flameng 1869 (*Gazette des Beaux-Arts*, 2e, 1, 1869, f.p.218).

Copy

Adamson sale, Christie's, 10 May 1875 (67).

Versions

PARIS Mme. de Guiringaud 1937, 31.1 × 23.8, ex-Baron Rivet collection, unfinished.[9]
A. Sambon 1940, 23 × 18.[10]
A second interpretation of the subject, showing Marguerite drawing back a curtain to reveal the inscription, and with two hounds, was shown at the 1827–8 Salon *2e supplément*, no.1604;[11] several examples of this type are recorded[12] and this composition was engraved by C. Heath in 1830, Normand *fils* in 1836, and Jazet.

Provenance

W. Webb sale, Paris, 23–4 May 1837 (6, *'François Ier et la belle Marguerite de Navarre: intérieur'*), 1,505 fr.;[13] Brown sale, Paris, 12–13 March 1839 (96, *'François Ier, étendu dans un large fauteuil, regarde d'un air malin Diane de Poitiers qui, debout près de lui, lit sur les vitres la devise:* Souvent femme varie, bien fol est qui s'y fie. *Ce tableau le plus terminé qu'ait fait cet artiste est d'un superbe coloris d'une touche ferme et savante:...'*); Paul Périer (1812–97), but not identifiable in his sales; the baron Delessert (1773–1847); la galerie Delessert sale, Paris, 15–18 March 1869 (128, *'François Ier et Marguerite de Navarre... Cabinets Brown et Paul Perrier...'*, 46 × 33), bt. by the 4th Marquess of Hertford, 31,000 fr.;[14] rue Laffitte inventory 1871 (241); Hertford House inventory 1890.

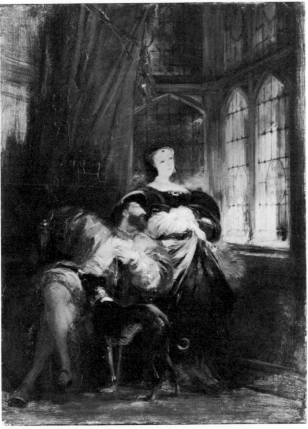

P322

Exhibition

Bethnal Green 1872–5 (43, as *Francis I and his Mistress* 1872, and *Francis I & Marguerite de Navarre* 1874).

References General

Shirley, p.113, as 1827; Ingamells, p.55.

[1] First noted in the *Revue internationale de l'art et de la curiosité*, I, 1869, p.324, where P322 is described as '*un bijou, s'il n'avait été craquelé dans certaines parties*'.

[2] P. de la Force, *Nouveaux Voyages de France*, 1724, p.16; the discovery repeated, for example, by M. Gaillard, *Histoire de François Ier*, 1769, VIII, p.35, and see J. Bacon, *The Life and Times of Francis I*, 1829, II, p.113 and note b. None of these references includes an episode with Marguerite de Navarre; Bonington seems to have taken this from Richard, see below. The identity of Marguerite has varied, see provenance and exhibition, above; Mary Shelley wrote a short story, 'The False Rhyme', *The Keepsake*, 1830, pp.265–8, elaborating Bonington's second version of the subject. The verse is not always accepted as by François Ier today, cf. Mirepoix *et al.*, *François Ier*, 1967, p.283 (though it is quoted approvingly by D. Seward, *Prince of the Renaissance*, 1974, p.175).

[3] Salon 1804 (377, '*François Ier: il montre à la Reine de Navarre, sa soeur, les vers suivants qu'il vient d'écrire sur une vitre avec son diamant: Souvent femme varie. Bien fol qui s'y fie. On a vu long-tems ce distique gravé sur le vitrail d'une fenêtre du château de Chambord*'); he exhibited it again in the 1814 Salon, no.1389. See M.C. Chaudonneret, *La peinture Troubadour*, 1980, pp.66–7, no.10. The composition was engraved by A. Boucher and Baron Desnoyers, and may also have inspired Devéria (see B. S. Wright, *Art Bulletin*, LXIII, 1981, p.282). The grouping of brother and sister may derive from the miniature showing them playing chess together in Jacques le Grant, *Livre des échecs amoureux* (illus. Mirepoix, *op. cit.*, p.9).

[4] Illus. R. Huyghe, *Delacroix*, 1963, fig.122.

[5] Ingres had used a similar head for his *François Ier reçoit les derniers soupirs de Léonard de Vinci* of 1818, shown in the 1824 Salon (Wildenstein, no. 118).

[6] R. Strong, *And when did you last see your father?*, 1978, p.89, illustrating the Clouet drawing, and Nottingham, 1965, no.120 (a pencil copy by Bonington of a portrait of Eléonore d'Autriche). One might equally point to the enamel portrait of Marguerite de Navarre in the Petit Palais (illus. Mirepoix, *op. cit.*, p.190).

[7] It was engraved in 1660 and 1772. Bonington could have seen the original when he passed through Genoa on 8–9 June 1826; he could also have taken the pose of Marguerite for his second version of the composition from this Veronese.

[8] C. Blanc, *Gazette des Beaux-Arts*, 2e, I, 1869, p.218.

[9] Exhibited BFAC 1937(27).

[10] Shirley, p.104.

[11] Before 1968 it was supposed that P322 was shown in the Salon, but Spencer has since pointed out that the Salon reviews stated that the picture showed two hounds.

[12] Six versions, by or attributed to Bonington, may be identified as follows:

i) T. Woolner sale, Christie's, 12 June 1875(129)

ii) James Orrock, exh. Edinburgh 1886(1449)

iii) J. M. Scott sale, Christie's, 27 June 1913(51); Turner sale, Sotheby's, 1–2 June 1948(22); Agnew 1950; O. Bertram sale, Sotheby's, 4 July 1956(27); A. D. Rofe, panel 17.1 × 13.3

iv) H. Munro sale, Christie's 19–23 March 1880(212); J. S. Forbes; W. Fothergill sale, Robinson and Fisher, 5 July 1928(171); bt. Leggatt; H. L. Fison sale, Christie's, 6 November 1959(8); British Art Center, Yale (983 lent Paul Mellon); Mellon sale, Sotheby's, 18 November 1981 (137) as after Bonington; 76.8 × 64.8.

v) anon. sale, Spik's, Berlin, 6 December 1972(230), 35 × 27

vi) Art Institute of Chicago (no.1934.387), an unfinished sketch, 22.3 × 14.4. An oil sketch for one of the versions was in Bonington's sale, Christie's, 29–30 June 1829 (7, *Francis I and his sister*), bt. Triphook, £2.5. Another composition (a third oil) by Bonington, *François Ier et la duchesse d'Etampes*, now in the Louvre, has also been titled *François Ier and his sister* (e.g. a version in the W. J. Thompson sale, Christie's, 24 January 1913, lot 87).

[13] C. Blanc, *Histoire des Peintres, Ecole Anglaise*, 1863, 'Bonington', p.15, notes that this picture in the Webb sale (which he lists as that of Brown, see Dubuisson, p.188) passed to Périer and was then in the Delessert collection. P. Mantz, *Gazette des Beaux-Arts*, 2e, XIV, 1876, p.300, repeats this provenance.

[14] The *Revue Internationale de l'art et de la curiosité*, I, 1869, p.324, implies that Périer acquired P322 at the Brown sale: '*M. Paul Périer, qui l'a possédé* [P322], *le reconnaissait un peu plus avarié que lorsqu'il le détenait, il y a 30 ans ...*'.

P323 *Henri III*

The King in black wearing the blue ribbon of the Saint-Esprit;[1] Don John in white with gold trimmings holding a red cap; the *mignon* in a yellow-striped jerkin and red hose; green covered table.

Canvas, relined 54 × 64.4

There is a diagonal tear in the bottom left corner, and a fine craquelure in the darker areas. The surface has been heavily ironed.

Henri III (1551–89), King of France from 1574. The subject, which has in the past been variously described,[2] is taken from Alexandre Dumesnil's *Histoire de Don Juan d'Autriche*, 1825, a quotation from which was given by Bonington for the 1828 RA catalogue, see Exhibitions below. *En route* from Spain to the Netherlands in October 1576, Don Juan of Austria, disguised as a servant to Octavio Gonzaga, a gentleman of his retinue, gains an audience in the Louvre with Henri III, then suspiciously regarded by Spain. The real subject, however, is the intimate characterisation of Henri III.[3]

First exhibited in May 1828, see below, P323 has long been regarded as one of Bonington's most successful essays in historical genre, in which invention and colour overcome a certain lack of substance.[4] It is one of his last histories, and one of the largest.[5] Johnson has indicated[6] the probable influence of Delacroix, who was also interested at this time in Henri III and his times;[7] he lent a 'head of Henri III' to Bonington,[8] probably the drawing after the Jean Decourt portrait of c.1581 which was clearly Bonington's ultimate source,[9] and Delacroix's *Henri IV and Gabrielle d'Estrées* of 1827–8[10] shows the same limp hand holding a fan and certain similarities in handling. The pose of Henri III in P323 recalls

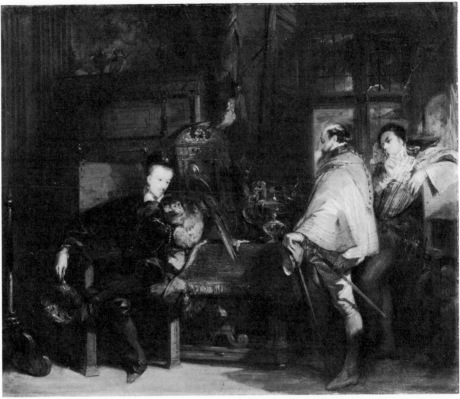

P323

Watteau's *Mezzetin*[11] and that of Don Juan (like that of the Ambassador in P351) seems to derive from the central figure in van de Venne's *Fête donnée à l'occasion de la Trêve de 1609* (Louvre).[12]

Drawing

Mr. Bonington's sale, Foster's, 6 May 1836 (29, 'The original sketch of Henry III of France for the celebrated picture'), bt. Colnaghi, 16s.

Copies

BEAUMONT LE ROGER private collection, later-nineteenth-century copy, inscribed '*traitée avant le grand tableau appartenant à Lord Herfort*'. LONDON A. L. Nicholson 1946; 54 × 64, ex-W. Manson and H. M. Allen collections and Christie's, 18 February 1927(51).

Version

PARIS Mme. Sayer 1931; an oil sketch similar to P323.

Provenance

Bonington sale, Sotheby's, 2nd day, 30 June 1829 (223, 'Henry, King of France, receiving the Spanish Ambassador ... exhibited at the Royal Academy in ... 1828'), bt. in (Colnaghi 80gn.); Mr. Bonington's sale, Christie's, 2nd day, 24 May 1834 (149, 'Henry III ... receiving the Spanish Envoy, the celebrated picture'), bt. Laneuville, £100; B. G. Windus (1790–1867); Sotheby's, 4 July 1848 (287, 'King Henry III of France receiving the Spanish Ambassador ... from the collection of Benjamin Godfrey Windus ... exhibited at the Royal Academy ... 1828'), bt. White, £50; Lord Henry Seymour (1805–59); his sale, Paris, 2nd day, 14 February 1860 (63, *Henri III recevant l'ambassadeur d'Espagne*), bt. Laboureau for the 4th Marquess of Hertford, 49,000 fr.; rue Laffitte inventory 1871 (681); Hertford House inventory 1890.

Exhibitions

RA 1828 (248, 'Henry III of France: '*Je (Don Juan) suis allé ce matin au Louvre sous les auspices de Gonzagues – Le Roi venait de présider au conseil, nous l'avons trouvé dans son cabinet avec une demie douzaine de petits chiens, ses plus affectionnés mignons des perroquets, et une guenon qui sautait sur les épaules de sa majesté. – On a fait sortir les chiens et les mignons. Nous demeurés* [sìc] *avec les perroquets. Hist. de Don Juan d'Autriche*');[13]
London, Suffolk Street, *Bonington*, 1832 (82, *Henry III of France*), and 76 Great Russell Street, 1833 ('admirable sketch for a larger picture, representing that most frivolous and mischievous lunatic Henry the third of France and some of his courtiers');[14] Bethnal Green 1872–5 (50, *Henri III receiving the English Ambassador*).

References General

Shirley, p.116, as 1827–8; Ingamells, pp.22, 55, 59, 72 n.78.

[1] The Order was revived by Henri III in 1579, three years after the incident depicted in P323 is alleged to have happened.

[2] See Provenance and Exhibitions. *The Times*, 6 May 1828, described 'the imbecile King' as receiving the 'Spanish and Austrian Envoys', otherwise until 1872 the subject was invariably the reception of a Spanish Ambassador; in 1872, at the Bethnal Green exhibition, the title became Henri III receiving the English Ambassador and, although there seems to have been no justification for it, it has been retained ever since.

[3] The *Literary Gazette*, 17 May 1828, remarked that 'as a graphic illustration of the character and habits of the French monarch it may be ranked with some of the well-described scenes by Scott in Quentin Durward or any other of his historical novels'.

[4] P323 was well received at the RA and admired by T. Gautier (*Gazette des Beaux-Arts*, 1ère, v, 1860, p.307) and P. Mantz, '*nous nous rappellons cette peinture comme on se rappelle l'aspect souriant d'une corbeille fleurie*' (*Gazette des Beaux-Arts*, 2e, XIV, 1876, p.302); criticism of the insubstantial figures was given by C. Blanc, *Histoire des Peintres, Ecole Anglaise*, 1863, '*Bonington*', p.12, and A. Dubuisson, *La Revue de l'Art ancien et moderne*, XXVI, 1909, p.388.

[5] Delacroix told Blanc, *op. cit.*, p.4, that at the end of his life Bonington was ambitious '*de faire de la peinture en grand. Il ne fit pourtant aucune tentative, que je sache, pour aggrandir notablement le cadre de ses tableaux; cependant, ceux où les personnages sont le plus grands datent de cette époque, notamment le Henri III . . . un de ses derniers*'. Only the *Quentin Durward at Liège* (Castle Museum and Art Gallery, Nottingham, 64.3 × 54, Nottingham 1965, no. 293, pl.44) of recorded histories is as large.

[6] L. Johnson, *The Burlington Magazine*, CXV, 1973, pp.672–6.

[7] *Ibid.*, CXVIII, 1976, p.620. Cf. Delacroix's *Henri III at the death bed of Marie de Clèves* (Johnson, *The Paintings of Eugène Delacroix 1816–31*, 1981, no. 126).

[8] As recorded in Delacroix's Louvre sketchbook, RF23355, f. 42v: [*Rivet*] *a la tête d'Henry III que j'avais prêtée à Bonington*, quoted by Johnson, 1973, p.675.

[9] Delacroix's drawing (with Nathan, Zurich, 1973) is illus. by Johnson, 1973, p.673. A good example of Decourt's portrait in oil is in the Musée Condé, Chantilly (*Inventaire*, 1970, no.39), and Decourt's own drawing, in reverse sense to Delacroix's, is in the Bibliothèque Nationale (illus. Johnson, 1973, p.673).

[10] Johnson 1981, no.127.

[11] H. Adhémar, *Watteau*, 1950, no.206; engraved in reverse by B. Audran. Bonington could have seen a copy sold in 1822, but the original painting was in Russia in his time.

[12] A drawing from this figure by Bonington is in the Castle Museum and Art Gallery, Nottingham (Nottingham 1965, no. 132).

[13] This quotation differs somewhat from the text of the 1827 edition of Dumesnil, p.135, where '*(Don Juan)*' is omitted, the *mignons* are named as Quelus and Saint Maigrin, and the monkey also climbs '*sur la tête de sa majesté*'; Dumesnil explained, p.133, that he was quoting letters, from Don Juan to the widow Quixiada, whose authenticity was open to doubt.

[14] Recorded in Anderdon's annotated RA catalogues (preserved in the Library of the Royal Academy), XX, 1828.

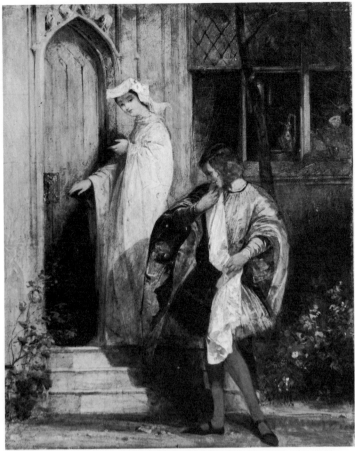

P333

P333 *Anne Page and Slender*

She wears a white head-dress and a lemon yellow dress; he wears a scarlet jerkin with a green lining and red hose.

Canvas 45.7 × 37.8

The varnish is somewhat discoloured, and there is a wide craquelure generally confined to the lighter areas; a small loss, centre right. *Pentimenti* reveal gothic tracery on the left-hand side of the doorway, and the porch was originally much wider.

The subject is taken from Shakespeare's *The Merry Wives of Windsor*, I, i, 277; before her father's house at Windsor, Page to Slender: 'Will't please your worship to come in, sir?'

Probably painted in 1825, when Bonington was closest to Delacroix, and in any case before the Italian visit of 1826. The composition connects by size, subject and configuration with several of Delacroix's works from the period 1824–26.[1]

The figures derive directly from illustrations to Joseph Strutt's *Complete View of the Dress and Habits of the People of England*, 1796–9; a fourteenth-century figure served for Page, and a fifteenth-century figure for Slender.[2]

Drawings

LONDON Mr. Bonington's sale, Christie's 1st day, 23 May 1834 (27, 'Ann Page and Slender, vignette in bistre'), bt. Pickering, £2.18. British Museum (no. 1857-2-28-154), a sheet of four studies copied from Strutt's *Dress and Habits* (see above), including that used for Page in P333.

Engravings

S. W. Reynolds 1829 (reversed); Baron 1853, as *La Châtelaine, Galerie du feu Duc d'Orléans*.

Provenance

Anon. sale, Phillips, 23 February 1833 ('Anne Page and Slender'), 60 gn.;[3] Ferdinand-Philippe, duc d'Orléans (1810–42); Hélène, his duchesse (1814–58); her sale, Paris, 1st day, 18 January 1853 (6, *Le Page et la Courtisane*, 45 × 37), bt. by the 4th Marquess of Hertford, 8,200 fr.; rue Laffitte inventory 1871 (229); Hertford House inventory 1890.

Exhibitions

Paris, Boulevard des Italiens, 1860 (100, *Anne Page et Slender*) lent Hertford; Bethnal Green 1872–5 (53).

References General

Shirley, p.104, as 1826; Ingamells, p.43.

[1] Cf. L. Johnson, *The Paintings of Eugène Delacroix 1816–31*, 1981, nos. 102 and 106–9, the subjects from Shakespeare, Cervantes, etc.
[2] First pointed out by R. Strong, *And when did you last see your Father?*, 1978, p.89, figs. 105–7; the fourteenth-century figure from Strutt's pl. XCIII ('Ladies of High Rank') and the fifteenth-century figure from pl. CX ('Persons of High Rank'); Slender's shoes, however, come from pl. CXIX ('Persons of Distinction of the 15th century'). For Slender Bonington used fourteenth-century colouring on a fifteenth-century costume, according to Strutt's tinted plates.
[3] Cf. The *Morning Post*, 27 February 1833 (Whitley Papers, British Museum).

P339 *On the Seine near Mantes*

Looking west, in pale summer evening light; in the distance the twin towers of the church of Notre-Dame with, to the left, the fourteenth-century tower of S. Maclou.

Canvas 31.3 × 46

Cleaned in 1978 by Hargrave, when old retouchings on the centre boat were removed. There are *pentimenti* on the church towers.

Mantes, in the province of Seine-et-Oise, between Paris and Rouen; Bonington was a frequent visitor, for his close friend Baron Rivet had a country residence there.

Possibly painted 1823–4. The heavy painting of the distant landscape and the slight irresolution in the centre group of figures and boats suggest a comparatively early date. The composition recalls some of Turner's river scenes of c.1807–10.[1]

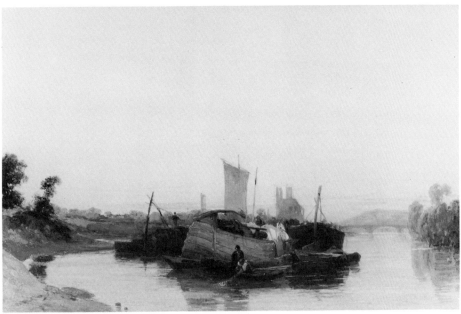

P339

Versions

LONDON Wildenstein 1946, 29.2 × 38.7, without the left-hand trees, ex-P.M. Turner collection (Shirley, p.90, pl.27).
Two related drawings are recorded: Sotheby's, 12 July 1967 (261), water-colour 10 × 27, without the boats, and Sotheby's, 20 April 1972 (70), wash drawing 14 × 21.6, the composition extended to the left, ex-Gregory sale, Sotheby's, 20 July 1949 (5).

Provenance

Possibly Arrowsmith sale, Paris, 20 February 1826 (10, '*Vue de Mantes: sur le devant la Seine chargée de bateaux*'), 330 fr., and Gérard sale, Paris, 10 December 1827 (76, '*Vue prise près de Mantes, sur la Seine, au soleil couchant. Ce tableau, d'un bel effet, rappelle les ouvrages de Cuyp*'), bt. du Sommerard, 280 fr. Lord Henry Seymour (1805–59); his sale, Paris, 1st day, 13 February 1860 (53, *Vue des Bords de la Seine*, 29 × 44),[2] bt. Laboureau, 2,500 fr.; the 4th Marquess of Hertford; Hertford House inventory 1890.

Exhibition

Bethnal Green 1872–5 (51, *The Seine near Rouen*).

References General

Shirley, p.93, as 1824; Ingamells, p.34.

[1] Cf. M. Butlin and E. Joll, *The Paintings of J. M. W. Turner*, 1977, nos. 90, 99 and 185, for example.
[2] Described in the *Gazette des Beaux-Arts*, 1ère, v, 1860, p.307, as '*d'un jaune peut-être un peu froid*'. While this seems certainly to be P339, the earlier sales references are more speculative.

P341 *On the Coast of Picardy*

A summer morning effect.

Canvas, relined 36.8 × 50.7

The surface is somewhat flattened as a result of relining, and is slightly rubbed. Immediately to the left of the grounded ship, in an area roughly 9 × 9 cm., the original paint surface has been scraped down and repainted, probably to modify the line of the distant cliffs. The vertical edges are discoloured beneath the frame.

A pencil inscription on the relining stretcher: *Bonnington Paris 1826*, was probably copied from the original canvas. The date would fit the accomplished handling and spatial certainty of P341.[1] The composition recalls a Turner water-colour of Scarborough.[2]

Drawing

LONDON British Museum (no. 1889–7–5–30), pencil drawing of the fallen crow's nest, reversed (Nottingham 1965, no.11).

Engravings

J. D. Harding 1829, as *On the Coast of Picardy*; C. Lewis 1833, as *Sea Shore*.

Versions

Mr. Bonington's sale, Christie's, 2nd day, 24 May 1834 (140, 'A sea shore with cliffs, and a brig aground, and a man with two horses in the foreground'), bt. Webb, 34 gn.
Four versions of uncertain attribution are otherwise recorded: with T. M. Dorrien-Smith 1953, oil 35.6 × 47.3; with Agnew 1919, oil 21.6 × 27.9, omitting the horses; with D. Towner 1968, sepia 14.9 × 22.6, possibly by Bonington; with H. Stonham 1921, water-colour copy, possibly the water-colour with L. J. Pritchard 1980, 15.2 × 21.6, showing two additional figures on the left-hand side.

Provenance

The 6th Duke of Bedford (1766–1839) by 1829;[3] Georgiana, his Duchess (d.1853); her sale, Bedford Lodge, Campden Hill, Farebrother, Clarke and Lye, 4th day, 14 July 1853 (758, *Coast Scenery*), bt. Mawson for the 4th Marquess of Hertford, 220 gn.;[4] Hertford House inventory 1870.

Exhibitions

Possibly Cosmoramic Galleries, Regent's Park, 1834 (46, *Marine View*) lent Bedford;[5] Bethnal Green 1872–5 (46, *Sea-Shore: a Brig aground*).

References General

Shirley, pp.90–1, as 1823; Ingamells, p.46.

[1] It compares with those larger coast scenes shown at Nottingham 1965, nos.267–8, and with the *Near Quilleboeuf* in the Yale Center for British Art, New Haven.
[2] RA 1811; A. Wilton, *J. M. W. Turner*, 1979, no.528. See Turner P654.
[3] Both Harding's and Lewis's plates acknowledged the original picture in the Duke of Bedford's collection. In 1826 A. W. Callcott had advised the Duke of Bedford to visit Bonington's Paris studio (Earl of Ilchester, *Chronicles of Holland House 1820–1900*, 1937, p.107; I am grateful to Edward Morris for this reference).
[4] Hertford bought P341 on Mawson's advice, cf. *Letters*, nos.31–3, pp.46–8.
[5] Though this could equally apply to Nottingham 1965, no.266, for example.

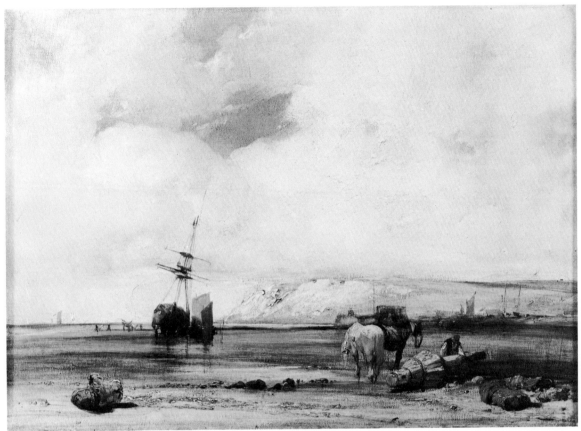

P341

P351 *Henri IV and the Spanish Ambassador*

The King in black wearing the blue ribbon of the Saint-Esprit; the Queen in brown, the Ambassador in white; the three children, from the left, in green, beige and red; the table is covered with a red Turkey rug; red curtains.

Canvas, relined 38.4 × 52.4

There are traces of bitumen in some of the darker passages, and a matt area, upper right centre, is probably the result of a hot iron used in relining.

Henri IV (1553–1610), King of France from 1589, and his Queen, Marie de Médicis (1573–1642). The subject is taken from '*Henri IV, Bon Père de famille*' in the *Mémorial pittoresque de la France* of 1786;[1] at Fontainebleau in 1604 the King is giving the Dauphin a piggy-back when

> 'an Ambassador arrives, to discover the conqueror of the Catholic League and the Monarch of France in this undignified position. The worthy Henri, without getting up, stopped and said:
> – Have you any children, Ambassador?
> – Yes, Sire.
> – Then I may finish my trip round the room.'

In 1604 the King had only two legitimate children, Louis, the Dauphin and future Louis XIII (b.1601), and Elisabeth (b.1602), who m. Philip IV of Spain; the third child was Christine (b.1606), who m. the Duke of Savoy. In 1817 both Ingres and Révoil painted this subject, making the ambassador Spanish, encouraged doubtless by the anecdotes told by Péréfixe concerning Henri IV and Don Pedro de Toledo, the ambassador with whom he helped negotiate the twelve year truce between Spain and the Netherlands in 1609.[2]

Probably painted 1827–8, and first exhibited in February 1828, P351 has since been generally admired as an essay in historical genre,[3] though it has not escaped criticism for the awkwardness of some of the figures.[4] The head of the King derives from his portrait by Pourbus of 1610;[5] the costume (at least) of the Ambassador seems to derive from the central figure in van de Venne's *Fête donnée à l'occasion de la Trève de 1609* (Louvre), and the perfunctory figure of the Queen seems based on Rubens's 1622 portrait in the Prado. The children's dress appears to date from the 1630s;[6] the costume of the central child recurs in P698. The motifs of the centrally seated Queen and the suspicious *griffon* were probably inspired by the Ingres composition (see note 2), and Johnson has indicated the probable influence of Delacroix's *Henri IV and Gabrielle d'Estrées*, both in subject and in the handling of the white satin draperies.[7]

Drawings

NOTTINGHAM Castle Museum and Art Gallery; pencil studies for the Ambassador, after van de Venne, see above, and for the *brocca* on the table (Nottingham 1965, nos. 132, 153). See also P733.

Engraving

L. Flameng 1870.[8]

Versions

LONDON Christie's, 30 April 1915 (18), drawing 24.1 × 30.5. Christie's, 28 July 1927 (33), oil 29.2 × 34.3.

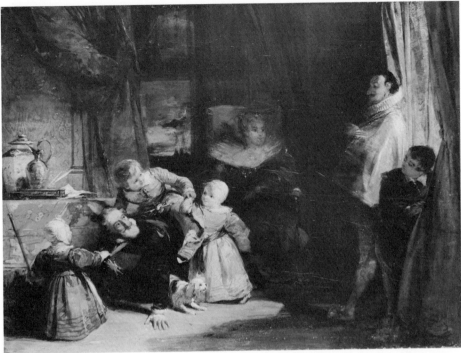

P351

Provenance

A.-P. Coutan (1792–1837);[9] his sale, Paris,
19 April 1830 (7, *Henri IV jouant avec ses
enfans*), 3,050 fr.; Gendron, from whom
acquired in 1837 by Anatole Demidoff
(1813–70); his sale, Paris, 1st day,
21 February 1870 (4, '*Henri IV et l'ambassadeur
d'Espagne . . . collection Gendron, acquis en 1837
pour San Donato*', 40 × 53), bt. Mannheim for
the 4th Marquess of Hertford, 83,000 fr.; rue
Laffitte inventory 1871 (423); Hertford House
inventory 1890.

Exhibitions

Paris, Salon, 1827–8, *2e supplément* (1605);
Bethnal Green 1872–5 (45).

References General

Shirley, p.113, as 1827; Ingamells, pp.55, 59.

[1] M.L.B. . . . *Mémorial pittoresque de la France, ou Recueil de
toutes les belles Actions, Traits de Courage, de Bienfaisance, de
Patriotisme et d'Humanité, arrivées depuis le Règne de Henri IV
jusqu'à nos jours, ouvrage proposé . . . et dédié à M. Le Vicomte de
Vaudreuil*, 1786, pp.19–22. The author adds that the same
tale was told of the Spartan King Agesilaus, and adds, in a
note: '*Peu d'historiens contemporains ont rapporté cette anecdote
touchante de la vie privée de Henri IV. On a même été jusqu'à la

croire apocryphe et renouvelée des Grecs. Mais, outre que nous ne
sommes pas les premiers à la publier, elle est si bien dans le caractère
du bon Roi . . . que nous n'avons pu nous résoudre à nous en dessaisir.
Si nous essuyons quelques reproches à ce sujet, nous sommes certains
qu'ils ne nous seront pas addressés de la part des Bons pères de
famille ou de leurs enfans*'. The story is illustrated with an
engraving by Bellavoine showing only the Dauphin of the
King's children. See also the catalogue, *De David à
Delacroix*, Grand Palais, 1974, p.499.
[2] H. Péréfixe, *Vie de Henri IV*, 1660; English ed. 1896,
pp.286–9. Ingres took his *Don Pedro of Toledo*
(Wildenstein, no.141) from this source. The original
version of the Ingres *Henri IV jouant avec ses enfants* is in the
Petit Palais, and there is a version in the Victoria and Albert
Museum (see Wildenstein, nos. 113–15). Révoil's version is
in a French private collection, see M. C. Chaudonneret,
La peinture Troubadour, 1980, p.134, no.13. Both Ingres and
Révoil showed four children (the fourth doubtless intended
for the duc d'Orléans, 1607–11) and their pictures were
commissioned, respectively, by the duc de Blacas and the
duc de Berri, who were close friends.
[3] See for example, *Le Miroir*, 20 February 1828;
E. Galichon, *Gazette des Beaux-Arts*, 2e, III, 1870, pp.99–100,
and P. Mantz, *ibid.*, 2e, XIV, 1876, pp.299–300 (he
considered that Bonington's reputation as a history painter
rested on P323 and P351).
[4] See, for example, A. Dubuisson, *La Revue de l'Art ancien et
moderne*, XXVI, 1909, p.388, and Dubuisson, p.123.
[5] See R. Strong, *And when did you last see your father?*, 1978,
p.87, illus.

[6] Strong, *loc. cit.*, suggested the costumes derived from van Dyck's portraits of the children of Charles I, but see also the engravings by Abraham Bosse whose work was known to Bonington (cf. Nottingham 1965, nos.114–16), e.g. *un maître d'école*, c.1630–40 (illus., C. Piton, *Le costume civil en France*, n.d., p.203).
[7] L. Johnson, *The Burlington Magazine*, CXV, 1973, p.675, and *The Paintings of Eugène Delacroix 1816–31*, 1981, no.127.

[8] Dubuisson, p.162; printed in the *Gazette des Beaux-Arts*, 2e, III, 1870, p.100, a reduced version in the Demidoff sale catalogue.
[9] Coutan also owned the water-colour version, P733, and one of the Ingres versions (Wildenstein, no.204, dated 1828).

P362 *Landscape with Timber Waggon*

Late summer evening effect.

Canvas, relined 50.5 × 68.7

Cleaned in 1978 by Hargrave. The surface is rubbed and somewhat flattened by ironing during relining before 1900.

Probably painted in 1825, the subject perhaps inspired by Constable's *Hay Wain* which Bonington saw in the 1824 Salon. Constable's *truth* and *vivacity* appealed to many young French artists[1] and here the bold lights, colour contrasts (such as the red yoke on the black horse) and scumbled paint contrast with Bonington's usual suavity. The clumped, wispy trees further suggest that Bonington may already have seen Turner's work,[2] implying a date after his return from London in September 1825. It is conceivable that P362 is a later version of the extended composition noticed below.

Engravings

See Versions below.

Versions

The following show the composition extended to the left, as it was engraved by C. Lewis 1831 and P. J. Delbarre.
LONDON Butler sale, Christie's, 7 July 1911 (22), as given by Bonington to de Sency. Coats sale, Christie's, 12 April 1935 (32), 66 × 77.5, ex-Nettlefold collection (illus. Dubuisson, f.p.121). Sotheby's, 13 March 1929 (75), 66 × 96.5, ex-Gillot and Woolner collections. Sotheby's, 12 March 1980 (94), 35.5 × 49.5, possibly a copy of the Ottawa version, see below.
OTTAWA National Gallery of Canada, 36.8 × 50.8 (illus. Shirley, pl.57).
Other unverified versions include Webb sale, Paris, 23–4 May 1837 (14), and Vernon sale, Christie's, 6 May 1842 (84).

Provenance[3]

J.-P. Collot sale, Paris, 29 May 1852 (1, *Paysage avec figures*, 51 × 69), bt. by the 4th Marquess of Hertford, 4,100 fr.; rue Laffitte inventory 1871 (136); Hertford House inventory 1890.

Exhibitions

Paris, Boulevard des Italiens, 1860 (102); Bethnal Green, 1872–5 (49).

References General

Shirley, p.102, as 1826; Ingamells, p.38.

[1] See Ingamells, pp.12,38 and 69 nn.16 and 17; Tate Gallery, *Constable*, 1976, no.192.
[2] Cf. M. Butlin and E. Joll, *The Paintings of J. M. W. Turner*, 1977, nos.130, 140 and 230. Similar trees appear in Bonington's *View on the Seine* in the Virginia Museum of Fine Arts (Nottingham 1965, no.258) which Cormack has argued should be dated after the London visit and the sight of Turner's 'similar drawings and prints' (*Master Drawings*, III, 1965, p.287).
[3] There are three seals on the *verso*: one is a Lombardo-Venetian nineteenth-century customs stamp; the others show a seated woman with a two-storied aqueduct and the motto NATVRA DVXIT INITIVM, and the Gothic initials A M above an anchor with the inscription Abramo MIELI. The same seals recur on P525 (Follower of Beccafumi).

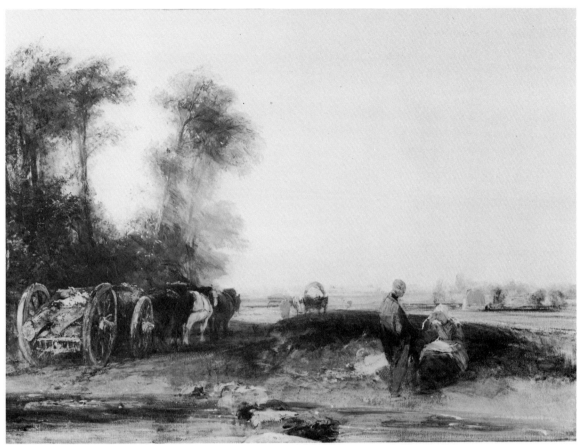

P362

P375 *Venice: the Piazza S. Marco*

From the west, in an early evening light; on the left the Torre dell'Orologio, on the right the Procuratie Nuove. Unfinished; the façade of S. Marco lacks the mosaic panels and bronze horses; there are no flag poles; the Campanile lacks windows on the left-hand side, and the Procuratie are hardly more than blocked in.

Canvas, relined 99.4 × 80.3

Heavily ironed in relining in 1884, and the varnish is somewhat discoloured. There are several losses in the foreground figures, a damage half-way down the left-hand side of the Campanile and a run of sepia glaze down the right-hand side. There are several *pentimenti* on the edges of the Campanile. The appearance of the archway (?) on the extreme right-hand edge suggests the composition has been reduced in width, possibly during the relining.

Presumably started in 1828 and left unfinished at the artist's death. P375 exemplifies the larger type of Venetian view, worked up from drawings made in Venice in 1826, which Bonington wished to produce in his final year as exhibition pieces.[1] The alignment of the Procuratie Nuove shows a precarious grasp of perspective,[2] and a similar view by Canaletto at Windsor makes an interesting comparison with its thinner Campanile and wider Piazza.[3]

Drawing

CAMBRIDGE Fitzwilliam Museum (PD2–1961), water-colour 25.9 × 20.8, signed and dated 1826 (Shirley pl.94), showing many detailed differences of proportion, particularly in the Campanile.

Copy

LONDON Sotheby's, 22 January 1981 (121), water-colour by H. B. Brabazon.

Provenance

Bonington sale, Sotheby's, 2nd day, 30 June 1829 (162, 'an upright view of the church of St Mark at Venice, unfinished'), bt. Cottley, £18; Webb sale, Paris, 23–4 May 1837 (51, '*Place St Marc, grand tableau non terminé*'); anon. sale, Paris, 15 March 1852 (116, '*Vue de place Saint-Marc à Venise. Tableau non terminé*'), 175 fr.; the 4th Marquess of Hertford; Hertford House inventory 1890.

Exhibition

Bethnal Green 1872–5 (48).

References General

Shirley, p.112, as 1827; Ingamells, p.55.

[1] Cf. *The Ducal Palace with a Religious Procession*, 114.3 × 162.5, exh. RA 1828, Tate Gallery (on loan to the Bowes Museum); Bonington's obituary in *The Gentleman's Magazine*, 98, 1828, ii, p.643, said it had been his intention to paint a series of pictures similar to the Tate picture. See also P323 note 5.
[2] Ruskin wrote of Bonington that 'If the young genius had learned the first rules of perspective, and never seen either Paris or Venice, it had been extremely better for him' (E. Chesneau, *The English School of Painting*, 1885 ed., p.135n.).
[3] See W. G. Constable, *Canaletto*, rev. by J. G. Links, 1976, no.12, pl.13.

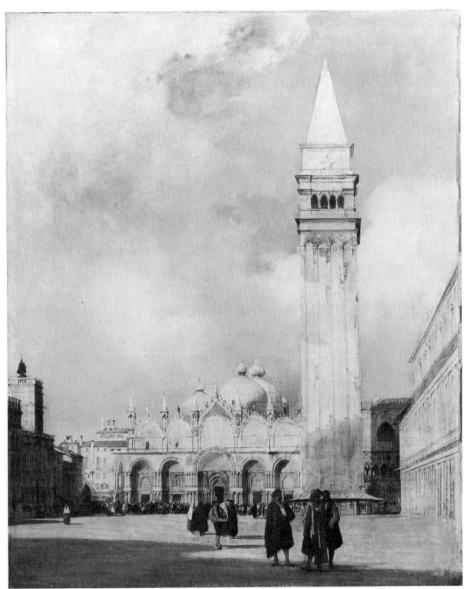

P375

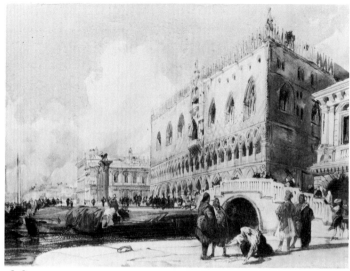

P656

P656 *Venice: the Doge's Palace from the Ponte della Paglia*

Looking west from the Ponte della Paglia, past the columns of S. Marco and S. Todaro towards the Library.

Water- and body-colour with gum varnish over the darker area, on paper 20.1 × 27.4 laid down on paper

The whites on the Prisons have darkened. The mounting sheet is inscribed, perhaps in a contemporary hand: *Palais Ducal Venise*.

The topography has been somewhat skimped; ten arches are shown in the right half of the loggia, where there are sixteen; ten, instead of seventeen finials, etc.; the fenestration of the Palace shows an extra top storey window, and the iron grille to the end bay of the Prisons has been omitted.

Probably painted in 1827–8. The lax topography (particularly when compared with the drawing, see below), and casual execution (seen particularly in the drawing of the Doge's Palace), while not undermining the attribution, strongly suggest that P656 is a later replica. It is known that Bonington was latterly under pressure to produce such views.[1] The foreground figure second from the right recalls the *souliote* costumes painted by Bonington and Delacroix in 1825–6.[2]

Drawing

BOWOOD pencil 27.4 × 38.1, a more accurate view (Nottingham 1965, no.80; illus. Dubuisson, f.p. 107).

Copy

A canvas, with Mrs. A. Platt 1975.

Versions

LONDON D. Goldberg 1979, water-colour, smaller than P656 but showing a slightly more extensive view, attributed to Bonington.
PARIS Louvre (R.F.368), oil 41 × 54, shown in the 1827 Salon (Nottingham 1965, no.286; Shirley, pl.117).

Provenance

Possibly Lewis Brown sale, Paris, 2nd day, 18 April 1837 (73, '*Vue du Palais ducal à Venise prise du côté de la mer: sur le devant, des Embarcations riches . . .*'), £15. Brown sale, Paris, 7 March 1843 (19, '*Vue du Palais ducal à Venise prise du côté de la mer; un grand nombre de petites figures spirituellement touchées et finement exécutées ornent ce beau dessin . . .*'), bt. Wallace for the 4th Marquess of Hertford, 1,000 fr.; probably rue Laffitte inventory 1871 (487, Bonington, '*le palais des doges*'); Hertford House inventory 1890.

Exhibitions

Bethnal Green 1872–4 (614) and 1874–5 (648a); Belfast 1876 (64, 74 or 103).

References General

Shirley, pl.128; Ingamells, p.51.

[1] See Dubuisson, p.81; Ingamells, p.22.
[2] Cf. Nottingham 1965, nos. 107–8 (probably by Delacroix) and 289–90. See L. Johnson, *The Burlington Magazine*, CVII, 1965, p.319, and *The Paintings of Eugène Delacroix 1816–31*, 1981, nos. 29–31.

P657 '*The Arabian Nights*'[1]

Signed below left: *R P Bonington 1825*.

Pencil, water- and body-colour with gum varnish over the darker areas, on paper 24 × 18.6 laid down on paper

The varnish has developed a fine craquelure and the whites on the left-hand curtain and on the sleeve of the right-hand figure have darkened.

The present title appeared on the old mount, and the figures have been interpreted as the King, Shahrazad and her sister, Dunyazad, from the *Prologue*; but the King is strangely obscure and it is possible that the sisters are shown with their father, the Vizier. The composition could equally represent an eastern genre scene, but see Provenance below.

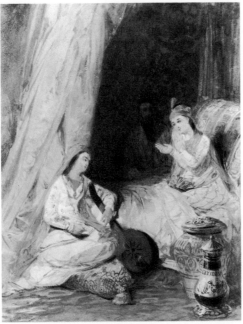

P657

P657 appears an early and tentative figure composition, possibly dating from before the London visit in June 1825. According to Saunier[2] Géricault (who d. in March 1824) had introduced Bonington to the oriental collection of J.-R. Auguste, and he probably knew of Delacroix's interest in Persian miniatures which dated from 1817.[3] The execution of the heads and head-dresses in P657 is heavy-handed, while the yellow curtain and the patterns on the cushion, sofa and foreground jars are weak compared, for example, with similar features in P750 of the following year. The attribution of P657 was doubted by the compiler in 1979 but, on balance, the weaknesses seem no greater than those in P733, for example.

Provenance
Possibly A.-P. Coutan sale, Paris, 19 April 1830 (116, *Sujet tiré des Mille et une Nuits*), 425 fr., or Mr. Bonington's sale, Christie's 2nd day, 24 May 1834 (115, 'A subject from the Arabian Nights; a Persian princess on an ottoman, with an attendant at her feet'), bt. Laneuville, £20. The 4th Marquess of Hertford; Hertford House inventory 1890.

Exhibition
Bethnal Green 1874–5 (706, *Eastern Women*).

References General
Shirley, p.97; Ingamells, pp.26, 65, the attribution doubted.

[1] Until 1913 P657 was catalogued as *Interior of a Harem* by Decamps.
[2] C. Saunier, *Gazette des Beaux-Arts*, 4e, IV, 1910, p.52; Bonington's studio at 11 rue des Martyrs, where he was first recorded in 1826, shared the same address with Auguste.
[3] See R. Escholier, *Delacroix*, 1926, pp.110–11, 118; R. Huyghe, *Delacroix*, 1963, p.119.

P668 *Meditation*[1]

In mid-seventeenth century costume, the old lady in black with a white under-skirt, the girl in white with lemon yellow bodice; plum-coloured curtains and umber wall hangings with red figuring. Signed below left: *R Bonington 1826*.

Water- and body-colour with gum varnish over the darker areas, on paper 21 × 16.2 laid down on paper

There is a small loss on the upper left edge of the girl's skirt, and some tiny scratch marks by the old lady's right shoulder.

Possibly painted before the Italian visit of April 1826. The girl's dress may derive from that of the girl in ter Borch's *Concert* in the Louvre and recurs in P672; the figure of the old lady is taken from an engraving of van Dyck's *Francesca Bridges*, see Drawings below.

Drawings
NOTTINGHAM Castle Museum and Art Gallery, pencil drawings for the girl's dress after ter Borch, and for the old lady after van Dyck (Nottingham 1965, nos.121 and 125). A drawing *Reading the Bible* was in Mrs. Bonington's sale, see below.

Engravings
S.W. Reynolds 1827, as *Meditation*;[2] Normand *fils*.

Copies
NOTTINGHAM Castle Museum and Art Gallery, oil 24.5 × 18.4.
YORK City Art Gallery (no.305), oil 35.6 × 26.7.

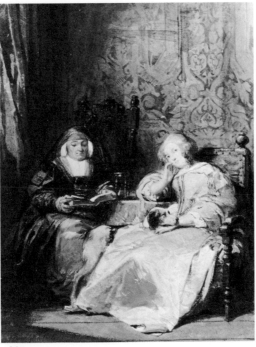

P668

Versions

Mrs. Bonington's sale, Sotheby's, 10 February 1838, (57, 'Reading the Bible. It was from this drawing that the artist made his large picture'). A variant in oil from the Horteloup collection was exhibited in Paris 1923 (listed in the 1928 edition of this catalogue).

Provenance

de Lopez sale, Paris, 31 January 1832 (1, '*La Lecture de la Bible. Une mère abesse fait la lecture à une jeune dame, dont l'air distrait indique assez qu'elle pense à toute autre chose; un chien de chasse appuie sa tête sur ses genoux, et semble prendre part à sa rêverie. On retrouve dans cette composition pleine de charme et de poésie, tout le brillant, le coloris, et l'élévation de Wandick*'), 1,700 fr,; Lewis Brown sale, Paris, 2nd day, 18 April 1837 (82, '*La Lecture de la Bible: une vieille Dame vêtue de noir et assise dans un fauteuil, lit un passage de la Bible à une jeune Femme qui l'écoute avec beaucoup d'attention*'), 14gn.; the 4th Marquess of Hertford; rue Laffitte inventory 1871 (498, '*une mère et sa fille*'); Hertford House inventory 1890.

Exhibitions

Bethnal Green 1874–5 (700, *Inattention*); Belfast 1876 (78).

References General

Shirley, p.106; Ingamells, p.46.

[1] Until 1904 P668 was catalogued as *Reading aloud*. The mood of the girl has been characterised as both attentive (Brown sale 1837) and inattentive (de Lopez sale 1832 and Bethnal Green exhibition 1874).
[2] Also published in G. Hamilton, *L'Ecole anglaise*, II, 1831–2, p.111, with verses by Mrs. Wilson.

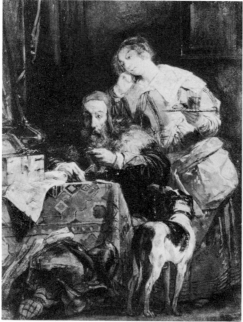

p672

p672 *The Antiquary*[1]

He wears a red cap and fur-collared jacket of the later-sixteenth-century Italian style; she wears a yellow dress of the later-seventeenth-century Dutch style.

Water- and body-colour with gum varnish over the darker areas, on paper 20.7 × 16 laid down on paper

The varnish has discoloured and there is a fine craquelure in the thicker areas, e.g. to the left of the man's head and below his left arm. The whites on the cloth and dog have darkened.[2]

Probably painted in 1827. The old man, like the similar figure in p698, is based on a portrait formerly attributed to Tintoretto of Doge Nicolò da Ponte,[3] probably via the reversed engraving by L. Vorsterman, see below. The girl's costume recurs in p668 and may derive from that of the girl in ter Borch's *Concert* in the Louvre.

Drawings

BOWOOD pencil, of the Doge Nicolò da Ponte, probably from Vorsterman's engraving with which it agrees in size and sense (Nottingham 1965, no.141).

NOTTINGHAM Castle Museum and Art Gallery, pencil, for the girl's dress after ter Borch (Nottingham 1965, no.125).

Engraving

S.W. Reynolds 1829, as *The Antiquary*.

Versions

LONDON art market 1982, water-colour 22.3 × 16.5, ex-G. de Rothschild, Mrs. Pleydell Bouverie and Mrs. Wohl collections, possibly a copy of p672.

PARIS P. Touzet 1950, oil on paper 26 × 18.5, possibly a copy.

Provenance

Lewis Brown sale, Paris, 1st day, 17 April 1837 (1, '*Un Antiquaire examinant avec une loupe un objet précieux; derrière lui, une jeune Fille debout et accoudée sur le dossier de son fauteuil, regarde avec attention l'objet qui l'occupe, et de la main gauche tient une assiette sur laquelle est un verre à moitié rempli de vin. Une cuirasse, devant la table sur laquelle est appuyé l'antiquaire, qui est couverte de vieux parchemins et d'une cassette à bijoux et un chien noir et blanc debout, garnissent le premier plan de ce dessin*'), bt. Anatole Demidoff (1813–70), 1,140 fr.; his sale, Paris, 2nd day, 14 January 1863 (42, *L'Antiquaire*), bt. by the 4th Marquess of Hertford, 5,100 fr.; Hertford House inventory 1890.

Exhibitions

Bethnal Green 1874–5 (698, *The Jeweller*); Belfast 1876 (80).

References General

Shirley, p.115, as 1827; Ingamells, p.51.

[1] P672 was catalogued in 1900 as *The Gold Weigher*, the present title being introduced in 1904.
[2] M. Hardie, *Water-colour Painting in Britain*. II, 1967, p.182, cited P672 as showing 'a hybrid and meretricious result that is certainly very near to oil painting'.
[3] A version of the oil was sold Paris, Hôtel Drouot, 24 February 1908 (62), and another is at Kansas University, attributed to the Master of the Corsini Adulteress.

P674 *A Venetian Scene*

In mid sixteenth-century Venetian costumes; the central male figure in a coat of Venetian red over a blue jerkin; the lady by him in white with a lemon yellow drape. Signed bottom right: RPB, the signature cropped along the lower edge.

Pencil, water- and body-colour, with gum varnish over the darker areas, on paper 18 × 24.9 laid down on paper

The varnish has developed a fine craquelure.

Probably painted in 1828; the loose technique and restrained touches of brilliant colour seem typical of Bonington's final year (cf.P708). The subject is a re-working of Veronese, recalling passages in his *Marriage Feast at Cana* (Louvre) or

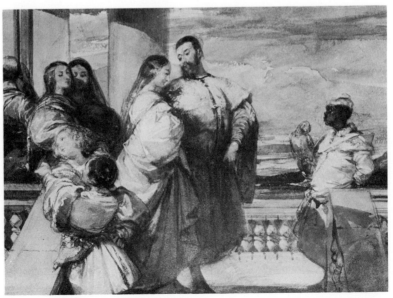

P674

Supper in the house of Levi (Accademia). The costumes seem to derive from Titian's frescoes in the Scuola del Santo, Padua, which Bonington sketched *in situ* between 19 and 24 May 1826; the lady's profile head recalls that of Mary in Sebastiano del Piombo's *Visitation* (Louvre) which Bonington had previously copied. Bonington's *Promenade vénitienne* of 1826,[1] which drew on the same sources, directly anticipated P674.

Drawings

BOWOOD pencil, of the head of Mary after Sebastiano del Piombo, see above (Nottingham 1965, no. 136).[2]
NOTTINGHAM Castle Museum and Art Gallery, pencil, after Titian, see above (Nottingham 1965, no.145).

Provenance[3]

Brown sale, Paris, 12–13 March 1839 (74, '*Seigneur vénitien et sa suite prenant le frais sur la terrasse de son palais. Fort belle composition d'une grande richesse de couleur digne du pinceau de Paul Véronèse...*'), 2,310fr.; Paul Périer (1812–97); his sale, Paris 19 December 1846 (46, '*Promenade vénitienne*'), 925 fr.; the 4th Marquess of Hertford; Hertford House inventory 1890.

Exhibitions

Bethnal Green 1874–5 (657a, *Venetian Group*); Belfast 1876 (76).

References General

Shirley, p.117, as 1828; Ingamells, p.51.

[1] French private collection, ex-Brown sale 1837, lot 14, bt. Paul Périer (Nottingham 1965, no.241).
[2] For other uses of this drawing by Bonington and Delacroix, see L. Johnson, *The Burlington Magazine*, CXVIII, 1976, p.621.
[3] P674 was previously identified with lot 6 in Lord Seymour's sale, but see P675.

P675 *The Earl of Surrey and Fair Geraldine*

Surrey in red, Geraldine in green. Signed bottom left: RPB.

Pencil, water- and body-colour, with gum varnish over the darker areas, on paper 14 × 11.9 laid down on paper

Henry Howard, Earl of Surrey (1518–47), poet, executed on a trumped-up charge of treason. Although Geraldine was named in only one of his poems, *Description and Praise of his love Geraldine*, it was supposed that she was the constant subject of his verse; she was identified as Lady Elizabeth Fitzgerald (b. c.1528) daughter of the 9th Earl of Kildare and Lady of the Bedchamber to the Princess Mary.[1]

Probably painted in 1826. While the literary-historical subject recalls Bonington's close association with Delacroix (cf.P333), the figures, the light and the architecture suggest that Bonington had already been to Italy, and that it was painted soon after his return in June 1826. The figure of Surrey is taken from the portrait of an unknown man at Hampton Court, engraved by Scriven in 1815 as a portrait of Surrey by Holbein.[2]

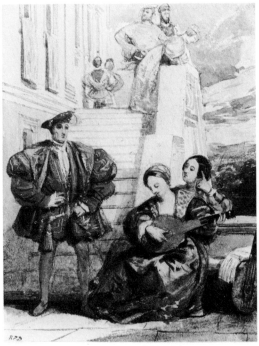

p675

Version

A drawing of *The Earl of Surrey and Fair Geraldine* appeared three times at Christie's in the mid-nineteenth century:
Utterson sale, 24 February 1857 (371),
Hibbert sale, 2 May 1860 (209), and Agnew sale, 28 October 1861 (977).

Provenance

Lord Henry Seymour (1805–59); his sale, Paris, 1st day, 13 February 1860 (6, *Scène vénitienne*),[3] bt. Laboureau, 1,290 fr.;
the 4th Marquess of Hertford; Hertford House inventory 1890.

Exhibition

Bethnal Green 1872–5 (618).

References General

Shirley, pp. 101–2, as 1825–6; Ingamells, p. 43.

[1] Surrey's poem was first published in 1557; the first account of the Geraldine romance was given by Thomas Nash in *The Life of Jack Wilton*, 1594. Bonington probably saw G. F. Nott's edition of Surrey's poems in which Nash's tale was embroidered (1815, I, pp.xxxvii–ix, cxvii–cxxix).

[2] E. K. Waterhouse, *Painting in Britain 1530–1790*, 1953, pl.8; the engraving illus. in R. Strong, *And when did you last see your father?*, 1978, p.88. A half-length engraving by Scriven of the portrait was used as the frontispiece for Nott's edition of Surrey's poems, see note 1.

[3] Previously identified as P674, but the *Gazette des Beaux-Arts*, 1ère, v, 1860, p.307, described this lot as '*Un jeune homme en rouge, et de jeunes femmes faisant de la musique au pied de la colonnade d'un palais de marbre; un vrai petit Véronèse.*'

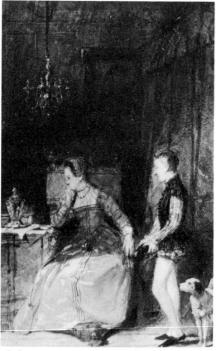

P676

P676 *Lady and Page*

She wears a yellow skirt, brown bodice and red cap, in the later-seventeenth-century Dutch style; he wears a black doublet and white hose, suggestive of mid-sixteenth-century Italy; dull red curtains and green table-cloth.

Pencil, water- and body-colour with gum varnish over the darker areas, on paper 15 × 9

The varnish is developing a fine craquelure and, particularly in an area lower right, a tendency to bubble causing minor losses.

Probably painted in 1826[1] and in any case before the Italian visit of April 1826. It may be compared with P668 and P732 from the same year.

Provenance
Lord Henry Seymour (1805–59); his sale, Paris, 1st day, 13 February 1860 (3, *Le Page messager*),[2] bt. Laboureau, 1,050 fr.; the 4th Marquess of Hertford; rue Laffitte inventory 1871 (484); Hertford House inventory 1890.

Exhibition
Bethnal Green 1872–5 (611).

References General
Shirley, p.97, as 1825; Ingamells, p.46.

[1] Due to a misreading of the description given in the *Gazette des Beaux-Arts*, 1ère, v, 1860, p.306, the date has previously been given as 1824, but see Ingamells, p.70 n.29.
[2] Described in the *Gazette des Beaux-Arts, loc. cit.*, as '*Le Page messager, et porteur sans doute, comme celui de M. de Marlborough, d'une triste nouvelle*'.

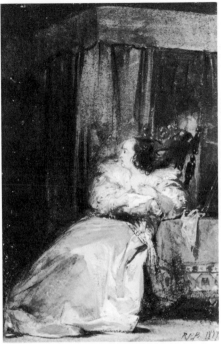

P678

P678 *The Letter*

She wears a yellow dress and her collar suggests French-Flemish costume of the 1620s; dull red curtains, red table-cloth. Signed, or inscribed, bottom right: RPB 1827.

Water- and body-colour with gum varnish over the darker areas, on paper 15.1 × 10

Darkened whites on the head were reversed in 1980. The thick varnish is cracking, resulting in some small losses lower left.

The signature and date may have been added, but the dramatic pose, bold touches and strong light would suggest that P678 could be later than P668 and P732 which are dated 1826.

Provenance
Lord Henry Seymour (1805–59); his sale, Paris, 1st day, 13 February 1860 (2, *Jeune Femme lisant une lettre*),[1] bt. Laboureau, 1,390 fr.; the 4th Marquess of Hertford; rue Laffitte inventory 1871 (485, '*La lecture interrompue*'); Hertford House inventory 1890.

Exhibition
Bethnal Green 1872–5 (617).

References General
Shirley, p.115; Ingamells, p.50.

[1] Described in the *Gazette des Beaux-Arts*, 1ère, v, 1860, p.306, as '*Jeune femme assise, lisant une lettre, expression très dramatique*'.

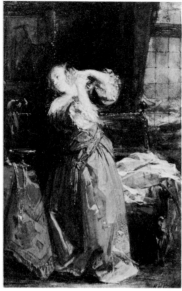

P679

P679 *A Lady dressing her Hair*

Wearing an emerald green dress, suggesting French-Flemish costume of the 1620s; blue and red parrot, red-covered table and scarlet chair, with blue-grey curtains behind. Signed bottom right: RPB. 1827.

Pencil, water- and body-colour with gum varnish over the darker areas, on paper 15.2 × 10.2 laid down on a second sheet 15.5 × 10.5 with a brown border-line

A particularly happy example of Bonington's historical genre, apparently without a specific literary source (though strongly reminiscent of Keats's *The Eve of St. Agnes*: '... her vespers done, /Of all its wreathed pearls her hair she frees').

Provenance
Lord Henry Seymour (1805–59); his sale, Paris, 1st day, 13 February 1860 (5, *La Toilette*),[1] bt. Laboureau, 2,430 fr.; the 4th Marquess of Hertford; rue Laffitte inventory 1871 (483); Hertford House inventory 1890.

Exhibition
Bethnal Green 1872–5 (610).

References General
Shirley, p.114; Ingamells, p.51.

[1] Described in the *Gazette des Beaux-Arts*, 1ère, v, 1860, p.306, as '*jeune femme debout, rajustant sa blonde chevelure*'.

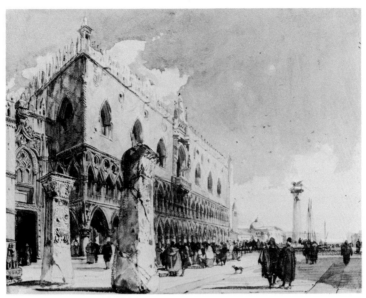

p684

P684 *Venice: the Piazzetta*

Looking south from immediately behind the Pilastri Acritani; from the left, the porphyry Tetrarchs on the south façade of the Treasury of S. Marco; the open Porta della Carta; the west front of the Doge's Palace, and the column of S. Marco; in the distance the campanile and church of S. Giorgio Maggiore.

Pencil and water-colour on whatman paper 17.4 × 22.2

Two small fox marks in the sky to the right.

The topography has been slightly romanticised; the Pilastri are exaggerated and the façade of the Doge's Palace is cursorily treated.[1]

Probably painted in 1826, and based on a pencil drawing made in Venice (see below) where Bonington stayed between 20 April and 19 May that year. It may be compared with P701 and with the dated *Verona: Corso Sant'Anastasia* in the Victoria and Albert Museum,[2] as an example of the sparkling Italian water-colours Bonington produced immediately after (or possibly during) his journey.

Drawings

BOWOOD pencil 26 × 36.2, a careful study showing a slightly extended view to the left with the Palace more dramatically foreshortened (Nottingham 1965, no.81). MANCHESTER City Art Gallery, water-colour 19.4 × 24.8, signed and indistinctly dated, the view-point slightly further to the right to include the column of S. Todaro; Nottingham 1965, no.220, and see Appendix v, no.11.

Copy

NEWCASTLE UPON TYNE Laing Art Gallery, water-colour.

Provenance

Possibly Brown sale, Paris, 12–13 March 1839 (69, '*Place du palais ducal à Venise: une infinité de personnages se promenant le long des arcades à droite desquelles s'élève le lion de saint Marc*'), and Brown sale, Paris, 7 March 1843 (7, '*Vue d'une*

partie de la place Saint-Marc, à Venise, et des deux colonnes qui l'ornent, et dans le fond, plusieurs Monumens: dessin orné de petites figures spirituellement touchées et d'une exécution énergique') bt. Véron, 335 fr. The 4th Marquess of Hertford; Hertford House inventory 1890.

Exhibitions

Bethnal Green 1874–5 (713); Belfast 1876 (64, 74 or 103).

References General

Shirley, p.107, as 1826; Ingamells, p.51.

[1] The carving on the north-west corner is omitted, for example. The relief over the Porta della Carta of the Doge Foscari with the lion of S. Marco had been destroyed in 1797 and was not replaced until 1885.
[2] Nottingham 1965, no.219. The dated water-colour of the Piazza S. Marco in the Fitzwilliam Museum, Cambridge, see P375, also belongs to this series.

P688

P688 *Souvenir of van Dyck*

In Flemish costume of the 1620s, the lady in black and gold in a red-upholstered chair, the right-hand girl in a dull red dress. Signed bottom left: *R P Bonington.*

Water- and body-colour with gum varnish over the darker areas, on paper 19.1 × 12.7

The white lights on the lady's nose, eyes and hairband, and on the right-hand girl's collar, have darkened.

Probably painted in 1826. The composition derives from van Dyck's *John, Count of Nassau, with his Family* (formerly at Panshanger, now at Firle Place), which was engraved by B. Baron in 1761; the lady in P688 is based on the Countess and the two children on a similar group on the far right of van Dyck's composition.

Provenance

Lewis Brown sale, Paris, 2nd day, 18 April 1837 (74, '*Une Dame en costume du temps de Marie de Médicis, assise dans un fauteuil, un petit Chien sur ses genoux, écoute avec attention ses deux jeunes Filles debout près d'elle, et dont l'une lui présente une rose à la suite d'un compliment qu'elles viennent de lui réciter . . .*'), £44; F. Villot (1809–75); his sale, Paris, 25 January 1864 (77, '*Portrait de femme et de ses deux filles. Une femme en costume du temps de Louis XIII, vêtue d'une robe de dessous feuille-morte, d'une robe de dessus en satin noir, assise dans un fauteuil, tenant un petit chien. Auprès d'elle ses deux petites filles debout. L'une d'elles a une rose à la main. Fond de paysage. Aquarelle . . . où l'artiste a cherché à imiter Van Dyck*'), bt. by the 4th Marquess of Hertford, 1,165 fr.; Hertford House inventory 1890.

Exhibition

Bethnal Green 1872–5 (616).

References General

Shirley, p.65, as later than P270 but not in his catalogue; Ingamells, p.43.

P696 *The Great Staircase of a French Château*

The figures on the stairs appear to be in earlier-seventeenth-century French-Flemish costume, the two pages in sixteenth-century Italian dress; the staircase suggests late-seventeenth-century French architecture.[1] Signed bottom left: *R P Bonington 1825*.

Water- and body-colour with gum varnish over the darker areas, on paper 18.1 × 16.8

An elaborate early essay in historical genre, distinguished by the dramatic foreground lighting, the small scale of the figures, and the prominent architectural features such as Bonington had been drawing in previous years, but which he was not to stress in subsequent genre pieces.[2] The dogs derive from Rubens's *Apotheosis of Henri IV*, and the pose of the man greeting the lady may derive from the similarly posed figure in *The Exchange of the two Princesses* also part of Rubens's Marie de Médicis cycle in the Louvre. The attribution of P696 was doubted by the compiler but, as with P657, the peculiarities seem, on balance, to be a part of Bonington's evolving style and P696 may have been painted at the same time as P333 and P733.

Provenance

Brown sale, Paris, 7 March 1843 (14, '*Une Dame, suivie de plusieurs personnages, descend l'escalier d'un palais, elle est rencontrée par un personnage qui la salue et la complimente; sur le devant, deux Pages près d'un pilastre à hauteur d'appui, l'un desquels tient deux chiens en lesse*'), bt. Wallace for the 4th Marquess of Hertford, 330 fr.; rue Laffitte inventory 1871 (486); Hertford House inventory 1890.

P696

Exhibition
Bethnal Green 1874–5 (701, *The Hall
Staircase*).

References General
Shirley, p.97; Ingamells, p.64, the attribution
doubted.

[1] Cf., for example, l'Escalier de la Reine at Versailles of
1679–81.
[2] A late re-working of the subject is the damaged water-
colour *On the Staircase*, dated 1828, in the Whitworth Art
Gallery, University of Manchester (Nottingham 1965,
no.244; Shirley, pl.153), where the figures dominate the
composition, see Appendix v, no.12.

P698 *Old Man and Child*

He wears a red cap and fur-collared jacket of the later-sixteenth-century Italian
style; the child in white holding a puppet is dressed in the fashion of the 1630s;
silver-blue curtain and deep-red chair. Signed bottom right: *R P Bonington 1827*.

Water- and body-colour with gum varnish over the darker areas, on paper
19.2 × 14.2 laid down on paper

The thicker layers of varnish – to the left of the man's head, by his left knee and
behind the girl's head – have cracked causing small losses. White heightening
on the curtain and the child's dress and bonnet has darkened.

P698

One of Bonington's most accomplished genre scenes, apparently without a literary source (though the lean old man with his armour inevitably recalls Don Quixote). His head-dress and collar derive from a portrait formerly attributed to Tintoretto of the Doge Nicolò da Ponte, see P672. The child's dress recurs in P351 (q.v., note 6).

Drawing

See P672.

Versions

LONDON Christie's, 18 March 1980 (206, *Grandpapa*), replica, 19.1 × 14, signed RPB, ex-Haldimand collection (formed 1826–8).
PARIS Petit, 16–19 June 1919 (53, *Enfant à la marotte*), 19 × 14, signed *R P Bonington*.

Provenance

Lewis Brown sale, Paris, 2nd day, 18 April 1837 (62, '*Assis dans un fauteuil et les mains appuyées sur les genoux, un Vieillard coiffé d'une barette rouge tient entre ses jambes une petite Fille qui lui parle et qu'il écoute avec une grande attention*'),
bt. Anatole Demidoff (1813–70), 3,700 fr.; his sale, Paris, 2nd day, 14 January 1863 (43, *Le vieillard*), bt. by the 4th Marquess of Hertford 9,100 fr.; Hertford House inventory 1890.

Exhibitions

Bethnal Green 1874–5 (703); Belfast 1876 (82).

References General

Shirley, p.115; Ingamells, p.51.

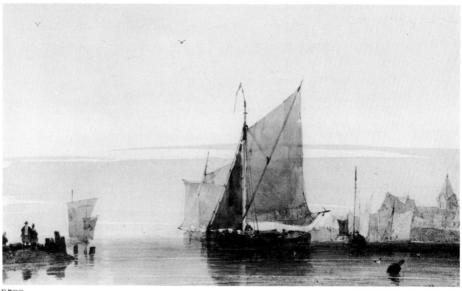

P700

P700 *Fishing Boats*

An early morning effect, looking east. Signed bottom right: *R P Bonington*.

Pencil and water-colour on paper 16.7 × 26.5 laid down on paper

Lightly cleaned in 1979. The colour has faded, as is particularly noticeable in the sky.

Probably painted c.1822.[1] The old mount had the inscribed title: *A Dead Calm*.

Provenance

Possibly Lewis Brown sale, Paris, 1st day,
17 April 1837 (20,'*Groupe d'Embarcations sur
une mer calme; effet de soleil levant*'), £30. Brown
sale, Paris, 7 March 1843 (15, '*Marine calme;
plusieurs bâteaux pêcheurs ayant leur voiles déployées
garnissent le devant . . .*'), bt. Wallace for the 4th
Marquess of Hertford, 600 fr.; Hertford
House inventory 1890.

Exhibition

Bethnal Green 1874–5 (712).

References General

Shirley, p.91, as 1823; Ingamells, p.34.

[1] A date also implied by M. Hardie, *Water-colour Painting in Britain*, II, 1967, p.181.

P701

P701 *Bologna: the Leaning Towers*

From the Via Rizzoli, the Torre Asinelli on the right, the Torre Garisenda on the left; the dome of S. Bartolomeo beyond.

Pencil, water- and body-colour with touches of gum varnish, on paper
23.4 × 16.9 laid down on paper

The towers date from the early twelfth century; the Garisenda, whose list Bonington has greatly exaggerated,[1] was described as leaning by Dante (*Inferno* XXXI, 136).

Probably painted in 1826, and based on a drawing made in Bologna (see below) where Bonington stayed briefly on his way from Venice to Florence between 19 and 24 May 1826. It may be compared with P684 and belongs to an outstanding group of Italian water-colours probably executed immediately after his return to Paris in June 1826 (see P684 note 2).

Drawings

LONDON P. M. Turner 1940, pencil
18.7 × 11.4, with the Torre Garisenda more
concealed and no awnings on the first-floor
windows to the right, inscribed *Bolognia; show
both sides of the small tower*, and probably
preparatory for P701; ex-Heseltine sale,
Sotheby's, 29 May 1935 (290) (Shirley,
pl.104); it directly resembles an unfinished
etching by Bonington of 1826–7[2] and the
engraving by W. J. Cooke 1831.[3]
What appears to be a second pencil drawing,
closely comparable to the above, sold
Christie's, 25 February 1921 (70),
ex-H. E. Walters collection and J. E. Taylor
sale, Christie's, 8 July 1912 (178).

Version

CIRENCESTER private collection, water-colour
20 × 12.7, by T. S. Boys, probably connected
with Boys's work on the Bonington etching,
see note 2.

Provenance

Brown sale, Paris, 12–13 March 1839 (64,
'*Place publique, à Bologne. Malgré la grande
vigueur qui règne . . . l'artiste a su faire circuler l'air
autour de ses bâtimens et conserver à ses ombres toute*

leur transparence'); Anatole Demidoff
(1813–70); his sale, Paris, 2nd day, 14
January 1863 (37, *Une place à Bologne*), bt. by
the 4th Marquess of Hertford, 3,650 fr.;
Hertford House inventory 1890.

Exhibition

Bethnal Green 1874–5 (711).

References General

Shirley, p.105; Ingamells, p.51.

[1] The inaccuracy is demonstrated by comparison with the
water-colour of the same view by Callow, dated 1864, in
the Victoria and Albert Museum (J. Reynolds, *Callow*,
1980, fig.84; J. Roundell, *T. S. Boys*, 1974, figs.1 and XX).
M. Hardie, *Water-colour Painting in Britain*, II, 1967, p. 183,
also draws attention to Bonington's comparative weakness
in perspective, cf. P375 note 2.
[2] Curtis, no.62, listing seven states of which only the first is
entirely by Bonington. Boys added the sky for the second
state, published by Colnaghi, 15 October 1828 (Shirley,
pl.157).
[3] The plate appeared in *The Gem*, 1832, *The Amaranth*, and
The Coronal, 1835.

P704 *Rouen*

Late summer evening effect, looking north-east across the Seine to the three
towers of Rouen Cathedral.

Water- and body-colour with gum varnish over the darker areas, on paper
17.9 × 23.5

Probably painted in 1825; the busy and dramatic composition, the dragged
colour and the use of gum varnish, suggest a date no earlier.[1] It may owe
something to Turner's view of Basle in the *Liber Studiorum* (R.5), while the
inclusion of the central Cathedral tower which had collapsed in 1822 indicates
that Bonington was working from previous drawings.

Engraving

J. D. Harding 1830.

Copies

A copy in sepia was with A. M. Russell in
1958, and another in pencil was with
B. R. Braga in 1960.

Version

Lewis Brown sale, Paris, 1st day,
17 April 1837 (8, '*Vue de Rouen: sur le devant, la
Seine couverte d'Embarcations d'une couleur riche et
harmonieuse; effet de soleil levant*'), bt.
Anatole Demidoff, 800 fr.; his sale, Paris, 2nd
day, 14 January 1863 (39, *Vue de Rouen*),
4,550 fr., wrongly said to have been bt. by the
4th Marquess of Hertford;[2] with Agnew,
Manchester.[3]

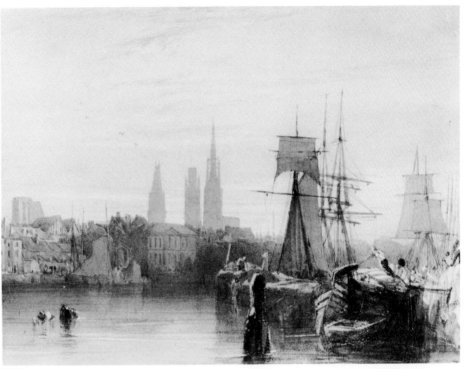

P704

Provenance

J. Barnett 1830;[4] probably de Lopez sale,
Paris, 31 January 1832 (5, '*Vue de Rouen,
délicieuse aquarelle tout à fait dans le goût de Claude
Lorrain. . .*'), 500 fr.; Brown sale, Paris,
7 March 1843 (26, '*Vue de Rouen. Sur le devant,
la Seine couverte de bateaux à voiles, et dans le fond,
des maisons et des monumens. . . la vapeur du soir au
soleil couchant y est parfaitement rendue*'),
bt. Wallace for the 4th Marquess of Hertford,
760 fr.; probably rue Laffitte inventory 1871
(230, '*la Seine à Rouen*'); Hertford House
inventory 1890.

Exhibitions

Bethnal Green 1874–5 (707); Belfast 1876
(65).

References General

Shirley, p.105, as 1826; Ingamells, p.38.

[1] See Shirley, pp.62–3, and M. Hardie, *Water-colour
Painting in Britain*, II, 1967, p.182.
[2] *La Chronique des Arts*, II, 1863, p. 84, but the Pillet papers
in the Archives des commissaires-priseurs (Archives de
Paris) deny this.
[3] Dubuisson, p. 194.
[4] Harding's 1830 lithograph is lettered: 'From a drawing in
the collection of Mr. J. Barnett'.

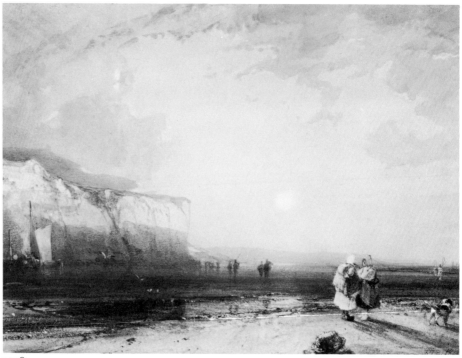

P708

P708 *Sunset in the Pays de Caux*

Signed bottom right: R P.B. 1828.

Pencil, water- and body-colour with gum varnish over the darker areas, on whatman paper 19.8 × 26.3

The *pays de Caux*, the chalk plateau north of the Seine in Normandy which ends at the channel coast in spectacular cliffs stretching from the cap de la Hève to Tréport.

One of Bonington's finest water-colours, and one of his last. Although a sense of place is carefully preserved, P708 aspires to an elegiac mood unusual in Bonington's work. Both execution and concept recall Turner; the blotted sun, the dragged colour of sky and foreshore and, above all, the dramatic confrontation with the light; Bonington may have remembered the Mildmay Sea Piece, engraved in the *Liber Studiorum* (R.40), the *Mortlake Terrace* which he saw at the RA in 1827 and, perhaps, some of the Cowes oils Turner painted in 1827.[1] It seems clear that subsequently such works by Bonington encouraged Turner to produce, for example, his *Calais Sands* (RA 1830) and *Fort Vimieux* (RA 1831).[2] Where Turner could suggest to Bonington effects of grandeur and particular virtuosity in execution, Bonington offered him the example of the decorative, lyrical touch (seen in P708, for example, in the foreground figures and the rich luminous shadows on the cliff face).

Drawings

Two related pencil drawings were exh. BFAC 1937: no.119c, lent by Sir Hickman Bacon, and no.125a, lent by P. M. Turner.
Another related pencil sketch is in one of the Newton Fielding sketchbooks in the Castle Museum and Art Gallery, Nottingham.

Engraving

W. Miller 1831, as *Sea-Shore, Cornwall*.

Copies/Versions

Versions in oil, attributed to Bonington, include:
MANCHESTER City Art Gallery, 30.5 × 39.7, ex-P. M. Turner and Assheton-Bennett collections (Shirley, pl.25).
NEW YORK exh. Blakeslee Gallery 1898, no.9, 30.5 × 35.6.
P. Gosselin 1940, 21.8 × 23 (Shirley, pl.37).
French private collection 1983, panel 19.5 × 27.
Others recorded in the collections of Mrs. B. Goody 1957, T. W. Newbolt 1970, and F. S. Arthur 1972.
A variant, 61 × 76.2, exh. Cleveland Museum of Art 1909–46 as Cotman.

A water-colour version was with R. J. Spac 1962, and a wash drawing with Dr. D. W. Wynne Jones 1973; both appear to be copies.

Provenance

Lewis Brown sale, Paris, 2nd day, 18 April 1837 (66, '*Plage à marée basse avec falaises blanches et garnies de petites Figures d'une couleur riche; ce beau dessin, effet de soleil couchant, est d'une transparence et d'une richesse de lumière telles, que l'on peut le comparer à une production de Claude Lorrain*'), bt. Anatole Demidoff (1813–70), 2,382 fr.; his sale, Paris, 2nd day, 14 January 1863 (40, *Plage à marée basse*), bt. by the 4th Marquess of Hertford, 8,780 fr.; rue Laffitte inventory 1871 (584, '*soleil couchant*'); Hertford House inventory 1890.

Exhibitions

Bethnal Green 1874–5 (710); Belfast 1876 (70).

References General

Shirley, pp.116–7; Ingamells, p.38.

[1] M. Butlin and E. Joll, *The Paintings of J. M. W. Turner*, 1977, nos.3, 239 and 267.
[2] *Ibid.*, nos.334 and 341.

P714 *Milan: interior of S. Ambrogio*

Looking towards the high altar from the third bay of the nave, the bronze serpent on a granite column in the left foreground, the organ case facing it on the right. Signed bottom right: RPB 1827, the signature cropped along the lower edge.

Water- and body-colour with gum varnish over the darker areas, on buff paper 22.1 × 28.6

S. Ambrogio, essentially a twelfth-century basilica, where the Lombard Kings and Germanic Emperors were crowned; the bronze serpent was considered to have been that described in Numbers XXI, 9. Comparison with surviving features and with an interior view of 1824[1] suggests that Bonington has tended to gothicise the proportions; the nave is narrower, the arches more pointed, the altar canopy narrower and more pointed, and the pulpit more upright. An extensive restoration, undertaken principally between 1858 and 1890,[2] has since changed the view; the arches are now rounded, and the organ case and choir screen have been removed.

Bonington was in Milan from 11 to 14 April 1826 and P714 is based on drawings he then made, see below. It has always been regarded as one of his outstanding water-colours,[3] remarkable for its rendering of cool interior light.

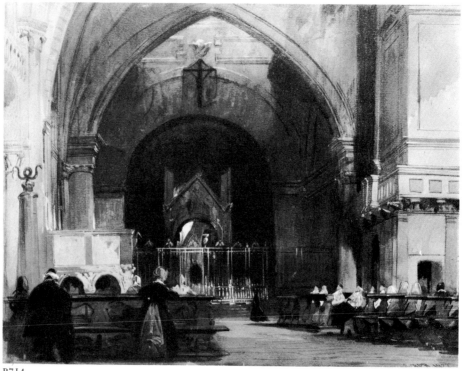

P714

Versions

LONDON Sir John Braithwaite, water-colour 18.7 × 16.8, a more sombre view, possibly executed in Milan, ex-E. J. Weldon sale, Sotheby's, 11 November 1936 (37); Nottingham 1965, no.217.
Sotheby's, 24 June 1977 (104), oil sketch bearing signature, 16.5 × 21.5, the view point slightly further from the altar; possibly ex-Bonington sale, Christie's, 29–30 June 1829 (61), Webb sale, Paris, 23–4 May 1837 (15); later with Major A. W. Allan and sold Sotheby's, 29 June 1929 (61).

Provenance

Possibly Bonington sale, Christie's, 2nd day, 30 June 1829 (207, 'Interior of a Church at Milan, highly finished in colours'), bt. Hull, 11 gn., and Lewis Brown sale, Paris, 1st day, 17 April 1837 (2, '*Vue d'intérieur d'une Église de Venise;*[4] *des Prêtres assis dans des stalles et plusieurs Figures à genoux et vues de dos, garnissent ce dessin . . . La lumière est distribuée . . . avec un art prodigieux et l'entente du clair-obscur y est d'une rare perfection*'), £29.10. Anatole Demidoff (1813–70); his sale, Paris, 2nd day, 14 January 1863 (38, *Intérieur d'une église*), bt. by the 4th Marquess of Hertford, 4,150 fr.; Hertford House inventory 1890.

Exhibitions

Bethnal Green 1874–5 (709, *Interior of a French Church*); Belfast 1876 (63).

References General

Dubuisson, pp. 111, 185; Shirley, p. 114; Ingamells, p. 51.

[1] Aquatint by A. Sanquirico in G. Ferrario, *Sant'Ambrogio in Milano*, 1824, pl.11, f.p.89.
[2] Deplored by A. K. Porter, *Lombard Architecture*, II, 1916, pp.534–5, 575–6. The 1913 Baedeker *Northern Italy*, p.182, stated that the 'excrescences of the 17th–18th century' were all removed by F. Schmidt (1858 and after) and G. Landriani (1865–89).
[3] Cf. A. Dubuisson, *La Revue de l'Art ancien et moderne*, XXVI, 1909, pp.202, 379: '*merveille d'observation et de délicatesse*' and '*petit chef d'oeuvre d'observation où la lumière mystérieuse et douce des vieilles basiliques est rendue avec une rare perfection*'.
[4] The title inscribed on the old mount of P714 was: *Chapel St. Mark's, Venice*.

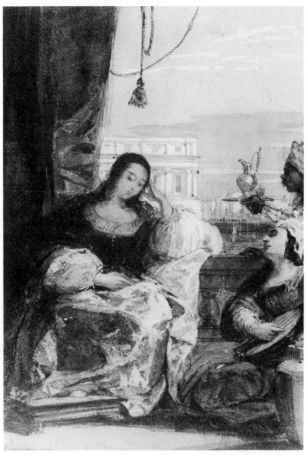

P726

P726 *La Siesta*[1]

In sixteenth-century Italian costume; the left-hand woman wears a red skirt, the lutanist has a bright green drape; dull red-brown curtains. Signed bottom left: RPB.1828.

Pencil, water- and body-colour with gum varnish over the darker areas, on paper 18.6 × 13 laid down on paper

The whites on the lutanist's hand and on the right-hand woman's left sleeve have darkened.

Like P674, P726 is a re-working of an earlier subject, in this case *Le Repos* of 1826;[2] the figures are larger and the composition is more full in P726.

Engraving

J. D. Harding 1829, as *La Siesta*, the composition extended slightly to the right.

Version

PARIS Sedelmeyer sale, 16–18 May 1907 (9), oil 46.5 × 39, a simplified version; this, or another, with the Galerie 18, Paris, 1972.

Provenance

J. Carpenter 1829;[3] Brown sale, 7 March 1843
(18, 'Dans une galerie donnant sur un grand canal de
Venise, dont on aperçoit plusieurs de ses beaux palais
dans le fond, est une jeune Dame richement vêtue et
assise près d'une large draperie... qui paraît
écouter... une romance chantée par une de ses
suivantes qui est accroupie à ses pieds; derrière elle,
un nègre qui porte sur un plateau une aiguière
d'argent'), bt. Paul Périer (1812–97), 370 fr.;
his sale, Paris, 19 December 1846 (41, La
Vénitienne), 1,005 fr.; the 4th Marquess of
Hertford; Hertford House inventory 1890.

Exhibition

Bethnal Green 1874–5 (702, Scene in Venice).

References General

Shirley, p.117; Ingamells, p.51.

[1] Catalogued in 1900 as A Balcony Scene, changed to Le
Repos or La Siesta in 1913, and to La Siesta in 1928.
[2] One of the Cahier de Six Sujets; Curtis, no.44.
[3] Harding's lithograph is lettered 'From a drawing in the
Possession of Mr. Carpenter'; J. Carpenter & Son published
Harding's lithographs after Bonington.

P727 *Charles V visits François Ier after the Battle of Pavia*

The page on the left is in emerald green; Charles V in black; lilac coloured curtains.

Water- and body-colour with gum varnish over the darker areas, on paper 13 × 16.5

The whites on the dog and on the paper on the table have darkened; the gum varnish is tending to bubble. Down the left-hand side a strip of paper, 7 mm. wide above and 17 mm. below, with a straight edge, appears to be an original addition.

François Ier (1494–1547), King of France from 1515, and Charles V (1500–58), the Holy Roman Emperor; Charles defeated François at the battle of Pavia, 24 February 1525, and took him captive to Madrid where he became ill. Charles visited him, concerned that his prisoner might die before a settlement had been reached, but François recovered to sign the Treaty of Madrid early in 1526 (by which he agreed to a marriage with Charles's sister, Eléonore d'Autriche, solemnised in 1530). The elderly figure of Charles V in P727 is an anachronism; he was then twenty-five. In 1837 the subject was described as *The Death of Leonardo da Vinci* (as is incribed on the old mount), and it was engraved as such c.1890, see below.[1] The present title seems sufficiently authenticated by Harding's 1829 lithograph, and was also used in 1839 (see Provenance).

Probably painted in 1827, and evidently after the Italian visit (the figures are flavoured by Veronese, despite a Rembrandtesque gloom). While P727 shows a developed sense of historical drama, the awkwardness of the foreground page might suggest that it precedes the histories of 1827–8, such as P351 and P323.

Engravings

J. D. Harding 1829, as *Charles V visiting Francis I after the battle of Pavia*; F. Courbin (b.1869), as *La Mort de Léonard de Vince*.

Copies/Versions

Two oils, attributed to Bonington, are recorded:
LONDON P. M. Turner 1940, 25.4 × 30.5, ex-Lord Effingham's collection.

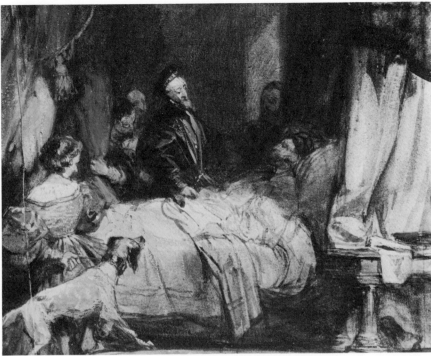

P727

VERSAILLES, private collection, 37.5 × 46.
A variant composition, attributed to
Bonington, was in the Sedelmeyer sale, Paris,
16–18 May 1907 (7).
A version in water-colour, the same size as
P727, probably a copy, is in a private
collection, London.
A *Charles V visiting Francis I* by Bonington was
exh. Grosvenor Gallery 1888 (96),
29.2 × 34.3, lent T. Woolner.

Provenance

W. Clarkson Stanfield (1793–1867) in 1829;[2]
Lewis Brown sale, Paris, 1st day, 17 April
1837 (6, '*François Ier visitant Léonard de Vinci,
malade, dont il tient une des mains: sur le devant et
au pied du lit, un jeune Page vêtu de vert et vu de dos,
tient en lesse un Chien blanc . . .*'), bt. Brown (the
brother of the deceased), 1,120 fr.; Brown sale
Paris, 12–13 March 1839 (72, '*François Ier,
malade au lit, reçoit la visite de Charles V*'); Brown
sale, Paris, 7 March 1843 (16, '*Le Malade.
Dans un appartement tendu de larges draperies, est
un homme malade et couché dans un lit; à côté de lui
et debout un Docteur, vêtu d'une ample robe de satin*
*noir, lui tâte le pouls et paraît donner ses avis sur sa
maladie; plusieurs Personnages qui l'entourent
paraissent écouter avec attention ce qu'il dit et
regarder le malade avec curiosité; sur le devant, à
gauche du spectateur, un Page de vert et vu de dos,
tient en lesse un chien blanc*'), bt. Wallace for the
4th Marquess of Hertford, 410 fr.; Hertford
House inventory 1890.

Exhibition

Bethnal Green 1872–5 (702, *Death of Leonardo
da Vinci*).

References General

Shirley, p.111, as 1826–7; Ingamells, p.55.

[1] Catalogued as the *Death of Leonardo da Vinci* in 1900, the
title changed to the present one in 1913. The death of
Leonardo in the arms of Francis I was described by Vasari
and provided a popular subject for the Troubadour
painters; the Ingres version (Salon 1824, Wildenstein,
no.118, a pendant to his *Henri IV jouant avec ses enfants*, see
P351) may have encouraged the use of the title for P727.
[2] Harding's lithograph is lettered 'From a Drawing in the
Possession of Clarkson Stanfield Esqre'.

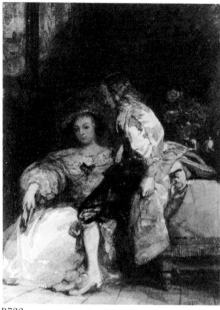

P732

P732 *Lady and Cavalier*

In English costume of c.1640; she wears a white skirt, he wears a pink satin blouse with black doublet and white hose; light-green table-cloth with pink roses in the vase. Signed bottom right: RPB. 1826, the signature cropped along the lower edge.

Pencil, water- and body-colour with gum varnish over the darker areas, on paper 13.4 × 10

White heightening, on the book and on the cavalier's legs, has darkened.

Probably executed before the Italian visit in April 1826. The cavalier's left leg is unresolved and the left shoe disproportionately large.

Engraving
Bonington 1826, *Cahier de Six Sujets* as *La Conversation*;[1] the figure group, except for details of light and shade, the same, but several variations elsewhere (e.g. in the lithograph there is a curtain to the left, a picture on the wall, centre, and the floor-boards run across the picture).

Provenance
Brown sale, Paris, 7 March 1843 (24, '*La Conversation. Dans un appartement, une jeune Dame assise dans un large fauteuil parait écouter avec attention un jeune homme qui s'appuie sur une table recouverte d'un tapis vert, sur laquelle un vase avec des pavots*'), bt. Wallace for the 4th Marquess of Hertford, 1,015 fr.; Hertford House inventory 1890.

Exhibition
Bethnal Green 1874–5 (704, *Maid and Page*).

References General
Shirley, p.97, as 1825; Ingamells, p.46.

[1] Curtis, no.46; the lithograph is the same size as P732.

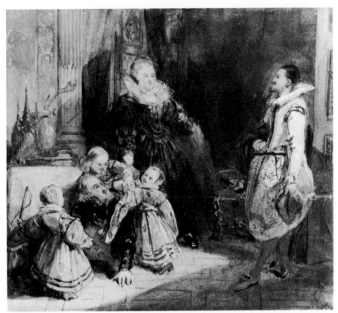

P733

P733 *Henri IV and the Spanish Ambassador*

The King in black wearing the blue ribbon of the Saint-Esprit; the Queen in purple, the Ambassador in white with red hose.

Pencil, water- and body-colour with gum varnish over the darker areas, on paper 15.5 × 17.2

For the subject, see P351.

Although the composition relates fairly closely to P351, it is much less successful and is probably considerably earlier, c.1825.[1] The figure of the Queen, the drawing of the floor and of the centre child, and the alignment of the right-hand doorway are all weak, while the lighting has none of the brilliance of the later oil. The figure of the Ambassador is taken from the right-hand centre figure in van de Venne's *Fête donnée à l'occasion de la Trêve de 1609* (Louvre); the King's head is very close to that in the Ingres version of the subject shown in the 1824 Salon (see P351). The Queen derives from a Rubens portrait, see Drawings.

Drawings
LONDON British Museum (no.1852–2–28–155), pencil, the head of Marie de Médicis after Rubens's *Henri IV confers the Regency on the Queen* (Louvre), in the reverse sense to the head in P733 (Nottingham 1965, no.148).
NOTTINGHAM Castle Museum and Art Gallery, pencil, 'Male Costume 1580', may have helped furnish the figure of the Ambassador (Nottingham 1965, no.140; Shirley, pl.73). A sheet of figure studies, exh. BFAC 1937 (99) as Bonington, and associated by Shirley with P733 (p.66), is no longer accepted as by Bonington.[2]

Versions
See P351.

Provenance

A.-P. Coutan (1792–1837);[3] his sale, Paris,
19 April 1830 (114, '*Henri IV jouant avec ses
enfans, au moment de l'arrivée de l'ambassadeur
d'Espagne*'), 603 fr.; Lewis Brown sale, Paris,
1st day, 17 April 1837 (12, '*Henri IV et
l'Ambassadeur d'Espagne*'), bt. Dubois,
2,000 fr.; Paris, 23 April 1845, acquired by the
4th Marquess of Hertford, 2,300 fr.;[4] rue
Laffitte inventory 1871 (495, '*le Prince à
cheval*'); Hertford House inventory 1890.

Exhibition

Bethnal Green 1874–5 (704).

References General

Shirley, p.106, as 1826; Ingamells, p.59, as
c.1827.

[1] Such a date is also implied by M. Spencer, *Apollo*, LXXXI,
1965, p.474.
[2] The sheet bears colour notes in French, otherwise
unknown with Bonington, and the attribution is rejected by
Spencer (letter on file).
[3] See P351 note 9.
[4] Entry in the 4th Marquess's account book in the Wallace
Collection archives, '*25 avril aquarelle de Bonnington Henri 4 et
ses enfans 2300*'.

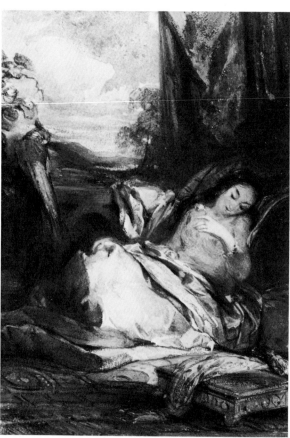

P734

P734 *Odalisque in Red*

Wearing a red skirt, holding blue and white flowers; an emerald green cushion above the stool on the right, plum-coloured curtain and red parrot. Signed lower right: RPB. 1827.

Pencil, water- and body-colour with gum varnish over the darker areas, on paper 21.5 × 15 laid down on paper

The varnish is cracking in the thicker areas, resulting in small paint losses above the foreground stool, to the left of the head and in the background area below.

The bold execution and strong, Venetian colour provide a marked contrast with P749. P734 may be compared with Bonington's *Odalisque au palmier*, also dated 1827, in the Louvre,[1] and the oil by Delacroix of 1827, *Woman with Parrot*, in the Musée des Beaux-Arts, Lyon.[2]

Engravings
S. W. Reynolds c.1835, as *Evening*;[3] J. Laurens (reversed).

Versions
PARIS G. Renand, oil 24 × 18.5 (Shirley, pl.126). P. Prouté, oil 24 × 17 (exh. Musée Jacquemart-André, *Bonington*, 1966, no.81).

Provenance
Possibly Webb sale, Paris, 12–13 March 1833 (17, '*Odalisque à demi nue, couchée sur des coussins et jouant avec une belle de jour; un Perroquet rouge est perché sur un balcon au-dessus duquel on voit un joli Paysage; de riches draperies couvrent et entourent la figure...*'). Paul Périer (1812–97); his sale, Paris, 19 December 1846 (42, *L'Odalisque Blanche*), bt. by the 4th Marquess of Hertford, 3,000 fr.; Hertford House inventory 1890.

Exhibition
Bethnal Green 1874–5 (705, *Woman asleep*).

References General
Shirley, p.114; Ingamells, p.46.

[1] Nottingham 1965, no.242; Shirley, pl.138.
[2] L. Johnson, *The Paintings of Eugène Delacroix 1816–31*, 1981, no.9.
[3] Reynolds's plate described as 'by the late S. W. Reynolds' (he d.1835), and issued with a pendant *Morning* (cf. Dubuisson, pp.161, 163; A. Whitman, *S. W. Reynolds*, 1903, nos. 336–7).

P749 *Odalisque in Yellow*

Wearing a yellow skirt, a red-striped head-dress, reclining on a purple sofa; a blue Chinese porcelain vase in the left foreground. Signed centre left: *R P Bonington 1826*, the signature cropped along the lower edge.

Water- and body-colour with gum varnish over the darker areas, on paper 15.5 × 17.4

The varnish shows a fine craquelure which has caused minute losses (e.g. on the back of the sofa). White heightening on the feet has darkened.

Since 1874, P749 has been known as *Medora*, a title taken from Byron's *The Corsair* of 1814, but there seems to have been no evidence for it.[1] P749 fits with

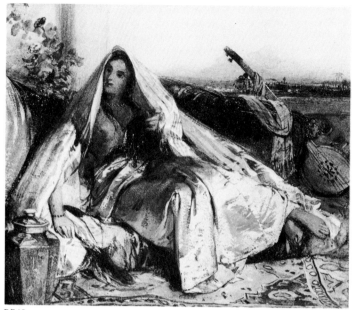

P749

other middle-eastern subjects, apparently without specific literary sources, which Bonington painted under the inspiration of Delacroix and Auguste (see P657, P734 and P750).

Probably painted while Bonington was sharing Delacroix's studio, and in any case before his Italian visit.

Provenance

Lewis Brown sale, Paris, 2nd day, 18 April 1837 (60, '*Odalisque étendue sur son divan et entourée de riches tapis et instrumens de musique; un Vase de porcelaine orne le devant*'), bt. Brown (brother of Lewis), 1,105 fr.; Paul Périer (1812–97); his sale, Paris, 19 December 1846 (43, *L'Odalisque à la robe jaune*), bt. by the 4th Marquess of Hertford, 2,020 fr.; Hertford House inventory 1890.

Exhibition

Bethnal Green 1874–5 (699, *Medora*).

References General

Shirley, p.105; Ingamells, p.43.

[1] Byron's Medora awaited her husband, Conrad, while he fought the Seyd; but her hair was long and fair (I, xiv) and no passage in the poem seems to fit P749 exactly.

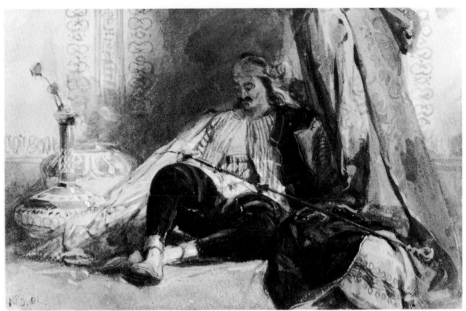

P750

P750 *Turk Reposing*

Wearing a red cap and red-striped smock; blue-patterned tiles, red flowers and red curtains. Signed bottom left: R.P.B. 1826.

Pencil, water- and body-colour with gum varnish over the darker areas, on paper 11.3 × 17.7

The white heightening on the right-hand drape and on the pots has darkened.

Like P749 probably painted while Bonington was sharing Delacroix's studio,[1] and in any case before the Italian visit. It may be compared with Delacroix's *Seated Turk*, now dated 1825, in the Louvre.[2]

Versions

Bonington exhibited a *Turc assis* at the Galerie Lebrun, Paris, May 1826, no.17.
Two versions in oil, each without the tall vase seen in P750, are recorded:
NEW YORK Emmons sale, 14–15 January 1920 (127), 38.7 × 41.3, ex-Sayle collection, Boston, Mass.[3]
DUBLIN National Gallery of Ireland, 24 × 29.2, in the reverse sense to P750, probably the picture lithographed by R. J. Lane in 1829, and from the collections of Sir Thomas Lawrence, Samuel Rogers and T. Birchall.[4]

Provenance

Lewis Brown sale, Paris, 2nd day, 18 April 1837 (78, '*A demi couché sur un sopha richement couvert de tapis et entouré de draperies des couleurs les plus riches, un Turc se repose à l'ombre d'un beau rideau; tout le haut de la figure est dans la demi-teinte et la lumière en éclaire le bas*'), £10; Brown sale, Paris, 7 March 1843 (27, '*Sur un divan, un Turc assis la tête appuyée sur une de ses mains, tient de l'autre une longue pipe; près de lui un narguiller et un vase de parfums*'), bt. Wallace for the 4th Marquess of Hertford, 550 fr.; Hertford House inventory 1890.

Exhibition
Bethnal Green 1872–5 (699).

References General
Shirley, p.105; Ingamells, p.46.

[1] As with P749 it is tempting to suppose the subject was inspired by Byron's *The Corsair* (e.g. 'High in his hall reclines the turban'd Seyd . . . the long chibouque's dissolving cloud supply'), but no passage fits exactly.

[2] L. Johnson, *The Paintings of Eugène Delacroix 1816–31*, 1981, no.35.

[3] Sometimes identified as the original of Lane's lithograph, but this was refuted by P. Oppé, *Bonington*, BFAC 1937, under no.30.

[4] Oppé, *loc. cit.*; Shirley, pl.97. Although he already owned P750, Hertford was anxious to acquire the *Turk* in the Rogers sale, see *Letters*, nos. 64–5 and 67, pp.77, 79 and 81.

After Bonington

P319 *Bergues: Market Day* [1]

The sixteenth-century *beffroi* in the mid-distance; the sunlit market glimpsed beyond.

Millboard[2] 35.2 × 25.2

The bottom corners have been knocked, and there are minor losses bottom right. A discoloured strip, approximately 7mm. wide, runs round the outer edges.

Bergues, five miles south of Dunkirk; the celebrated belfry was destroyed in 1944 and a replacement built after the war. Bonington was a frequent traveller in north-east France from 1821, and he spent most of 1824 in Dunkirk.

Previously catalogued as by Bonington, but the execution, ranging uncomfortably between heavily impasted lights and thinly glazed shadows, suggests a less practised hand.[3] The composition closely resembles Bonington's lithograph of Bergues, *Jour du Marché*, published in *Restes et Fragmens*, 1824,[4] but the right-hand dormer window is much less certainly positioned and lit, and the number and activity of the figures have been increased. The fenestration of the two nearest left-hand houses relates more closely to a pencil drawing at Bowood of houses at St-Omer.[5] It has been suggested that Corot remembered P319 when he painted *Le beffroi de Douai* in 1871,[6] but his inspiration may rather have been Bonington's lithograph.

Provenance
Probably Lord Henry Seymour (1805–59); his sale, Paris, 1st day, 13 February 1860 (60, *Vue de Ville*, 54 × 24),[7] bt. Laboureau, 6,000 fr. The 4th Marquess of Hertford; rue Laffitte inventory 1871 (530, '*esquisse, vue de ville*'); Hertford House inventory 1890.

Exhibition
Bethnal Green 1872–5 (42, as *Tower, Rouen, 1872*, *La Tour au Marché, Bergues*, 1874).

References General
(as Bonington): Dubuisson, p.147; Shirley, p.88, as 1822; Ingamells, p.34, as c.1822–3.

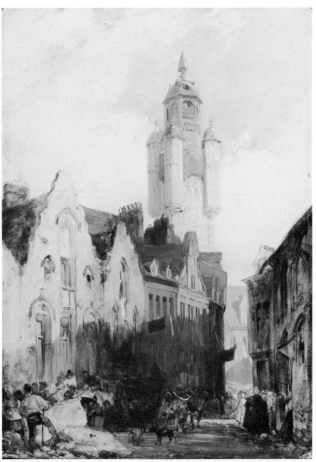

P319

[1] P319 did not appear in the 1st edition of the Catalogue; in the 2nd (1900) it was called *A Street Scene in a Flemish City*; the present title first appeared in the 3rd edition (1901).
[2] The board bears *verso* the label: *R. Davy, 83 Newman Street, London;* Davy supplied boards to Bonington (cf. Nottingham 1965, nos.258–9 and 275); see M. Cormack, *Master Drawings*, III, 1965, p.287.
[3] M. Spencer, *Apollo*, LXXXI, 1965, p.473, considered P319 a late landscape and 'one of Lord Hertford's most inspired acquisitions', but P. Noon, *Drawing*, III, 1981, p.41, thought it 'certainly not by Bonington but by a contemporary follower', and I have come to accept this view entirely.

[4] Curtis, no.6. The second state was titled *La tour du Marché*. The composition was also engraved by W. J. Cooke 1831.
[5] Nottingham 1965, no.56. A copy, from the E. V. Utterson collection, is in the British Museum, no.1857–2–28–129.
[6] A. Brookner, *The Times Literary Supplement*, 21 March 1980, p.319.
[7] Described in the *Gazette des Beaux-Arts*, 1ère, V, 1860, p.307, as '*Vue d'une rue de Rouen, étincelante d'effet et de vérité historique*'. P319 was exhibited in 1872 as a view of Rouen, see above. The dimensions given in the sale catalogue are clearly mistaken; perhaps 34×24 was intended.

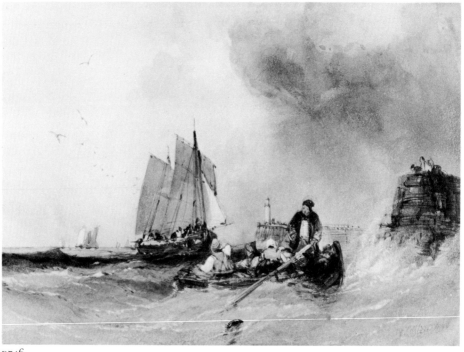

P746

William Callow (1812–1908)

Born on 28 July 1812 in Greenwich. He was articled to Theodore Henry Fielding in London in 1823 and in 1829 went with him to Paris where he stayed almost continuously until 1841. Louis-Philippe's children were his pupils 1834–41. He returned to London in 1841; in 1855 he settled in Great Missenden where he died on 20 February 1908. A prolific painter, he exhibited at the ows from 1838, BI 1848–67 and RA 1850–76.

P746 *Entering Harbour*

Signed bottom right: *W. Callow. 1842.*

Water-colour on paper 23.8 × 32 laid down on card

The title on the old mount is given as *French Fishing Boats*.

Provenance
Acquired by the 4th Marquess of Hertford; Hertford House inventory 1890.

Exhibitions
Bethnal Green 1874–5 (684); Belfast 1876 (57).

Reference General
J. Reynolds, *William Callow*, 1980, p.170.

Thomas Sidney Cooper (1803–1902)

Born on 26 September 1803 in Canterbury where he was first a coach painter and scenic artist, before entering the RA schools in 1824. From 1827 to 1830 he worked in Brussels, spending some time in the studio of Eugène Verboekhoven whose animal subjects, together with those of Cuyp and Potter, had a profound effect upon him. Following the political disturbance which led to Belgian independence in 1830, Cooper returned to London early in 1831 to embark on a very long and successful career as an *animalier*. He exhibited at the BI 1833–59 and RA 1833–1902; he was elected ARA 1845 and RA 1867. He died in Canterbury on 7 February 1902.

Abbreviation

Sartin S. Sartin, *Thomas Sidney Cooper*, 1976

P309 *An Evening Scene*

Signed bottom right: *T. Sidney Cooper ARA/1852*.[1]

Mahogany panel 75.3 × 76 × 0.8 two horizontal members, the upper 20.2 wide; two short oak battens added to the top and bottom edges bring the maximum height to 76.1 painted area 76 diameter

The panel appears to have been cradled before the picture was painted;[2] there are three horizontal splits, at 21, 27 and 38 cm. above the bottom edge. The varnish is much discoloured.

The composition is particularly reminiscent of Cuyp. P309 was one of three circular compositions on panel painted in 1852, perhaps a commissioned series.[3]

Provenance

William Llewellyn of Bristol;[4] his sale,
Foster's, 4 April 1855 (32, 'An Evening Scene, with a group of three cows, circular [75] in diameter'), bt. in, 92 gn.;[5] the 4th Marquess of Hertford; Hertford House inventory 1870.

Exhibition

Bethnal Green 1872–5 (41).

Reference General

Sartin, no. 100.

[1] Previously misread as... *Cooper RA...*, and the *RA* supposed to be a later addition, but the signature has not been altered.

[2] Spills of paint from the ground run between the battens; the cradle, of nine horizontal members and nine vertical battens, is labelled; *Charles Robertson & Co, 51 Long Acre, London.*

[3] The other two being: *Goats in the Highlands*, panel 76.2 diameter, sold Christie's, 17 April 1964 (59), and formerly in the Llewellyn collection with P309 (Sartin, no. 101), and *Mountain Sheep*, panel 76.2 diameter, sold Sotheby's, 11 July 1972, lot 157 (Sartin, no. 102).

[4] Two seals on the verso of P309, recorded in 1915 – on a shield, the crest a chapeau upturned ermine, a bull gorged with a crown; and an earl's coronet (no longer visible) – suggest that the picture had previously belonged to a noble collector. The seal may have been that of a member of the Ashley Cooper family, Earls of Shaftesbury.

[5] Hertford purchased the Sant P602 at this sale.

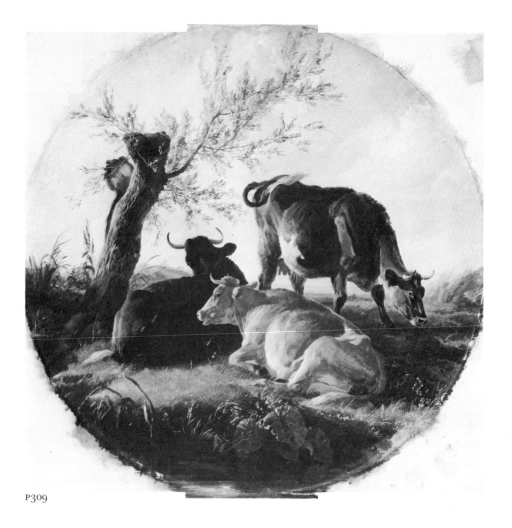

P309

Stephen Poyntz Denning (c. 1787[1]–1864)

A pupil of J. W. Wright in London, whose address he used between 1814 and 1817. He showed small-scale portraits in oil and water-colour at the RA 1814–52, and two genre scenes in oil at the BI in 1844. From 1821 he was Curator of the Picture Gallery at Dulwich, where he died on 18 June 1864.

[1] As given by P. Murray, *Dulwich Picture Gallery, A Catalogue*, 1980, p.50. Previously said to have been born in 1795.

P765 *Queen Victoria (after Sully)*

There are minor variations from P564, e.g. different folds in the gloves in her right hand, no fluted column top left, fewer medallions on the Garter collar, and more ermine visible round the shoulders.

Water- and body-colour with gum varnish over the darker areas, on paper 39.1 × 35 laid down on card

For the sitter see Sully P564.

The differences from P564, described above, largely coincide with the variations in Wagstaff's 1840 engraving (see p.181) which was doubtless the prime source for P765. Denning could have seen P564 at the RA in 1840 and P765 was probably painted in, or very soon after, that year.

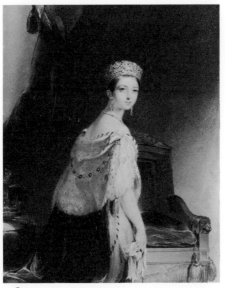

P765

Engravings/Versions
See Sully P564.

Provenance
The 2nd Duke of Buckingham (1797–1861) of Stowe, where he received the Queen and Prince Albert in 1845; Stowe sale Christie's, 21st day, 12 September 1848 (additional lot 17),[1] bt. Redfern for the 4th Marquess of Hertford, 32 gn.; Hertford House inventory 1870 as an enamel after Winterhalter.

Exhibition
Bethnal Green 1872–5 (615).

[1] See H. R. Forster, *The Stowe Catalogue priced and annotated*, 1848, p.163: 'Portrait of the Queen – in water-colours, after Sully – (Denning)'.

William Derby (1786–1847)

Born on 10 January 1786 in Birmingham, where he first studied under Joseph Barber. In 1808 he came to London and set up as a painter of miniature portraits and as a copyist. His best-known works are the water-colour copies he made for Lodge's *Portraits* (see below) between 1825 and 1834. He exhibited at the RA 1811–34 and 1837, and intermittently at the BI 1822–42. He died in London on 1 January 1847.

P709 *The Duke of Wellington (after Lawrence and Evans)*

Grey hair, blue eyes, wearing a red tunic and blue-grey cloak.

Water-colour on card 18.2 × 14.2

For the sitter see Morton P632.

One of a series of water-colour portraits made for Lodge's *Portraits* (see Engraving, and P713). An inscription on the *verso*[1] states that P709 was painted in 1834 and copied from two sources: the head from a chalk drawing by Lawrence belonging to Mr. Harding, and the figure from a picture by W. Evans. The Lawrence drawing, now untraced, was bought by Harding at Lawrence's sale, Christie's, 18 June 1831, lot 69, for 37 gn.. William Evans of Eton remains an obscure copyist; seventeen of his small portraits after various masters, including Lawrence, Beechey and Reynolds, were also in the Bicknell sale. There are five recorded versions of his portrait in oils of the Duke of Wellington, similar to P709 but with a markedly inferior head;[2] one was engraved for Lodge by Ryall on 1 June 1834 'From the original by Wm. Evans Esqr.', but was clearly regarded as unsatisfactory, leading to the commissioning of P709 with a superior head, engraved the following year.

Engraving
H. T. Ryall 1835, for E. Lodge's *Portraits of Illustrious Personages of Great Britain*, 1835, XII, no.20.

Provenance
George Knott (1797–1844) of Bohun Lodge, East Barnet; his sale, Christie's, 26 April 1845 (1), bt. Elhanan Bicknell (1788–1861) of Herne Hill, 15 gn.; his sale (drawings), Christie's, 1st day, 29 April 1863 (51), bt. Wells for the 4th Marquess of Hertford, £29; Hertford House inventory 1890.

Exhibitions
Bethnal Green 1872–5 (622, as an enamel by Henry Bone until 1874 when correctly described); Belfast 1876 (101).

[1] In pencil: '*Duke of Wellington Sir Thomas Lawrence Mr Harding's /W Derby 1834 figure from a picture by Evans*'; and in ink: '*Arthur Wellesley Esq / Duke of Wellington / From the Original Chalk by / Sir Thomas Lawrence PRA / In Mr Harding's possession and / bought at Sir Thomas Lawrence's sale / Drawn by W Derby 1834 / Figure from a picture by W. E …*'
[2] These five are (or were): with Lord Cottesloe; Eton College; Henry E. Huntington Library, San Marino; ex-Jennens collection, and Sotheby's, 23 March 1977 (86).

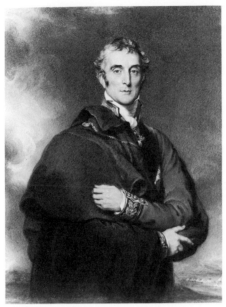

P709

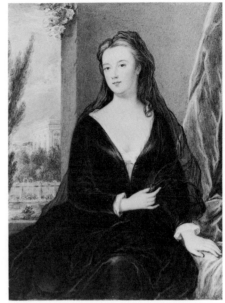

P713

P713 *Sarah, Duchess of Marlborough (after Maria Verelst)*

Fair hair, grey eyes, wearing black; a red-brown drape to the right. Signed top right: W. DERBY 1823.

Water-colour with gum varnish, on card 18.1 × 14.2

Sarah Jennings (1660–1744) m. in 1678 John Churchill, 1st Duke of Marlborough (1650–1722); particularly remembered for her ascendancy over Queen Anne and her want of tact.

P713 was one of a series of water-colour portraits made for Lodge's *Portraits* (see Engraving, and P709). It was copied from the portrait at Blenheim,[1] then believed to be by Lely but attributable to Maria Verelst c.1725 (and in any case after 1722 since the sitter is shown as a widow).[2]

Engraving
H. T. Ryall 1835, for E. Lodge's *Portraits of Illustrious Personages of Great Britain*, 1835, V, no.15.

Provenance
Elhanan Bicknell (1788–1861) of Herne Hill; his sale (drawings), Christie's, 1st day, 29 April 1863 (57), bt. Wells for the 4th Marquess of Hertford, 21 gn.; Hertford House inventory 1890.

Exhibitions
Bethnal Green 1872–5 (621, as after Kneller; an enamel 1872, water-colour 1874); Belfast 1876 (93).

[1] P713 is inscribed *verso*: '*Sarah Jennings / Duchess of Marlborough / From the original of Sir Peter Lely / in the Collection of His Grace / The Duke of Marlborough / at Blenheim. / Drawn by Wm Derby 1823*'.
[2] This attribution appears to be unpublished; the portrait compares very closely with that of Lady Grisell Baillie at Mellerstain which is signed and dated *Mrs Verelst P.1725*.

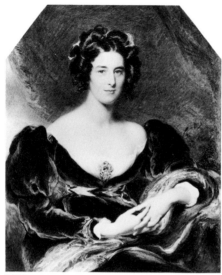

P725

P725 *Sarah, Lady Lyndhurst (after Lawrence)*

Black hair, grey eyes, wearing a black dress; a red drape behind.

Water-colour with gum varnish, on card 28.8 × 23.4 irregular hexagon

Sarah Brunsden (1795–1834), m. 1st in 1814 Col. Charles Thomas (d. 1815 at Waterloo), and 2nd in 1819 John Singleton Copley (1772–1863), son of the painter of that name, cr. Baron Lyndhurst 1827, and three times Lord Chancellor, 1827–30, 1834–5 and 1841–6.

P725 was copied from the portrait by Lawrence painted in 1828, now in a private collection,[1] which was engraved by S. Cousins in 1836.

Provenance
Elhanan Bicknell (1788–1861) of Herne Hill;
his sale (drawings), Christie's, 1st day,
29 April 1863 (66), bt. Wells for the
4th Marquess of Hertford, 12 gn.; Hertford
House inventory 1890.

Exhibitions
Bethnal Green 1872–5 (608, as an enamel by
Bone until 1874 when correctly described);
Belfast 1876 (98).

[1] K. Garlick, *Thomas Lawrence*, 1954, p.48, and
The Walpole Society, XXXIX, 1964, p.134.

John Downman (1750–1824)

Born in Ruabon, North Wales. He studied under Benjamin West in London and entered the RA Schools in 1769. He visited Rome with Wright of Derby in 1773–5, apparently intent on becoming a history painter, but by 1777 he was painting portraits in Cambridge and by 1780 he had evolved his most characteristic portrait manner, the half-length oval in black chalk and stump with light washes of colour. He exhibited portraits and a number of fancy subjects at the RA 1769–1819, and was elected ARA 1795. He practised in the west country 1806–8 and is recorded at Chester in 1818–19. He died at Wrexham on 24 December 1824.

Abbreviation

Williamson G. C. Williamson, *John Downman*, 1907

P751 *Portrait of a Lady*

Powdered hair dressed with a white kerchief with a yellow and black pattern; wearing a light blue dress. Signed below left: JD 1781.

Black chalk, stump and wash with white heightening, on paper 22.5 × 19 laid down on card, in an oval mount 21 × 16.7

The paper is discoloured and the washes faded. The left elbow is continued behind the mount.

MacColl tentatively identified the sitter as Frances Ingram Shepheard (1761–1841), later Lady William Gordon, younger sister of the 2nd Marquess of Hertford (see P753 note 2), but with insufficient evidence.[1] There is a certain resemblance to Lady Elizabeth Seymour-Conway (cf. Reynolds P31), and see P754 note 7.

Provenance/Exhibition

See P754.

[1] D. S. MacColl, *The Burlington Magazine*, XLIV, 1924, pp.138, 141; the 'facial angle and type of nose' suggested to him that P751 and P753 might be sisters of the 2nd Marchioness as seen in P754. Downman's portrait of Lady Gordon, dated 1786 (Williamson, pl.56), does not furnish a convincing resemblance.

P752 *The 3rd Marquess of Hertford as a Boy*

Red hair, wearing a white hat trimmed with blue ribbon, a white smock and red sash. Signed centre left: JD 1781.

Black chalk, stump and wash with some body-colour, on paper 22 × 17.2 laid down on card, in an oval mount 21 × 16.5

The paper is discoloured and the washes faded. There is a small spill of paint below the neck. Faint horizontal lines at shoulder level and some underdrawing

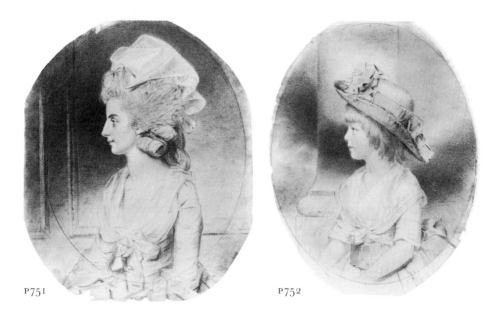

P751 P752

lower left, by the base of the column, suggest the background was changed, which may explain the use of body colour in the upper right area and the strong black washes on the column and to the right.

Francis Charles Seymour-Conway (1777–1842), Viscount Beauchamp 1793, Earl of Yarmouth 1794, succeeded as 3rd Marquess of Hertford in 1822; he m. in 1798 Maria Fagnani (1771–1856) by whom he had Richard, later 4th Marquess of Hertford, and Frances (1799–1822, who m. in 1822 the marquis de Chévigné); KG 1822. His portrait was also drawn by Richard Dighton 1818 (engr. as *A View of Yarmouth*), painted by Lawrence c.1822 (Washington, National Gallery of Art, no.2348) and drawn by A. Wivell c. 1835 (formerly in the collection of the Earl of Crawford and Balcarres).

The sitter is sufficiently identified by his age, his red hair and Downman's note that he had drawn Lady Beauchamp's little boy (see P754 under Replicas).

Provenance/Exhibition
See P754.

P753 *Portrait of a Lady*

Powdered hair dressed with a white ribbon, wearing a light blue dress. Signed below left: *J. Downman Pt 1783*.

Black chalk, stump and wash with white heightening, on paper 22.5 × 19 laid down on card, in an oval mount 21 × 16.5

The paper is discoloured and the washes faded. The landscape view on the right is concealed by the mount.

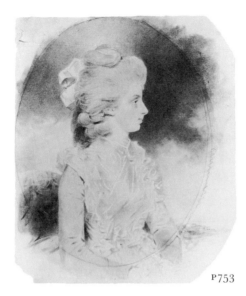 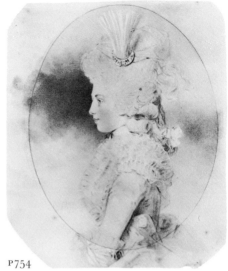

P753 P754

MacColl tentatively identified the sitter as Elizabeth Ingram Shepheard (m. in 1782, d. 1817) second youngest sister of the 2nd Marchioness of Hertford (see P754 below), but with insufficient evidence.[1] Her profile resembles that of the 2nd Marquess of Hertford as drawn by Downman the same year,[2] in which case she might be one of his sisters (cf. Reynolds P31, P33). See also P754 note 7.

Provenance/Exhibition
See P754 below.

[1] D. S. MacColl, *The Burlington Magazine*, XLIV, 1924, pp.138, 141; the 'facial angle and type of nose' suggested to him that P753 and P751 showed sisters of the 2nd Marchioness as seen in P754.
[2] Ragley; oval 20 × 16.2, signed and dated 1783; exh. Birmingham 1938 (175).

P754 *Isabella, Marchioness of Hertford, as Lady Beauchamp*

Powdered hair dressed with an egret and a white kerchief with a yellow pattern; wearing a white dress. Signed below left: JD/1781, and again behind mount bottom left: JD/1781.

Black chalk, stump, pastel and wash with white heightening, on paper 22.5 × 19.1 laid down on card, in an oval mount 21 × 16.7

The paper is discoloured and the washes faded. Some iron stains near the edges and a grey (discoloured?) spot in the hair. The left forearm and waist are concealed by the mount.

Isabella Anne Ingram Shepheard (1760–1834), daughter and co-heir of Charles Ingram, 9th and last Viscount Irwin (d.1778), m. in 1776, as his second wife, Francis, Viscount Beauchamp, Earl of Yarmouth 1793, who succeeded as 2nd Marquess of Hertford in 1794; for her only child see P752 above; between c.1807 and 1820 she was the confidante of the Prince of Wales (later George IV; see Hoppner P563, Lawrence P559); she lived in Hertford House from 1798. Her portrait was also painted by Reynolds 1781 (whole-length at Temple Newsam) and 1789 (half-length in a private collection), and Hoppner 1784 (Henry E. Huntington Library and Art Gallery, San Marino), drawn by Edridge c.1790,[1] and engraved by Hopwood 1816.

Two replicas of P754 were inscribed by Downman *Lady Beauchamp* (see below), which seems sufficient proof of identify. In the same year Downman drew her brother-in-law, Captain Hugh Conway,[2] and in 1783 her husband (see P753 note 2).

Replicas

WINDSOR Gower Lodge (formerly), in the collection of Lord Ronald Sutherland Gower (1845–1916); inscribed by Downman: '*Lady Beauchamp 1781 Original study ... I drew three of this, and her little boy*'.[3]

CAMBRIDGE Fitzwilliam Museum (no.2314); oval 22.8 × 18.4, inscribed: '*Lady Beauchamp. Duplicate study 1781 for a half-length of which I drew three ...*'.[4]

DERWYDD Dyfed, 1957; called Miss Way, signed and dated 1781.[5]

Provenance

(P751–4) Probably commissioned by the 1st or 2nd Marquess of Hertford. All four were framed in Paris[6] where they may have been in the collection of the 3rd Marchioness of Hertford, before passing to the 4th Marquess. Hertford House inventory 1890.[7]

Exhibition

(P751–4) Bethnal Green 1874–5 (716–9, sitters unidentified).

[1] See Wallace Collection, *Summary Illustrated Catalogue of Pictures*, 1979, p.296.

[2] British Museum; oval 21 × 17.1, inscribed '*The Honble Capn Hugh Conway 1781. First Sitting ... I drew three portraits of him*' (L. Binyon, *Drawings by British Artists ... in the British Museum*, II, 1900, p.40, no.8).

[3] Illus. Lord Ronald Sutherland Gower, *Bric à Brac*, 1886, p.86, and Williamson, pl.21, reversed and described as Miss Way in the Hodgkins collection.

[4] Sir Edward F. Coates sale, Sotheby's, 15 February 1922, lot 1 no.17, illus. with inscription by Downman.

[5] J. Steegman and R. L. Charles, *Portraits in Welsh Houses*, II, *South Wales*, 1962, p.53, no.44. A letter on file from Miss A. A. J. Stepney-Gulston, dated 27 February 1957, suggests that the Miss Way identification, inscribed on the *verso* by her uncle, was taken from Williamson, see note 3 above.

[6] Each of the four carved and gilded frames bears a label *verso* of which all that can now be read is: *Papeterie et Coutellerie / Encadrements / Garnitures des Bureaux / Paris*.

[7] P751–4 were subsequently catalogued as unknown sitters until D. S. MacColl identified P752 and P754, *The Burlington Magazine*, XLIV, 1924, pp.138–41, and see P751 above, note 1, and P753 note 1. Unhappily MacColl's identification of P754 was illustrated in the 1928 catalogue by P751. In the 1968 catalogue the drawings were identified as Isabella (P751), Frances (P753) and Elizabeth (P754) Ingram Shepheard.

Hans Eworth (active 1540–1573)

A Netherlandish artist, he was a member of the Antwerp Guild of S. Luke in 1540. He came to England c.1545 and his earliest known work is the *Turk on horseback* (Brocklesby Park) of 1549; thereafter there are a number of dated portraits up to 1570. He was a Court Painter to Mary I, but then fell out of Royal favour until 1572, when he designed the *décor* and costumes for a fête staged by Elizabeth I. He is last recorded in 1573 in the employ of the Office of Revels. His name is variously spelt in contemporary documents (e.g. Jan Euworts, Hew Hawarde, etc.).

P535 *John Selwyn*

Brown hair and greying beard, grey eyes, wearing a black hat set with pearls, a fur-trimmed dark brown coat over a buff doublet and black embroidered breeches; a black locket hangs round his neck from a black ribbon; he holds his kid gloves in his right hand, on the first finger of which he wears a gold ring; there is a green stone ring on the first finger of his left hand; copper green background. Inscribed top left: HE, and top right: AETATIS 54./1.5.7.2. above the arms of Selwyn of Friston (*arg. on a bend cotised sa., 3 annulets or and a bordure engrailed gu.*).[1]

Oak panel 86.4 × 62.8 × 0.4 four vertical members, the joins at 12.2, 24.2 and 39.6 from the left hand edge

Cleaned in 1857[2] and later fitted with a constricting cradle which aggravated eight vertical splits (three from the top edge and five from the bottom). This cradle was removed in 1977 when P535 was cleaned by Cobbe. There are old damages above the head, by the sitter's left cuff and in the bottom corners. The green background was found to be damaged underneath up to five layers of brown overpainting (see diagram);[3] a filling from an old repair ran on to the green, below the first layer of brown. An inscription on the top layer of brown (a coronet above *Robertus C⁰:/Leicestriae*, placed above and below the original age and date, and concealing the coat of arms) was removed, but the coat of arms, together with the HE monogram, the age and the date, although not perhaps contemporary with the portrait, were retained. The monogram, age and date are painted in lead-tin yellow, which may indicate a date at least before the early eighteenth century (see note 3).

The simplest, and possibly the correct, reading of the inscriptions now seen on P535 is as follows: the portrait was originally signed HE and inscribed AETATIS 54 1572; between 1572 and c.1611 two layers of brown were applied over the green background which had been damaged, but the original inscriptions were preserved or copied; the arms of Selwyn (which were only confirmed in 1611) were then added; the next layer of brown overpaint erased the monogram; finally, in the late eighteenth/early nineteenth century, the arms were painted out and the wilful inscription *Robertus C⁰: Leicestriae* added (to increase the historical value of

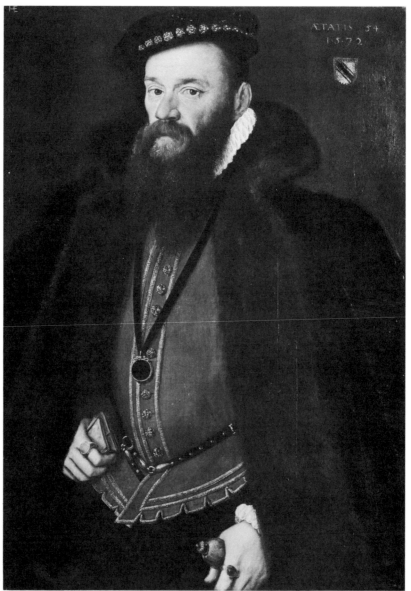

P535

the portrait). The arms, with the inscriptions now seen, would seem to identify John Selwyn of Friston, Sussex, whose younger son was born in 1548.[4]

Catalogued as Flemish School in 1900, P535 was attributed to Eworth by Cust in 1913[5] (before, of course, his monogram was revealed) and from 1920 has here been catalogued as Eworth. Later lists of Eworth's work, compiled by Collins Baker and Constable in 1930 and Strong in 1969,[6] omitted P535, but the recent cleaning and re-emergence of the monogram would seem to vindicate Cust.

Inscription on P535 before cleaning
(Hamilton Kerr Institute)

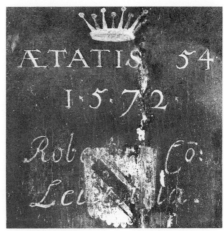

Inscription on P535 during cleaning
(Hamilton Kerr Institute)

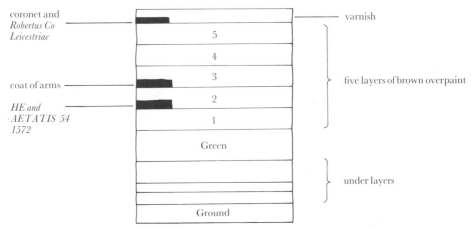

Diagram showing structure of P535 (Hamilton Kerr Institute)

Version

PARHAM PARK panel 68.6 × 43.2, half-length, inscribed *anno. dni. 1568/aetatis. suae. 51*, called the 3rd Earl of Worcester.

Provenance

Acquired by the 3rd Marquess of Hertford; Dorchester House inventory 1842 as '*Zucchero, Robert Dudley Earl of Leicester*'; Hertford House inventory 1870 as '*Porbus, Robert Earl of Leicester*'.[7]

Exhibitions

Bethnal Green 1872–5 (94, as *Robert Dudley, Earl of Leicester*, ascribed to Antonio More); RA 1880 (164, as P. Pourbus, *R. Dudley, Earl of Leicester*).

[1] I am grateful to Dr. Eric Gee for this identification, and for his notes on the Selwyn family; he points out that only two annulets are visible in the arms on P535, but the condition of the paint is not good.

[2] Evans invoice.

[3] The analysis of the paint layers was made by Pamela England at the Hamilton Kerr Institute, Cambridge.

[4] Cf. *Harleian Society*, LIII, 1905, pp.108–9, and LXXXIX, 1937, p.97.

[5] L. Cust, 'The Painter HE: Hans Eworth', *The Walpole Society*, II, 1913, pp.17, 39, pl.XIB.

[6] C. H. Collins Baker and W. G. Constable, *English Painting*, 1930, pp.24–6; R. Strong, *The English Icon*, 1969, pp.83–4.

[7] The present frame of P535 (like that on the van der Meulen P534) was made in 1872 to match that of the Pourbus P26 (invoice in Wallace Collection archives), so that Wallace had his three portraits then attributed to 'Porbus' in matching frames.

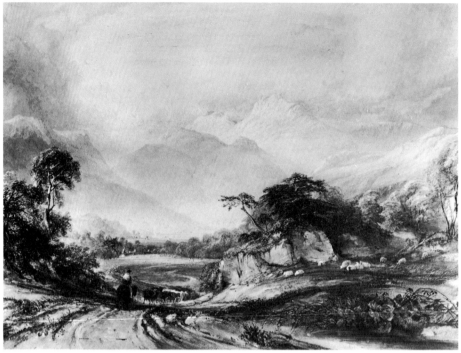

P690

Anthony Vandyke Copley Fielding (1787–1855)

Born on 22 November 1787 in Sowerby, his childhood was spent in London and Cumbria. He settled in London in 1809 and became a pupil of John Varley (whose wife's sister he married). He was a highly productive landscape painter exhibiting at the RA 1811–42 and BI 1812–55 and showing 1,748 works at the OWS 1813–55 of which he was President 1832–55. He was a gold medallist at the Paris Salon in 1824. He died in Worthing on 3 March 1855.

P690 *Langdale Pikes*

Looking north-west to the sunlit peak of Harrison Stickle with Pavey Ark to the right. Signed, bottom centre: *Copley Fielding 1839*.

Water-colour with traces of gum varnish on the darker areas, on paper 45.8 × 61.5

The greys and blues of the distance are markedly faded.

Langdale Pikes, near Grasmere in Cumbria.

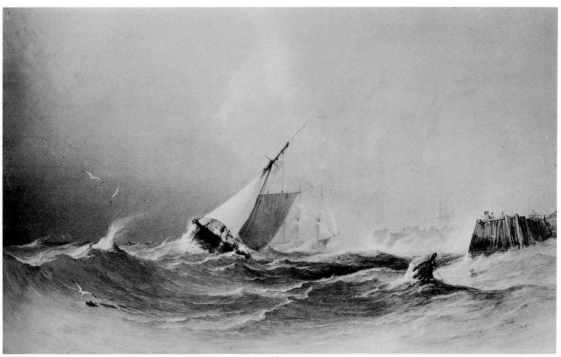

P691

P691 *Bridlington Harbour*

A storm blowing in from the east. Signed below left: *Copley Fielding 1839*.[1]

Water-colour with traces of gum varnish on the anchorage buoy and hull of the
foreground vessel, on grey paper 47.5 × 78 laid down on panel

Bridlington, Humberside; the two piers seen on the right were constructed in
1816–48 and were therefore incomplete when P691 was painted.

[1] Previously quoted as 1837, but the final 9 is clear.
[2] Seen in Bicknell's collection at Herne Hill by Waagen
(II, p.351) who called it *Burlington Harbour*.

P715

P715 *Crowborough Hill*

Looking east on a summer afternoon. Signed bottom right: *Copley Fielding 1838*.

Water-colour with traces of gum varnish in the foreground darks, on paper 42 × 59.3 (sight)

Crowborough Hill, identifiable today as Beacon Hill on the west side of Crowborough, East Sussex.

Provenance
See P690; Bicknell sale, 2nd day, 30 April 1863 (266), bt. Wells for the 4th Marquess of Hertford, 760 gn.; Hertford House inventory 1890.

Exhibitions
Bethnal Green 1872–5 (651); Belfast 1876 (75).

p716

p716 *Loch Katrine*

Looking west in evening light with the wooded Ellen's Isle in the centre. Signed lower left: *Copley Fielding 1838.*

Water-colour with gum varnish over the foreground darks, on paper 30.3 × 40.3

Loch Katrine beyond the Trossachs in the Central Region of Scotland.

Provenance
See p690; Bicknell sale, 1st day, 29 April 1863 (128), bt. Wells for the 4th Marquess of Hertford, 260 gn.; Hertford House inventory 1890.

Exhibitions
Bethnal Green 1872–5 (655); Belfast 1876 (73).

P718

P718 *Traeth Mawr*

Looking east on a summer's day, the peaks of Moelwyn Mawr and Moelwyn Bach on the right. Signed bottom left: *Copley Fielding 1838*.[1]

Water-colour with gum varnish on the foreground darks, on paper 42.6 × 60

The greys and blues of the distance are markedly faded.

Traeth Mawr, Gwynedd, North Wales; the large sands of the estuary of the river Glaslyn reclaimed by William Madocks in 1807–11.

Provenance
See P690; Bicknell sale, 1st day, 29 April 1863 (126), bt. Wells for the 4th Marquess of Hertford, 420 gn.; Hertford House inventory 1890.

Exhibitions
Bethnal Green 1872–5 (647); Belfast 1876 (85).

[1] Described as by *Copley Fielding 1850* in the Bicknell sale.

Thomas Gainsborough (1727–1788)

Baptised on 14 May 1727 at Sudbury, Suffolk, the son of a clothier. He came to London c.1740 as a pupil of Hubert Gravelot, before establishing his own studio c.1745. He practised landscape and portrait painting in Sudbury 1748–52, Ipswich 1752–9, and Bath 1759–74, before finally settling in London. Though his reputation was made by portraiture which owed not a little to van Dyck and Watteau, he was happier painting landscapes, initially in the manner of Wijnants and Ruisdael and later in a more conceptual, personal style. An impulsive man, he was temperamentally opposed to his admired contemporary, Reynolds; 'Genius & regularity are utter Enemies', he once wrote. A founder member of the RA where he exhibited 1769–72 and 1777–83. He died in London on 2 August 1788 and was buried at Kew, next to his old Ipswich friend, Joshua Kirby.

Abbreviations

Waterhouse 1953 E. K. Waterhouse, 'Preliminary Check List of Portraits by Thomas Gainsborough', *The Walpole Society*, XXXIII, 1953

Waterhouse 1958 E. K. Waterhouse, *Gainsborough*, 1958

P42 *Mrs. Mary Robinson ('Perdita')*

Blue eyes, powdered hair dressed with blue ribbon; wearing a black bow beneath her chin, a white dress with light blue trimmings, and holding a miniature of a red-coated man; a white pomeranian dog by her side.

Canvas, relined 233.7 × 153

Heavily ironed in relining in 1904. The varnish is somewhat discoloured and is perished in areas around the head and in the landscape (centre left and above right). *Pentimenti* show that the bow at her neck was redrawn, and there are minor damages on the skirt (bottom right) and in the upper-right tree. A vertical seam runs 8.2 cm. from the right-hand edge.

Mary Darby (1758–1800), m. in 1774 Thomas Robinson by whom she bore a daughter; following her appearance in *The Winter's Tale* at Drury Lane in December 1779 she enjoyed a liaison with the Prince of Wales (later George IV, see Hoppner P563, Lawrence P559) which was over by 1781; in 1783 she became paralysed from the waist down following a miscarriage, and thereafter devoted herself to writing novels and poems; the 2nd Marquess and Marchioness of Hertford were amongst her later admirers.

Commissioned by the Prince of Wales in 1781;[1] sittings were recorded in August[2] and October[3] that year. Gainsborough withdrew P42 from the Royal Academy exhibition in 1782 following adverse comparisons with her contemporary portraits by Romney, see P37, and Reynolds (now at Waddesdon Manor).[4] While his composition may have been influenced by the character of Shakespeare's Perdita ('poor lowly maid/Most goddess-like prank'd up', *The*

P42

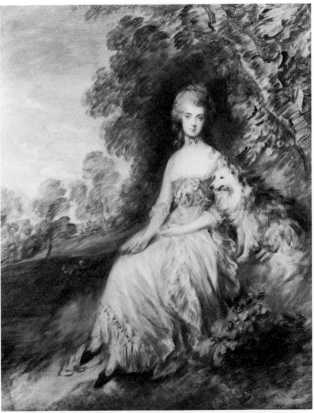

Gainsborough: *modello* for P42. Windsor Castle
(Reproduced by gracious permission of Her Majesty The Queen)

Winter's Tale, IV, iii, 10), Gainsborough seems also to have recalled Watteau's *La Rêveuse* which he could have known through the engraving by P. Aveline.[5] The miniature has, inevitably, been supposed to show the Prince of Wales (who had given Mrs. Robinson his picture by Jeremiah Meyer in 1780)[6] and the circumstances of the commission render this more likely than not. Together with the contemporary portraits by Romney and Reynolds (see above), P42 demonstrates Mrs. Robinson's accomplished facility for adapting deportment to dress.[7] See also Reynolds P45 and Romney P37.

Copy

LONDON Sotheby's, 15 May 1946 (23), chalk drawing, omitting the dog.

Versions

WADDESDON MANOR 76.2 × 64.1 oval, bust-length replica from the sitter's sale, 1785.[8]
WINDSOR CASTLE 76.2 × 63.5, a *modello* for P42, bought for the Prince of Wales 1797 (Millar, no.804).

P42 detail

Provenance

Commissioned by the Prince of Wales 1781 (see above); at Carlton House 1816;[9] sent by the Prince to the 2nd Marquess of Hertford, 13 April 1818;[10] Hertford House inventory 1834.

Exhibitions

Manchester, *Art Treasures*, 1857 (saloon H, no.42, the sitter unidentified); Bethnal Green 1872–5 (5, the sitter unidentified 1872, 'possibly Mrs. Robinson' 1874); RA 1894 (139).

References General

Waterhouse 1953, pp.91–2, and 1958, no.579; Ingamells, *Mrs. Robinson and her Portraits*, 1978.

[1] E. K. Waterhouse, *The Burlington Magazine*, LXXXVIII, 1946, p.276, first published the list of pictures painted by Gainsborough for the Prince of Wales, dated July 1784, which included 'a full length of Mrs. Robinson 105 0'; see also Millar, no.804.

[2] *Morning Herald*, 25 August 1781.

[3] W. T. Whitley, *Thomas Gainsborough*, 1915, p.181.

[4] Painted January–April 1782; Waterhouse, *Reynolds*, 1941 p.73, and *The James A. de Rothschild Collection at Waddesdon Manor, Paintings*, 1967, no.28. See Appendix V, no.67. For a miniature copy, attributed to John Hazlitt, see Wallace Collection, *Catalogue of Miniatures*, 1980, no.317, M40.

[5] H. Adhémar, *Watteau*, 1950, no.145, pl.77 (the painting); the engraving is reversed, but in the same sense as P42. Gainsborough's *Mrs. Sheridan* (National Gallery, Washington) shows a further development of this composition.

[6] See Ingamells 1978, pp.11, 12, 35 n.16, illus. p.11.

[7] Cf. Laetitia Matilda Hawkins, *Memoirs, Anecdotes, Facts and Opinions*, 1824, II, p.24 (quoted in Ingamells 1978, p.15).

[8] Waterhouse 1958, no.581, and 1967, *op. cit.*, no.9. This was surely the 'highly finished portrait of Mrs. Robinson by Gainsborough' which appeared in the sale of her effects (taken in execution by the Sherriff's office), Hutchins, Boulton and Phillips, 7 January 1785, and sold for 32 gn. (cf. *Morning Herald*, 8 January 1785, and Whitley, *op. cit.*, p.183). Probably the portrait by Gainsborough which was rumoured to be going to France in October 1781 (Whitley, *op. cit.*, p.178), where Mrs. Robinson was staying between mid-October and mid-December that year. Waterhouse 1953, pp.91–2, had previously suggested that P42 was the portrait sold in 1785, but this now seems impossible. Isaac Espinasse, who owned the Waddesdon portrait in 1868, told Graves in a letter of 1872 that his grandfather had acquired the portrait direct from the sitter. G. W. Fulcher, *Gainsborough*, 1856 ed., p.222, listed a whole-length of Mrs. Robinson in the collection of J. Espinasse, presumably in error.

[9] As quoted by Millar, under no.804. Mrs. Robinson had described her whole-length portrait by Gainsborough as in the Prince's possession in 1799 (MS.Sketch by Mrs. Robinson, printed in *Drama*, summer 1950, pp.12–14, dateable 1799 on internal evidence).

[10] As given by Millar, under no.804.

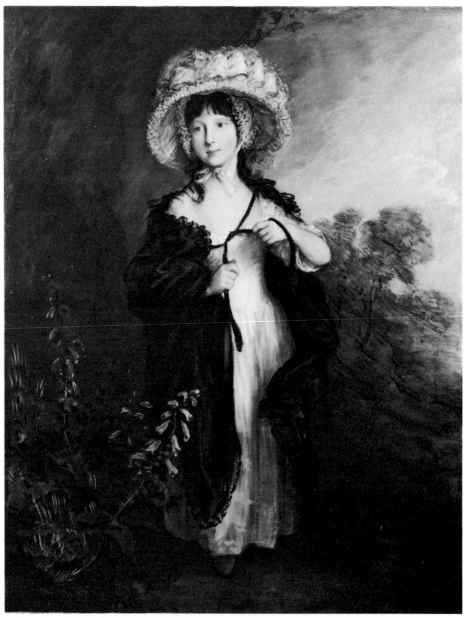

P44

P44 *Miss Elizabeth Haverfield*

Dark brown hair, grey eyes, wearing a white bonnet, a black cloak over a white dress and red slippers; blue foxgloves in the left foreground.

Canvas, relined[1] 126.2 × 101

Cleaned by Pemberton-Piggott in 1980. *Pentimenti* around her right shoulder show the figure was moved slightly to the right; her left hand was first placed slightly lower and the tie of her cloak came down to it; the lower right-hand edge of the cloak has been moved in, and her left foot brought forward. There is a fairly prominent craquelure in the flesh areas and in the thicker passages of the white dress. The landscape background immediately behind the figure is thinly painted and is somewhat unresolved. Vertical marks at 1 cm. and 7 cm. from the right-hand edge, and at 6 cm. from the left, probably result from the canvas being loosely stretched when being painted so that the paint tended to accumulate along the edges of the temporary stretcher being used.[2]

Elizabeth Anne Haverfield, daughter of John Haverfield of Haverfield Lodge, Kew (where he was a superintendent gardener), m. on 8 November 1794 James Wyld of Speen, Bucks., later rector of Blumsdon St. Andrew, Wilts.; she d. at Blumsdon House, Wilts., on 13 November 1817.[3]

P44 is a late work from the 1780s; since the sitter was probably born at the latest in 1776 a date in the earlier part of that decade seems indicated.

Copy

A poor drawing (inscribed: *Gainsborough 177* [*5* or *9*]) was in the collection of W. Manston 1969.[4]

Provenance

Haverfield Lodge, Kew, whence bt. by Hogarth c.1850;[5] his sale, Christie's, 26 March 1859 (72, 'The Morning Walk, Portrait of Miss Haverfield. A splendid work of the artist, never before out of the possession of the family for whom it was painted.'), bt. Holmes for the 4th Marquess of Hertford, 720 gn.; Hertford House inventory 1870 as Miss Boothby.[6]

Exhibitions

Bethnal Green 1872–5 (2, as *Miss Boothby* 1872, *Miss Haverfield* 1874); RA 1894 (34).

References General

Waterhouse 1953, p.55, as 'a very late work', and 1958, no.355, as from the 1780s.

[1] Relined before 1859, since the 1859 sale marks are on the lining canvas, and probably after c.1850 when it was acquired by Hogarth. Old nail holes on the original canvas show that it was relined at a slight angle (up on the right), making the figure more upright.

[2] As observed by Pemberton-Piggott in her report on the cleaning of P44.

[3] Cf. *The Gentleman's Magazine*, 64, 1794, ii p.1054, and 87, 1817, ii, p.379; J. A. Venn, *Alumni Cantabrigiensis*, II, vi, 1954, p.604.

[4] Illus. *Apollo*, XLIV, 1946, p.23.

[5] Christie's copy of the 1859 sale catalogue is annotated '*removed about 9 yrs house at Kew*'.

[6] Presumably because of the generic resemblance to Reynolds's *Penelope Boothby* of 1788 (illus. Armstrong, *Reynolds*, 1900, f.p.182). In the 1890 and 1897 Hertford House inventories P44 was described as '*Miss Haverfield in her mothers dress*'.

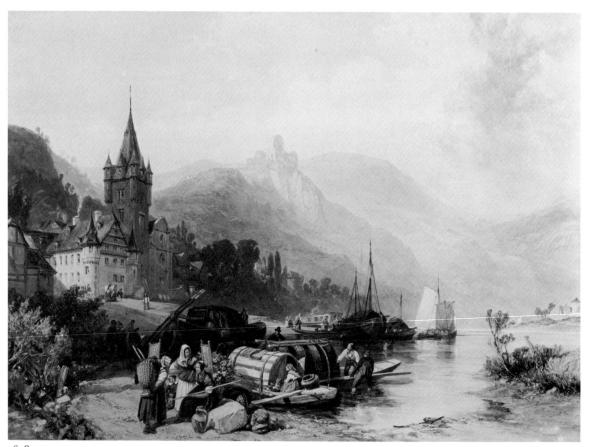

P658

James Duffield Harding (1797–1863)

Born on 6 October 1797 in Deptford, the son of a drawing master. He took lessons from Samuel Prout c.1813 and was apprenticed for one year to the engraver John Pye. He exhibited British and European landscape views in oil and water-colour at the RA 1811–18 and 1843–58, the OWS 1821–46 and 1856–62, and on five occasions at the BI between 1827–50. He travelled frequently in Europe from 1824. A dedicated teacher, he published a number of Drawing Books and teaching manuals illustrated with lithographs; one, dedicated to Louis-Philippe in 1836, earned him a Sèvres breakfast service. He died in Barnes on 4 December 1863.

P658 *Bernkastel on the Moselle*

Looking south with the ruined Electoral castle of Landshut in the mid-distance, and the Hunsrück mountains beyond; the foreground figures carry *Hütten*, baskets used for the grape harvest.

Pencil, water- and body-colour with varnish on the darker areas, on thin card
77.5 × 105.2 laid on panel[1]

The blues and greys of the distance are faded. There are a number of *pentimenti*, e.g. the masts of the boat in the centre mid-distance, the figures on the boat in the left mid-distance, and the framework of the canvas cabin on the foreground boat.

Bernkastel in the Rhineland Palatinate, West Germany, famed for its vineyards. Harding had travelled on the Moselle in 1834 and on the Rhine in 1837; P658 probably dates from before 1843 when he turned increasingly to oils, and possibly after 1838 when Bicknell began collecting.

Provenance
Elhanan Bicknell (1788–1861) of Herne Hill; his sale (drawings), Christie's, 1st day, 29 April 1863 (113), bt. Wells for the 4th Marquess of Hertford, 280 gn.; Hertford House inventory 1890.

Exhibition
Bethnal Green 1872–5 (603, as Wylde 1872, Harding 1874).

[1] Stamped: *Hogarth Print Seller . . . 5 Haymarket London.*

Silvester Harding (1745–1809)

Born on 25 July 1745 in Newcastle-under-Lyme, from 1758 he was a strolling actor for some years. He came to London in 1775 and practised as a miniature painter, exhibiting at the RA 1776–1802. In 1786 he set up in Fleet Street as a print and bookseller with his brother, Edward; they published several illustrated works, including the *Biographical Mirrour* (two volumes, 1795 and 1798) for which Silvester made water-colour copies of historical portraits. He died in London on 12 August 1809.

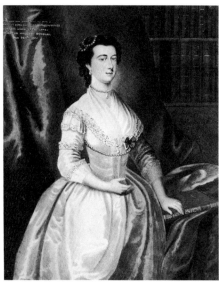

P770

P770 *Anne, Viscountess Irwin (after Philips)*

Black hair, blue eyes, wearing a white satin dress; a blue drape behind. Signed, and inscribed, centre right: *CPhillips pinxt. 1738/S Harding Del 1801*, and inscribed top left: THE LADY ANN DAUGHTER TO THE 3/EARL OF CARLISLE, VISCOUNTESS DOWAGER/IRWIN AND WIDOW OF THE LATE/BRIGADIER WILLIAM DOUGLAS/DIED DECr 4 1764.

Water-colour on paper 19.3 × 15.3

Anne Howard (before 1696–1764), 2nd daughter of the 3rd Earl of Carlisle, m. 1st in 1718 Rich, 5th Viscount Irwin (d.1721), and 2nd in 1737 Col. William Douglas (d.1748); she was a writer of indifferent verse and a Lady of the Bedchamber to the Princess of Wales 1736–64. Portraits of her by Dandridge and Richardson are at Temple Newsam.

As the style and inscription make clear, P770 was copied from a portrait painted by Charles Philips (1708–47) in 1738 and now untraced. P770 was doubtless acquired by the 2nd Marquess of Hertford, whose second wife was the eldest daughter of the last Viscount Irwin (see Downman P754).

Engraving
Anon., as bust-length oval 'From an original in the Possession of Mr. Harding', 1802, 1803 and 1806.

Provenance
Probably acquired by the 2nd Marquess of Hertford and identifiable with '*female cousin of the late Marquis framed & glazed A Kauffman*' in the Hertford House inventory 1834.

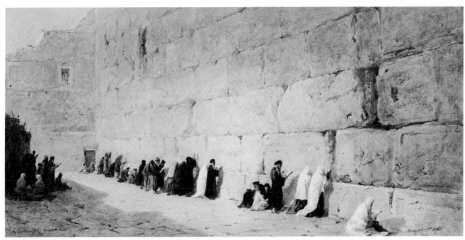

P694

Henry Andrew Harper (1835–1900)

Born in Blunham, Bedfordshire. He exhibited landscape views at the RA 1865–88, concentrating on Eastern scenes 1873–7. He was a committee member of the Palestine Exploration Fund and published books on the Holy Land. He died in London on 3 November 1900 and his obituary described him as of Buckhurst Lodge, Westerham, Kent. Sir Richard Wallace made Harper two payments of 200 gn. in 1873, another in 1874, and one of £10 in 1878 (see Appendix V, nos. 34–6).

P694 *Jerusalem: the Wailing Wall*

Inscribed bottom left: *The Jews Wailing Place Jerusalem*; signed bottom right: *Henry A. Harper/1874.*

Water- and body-colour on paper 34 × 68 laid down on thin card

Provenance
With P695 below, purchased from the artist by Sir Richard Wallace in May 1874 for 200 gn.; Hertford House inventory 1890.

Exhibition
RA 1874 (829).

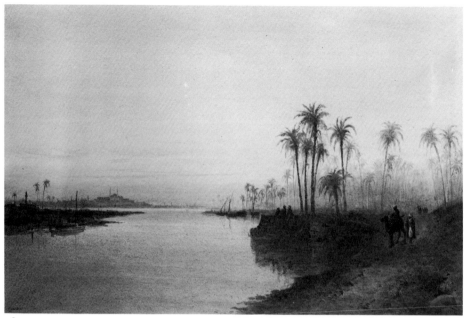

P695

P695 *Cairo: from the Nile looking south*

Inscribed bottom left: *Cairo*; signed bottom right: *Henry A. Harper 1874*.
Water-colour on paper 48.8 × 73.6.

Provenance
See P694 above.

William Hilton (1786–1839)

Born on 3 June 1786 in Lincoln, the son of a minor painter, he studied under J. R. Smith before entering the RA schools in 1806. Like his friend Haydon he was dedicated to history painting, and his style developed from the Neo-Classic to a Titianesque Baroque. He exhibited at the BI 1808–39 and RA 1803–38; he was elected ARA 1813, RA 1819, and Keeper 1827. In 1825 he visited Italy with Thomas Phillips.[1] He died in London on 30 December 1839, and the following year sixty-seven of his paintings were shown at the BI.

[1] Cf. M. R. Pointon, *Journal of the Warburg and Courtauld Institutes,* xxv, 1972, pp.339–58.

P633 *Venus in search of Cupid surprises Diana*

Diana, on the left, covers herself with a white drape on seeing Venus approach from the right; Cupid flies in the trees above. Inscribed, *verso: W. Hilton. R.A.*[1]

Canvas 154.8 × 191

The canvas is buckling at the edges where there are small losses. There is a local craquelure round the figure of Venus, an area which has been reworked: the paint is heavily impasted on the left, the trees have been modified on the right, as has the red drapery below. There are further *pentimenti* in the distant landscape. The impress of the stretcher is reflected in the paint surface.

The subject is taken from Spenser, *The Faerie Queene,* III, vi, 11–25; Venus, seeking her son, Cupid, wanders in the woods and finds Diana bathing with her attendants:

'She was asham'd to be so loose surprized,
And woxe halfe wroth against her damzels slacke,
That had not her therof before auized,
But suffred her so carelesly disguized
Be overtaken. Soone her garments loose
Vpgath'ring, in her bosome she comprized,
Well as she might, and to the Goddesse rose,
While all her Nymphes did like a girlond her enclose.'

This episode was described by Leigh Hunt, in his 'Gallery of Pictures from Spenser',[2] as 'a picture so completely in the style of Titian that one might have fancied him to have written it ... the recollection of [his] Bath of Diana is forced upon us'. Hilton exhibited six other subjects from the *Faerie Queene* between 1809 and 1832.

Recognised by Roberts in 1977 as the picture shown at the RA in 1820,[3] P633 is a close rendering of the Spenser text given in the RA catalogue (as quoted above). Hilton's composition follows Hunt's interpretation and is much influenced by Titian's *poesie* (see Titian P11), of which the *Death of Actaeon* had been shown at

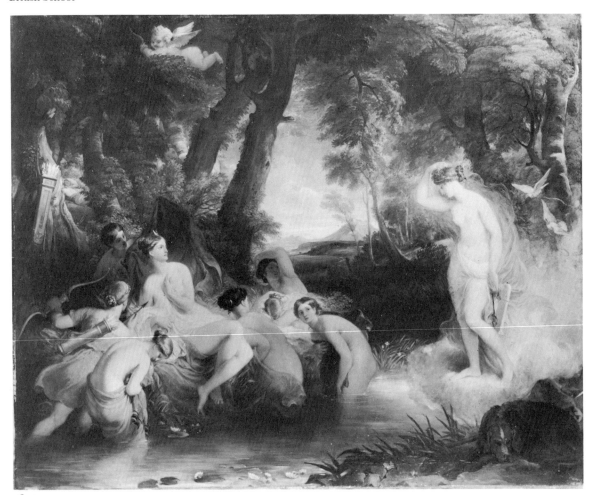

p633

the BI in 1819 and *Diana and Actaeon* (Hunt's 'Bath of Diana') and *Diana and Callisto* were then in the Stafford Gallery. In 1818 Hilton had painted *The Rape of Europa* (now at Petworth) which was evidently inspired by the Titian *poesia* of that title shown at the BI in 1816.

Provenance

Thomas Wright (d.1845) of Upton Hall, Newark;[4] his sale, Christie's, 7 June 1845 (49, 'Venus approaching the bath of Diana in search of Cupid, from Spenser's Faery Queen'), bt. Norton, 310 gn.; by 1847 in the collection of Charles, Baron Townshend (1785–1853); his sale, Christie's, 13 May 1854 (40, '... the well known chef d'oeuvre'), bt. Mawson for the 4th Marquess of Hertford, £640;[5] Hertford House inventory 1870.

Exhibitions

RA 1820 (170, 'Venus in search of Cupid surprises Diana at her bath 'Soon her garments *loose upgathering*, etc' – Spenser's Faerie Queene'); BI 1847 (146) lent Townshend;

Manchester, *Art Treasures*, 1857 (saloon H, no.39); Bethnal Green 1872–5 (35).

[1] As Lord Hertford wrote to Mawson (*Letters*, no. 51, p.63, 29 March 1855), "Some fool wrote in black paint the name of 'Hilton R.A.' on the back of the canvass & I see with pain that the letters have made their way thro' from the rear to the front, as one might say at Sebastopol...".
[2] L. Hunt, *Imagination and Fancy*, 1844, p.117, quoted by I. Jack, *Keats and the Mirror of Art*, 1967, pp.15–16. Jack implies (pp.20–1) that Hunt's essay resumed much earlier conversations he had had with Keats (d.1821, whose portrait Hilton painted in 1819), making it possible that Hilton was inspired by Hunt, rather than the reverse.
[3] K. Roberts, *The Burlington Magazine*, CXIX, 1977, p. 722.
[4] For whom, see W. G. Constable, *Richard Wilson*, 1953, pp.149–50.
[5] Bought on Mawson's advice, see *Letters*, nos. 41–2, pp.53–4.

Hans Holbein the Younger (1497–1543)

Born in Augsburg, he worked in London 1526–8 and 1532–43, from 1536 as Court Painter to Henry VIII; he died in London. For his portrait in miniature, see *Catalogue of Miniatures*, 1980, no.3 (M203).

After Holbein

P547 *Edward VI as Prince of Wales*

Fair hair, blue eyes, wearing a dark hat with a white plume and a yellow jerkin.

Oil on paper on panel 73 × 54.8 painted area 69.5 × 54.8

The corners are torn, there are minor retouchings in the face, and the varnish is greatly discoloured. Revarnished in 1859 and cleaned by Buttery in 1885.

P554 *Queen Jane Seymour*

Fair hair, blue-grey eyes, wearing a black and gold head-dress and a yellow dress.

Oil on paper on panel 72.6 × 54.8 painted area 68.5 × 54.8

Condition as for P547.

P547 and P554 are weak, enlarged copies of drawings at Windsor Castle,[1] almost certainly taken from the engravings published by John Chamberlaine 1792–1800.[2] They appear to have been acquired by the 3rd Marquess of

P547 P554

Hertford, doubtless to emphasise his pedigree: the Earl of Hertford of the first creation became, in 1547, Duke of Somerset and governor of the young King Edward VI (1537–53) whose mother was Hertford's sister, Jane Seymour (1509?–37), third Queen of Henry VIII.

Provenance

See above; probably the '*Two Portraits Queens*' in the Dorchester House inventory 1842; in Hertford House 1859 as '*Zucchero, a pair of portraits*';[3] Hertford House inventory 1870 as Zucchero.

Exhibition

Bethnal Green 1872–5 (115 and 111 respectively).

[1] P547 from a drawing formerly attributed to Holbein but by an inferior hand (William Scrots?), see K. T. Parker, *The Drawings of Holbein at Windsor Castle*, 1945, no.85, and R. Strong, *National Portrait Gallery, Tudor and Jacobean Portraits*, 1969, p.93. P554 from the Holbein drawing, see Parker, *op. cit.*, no.39, and The Queen's Gallery, *Holbein*, 1978–9, no.46.

[2] *Imitations of Original Drawings by Hans Holbein, in the Collection of His Majesty, for the Portraits of Illustrious Persons of the Court of Henry VIII*, 1792–1800, and subsequent editions. The genesis of the work is described by Parker, *op. cit.*, pp.20, 22, 60–1.

[3] Evans invoice.

John Hoppner (1758?–1810)

Born in London; his parentage is uncertain, and there was a report that he was a natural son of George III. He entered the RA schools in 1775 and exhibited portraits at the RA 1780–1809, being elected ARA 1793 and RA 1795. He was called Portrait Painter to the Prince of Wales in the RA catalogue of 1789, by which time he was living very near Carlton House. After the death of Reynolds, to whom Hoppner owed much, he contested the lead in English portraiture with Lawrence. In 1802 he visited Paris. He died in London on 23 January 1810 in his fifty-first year.

P563 *George IV as Prince of Wales*

Powdered hair, blue eyes, wearing a dark grey coat with the Star of the Garter, a white waistcoat and buff breeches; he holds a stick in his left hand.

Canvas, relined 126.5 × 100.4

Heavily ironed in relining.[1] There are traces of bitumen by his right cuff, in the shadows of the coat and behind the head, and a prominent shrinkage craquelure in the sky to the left has been retouched. An old tear runs across the coat over his left leg on which there is also a small damage. *Pentimenti* suggest that the coat was redrawn.

For the sitter see Lawrence P559. When Prince of Wales, George IV particularly favoured Lord Yarmouth (later the 3rd Marquess of Hertford).[2]

Possibly the portrait shown at the RA in 1792. The Prince seems younger than in his other known portraits by Hoppner, which were: RA 1796 (98), generally identified as the whole-length in Garter Robes now at Buckingham Palace (Millar, no. 834), of which there are good versions with the Corporation of Liverpool[3] and at Ragley,[4] and RA 1807 (74), in Garter Robes,[5] possibly the 'extra size Half Length' sent to Persia and now untraced.[6] Hoppner also copied earlier portraits of the Prince by Reynolds.[7] Comparison of P563 with the half-length of Henry Lascelles (later 2nd Earl of Harewood) by Hoppner at Harewood demonstrates the resemblance of the two men which the Prince found so disturbing.[8]

Version

A smaller version was in the possession of Lady Cynthia Colville 1955, said to have been given by the sitter to Mrs. Crewe.

Provenance

Delivered to the Prince by Mrs. Hoppner, 14 June 1810; Mrs. Hoppner included it in her account to the Prince of 30 July 1810, '*Half Length Portrait of HRH the Prince of Wales in Plain Clothes*', 50 gn.; set in a new frame by Smith (his label remains on the frame which bears the Prince's feathers and motto *ich dien*),

P563 was sent to Lord Yarmouth (later 3rd Marquess of Hertford) on 31 August 1810;[9] St. Dunstan's Villa inventory 1842 as Northcote; St. Dunstan's sale, Phillips, 9 July 1855 (122, as Northcote), bt. Mawson for the 4th Marquess of Hertford, 40 gn.;[10] Hertford House inventory 1870 as Hoppner.

Exhibitions

Possibly RA 1792 (100); Bethnal Green 1872–5 (18, listed as both Hoppner and Romney in 1874[11]).

P563

References General

W. McKay and W. Roberts, *John Hoppner RA*, 1909, p.95; O. Millar, *The Later Georgian Pictures in the collection of Her Majesty the Queen*, 1969, I, p.50.

[1] Mawson had P563 repaired after buying it for Lord Hertford in 1855 (see *Letters*, no.57, p.70). The stretcher is stamped F. LEEDHAM LINER; he is recorded in London 1844–56 and 1866–71.
[2] See Ingamells, 1983, pp.20–4, 46–7.
[3] Illus. *Kings and Queens of England, souvenir*, 1953, pl.32.
[4] Engraved by W. Say 1812 as in Lord Hertford's possession (i.e. the 2nd Marquess of Hertford); probably presented to Lord Hertford following the Prince's visit to Ragley in 1796.
[5] Cf. Farington, *Diary*, 2 May 1807, describing the Prince buckling on the belt which belonged to his robes when sitting to Hoppner.

[6] Cf. Millar, *loc cit.*; in Mrs. Hoppner's account of 30 July 1810 to the Prince there was '*An Extra sized Half Length in the Robes of the Garter of HRH the Prince of Wales delivered to Sir Gore Ouseley to be taken to Persia*'. Ouseley was appointed Ambassador to Persia on 6 March 1810.
[7] E.g. in the Mansion House, York, a copy of the whole-length in Robes with negro page painted by Reynolds in 1787, and a Hoppner copy of the 1785 Reynolds half-length was formerly at Conishead Priory (see Reynolds P47 note 6, and M. Davies, *National Gallery Catalogues, The British School*, 1959, p.82).
[8] Cf. Farington, *Diary*, 25 January 1796, when the Prince desired Hoppner to alter his portrait so that it less resembled Mr. Lascelles 'the Pretender'.
[9] These movements, and Mrs. Hoppner's account, are given in Millar, *loc. cit.*
[10] Hertford was 'anxious' to have P563 which he described to Mawson as by Northcote, following the Phillips sale catalogue (see *Letters*, no.55, p.67, and note 1 above).
[11] Bethnal Green catalogue 1874, pp.2, 81.

Edwin Henry Landseer (1802–1873)

Born on 7 March 1802 in London, son of the engraver John Landseer. Studied with Haydon in 1816 before attending the RA schools. Exhibited at the BI between 1818 and 1865 and regularly at the RA from 1817, principally animal subjects which gained a wide popularity through engravings; elected ARA 1826, RA 1831, but declined the Presidency in 1865. He was knighted in 1850 and enjoyed considerable Royal patronage. In 1866 he completed the four lions for the Nelson monument in Trafalgar Square. From 1858 he became increasingly dogged by depression and he died in London on 1 October 1873.

Abbreviations
Graves 1876 A. Graves, *Catalogue of the Works of the late Sir Edwin Landseer RA*, 1876
Ormond 1981 R. Ormond, *Sir Edwin Landseer*, Philadelphia-London, 1981

P257 *Doubtful Crumbs*

A dozing mastiff rests his paws on a bare bone which a black and tan terrier regards hungrily; the floor is covered with pink and grey tiles.

Canvas, relined[1] 62.2 × 74.6 made up to 63.4 × 75.9

There is a pronounced craquelure in the darks and in the green shadows on the right.

Painted in 1859, according to Graves. When it was shown at the RA that year both *The Times* (30 April) and *Art Journal* (1859, p.164) particularly admired the puppy's head: 'none but Landseer', said *The Times*, 'can thus render the human in the canine expression'. It was gently derided by the Catchpenny Critic of *Punch* who admired the two French poodles in Mr. Cribb's *Forbidden Crusts*, 'the expression of [whose] noses is rendered with great taste'.[2]

P257

Engravings

T. Landseer 1862; J. P. Pratt 1890.

Provenance

Bought from the artist for £300 by Elhanan Bicknell (1788–1861) of Herne Hill; his sale (pictures), Christie's, 25 April 1863 (105, *Two Dogs*: 'looking for the crumbs that fall from the great man's table'), bt. Wells for the 4th Marquess of Hertford, 2,300 gn.; rue Laffitte inventory 1871 (185); Hertford House inventory 1890.

Exhibitions

RA 1859 (138, *Doubtful Crumbs*); Bethnal Green 1872–5 (47).

Reference General

Graves 1876, p.32, no.405.

[1] The stretcher is stamped: W.MORRILL/LINER; he practised in London from 1866.

[2] Quoted by D. Robertson, *Sir Charles Eastlake*, 1978, p.207.

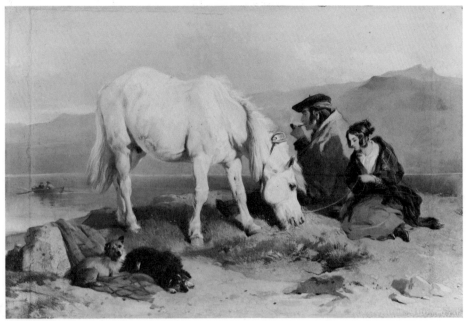

P373

P373 *A Highland Scene*

The two dogs lie on a red rug; the man wears a beige cloak, the woman a rust-brown skirt and a dark plaid shawl.

Mahogany panel $28 \times 42.4 \times 0.6$ five members: the main section 27×36.6 with strips 0.5 wide along the top and bottom; the left section 28×2.6, the right 28×3.2. When the panel was cradled capping strips were added to the edges bringing the overall size to 28.8×43.2

The panel was probably cradled c.1896.[1] The joins in the panel have been retouched; there is a marked craquelure in the darks and the woman's skirt which has been retouched. In the upper right corner there is a horizontal surface scratch 13 cm. long.

P373 was probably painted c.1834. The white pony recurs in *The Drover's Departure* (Sheepshanks Gift, Victoria and Albert Museum) which was shown at the RA in 1835, but not the two figures (as Graves suggested). Landseer was a regular visitor to the Scottish highlands from 1824 onwards.

Provenance
Gen. the Hon. Edmund Phipps (1760–1837); the Hon. Edmund Phipps (1808–57); his sale, Christie's, 25 June 1859 (93, 'Highlander and his Daughter . . .'). bt. Mawson for the 4th Marquess of Hertford, 815 gn.; rue Laffitte inventory 1871 (213); Hertford House inventory 1890.

Exhibition
Bethnal Green 1872–5 (11).

References General
Graves 1876, p.18, under no.207; Ormond 1981, p.85.

[1] The cradle is similar to those fitted by Morrill to the Rubens P63 in 1896 and the Cima P1.

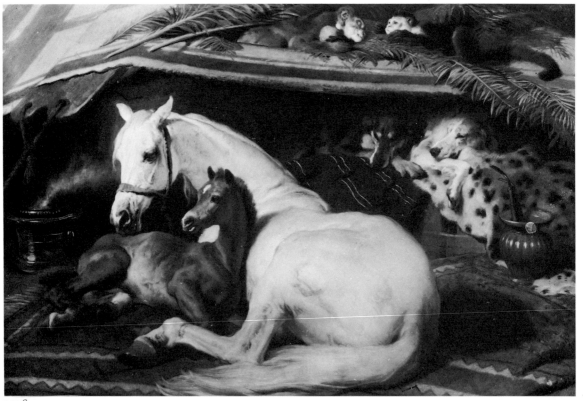

P376

P376 *The Arab Tent*

A grey Arab mare and her brown foal rest on an eastern carpet of a dull-red, blue and white pattern, before a beige and brown tent, on the roof of which lie palm fronds, a baboon with an ear-ring holding an orange, and a black monkey; to the left a fire burning in a brass brazier; in the centre two Persian greyhounds rest on a blue-grey, red-striped rug and a cheetah skin; to the right, two oriental pipes in a turquoise jar.

Double canvas 153.6 × 226.4

Revarnished for Sir Richard Wallace by Buttery in October 1879.[1] The canvas was laid on a fine linen cloth before stretching; the corners are now buckling due to a tear on the fold in the bottom right corner and to the uneven adjustment of the stretcher. Battens have been added to the right-hand and bottom edges of the canvas. The darkest areas and the whites show a pronounced craquelure, and there is a shrinkage craquelure on the muzzle of the mare. *Pentimenti* show that the mare was first placed slightly higher.

Painted in 1866, according to Graves. When shown at the RA in 1866 P376 was titled *Mare and Foal – Indian Tent, etc.*, but *The Times* (5 May) pointed out that what Landseer chose to call an Indian tent 'should rather be called an Arab tent, having regard to its material, colour and occupants'.[2]

Engravings
T. Landseer 1875; C. A. Tomkins 1883.

Provenance
Bought from the artist by the Prince of Wales (later Edward VII) before 1868; acquired from the Prince between April 1874[3] and October 1879 (see above) by Sir Richard Wallace; Hertford House inventory 1890.

Exhibitions
RA 1866 (92, see above); Leeds, *National Exhibition of Works of Art*, 1868 (1341, *The Indian Tent*), lent by the Prince of Wales; RA, *Landseer*, 1874 (239, *Arab Tent*), lent by the Prince of Wales; Ipswich 1880 (17, *The Indian Tent*), lent Wallace.

Reference General
Graves 1876, p.34, no.425.

[1] Copy of invoice in Wallace Collection archives.
[2] A label, *verso*, reads: '*The Arab Tent belonging to the Prince of Wales.*'
[3] When the RA Landseer exhibition ended. Graves listed P376 as in the collection of the Prince of Wales.

P589 *Miss Ellen Power*

Dark chestnut hair, wearing a black dress and holding a white canary. Signed in monogram bottom right: EL.

Pastel on buff paper on millboard 64 × 48.4

Faint black lines run across the left arm and down through the skirt, reducing the size to 57 × 44.5 but retaining the monogram.

Ellen ('Nelly') Power, daughter of Col. Robert Power and niece of the Countess of Blessington (see Lawrence P558); with her elder sister Marguerite (c.1815–67) she lived with Lady Blessington 1831–49 (performing an editorial role for *The*

P589

Keepsake and *The Book of Beauty*) and with the comte d'Orsay in Paris 1849–52. It is not clear what then happened to Ellen; she may have become a nun[1] and died in 1872,[2] or she may have died in a London almshouse after 1902.[3]

Drawn in 1841, according to Graves. Other portraits of Ellen Power in the Gore House sale were a miniature by Eugène Lami (lot 615), a drawing by d'Orsay ('with a bird', lot 1034), and an engraving by Lemon (lot 1149).

Engraving
H. Robinson 1842, for *The Book of Beauty*.

Copy
A copy in oil by d'Orsay was in the Gore House sale, 1849, lot 1038.

Provenance
The Blessington sale, Gore House, Phillips, 7th day, 15 May 1849 (1056), bt. by the 4th Marquess of Hertford, 65 gn.; Hertford House inventory 1890.

Exhibition
Bethnal Green 1872–5 (654).

Reference General
Graves 1876, p.23, no.292.

[1] Cf. Mrs. Newton Crosland, *Landmarks of a Literary Life*, 1893, p.121 (quoted by W. Connely, *Count d'Orsay*, 1952, p.615).
[2] Cf. S. C. Hall, *A Book of Memories*, 1872, p.404 (Connely, *loc. cit.*).
[3] Cf. M. Sadleir, *Blessington-D'Orsay*, 1933, pp.365–6.

Thomas Lawrence (1769–1830)

Born on 13 April 1769 in Bristol. A self-taught artist whose portrait drawings, made in his father's inn at Devizes, were already being admired in 1779. He moved to London in 1787 and showed a pastel at the RA that year. In 1790 his whole-lengths of Queen Charlotte (National Gallery, London) and Elizabeth Farren (Metropolitan Museum of Art, New York) established his reputation and on the death of Reynolds in 1792 he was appointed Principal Painter to the King. He exhibited portraits (and three histories) at the RA 1787–1830, and was elected ARA 1791 and RA 1794. The Prince Regent (later George IV), to whom Lawrence was introduced in 1814, richly influenced his later years, knighting him in 1815 and commissioning the series of portraits of European sovereigns and statesmen for the Waterloo Chamber at Windsor. In fulfilling this commission Lawrence visited Aix-la-Chapelle, Vienna and Rome in 1818–20 and Paris in 1825. He was elected PRA in 1820. He died in London on 7 January 1830. His remarkable collection of old master drawings was bought by Samuel Woodburn in 1835; many of those by Raphael and Michelangelo were acquired by the Ashmolean Museum, Oxford, in 1845.

Abbreviations

Garlick 1954 K. Garlick, *Sir Thomas Lawrence*, 1954

Garlick 1964 K. Garlick, 'A catalogue of the paintings, drawings and pastels of Sir Thomas Lawrence', *The Walpole Society*, XXXIX, 1964

Levey 1979 M. Levey, *Sir Thomas Lawrence*, National Portrait Gallery, 1979

P39 *Portrait of a Lady*

Within a painted oval; black hair dressed with a red-brown hair-band, brown eyes, wearing a golden yellow dress with a turquoise waist-band.

Canvas 76 × 63.5

The bottom and left-hand edges of the canvas wrapped round the stretcher are also painted black. *Pentimenti* show that the head-band was originally higher on the forehead and tied behind the head; there is a marked craquelure in the repainted areas. The varnish is discoloured.

An undoubted Lawrence, dateable c.1800 on grounds of style and costume, P39 was described in 1847 as an engraved portrait of Miss Siddons given by the artist to Morant, and this identification was repeated in 1851 and 1863 (see Provenance). In 1900 P39 was catalogued as Maria Siddons and in 1928 as Sally Siddons, following a diffident identification by Armstrong in 1913. There were attractive reasons for calling an early Lawrence portrait of a girl 'Miss Siddons', following his romantic entanglements in the 1790s with Sally (1775–1803) and Maria (1779–98), the eldest daughters of the celebrated actress, Mrs. Sarah Siddons,[1] but neither identity can here be proved. Cecilia Siddons (1794–1868), their younger sister, stated that neither had sat to Lawrence for an oil picture and 'none of the family recollect that he painted one from memory'.[2]

P39

Drawings by Lawrence which have a reasonable claim to show either Sally or Maria depict more languid girls (both were consumptive) with large eyes and straight noses.[3] The sitter in P39 looks more sanguine, and the engraving cited in nineteenth-century sale catalogues was titled *Mariana*.

Engraving
R. Graves 1832, as *Mariana* (for the *Forget me not*).

Provenance
George Morant (1770–1846) of Farnborough Place, Hants.;[4] his sale, Christie's 16 April 1847 (243, 'Miss Siddons ... presented by ... Lawrence to the late Mr. Morant – engraved'), bt. Hogarth, 51 gn.; Hogarth sale, Christie's, 13 June 1851 (44, 'Miss Siddons. Engraved'), bt. Stewart, 57 gn. (chalk marks from this sale remain visible on the canvas, *verso*); Elhanan Bicknell (1788–1861) of Herne Hill where noted by Waagen (II, p.351, as *Mrs. Siddons*); his sale (pictures), Christie's, 25 April 1863 (37, 'Miss Siddons, engraved'), bt. Wells for the 4th Marquess of Hertford, 140 gn.; Hertford House inventory 1890.[5]

Exhibition
Bethnal Green 1872–5 (4, as *A Lady* by Reynolds 1872, by Lawrence 1874).

References General
Garlick 1954, p. 57, as c.1800, and 1964, p.176, as Sally Siddons c.1795–1800, described as wearing a white dress; W. Armstrong, *Lawrence*, 1913, pp.163, 175.

[1] Lawrence's romance is described by O. G. Knapp, *An Artist's Love Story*, 1904; Farington mentioned his *affaires* in his *Diary*, 29 November 1804.

[2] Letter to Lawrence's executor, Archibald Keightley, in the National Portrait Gallery archives, quoted by Garlick 1954, p.58, and 1964, p.176.

[3] See Garlick 1964, pp.243–4, and Levey 1979, no.67.

[4] Presumably the George Morant who supplied frames for a number of versions of Lawrence's portraits of George IV, cf. O. Millar, *The Later Georgian Pictures in the collection of Her Majesty The Queen*, 1969, I, p.60.

[5] P39 was probably in the rue Laffitte in 1867 as a Reynolds (see Exhibitions above); cf. Reynolds P561 note 4.

P41 *Portrait of a Lady*

Fair hair, grey eyes, wearing white with a black gauze scarf; to the left a deer park.

Canvas, relined 76×63.4

There is a pronounced craquelure in the darker background passages and across the face where the cracks are filled by discoloured retouchings. The edges have been abraded by a tightly-fitting frame. The varnish is discoloured.

An attribution to Lawrence c.1792 seems beyond reasonable doubt. It may be compared for costume, handling and landscape with the two half-lengths Lawrence showed at the RA in 1792, *Lady Apsley* and *Lady Charlotte Greville* (Levey 1979, nos.5 and 8). The landscape compares closely with an oil sketch, formerly in Col. Grant's collection, said to have been painted by Lawrence in Ilam Park, Staffordshire.[1] Armstrong's contention that P41 is unfinished seems ill-founded. Garlick dated P41 c.1790–5 (1954) and in the 1790s (1964); Armstrong suggested 1788–90. P41 had previously been attributed to both Reynolds (see Provenance) and Hoppner.[2]

Version

NEW ORLEANS, McBride Galleries 1983; 76.8×63.5, ex-Lord Sudley and Newhouse Galleries, New York; the paint is thinner than in P41 and the surface seems free of craquelure.

Provenance[3]

Acquired by the 4th Marquess of Hertford after 1859[4] and before 1867 when Bürger saw at 2 rue Laffitte *'un des chef d'oeuvres de Reynolds: portrait de jeune femme, à mi-corps, assise en un parc, le bras gauche accoudé sur un tertre; de blanc toute vêtue . . . dans la chambre à coucher, ayant pour pendant, de l'autre côté d'un lit magnifique, une Jeune Fille de Greuze, accoudée sur un coussin; robe blanche et chapeau à plumes.';*[5] rue Laffitte inventory 1871 (671, Reynolds,*'Portrait de femme'*); Hertford House inventory 1890 as Miss Nesbitt by Reynolds.[6]

Exhibition

Bethnal Green 1872–5 (22).

References General

Garlick 1954, p.65, and 1964, p.206; Lord Ronald Sutherland Gower, *Sir Thomas Lawrence*, 1900, p.172; W. Armstrong, *Lawrence*, 1913, p.175.

[1] Garlick 1964, p.209, as 1795–1800; exh. *Lawrence*, RA 1961 (32).

[2] Cf. the first five editions of this catalogue, 1900–05; A. L. Baldry, *The Wallace Collection*, 1904, p.111; H. P. K. Skipton, *Hoppner*, 1905, f.p.20.

[3] P41 was tentatively associated in the 1968 catalogue with the St. Dunstan's sale, Phillips, 9 July 1855 (124, Lawrence, *A Portrait of a Lady*), but Hertford made no mention of this picture in his correspondence with Mawson concerning the sale (*Letters*, nos.54–7, pp.66–70).

[4] On 23 June 1859 Hertford wrote Mawson that he had no 'Sir Joshuas' in Paris (*Letters*, no.92, p.117).

[5] W. Bürger, 'Les Collections Particulières', *Paris Guide*, I, 1867, p.538. This quotation has previously been associated with the Reynolds P45 which, however, was always in Hertford House after its purchase by Lord Hertford in 1859. The description here given can only apply to P41 of all the 4th Marquess's portraits. The 'pendant' Greuze was P403.

[6] See Reynolds P43, which appeared twice in the 1890 inventory, once in the position occupied by P41 (as is revealed in photographs of the interior of Hertford House taken in the 1890s and preserved in the Wallace Collection archives).

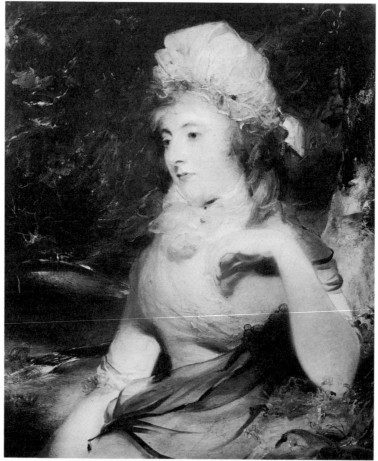

P41

P558 *Margaret, Countess of Blessington*

Black hair, blue eyes, wearing white with a corsage of blue cornflowers, a stone ring on the second finger of her left hand and a pearl bracelet with a diamond clasp on her right wrist; a Countess's ermine-lined stole lies over the arm of her red chair; the background is a rich turquoise.

Canvas 91.5 × 67

Minor retouchings on the throat and arms. *Pentimenti* show that the hair originally spread more on the right-hand side; her left arm and hand were slightly higher, suggesting that the chair arm was first intended to come further into the composition – the bottom 6 cm. of the picture are not entirely resolved. Further *pentimenti* on her left shoulder and the top of the chair.

Margaret Power (1789–1849), authoress, b. Knockbrit, co. Tipperary; m. 1st in 1804 Maurice Farmer (d. 1817), and 2nd in 1818 Charles, 2nd Viscount Mountjoy, cr. Earl of Blessington 1816 (d. 1829); from 1822 Alfred, comte d'Orsay (1801–52), was her constant companion; she was installed in Manchester Square 1816–18; from 1822–30 she travelled in France and Italy (where she met Byron); lived in Gore House, Kensington, 1836–49, which became famous for its literary gatherings; edited *The Book of Beauty* 1834–46 and *The Keepsake* 1840–9; declared bankrupt 1849, she sold Gore House and its contents, and d. in Paris within a few months.

One of Lawrence's outstanding characterisations, P558 was painted in his Russell Square studio[1] and first shown at the RA in 1822; the following year Byron wrote that it had 'set all London raving'.[2] According to Madden,[3] Lawrence thought it his *chef d'oeuvre* and refused to copy it for Lord Blessington, saying 'that picture could neither be copied or engraved' (but see below). It attracted nevertheless, some criticism; *The Englishman* (14 May 1822) thought it had been 'got up for exhibition effect' and was 'too carelessly executed to add, in any degree, to the reputation of the artist'.[4] P. G. Patmore, who saw Lady Blessington and her husband looking at P558 on the opening day of the Academy exhibition, later remembered:[5]

> 'I have seen no other instance so striking, of the inferiority of art to nature ... As the original stood before it ... she fairly 'killed' the copy ... There is about [P558] a consciousness, a 'pretension', a leaning forward, and a looking forth, as if to claim or court notice and admiration, of which there was no touch in the [sitter] ... there was about her face, together with that beaming intelligence which rarely shows itself upon the countenance till that period of life, a bloom and freshness which as rarely survives early youth ...'

P558 remains the best-known portrait of Lady Blessington (a popular lithograph showed her standing before it),[6] but her likeness was taken many times, as Ormond has shown.[7] In the Gore House sale there were oils of her by Grant, d'Orsay and Valentini, drawings by Chalon, Cosway, Grant, Landseer and

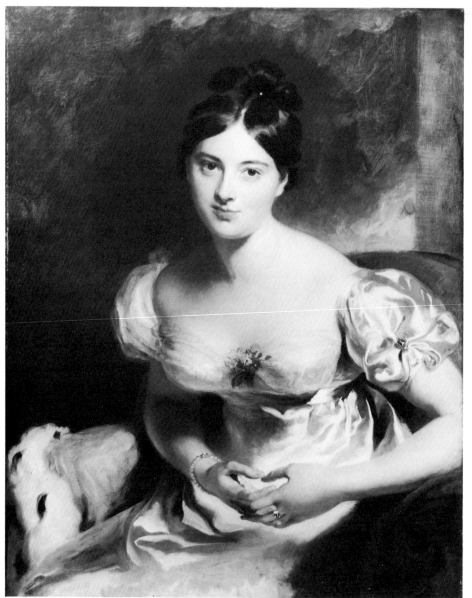

P558

d'Orsay, miniatures by Cosway, Maclise, Lane and Parris, and marble busts by Bartolini and d'Orsay. Drawings of her by Chalon (c.1834) and Charles Martin (1844) are in the National Portrait Gallery, London (nos.1309 and 1645a), and by Cattermole and Stroehling (1812) in the British Museum (nos.1889–7–24–1 and 1885–7–11–5).

P558 detail

Drawing

Ormond records a drawing, attributed to Lawrence, exh. Amateur Art Exhibition, London, 1890 (50), lent by Lady Arthur Wellesley.[8]

Engravings

J. H. Watt 1832, for *The Amulet*;[9] S. W. & W. Reynolds c.1835, as *English Lady: Dame Anglaise*; S. Cousins 1837.

Copies/Versions

HUGHENDEN MANOR listed in Disraeli's 1881 inventory as Lawrence.

LONDON Christie's, 13 May 1899 (71), 49.5 × 40.5,[10] possibly the version with Agnew 1919.

NEW YORK Ralston sale, American Art Association, 12 March 1926 (75), ex-de Ridder collection, Paris.

STAPLEHURST Kent, private collection 1958.

Copies in miniature are in Dublin, National Gallery of Ireland, and the Wallace Collection (M27); one of these was possibly lot 658 in the Gore House sale.

Provenance

Lady Blessington, who appears to have had P558 with her abroad 1822–30;[11] her sale, Gore House, Phillips, 7th day, 15 May 1849 (1032, 'regarded as the finest Portrait ever painted by the artist...'),[12] bt. Mawson for the 4th Marquess of Hertford, 320 gn.; Hertford House inventory 1870.

Exhibitions

RA 1822 (80); BI 1833 (10); Bethnal Green 1872–5 (6).

References General

Garlick 1954, p.28; Garlick 1964, p.38.

[1] R. R. Madden, *The Literary Life and Correspondence of the Countess of Blessington*, 1855, III, pp.157–8, quotes an undated letter from Lawrence to Lady Blessington asking her to bring her pearl necklace to a sitting at Russell Square.

[2] In a letter to Lady Harding, dated Genoa, 17 May 1823, quoted by M. Sadleir, *Blessington-D'Orsay*, 1933, p.72. Though Byron wrote her an *Impromptu* (1823) and *To the Countess of Blessington* (n.d.: 'Were I now as I was, I had sung/What Lawrence has painted so well'), his acquaintance with Lady Blessington was probably casual (cf. R. Blake, *Disraeli*, 1969 ed., p.144 n.1).

[3] Madden, *op. cit.*, p.153.

[4] I am grateful to Philip Vainker for this reference.

[5] P. G. Patmore, *My Friends and Acquaintance*, 1854, I, pp.169, 172.

[6] By Alfred Croquis (Daniel Maclise), *Fraser's Magazine*, 1833.

[7] R. Ormond, *National Portrait Gallery, Early Victorian Portraits*, 1973, I, pp.39–41.

[8] Lord Ronald Sutherland Gower, *Sir Thomas Lawrence*, 1900, p.172, lists a drawing by Lawrence of an unknown lady, exh. Amateur Art Exhibition, London, 1898, lent by Lady Wellesley.

[9] A pirated copy of this print (example in Witt Library) shows Lady Blessington with ringlets, weighed down with jewelry, a crucifix in her hands.

[10] Stated in the sale catalogue to have come from Lord Northwick's collection, but not in his sale 1859.

[11] Byron may have seen P558 in Genoa, cf. note 2, and it was not engraved before 1832.

[12] P558 is seen hanging by a pier glass in Gore House, balanced by Lawrence's earlier portrait of Lord Blessington, in a water-colour by d'Orsay (private collection; photograph in National Portrait Gallery archives).

P559 *George IV*

Blue eyes, chestnut wig, wearing black with the Golden Fleece of Austria suspended from a red ribbon round his neck,[1] and the badge of the Garter; gold rings on the third and little fingers of each hand. On the pink damask sofa, a document inscribed: *George R.*; on the round boulle pedestal table[2] an ormolu inkstand;[3] red drapes hang above the window.

Canvas 270.5 × 179

The stretcher has been cut 61 cm. up on each vertical member and poorly repaired; there are three irregular horizontal members. The paint surface has suffered from damp in the upper part (there are spill marks *verso*); there are old repairs by the right leg and below the right knee, and other minor losses. The varnish is discoloured.

George IV (1762–1830), Prince Regent 1811–20, and King 1820–30. During his liaison with the Marchioness of Hertford c.1807–20 (see Downman p754) George IV was a frequent visitor to Hertford House. The setting of p559 is reminiscent of the Golden Drawing Room at Carlton House (see note 2). For a more youthful portrait, see Hoppner p563.

Painted in 1822. On 1 July Lawrence wrote to his sister that the near approach of the King's departure for Scotland (10 August) was making him work hard on the portrait, which he considered 'perhaps my most successful resemblance [of the King], and the most interesting from its being so entirely of a simple domestic character'.[4] Thackeray referred to p559 as 'the famous' portrait of the King,[5] and it was engraved five times by 1841 (see below). Constable found 'a blustering pomposity' in the pose,[6] and it was also criticised (perhaps not too seriously) for the inconsiderate posing of the King before an open window,[7] and for the apparent discomfort of his close-fitting clothes.[8]

Drawing

LONDON Clarence House, 91.5 × 76.2, a full-size chalk drawing for the head (Levey 1979, no.84).

Engravings

C. Turner 1824 (half-length); Saunders and Ottley 1828 (half-length); W. Finden 1829; E. Scriven 1831 (half-length); P. Thomas 1841; Normand *fils*.

Copies

BAMBERG Residenz, 51 × 40, half-length copy by A. Macco 1826–7.
LONDON Sotheby's, 4 July 1934 (174), bust-length copy set in Stobwasser box lid. Sotheby's, 6 July 1981 (10), bust-length enamel by Henry Bone set in tortoiseshell snuff box. Victoria and Albert Museum (A73–1965), small statuette in pink wax based on p559, pub. J. Cave 1830.

Versions

BRIGHTON Art Gallery (no.336), 267 × 150.
BUCKINGHAM PALACE 61 × 42, probably the picture delivered to the King by Lawrence in 1830 'a small whole-length of his Majesty' (Millar, no.924).
CHATSWORTH 139 × 109, three-quarter length.
CROFT CASTLE 91 × 71, half-length.
KENNEBUNKPORT Maine, Booth Tarkington collection, 127 × 101, three-quarter length.
KIMBRIDGE HOUSE Hants.
LONDON Foster's, 6 July 1938 (195), whole-length. The Hon. Mrs. Hebeler, a portrait presented by George IV to Lord Ravensworth.
LOWTHER CASTLE sale, 29 April 1947 (1794), 140 × 112, three-quarter length.
NEW YORK Clendenin J. Ryan sale, 19 January 1940 (212), 91 × 71, half-length, said to have been 'presented to the King's

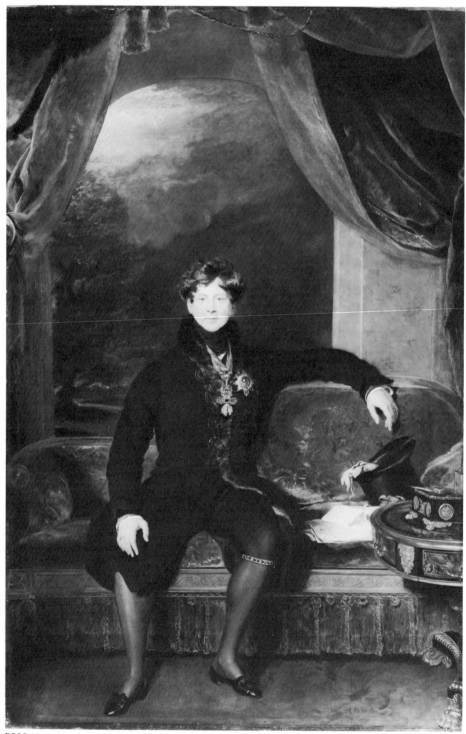

P559

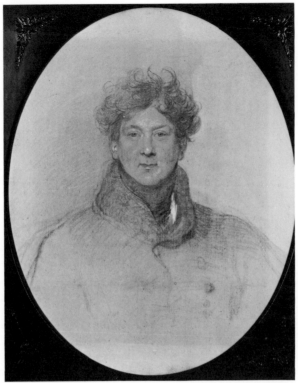

Lawrence: Study for P559. Clarence House.
(Reproduced by gracious permission of Her Majesty Queen Elizabeth
The Queen Mother)

financial adviser'. Parke-Bernet, 3 December
1942 (39), 91 × 71, half-length, 'painted for
John Bridge in 1828'.
RAGLEY 76 × 63, bust length.
WISTOW HALL 91 × 71, half-length.

Provenance

Painted for Elizabeth, Marchioness
Conyngham (c.1766–1861);[9] given by Lord
Conyngham (presumably the 2nd Marquess,
d. 1876) to the Duke of Teck (1837–1900,
who came to England in 1864),[10] from whom
bought by Sir Richard Wallace in July 1883
for £600;[11] Hertford House inventory 1890.

References General

Garlick 1954, p.39, and 1964, pp.87–8; Levey
1979, p.20.

[1] George IV received the Order in July 1815 after
Waterloo, by special dispensation from the Pope; the Order
was officially confined to Catholics. The Duke of
Wellington's Golden Fleece (see Morton P632) was of the
Spanish Order which was not confined to Catholics.

[2] I am most grateful to Geoffrey de Bellaigue (letter on file
dated 14 July 1978) for the identification of this table as
that now in the Crimson Drawing Room at Windsor.
Probably also identifiable with one of the tables shown in
the Blue Velvet Closet and the Golden Drawing Room at
Carlton House in Pyne's *Royal Residences* (plates dated 1818
and 1817 respectively).

[3] Identified by de Bellaigue (see above) as one of a pair
acquired by George IV usually kept in the Bow Room at
Buckingham Palace.

[4] D. E. Williams, *The Life and Correspondence of Sir Thomas
Lawrence*, 1831, II, p.319. Elsewhere Lawrence remarked
that the King 'seemed to make it a great point that pictures,
his own portrait and others, should be instantly finished'
(*ibid.*, p.253).

Ormolu inkstand (Buckingham Palace) and boulle table
(Windsor Castle) shown in P559.

(Reproduced by gracious permission of Her Majesty the Queen)

[5] *Vanity Fair*, 1848, ch.48; Rebecca Sharp orders from
Colnaghi 'the finest portrait' of the King 'that art had
produced' and chose 'the famous one . . . in a frock coat
with a fur collar, and breeches and silk stockings, simpering
on a sofa from under his curly brown wig'.

[6] *Conversations of James Northcote R.A. with James Ward*, ed.
E. Fletcher, 1901, pp.147–8; Constable told Ward that he
had had great difficulty in restraining from laughter when
Lawrence showed him the portrait of the King 'sitting on a
sofa, with his arms thrown over the back of it'.

[7] Unpublished letter, in a private collection 1951,
addressed to John Parkinson, 17 May 1823: P559 is
described as 'a most masterly Production', but why the
King 'sits on a Sofa, with his back to a large open Window,
except to get a stiff Neck – the Painter best knows . . .'
(transcript in Wallace Collection archives).

[8] A. Cunningham, *Lives*, 1846 ed., VI, p.253: 'Lawrence
prided himself much on the portraits which he painted of
George IVth, and preferred one in his private dress to the
others; yet the King was full-bodied, inclining to be
corpulent, and, when painted in his tight close-bodied
dress, looked ill at ease: his clothes in the picture fit so tight,
that they seem to give him pain'.

[9] P559 was previously thought to have been painted for the
King who, it was supposed, lent it to the posthumous
Lawrence exhibition at the BI in 1830, no.1, and then
presented it to Lady Conyngham. But the King was dead
before the exhibition ended, and the two portraits of the
King in the exhibition are identified by Millar under nos.
873 and 924. An anonymous satire of Lady Conyngham,
published in July 1829, *A Lady-playing with A-Sovereign*,
shows her seated on a sofa in a pose not unrelated to that of
the King in P559, with P559 hanging on the wall behind (it
is shown reversed).

[10] Information from letters in the National Portrait Gallery
archives from D. C. Bell of the Privy Purse Office to George
Scharf, Secretary of the National Portrait Gallery: on 7
June 1883 Bell wrote that 'by reference to some old record
book of George IV's time I ascertained that [P559] was
given to the Marchioness of Conyngham and also I was
told by an old servant that it was at Bifrons a few years ago';
on 8 June he added that P559 had been given by Lord
Conyngham to the Duke of Teck.

[11] Through the agency of Sir Richard Wallace, the Duke of
Teck had offered P559 to the National Portrait Gallery for
£1,000; on 9 June 1883 the Trustees offered him £600
which he refused, whereupon Wallace himself bought it,
with the understanding, as he wrote to the Duchess of Teck,
that it would be at her disposal whenever she wished to
have it back, for the same sum (letter dated 9 July 1883;
Royal Archives, Windsor Castle, Vic. Addl. MSS.A/8/2565).

Steven van der Meulen (active 1543–1568)

An Antwerp artist. He studied under Willem van Cleve in 1543 and was admitted to the Antwerp Guild of S. Luke in 1552. By 1560 he was residing in London. In 1561 he visited Sweden to paint the portrait (now in Gripsholm Castle) of Eric XIV, a prospective bridegroom of Elizabeth I. He was extensively patronised by John, 1st Baron Lumley, and appears in the Lumley inventories as 'The famous paynter Steven'. No works by him can be identified after 1568.[1]

[1] The fullest account of van der Meulen is that given by R. Strong in *The English Icon: Elizabethan & Jacobean Portraiture*, 1969, pp.119–34.

Attributed to van der Meulen

P534 *Robert Dudley, Earl of Leicester*

Dark brown hair with light brown moustache and beard, grey eyes, in rich Court dress, of a black velvet cap with jewelled hat-band and gold and white plumes, a golden-brown doublet richly embroidered and decorated with pearls and white enamelled roses, and the badge of the Garter suspended from a drop of pearls and garnets; a dagger at his right hip, his sword hilt inscribed: AETATIS 28 156.; his right hand rests on a combed morion helmet which bears a medallion of a warrior's head with the inscription: . . . MEUS . . .

Oak panel 91.2 × 71 × 0.4 three vertical members, the joins at 19.5 and 46 from the left-hand edge

Cleaned in 1857[1] and cradled by Buttery in 1879.[2] The joins in the panel have been refilled and retouched, and the varnish is much discoloured. The hands are much restored.

Robert Dudley (1532?–88), the presumptuous favourite of Elizabeth I, fifth son of the Duke of Northumberland, m. in 1550 Amye Robsart (d.1560), sister of Lady Jane Grey; knighted in the reign of Edward VI (see After Holbein P547); proclaimed his sister-in-law Queen, but was pardoned by Queen Mary 1554; KG and Privy Councillor 1559; cr. Earl of Leicester 1564; m. in 1573 Lady Sheffield (d.1577) and entertained Elizabeth I at Kenilworth 1575; m. in 1578 the Countess of Essex; he led an expedition against Spain in the United Provinces of which he was elected Governor 1586, but was recalled in 1587.

The identity is confirmed by comparison with the anonymous portrait of Leicester, no.447 in the National Portrait Gallery, London. P534 is the earliest accepted portrait of Leicester and was attributed to van der Meulen c.1560–5 by Strong in 1969.[3] Previously catalogued as Flemish School and, until 1928, as Leicester's elder brother, Ambrose, Earl of Warwick.

P534

Provenance

Acquired by the 3rd Marquess of Hertford; Dorchester House inventory 1842 as '*Zucchero, Ambrose, Earl of Warwick*'; Hertford House inventory 1870 as '*Porbus, Ambrose, Earl of Warwick*'.[4]

Exhibitions

On each occasion as *The Earl of Warwick* by Porbus: Bethnal Green 1872–5 (95); RA 1880 (166); RA 1893 (178).

[1] Evans invoice.

[2] The cradle consists of twelve vertical mahogany members and twelve horizontal oak battens.

[3] R. Strong, *National Portrait Gallery, Tudor and Jacobean Portraits*, 1969, I, p. 195; a full survey of Leicester's iconography is given on pp. 191–6, and see pls. 378–88.

[4] The present frame of P534 (like that on the Eworth P535) was made in 1872 to match that of the Pourbus P26 (invoice in Wallace Collection archives), so that Wallace had his three portraits then attributed to 'Porbus' in matching frames.

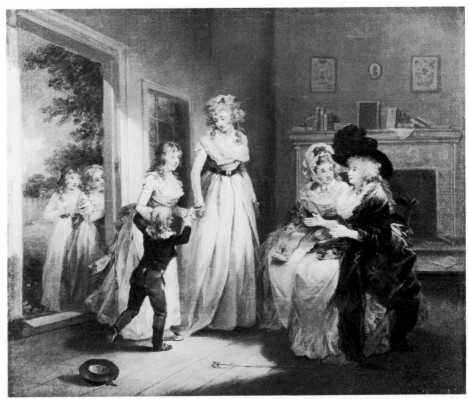

P574

George Morland (1763–1804)

Born on 26 June 1763 in London, the son of the painter H. R. Morland to whom he was first apprenticed for seven years in 1777. He visited Calais and St-Omer in 1785 by which time he was painting sentimental genre scenes, somewhat in the manner of Boilly. In 1786 he married Anne, the sister of William Ward who engraved sixty-nine of Morland's pictures and who married Morland's sister. In the 1790s he turned to rustic genre, but his later years were clouded by reckless self-indulgence. He exhibited intermittently at the SA 1777–91, FS 1775–82, and RA 1773–1804. He died of a brain fever in London on 29 October 1804.

P574 *A Visit to the Boarding School*

A young governess in white, with scissors hanging at her waist, brings in the younger daughter, whose little brother runs up to her, while her mother sits, a basket of fruit in her lap, with her older sister who holds a sampler (similar to one framed on the wall behind) in her lap; there is a riding crop on the floor. Signed indistinctly bottom right: *G Morland*.

Canvas, relined 61.7 × 74.7

Pendant to *A Visit to the Child at Nurse* (sold Christie's, 11 April 1980, lot 117) in which the infant younger daughter, seen at boarding school in P574, is visited by her mother and older sister.[1] The *Child at Nurse* was engraved by Ward in 1788; P574, the later picture, in 1789.

Engraving

See above.

Provenance

Anon. sale, Christie's, 5 February 1791 (55), bt. Edward Knight of Portland Place, London, 12½ gn.; Durlacher, 5 March 1873, bt. by Sir Richard Wallace, £500;[2] Hertford House inventory 1890.

References General

G. Dawe, *George Morland*, ed. J. J. Foster, 1904, pp. 122, 156; G. C. Williamson, *George Morland*, 1904, p. 133.

[1] Illus. Williamson, *op. cit.*, f.p.48; it appeared with P574 in the anon. sale at Christie's, 5 February 1791 (56), bt. 'CT', 8½ gn.

[2] Receipt in Wallace Collection archives.

Andrew Morton (1802–1845)

Born on 25 July 1802 in Newcastle upon Tyne, he studied at the RA schools. Amongst the portraits he exhibited at the RA 1821–45 were those of Wellington (1835), John Gurwood (1842) and Mrs. Gurwood (1843). His whole-length William IV is in the National Maritime Museum, Greenwich, with three other portraits of naval sitters. He died in London on 1 August 1845.

P632 *The Duke of Wellington with Colonel Gurwood at Apsley House*

In the library[1] Wellington, white-haired, wearing the blue Garter sash and the red collar of the Golden Fleece, sits in a red leather arm chair holding printed proofs, one page headed *Waterloo*; Gurwood, with greying hair, wearing black with a maroon waistcoat, pulls out a folded dispatch inscribed: *June 1815/A to E/Bruxelles/~~Waterloo~~ June 19 1815/To N 23/Lord Bathurst/Report of the Operations/Battle of Waterloo*. On the floor lie letters addressed to Wellington and some fine leather-bound volumes, two inscribed *Marlborough* and *Dispatches*.

Canvas, relined 238.2 × 182.9

Cleaned by Byard in 1922, and surface cleaned in 1982. The edges have been retouched and the darker passages are bituminous.

Arthur Wellesley (1769–1852), Knight of the Order of the Golden Fleece 1812, KG 1813, cr. Duke of Wellington 1814; defeated Napoleon at Waterloo 18 June 1815, and given Apsley House and Stratfield Saye by the Nation 1817; Conservative Prime Minister 1828–30 and 1834. John Gurwood (1790–1845), enlisted as an Ensign 1808, fought in the Peninsular Wars and at Waterloo, sustaining wounds in both campaigns; Brevet-Colonel 1841; Private Secretary to Wellington 1837–44 and editor of his *Dispatches*; died by his own hand.

When P632 (or a version, see below) was shown at the RA in 1840 *The Times* (6 May) remarked that the likeness of Gurwood was 'excellent and full of

P632

life'. Wellington is shown explaining that his dispatch describing the battle of Waterloo was begun at Waterloo and finished at Brussels (and hence the crossed out inscription quoted above; see Exhibitions below); the proofs he holds are presumably those of the *Dispatches* edited by Gurwood (the Waterloo dispatch appeared in vol.XII, 1838, pp.478–84). P632 is an indifferent picture (Wellington's right hand must be the most incompetent piece of painting in the Collection), but was doubtless acquired by Lord Hertford for sentimental reasons; Wellington had once thought highly of him,[2] and Gurwood was one of his closest friends (transcripts of Hertford's letters to him 1829–44 are in the Wallace Collection archives).

Version

LONDON Christie's, 18 July 1924 (58), 271 × 184, showing minor differences, e.g. a clock stands in the left hand corner.

Provenance

Morton sale, Christie's, 14 March 1846 (38, '... I began the Despatch at Waterloo and finished it at Bruxelles...'), bt. Powett, 20½ gn.; the 2nd Baron Northwick (1769–1859);[3] his sale, Thirlestane House, Cheltenham, Phillips, 4th day, 29 July 1859 (380), bt. Mawson for the 4th Marquess of Hertford, 200 gn.; Hertford House inventory 1870.

Exhibitions

Either P632 or the version described above: RA 1840 (463, "Apsley House. The Duke of Wellington explaining to the compiler of his despatches the date of that which describes the battle of Waterloo. 'I began the despatch at Waterloo and finished it at Bruxelles'"); P632 was exh. Bethnal Green 1872–5 (23).

Reference General

Lord Gerald Wellesley and J. Steegman, *The Iconography of the first Duke of Wellington*, 1935, p.37.

[1] The book-cases and chair remain at Apsley House.
[2] Cf. *The Reminiscences of Captain Gronow 1810–60*, 1892, pp.327–8.
[3] P632 was not listed in *Hours in the Picture Gallery of Thirlestane House*, 1846, indicating that Northwick may well have acquired the picture from the Morton sale that year.

P703

William Andrews Nesfield (1793–1881)

Born on 19 February 1793 in Chester-le-Street, he graduated at Trinity College, Cambridge, before enlisting in the army in 1809. He fought in Spain and Canada and retired on half pay in 1816. Elected a member of the ows in 1823, his activity as a water-colour painter was principally between 1823 and 1843. He retired from the Society in 1852 and devoted himself increasingly to landscape gardening. He died in London on 2 March 1881.

P703 *Kilchurn Castle, Loch Awe*

From the south, with rain blowing in from the west. Signed, bottom right: W.A.N.

Water-colour with gum varnish in the darker foreground areas, on card 26.5 × 36.8

Kilchurn Castle at the east end of Loch Awe, Strathclyde, with Ben Cruachan in the Grampian mountains.[1]

Between 1872 and 1900 the signature was interpreted as being that of W. A. Nasmyth; this was corrected in the second edition of this catalogue in 1900.

Provenance

Elhanan Bicknell (1788–1861) of Herne Hill; his sale (drawings), Christie's, 1st day, 29 April 1863 (93, *Kilchurn Castle, Loch Awe*, by W. A. Nesfield), bt. Wells for the 4th Marquess of Hertford, 60 gn.; Hertford House inventory 1890 as Nasmyth.

Exhibitions

Bethnal Green 1872–5 (649, as Nasmyth); Belfast 1876 (81, as Nasmyth).

[1] The old mount is inscribed: *Loch Awe & Ben Cruachan.*

p617

Gilbert Stuart Newton (1794–1835)

Born on 2 September 1794 in Halifax, Nova Scotia. He studied under his uncle, Gilbert Stuart, in Boston before leaving for Europe. He visited Florence and Paris and entered the RA schools in 1817. He exhibited portraits and small literary and genre subjects (many of which were engraved) at the RA 1818–33 and BI 1821–31. He was elected ARA 1828 and RA 1832. His last years were plagued by mental illness and he died in a Chelsea asylum on 5 August 1835.

p617 *The Gentle Student*

Chestnut hair with a red rose, wearing a black head veil, a golden brown dress and black armlets; the book has a marbled fore-edge. Signed in the lower spandrels: *G S Newton/1829*.

Millboard 30.3 × 25 the inside of the painted oval 28.8 × 23

There are traces of bitumen on the veil and book.

Between 1872 and 1899 p617 was incorrectly identified as a portrait of Lady Theresa Lewis.[1]

Engravings

C. Rolls 1833, as *The Gentle Student* (for *The Amulet*); S. Sangster 1847 (for the *Art Union*).

Provenance

Gen. the Hon. Edmund Phipps (1760–1837) by 1833;[2] the Hon. Edmund Phipps (1808–57); his sale, Christie's, 25 June 1859 (82, 'The Gentle Student, the well known engraved picture'), bt. Mawson for the 4th Marquess of Hertford, 200 gn.;[3] Hertford House inventory 1870 as *The Fair Student*.

Exhibition

Bethnal Green 1872–5 (27, as *Lady Theresa Lewis*).

[1] Probably because there is a loose connection between P617 and Newton's engraved portrait of Lady Theresa Lewis in composition, but not likeness; the identification was rejected by Lady Theresa Lewis's daughter (letter on file dated 22 December 1899).
[2] P617 was described as in his possession when engraved for *The Amulet*.
[3] Bought on Mawson's advice, see *Letters*, no.90, p.113.

Allan Ramsay (1713–1784)

Born on 2 October 1713 in Edinburgh, the son of a poet (see Wilkie P352); he studied in London and first visited Italy in 1736–8. By 1740 he had a prosperous portrait practice in London. His whole-length portraits of George III and Queen Charlotte of 1760–2 led to his appointment as Principal Painter to the King in 1767, and from 1766 he painted little other than replicas of these Royal portraits. He died in Dover on 10 August 1784.

Studio of Ramsay

P560 *George III*

Powdered hair, blue eyes, wearing his coronation robes over a gold coat.

Canvas, relined 80.3 × 64.3

There are minor damages in the cape, bottom left, and either side of the head. The varnish is discoloured.

George III (1738–1820), eldest son of Frederick, Prince of Wales; King 1760–1820; m. in 1761 Charlotte, daughter of Charles, Duke of Mecklenburg-Strelitz, by whom he had fifteen children (of whom for George IV, see Hoppner P563 and Lawrence P559).

It seems doubtful whether Ramsay's brush touched P560 which, however, appears to date from the eighteenth century and is in a good carved and gilt eighteenth-century frame bearing the Royal crown. Copied from the original whole-length portrait painted by Ramsay for the King in 1760–1, now in Buckingham Palace (Millar, no.996). Millar records extensive payments to Ramsay between 1762–81 for countless repetitions of his portraits of the King and Queen, and he employed several studio assistants to help him in this industry.[1] A good pair of whole-lengths is at Ragley, see Appendix V, no.55.

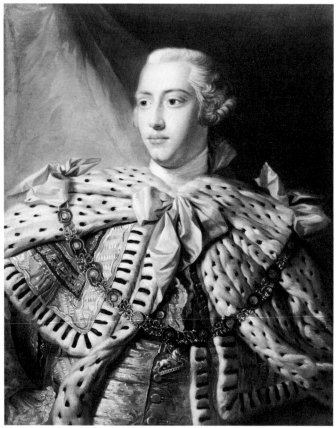

P560

Provenance

Possibly identifiable with a portrait of '*a Nobleman in Robes of Office, in a carved and gilt frame*' recorded at Sudbourne in 1842, 1871 and 1874. Hertford House inventory 1890 as Romney.

[1] Cf. A. Smart, *The Life and Art of Allan Ramsay*, 1952, pp.121–2, and *Allan Ramsay*, RA 1964, no.51.

Joshua Reynolds (1723–1792)

Born on 16 July 1723 in Plympton, Devon, the son of a schoolmaster. He studied with Hudson in London 1740–3 and practised as a portrait painter in London and the west country before sailing to Italy in 1749. He stayed principally in Rome, but also visited Florence, Bologna and Venice before returning to London in 1753. The visit was crucial to his development; throughout his life he recalled the Sistine Chapel decorations, the sculptors of antiquity, the Bolognese seventeenth-century classicists and the Venetian sixteenth-century painters. He became increasingly successful in London, and his friendships with Garrick, Burke, Goldsmith and Johnson were both warm and shrewd. He exhibited at the SA 1760–8 and in 1768 was elected the first President of the RA where between 1769 and 1790 he exhibited 244 pictures (of which 32 were not portraits). He was knighted in 1769. His fifteen *Discourses*, delivered to the Academy students, remain an eloquent and nimble advocacy of that 'general and intellectual beauty' which constituted the classical ideal. Reynolds's practice could differ agreeably from his preaching; visits to Paris in 1768 (9 September–23 October) and 1771 (13 August–6 September), the Netherlands in 1781 (24 July–14 September) and Brussels in 1785 (August and September) modified his ideas, and he often took from his contemporaries. In 1784 Reynolds succeeded Ramsay as Principal Painter to the King, but his Royal portraits were not a success. He ceased to paint, because of failing eye-sight, in the summer of 1789 and he died in London on 23 February 1792. He was buried with great pomp in St. Paul's Cathedral.

Reynolds employed a number of pupil-assistants (such as Marchi from 1752, Northcote 1771–6 and Doughty 1775–8) and the frequent discrepancy between the heads and draperies of his portraits suggests a busy studio practice. Reynolds's painting technique was often experimental and many of his pictures have not lasted well.

Abbreviations

Graves and Cronin	A. Graves and W. V. Cronin, *A History of the Works of Sir Joshua Reynolds*, 4 vols., 1899–1901
Ledgers	Reynolds's two surviving ledgers recording payments he received are preserved in the Fitzwilliam Museum, Cambridge; they were published by M. Cormack, *The Walpole Society*, XLII, 1970, pp.105–69 (to which reference is here made)
Leslie and Taylor	C. R. Leslie and T. Taylor, *Life and Times of Sir Joshua Reynolds*, 2 vols., 1865 (commenced by Leslie, who d. 1859, and completed by Taylor)
sitter-books	Preserved in the Royal Academy Library, from 1757 to 1789 but the sequence is not complete. The 1755 sitter-book is in the Cottonian Library, Plymouth.
Waterhouse 1941	E. K. Waterhouse, *Reynolds*, 1941

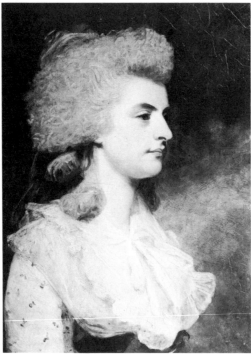

P31

P31 *Lady Elizabeth Seymour-Conway*

Powdered hair dressed with a blue ribbon, brown eyes.

Canvas, relined 60.7 × 46.5

There are traces of bitumen around the head and the impasted flesh areas are marked by craquelure.

Elizabeth Seymour-Conway (1754–1825), eighth child and fifth daughter of Francis Seymour-Conway, Earl of Hertford (cr. Marquess of Hertford 1793) and his wife Lady Isabella Fitzroy (daughter of the 2nd Duke of Grafton); she died unmarried. Though Walpole considered Gertrude, the third Hertford daughter, to be very pretty she was 'not so beautiful as her next two sisters',[1] i.e. Elizabeth and Frances (see P33 below).

Lady Elizabeth Seymour-Conway sat to Reynolds on 5, 11, 13 and 29 June 1781; on each occasion her name appears next to that of Lady Lincoln in the sitter-book. For further discussion see P33.

Provenance
See P33 below.

Exhibitions
Bethnal Green 1872–5 (28); RA 1893 (27).

References General
Graves and Cronin, I, p.192, and IV, p.1286; Waterhouse 1941, p.73.

[1] Walpole to Mann, 9 September 1771 (*Correspondence*, XXIII, 1967, p.323).

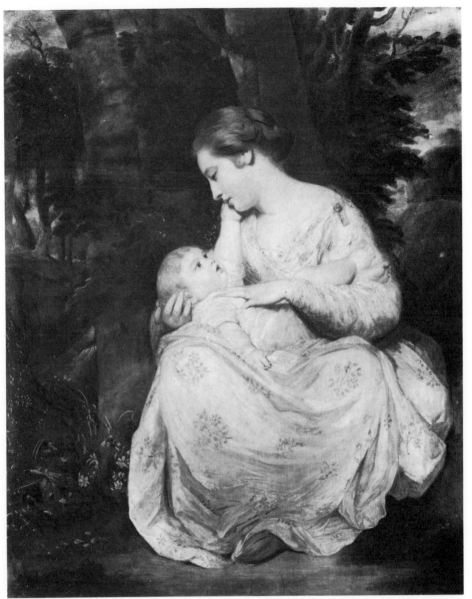

P32

P32 *Mrs. Susanna Hoare and Child*

Mrs. Hoare has chestnut hair and wears a white dress with gold trimmings and brown slippers; the child is fair haired.

Canvas, relined 132.5 × 101.6

There is a prominent craquelure in the flesh areas and in the impasted whites of the dress. *Pentimenti* show her right shoulder first appeared beyond the child's

raised left arm, and her right hand has been modified. Loose paint in the lower left area was laid in 1982.

Susanna Cecilia Dingley (1743–95) of Lamb Abbey, near Eltham, Kent, m. in 1762 Richard Hoare (d. 1778) of Boreham House, Essex, a partner in Hoare's Bank; there were five children: Henry Richard (7 April 1766–9 March 1768), Henry Benjamin (d. young, in 1779), Susanna Cecilia (d. young, 22 February 1768), Sophia (m. in 1783, d. 1826), and Harriet Ellen (m. 1788).

P32 was almost certainly painted in 1763–4. Mrs. Hoare does not appear in the sitter-books, but the volume for 1763 is missing; she paid Reynolds 70 gn. on 12 September 1765 (then the normal price for a canvas of this size).[1] Since 1872 it has been supposed that the child in P32 was the eldest son (see above) and the portrait was accordingly dated 1767–8, but there is no evidence to support this theory.[2] The dating here proposed would indicate that the child must rather be the eldest daughter. The pose is evidently taken from a *Madonna and Child* composition, possibly a relief or plaquette.

Version

BOSTON Museum of Fine Arts (no.1982.138), 74 × 62, half-length sketch, ex-Bridgewater House, sold Sotheby's, 18 June 1976 (118); catalogued in the nineteenth century as West,[3] it shows Mrs. Hoare's right shoulder as it appears beneath the *pentimento* in P32.

Provenance

By descent to the sitter's second daughter, Sophia, who m. William Bucknall (1750–1814); the sitter's third daughter, Harriet, who m. Col. Webb; the Hon. Mrs. Berkeley Paget, daughter of Mrs. William Bucknall, who directed that P32 should be sold on her death; Christie's, 26 March 1859 (70, '... never before been out of the possession of the family for whom painted'), bt. Holmes for the 4th Marquess of Hertford, 2,550 gn.; Hertford House inventory 1870.

Exhibitions

BI 1813 (105, *Lady and Child*) lent Bucknall; RA 1872 (7, *Mrs. Hoare and Child*); Bethnal Green 1872–5 (17, *Mrs. Hoare and Son*).

References General

Graves and Cronin, II, p.467, and IV, p.1340; Waterhouse 1941, p.59.

[1] *Ledgers*, p.123. Graves and Cronin, IV, p.1340, give Mrs. Hoare as sitting in January 1764, but this seems a misreading of '*Mrs Hews*'. There might have been an additional fee for the inclusion of the child (cf. *Ledgers*, p.139; Lady Waldegrave in 1763 paid 40 gn. for a 76 × 63 portrait of herself and child, when the normal price for a single figure was then 35 gn.).
[2] The earliest editions of this catalogue further supposed that the boy in P32 was the *Master Hoare* painted by Reynolds in 1788 (Toledo Museum of Art) who was, in fact, the son of Sir Richard Hoare, 2nd Bt.
[3] Letter on file from E. G. Thompson, Bridgewater House, 2 February 1933, also mentioning an old label found behind the picture in 1900 reading '*A lady and child. Original sketch by West*'.

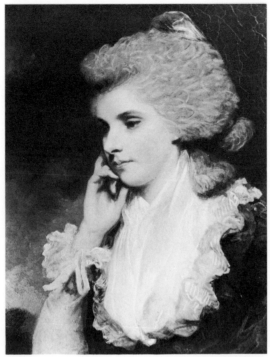

P33

P33 *Frances, Countess of Lincoln*

Powdered hair, brown eyes, wearing a black dress.

Canvas, relined 60.7 × 46.5

There are traces of bitumen in the background and the impasted flesh areas are marked by craquelure.

Frances Seymour-Conway (1751–1820), seventh child and fourth daughter of the Earl of Hertford (see P31 above), m. on 25 April 1775 Henry, Earl of Lincoln (d. 1778, second son of the 2nd Duke of Newcastle) by whom she had a daughter Catherine (1776–1804, m. William, Viscount Folkestone) and a son Henry (1777–9); from 1787 she lived at Putney Common and it was at her house that her father died in 1794 after a fall from his horse. Walpole described her as 'a sweet young woman in person, temper and understanding' who deserved 'such vast fortune' as her marriage brought her.[1] See also P31 above.

Lady Lincoln appears in Reynolds's sitter-books on 23, 24, 28 and 31 May and 5, 11, 13, 15, 19 and 29 June 1781, and 9 March 1782. Her five-year-old daughter sat to Reynolds on 18 and 21 May 1781.[2] The *penserosa* pose relates to that of Mrs. Braddyll, see P47.

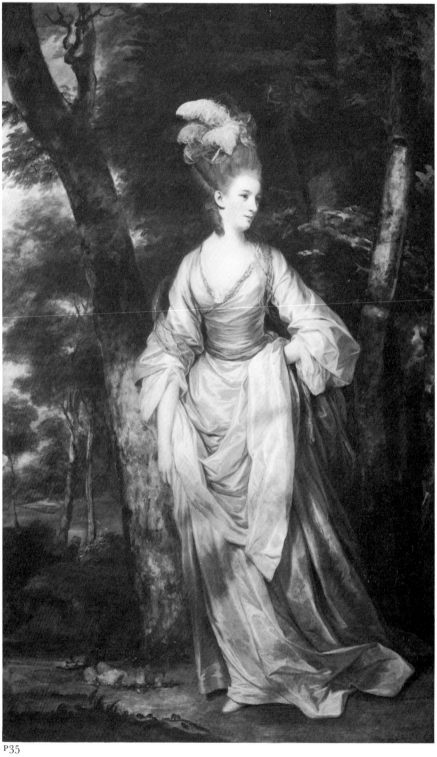

P35

P31 and P33 were commissioned by the Earl of Hertford (who himself appears in Reynolds's sitter-book on 9 May 1781); he paid 100 gn. for them in September 1784.[3] While the sitters are named in the sitter-books, their portraits were listed in the Hertford House inventories of 1834, 1846 and 1870 as '*Sisters of the 2nd Marquess of Hertford*'; they were identified at Bethnal Green in 1872 and in the 1890 inventory. No inscriptions have been recorded from the original canvases; the portraits were perhaps distinguished on the reasonable assumption that Lady Lincoln, as a widow, would be in black (and pensive). Lord Hertford had also commissioned from Reynolds a portrait of his eldest daughter Anne (1744–84, m. in 1766 the 6th Earl of Drogheda) for which he paid 35 gn. in 1775.[4]

Provenance

With P31: commissioned by the Earl of Hertford (see above); Hertford House inventory 1834; both portraits were reframed in 1859.[5]

Exhibitions

Bethnal Green 1872–5 (31); RA 1893 (28).

References General

Graves and Cronin, II, p.585, and IV, p.1358; Waterhouse 1941, p.74.

[1] Walpole to Mann, 9 January 1775 (*Correspondence*, XXIV, 1968, p.71).
[2] The portrait now in the collection of Lord Radnor, exh. RA 1968 (121), commissioned by Lady Lincoln who paid for it in March 1782 (*Ledgers*, p.158) – which may explain her appearance in the sitter-book on 9 March 1782.
[3] *Ledgers*, p.155.
[4] *Ledgers*, p.150; illus. Graves and Cronin, II, f.p.760, as in Lord Drogheda's collection.
[5] Evans invoice.

P35 *Mrs. Elizabeth Carnac*

Powdered chestnut hair with white and pink plumes, brown eyes, wearing a white dress with a golden yellow drape, and white slippers.

Canvas, relined[1] 240.4 × 146.4

Lightly cleaned by Vallance in 1958. The impasted passages of the flesh and dress are marked by craquelure. A small tear is visible across the bottom right edge of the skirt. The background is thinly painted and some of the glazes have run. *Pentimenti* show alterations to her right shoulder and upper arm (so that the wrap folds rather awkwardly) and to the left edge of the skirt (which was further to the left); there seems to have been a loop of drapery in her right hand, and two branches have been painted out, top centre left.

Elizabeth Catharine Rivett (1751–80), second daughter of Thomas Rivett MP of Morledge, Derby, and Blore Manor, Staffs., m. in 1769, as his second wife, Brigadier-General John Carnac (1716–1800) of the East India Company;[2] they left London on 11 April 1776 for Bombay, where Carnac had been appointed Second Member of Council, but in 1779 he was dismissed by the Company following the Convention at Worgaum (at which the Mahrattas had dictated terms to the Company's Bombay forces); he stayed in India, but Mrs. Carnac died soon after at Broach and was buried in Bombay Cathedral; their marriage was childless.[3]

P35 was evidently begun before April 1776, and the extravagant head-dress would indicate a date of c.1775. Mrs. Carnac does not appear in the Reynolds sitter-books, but the volumes for 1774–6 are missing, and no payment for the portrait is recorded. Since the Carnacs were given less than four weeks notice of their departure for Bombay,[4] it would seem likely that P35 was then unfinished and was never claimed thereafter. J. R. Smith's engraving of 1778 may be taken to indicate Reynolds's satisfaction with P35.

Engravings
J. R. Smith 1778;[5] S. W. Reynolds.

Copies
JOHANNESBURG private collection, a reduced copy made by Miss Wilkinson 1958 for descendants of the sitter.
LONDON with Power 1912, pen and ink sketch 57 × 34, allegedly from Reynolds's sale.
MILAN private collection 1961, half-length with plain dark background, 96 × 75.

Versions
Other portraits called Mrs. Carnac and attributed to Reynolds are/were:
CINCINNATI Art Museum (no.1946.117), 61 × 46, bust-length oval in white facing left.
LONDON Drummond sale, Christie's, 27 June 1919 (201), 51 × 44, three-quarter length in pink seated in a wood.
NEW YORK formerly with Scott and Fowles, bust-length in white facing left.

Provenance
Reynolds sale, Greenwoods, 3rd day, 16 April 1796 (47, *Mrs. Carnack*, a whole length), bt. Capt. Walsh, 70 gn.; Sir James Rivett Carnac (1785–1846), the sitter's nephew whose father (d.1802) had been Brig. Carnac's residuary legatee; he spent most of his life in India but probably bought P35 when he came to London in 1820; he left it to his wife with the instruction that she should sell it at her death; his widow d.1859; anon. sale, Christie's, 15 June 1861 (107), bt. Haines for the 4th Marquess of Hertford, 1,710 gn.;[6] Hertford House inventory 1870.

Exhibitions
Bethnal Green 1872–5 (10); RA 1894 (131).

References General
Graves and Cronin, I, pp.152–3; Waterhouse 1941, p.69, as c.1778.

[1] The stretcher is stamped W.MORRILL; he is recorded in London from 1866.
[2] His portrait by Humphry, inscribed *Calcutta 1786*, is on loan to the National Portrait Gallery, London, no. L152 (22).
[3] For much of this résumé I am indebted to the letters on file from D. C. Rivett-Carnac, which are gratefully acknowledged.
[4] The East India Company resolved Carnac's appointment on 18 March 1776 (information from D. C. Rivett-Carnac).
[5] Graves and Cronin, IV, p.1477, record that a copy had fetched the highest price ever paid for an engraving after Reynolds; and see J. Maas, *The Connoisseur*, CXLV, 1960, pp.237, 239.
[6] Lord Hertford was persuaded by Mawson to acquire P35; he commented afterwards that Mrs. Carnac 'has cost us a pretty penny. All pretty girls have that fault, more or less' (*Letters*, nos.102–4, pp.131–2).

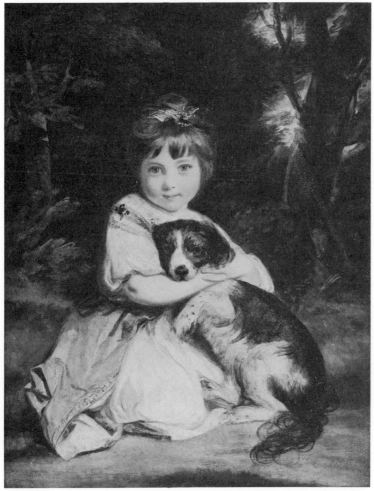

P36

P36 *Miss Jane Bowles*

Brown hair dressed with a blue and white ribbon with pearls, blue eyes, wearing a white dress with gold trimmings and a blue silk overskirt with a lilac sheen; the spaniel is black and white.

Canvas, relined 91 × 70.9

There is a noticeable craquelure round her right shoulder. *Pentimenti* indicate slight alterations to the shoulders and to the dog's back. There is a tiny loss, bottom centre left. Revarnished in 1953. The overskirt is very vigorously painted, but appears not to have been retouched.

Jane Bowles (1772–1812), eldest child of Oldfield Bowles of North Aston,[1] m. in 1791 Richard Palmer (1775–1806) of Holme Park, Sunning, Berks., by whom she had eleven children.

Payments for Miss Bowles were made on 6 May 1775 and 6 June 1776, each of 25 gn.,[2] indicating a date of 1775 for P36, when the sitter was three or four years old. There are no sitter-books for 1774–6. Leslie and Taylor tell a tale of how Reynolds induced the engaging expression on the child's face,[3] but Oldfield Bowles's diaries are said to give a different account.[4] The composition displays a *sensibilité* akin to Greuze whose works Reynolds may have seen in Paris;[5] comparable Reynolds portraits, showing a little girl with a big dog, include those of the Hon. Caroline Fox of c.1769–70[6] and of the Princess Sophia Matilda of Gloucester of 1774 (Windsor Castle; Millar, no.1016).

Engravings

W. Ward 1798, as *Juvenile Amusement*; C. Turner 1817; W. Fry; S. W. Reynolds; J. E. Coombes 1828, as *Fanny's Favourite*; S. Cousins 1874; J. Rogers; W. Say.

Copies/Versions

LONDON Wynn Ellis sale, Christie's, 6 May 1876 (89), 47 × 38. Earl of Arran sale, Puttick and Simpson, 2nd day, 15 July 1885 (173). Foster's, 6 April 1892 (155).
Other copies/versions are/were with A. H. Allen in Beverley Hills, A. U. Newton in Palm Beach, J. Fadda in Mulhouse and S. F. Bund in Cornwall.

Provenance

By descent to the sitter's only brother, C. O. Bowles (1785–1862); his sale, Christie's, 25 May 1850 (13, 'The celebrated picture of a little girl with a spaniel'), bt. Mawson for the 4th Marquess of Hertford, 1,020 gn.; Hertford House inventory 1870.

Exhibitions

BI 1813 (52), 1823 (14) and 1840 (70), on each occasion lent C. O. Bowles; Manchester, *Art Treasures*, 1857 (saloon H, no.20); Bethnal Green 1872–5 (7);[7] RA 1892 (102).

References General

Graves and Cronin, I, p.107, and IV, p.1270; Waterhouse 1941, p.65.

[1] For whom, see W. G. Constable, *Richard Wilson*, 1953, p.145; he was an amateur painter of some distinction.
[2] *Ledgers*, p.145.
[3] II, pp.134–5: Sir George Beaumont told how he persuaded Bowles to go to Reynolds, rather than Romney, and how Reynolds played tricks with the child at table so that she later sat to him 'with a face full of glee'.
[4] Information from A. H. Lowther-Pinkerton in 1967.
[5] E.g. Greuze's *Girl with a dog* shown in the 1769 Salon, or the *Boy with a dog* (P419 in the Wallace Collection); Greuze's obituary recalled that Reynolds's respect for him was such that he wished to come over to Paris to make his acquaintance (*Journal des Débats*, 27 March 1805; and see A. Brookner, *Greuze*, 1972, pp.88, 150 and pls.46, 51).
[6] Illus. Graves and Cronin, II, f.p.608, and see Waterhouse 1941, p.60.
[7] Described as "Engraved under the title of '*Love me, Love my Dog*'", but this was a confusion with Greatbach's engraving of that title after Hoppner's *Arabella Jane Wilmot* (cf. McKay and Roberts, *Hoppner*, 1909, p.271).

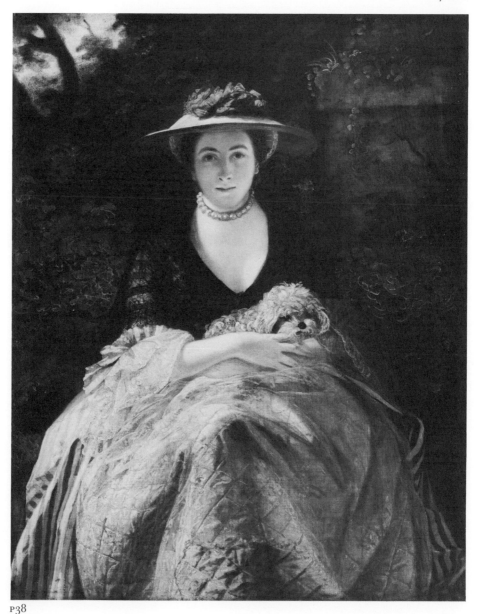

P38

P38 *Miss Nelly O'Brien*

Auburn hair, blue eyes, wearing a straw hat with turquoise trimmings, a blue-striped silk dress with a black lace shawl and a quilted pink underskirt.

Canvas, relined 126.3 × 110

Heavily ironed in relining. There are *pentimenti* above the dog's head, on her right hand and on the stone ledge in the background where there seems to have been more foliage.

149

Nelly O'Brien (d.1768), courtesan, a friend of Reynolds and mistress of the 3rd Viscount Bolingbroke by 1763; she bore a son in 1764, and d. in Park Street, Grosvenor Square.[1]

Nelly O'Brien sat to Reynolds on 6 November 1760, six times in December 1761, twenty-eight times between 11 January and 2 October 1762 – there is no sitter-book for 1763 – seven times between 17 May and 15 June 1764, on 7 May 1765, 10 May 1766, and four times between 5 March and 27 December 1767.[2] These dates, which doubtless include sittings as a model for other portraits and fancy pieces,[3] would suggest that Reynolds's two main portraits of Nelly O'Brien, P38 and the comparable, but hatless, three-quarter length now in the Hunterian Art Gallery, University of Glasgow,[4] were painted in 1762–4. He showed one portrait of her at the SA in 1763, which Walpole remarked was a 'very pretty picture'.[5] The Ledgers record that Reynolds sold one portrait of her in 1772 (see Provenance), and he was paid for another by the executors of the 8th Earl of Thanet in 1786.[6] The pose of P38 is reminiscent of van Dyck's Countess of Pembroke in the Wilton *Family Group* and it also suggests that Reynolds may have seen Rembrandt's *Woman with a lap dog*, then in Paul Methuen's collection (Bredius 398; Toronto Art Gallery).[7] Mannings has suggested further precursors of the composition in Restoration painting.[8] The delicate colours and careful description of textures also recall contemporary portraits by Ramsay, such as the *Countess of Elgin* with her rose-coloured dress and black shawl.[9] Despite, or because of, such eclecticism, P38 remains one of Reynolds's most beautiful portraits.

Engravings
C. Phillips 1770; S. Okey; S. W. Reynolds; J. Dixon; H. Linton 1862.

Copies/Versions
LONDON Mrs. Finkielman, c.1950, a reduced nineteenth-century copy.
WASHINGTON, National Gallery of Art; 76 × 63, half-length nineteenth-century copy, ex-Widener collection (Graves and Cronin, II, p.705).
The many versions of Reynolds's Nelly O'Brien listed by Graves and Cronin appear to relate to the Glasgow version (see note 4).

Provenance
Probably the *Miss Obrien with a hat* sold by Reynolds in November 1772 to Mr. Simons, 35 gn.;[10] possibly John Hunter (1728–93); his sale, Christie's, 29 January 1794 (107, 'Mrs. Nelly O'Brian, a very capital fine portrait'), 20 gn.; certainly Caleb Whitefoord (1734–1810); his sale, Christie's, 5 May 1810 (102, '. . . painted with the magic effect of Rembrandt'), bt. by the 2nd Marquess of Hertford, 61 gn.; Hertford House inventory 1834.

Exhibitions
Possibly SA 1763 (99), see above; Manchester, *Art Treasures*, 1857 (saloon H, no.19); RA 1872 (81); Bethnal Green 1872–5 (8).

References General
Graves and Cronin, II, pp.702–3, and IV, p.1379; Waterhouse 1941, pp.48, 52.

[1] Biographical notes from Walpole, *Correspondence*, x, 1941, p.53 n.
[2] The dates not quoted are: 11, 14, 17, 21, 25 and 30(?) December 1761; 15, 21, 22, 27 January, 3, 9, 16, 22 February, 12 March, 19 April, 12, 14 May, 1, 7, 10, 12, 16, 19, 24, 29 June, and 5, 8, 13, 20, 24 and 29 July 1762; 21 May and 1, 4, 5 and 12 June 1764; 3, 8 April 1767.
[3] Cf. Leslie and Taylor, I, p.213.
[4] Waterhouse 1941, p.50, pl.103, as 1764–7, but it may be earlier.
[5] *The Walpole Society*, XXVII, 1939, p.76. It is often identified with P38, cf. Waterhouse 1941, pp.48, 52, and *Reynolds*, 1973, p.46 n.29. Leslie and Taylor, I, pp.188 n.7, 222–3 n.2, said that P38 was painted in 1763, but they do not identify the SA portrait.

[6] Cf. *Ledgers*, p.165, 'Aug. 1786 Lord Tenet (qu. Thanet). Bill paid in full £261.10'. An undated account from Reynolds to Lord Thanet for £367.10 which included a portrait of Nelly O'Brien, was sold Sotheby's, 25 January 1955, lot 398.

[7] Waagen, IV, p.91, described P38 as 'after the manner of Rubens' *Chapeau de Paille*', but it seems most doubtful that Reynolds then knew of the Rubens, cf. G. Martin, *National Gallery Catalogues, The Flemish School*, 1970, p.181 n.47.

[8] D. Mannings, *The Connoisseur*, CLXXXIII, 1973, pp.191–3, instancing Lely's *Viscountess of Weymouth* (Longleat) and Kneller's *Viscountess Carteret* (Ham House).

[9] Cf. A. Smart, *Ramsay*, 1952, pp. 106, 130, and pl.XXIA, f.p.176. W. Armstrong, *Reynolds*, 1900, pp.164–5, first indicated the influence of Ramsay on P38.

[10] *Ledgers*, p.131, annotated '*The frame paid to me 4G.½*.' Leslie and Taylor, I, p.189 n., record that P38 'is said to have been sold at Christie's for three guineas' on Nelly O'Brien's death in 1768, and say that a portrait of her did sell for 3 gn. in 1789 ('the year that Alderman Boydell paid Sir Joshua 500 guineas for his Puck'); here they were perhaps misquoting Northcote (*Memoirs of Sir Joshua Reynolds*, 1818, II, p.232) who records the sale of a portrait of Nelly O'Brien for 10 gn. in 1787.

P40 *The Strawberry Girl*

Chestnut hair, brown eyes, wearing a cream head-dress and dress with a red sash and a black bow at the neck; a pottle filled with strawberries over her right arm.

Canvas, relined 76.1 × 63.1

Her pale complexion must in part reflect vanished glazes. The canvas was heavily ironed in relining, and the varnish is much discoloured. There are dark retouchings in the left background area, and *pentimenti* round both shoulders, the left cheek and in the upper right area, where the outline of the rock has been altered and the foliage reduced.

P40 appears to be the prime version, shown at the RA in 1773, of a composition which Reynolds repeated many times and considered one of his best works.[1] The *pentimenti* and the adventurous technique of scumbles and glazes do not suggest a replica, although the Bowood version, which Reynolds sold to Lord Carysfort in 1774 (see below), was long considered the original;[2] it was the more frequently copied and engraved, but this might reflect availability rather than choice. In characterisation, lighting and technique P40 suggests the influence of Rembrandt, as Hendy and White have emphasised[3] (and cf. P38 and P48). The model was previously supposed to be Reynolds's younger niece, Theophila ('Offy') Palmer (1757–1848), later Mrs. Gwatkin,[4] but she would clearly have been too old to pose for P40 in 1773; the confusion may have arisen from the fact that Reynolds's *Young Girl with a scarlet muff*, a closely related composition, was long known as a portrait of Theophila Palmer.[5] Of the many pictures Reynolds painted of children in the 1770s (cf. P36 and P48) P40 is perhaps the most imaginative, as he himself recognised.

Engravings
S. Cousins 1873; G. Zobel; J. G. Smethwick 1879.

Copies/Versions
BOWOOD 75 × 62, the first replica (see above and note 2), differing from P40 in that a fringe from the head-dress conceals her hair and there is no tree to the right; engraved by T. Watson 1774, W. Richardson 1800, F. Stacpoole 1858, T. G. Appleton 1875, H. Meyer and S. W. Reynolds. In 1778 Reynolds noted the use of '*cera Sol.*' on a Strawberry Girl, perhaps a third version.[6] The following versions have also been attributed to Reynolds (A indicates the Bowood type, B as P40).

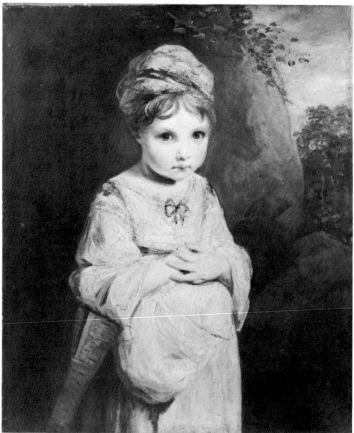

P40

Type A
AMSTERDAM Mak van Waay, 8 February 1966
(452), panel 61 × 50.
BRUSSELS Chasles sale, Fievez, 16 December
1929 (70), 36 × 27.
LONDON Sotheby's, 15 May 1957 (180), panel
25 × 20.
Type B
BALTIMORE Walters Art Gallery (no.37.98),
76 × 66, exh. Leeds 1868 (1050) lent J. H.
Chance.
LONDON Matthiesen, 1948, probably the
picture formerly with F. Partridge, 76 × 63.
OAKHAM with Col. W. B. Brocklehurst 1900.
OBERLIN Allen Memorial Art Museum
(no.44.53) 77 × 64, exh. Grosvenor Gallery
1883–4 (86), bequeathed by Mrs. F. F.
Prentiss 1944.
Many later copies are known; Graves and
Cronin list a number of versions in nineteenth-
century sales; see also note 5.

Provenance

Reynolds sale, Greenwood's, 3rd day,
16 April 1796 (52), bt. Willett (John Willett-
Willett); his sale, Coxe's, 1 June 1813 (80), bt.
Samuel Rogers (1763–1855); his sale
Christie's, 5th day, 2 May 1856 (601), bt.
Mawson for the 4th Marquess of Hertford,
£2,215;[7] Hertford House inventory 1870.

Exhibitions

RA 1773 (242); BI 1823 (46), 1833 (18), 1843
(8), on each occasion lent Rogers;
Manchester, *Art Treasures*, 1857 (saloon H,
no.18); Bethnal Green 1872–5 (20).

References General

Graves and Cronin, III, pp.1214–5, and IV,
p.1463; Waterhouse 1941, p.63.

[1] Cf. Northcote, *Memoirs of Sir Joshua Reynolds*, 1818, II, pp.7–8, recalling that Reynolds once said no man ever could produce more than half-a-dozen really original works in his life, and that the *Strawberry Girl* was one of his.

[2] By Graves and Cronin, for example, III, pp.1213–4 (although elsewhere, III, p.1215, they called it 'a first replica'). Leslie and Taylor, II, p.20 n.2, considered the Bowood picture 'one of the best repetitions'; Waterhouse, 1941, p.63, and *Reynolds*, 1973, p.47, concurs. Earlier editions of this catalogue supposed P40 to be a variant of the Bowood picture.

[3] P. Hendy, *The Burlington Magazine*, XLVIII, 1926, pp.83–4, suggested Reynolds may have seen the *Young Girl holding a medal*, formerly attributed to Rembrandt and very probably at Rousham in Reynold's time (cf. C. White, *Rembrandt in 18th century England*, Yale, 1983, p.110, no.66); C. White, *op. cit.*, p.37, no.44, also suggests the influence of Rembrandt's *Young Girl leaning on a window sill* (Dulwich College Picture Gallery).

[4] By, for example, Leslie and Taylor, II, p.6; F. G. Stephens, *English Children... by Reynolds*, 1884, pp.37–8; E. Hamilton, *Engraved works of Reynolds*, 1884, p.125; W. Armstrong, *Reynolds*, 1900, p.242, and in previous editions of this catalogue.

[5] Ex-Thomond sale, Christie's, 18 May 1821 (68); Rosebery sale, Christie's, 5 May 1939 (112), as a portrait of Theophila Palmer; probably the picture in a Swedish private collection in 1961 called Goya (*sic*); Waterhouse 1941, pp.58–9.

[6] *Ledgers*, p.168; '*cera Sol.*' probably means 'wax varnish only', i.e. *cera solamente*.

[7] Hertford bought on Mawson's advice, see *Letters*, nos. 62, 64–5 and 67–9, pp.74, 77–8, 81, 83–4.

P43 *Mrs. Mary Nesbitt*

Powdered hair with a gold pin, brown eyes, wearing a white dress and a white gauze scarf with gold trimmings; background of blue sky and white clouds.

Canvas, relined 75.5 × 62.5 within a painted oval 72 × 57.7

The lower right area is severely marked by bitumen. The face bears a heavy craquelure[1] and has been restored on the cheek, chin, nose, eyes and ear. Heavily ironed in relining.

Mary Davis (c.1735–1825) m. Alexander Nesbitt, a banker (d. before 1775); by c.1771 she was the acknowledged mistress of the 3rd Earl of Bristol (d.1779), by whose will she benefited considerably; she lived at Norwood House, Streatham, from c.1770; in the later 1790s she travelled (and intrigued) on the Continent; she died abroad, aged ninety.[2]

Mrs. Nesbitt sat to Reynolds on 7, 11 and 16 May 1781. He painted a three-quarter length of her as Circe[3] as well as P43; the heads in each are similarly posed and the hair styles consistent with the date of 1781. There are no records of payments. While P43 has always been called Mrs. Nesbitt, it was proposed in 1874 that she was Mrs. Arnold Nesbitt, sister of Henry Thrale (the friend of Dr. Johnson).[4] P43 compares closely, however, with other portraits of Mary Nesbitt: the Reynolds mentioned above, a miniature dated 1770 by Humphry,[5] and an anonymous profile engraving of 1776.[6] The pose in P43 is curiously reminiscent of a statuette, *La Crainte*, by J.-B. Lemoyne II,[7] though the dove is doubtless intended as a symbol of innocence (perhaps a vindication of Mrs. Nesbitt's character, following the death of her protector and her consequent inheritance).

Provenance

Gen. the Hon. Edmund Phipps (1760–1837), nephew of the 3rd Earl of Bristol; the Hon. Edmund Phipps (1808–57); his sale, Christie's, 25 June 1859 (98), bt. Mawson for the 4th Marquess of Hertford, 600 gn.;[8] Hertford House inventory 1870.

Exhibitions

BI 1843 (37); Bethnal Green 1872–5 (21, as *Mrs. Nesbit, Actress*, 1872; and *Mrs. Nesbitt, Wife of Alexander Nesbitt, Esq., MP, and sister to Mr. Thrale the brewer, a friend of Dr. Johnson*, 1874).

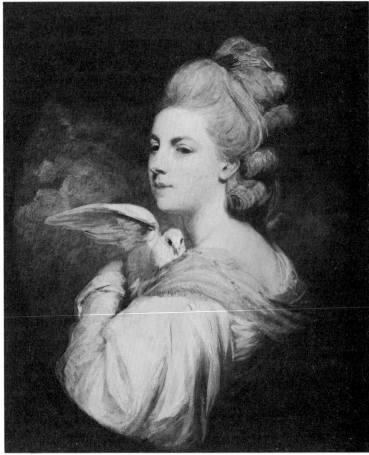

P43

References General

Graves and Cronin, II, p.690, and IV, p.1377;
Waterhouse 1941, p.73, as Mrs. Arnold
Nesbitt.

[1] As first remarked by Mawson, cf. *Letters*, no.90, p.113.
[2] For this brief biography I received valuable help from the
Hon. David Erskine who indicated references in *The Letters
of Junius*, ed. J. Cannon, 1978, p.317 (Mary Nesbitt as
'Polly Davis'), and J. H. Adeane ed., *The Early Married Life
of Lady Stanley*, 1899, particularly pp. 432–4; and see also
Walpole, *Correspondence*, XXXIII, 1965, p.149 n.
[3] Waterhouse 1941, p.73; 127 × 101, now in the Smith
College Museum of Art, Northampton, Mass. (illus. *Art
Quarterly*, XXI, 1958, p.222); Graves and Cronin, II, p.690,
record a whole-length version, sold Christie's, 4 May 1810
(95).

[4] See Exhibitions and A. and C. Nesbitt, *The History of the
Family of Nesbitt or Nesbit*, 1898, p. 41; the identity was
revived in the 1928 catalogue, primarily, it would seem,
because Gen. Phipps (who once owned P43) was known to
have been a particular favourite of Mrs. Thrale – but he
was also a nephew of Lord Bristol and his father had been a
friend of Mary Nesbitt.
[5] Illus. G. C. Williamson, *Ozias Humphry*, 1918, f.p.176.
Humphry had first met Mary Nesbitt in Reynolds's studio
c.1764 (*ibid.*, pp.31–2, and see pp. 99–100).
[6] Example in the National Portrait Gallery archives.
[7] The *modello* shown in the 1771 Salon; a marble version,
dated 1775, is at Waddesdon (T. W. I. Hodgkinson, *The
James A. de Rothschild Collection at Waddesdon Manor,
Sculpture*, 1970, pp.64–5, no.22).
[8] Mawson told Hertford P43 was 'not a first rate picture'
but, having seen a photograph, Hertford instructed him to
buy it (*Letters*, nos. 90–2, pp.113–7). According to A. and C.
Nesbitt, *loc. cit.*, Hertford believed the portrait showed
Mrs. Mary Nesbitt.

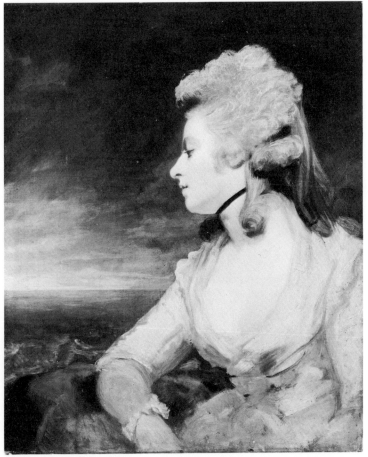

P45

P45 *Mrs. Mary Robinson ('Perdita')*

Powdered hair, a black bow beneath her chin, wearing a white dress with a salmon pink bow.

Canvas 77 × 63.5

An old tear runs down from the forehead to the left. There are *pentimenti* round the nose, chin and neck.

For the sitter see Gainsborough P42.

Painted in 1783–4. There is no sitter-book for 1783, but on 19 January 1784 it was reported that Reynolds had nearly finished a portrait of Mrs. Robinson;[1] she appears in the sitter-book on 3 February, but her portrait is still unfinished on 14 April.[2] P45 casts her in a contemplative rôle (the pose recalling Veronese's *Vision of S. Helena* in the National Gallery, London) which reflects the change in her fortunes after the extroverted portraits by Romney (P37) and Gainsborough

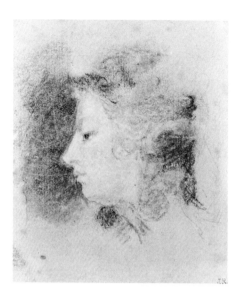

Reynolds: Study for P45
The British Museum

(P42) of 1781–2. In the summer of 1783 she had contracted a fitful paralysis from the waist down and thereafter her life was devoted increasingly to literary pursuits. Though she never owned P45 Mrs. Robinson admired it greatly; it inspired a passage in her *Memoirs*[3] and was engraved as the frontispiece for several of her literary works, see note 9. Reynolds and Mrs. Robinson were to become well acquainted. He had already painted her portrait in 1782 (Waddesdon Manor),[4] but a third portrait (the best example in the Taft Museum, Cincinnati) seems doubtfully identified.[5] Reynolds admired her 'wonderful facility' in writing verse, and she composed a *Monody* on his death.[6] Despite the panache of the Waddesdon picture and the pleasant melancholy of P45, Reynolds never succeeded with Mrs. Robinson's portraiture, according to Northcote.[7]

Drawing

LONDON British Museum (no.1887-7-22-19); chalk study for the head, showing a slight variation in the hair and chin.[8]

Engravings

W. Birch 1787, as *Contemplation*; T. Burke 1791;[9] S. W. Reynolds.

Versions

BOSTON Museum of Fine Arts, 76 × 63, studio version, ex-Wynn Ellis and T. H. Woods collections.

NEWCASTLE UPON TYNE Laing Art Gallery, 53 × 43, ex-Quilter and E. E. Cook collections.

NEW HAVEN Yale Center for British Art, 89 × 69, an extended, unfinished version, ex-Ludlow collection.

Other versions recorded with the Dowager Lady Harcourt 1937 (a small version); with Lord Granville between 1862 and 1891, 61 × 48; Bowring Hanbury sale, Puttick and Simpson, 31 May 1932 (70), 76 × 63; Lytton sale, Anderson, New York, 12 March 1927 (110), 25 × 21.

Provenance

There is some confusion over the many versions, but probably Reynolds sale, Greenwood's, 3rd day, 16 April 1796 (3, a three-quarter portrait, i.e. 76 × 63), bt. Cribb, 29 gn.; possibly with the Prince of Wales in 1799.[10] Gen. the Hon. Edmund Phipps (1760–1837) by 1823; the Hon. Edmund Phipps (1808–57); his sale, Christie's, 25 June 1859 (100), bt. Mawson for the 4th Marquess of Hertford, 800 gn.;[11] Hertford House inventory 1870.

Exhibitions

BI 1823 (38) lent Phipps; Bethnal Green 1872–5 (3).

References General

Graves and Cronin, II, p.833, and IV, p.1400; Waterhouse 1941, p.76; Ingamells, *Mrs. Robinson and her Portraits*, 1978.

[1] The *Morning Chronicle*, 19 January 1784; 'Reynolds has nearly finished three enchanting portraits of the Duchess of Devonshire, the Duchess of Rutland and Mrs. Robinson'.
[2] The *Morning Herald*, 14 April 1784: '*Mrs. Robinson*. The air, the disposition of the head, and the likeness, are admirable. Why does not Sir Joshua proceed on a portrait in which he has already been so successful?'. This is misquoted by Graves and Cronin, IV, p. 1480ee.

[3] *Memoirs of the late Mrs. Robinson, written by herself*, 1930 ed., p.165; describing how she nursed her daughter one summer at Brighthelmstone and 'beguiled her anxiety by contemplating the ocean, whose successive waves, breaking upon the shore, beat against the wall of their little garden. To a mind naturally susceptible, and tinctured by circumstances with sadness, this occupation afforded a melancholy pleasure ... Whole nights were passed ... at her window, in deep meditation, contrasting with her present situation the scenes of her former life'.
[4] RA 1782; see Gainsborough P42, note 4.
[5] Waterhouse 1941, p.76, as Mrs. Robinson.
[6] See Ingamells 1978, p.26.
[7] *Conversations of James Northcote R.A. with James Ward*, ed. E. Fletcher, 1901, p.59.
[8] Exh. *Gainsborough and Reynolds in the British Museum*, 1978, no.91.
[9] Used for Mrs. Robinson's *Poems* 1791, *Lyrical Tales* 1800, and her posthumous *Poetical Works* 1806. It shows a slight variation in the hair compared with P45. Reynolds mentioned to Mrs. Robinson in a letter dated December 1790 'the Picture is ready, whenever Mr. Burke calls for it' (Mrs. Robinson, *Memoirs*, p.xiii; see note 3).
[10] A MS. Sketch by Mrs. Robinson, printed in *Drama*, summer 1950, pp.12–14, dateable 1799 on internal evidence, refers to Reynolds's two portraits of Mrs. Robinson; the original of the first 'now in the possession of the Marchioness of Hertford' (i.e. the Waddesdon portrait) ... the other, which has been engraved for her poems (cf. note 9) belongs to the Prince of Wales'.
[11] Bought on Mawson's advice (*Letters*, nos.90–1, 93, pp.113, 116, 118).

P47 *Mrs. Jane Braddyll*

Powdered hair, blue eyes, wearing a black gown over a white bodice.

Oak panel 75.5 × 63 × 1.2 four horizontal members, the joins at 18, 39 and 60 cm. above the bottom edge.

There are bituminous marks around the head, and there is a close-grained vertical craquelure in the flesh areas. The varnish is much discoloured. Restored by Mawson in 1854–8 on Lord Hertford's instruction ('pray arrange the Reynolds in your best manner that I should find Mrs. Braddyll a few years younger than she is at present')[1]: her right cheek has been thinned, her eyes and the shadows round the chin retouched and her right hand slightly altered to suit the adjusted cheek.[2]

Jane Gale (d.1819), daughter and sole heir of Matthias Gale of Catgill Hall, Cumberland, m. in 1776 her cousin Wilson Gale (1755–1818), who took the additional surname of Braddyll in 1776, of Conishead Priory, MP and Groom of the Bedchamber to George III, by whom she had a son, Thomas Richmond Gale Braddyll (1776–1862), and six daughters; she d. at Hampton Court.

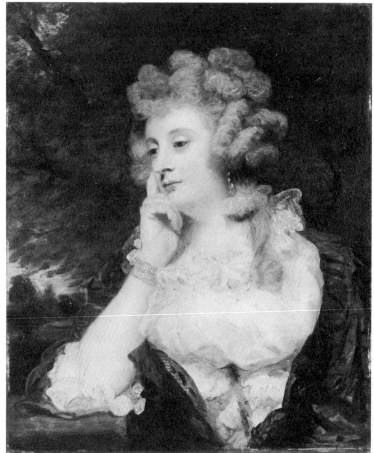

P47

Mrs. Braddyll sat to Reynolds on 29 January, 8, 16, 21, 25 and 28 February, 16 and 21 May and 4, 5, 7 and 9 June 1788. Her husband was sitting for the pendant portrait in January, February and March.[3] Payments of 50 gn. were made for each portrait in July 1789.[4] In August 1788 P47 was anonymously described as 'a portrait full of magical beauty . . . in the Penseroso stile';[5] the pose is comparable with that of P33. Reynolds painted Mr. and Mrs. Braddyll with their son in 1789 (see note 2), and they owned at least three other portraits by him.[6] Mrs. Braddyll had previously been painted by Romney in 1777 and 1780 and by Hoppner in 1788 (present locations unknown).

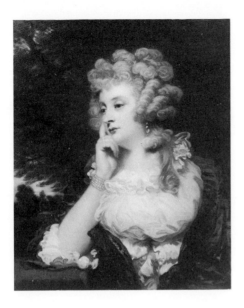

S. Cousins after Reynolds: *Mrs. Braddyll.*
The British Museum

Engravings

S. Cousins 1847;[7] W. J. Edwards 1865; J. W.
Chapman 1893; C. Waltner 1894.

Copies

A miniature copy by G. Engleheart was in the
H. S. Braddyll sale, Sotheby's, 2 February
1946 (162),[8] possibly the miniature with W. B.
Wilson, Llangollen, 1976.
Other copies were with A. A. Dick, Glasgow,
1929, and Mrs. Bath, Malvern, 1964.

Version

NEW YORK A. R. Carpenter 1972, 76 × 63,
variant holding an apple in her right hand.

Provenance

By descent to the sitter's son; his (anon.) sale,
Christie's, 23 May 1846 (38), bt. Charles,
Baron Townshend (1785–1853), 80 gn.; his
sale, Christie's, 13 May 1854 (45), bt. Mawson
for the 4th Marquess of Hertford, 215 gn.;[9]
Hertford House inventory 1870.

Exhibitions

BI 1850 (93) lent Townshend; Bethnal Green
1872–5 (30); RA 1892 (107).

References General

Graves and Cronin, I, pp.110–1; Waterhouse
1941, p.80.

[1] Hertford to Mawson, Paris, 21 May 1854; he
acknowledged Mawson's successful treatment on
11 September 1858 (*Letters*, nos.42, 88, pp.54, 110).
[2] The rejuvenation may be judged by comparison with
Reynolds's portrait of Mrs. Braddyll painted in 1789 in the
Braddyll Family (Fitzwilliam Museum, *Catalogue of Paintings*,
III, 1977, pp.204–5, pl.15), and with the Cousins engraving
of 1847 (illus. A. Whitman, *Samuel Cousins*, 1904, f.p.104).
[3] Exh. RA 1788 (189); sold Christie's, 25 February 1865
(97); engraved by G. Sanders.
[4] *Ledgers*, p.147.
[5] As quoted by Graves and Cronin, *loc. cit.*
[6] In 1788 the Prince of Wales gave Braddyll his portrait by
Reynolds, now no.890 in the National Gallery, London
(for a miniature copy, see Wallace Collection, *Catalogue of
Miniatures*, 1980, no.110, M39). Reynolds painted Master
Braddyll in 1784 (exh. Birmingham 1961, no.81), and
there was a studio version of the Count of Schaumburg-
Lippe in the Braddyll sale, Christie's, 23 May 1846, lot 40
(cf. Millar, no.1027); see also note 2.
[7] Engraved for Lord Townshend, see Graves and Cronin,
IV, pp.1270–1; and see note 2.
[8] This sale also included miniatures of Mrs. Braddyll by
Mee and Cosway.
[9] Mawson had told Hertford that P47 was not in very good
condition, but he urged the purchase (*Letters*, no.41, p.53;
and see note 1).

P48 *S. John the Baptist in the Wilderness*

Wearing a dull green-brown drape; the scroll inscribed *voice* ('the voice of one crying in the wilderness', John 1, 23).

Canvas, relined 132 × 102.2

In poor condition, heavily retouched throughout. Relined in 1879, but internal cleavage necessitated the transfer of the paint-layer to a new canvas in 1911–13. There remains a general tendency to flake, and the surface was last secured in 1983. The varnish is much discoloured.

Painted c.1776, one of three surviving versions of a subject exhibited by Reynolds at the RA that year. The eccentricity of condition and the provenance confirm the attribution, although P48 is not one of the engraved versions. The composition ultimately derives from similar subjects by Raphael,[1] Reni,[2] and Guercino,[3] but Reynolds has introduced a child (doubtless one of his 'beggar boy' models, as described by Northcote[4]) for their more mature figures, and has created a Rembrandtesque gloom. The expression of the head may have been taken from Le Brun's *étonnement* in the *Traité des passions*.[5] The lamentable drawing of S. John's left leg may have been aggravated by retouching.

Versions

BELVOIR CASTLE (formerly), generally presumed to have been the original version, shown at the RA 1776 (243); sold by Reynolds to Lord Granby on 26 April 1776[6] and destroyed by fire on 26 October 1816.[7] It was probably the version engraved by J. Grozer in 1799, which shows a more open landscape to the right and a stronger diagonal light from the left.
ARBURY a second variant, apparently the picture engraved by S. W. Reynolds,[8] similar to the Grozer engraving except that the cross projects above the lamb's back and has the text A[GN]VS D[E]I.
MINNEAPOLIS Institute of Arts, a third variant showing a more lively figure.[9]
Apart from P48, six other S.Johns appeared in the posthumous Reynolds sales: Greenwood's, 3rd day, 16 April 1796 (after 67), bt. Collins, 7 gn.; Christie's, 18–19 May 1821, 1st day, lot 17, bt. Danby, 72 gn., and 2nd day, lot 43 (oval, 74 × 61), bt. Rev. Mr. Triste, 30½ gn.; Christie's, 26 May 1821 (33, 'Study . . .'), bt. Garrard, 10 gn.; and (33A, '. . . 2nd study'), bt. Wansey, 15s.
Versions were subsequently in the Northwick sale, Phillips, 4th day, 29 July 1859 (333), and the Phillips sale, Christie's, 25 April 1913 (60). Reynolds's *Master Wynn as Child S. John* of c.1774, formerly at Wynnstay, has sometimes been confused with this composition (and

may indeed be represented among the versions listed above), but it is a distinct type.[10]

Provenance

Reynolds sale, Greenwood's, 3rd day, 16 April 1796 (63), bt. Willett (John Willett-Willett), 150 gn.; his sale, Coxe's, 31 May 1813 (117, ". . . It is indeed 'The voice of one crying in the Wilderness', and not only the voice, but the enthusiastic look and expression of a Heaven-sent messenger, though embodied in an Infant's form"), bt. by the 3rd Marquess of Hertford, 168 gn.; Dorchester House inventory 1842; Hertford House inventory 1870.

Exhibition

Bethnal Green 1872–5 (9).

References General

Graves and Cronin, III, p.1197, and IV, p.1460; Waterhouse 1941, p.67.

[1] Versions in the Louvre and Uffizi; an old copy in the Victoria and Albert Museum (no.5470–1856).
[2] Cf. examples in Dulwich College Picture Gallery and at Temple Newsam, Leeds; Leslie and Taylor, II, p.149, termed Reynolds's S.John 'a plagiarism from Guido'. Roger Fry suggested the influence of Ludovico Carracci (his edition of Reynolds's *Discourses*, 1905, p.ix, referring to the Minneapolis version in particular).

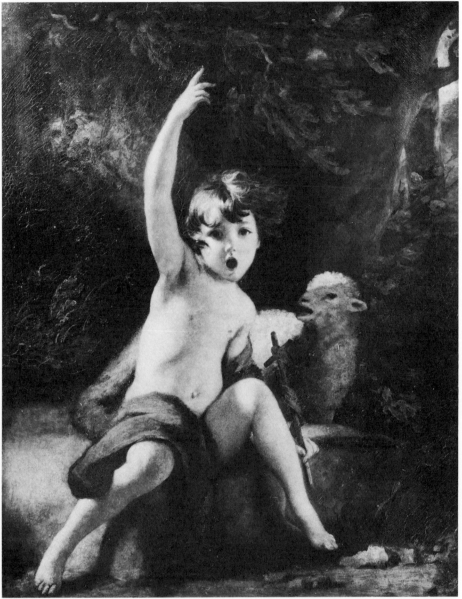

P48

[3] Forlì, Pinacoteca; exh. *Guercino*, Bologna, 1948, no.96.
[4] *Conversations of James Northcote R.A. with James Ward*, ed. E. Fletcher, 1901, p.77.
[5] Cf. the edition of Amsterdam, 1702, fig.2, f.p.16.
[6] *Ledgers*, p.153.
[7] Cf. Graves and Cronin, III, p.1197, and IV, p.1460; Waterhouse 1941, p.67.

[8] It may be seen in an interior view of Arbury, illus. *The Connoisseur*, CLXIII, 1966, p.5.
[9] Illus. Waterhouse, *Reynolds*, 1973, pl.71 (and cf. Doughty House catalogue, III, 1915, no.410, and *Les Arts*, August 1905, p.17, where it is illustrated in an earlier state); see also Waterhouse in the Minneapolis *Bulletin*, 1968, pp.51–3.
[10] Waterhouse 1941, pl.161. Leslie and Taylor, II, p.148, first suggested it may have been RA 1776.

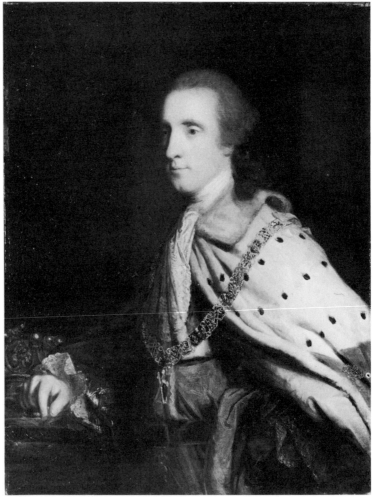

P561

P561 *The 4th Duke of Queensberry ('Old Q') as Earl of March*

Powdered hair, blue eyes, wearing an Earl's robes and the collar and badge of the Thistle; his left hand is on his hip; an Earl's coronet rests on a red cushion to the left, and there are traces of a pillar on the right.

Canvas, relined 91 × 67.5

Repaired by Vallance in 1946; there is a small damage above his left shoulder. The face appears rubbed, doubtless because of perished glazes, and the shadows round the nose have been strengthened. The varnish is much discoloured. There are *pentimenti* on his left shoulder, where there may have been a ribbon from his hair, and the black spots of the ermine have been moved. The collar and badge are additions, see below.

William Douglas (1725–1810), 3rd Earl of March, succeeded as 4th Duke of Queensbury 1778, and known as 'Old Q'; gambler, wit and rake, almost certainly the father of Maria Fagnani (who became the 3rd Marchioness of Hertford) to whom he gave and bequeathed considerable amounts of money and property. His portrait was painted by Ramsay in 1742 (Drumlanrig); others, showing him in old age, are attributed to Opie (National Portrait Gallery, no.4849) and drawn by Hoppner (Fogg Art Museum, Cambridge, Mass., no.530.1929); he was also the subject of numerous satirical prints in the last twenty years of his life.

Lord March sat to Reynolds on 6 June and 14 July 1759[1] and paid 22½ gn. for his portrait on 16 December 1760.[2] He was made a Knight of the Thistle on 13 April 1763 and the insignia of that office were then added to the portrait; they sit unhappily over his robes (which themselves are evidently studio work). Mannings has drawn attention to the derivation of the composition from a Kneller kit-cat formula.[3]

Version
In the collection of the Marquess of Queensbury.

Provenance
Presumably bequeathed by the sitter to the 3rd Marchioness of Hertford (see above); Dorchester House inventory 1842; rue Laffitte, Paris, 1867;[4] Hertford House inventory 1890.

Exhibition
Bethnal Green 1872–5 (1).

References General
Graves and Cronin, II, p.619, and IV, p.1366; Waterhouse 1941, p.46.

[1] The 1759 sitter-book is curiously bound; Lord March's sittings appear on ff.52 and 62. On f.63 Reynolds wrote: *'Rich Frame with an Earl's Coronet for Lord March'*, but there is no sign that the present eighteenth-century frame of P561 ever bore such a coronet.

[2] *Ledgers*, p.128, as a first payment. A Reynolds kit-cat normally cost 30 gn. in 1759 (see *Ledgers*, p.105).

[3] D. Mannings, *The Connoisseur*, CLXXXIII, 1973, pp.187–8.

[4] W. Bürger, *'Les Collections Particulières', Paris Guide*, I, 1867, p.538, recorded three Reynolds in the rue Laffitte; one was P41, now attributed to Lawrence, and since P561 did not figure in the 1870 inventory of Hertford House it was almost certainly another; the third was probably the Lawrence P39 which was exhibited at Bethnal Green in 1872 as a Reynolds.

David Roberts (1796–1864)

Born on 2 October 1796 in Stockbridge, near Edinburgh where he was first apprenticed to a house-painter. He became a scenic artist, active in the north, before coming to London in 1822. He continued to work for the theatre, but turned increasingly to architectural and topographical subjects which he exhibited at the BI 1824–59 and RA 1826–64. He was elected ARA 1838 and RA 1841, and was President of the SBA in 1830 before resigning in 1834. He became an inveterate traveller, his most celebrated expeditions being those to Spain and North Africa in 1832–3 and to Egypt and the Holy Land in 1838–9. His work became widely known through engraving. In 1841 his daughter married the second son of Elhanan Bicknell, one of his principal patrons. Roberts died in London on 25 November 1864. He left a MS. Journal and a 'Thumbnail Sketch' Journal, recording 252 of his oil paintings, which remain in private collections.

Abbreviation

Ballantine J. Ballantine, *Life of David Roberts*, 1866

P258 *Lierre: interior of S. Gommaire*

Looking east towards the chancel. Signed bottom right: *David Roberts. R.A. 1850.*

Canvas[1] 121.8 × 94

Some small losses down the right-hand edge; the varnish is discoloured.

Lierre in Belgium, ten miles south-west of Antwerp; the fine sixteenth-century rood-loft at S. Gommaire had recently been restored in 1850 when Roberts painted P258; subsequently the sham pierced and painted battlement round the top was removed.[2] Roberts visited Belgium c. 1826 and in 1845, 1849, 1850 and 1861.[3] Apart from the version listed below he also painted the *Shrine of S. Gommaire*, RA 1850(445), now in the Harris Art Gallery, Preston, and a water-colour interior, from the north transept looking south, is in a private collection.

Engraving

O. Jewitt 1858 (for the *Art Journal*).

Version

LONDON Sotheby's, 10 July 1973 (128), 114.3 × 91.4, a similar view, possibly that shown at the RA 1857 (418).[4]

Provenance

Bought from the artist for 300 gn. by Elhanan Bicknell (1788–1861) of Herne Hill; his sale (pictures), Christie's 25 April 1863 (95), bt. Wells for the 4th Marquess of Hertford, 1,370 gn.; rue Laffitte inventory 1871 (216); Hertford House inventory 1890.

Exhibitions

RA 1850 (202); Paris, *Exposition Universelle*, 1855 (930) lent Bicknell; Bethnal Green 1872–5 (40); South Kensington, *International Exhibition*, 1874 (153).

Reference General

Ballantine, p. 250, no. 156.

[1] Stamped, *verso: Winsor & Newton/38 Rathbone Place* and bearing label: '*chassis 3/No 14/Roberts/Intérieur de cathédrale*'.
[2] Cf. T. F. Bumpus, *The Cathedrals and Churches of Belgium*, 1909, pp. 282–4 and pl. f. p. 268 showing the additions removed.
[3] Dates given in *David Roberts*, Scottish Arts Council catalogue, 1981, p. 45.
[4] Ballantine, p. 252, no. 210, sold to T. Baring for £600.

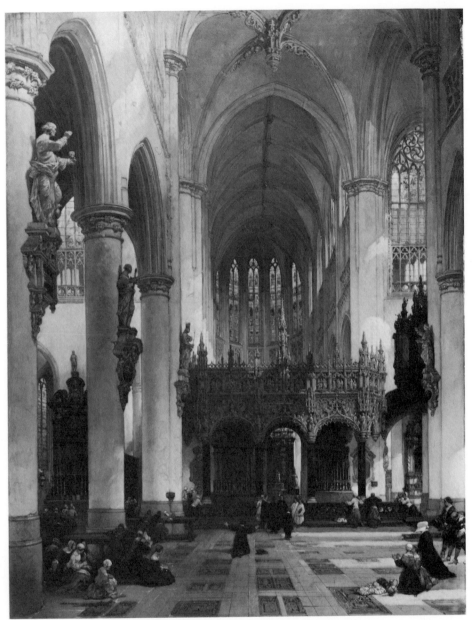

P258

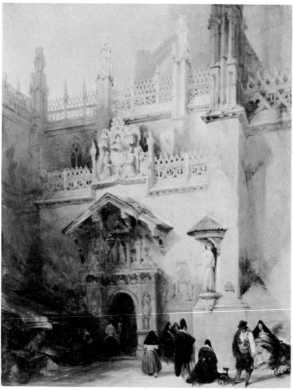

P587

P587 *Granada: the Chapel of Ferdinand and Isabella*

The doorway to the sixteenth-century *Capilla Real* on the south side of Granada Cathedral. Signed to the right on pilaster: *David Roberts 1838*/GRANADA.

Mahogany panel[1] 47.5 × 37.5 × 1.1 painted area 47 × 37

The blacks are bituminous and the varnish is much discoloured.

Roberts travelled in Spain between December 1832 and August 1833 (see also P659 and P697 below); he spent three weeks in Granada. He also painted a large oil of the interior of the *Capilla Real* for Beckford (RA 1836, no.422), now a bituminous wreck,[2] and an ink and wash drawing of the same interior is in the Victoria and Albert Museum (no.78–1881).

Provenance
Painted for Elhanan Bicknell (1788–1861) of Herne Hill; his sale (pictures), Christie's, 25 April 1863 (82), bt. Wells for the 4th Marquess of Hertford, 260 gn.; Hertford House inventory 1870.

Exhibition
Bethnal Green 1872–5 (32); South Kensington, *International Exhibition*, 1874 (170).

Reference General
Ballantine, p.249, no.99.

[1] Inscribed *verso*: ENTRANCE to the CHAPEL of FERDINAND & ISABELLA/GRANADA.
[2] Sold Sotheby's, 29 February 1984 (44).

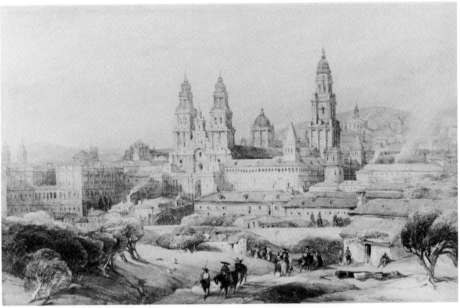

P659

P659 *Santiago: the Cathedral from the south-west*

The west front of the Cathedral with the cloisters on the right and the Hospital Real (now a hotel) on the left. Signed bottom right: *D.Roberts 1837*.

Pencil, water- and body-colour with varnish on the foreground figures, on paper 24.3 × 39 (sight)

See P587 above. Roberts's visit to Spain was curtailed by an outbreak of cholera and he did not get to Santiago; P659 was worked up from a drawing by Richard Ford (see Version below).

Engraving

W. Wallis 1837 (for *Jennings Landscape Annual 1838*, lettered: *The Seminario & Cathedral of Santiago / From the Paseo de Sa. Susanna / Drawn by David Roberts from a sketch by Richard Ford . . .*).

Version

LONDON Sir Brinsley Ford, pencil 27.5 × 40.5, by Richard Ford, inscribed: *Cathedral and Governor's House, San Iago from hill under Sta. Susanna. June 16, 1832.*[1] Clearly the drawing from which Roberts made P659, elaborating the foreground.

Richard Ford: *Santiago.*
(Sir Brinsley Ford)

Provenance

Commissioned for £20 by Jennings;[2] Elhanan
Bicknell (1788–1861) of Herne Hill; his sale
(drawings), Christie's, 2nd day, 30 April 1863
(264), bt. Wells for the 4th Marquess of
Hertford, 250 gn.; Hertford House inventory
1890 as *Valladolid* (the title on the old mount).

Exhibitions

Bethnal Green 1872–5 (650, as *Valladolid*);
Belfast 1876 (83, as *Valladolid*).

[1] Exh. *Richard Ford in Spain*, Wildenstein, London, 1974,
no.130, fig.73,
[2] According to Ballantine, p. 254.

P680 *Baalbec: the Temple of Jupiter*

Looking north; the Temple of Jupiter on the right, and the six huge columns
from the Temple of the Sun on the left. Signed bottom left: *D. Roberts 1842*.

Pencil, water- and body-colour with varnish, on thin card 13.5 × 20.3

Baalbec, in Lebanon; the Temple of Jupiter was built by Antoninus Pius in the
2nd century A.D. and the Temple of the Sun, never completed, perhaps dates
from the same period. The Temple of Jupiter is aligned in front of the Temple of
the Sun, though this is not particularly apparent in P680.

Roberts, suffering from fever, was at Baalbec on 2–8 May 1839; 'such was my
delight and wonder at the stateliness of the Temple', he wrote in his *Journal*,[1]
'that I could not resist visiting and examining every portion of it, until I was
exhausted'. P680 was not amongst his engraved views of Baalbec; it derives from
the large oil described below.

Version

LONDON Sotheby's, 24 November 1976 (304),
149.9 × 241.3, signed and dated 1842,
showing the same basic composition in a more
elaborate form, e.g. the Temples are correctly
aligned, the Saracen Citadel projecting from
the right of the Temple of Jupiter is more
detailed, and the foreground has more
figures;[2] engraved by J. Pye 1849.

Provenance

Painted for Elhanan Bicknell (1788–1861) of
Herne Hill; his sale (drawings), Christie's,
1st day, 29 April 1863 (120), bt. Wells for the
4th Marquess of Hertford, 105 gn.; Hertford
House inventory 1890.

Exhibitions

Bethnal Green 1872–5 (601); Belfast 1876
(102).

[1] Quoted in the text accompanying the lithographed views
of Baalbec in *Egypt, Syria and the Holy Land*, II, 1843.
[2] Probably Ballantine, p.249, no.106, as 1841, sold to
G. Knott for £420; illus. L. Thornton, *The Orientalists,
Painters-Travellers 1828–1908*, 1983, p.63.

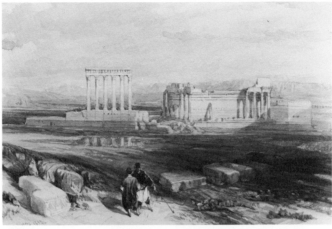

P680

P689

P689 *Mainz: the Cathedral from the south-west*

The Markt in the foreground and S. Gothard's Chapel projecting to the left. Signed bottom centre: *D. Roberts 1832*.

Pencil, water- and body-colour with varnish on the foreground figures, on paper 22.8 × 31 (sight)

Mainz, West Germany, on the left bank of the Rhine; the Cathedral was thoroughly restored in 1869–79 when the present central tower was built.

Provenance

Anatole Demidoff (1813–70); his sale, Paris, 2nd day, 14 January 1863 (70), bt. by the 4th Marquess of Herford, 2,420 fr.; Hertford House inventory 1890.

Exhibitions

Bethnal Green 1874–5 (688); Belfast 1876 (60).

P697

P697 *Tetuan: the Great Square*

Looking north; a joust takes place in the left mid-distance; the Riff mountains in the distance. Signed bottom right: *David Roberts 1837*.

Pencil, water- and body-colour with some varnish, on paper 27.2 × 38.7 (sight)

Tetuan, Morocco, formerly the seat of the Governor of Spanish Morocco. In the course of his Spanish trip (see P587 above) Roberts crossed the Straits of Gibraltar in April 1833.

P697 was worked up from earlier drawings for engraving; Turner considered it the finest drawing in the Bicknell collection (see Provenance).

Engraving

E. Goodall 1837 (for *Jennings Landscape Annual* 1838, lettered: *Great Square of Tetuan from the Jew's Town during the celebration of the marriage of the son of the Governor Ash-Ash in April 1833...*).[1]

Provenance

Commissioned for £20 by Jennings;[2] Elhanan Bicknell (1788–1861) of Herne Hill; his sale (drawings), Christie's, 1st day, 29 April 1863 (130, quoting Turner's comment), bt. Wells for the 4th Marquess of Hertford, 410 gn.; Hertford House inventory 1890.

Exhibitions

Bethnal Green 1872–5 (646); Belfast 1876 (88).

[1] The festivities as witnessed by Roberts are described in the *Landscape Annual*, pp.216–18.
[2] According to Ballantine, p. 254.

George Romney (1734–1802)

Born on 15 December 1734 in Dalton-le-Furness, Lancs., he studied under Christopher Steele in Kendal 1755–7 before setting up his own practice as a portrait painter in Kendal and Lancaster. In 1762 he came to London where he exhibited at the FS 1763–9 and SA 1770–2. He visited Paris in 1764 and stayed in Italy 1773–5. On his return he entered the most successful period of his portraiture. He returned in 1796 to Kendal, having become somewhat unstable, and died there on 15 November 1802.

Abbreviation

Ward and Roberts H. Ward and W. Roberts, *Romney*, 2 vols., 1904

P37 *Mrs. Mary Robinson ('Perdita')*

Brown eyes; powdered hair; wearing a white cap, white fichu neckerchief, black silk cape and light-brown-sleeved dress; she carries a grey muff.

Canvas, relined 75.7 × 63.2

Minor losses in background areas, the surface somewhat flattened by the relining which probably took place in 1903.[1]

For the sitter, see Gainsborough P42. The large muff and half-dress hat were newly fashionable in the 1780s.[2]

A mezzotint after P37 by J. R. Smith was published on 25 August 1781 which would imply that sittings to Romney were amongst those he gave to 'Mrs. Robinson' between 29 December 1780 and 19 July 1781.[3] The pose relates closely to that of the *Jeune femme au manchon* attributed to Boucher in the Louvre.[4] P37 was used as the source for a caricature of Mrs. Robinson published in 1783.[5] Romney completed a second portrait of Mrs. Robinson in March 1782 (probably also based on the 1781 sittings) but it is now untraced.[6] See also Gainsborough P42 and Reynolds P45.

Engravings

J. R. Smith 1781;[7] La Guillermie 1866 (as Reynolds).[8]

Copies

A small oval pastel copy 31.8 × 22.9, attributed to Reynolds, exh. *National Portraits Exhibition*, South Kensington, 1868 (9), lent D. Parsons'.[9]
A miniature copy, attributed to Engleheart, sold Christie's, 9 February 1960 (150).

Version

A 'sketch' of Mrs. Robinson by Romney was in the artist's sale, Christie's, 27 April 1807 (5).

Provenance

Romney sale, Christie's, 27 April 1807 (72), bt. in at 19 gn.; Romney sale, Christie's, 29 June 1810 (22), bt. by the 2nd Marquess of Hertford, 20 gn.; Hertford House inventories 1834 and 1843 as Reynolds and 1870 as Hoppner.

Exhibition

Bethnal Green 1872–5 (19, as Hoppner 1872, Romney 1874).

References General

Ward and Roberts, I, pp.93–6, II, pp.132–3; Ingamells, *Mrs. Robinson and her Portraits*, 1978.

P37

[1] A letter in the archives from Messrs Haines & Sons, picture restorers of Thurloe Square, dated 31 October 1903, saying that 'the Romney portrait is now finished' probably refers.

[2] See C. W. and P. Cunnington, *English Costume in the 18th century*, 1964, pp.349, 352 and 398.

[3] The intermediate dates being 6, 21,25, 29 January, 2, 8, 18, 23 February, 9 March, 1, 8, 18, 28 April, and 1 and 7 July; see Ward and Roberts, I, pp.93–6. The name recurs throughout 1782 but then in conjunction with 'Mr.', 'Capt.' or 'Major' Robinson.

[4] A. Ananoff, *Boucher*, 1976, no.335, where dated 1749 and considered a replica of a pastel by Boucher in a French private collection; and Ananoff, *L'Opera completa di Boucher*, 1980, nos.349 and 349a.

[5] Illus. Ingamells 1978, p.18; *Scrub and Archer*, with Mrs. Robinson as Gipsey, a lady's maid, from Farquhar's *The Beaux Stratagem*, published 25 April 1783.

[6] The *Public Advertiser*, 13 March 1782, announced 'Romney has now finished another portrait of Mrs. Robinson'. On 18 March the same paper described it as 'a whole length', but the *Morning Herald*, 19 April 1782, said Mrs. Robinson had sat twice to Romney for 'a head' and 'a half length' (i.e. canvases 61 × 46 and 127 × 101). The 'Mrs. Robinson 3 qrs. ('Perdita')' of 1781 noted by the Rev. John Romney in his MS. rough lists (quoted by Ward and Roberts, II, p.133) was, presumably, P37 (a 'three-quarters' meaning a canvas 76 × 63). Ward and Roberts, *loc. cit.*, identified a second portrait of Mrs. Robinson by Romney as then belonging to A. E. Davis, London: 53 × 43, in white, her chin supported by her right thumb and forefinger; exh. *National Portraits Exhibition*, 1868 (22). From a photograph the identity of the sitter seems dubious.

[7] Illus. Ingamells 1978, p.16. The outline of the cap differs slightly from P37 and the format is oval.

[8] *Gazette des Beaux-Arts*, 1ère, XXI, 1866, f.p.410, as *Jeune Fille au Manchon...Reynolds Pinxt.*

[9] Possibly the pastel ascribed to Reynolds in a private collection in New Jersey 1957, and in Chicago 1971 (letters on file).

P602

James Sant (1820–1916)

Born on 23 April 1820 in Croydon, he studied under John Varley and
A. W. Callcott before entering the RA schools in 1840. Between 1840 and 1915
he regularly exhibited portraits and sentimental genre scenes at the RA; elected
ARA 1861 and RA 1869, retiring in 1914. He was appointed Principal Painter to
the Queen in 1871. He died in London on 12 July 1916.

P602 *Sentiment*

Within a painted oval; chestnut hair dressed with a red rose, wearing a black
velvet collar, a red-brown dress, turquoise wrist-bands and a black veil behind
her head, holding a pink rose.

Canvas, relined 76 × 63

Relined in 1983 when minor damages were repaired. The composition has been
radically changed; a leafy bush remains visible in the upper spandrels and
down the left side of the composition. The darker areas show a bituminous
craquelure.

In 1913 the artist identified the model in p602 as his sister Julia (1835–67, later Mrs. William Cockburn) aged 'sixteen or eighteen', indicating a date of 1851–3; he also pronounced p602 one of his strongest works.[1]

Provenance
William Llewellyn, Bristol; his sale, Foster's, 4 April 1855 (58, *Sentiment*, 61 × 73.7), bt. by the 4th Marquess of Hertford, 51 gn.; Hertford House inventory 1870 as '*The Rosebud*'.

Exhibition
Bethnal Green 1872–5 (34, as *Portrait of a Lady*).

[1] Sant visited the Wallace Collection in 1913, when his comments were recorded by MacColl.

William Clarkson Stanfield (1793–1867)

Born on 3 December 1793 in Sunderland. He was first a child actor before going to sea 1808–15, visiting China. In 1816 he settled in London where he became a successful scenic artist and a regular exhibitor of marines and landscape views at the BI 1820–53, SBA 1823–30 and RA 1820–67. He was elected ARA 1832 and RA 1835. From 1823 he travelled regularly in Europe, including visits to Italy in 1824, 1830 and 1838–9. He was patronised by William IV and Queen Victoria, and was a friend of Dickens, Marryat and, in particular, David Roberts (q.v.). He became a Catholic convert in 1846 when he was rebaptised Thomas Clarkson Stanfield. He died in London on 18 May 1867.

Abbreviation
Van der Merwe P. van der Merwe, *Clarkson Stanfield*, Tyne and Wear Council Museums, 1979

P343 *Beilstein on the Moselle*

Beilstein in the mid-distance dominated by the ruins of the Hohenbeilstein to the right; the Hunsrück mountains in the distance.

Canvas[1] 114.3 × 163.7

The stretcher was replaced in 1983 when the picture was surface cleaned. There is a fairly prominent craquelure in the impasted passages of the sky, and the construction of the old stretcher is reflected in surface cracks. The darker foreground areas are bituminous.

Beilstein in the Rhineland Palatinate, West Germany. Stanfield travelled down the Moselle between September and November 1836.

P343 relates to pl.IV in Stanfield's *Sketches on the Moselle, the Rhine, & the Meuse*, 1838, but differs in that the viewpoint is slightly further to the left; the lithograph shows different figures and omits the cliff in the left foreground.

Provenance
Bought from the artist by Elhanan Bicknell (1788–1861) of Herne Hill, 250gn.; his sale (pictures), Christie's, 25 April 1863 (107), bt. Wells for the 4th Marquess of Hertford, 1,500 gn.; Hertford House inventory 1890.

Exhibitions
RA 1837 (78); Bethnal Green 1872–5 (29, as *Bacharach on the Rhine*).

[1] Stamped *verso*: *T. Wikey, 13 Catherine St, Strand.*

P343

P354

P354 *Orford*

Looking north-west on a summer evening; Orford Castle on the left and the church of S. Bartholomew on the right. Signed bottom left centre: *CStanfield 1833*.

Millboard[1] 25 × 30.5

There are traces of bitumen in the foreground darks and the varnish is greatly discoloured. The corners have been knocked.

Orford on the river Ore, Suffolk; the church tower is shown after its partial collapse in 1830. Orford was a Hertford family borough; one mile to the north lies the village of Sudbourne, of which the Hertfords were Lords of the Manor until 1874, and Sir Richard Wallace 1874–84.

Stanfield had been engaged by Murray in July 1833 to make a series of drawings for the works of the Suffolk poet George Crabbe, and he visited East Anglia that year. A comparable view, but showing horses and a cart in the foreground, was engraved by E. Finden for *The Life of George Crabbe* by his son, published in 1838. Turner had previously drawn the same view for his *Picturesque Views in England and Wales*, 1827.

Provenance
The Rev. Oliver Raymond of Middleton Rectory, Sudbury, from whom purchased by Sir Richard Wallace in February 1875, £300;[2] Hertford House inventory 1890.

Exhibition
Ipswich 1880 (14).

Reference General
Van der Merwe, p.96, no.139, and p.107.

[1] The panel bears *verso* the label: *R. Davy, 25 Newman Street.*
[2] Letters from Raymond to Wallace concerning this purchase are in the Wallace Collection archives; he had first asked £400, which Wallace declined because of the marked cracking of the surface. The panel is inscribed *verso: Rev[d] O Raymond/Middleton/Sudbury.*

P667

P667 *Venice: Canal Scene*

Inscribed bottom centre: *Venice Oct.* 5^{th} *1830.*

Pencil, water- and body-colour on paper 33.7 × 23.5 (sight)

The view seems to show the Rio S. Marina with the Palazzo Castelli (formerly Correr-Pisani) on the left.

A fine study, in the Bonington manner, made on the spot. On the day he painted P667 Stanfield wrote to this wife 'I am hard at it from morning till night (Venice is truly magnificent!) . . . one of my eyes are completely closed up with a Musquito bite in the night . . .'.[1]

Provenance
Brown sale, Paris, 7 March 1843 (100, '*Vue d'un Canal de Venise; très belle étude faite d'après nature. 5 octobre 1830*'); the 4th Marquess of Hertford; Hertford House inventory 1890.

Exhibitions
Bethnal Green 1874–5 (714); Belfast 1876 (84).

[1] Van der Merwe, p.117, no.183.

P712

P712 *Venice: S.Giorgio Maggiore*

Looking south-east across the Bacino. Signed on a sack, in monogram: CS.

Pencil, water- and body-colour with touches of varnish on the foreground figures, on paper 19.4 × 25.8 (sight)

P712 was doubtless worked up from drawings made in Venice in 1830; it lacks the spontaneity of P667.

Provenance

Possibly Brown sale, Paris, 7 March 1843 (101, '*Vue de Venise; sur le devant, une partie de la mer sur laquelle plusieurs embarcations, et à gauche quelques petites figures sur un terrain . . . d'une touche extrêmement spirituelle*'). The 4th Marquess of Hertford; Hertford House inventory 1890.

Exhibitions

Bethnal Green 1872–5 (682a); Belfast 1876 (55).

Thomas Sully (1783–1872)

Born on 19 June 1783 in Horncastle, Lincolnshire, of a theatrical family who took him to America in 1792 and settled in Charleston, South Carolina. He began to practise as a portrait painter in New England in 1801 and moved to Philadelphia in 1807. He became an American citizen in 1809. He twice returned to England, in 1809–10 and in 1837–8 (see below). His MS. Journal and 'Account of Pictures' record over 2,000 portraits and 550 imaginative subjects, as well as many copies. He died in Philadelphia on 5 November 1872.

Abbreviations

Fabian	Monroe H. Fabian, *Mr. Sully, Portrait Painter*, National Portrait Gallery, Washington, 1983
Biddle and Fielding	E. Biddle and M. Fielding, *The Life and Works of Thomas Sully*, Philadelphia, 1921

P564 *Queen Victoria*

Chestnut hair, blue eyes, wearing coronation regalia; a deep red drape to the right. Signed, *verso: TS. June/1838/London*.[1]

Canvas 142.5 × 112.5

There are minor losses round the edges and some retouchings, e.g. behind the neck and above the throne. The impasted flesh colours show a local craquelure. *Pentimenti* indicate that the throne was first much larger and extended to the left,[2] and there were minor adjustments to the right wrist.

Alexandrina Victoria (1819–1901), only child of George III's fourth son, the Duke of Kent, and Mary Louisa Victoria, fourth daughter of Francis, Duke of Saxe-Coburg-Saalfeld (Gotha); succeeded as Queen 20 June 1837 and crowned 28 June 1838; m. in 1840 Albert, Prince of Saxe-Coburg-Gotha, her first cousin, by whom she had nine children (see von Angeli P557).

Fabian has recently published a full survey of Sully's portraits of Queen Victoria, from which the following account is drawn. P564 was commissioned expressly for engraving by Messrs. Hodgson and Graves on 16 May 1838 for £200; Sully began it on 25 May and completed it on 24 June. The engraving (see below) was published on 30 November 1840.

When it was known in Philadelphia that Sully was coming to London in 1837 he was commissioned by the Society of the Sons of St. George to paint a whole-length portrait of the Queen. He received five sittings at Buckingham Palace between 22 March and 14 May 1838, and his daughter Blanche modelled the regalia later in May. Sully recorded his impressions of the Queen in his Journal, 22 March 1838:

> 'She is short, 5 feet 1 & ¼ of an inch – of good form, particularly the neck and bosom – plump, but not fat. Neatly formed head – perhaps rather infantile in the contour of the face. Forehead well proportioned – Eyes a *little* prominent but kind and intelligent. Her nose well formed and such as I have frequently seen in persons of wit & intellect. A lovely, artless mouth when at rest – and when so, it is

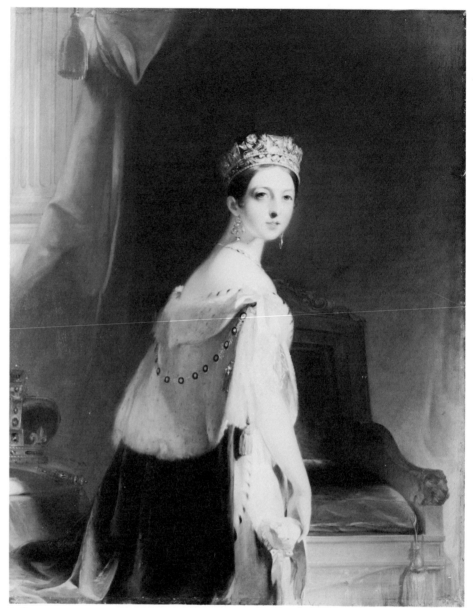

P564

a little open, showing her teeth – Eyes light blue & large – Hair light Brown, smoothly braided from the front. And to sum up all, and apart from all prejudice, I should say decidedly, that she was quite pretty.'

Later he confided that she was 'like a well-bred lady of Philadelphia or Boston'.[3]

Sully's initial sketch from the life was admired and knowledge of the Queen's approval led to the commissioning of P564; the Sons of St. George had agreed that the portrait being painted in London could be exhibited and engraved.

Drawings

Five pencil studies, three of the robes, one of the train and one of the throne in the House of Lords, are in a private American collection (Fabian, nos. 52–6).

Engravings

C. E. Wagstaff 1840 (see Denning P765); anon. French c.1840 (in reverse).

Copies

LONDON, National Portrait Gallery (no. 1891A), water-colour 20.6 × 15.9, bust-length, by W. Warman, 1838.
See Denning P765.

Versions

Sully painted four other portraits from the sittings he received from the Queen; in chronological order:
NEW YORK Metropolitan Museum of Art, 91.4 × 72.1, signed *TS. London May 15th 1838. My original study/of the Queen of England, Victoria 1st/Painted from the life/Buckingham House*; bust-length (Biddle and Fielding, no.1853; Fabian, no.58).
Formerly CHARLESTON South Carolina, Saint Andrew Society, whole-length, painted for himself between 2 October and 20 December 1838; destroyed by fire 1865 (Fabian, p.99).
MARYLAND private collection, 238.8 × 147.4, signed *TS 1838*; whole-length painted for the Society of the Sons of St. George, Philadelphia, between 30 September 1838 and 14 January 1839; sold by the Society c.1950 (Biddle and Fielding, no.1855; Fabian, no.59). A reduced copy by Charles Cohill (fl.1835–60) is in a private collection, Philadelphia.
BUCKINGHAM PALACE 61 × 50.8, bust-length, painted for Samuel Rogers between 7 and 23 December 1839 (Biddle and Fielding, no.1857; Fabian, p.99, fig.2).

Provenance

Commissioned by Hodgson & Graves of 6 Pall Mall, 1838 (see above); they exhibited P564 in 1840 (see below); acquired by Charles Meigh of Grove House, Shelton; his sale, Christie's, 9 June 1855 (42, 'the original engraved picture'), bt. Caw, 43 gn.; the 4th Marquess of Hertford; Hertford House inventory 1870 as '*Winterhalter H.M. Victoria*'.

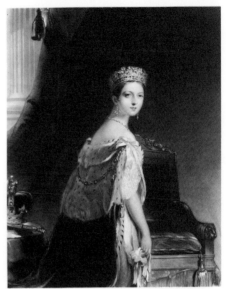

C. E. Wagstaff after Sully: *Queen Victoria*. National Portrait Gallery

Exhibitions

RA 1840 (483) lent from 6 Pall Mall; Bethnal Green 1872–5 (60).

References General

Fabian, pp.94–9; Biddle and Fielding, no.1854; T. C. Knauff, *A History of the Society of the Sons of St. George*, Philadelphia, 1923, pp.96–116; A. ten Eyck Gardner, *Metropolitan Museum of Art Bulletin*, v, 5, 1947, pp.144–8.

[1] Inscribed, *verso*, in chalk: *Picture of the Queen to be framed* and *T. Sully*; the canvas is stamped: *T.Brown/164 High Holborn/London*. The present frame, bearing a crown, was presumably commissioned by Hodgson and Graves for the RA exhibition in 1840.
[2] Agreeing more with the final whole-length composition.
[3] T. Sully, *Hours at Home*, 1870, p.70.

P578

William Robert Symonds (1851–1934)

Born in Yoxford, Suffolk, he studied in Antwerp and settled in London in 1881. A portrait painter, he exhibited regularly at the RA from 1876. He died in London on 7 November 1934.

P578 *Sir Richard Wallace*

White hair, brown eyes, wearing a dark blue cravat and a black coat. Signed bottom left: *W.R.Symonds/1885*.

Canvas 67.6 × 56.2

There is a wide craquelure on the coat. Traces of old nail holes 1 cm. above the bottom edge, and a small hole in the bottom left area. The edges of the canvas have been abraded by a tight-fitting frame and the canvas turn-over is painted black.

Richard Jackson (1818–90), illegitimate son of the 4th Marquess of Hertford and Mrs. Agnes Jackson, née Wallace; lived in Paris from 1824, firstly with his grandmother, the 3rd Marchioness of Hertford, and then acting as his father's secretary; changed his name to Wallace 1842; succeeded to his father's unentailed estates in London, Paris and Lisburn, and to his collections, 1870; for his

philanthropy during the siege of Paris he was created a Baronet and *Commandeur de la Légion d'Honneur*, 1871; m. in 1871 Amélie Julie Castelnau, by whom he had one son, Edmond (1840–87); settled in Hertford House, London, 1872; Conservative MP for Lisburn 1873–85; KCB 1878; d. at Bagatelle, Paris. His widow (d. 1897) bequeathed the Wallace Collection to the Nation.

When Wallace sold the Sudbourne estate (see Stanfield P354) in 1884 tenants and friends on the estate commissioned P578 from Symonds, a locally-born artist. It was painted in his Holland Park studio and the artist later remembered that Wallace '*never sat, but always preferred to stand with one hand resting on the back of a chair & smoking a cigar*'.[1] He also recalled Wallace's charm and extreme kindness; he had talked of Velázquez, of his interest in collecting snuff-boxes, and of a room at Sudbourne decorated in the French style which pleased him so much he had not had the heart to remove the furniture when the Manor was sold.

Other portraits of Wallace are as follows:

1826 Drawing by Candide Blaize (Victoria and Albert Museum, P13-1943).

1857 Photograph inscribed *Chant et cie*(?) *1857*, seated three-quarter length, bare-headed (print in Wallace Collection archives; illus. B. Falk, '*Old Q's' Daughter*, 1937, f.p.196).

c.1867 Photograph, with his father and Mme. Oger, seated at Bagatelle (Musée Carnavalet, Paris; print in Wallace Collection archives; illus. Falk, f.p.240; D. Mallett, *The Greatest Collector*, 1979, pl.11).

1871 Photograph, with the Committee of the British Charitable Fund, Paris (illus. Mallett, pl.17).

Presentation of P578 to Sir Richard Wallace at Hertford House, 9 August 1886; Sir Richard and Lady Wallace on the extreme left, with John Murray Scott behind Lady Wallace and the artist on the extreme right.

1872 Three bust-length photographs by Elliot and Fry (Wallace Collection archives; cf. Falk, f.p.272).

1873 Drawing by Baudry, etched by Jacquemart for the *Gazette des Beaux-Arts*, 2e, VII, 1873, f.p.74, three-quarter length standing to right, the head based on one of the Elliot and Fry photographs.

1873 Cartoon by Spy for *Vanity Fair*, 29 November 1873; whole-length standing with top hat and cane (example in Wallace Collection archives; illus. Falk, f.p.284).

c.1873 Water-colour by Richard Dighton, whole-length with top hat and cigar (Wallace Collection archives; illus. Falk, f.p.196).

1886 Photograph by J. Thomson of the presentation of P578 in the court-yard of Hertford House (Wallace Collection archives).

c.1887 Two photographs by Vernon Kaye; whole-length seated, in gallery 19 of Hertford House (Wallace Collection archives; cf. Mallett, pl.25).

1888 Three photographs by J. Thomson; three-quarter length seated in smoking jacket and cap, in Hertford House (Wallace Collection archives; cf. Falk, f.p.304).

1889 Painting by H. J. Brooks, *Private View of the Old Masters Exhibition, Royal Academy, 1888*; Wallace is one of the fifty-eight whole-length figures (National Portrait Gallery, London, no.1833; illus. Falk, f.p.320).

1899 Posthumous marble bust by E. Hannaux (presented to the Wallace Collection by J. Murray Scott, 1900, s46).

A drawing by the marquis de Malterre, in Hertford House 1890, was last recorded in Murray Scott's collection at Connaught Place in 1903, where there was also an anonymous crayon portrait.

Provenance
Presented to Sir Richard Wallace by Tenants and Friends of the Sudbourne Estate (see above), 9 August 1886; Hertford House inventory 1890.

Exhibitions
RA 1885 (471); Ipswich, Art Club 12th exhibition, 1886 (242).

[1] Letter from the artist on file dated 28 April 1927.

Joseph Mallord William Turner (1775–1851)

Born on 23 April 1775 in London, the son of a barber. In 1789 he enrolled as a student at the RA where he was to exhibit from 1790 to 1850, being elected ARA 1799, RA 1802 and Professor of Perspective 1807–37. He was a constant traveller in Great Britain, France, Switzerland and Italy in search of landscape effects and the sketches he then made are preserved in some 260 sketch books in the British Museum, part of the Turner Bequest to the Nation of all the works which remained in his possession at his death. He first visited Yorkshire in 1797 and 1801; in 1809 he met Walter Fawkes at Farnley Hall, near Otley, where he stayed almost annually until 1824. The Yorkshire landscape was an inspiration for him; from it he took not only many generally topographical views but also ideas for historical subjects, such as *Hannibal crossing the Alps* (RA 1812; Tate Gallery). The imaginative richness of his later landscapes remains without compare in English painting. He died in London on 19 December 1851, and was buried in St. Paul's Cathedral.

Abbreviations

Finberg A. J. Finberg, *The Life of J. M. W. Turner*, 2nd. ed., 1961

Hill 1980 D. Hill, *Turner in Yorkshire*, catalogue, York Art Gallery, 1980

Hill 1984 D. Hill, *In Turner's Footsteps*, 1984

Rawlinson W. G. Rawlinson, *The Engraved Work of J. M. W. Turner*, 2 vols., 1908, 1913

T. B. The Turner Bequest of drawings in the British Museum, catalogued by A. J. Finberg, *A Complete inventory of the Drawings of The Turner Bequest*, 2 vols., 1909

Wilton A. Wilton, *The Life and Work of J. M. W. Turner*, 1979

P651 *Woodcock Shooting on Otley Chevin*[1]

An autumn scene; the sportsman on the left and the beater with raised stick in the centre. Signed bottom left: *JMW Turner RA/1813*.

Water-colour with touches of gum varnish, on paper 28 × 39.8 laid down on card, the edges trimmed

The distant greens and blues are somewhat faded.

Otley Chevin, a hill two miles south of Otley in West Yorkshire. In the Bicknell sale catalogue of 1863 the sportsman was named as Sir Henry Pilkington in error for Sir William Pilkington, 8th Bt. (1775–1850) of Chevet Hall, near Wakefield, for whom all four of the Turner water-colours in the Wallace Collection were painted, together with others.[2] He was the brother-in-law of Walter Fawkes of Farnley (which is within five miles of Otley Chevin).

P651

Drawing

A pencil study for P651 is in the *Woodcock Shooting* sketchbook (T. B. CXXIX-47); on p.4 of this sketchbook Turner notes a list of subjects including *Grouse Shooting* (no.8) and *Woodcock* (no.10).

Engraving

B. & G. Leighton 1852 (Rawlinson, no.849).

Provenance

With P654, P661 and P664, acquired from the artist by Sir William Pilkington (see above), from whom purchased by Elhanan Bicknell (1788–1861) of Herne Hill for £600; his sale (drawings), Christie's, 2nd day, 30 April 1863 (271, 'Woodcock shooting, scene on the Chiver, with portrait of Sir Henry Pilkington'), bt. Wells for the 4th Marquess of Hertford, 510 gn.; Hertford House inventory 1890.

Exhibitions

Bethnal Green 1872–5 (657); Belfast 1876 (90); RA 1887 (50).

Reference General

Wilton, no.534.

[1] Title as given in Finberg, p.203, and Hill 1980, p.38 under no.47.
[2] There was no Sir Henry Pilkington (cf. Burke's *Baronetage*); the correct identification first published by Hill 1980, p.38. Farington (*Diary*, 11 June 1804) mentions 'Mr. Pilkington' as an amateur landscape painter, fond of the arts, brother of Sir Thomas Pilkington of Stanlie Chevot (whom he succeeded in 1811). Two other Turner water-colours from his collection have been identified: *On the Washburn under Folly Hall* (Wilton, no.538; Hill 1980, no.47) and *Rievaulx Abbey* (Wilton, no.785; Hill 1980, no.143).

p654

p654 *Scarborough Castle: Boys Crab Fishing*

Looking north across South Bay; crabs and star-fish in the right foreground. Signed centre left: *JMW Turner RA/1809*.

Water-colour with touches of gum varnish, on paper 27.9 × 39.8 laid down on card, the edges trimmed

The distant washes are markedly faded.

Turner first drew this view on his second Yorkshire visit in 1801 (see below) and he seems to have returned to this drawing to paint p654. Previously considered to have been the water-colour shown at the RA in 1811,[1] but this seems unlikely, see Versions below.

Drawing

A pencil study of 1801 is in the *Dunbar* sketchbook (T.B. LIV-95a, 96). T.B. CXCVI-B is a 'colour beginning' for p654.[2]

Versions

ENGLAND private collection, water-colour 68.7 × 101.6, a less accurate treatment; exh. RA 1811 (392), bt. Fawkes (Wilton, no.528; Hill 1980, no.10).[3] A 'colour beginning' for this is T.B CXCVI-C.

From further studies of Scarborough made in 1816/7 (*Scarborough 1* and *2* sketchbooks, T.B. CL-8, 31 and CLI-17) Turner painted another water-colour 27.8 × 39.4, dated 1818 (coll. Mr. and Mrs. E. V. Thaw; Wilton, no.751; Hill 1980, no.140).[4] A colour beginning for this is T.B. CCII-18.

Provenance

See p651; Bicknell sale, lot 268, 520 gn.

Exhibitions

Bethnal Green 1872–5 (656); Belfast 1876 (79); RA 1887 (48).

Reference General

Wilton, no.527.

[1] E.g. by Finberg, *Turner's Water-Colours at Farnley Hall*, 1912, no.76, and Agnew's, *Turner*, 1967, under no.43. But Finberg, p.474, Wilton, nos.527–8, and Hill 1980, no.10, all agree that P654 was not shown at the RA.

[2] i.e. a note of the colours used; the purpose of these 'colour beginnings' is not absolutely determined (cf. Finberg, *Inventory*, pp.598–9, and E. Joll, *Turner Studies*, I, i, 1980, pp.39–40).

[3] Exh. *Turner*, RA and Tate Gallery, 1974, no.113.

[4] Exh. *Turner*, British Museum, 1975, no.91. From it was taken the engraving for the *Ports of England* series (Rawlinson, no.779).

P661 *Hackfall, near Ripon*

An autumn scene; a girl in white adjusts the blue bow of her pink cape. Signed bottom right: ... *W. Turner RA.*

Water-colour with touches of gum varnish, on paper 27.9×39.6 laid down on card, the edges trimmed

Hackfall, a richly wooded valley of the river Ure, five miles north-west of Ripon, North Yorkshire, 'one of the most picturesque scenes in the north of England',[1] where William Aislabie built a number of 'pavillions, covered seats, and other accommodations' of which P661 appears to show the Fisher's Hut (or Hall) in the mid-distance and, on the distant hill, Mowbray Castle, an artificial ruin. A companion water-colour, *The River Ure at Hackfall*,[2] shows the same scene from the opposite direction.

P661 may be dated c.1816; it is based on a sketch made on Turner's tour of central Yorkshire late in August that year (see Drawing below).[3] Hill has suggested that P661 and its companion, described above, were probably among

P661

the 120 drawings commissioned from Turner in 1816 by Longmans for Whitaker's *History of Yorkshire*, but unused when the contract lapsed in 1819.[4]

Drawing

A pencil study for P661 is in the *Large Farnley* sketchbook (T.B. CXXVIII-37).[5]

Replica

PORT SUNLIGHT Lady Lever Art Gallery, water-colour 27.7 × 39.4 (Wilton, no.537).

Provenance

See P651; Bicknell sale, lot 269 ('Mowbray Lodge, Ripon, Yorkshire: Earl Ripon's seat'),[6] 510 gn.

Exhibitions

Bethnal Green 1872–5 (652); Belfast 1876 (58); RA 1887 (55).

Reference General

Wilton, no.536.

[1] T. Pennant, *A Tour from Alston-Moor to Harrowgate*, 1804, p.54; for Hackfall, see also *The History of Ripon*, 1806, pp.231–8, and J. R. Walbran, *A Guide to Ripon, Harrogate*, etc., 1851, pp.96–8.
[2] Sold Sotheby's, 7 July 1983 (171), catalogue entry by Hill; not in Wilton.
[3] Cf. Hill 1984, p.127 (note to p.102).
[4] The contract is discussed by Hill 1984, pp.23–6; see also Hill 1980, pp.73–4; Wilton, nos.559–81, and note 2 above.
[5] The *Large Farnley* sketchbook dates from 1816, as demonstrated by Hill 1984, pp.101–2, 104, 128 (note to p.102). He had previously dated it c.1814–15 (Hill 1980, under no.46).
[6] Mowbray Lodge does not figure in contemporary descriptions of Hackfall (see note 1); the Earl of Ripon had succeeded to Aislabie's estates in 1808.

P664 *Grouse Shooting on Beamsley Beacon*

Signed bottom right: *JMW Turner RA Pp.*[1]

Water-colour with touches of gum varnish, on paper 27.9 × 39.5 laid down on card, the edges trimmed

P664

The greens and blues of the distance are faded.

The subject has been identified by Hill[2] as the shooting party on Beamsley Beacon, near Bolton Abbey, North Yorkshire, which Turner joined with Walter and his brother Richard Fawkes on 12 August 1816. Richard (who had m. the sister of Sir William Pilkington, see P651) was the victim of a shooting accident on 13 August, and died three days later. Rawlinson identified the second figure from the right as Turner (the nose, at least, is convincing) and the mounted figure, third from the right, as Walter Fawkes.[3] P664 may be dated 1816, but Turner had previously noted the subject in the *Woodcock Shooting* sketchbook (see P651).

Drawing

A related pencil study, showing a similar landscape but with the figures and animals differently arranged, is in the *Large Farnley* sketchbook (T.B. CXXVIII-8), see P661 note 5.

Engraving

B. & G. Leighton 1852 (Rawlinson, no.848).

Provenance

See P651; Bicknell sale, lot 270 ('Grouse Shooting, the Moor, with portrait of the Artist, the dogs painted by Stubbs'),[4] 430 gn.

Exhibitions

Bethnal Green 1872–5 (653); Belfast 1876 (54); RA 1887 (49).

Reference General

Wilton, no.535, as c.1813.

[1] i.e. Professor of Perspective; the PP recurs on several Turner drawings between 1809 and c.1816.

[2] Hill 1984, pp.102, 127 (note to p.102).

[3] Rawlinson, under no.848. In a letter on file dated 5 May 1913, Rawlinson said he could not recall the evidence for the identification of Fawkes: '*had I seen your catalogue with the 1863 Christie's description giving Sir Henry Pilkington's name, I should not have printed Mr Fawkes's. But I have a vague impression – very vague – that I heard so from the late Mr. Ayscough Fawkes, or the late Major Fawkes – at Farnley in fact*'.

[4] The attribution of the dogs is quite fanciful; Stubbs died in 1806.

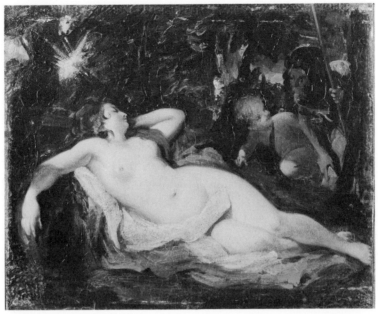

P566

Richard Westall (1765–1836)

Born in Hertford, he was apprenticed to an heraldic engraver in London in 1779 before studying at the RA schools. He shared rooms with Lawrence in Green Street 1790–4. Elected ARA 1792 and RA 1794, and exhibited at the RA 1784–1836 and BI 1806–34, principally fancies and historical subjects. His Neo-Classical histories painted for Payne Knight and Thomas Hope between 1795 and 1811 achieved a certain popularity, but his most sustained activity was as an illustrator. He was Queen Victoria's first Drawing Master 1827–36. He died in London on 4 December 1836.

P566 *Cimon and Iphigenia (after Reynolds)*

The sleeping Iphigenia is shown to Cimon by Cupid.

Canvas 21.3 × 25.8 laid down on panel 21.8 × 26.5

There is a prominent overall craquelure and the varnish is much discoloured.

The subject is taken from Boccaccio, *The Decameron*, 5th day, 1st story: the handsome son of a Cypriot nobleman was an imbecile called Cimon ('brute'); one day he discovered the sleeping Iphigenia and fell in love with her; the strength of his passion led him to overcome his weaknesses and ultimately he succeeded in marrying her.

P566 is copied from the Reynolds shown at the RA in 1789 and acquired by the Prince Regent in 1814.[1] The attribution to Westall is traditional and probably correct.

Versions

See above.

Provenance

Acquired by the 4th Marquess of Hertford;
Hertford House inventory 1870: '*Westall,
Cymon & Iphigenia after Reynolds*'.

[1] Buckingham Palace; 143.2 × 172.1 (Millar. no.1030).
The picture was also copied by Etty and Henry Bone, and
was first engraved by Haward in 1797.

P757 *Nymph and Cupids*

The nymph has dark hair and a blue scarf over her shoulders; a bunch of grapes
lies in front of her and there is a red drapery above and below her. Signed
bottom left: *R. Westall 179[3?]*.

Water-colour on thin grey card 29.7 × 38.5

A familiar theme with Westall who exhibited oils of this title at the RA in 1790,
1794 and 1795. The recent suggestion that the subject was Titania from *A
Midsummer Night's Dream (Summary Illustrated Catalogue*, 1979) seems misplaced.

Provenance

Acquired by the 3rd Marquess of Hertford;
Dorchester House inventory 1842: '*Lord
Hertford's Bedroom, Westall Venus & Cupids – a
drawing*'; Hertford House inventory 1870 as
'*Venus unveiled by Cupid*'.

Exhibition

Bethnal Green 1872–5 (13).

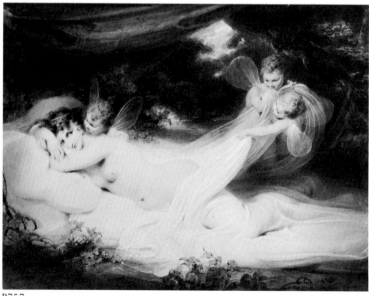

P757

David Wilkie (1785–1841)

Born on 18 November 1785 in Cults, Fifeshire, he first studied in Edinburgh before coming to London in 1805. His earlier work was much in the manner of Teniers (and was mocked as the 'Pauper Style'). He exhibited at the RA 1806–25 and 1829–41, being elected ARA 1809 and RA 1811. He visited France in 1814 and 1821, and in 1825–8 he made a convalescent tour on the Continent which included a period in Madrid (see Studio of Velázquez P6). Thereafter he adapted a looser, more dramatic style, influenced by Rembrandt and seventeenth-century Spanish painting. In 1830 he was appointed Principal Painter to the King, and he was knighted in 1836. In 1840 he visited the Holy Land, but died at sea on his return voyage, an event memorably described by Turner in his *Peace: Burial at Sea* (Tate Gallery).

Abbreviation

Cunningham A. Cunningham, *The Life of Sir David Wilkie*, 3 vols., 1843

P352 *The Cottage Toilet*

Glaud sits by the fire, a dog between his legs; Jenny, his daughter, in a pale blue bodice, dresses her fair hair; Peggy, his 'niece' (a foundling), wears a red bodice and a lavender coat; an unlaced corset lies on the foreground chair. Signed bottom left: *D. Wilkie 1824.*

Mahogany panel 30.1 × 38.4 × 0.6 painted area 29.2 × 37.1

There are traces of bitumen in the darks, and a shrinkage craquelure on the mirror, in the reds and on the foreground chair. The panel has a slight convex warp.

The subject is taken from Allan Ramsay, *The Gentle Shepherd*, v, ii, 1–6:[1]

> 'While Peggy laces up her bosom fair,
> With a blew snood Jenny binds up her hair;
> Glaud by his morning ingle takes a beek,
> The rising sun shines motty thro' the reek,
> A pipe his mouth; the lasses please his een,
> And now and than his joke maun interveen.'

(Peggy, it transpires, is the niece of Sir William Worthy; Patie, the gentle shepherd she loves, his son). This pastoral comedy by the father of the painter Allan Ramsay (see P560) was first published in 1728 and became very popular. An edition of 1788 was illustrated by David Allan and one of his plates may have inspired P352.[2] Wilkie painted at least three other scenes from *The Gentle Shepherd*,[3] and Cunningham remarked that all his pictures from Ramsay were 'exquisitely observed'.

P352 admirably reflects Wilkie's study of Rembrandt and Ostade, and his quest for depth and richness of tone. When Leslie saw it in Wilkie's studio he thought it 'a fine specimen of richness and depth of *chiaroscuro*'; he recalled that Wilkie demonstrated to him the importance of tone and glazes from a painting he

owned by Isaac van Ostade, but 'he might just as well have explained to me all his notions of tone and effect from [P352] . . .'.[4] Nevertheless, when P352, with *The Smugglers*, was shown at the RA in 1824 it was criticised for its 'dark, clammy style of colouring and handling'.[5]

Drawing

LONDON Sotheby's, 24 November 1977 (95), brown ink and wash, apparently a preliminary study for P352, with the three figures similarly engaged but differently disposed.

Engraving

J. C. Armytage 1849 (for *The Wilkie Gallery*).

Copies/Versions

English private collection, panel 20.3 × 24.3, a weaker version of P352.
A copy in enamel by William Essex (1784–1869) is in the Victoria and Albert Museum (no.922–1868).

Provenance

Commissioned by the 6th Duke of Bedford (1766–1839), 120 gn.; Georgiana, his Duchess (d.1853); her sale, Bedford Lodge, Campden Hill, Farebrother, Clark and Lye, 4th day, 14 July 1853 (775), bt. Mawson for the 4th Marquess of Hertford, £543;[6] Hertford House inventory 1870.

Exhibitions

RA 1824 (115, *Cottage Toilette*, with the quotation from Ramsay as given above); Bethnal Green 1872–5 (14); South Kensington, *International Exhibition*, 1874 (78).

Reference General

Cunningham, II, pp.108–109, and III, p.526.

[1] Text as given in *Poems by Allan Ramsay and Robert Fergusson*, ed. A. M. Kinghorn and A. Law, 1974, p.94.
[2] Cf. Patricia Campbell, *Country Life*, 14 August 1969, pp.399–400, where the Allan plate is illus. and the 1788 edition described as being for Wilkie 'a basic source of reference . . . a constantly recurring influence'.
[3] Cf. Cunningham, III, pp.524, 526, 531: *Scene from the Gentle Shepherd* 1803 (exh. BI 1841, no. 33); *Scene from the Gentle Shepherd* 1823 (a good version in the National Gallery of Scotland, no.839, and see Waterhouse, *Catalogue of Paintings and Sculpture*, National Gallery of Scotland, 1957, p.295); *Study of the Gentle Shepherd* 1840 (exh. RA 1841, no.112, and BI 1841, no.23).
[4] C. R. Leslie, *Autobiographical Recollections*, I, 1860, pp.80–1, quoted by F. Irwin, *The Burlington Magazine*, CXVI, 1974, p.216, in a useful discussion of P352 in relation to other Wilkies of this period.
[5] W. T. Whitley, *Art in England 1821–37*, reprint 1973, p.62.
[6] Bought on Mawson's advice, see *Letters*, nos.31–3, pp.46–8.

P357 *The Sportsman*

The farmer, on the left, wears a red waistcoat; his daughter a pink blouse, and the sportsman a blue cravat. Signed below left: *D. Wilkie.1824*.

Mahogany panel 26.8 × 31 × 0.6 painted area 25.5 × 29.6

There are small losses top centre and in the middle of the left-hand edge, and a shrinkage craquelure in the darks on the left. The panel has a slight convex warp.

A label *verso* describes P357 as:

> '*The Sportsman refreshing painted by Wilkie for General Phipps by whom the subject was suggested The Sportsman is a portrait of Lt Col. The Honble C. B. Phipps The Farmer's daughter pouring out Ale is a portrait of Lady Lepel Charlotte Phipps* [signed] *Edmund Phipps/May 21st 1844*'

Col. Sir Charles Beaumont Phipps (1801–66), second son of the 1st Earl of Mulgrave, and his sister Lady Lepel Charlotte Phipps (d.1869), nephew and

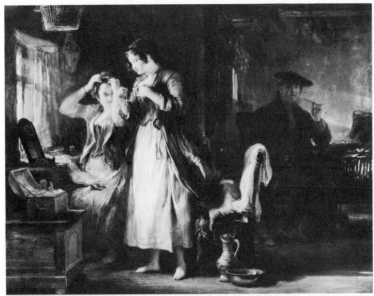

P352

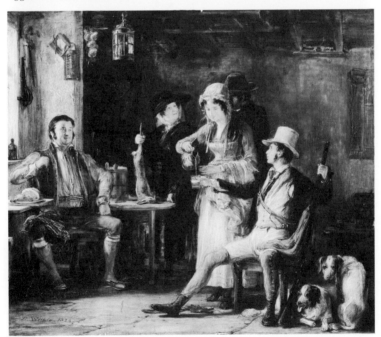

P357

niece of Gen. Phipps who commissioned P357. The composition recalls Wilkie's informal group portrait of *Sir Walter Scott and his Family* of 1817 (panel 28 × 37.6, Scottish National Portrait Gallery, no. 1303).

Drawing

LINLITHGOW The Binns, pen and wash, showing an earlier stage of the composition with the seated men closely comparable to those in P357 (one of seven small sketches on one sheet).

Provenance

Commissioned by Gen. the Hon. Edmund Phipps (1760–1837), 90 gn.; the Hon. Edmund Phipps (1808–57); his sale, Christie's, 25 June 1859 (88), bt. Mawson for the 4th Marquess of Hertford, 383 gn.;[1] Hertford House inventory 1870.

Exhibitions

Bethnal Green 1872–5 (15); South Kensington, *International Exhibition*, 1874, (83).

Reference General

Cunningham, III, p.526.

[1] After the sale Mrs. Phipps wrote to Lord Hertford in an attempt to get the picture back (*Letters*, no.93, p.118); P357 had been a favourite of the family, according to Mawson (*ibid.*, no. 90, p.113) who considered that it went very cheap at the sale and that Mrs. Phipps 'ought to have had more delicacy in wishing it to be returned' (*ibid.*, no.94, pp.118–19).

German School

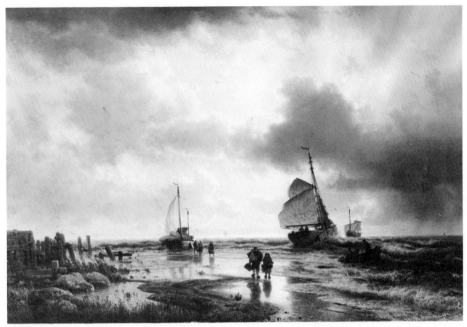

p618

Andreas Achenbach (1815–1910)

Born on 29 September 1815 in Kassel, he studied in the Düsseldorf Academy. He painted mainly Rhineland villages, Norwegian landscapes and North Sea coast scenes, much influenced by Dutch seventeenth-century painting. He died in Düsseldorf in April 1910.

P618 *The Ebb-tide*

A storm blowing up on an autumn morning; to the left a herring boat is being unloaded. Signed bottom left *A. Achenbach 1849*.

Mahogany panel 46.2 × 68.3 × 1.2

Slight abrasion on the thinner passages in the sky, and a marked craquelure within the heavily impasted lights round the clouds.

Provenance
Acquired by the 4th Marquess of Hertford, possibly after 1863;[1] rue Laffitte inventory 1871 (384); Hertford House inventory 1890.

Exhibition
Bethnal Green 1872–5 (558).

[1] A Dutch newspaper, dated February 1863, lines the panel, *verso*.

P557

Heinrich von Angeli (1840–1925)

Born on 8 July 1840 in Sopron (then in the Austrian Empire). He studied at the Vienna Academy and in Düsseldorf before practising as a history painter in Munich 1859–62. Returning to Vienna, he became a Professor at the Academy and a fashionable portrait painter. He met the Crown Princess of Prussia (see below) in 1873 and painted her portrait many times (e.g. in 1874, 1877, 1880, 1882 and 1893); she recommended him to Queen Victoria, whose portrait he painted in 1875, 1890 and 1899. He died in Vienna on 21 October 1925.

P557 *The Empress Frederick of Germany as Crown Princess of Prussia*

Within a painted oval; dark hair, grey eyes; she wears a rich parure of diamonds and emeralds with a rope of matched pearls, and a golden-yellow dress with a black lace shawl. Signed bottom right: *H v Angeli 1882.*

Canvas 71 × 58

The canvas bears, *verso*, the (half obliterated) stamp of a Viennese colourman.

Victoria Adelaide Mary Louisa (1840–1901), eldest child of Queen Victoria and Prince Albert, married in 1858 Frederick Hohenzollern (1831–88), later Crown Prince of Prussia and (for ninety-nine days) Emperor of Germany; she was the mother of William II of Germany. She took a lively interest in the fine arts and was acquainted with Sir Richard Wallace. Her name appears in the Visitors' Book for Hertford House[1] on 7 March 1879, 16 July 1881, 4 October 1882 (when she did not sign herself), 5 November 1882, 12 July 1887 and, within a month of Lady Wallace's death, on 12 March 1897. On Wallace's death she had written to Queen Victoria: '*He was a most generous and charitable man, and what a connoisseur of art!*'[2] Wallace had presented her with a Gouthière toilet mirror which had once belonged to Marie-Antoinette (it is now in the Schloss Fasanerie, Fulda),[3] perhaps in return for P557 which he kept in his study (Gallery 24).

P557, which is of replica quality, derives from a whole-length portrait painted by Angeli in 1882;[4] the shawl conceals the inconvenient position of the arms within the reduced and oval composition.

Provenance

Presented by the sitter, probably in 1882 (see above); Hertford House inventory 1890.

[1] Wallace Collection archives.
[2] Royal Archives, Windsor Castle, z 49/3; letter dated 7 August 1890.
[3] It had been sold at Christie's, 13 June 1867 (265).
[4] Illus., *The Empress Frederick, a Memoir*, 1913, f.p.284.

Christian Wilhelm Ernst Dietrich (1712–1774)

Born on 30 October 1712 in Weimar, he studied with his father and in Dresden c.1724–7 with Alexander Thiele, a landscape painter. Appointed Court Painter to the Elector Frederick Augustus II of Saxony (King Augustus III of Poland) in 1741. He visited Rome and Venice in 1743, but spent most of his life in Dresden, where he became a Professor at the Academy in 1764, and where he died on 24 April 1774. A diverse and eclectic artist, he painted pastiches of, for example, Watteau, Salvator Rosa, Adriaen Ostade and Rembrandt; he also decorated Meissen porcelain and practised as an etcher. There is a large collection of his work in Dresden.

P153 *The Circumcision*

The interior of a synagogue; Mary and Joseph kneel on the left; the circumcision is performed on the platform (*bimah*) in the centre; the empty chair in the right foreground is probably the Chair of Elijah on which the Child would have been placed by the *mohel* (circumciser) before the ceremony; in the right background the flame used to heat the knife.

Canvas, relined 44.7 × 63.2

PI 53

The paint surface is tending to lift in the lower right area, and the dark areas above Joseph have been retouched and are bituminous. The varnish is somewhat discoloured.

The subject is taken from Luke II, 22–38.

Painted in a Rembrandtesque idiom, and generally reminiscent of *The Tribute Money* (Bredius 586). Dietrich painted several synagogue scenes; the drawing of a comparable interior, a *Presentation in the Temple*, no.1416 in the Albertina, is dated 1757, and the related painting, 42 × 61, was sold Christie's, 26 February 1926 (86); two *Presentations in the Temple* in Dresden are dated 1739 and 1740.

Provenance
Paul Périer (1812–97); his sale, Paris, 16–17 March 1843 (9, '*Cérémonie dans un temple israëlite*, 44 × 63'), bt. Richard for the 4th Marquess of Hertford, 1,861 fr.; rue Laffitte inventory 1871 (362, Van Eekhout, '*la circoncision*'); listed at 105 Piccadilly 1874–5; Hertford House inventory 1890.

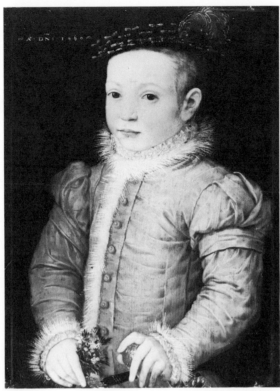

P533

German School (?) 1560

P533 *A Boy with a Nosegay*

Fair hair, grey eyes, wearing a black cap with gold trimmings and a red plume, a white ruff with pink edging, and a rose-coloured doublet with white fur trimming. Inscribed top left: A°. DNI. 1560.

Oak panel 36 × 26.5 × 0.5

The face and hands show several discoloured retouchings, and there are further restorations on his left sleeve and doublet.

Catalogued as by a follower of Holbein in 1900, and as German School from 1904. Bredius tentatively suggested an attribution to Jacob Seisenegger,[1] but there is no firm evidence that the panel is German.

Provenance
Acquired by the 3rd Marquess of Hertford; Dorchester House inventory 1842 as Holbein, '*A Portrait of a Youth*'; listed at 105 Piccadilly 1874–5 as '*Henry VIII as a Boy*'; Hertford House inventory 1890 as Holbein, '*Henry 8th as a youth*'.

Exhibition
RA 1880 (156, as School of Janet, *Henry VIII as a Boy*).

[1] Letter on file dated The Hague, 28 February 1901.

P338

August Xaver Karl Pettenkofen (1822–1889)

Baptised on 10 May 1822 in Vienna where he studied at the Academy under Kupelwieser. He was an illustrator and cartoonist but became best known for his realistic genre subjects, often of military scenes. In 1852 he first visited Paris where the works of Meissonier and Stevens influenced him greatly. He became a Professor at the Vienna Academy and was knighted in 1874. He died in Vienna on 21 March 1889.

Abbreviation

Weixlgärtner A. Weixlgärtner, *August Pettenkofen*, 2 vols., 1916

P338 *Robbers in a Cornfield*

Signed bottom right: *Pettenkofen 1852*.

Millboard 29.5 × 23.4

There is an overall craquelure, and the varnish is discoloured.

P338 was begun in Vienna and completed in Paris.[1]

Provenance

Commissioned by a Viennese collector (see note 1); Anatole Demidoff (1813–70); his sale, Paris, 1st day, 13 January 1863 (33, *Le Partage du butin*, '... *le costume délabré indique des échappés de quelque bande de reîtres du dix-huitième siècle...*'), bt. by the 4th Marquess of Hertford, 5,000 fr.; rue Laffitte inventory 1871 (105); Hertford House inventory 1890.

Exhibition

Bethnal Green 1872–5 (583).

Reference General

Weixlgärtner, II, p.354, no.93.

[1] Cf. A. de Lostalot, *Gazette des Beaux-Arts*, 2e, XV, 1877, p.411.

Manner of Pettenkofen

P621 *The Ambuscade*

The soldiers wear the uniform of the Austrian dragoons.[1] Inscribed bottom left: A.P. 1846.

Board[2] 20.1 × 26

The varnish is very discoloured.

Though exhibited in 1872 and listed in 1890 as by Pettenkofen, P621 was catalogued as by Pils between 1900 and 1920 when it was reattributed to Pettenkofen. Weixlgärtner, dismissing the Pils attribution on the grounds, primarily, of the uniforms, considered it to be an imitation of Pettenkofen by another hand, conceivably that of J. G. Raffalt (1836–65), perhaps derived from Pettenkofen's *Listeners* of 1846.[3] Though markedly inferior in execution to P338, P621 appears, from a photograph, to be quite close to the *Listeners*.

P621

Provenance

Acquired in Paris by the 4th Marquess of Hertford; rue Laffitte inventory 1871 (53); Hertford House inventory 1890.

Exhibition

Bethnal Green 1872–5 (543).

Reference General

Weixlgärtner, I, p.293 n.34, and II, p.344, under no.20.

[1] Weixlgärtner, I, *loc. cit.*
[2] With label *verso: 'W. Koller, Mariahilfer Hauptstrasse nr 9 blechernen Thurm, Wien'.*
[3] *Die Horcher*, illus. Weixlgärtner, I, p.21, and catalogued, II, p.344, no.20; it shows the same cottage and action as P621, but the figures are differently disposed. In 1916 it was in the collection of F. X. Mayer, Vienna.

Johann Georg Platzer (1704–1761)

Born on 25 June 1704 in St. Michael in Eppan, South Tyrol, he studied with his step-father, J. A. Kessler, in Innsbruck, and with his uncle, J. C. Platzer, in Passau, before entering the Academy in Vienna in 1728. He stayed in Vienna where, influenced by seventeenth-century Flemish masters such as Hendrik van Balen and Frans Francken the Younger, he painted small historical subjects, often on copper, which he would repeat with minor variations. There are six of his small panels in the Victoria and Albert Museum. He died in St. Michael in Eppan on 10 December 1761.

P634 *The Rape of Helen*

Helen, with blue and white drapery, is borne aloft, centre left; amongst the fighting soldiers two in the foreground are left-handed. Signed bottom right: *J.g./Plazer.* (sic).

Copper 40.3 × 59.4

The edges, within a band 7 mm. wide, are abraded. The varnish is much discoloured and spotted. There is a scratch across the drape of the swordsman standing on the central boat, and small losses on the right arm of the man holding his shield above his head, on the edge of the distant rotunda and in the figure group alongside it, and in the second mast from the left.

Helen, daughter of Zeus and Leda, married to the Greek Menelaus, is abducted by Paris and taken to Troy, an act which caused the Trojan War, the subject of Homer's *Iliad*. Platzer anachronistically includes a Roman Imperial standard in the bas-relief on the far right.

The pose of Helen recurs in van Balen's *Marriage of Peleus and Thetis* in Dresden (no.920). A related composition by Platzer, *Anthony and Cleopatra at the Battle of Actium*, is in the Wellington Museum, Apsley House,[1] and see Versions below.

P634

Versions

LONDON Sotheby's, 12 December 1973 (119), copper 48 × 62, a replica showing more sky above.

VIENNA Wolf sale, A. Kende, 7–8 June 1932 (76), copper 40 × 59, a related composition, reversed.

Provenance

A. Beurdeley, Paris, from whom purchased, 5 March 1872, by Sir Richard Wallace;[2] Hertford House inventory 1890.

Exhibition

Bethnal Green 1874–5 (381).

[1] C. Kauffmann, *Catalogue of Paintings in the Wellington Museum*, 1982, p.115, no.140.
[2] Invoice in Wallace Collection archives.

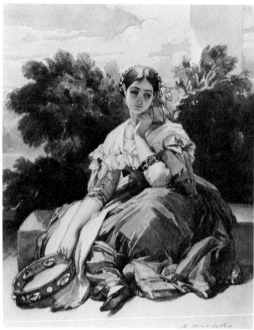

P669

Hermann Winterhalter (1808–1891)

Born on 23 September 1808 in St. Blasien in the Black Forest, younger brother of the portrait painter Franz Xaver Winterhalter (1806–73). Studied in Munich and Rome before settling in Paris where he assisted his brother and exhibited at the Salon 1838–41, 1847 and 1869. His portrait of his Parisian patron Nicolas-Louis Planat de la Faye is in the Louvre. On his brother's death he retired to Karlsruhe where he died on 24 February 1891.

P669 *A Girl of Frascati*

Dark hair, wearing a pink head-dress, blue dress and a pink and white shawl. Signed bottom right: *H. Winterhalter.*[1]

Water-colour with gum varnish in the darker areas, on paper 22.8 × 18.3

Frascati, to the south of Rome. Probably painted before 1838, while the artist was studying in Rome.

Provenance
Acquired by the 4th Marquess of Hertford; Hertford House inventory 1890.

Exhibitions
Bethnal Green 1874–5 (695); Belfast 1876 (67).

[1] Previous editions of this catalogue have listed P669 as by F. X. Winterhalter.

Italian Schools

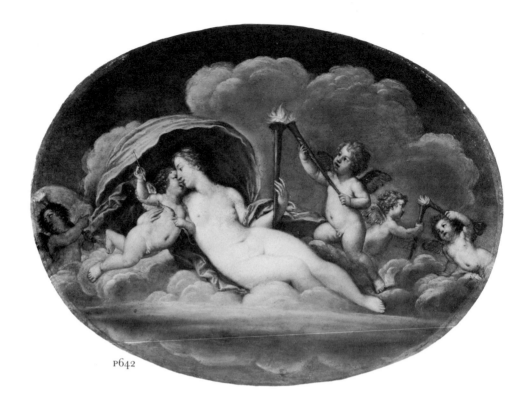

P642

Francesco Albani (1578–1660)

Born on 17 August 1578 in Bologna where he studied under Denis Calvaert before entering the Carracci Academy c.1595. He worked in Rome 1602–16 and 1623–5 and in Mantua 1621–2, but spent most of his life in Bologna. His later works were principally mythological scenes for private patrons; Lanzi hinted that the twelve children of his second marriage furnished models for the *amorini*, and stated that Albani made repetitions and 'practised his pupils in them, giving them his own touches'.[1]

[1] L. Lanzi, *History of Painting in Italy*, 1795, trans. T. Roscoe, 1847, III, p.89.

Studio of Albani

P642 *Venus and Cupid*

Soft pink drapery, clear blue sky.

Copper 29.7 × 39.6

Cleaned in 1859;[1] considerably retouched, e.g. on Venus's torch, her neck and shoulders, on Cupid's face, and round the edges of the panel. There are many small damages, most noticeably below the right arm of the extreme left-hand *amorino*, immediately below the extreme right-hand *amorino*, on Cupid's right hip, and in the sky in the bottom centre area. Lifting paint was secured in 1983.

P642 is not of prime quality; it repeats motifs found in Albani's work in the later 1620s. The Venus and Cupid appear in the versions of his *Dance of Cupids with the Rape of Proserpine* in the Brera, Milan, and at Dresden, with only minor variations (principally in that Cupid's right arm is lowered). The group also recurs in a *Repose of Venus* in the Uffizi, currently catalogued as Florentine School.[2] The motif of *amorini* passing fire from their torches recurs in Albani's *Fire*, one of the set of *Elements* in Turin, dateable 1626–8.

Provenance
Louis, marquis de Montcalm (1786–1862);
his sale, Christie's, 2nd day, 5 May 1849
(129), bt. by the 4th Marquess of Hertford,
370 gn.; Hertford House inventory 1870.

Exhibition
Bethnal Green 1872–5 (253).

[1] Evans invoice.
[2] *Gli Uffizi, Catalogo Generale*, 1980, p.494, no.P1509; '*opera assai modesta*'.

Beccafumi (c.1486–1551)

Domenico di Giacomo de Pace, *il Mecherino*, called Beccafumi after his earliest patron. He first studied in Siena, but visits to Rome c.1510–12 and 1519 and (almost certainly) to Florence greatly influenced his development. Apart from a later visit to Genoa and Pisa c.1541, he otherwise worked in Siena, undertaking a number of notable commissions for Church and State, including designs for the marble pavement, frescoes and bronze angels for the Duomo, a painted ceiling in the Palazzo Pubblico, and numerous altarpieces. A solitary man (according to Vasari) his highly personal Mannerism was one of the last major manifestations of the Sienese school.

Follower of Beccafumi

P525 *Judith with the Head of Holofernes*

Fair hair, white chemisette, pale yellow dress and red drapery with a green lining.

Poplar panel 86.2 × 47.5 × 2.6 two vertical members, the left 10.2 wide

There are retouchings throughout, most apparent in Judith's face, around her feet, and on the falchion to the right of her head. Vertical scratches run through Judith's left eye and left shoulder. A knot in the top left-hand corner has disturbed the surface of the panel. Blisters were treated in 1922, 1955, 1962 and 1974. The thick varnish is considerably discoloured.

The subject is taken from the apocryphal book of Judith VIII–XIV: Judith, a young Israelite widow, slew Holofernes, King Nebuchadnezzar's general, with his own sword in his own tent, allowing the Israelites to defeat the Assyrians.

P525 belongs to a series of three panels formerly attributed to Beccafumi.[1] The other two, now in the Musée Bonnat, Bayonne, show Sophonisba and Cleopatra,[2] the theme of the set evidently being famous women of antiquity.[3] The attribution to Beccafumi was first rejected by Pope-Hennessy in 1940,[4] and thereafter by Sanminiatelli[5] and Bacchesci.[6] P525 is evidently Sienese and reflects the influences of Sodoma[7] and Peruzzi,[8] as well as Beccafumi, but the extraordinarily small heads remain distinctive.

Provenance[9]

Prince Sigismondo Chigi-Albani (1798–1877), from whom purchased by the vicomte Both de Tauzia (1823–88); purchased from him by Sir Richard Wallace in 1872, see Appendix IV; Hertford House inventory 1890.

[1] This attribution was accepted by Berenson, *Lists* 1897, 1932, 1968; A. Venturi, *Storia dell' Arte Italiana*, IX, V, 1933, pp.450, 498–9, and M. Gibellino-Krasceninnicowa, *Il Beccafumi*, 1933, p.68; all agreed they were early works.

[2] Each panel 85.5 × 47; see E. Baccheschi, *L'opera completa del Beccafumi*, 1977, nos.186–7. The panels were given to Bayonne in 1921 by Léon Bonnat, a close friend of Tauzia, who must have acquired them from Tauzia's niece, Mlle. de Rumford. The Bayonne panels are inscribed, *verso: Propriété du Prince Chigi à Sienne* and *Prince Chigi à Rome*; see Provenance above.

[3] Part of a comparable set, securely attributed to Beccafumi, is in the National Gallery, London, nos.6368–9.

[4] J. Pope-Hennessy, *The Burlington Magazine*, LXXVI, 1940, p.115 n.11.

[5] D. Sanminiatelli, *Domenico Beccafumi*, 1967, p.169.

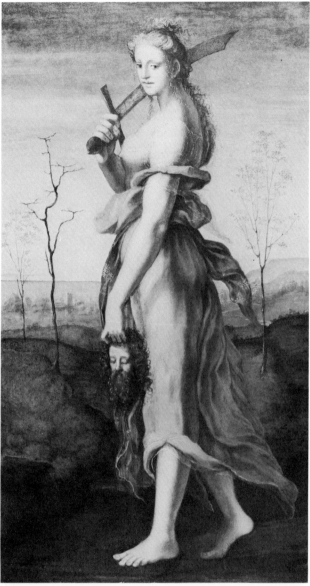

P525

[6] Bacchesci, *op. cit.*, no.201.

[7] Pope-Hennessy, *loc. cit.*, had tentatively suggested
Sodoma. Sodoma's *Judith*, no.354 in the Pinacoteca
Nazionale, Siena, shows a similar subject.

[8] First suggested by C. Phillips, catalogue 1900 and *Art
Journal*, 1901, p.103. Sanminiatelli, *loc. cit.*, suggested that
the artist must have seen the decorations of the Castello di
Belcaro, Siena, generally attributed to Peruzzi c.1534–5.
Pope-Hennessy, *loc. cit.*, considered that the Bayonne

Sophonisba could not have been conceived before Peruzzi's
Augustus and the Sibyl of 1528 (Fontegiusta, Siena).

[9] There are three seals on the *verso*: one is a Lombardo-
Venetian nineteenth-century customs stamp; the other two
are only partly legible: one appears to read NATVR[A].
DVXIT INITIUM, the other shows the Gothic initials A M above
an anchor and is inscribed [Abramo] MIELI (these seals
recur on Bonington P362). The provenance given here was
first published in the 1904 catalogue.

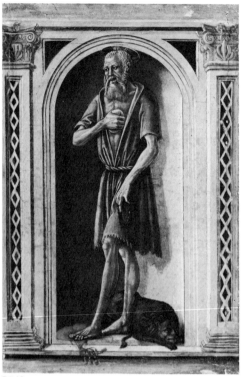

P543

Benvenuto di Giovanni (1436–c.1518)

Benvenuto di Giovanni di Meo del Guasta, a Sienese master, son of a mason, active between 1453 and 1509. He probably studied under Vecchietta, but he was also influenced by Paduan and Florentine works. His masterpiece is perhaps the triptych in S. Domenico, Siena, which is dated 1475. His son, Girolamo, was also a painter.

P543 *S. Jerome*

White-haired, wearing a grey tunic, a rosary in his left hand, a stone in his right; a Cardinal's red hat by his left foot, a lion to the right. The columns have pink capitals and bases.

Poplar panel 31 × 19.7 × 2.2 with strips added to each edge bringing the size to 32.7 × 21.6

Considerably retouched, e.g. on the legs, arms, beard, in the background shadow and the capitals and bases of the columns. There is a cross-grained craquelure. Three vertical splits, *verso*, have not affected the painted surface. The edging strips have been made up, probably to reproduce damaged parts of the original composition; the joins are splitting with some loss of paint.

S. Jerome, one of the four Latin Fathers of the Church, spent four years of penitence in the eastern desert before becoming Papal Secretary in Rome; his later years were spent in a monastery in Bethlehem where he completed his translation of the Bible into Latin c.404, and was allegedly accompanied by a lion from whose foot he had removed a thorn. The Cardinal's hat refers (anachronistically) to his Papal appointment, and the lion both to his biography and temperament.

P543 was catalogued as Ferrarese in 1900, and first attributed to Benvenuto di Giovanni by Phillips in the 1908 edition. It has been placed by Bandera after the Montepertuso altarpiece is S. Domenico, Siena, which is dated 1475, and before the *Ascension*, dated 1491 (no.434 in the Pinacoteca Nazionale, Siena), in what she has termed his Crivellesque phase, characterised in P543 by the prominent architecture (conceivably influenced by Jacopo della Quercia's prophets on the font in the Siena Baptistry) and the hard Paduan drawing.

Provenance

The vicomte Both de Tauzia (1823–88), from whom purchased by Sir Richard Wallace in 1872, see Appendix IV; Hertford House inventory 1890 as Andrea del Castagno.

Reference General

M. C. Bandera, '*Qualche osservazione su Benvenuto di Giovanni*', Antichità Viva, XII, 1974, i, pp.3–17.

Giovanni Battista Bertucci (active 1498–1516)

Giovanni Battista of Faenza, known as Bertucci the Elder (to distinguish him from his grandson, G. B. Bertucci the Younger, c.1540–1614); documented from 1498. Miraviki[1] has proposed he may have been the pupil and assistant of Pinturicchio, and his work also reflects the influences of Lorenzo Costa, Perugino and Francia. A dated altarpiece of 1506, signed *Joanes Baptista de Favetia*, is one of seven panels by him in the Pinacoteca, Faenza,[2] and there are four works attributed to him in the Museum of Fine Arts, Budapest.[1] His sons, Michele (d.1521) and Jacopo (c.1500–79), were also painters.

[1] L. Miraviki, *Bulletin du Musée Hongrois des Beaux-Arts*, 44, 1975, pp.56–64.
[2] A. Archi, *La Pinacoteca di Faenza*, 1957, pp.41–2, pls.8–11.

Attributed to Bertucci

P2 *An Idyll: Daphnis and Chloe*

Chloe has fair hair, Daphnis dark brown; both have white draperies.

Poplar panel 85.9 × 62.2 × 3.6

The panel has a convex warp and the paint surface is tending to lift in the central area. There are old damages on Daphnis's chest and upper right arm. Retouching is particularly apparent in the sky, on Chloe's left hip, and in the landscape to the left of Daphnis's head. There are *pentimenti* behind both heads.

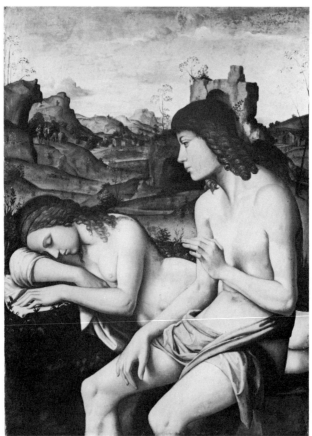

P2

The subject, first identified by Eisler,[1] is apparently taken from Longus, *Daphnis and Chloe*, the pastoral romance of two foundlings who turn out to be from noble families. Daphnis, the dark haired (1, 13), was found in an ivy thicket weaned by a goat (1, 2); Chloe, the fair haired (1, 17), was weaned by a ewe in 'a sacred cave of the Nymphs, a huge rock, hollow and vaulted within, but round without ... the mouth ... in the midst of the great rock' (1, 4).[2] P2 appears to illustrate both these sites, as well as the episode in 1, 25 where Daphnis looks longingly at the sleeping Chloe. The text of *Daphnis and Chloe* was not printed before 1559,[3] and the subject is not common before then; it may recur in two paintings by Paris Bordone (Louvre, inv.125; National Gallery, London, no.627).

An attribution to Francesco Bianchi Ferrari, proposed by Phillips in 1900 and retained in previous editions of this catalogue, was supported by Cook (1902),[4] Gardner (1911)[5] and, initially, by Berenson (*Lists* 1907), but was strongly contested by Venturi (1914).[6] Berenson subsequently proposed Ferrara-Bologna, perhaps Girolamo Marchesi (*Lists* 1932), and then Bertucci (*Lists* 1968),[7] an attribution recently affirmed by Zeri (orally, 1983). The distinctive hands, the

angularity of the drawing and the capricious landscape in P2 may be compared with similar features in Bertucci's *S. John the Baptist* from the S. Caterina Altarpiece (Faenza, Pinacoteca) and his *Marriage of S. Catherine* in the Museum of Fine Arts, Budapest, which has been dated c.1511–15 by Miraviki.[8]

Provenance

The vicomte Both de Tauzia (1823–88), from whom purchased by Sir Richard Wallace in 1872, see Appendix IV; Hertford House inventory 1890 as Ercole Grandi.

[1] R. Eisler, letter on file dated 26 January 1940.
[2] Trans. G. Thornley, 1657.
[3] See J. M. Edmonds, *Daphnis and Chloe*, 1916, pp.xii-xix.
[4] H. Cook, *Gazette des Beaux-Arts*, 3e, XXVII, 1902, p.454, indicating a comparison with no.1051 in the National Gallery, London, which is now given to Bertucci, and no.114 in the Kaiser-Friedrich Museum, Berlin, which was listed by Berenson (1907 and 1932) as Costa, and catalogued in 1931 (*Gemälde im Kaiser-Friedrich Museum*, p.312) as Modenese c.1520.
[5] E. G. Gardner, *The Painters of the School of Ferrara*, 1911, p.213.
[6] A. Venturi, *Storia dell' Arte Italiana*, VII, iii, 1914, p.1085n.: '*non sembra appartenere in alcun modo nè a lui, nè alla scuola modenese*'.
[7] In a letter on file, dated 6 March 1969, Luisa Vertova recorded that Berenson had first associated P2 with Bertucci in 1927.
[8] L. Miraviki, *Bulletin du Musée Hongrois des Beaux-Arts*, 44, 1975, p.64. A. Pigler, *Katalog der Galerie Alte Meister*, Budapest 1967, p.63, no.60, dates it c.1515.

Bronzino (1503–1572)

Agnolo di Cosimo di Mariano, called Bronzino, born on 17 November 1503 in Florence where he studied under Raffaellino del Garbo before becoming a favoured pupil of Pontormo c.1518. Except for a period at Pesaro 1530–2, he spent his life in Florence enjoying extensive Medici patronage. He excelled in portraiture, but also undertook decorative commissions, such as the frescoes for Eleonora di Toledo's chapel in the Palazzo Vecchio 1541–6, and histories. He had some standing as a poet and his literary works include twelve sonnets written on the death of Eleonora di Toledo in 1562. He died in Florence on 23 November 1572.

Studio of Bronzino

P555 *Eleonora di Toledo*

A pearl net over her chestnut hair, brown eyes; she wears a rich Spanish gown[1] of white, black and gold brocade; two strands of pearls, the shorter with a diamond and pearl pendant, pearl ear-rings and a garnet ring on the third finger of her left hand; blue background, with green fore- and back-ground ledges. Inscribed in black, above: FALLAX.GRATIA.ET.VANA.EST.PVLCHRITVDO ('Favour is deceitful and beauty vain', Proverbs XXXI, 30).

Poplar panel 77.8 × 58.7 × 3.5 two vertical members, the left 7.9 wide

Cleaned by Buttery in 1879. There are two vertical cracks, one 7.6 cm. long in the top left hand corner, the other 36 cm. long running up from the middle of the bottom edge, restrained by a transverse metal strip nailed to the *verso*. The paint surface is tending to lift along the grain, and there are many areas of retouching, noticeably in the face and in the blue background, where the retouchings are now a copper green. The main member of the panel is badly

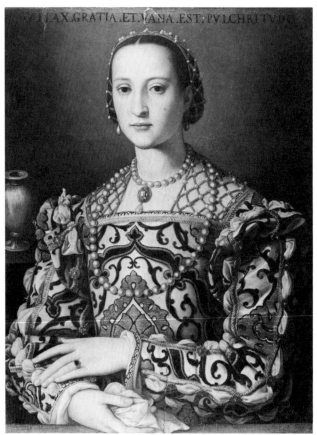

P555

knotted, top centre, as is reflected in the uneven paint surface above the head. The panel has a slight convex warp; a horizontal support, dovetailed into the panel, was removed before 1900. Horizontal edging strips were removed in 1977; vertical strips remain (not included in the measurements above).

Eleonora di Toledo (1522–62), only child of Don Pedro de Toledo, Marqués de Villafranca and Viceroy of Naples, m. in 1539 Cosimo de' Medici (1519–71), bringing him wealth and influence which helped make him Grand Duke of Tuscany 1569; she bore eight children, of whom Francesco (1541–87) and Ferdinando (1551–1609) became the second and third Grand Dukes. A portrait of c.1556–60 by Bronzino shows Eleonora emaciated by the illness which affected the last twelve years of her life (Berlin-Dahlem; a good studio version in the National Gallery, Washington, no.2068).[2]

P555 derives from Bronzino's *Eleonora di Toledo and her son, Francesco,*[3] painted c.1545 (Uffizi, no.748). The hands are repositioned to cover her rich gold belt in a pose related, in reverse, to that in the Washington studio portrait (see above). The garnet ring on her left hand does not appear in the Uffizi portrait. Although

Matteoli (1969)[4] considers P555 to be by Bronzino, the execution seems generally too hard for the master (the vase, which cannot be proved an addition, seems particularly weak), and McComb, Emiliani, Levey,[5] Baccheschi and Simon[6] regard it as derivative, at best from Bronzino's studio. Levey has suggested that P555 was posthumous, as the inscription (a phrase used in the mass for a holy woman) may indicate.[7] The vase, which Levey thought might perhaps symbolise death, may be an emblem of virtue (the *omnium virtutum vas*), as Langedijk has suggested,[8] or of beauty.[9] The fact that Eleonora was buried wearing the Spanish brocade dress seen in P555[10] may lend further support to the theory of a posthumous portrait.

Versions

See above, and note 2. No other version of P555 is recorded.

Provenance

Count Lochis of Bergamo;[11] his sale, Paris, 3 April 1868 (2, '*Eléonore de Tolède, fille naturelle de Charles-Quint et femme de Cosme de Médicis*', panel 78 × 60, inscribed FALLAX.GRATIA. ET.VANA.PULCHRITUDO), 12,900 fr.; presumably bought by, or on behalf of, the 4th Marquess of Hertford; probably rue Laffitte inventory 1871 (414, '*Véronèse, portrait de femme*'); Hertford House inventory 1890.

Exhibition

Bethnal Green 1872–5 (268).

References General

H. Schulze, *Die Werke Angelo Bronzinos*, 1911, p.xxi, as Bronzino c.1553–5; A McComb, *Agnolo Bronzino*, 1928, p.108; A. Emiliani, *Il Bronzino*, 1960, p.68; E. Baccheschi, *L'opera completa del Bronzino*, 1973, no.55c; K. Langedijk, *The Portraits of the Medici*, I, 1981, p.672, no.11, as Bronzino 'after' the Uffizi portrait.

[1] For which, see F. L. May, *Pantheon*, XXIII, 1965, p.12.
[2] For a full iconography of Eleonora, see K. Langedijk, *The Portraits of the Medici*, I, 1981, pp.692–708.
[3] This identity of the son seems now generally agreed, cf. Langedijk, *op. cit.*, pp.98–9.

[4] A Matteoli, *Commentari*, XX, 1969, 4, p.312 n.28; she believes the inscription to have been added, and sees P555 as the first portrait of Eleonora made by Bronzino, perhaps from the life, and pendant to the Cosimo de' Medici in the Uffizi, no.28. Langedijk, *op. cit.*, p.428, no.44, considers this portrait of Cosimo to be by Luigi Fiamingo, c.1553–60.
[5] M. Levey, *Painting at Court*, 1971, pp.107–8.
[6] R. Simon, letters on file dated 21 November 1982 and 24 November 1983; he agrees with Levey that it may be posthumous (see note 7) and tentatively suggests that P555 may have been the portrait of Eleonora '*cavata da un'altro che è in guardaroba*' sent from Florence to Spain c.1561–2 (see Gaye, *Carteggio*, 1840, III, p.94, no.92; Langedijk, *op. cit.*, p.693, no.7). I am most grateful to Dr. Simon for these and other comments, including the identification of P555 in the Lochis sale.
[7] Levey, *op. cit.*, p.219 n.30, remarks that 'it would be tempting to suggest' that P555, as a portrait of the dead Duchess, was that to be placed under *Temperantia* in the festival decorations at Florence for the marriage of Francesco de' Medici in 1565 (cf. K. Frey, *Der literarische Nachlass Giorgio Vasaris*, II, 1923, pp.195 ff. and *Carteggio Artistico inedito di D. Vinc. Borghini*, ed. A. Lorenzoni, 1912, p.28). Simon (see note 6) finds this idea attractive 'especially since an urn is often an attribute of *Temperantia*'.
[8] Langedijk, *op. cit.*, pp.67, 697.
[9] Cf. E. Cropper, *Art Bulletin*, LVIII, 1976, p.381.
[10] G. F. Young, *The Medici*, 1909, II, pp.287–8, and May, *loc. cit.* (see note 1).
[11] P555 was not amongst the pictures catalogued by Count Gugliemo Lochis (*La Pinacoteca e la Villa Lochis*, 1858) and bequeathed to the city of Bergamo in 1859. The 1868 sale, which contained eleven paintings, was perhaps that of his son.

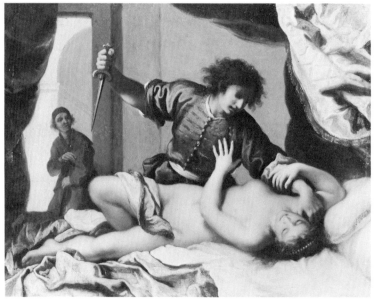

P643

Guido Cagnacci (1601–1663)

Born in San Arcangelo di Romagna on 20 January 1601. After studying with Guido Reni in Bologna c.1616–21, he went to Rome and Venice. He was working in Rimini in 1631 and Forlì 1642–4. His last years were spent as Court Painter to Leopold I in Vienna where he lived from c.1660 until his death in 1663.[1]

[1] For this date, and other biographical details, see M. Zuffa, *Arte Antica e Moderna*, VI, 1963, pp.357–81.

After Cagnacci

P643 *The Rape of Lucretia*

Tarquin wears a blue coat with gold decoration; his servant wears a green-grey coat and holds a sword; maroon and lilac drapes.

Copper 24.5 × 29.9

Cleaned by Lank in 1983, when minor losses, in the figure of Lucretia and in the drapery top right, were repaired and loose paint laid down.

The subject is taken from Livy I, 58: Sextus Tarquinius, son of Tarquinius Superbus, King of Rome, violates Lucretia, wife of Collatinus; "drawing his sword, he came to the sleeping Lucretia. Holding the woman down with his left hand on her breast, he said, 'Be still, Lucretia! I am Sextus Tarquinius. My sword is in my hand. Utter a sound and you die!' ... when he found her obdurate, he ... threatened her with disgrace, saying that when she was dead he

would kill his slave and lay him naked by her side, that she might be said to have been put to death in adultery with a man of base condition. At this dreadful prospect her resolute modesty was overcome ...".[1] Lucretia subsequently killed herself, but the incident sparked off the revolt which led to the establishment of the Roman Republic.

P643 is a copy of the larger canvas in the Accademia di S. Luca, Rome, traditionally, and probably correctly, attributed to Cagnacci, but recently attributed to Ficherelli (see below). Lanzi commented that it was a composition much copied by Roman and Bolognese artists.[2] The recent cleaning of P643 suggests it is a contemporary copy; there are minor variations (e.g. P643 shows no bracelet on Lucretia's wrist, her left foot is placed slightly further to the left, there is no button over Tarquin's sash, and the right-hand drapery is differently disposed). Hoogewerff attributed P643 to Cristoforo Allori, both arbitrarily and unconvincingly.[3]

Versions

ROME Accademia di S. Luca, 123 × 165,[4] the original composition, acquired in 1842 as Cagnacci and engraved as such by Giulio Tomba (1780–1841); an attribution to Bilivert made by Ricci in 1915[5] found some acceptance,[6] but subsequently Voss,[7] Heinz[8] and Young[9] favoured Cagnacci, while most recently McCorquodale and Cantelli have proposed Ficherelli.[10]

Other versions include:
BOLOGNA Pinacoteca Nazionale, copy by E. Taruffi (1633–1702).[11]
DRESDEN Gemäldegalerie, 128.5 × 191, acquired in 1722.[12]
FLORENCE Depositi delle Gallerie Fiorentine, attributed to Ficherelli.[13]
FORLI Palazzo Albiani, attributed to Cagnacci.[14]
GRENOBLE private collection, small copy, probably nineteenth century.
LONDON art market 1978, 110 × 141, attributed to Cagnacci and dated in the 1640s.[15]
Versions listed by Hoogewerff in Budapest, Kassel and Madrid all show Lucretia alone.[16]

Provenance

Mme. de Catellan, but not in her sale (Paris, 16 January 1816); the comte de Pourtalès-Gorgier (1776–1855) by 1841;[17] his sale, Paris, 27 March 1865 (24, as Cagnacci), bt. by the 4th Marquess of Hertford, 4,000 fr.; Bagatelle inventory 1871 (951, 'Le Guide, Tarquin et Lucrèce'); Hertford House inventory 1890 as Cagnacci.

Exhibition

Bethnal Green 1872–5 (257, as Cagnacci).

[1] Trans. R. O. Foster, 1952, p.201.
[2] L. Lanzi, *History of Painting in Italy*, 1795, trans. T. Roscoe, 1847, III, p.103.
[3] G. J. Hoogewerff, *Commentari*, XI, 1960, 2, pp.145–6; since C. Allori died in 1620–1 Hoogewerff argues for a date of 1620–1 for the original.
[4] Exh. *Il Seicento Europeo*, Rome, 1956–7, no.18, as Bilivert; illus., but not discussed, in *L'Accademia Nazionale di San Luca*, 1974, p.107, as Bilivert; see also note 6.
[5] C. Ricci, *Atti e memorie dell' Accademia di San Luca*, III, 1915, p.109 ff.
[6] From V. Golzio, *La Galleria e le collezioni della R. Accademia di San Luca in Roma*, 1939, p.11; and see note 4; exh. *Mostra del sei e settecento*, Palazzo Pitti, 1922, no.891, as Florentine School.
[7] H. Voss, *Kunstchronik*, X, 1957, 4, p.89: '... ist ein unzweifelhafter Cagnacci ...'.
[8] G. Heinz, *Jahrbuch der Kunsthistorischen Sammlungen in Wien*, LIV, 1958, p.193.
[9] E. Young, *Old Master Paintings*, Chaucer Fine Arts, December 1978, no.6.
[10] C. McCorquodale, *Painting in Florence 1600–1700*, RA 1979, p.66; G. Cantelli, *Repertorio della Pittura Fiorentina del seicento*, 1983, p.78.
[11] From the Zambeccari collection (L. Crespi, *Felsina Pittrice*, 1769, p.153, and cf. Hoogewerff, *loc. cit.*).
[12] K. Woermann, *Katalog*, 1908, p.148, no.375, as after Cagnacci.
[13] Cantelli, *loc. cit.* and pl.330, as a replica of the Accademia di S. Luca picture.
[14] Probably the picture recorded in the Isolani collection, Bologna, in 1741 as '*dal nostro Guido*' (cf. Hoogewerff, *loc. cit*).
[15] See note 9.
[16] Hoogewerff, *loc. cit.*
[17] Cf. J. J. Dubois, *Description des tableaux ... de M. le comte de Pourtalès-Gorgier*, 1841, p.32, no.95, as Cagnacci, recording the previous owner as Mme. de Catellan and listing the engraving by Tomba.

Canaletto (1697–1768)

Giovanni Antonio Canal, called Canaletto, born on 17 October 1697[1] in Venice, the son of a scene-painter, Bernardo Canal (c.1674–1744). He worked with his father in Venice, and in Rome in 1719–20. His earliest dateable views of Venice are from 1723, and by 1725 he was already being favourably compared with the leading *vedutiste*, Luca Carlevaris. In 1726 he participated in Owen McSwiney's imaginary tomb paintings and is recorded using the name Canaletto, probably to distinguish himself from his father.[2] By 1730 he was doing considerable business with Joseph Smith (appointed British Consul in Venice in 1744) who kept 50 of his paintings and 142 drawings, subsequently sold to George III and now at Windsor Castle. In the 1730s his work was in the greatest demand from English patrons, and many pieces from this period are of mechanical quality. Perhaps because the War of the Austrian Succession, 1741–8, restricted tourism and therefore his patronage, he turned to painting *capricci* and views of Rome (and probably of the Brenta and Padua). In May 1746 he was in London where he stayed until at least 1755, save for two visits to Venice in 1750–1 and 1753–4. He took a studio in Beak Street and his patrons included the Dukes of Northumberland, Richmond and Beaufort. Returned to Venice, he was elected to the Venetian Academy (founded in 1756) in 1763 when he was also elected Prior to the Collegio dei Pittori in Venice. His last dated work is of 1766. He died in Venice on 19 April 1768.

It seems unlikely that Canaletto's studio practice will ever be satisfactorily explained. There is cautious agreement that it was confined to a few assistants, of whom Bernardo Bellotto (1720–80), the son of Canaletto's sister Fiorenza, was the chief; he worked in his uncle's studio from c.1735 to c.1745. It is possible that Canaletto's father also assisted him, with A. Visentini (1688–1782), G. B. Moretti and G. B. Cimaroli. The majority of Canalettoesque paintings not by the master's hand must, however, be considered the works of imitators.

[1] For this date, see A. Bettagno in *Canaletto*, Fondazione Cini, 1982, p.19.
[2] The letter quoted by Constable, p.173, as dated 1722 and describing Canaletto's involvement with McSwiney's schemes, is in fact dated 1725/6; I am grateful to J. G. Links for this information.

Abbreviations

C/L	W. G. Constable, *Canaletto*, 2nd ed. revised by J. G. Links, 2 vols., 1976 (numbers refer to the oeuvre catalogue)
Parker	K. T. Parker, *Canaletto Drawings at Windsor Castle*, 1948
Puppi	L. Puppi, *The complete paintings of Canaletto*, 1970
Visentini	A. Visentini published 38 engravings after Canaletto; in 1735 the *Prospectus Magni Canalis* (12 views of the Canal and 2 carnival scenes), and in 1742 the *Urbis Venetiarum Prospectus Celebriores* (the 1735 set as section I, 12 more views of the Canal as section II, and 12 views of churches and the Piazza S. Marco as section III). *Views of Venice by Canaletto engraved by Antonio Visentini*, ed. J. G. Links, 1971, illustrates all the prints.

NOTE ON PREVIOUS ATTRIBUTIONS

In 1900 Claude Phillips wrote in the first edition of the picture catalogue that 'the majority of the works here set down to [Canaletto] for the sake of convenience cannot be reckoned as more than school pieces. The most authentic example of his art in the Wallace Collection is No.498'. In 1913 Rutter commented that, apart from P506 and P510 (which had been attributed in 1904 to Bellotto on Simonson's *fiat*), the Canalettos were 'the productions of Italian or English imitators, and mostly of inferior quality'.[1] In the same year, in the 13th edition of the catalogue, D. S. MacColl considered them 'either versions from [Canaletto's] hand or copies turned out in his studio. Our larger pictures belong to an intermediate kind, especially No.498, which is doubtless from his own hand; the figures are different in character from those in the small pictures. In the case of the small pictures it must remain doubtful whether Canaletto himself or an assistant was responsible'. In 1920, in the 14th edition, MacColl added that 'two or three different hands may be traced among the pictures'. Perhaps encouraged by this, W. G. Constable in the 15th edition (1928) divided up all the Canalettos between seven school hands, designated A to G, less P506 and P510 which he reattributed to Bellotto. A generation later Constable published the first edition of his *Canaletto* catalogue (1962), and Francis Watson wrote new entries for the 16th edition of the Wallace Collection catalogue (1968). Their opinions, while not exactly coinciding, were more favourable. The table on p.224 sets out the pictures in the order in which they are here catalogued and lists the previous attributions made by Constable in 1928, Watson in 1968 and Constable-Links in the 1976 edition of the oeuvre-catalogue *Canaletto*.

[1] F. Rutter, *The Wallace Collection*, 1913, p.43.

Canaletto

	1928	*1968*	*1976*
P497	School 'C'	Canaletto and studio	Canaletto
P499	School 'C'	Canaletto and studio	Canaletto
P506	Bellotto	Studio	Canaletto
P507	School 'F'	Canaletto and studio	Canaletto
P509	School 'B'	Canaletto and studio	Canaletto
P510	Bellotto	Studio	Canaletto
P511	School 'F'	Canaletto and studio	probably Canaletto
P516	School 'B'	Canaletto and studio	Canaletto

Studio of Canaletto

P496	School 'B'	Canaletto	attributed to Canaletto
P500	School 'E'	Studio	attributed to Canaletto
P505	School 'E'	Studio	Canaletto

After Canaletto

P492	School 'A'	Canaletto and studio	School
P495	School 'A'	Imitator	School
P501	English	English follower	School
P512	School 'A'	Imitator	School
P513	School of Guardi	Venetian school	School
P514	School 'G'	Studio	Studio
P515	School 'A'	Imitator	Studio

Manner of Canaletto

P498	School 'D'	Venetian school	School

P497 *Venice: the Bacino di S. Marco from S. Giorgio Maggiore*

A panoramic view from west to north taken from an elevated view-point above the Campo S. Giorgio, looking across the Canale della Giudecca and the Bacino. On the left, the north bank of the Giudecca with the campanile of S. Eufemia on the extreme left; the buildings on the Zattere, facing the Giudecca, include the church of S. Spirito. The tower of the Palazzo Venier dalle Torreselle (demolished in the nineteenth century) appears just to the left of the Salute, and the campanile of S. Maria della Carità by the figure of Fortune above the Dogana. To the right, the Palaces fronting the Grand Canal and, on the extreme right, the Prisons.[1] The *campanili* of S. Stefano and S. Moisè are prominent in the centre. A *burchiello* (a passenger barge which plied between Venice and Padua), towed by a *barca*, arrives from the left.

Canvas, relined 129.2 × 188.9

Cleaned by Vallance in 1948. The retouching of a large L-shaped tear, running from the right-hand edge through the Campanile and down through the Zecca to the right of the Campo S. Giorgio, has discoloured, as has a small circular repair in the sky to the left of the Campanile. Another tear runs vertically by the left-hand edge, just below centre. The surface is rubbed and the sky retouched in the upper right area.

Links suggests that the twin towers half way between the Salute and the left-hand edge are those of Angelo Raffaele, completed in 1735;[2] Watson suggested they belonged to S. Maria del Rosario, consecrated in 1736.[3] The campanile of the Carità, as seen in P497, collapsed in March 1744. It may therefore be assumed that P497, together with its pendant P499,[4] was painted between c.1735 and 1744; Pignatti suggests c.1740.[5] Watson thought that both P497 and P499 showed evidence of a little studio assistance.

P497 and P499, together with the fine related view at Boston (C/L131),[6] show Canaletto at his most ambitious, portraying the geographical, architectural and mercantile character of Venice. In P497 the figures are oriental and occidental, from Church, State and third estate, while the ships fly Dutch, British and Venetian flags. Such sense of place seems rivalled in his work only by the later views of London (as the pair at Windsor Castle, C/L428–9).

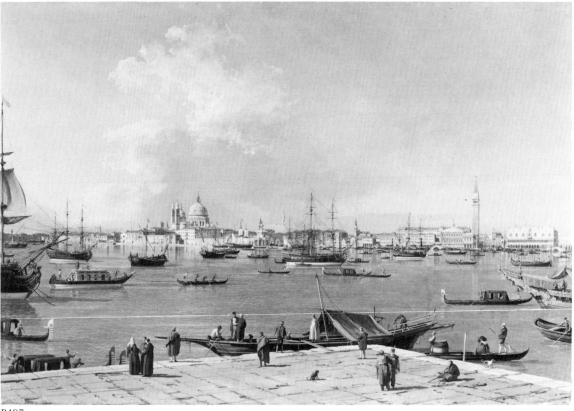

P497

Provenance

Acquired by the 1st Marquess of Hertford (1719–94); Hertford House inventory 1834; St. Dunstan's inventory 1842; Dorchester House inventory 1842; Hertford House inventory 1843, see Appendix II.

Exhibition

Bethnal Green 1872–5 (256).

References General

C/L137; Puppi, no.164.

[1] The windows are incorrectly detailed; the pediments, from the left, should be alternately segmental and triangular as shown in P499. The error is repeated in P509 and P514.

[2] Under C/L137.

[3] 1968 catalogue.

[4] P497 and P499 appear to be on the same type of canvas (but cf. the 1968 catalogue).

[5] T. Pignatti, *Canaletto, selected drawings*, 1970, p.7.

[6] P. Zampetti, *I Vedutisti Veneziani del settecento*, 1967, no.71, suggested that this picture *'costituisce un vero punto di arrivo dell'arte del Canaletto, per l'apertura più completa verso la natura. Il paesaggio non è più qualcosa che si veda dal di fuori, ma un mondo nel quale noi stessi siamo immersi'*.

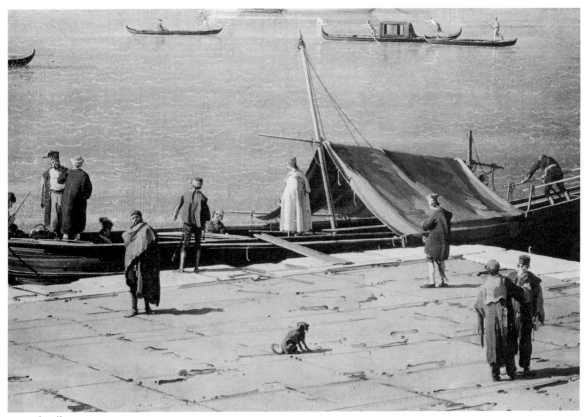

P497 detail

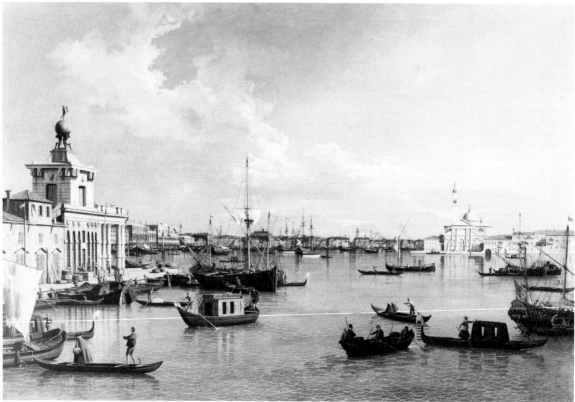

P499

P499 *Venice: the Bacino di S. Marco from the Canale della Giudecca*

A panoramic view from north-east to south-east taken from an elevated view-point above the Canale della Giudecca, with the Dogana in the left foreground. Beyond it stretch the Molo and the Riva degli Schiavoni, past the campanile of S. Pietro in Castello and the dome of S. Nicolò di Bari by the convent of S. Antonio (both demolished in 1807). On the right, the church of. S. Giorgio Maggiore, with the onion-shaped steeple built in 1726–8. There is a *burchiello* (see P497), centre left.

Canvas, relined 130.2 × 190.8

Cleaned by Vallance in 1948. Several minor retouchings in the sky have discoloured and a strip, approximately 1 cm. wide, along the bottom edge has been left uncleaned.

Perhaps as a consequence of assembling this view from separate drawings, the Dogana sits unhappily within the composition,[1] while the column of S. Todaro is unconvincingly hidden by the Library. S. Nicolò di Bari and the convent of S. Antonio were demolished to make room for the Giardini Pubblici.

The view furnishes an exact pendant for P497, showing the same subject from the opposite direction and lit from the opposite side. P499 relates quite closely to the finer composition at Boston (C/L131, see P497) which is taken from a more elevated view-point further to the right. Though the overall quality is high, Watson's suggestion of studio assistance seems justified by the pedantic execution of the Doge's Palace and the boat on the extreme right, and Constable noted that the possibility of studio help remained. For further discussion see P497.

Versions
BAKEHAM HOUSE 61 × 92.5 (C/L133).
ITALY private collection 61.5 × 96.5 (C/L135).
MILTON PARK 75.5 × 105.5 (C/L132).
PARHAM PARK 119.4 × 213.4, attributed to Bellotto.[2]

Provenance
Acquired by the 1st Marquess of Hertford (1719–94); Hertford House inventory 1834; St. Dunstan's inventory 1842; Dorchester House inventory 1842; Hertford House inventory 1843, see Appendix II.

Exhibition
Bethnal Green 1872–5 (264).

References General
C/L134; Puppi, no.163.

[1] As Watson pointed out, it seems to be viewed from a point further down the Giudecca and to the left; he suggested that this may have been due to the use of the *camera ottica* (*Canaletto*, 1949, p.19, and 1968 catalogue). Canaletto's use of such a device has been much debated and is generally considered to have been slight (see C/L, pp.161–2; Links, *Canaletto*, 1982, pp.104–6; O. Millar, *Canaletto*, The Queen's Gallery, 1980–1, p.20).
[2] S. Kozakiewicz, *Bernardo Bellotto*, 1972, z106.

P506 *Venice: the Grand Canal from the Palazzo Flangini to S. Marcuola*

Looking east; on the left, from the foreground, the Palazzo Flangini, the Scuola dei Morti with the voluted cupola of S. Geremia behind it,[1] the priest's house (*canonica*) of S. Geremia and the low garden wall of the Palazzo Labia; the mouth of the Cannaregio is almost concealed; a large warehouse(?) behind the site of the Palazzo Querini; the distant low buildings mark the site of the Campo S. Marcuola. On the right, the Riva di Biasio, with the Palazzo Zen crowned by twin obelisks and the Palazzo Bembo at the furthest point.

Canvas, relined 46.5 × 77.5

The varnish is discoloured and there are some minor paint losses, e.g. on the steps to the right and in the water, centre foreground.

This view (which was engraved by Visentini, 1742, II, 3) has since much changed. S. Geremia was rebuilt from 1753 (consecrated in 1760, but not completed until the nineteenth century), the Palazzo Querini was completed in 1828, and the Austrian bombardment of 1849 led to the remodelling of the Scuola dei Morti and the *palazzi* on the Riva di Biasio. Links has commented[2] that several view-points were used to assemble the composition.

Though of mechanical quality P506 and its pendant P510 appear to be by Canaletto. The prime version engraved by Visentini is almost certainly that now in the Wrightsman collection (ex-Harvey collection),[3] but P506 is the first listed by Constable. P506 and P510 were attributed to Bellotto by Simonson (1904), Constable(1928) and Fritzsche(1936), but the attribution was subsequently denied both by Constable and Kozakiewicz who, with Watson, considered that studio assistants were employed (though they differ to what extent).

Drawings

Pencil sketches of the buildings on the left-hand side, from the Palazzo Querini to the Campo S. Marcuola, are in the Accademia sketchbook, ff.47v, 48 and 49 (C/L, p.637, pl.168).

Versions

See above.
ENGLAND private collection, 61 × 91.5, replica quality (C/L257b).
LONDON Christie's, 11 July 1980 (121), 57.8 × 90.1, attributed to Bellotto.
MINNEAPOLIS Institute of Arts, 60 × 92.5, attributed to Canaletto (C/L257a).
PARIS Spiridon sale, 27 May 1911 (11), 38 × 62 (C/L257c).

Provenance

Sir Thomas Bernard;[4] his sale, Christie's, 31 March 1855 (69), bt. Edwards, 185 gn.; the 4th Marquess of Hertford;[5] Hertford House inventory 1870.

Exhibition

Bethnal Green 1872–5 (either 270, 279, 287, 311 or 323, all *On the Grand Canal* or *View on the Grand Canal*).

References General

C/L257; Puppi, no.83A; G. A. Simonson, *Francesco Guardi*, 1904, p.70; H. A. Fritzsche, *Bernardo Bellotto*, 1936, p.108, VG45;[6] S. Kozakiewicz, *Bernardo Bellotto*, 1972, Z231.

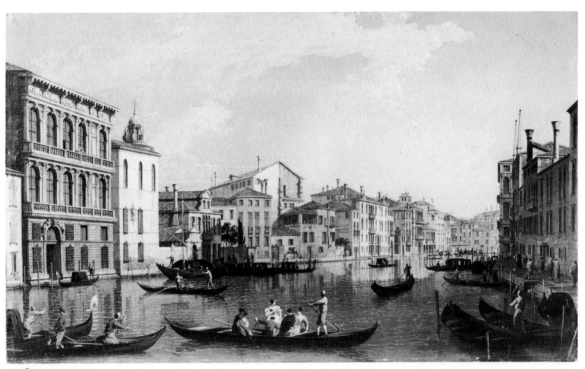

P506

¹ The cupola shown is something of a mystery; it sits on a hexagonal base, not a dome, but does not compare with other depictions of the campanile of S. Geremia (e.g. in the National Gallery, London, no.1058, C/L251C). Constable describes it as the cupola and dome of S. Geremia, but this was not completed in the early 1760s, cf. Guardi's views (Morassi, *Guardi*, 1973, nos.571–4). The Wrightsman painting, see below, shows a more slender cupola.
² *Apollo*, XC, 1969, p.226. Constable commented that there was an 'element of fantasy in the position of the Riva di Biasio, which is in fact farther along the Canal, northward'.
³ C/L257d; *Wrightsman Collection Catalogues*, V, 1974, pp.48–52 (entry by F. J. B. Watson); 47 × 77.7, the only other version corresponding to P506 in size.

⁴ The sale was of the 'remaining portion of the collection of the late Sir Thomas Bernard', probably the Sir Thomas Bernard (1750–1818) who was a founder member of the British Institution and who m. in 1815 Charlotte Hulse, who was some thirty years younger. Both P506 and P510 are inscribed, *verso: 490C Lady Bernard*.
⁵ Hertford had 'no fancy for' P506, much preferring the pendant P510, but he bought them both (*Letters*, no.51, p.63, and see P510, note 2).
⁶ VG45 is not securely identified in Fritzsche's list: '*Canal Grande. Flotte Staffierung, interessanter Wolkenschatten*', but it seems most likely that it is meant to be the pendant of P510, his VG46. Kozakiewicz, *op. cit.*, under Z177 omitted Fritzsche's VG38 which led him to identify VG46 as P512, incorrectly.

P507 *Venice: the Canale di S. Chiara*

Looking south-east; on the left the wall of the convent of Corpus Domini; across the canal the church of S. Croce with beyond it the campanile and church of S. Nicolò da Tolentino and the campanile of S. Maria dei Frari to the left. A *burchiello* (a passenger barge, see P497) in the mid-distance.

Canvas, relined[1] 58.7 × 93

There is a repaired damage in the sky, top centre; the surface is a little rubbed and the varnish is discoloured. A strip round the edges, approximately 5 mm. wide, remains uncleaned.

The view (which was engraved by Visentini, 1742, II, 1) has since greatly changed. The Convent was suppressed in 1810 and destroyed c.1861 when the railway station was built (cf. P498 Manner of Canaletto); S. Croce was also suppressed in 1810 and the site is now the Giardini Papadopoli. The large house, fourth from the right with a first-floor balcony, was occupied by the British Secretary Resident,[2] and still stands. Links has drawn attention[3] to a curious discrepancy between P507 and the version in the Musée Cognacq-Jay (C/L268). The latter shows a plain high wall running from S. Chiara to the first palace to the right of it, where P507 shows a house and chimney contained in a wall of various heights. This discrepancy is also reflected in the related drawings by Canaletto (see below) and Visentini.[4] There seems to be no satisfactory explanation; perhaps a new wall was built after P507 was painted, or perhaps Canaletto 'for once skimped and left out the detail', as Links suggests.

P507 and its pendant P511 are of mechanical quality, but attributable to Canaletto, though this has been contested. Fritzsche (1936) attributed them to Bellotto, but Kozakiewicz disagrees, preferring, with Watson, an attribution to Canaletto with studio assistance.

Drawings

WINDSOR CASTLE three related drawings: one related to Visentini's print (Parker, no.14; C/L600), one dated 1729 by Constable similar to the Cognacq-Jay painting (Parker, no.13; C/L602) and a slighter sketch, dated 1734, showing the plain wall (Parker, no.15; C/L601). Parts of the subject occur in the Accademia sketchbook, ff.30v, 31 and 32r (C/L, p.634).

Versions

LONDON private collection, 47.5 × 77, early 1730s, ex-Harvey collection, the view-point slightly further to the left and extended to the right (C/L267).
PARIS Musée Cognacq-Jay, 48.5 × 79, perhaps a replica of a lost original, corresponding to Visentini's print, see above (under C/L268).
WOBURN 47 × 80, early 1730s, similar to C/L267 (C/L266).

Provenance

Acquired by the 1st Marquess of Hertford (1719–94); Hertford House inventory 1834, see Appendix II.

Exhibition

Bethnal Green 1872–5 (either 270, 279, 287, 311 or 323, all *On the Grand Canal* or *View on the Grand Canal*).

References General

C/L268; Puppi, no.99B; H. A. Fritzsche, *Bernardo Bellotto*, 1936, p.108, VG44; S. Kozakiewicz, *Bernardo Bellotto*, 1972, z244.

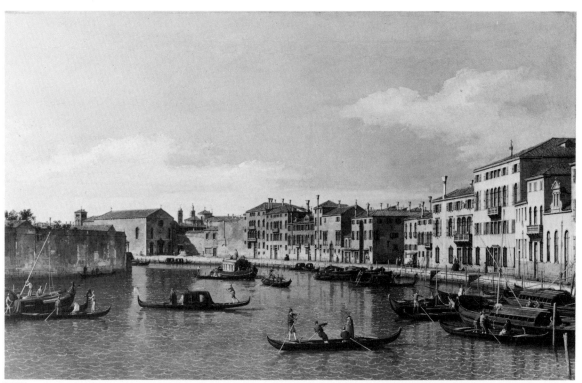

P507

¹ The stretcher is stamped: I. PEEL/LINER; he is recorded in London between 1835 and 1858.
² P507 shows the house with a blank shield between the two top windows; in a drawing at Windsor (Parker, no.14; C/L600) it appears over the door. Secretary Resident was a post superior to that of Consul.

³ 'Some notes on Visentini's drawings . . . in the Correr Library', *Bollettino dei Musei Civici Veneziani*, 1969, pp.13–18.
⁴ Drawing showing the plain wall in the British Museum album (C/L, p.672), another showing the wall as in P507 in the Museo Correr (C/L, pp.670–2). Visentini's engraving also shows the wall as in P507.

P509 *Venice: the Riva degli Schiavoni*

Looking east, from a slightly elevated view-point, the columns of S. Todaro and S. Marco on the left; the furthest five bays of the Doge's Palace arcade are boarded up and there are wooden huts either side of the Ponte della Paglia;[1] the windows of the Prisons on the south side are incorrectly detailed;[2] beyond, the dome of S. Zaccaria and the *campanili* of S. Giorgio dei Greci and S. Francesco della Vigna.[3]

Canvas, relined 58.2 × 93.5

Cleaned by Vallance in 1961. An addition along the bottom edge, approximately 1 cm. wide, has been made up on the lining canvas.

P509 and its pendant P516 show popular Canaletto views.[4] Constable records five other sets, and both views were engraved by Visentini (1742, II, 11 and 12) in a slightly modified form. P509 differs from the engraving by the inclusion of the column of S. Todaro and the adoption of a view-point slightly further to the right. Other similar views by Canaletto show detailed topographical differences, particularly in the red-brick Institute of the Pietà which appears between the *campanili* in P509, and the Molo,[5] shown in P509 without bollards and with the steps repaired.[6]

A mechanical production, but attributable to Canaletto, probably in the 1740s and before 1745 when the facade of the Pietà, shown in P509 beside the Institute, was reconstructed.

Versions

RINGWOOD Hants., 57 × 92.5, by Canaletto (c/L, under 112).
The following versions, listed by Constable as by Canaletto show only the column of S. Marco; except where noted each has a pendant comparable with P516 but generally showing the edge of the Molo running vertically up into the composition, as in Visentini's print (1742, II, 12).
BARNARD CASTLE Bowes Museum, 47.5 × 77.5, ex-Cook collection (c/L113a, pendant c/L95c1).
BELGIUM private collection, 58 × 85 (c/L111*, a different pendant).
CHATSWORTH 46.5 × 62, c.1727 (c/L115, a different pendant).
ITALY private collection, 46.5 × 62 (c/L115*, pendant c/L95aa).
MILTON PARK 73.5 × 104.5, mid-1730s (c/L114, pendant c/L98).

ROME Albertini collection, 110.5 × 185.5, probably, with its pendant, the original of Visentini's prints, ex-Duke of Leeds collection (c/L113, pendant c/L95).
TATTON PARK 58.5 × 102, c.1731–2 (c/L111, pendant c/L97).
A good studio version is no.940 in the National Gallery, London.

Provenance

Possibly William Wells sale, Christie's, 1st day, 12 May 1848 (34, 'View of the Doge's Palace and Quay of St. Mark, looking towards the prisons, with gondolas and numerous figures', 93 × 56), bt. in (N.W.), 170 gn.;[7] the 4th Marquess of Hertford; Hertford House inventory 1870.

Exhibition

Bethnal Green 1872–5 (284).

References General

c/L112; Puppi, no.247A.

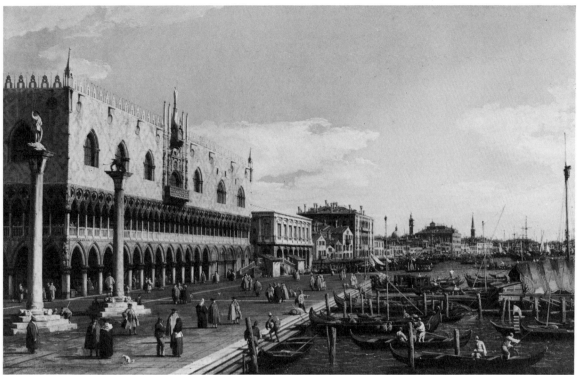

P509

[1] The arcade was boarded up in 1574 following a fire and not cleared until 1889 (see Links, *Canaletto and his Patrons*, 1977, p.xv).

[2] See P497 note 1.

[3] See Links, *The Burlington Magazine*, CIX, 1967, P.409. Constable thought the dome was that of S. Giorgio dei Greci, and suggested the further campanile might be that of S. Martino.

[4] See Links 1977, *op cit.*, p.28.

[5] Comparison between Visentini's plate, P509, the Tatton picture and the two comparable views at Windsor (C/LIII, 170 and 174) reveals several variations.

[6] Earlier views, such as those at Tatton and Chatsworth, show the steps dilapidated and small bollards in the centre of the Molo.

[7] Constable tentatively identified the Wells picture as no.940 in the National Gallery, London, but this is not taken up by Levey (*National Gallery Catalogues, Seventeenth and Eighteenth Century Italian Schools*, 1971, p.41).

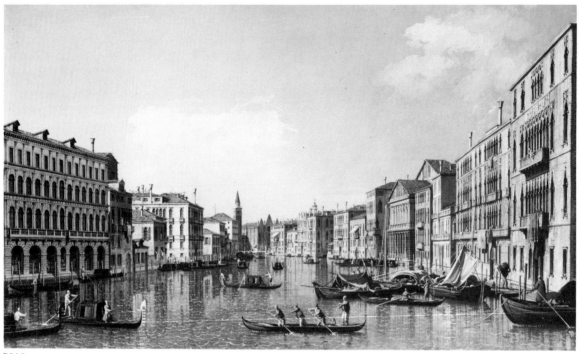

P510

P510 *Venice: the Grand Canal from the Palazzo Foscari to the Carità*

Looking south; in the left foreground the Palazzo Moro-Lin; in the distance the church and campanile of S. Maria della Carità with, just to the left of the campanile, the twin obelisks of the Palazzo Giustiniani-Lolin; on the right the Palazzo Foscari in the foreground, the Palazzo Rezzonico with a temporary wooden roof (the upper storey was completed in 1752–6) in the mid-distance, and the Palazzo Contarini dagli Scrigni with a gable window and tower beyond.

Canvas, relined 46.2 × 77.3

Cleaned and relined by Vallance in 1961.

The campanile of the Carità collapsed in 1744; the church is now the Accademia. The Contarini dagli Scrigni is shown without its gable in P492 which shows a similar view but differs considerably in detail. P510 shows more of the Moro-Lin and the view point is slightly higher, further up river and to the right; it is lit from the left, where P492 is lit from the right. It is also noticeable that in P510 the proportions of the buildings tend to be more perpendicular, as seen particularly in the windows of the Moro-Lin and the silhouette of the Carità.

Though of mechanical quality P510, like its pendant P506, may be attributed to Canaletto. For further discussion of the attribution see P506.

Versions
See P492 After Canaletto.

Provenance
Sir T. Bernard;[1] his sale, Christie's, 31 March 1855 (70), bt. King, 195 gn.;[2] the 4th Marquess of Hertford; Hertford House inventory 1870.

Exhibition
Bethnal Green 1872–5 (either 270, 279, 287, 311 or 323, all *On the Grand Canal* or *View on the Grand Canal*).

References General
C/L205; Puppi, no.71B; G. A. Simonson, *Francesco Guardi*, 1904, p.70; H. A. Fritzsche, *Bernardo Bellotto*, 1936, p.108, VG46;[3] S. Kozakiewicz, *Bernardo Bellotto*, 1972, Z167.

[1] See P506 note 4.
[2] Hertford preferred P510 to its pendant P506, and was prepared to pay '250 to 300 at most' for it (*Letters*, no.51, p.63, and see P506, note 5).
[3] Fritzsche undoubtedly intended P510, though Kozakiewicz identified VG46 with P512 (Fritzsche's description '*ähnlich VG38*', which he identifies as P492, leaves no doubt).

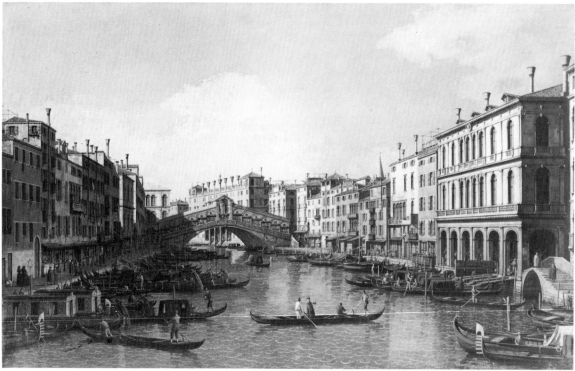

P511

P511 *Venice: the Grand Canal from the Palazzo Dolfin-Manin to the Rialto Bridge*

Looking north; on the right the bridge over the Rio S. Salvatore and the Palazzo Dolfin-Manin; the Fondaco dei Tedeschi (with the corner towers, taken down in 1836) beyond the Rialto; the spire of S. Bartolomeo just visible, centre right; on the left the Fondamenta del Vin with the Palazzo dei Camerlenghi beyond the Rialto.

Canvas, relined 58.5 × 93

The surface has been heavily ironed and is discoloured by old varnish. There are some minor retouchings in the lower left area, and a small repaired tear in the centre, above the gondola.

The view was engraved, with minor variations, by Visentini (1742, II, 8);[1] it may be compared with that in the Guardi P508.

P511 is of mechanical quality but is attributable to Canaletto, though this has been contested; see P507, the pendant view.

Versions

Five other versions are attributed to Canaletto.
LONDON A. Bisgood, 46 × 76 (C/L228a3). Artemis 1984, 85.7 × 134.5.
PARIS with Trotti 1930, 47.5 × 77.5, dated 1744 (C/L228). Musée Cognacq-Jay, 45 × 76, closely related to Visentini's print (C/L228a1).
ROME Galleria Nazionale, 68.5 × 92 (C/L228a4).
Constable lists a further six studio and school pieces.
CLUMBER PARK (formerly), 60 × 91.5 (C/L228b1).
GLASGOW Stirling-Maxwell (formerly), 67 × 104 (C/L228b4).
LONDON Tooth (formerly), 61 × 96.5 (C/L228b3).
MUNCIE Indiana, Ball State Teachers College, 46 × 58.5 (C/L228b5).
NEW YORK Salomon sale, 7 January 1928, lot 771 (C/L228b6).
VENICE Italico Brass (formerly), 62.3 × 95.3 (C/L228b3).

Provenance

Acquired by the 1st Marquess of Hertford (1719–94); Hertford House inventory 1834, see Appendix II.

Exhibition

Bethnal Green 1872–5 (319).

References General

C/L228a2, as probably by Canaletto; Puppi, no.94B; H. A. Fritzsche, *Bernardo Bellotto*, 1936, p.108, VG43; S. Kozakiewicz, *Bernardo Bellotto*, 1972, Z177.

[1] It differs from P511 in detail in the disposition of the boats and chimneys, the gables of the Dolfin-Manin, and the pulley on the house in the left foreground.

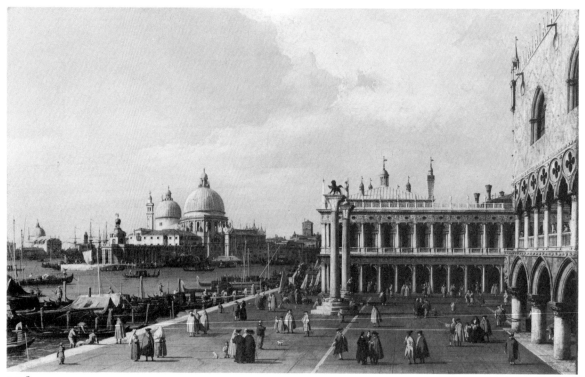

P516

P516 *Venice: the Molo with S. Maria della Salute*

Looking west from a slightly elevated view-point;[1] to the right the west end of the Doge's Palace, the columns of S. Marco and S. Todaro, the Library and, just to its left, the tower of the Palazzo Venier dalle Torreselle; the Molo has no bollards and the steps have been repaired (see P509, note 6); centre left, the church of S. Maria della Salute; far left, the church of the Redentore and, further right, the tower of S. Giacomo (demolished in the early nineteenth century), both on the Giudecca.

Canvas, relined 57.7 × 93.5

The varnish is discoloured and there is a prominent craquelure. There are retouchings in the sky in an area approximately 1 cm. diameter, top centre, and there are fillings along the bottom edge within a strip 1 cm. wide.

A mechanical production – the detailing of the Library as seen through the arcading of the Doge's Palace is not meticulous – but attributable to Canaletto, perhaps c. 1740–5. For further discussion, see P509, the pendant view.

Provenance

Possibly William Wells sale, Christie's, 1st day, 12 May 1848 (35, 'The Library of St Mark; and the church of Sta Maria della Salute, with figures on the quay – the companion' (to lot 34, see P509), bt. in (N. W.), 165 gn.; the 4th Marquess of Hertford; Hertford House inventory 1870.

Exhibition

Bethnal Green 1872–5 (288).

References General

c/L90; Puppi, no.245B.

[1] A similar view-point was used by Carlevaris, *Reception of the Conte di Colloredo*, dated 1726 (Dresden), and the *Entry of the Earl of Manchester into the Doge's Palace*, c. 1707 (Birmingham Art Gallery).

Studio of Canaletto

P496 *Venice: a Regatta on the Grand Canal*

Looking north-east from the Palazzo Balbi which displays red above green awnings; on the extreme left is the temporary *macchina della regatta* with blue pillars, displaying the arms of Alvise Pisani (Doge 1735–41; see P500, note 1); many of the figures are in carnival dress.

Canvas, relined[1] 58.7 × 93.3

Some discoloured retouchings in the sky to the left, some lifting paint above the roof-line, centre left, and repaired losses along the upper edge and on the furthest right gable. The surface is a little rubbed.

P496 shows one of the rowing races (for one-oared light gondolas) during the annual carnival. The course ran from the Motta di S. Antonio (today the Giardini Pubblici) to the Ponte della Croce and back to the Volta di Canal, between the Palazzo Balbi and the Rio Foscari (as seen in P496), where the winners were presented with coloured flags beneath the *macchina*.[2]

P496 is a good studio version of a subject engraved by Visentini (1735 I, 13) and repeated many times by Canaletto. The composition echoes Carlevaris's earlier *Regatta in honour of Frederick IV of Denmark* 1709 (Fredericksborg), and the prime version is that of c.1734 at Windsor Castle (C/L347).[3] In detail the composition of P496 does not recur in other versions. The Pisani arms on the *macchina* do not necessarily indicate the date, as Constable has pointed out.[4] Since the late eighteenth century P496 has had P500 as its pendant.

Versions

See above. Constable lists six autograph versions, two school pieces and six studio productions (C/L347–52).

Provenance

Acquired by the 1st Marquess of Hertford (1719–94); Hertford House inventory 1834, see Appendix II.

Exhibition

Bethnal Green 1872–5 (280).

Reference General

C/L352, as attributed to Canaletto.

[1] The stretcher is stamped: I.PEEL/LINER; he is recorded in London between 1835 and 1858.
[2] For a fuller account, see M. Levey, *National Gallery Catalogues: the Seventeenth and Eighteenth Century Italian Schools*, 1971, p.36.
[3] Levey, *Later Italian Pictures in the Royal Collection*, 1964, no.396; O. Millar, *Canaletto*, The Queen's Gallery, 1980–1, no.19.
[4] See P500, note 2.

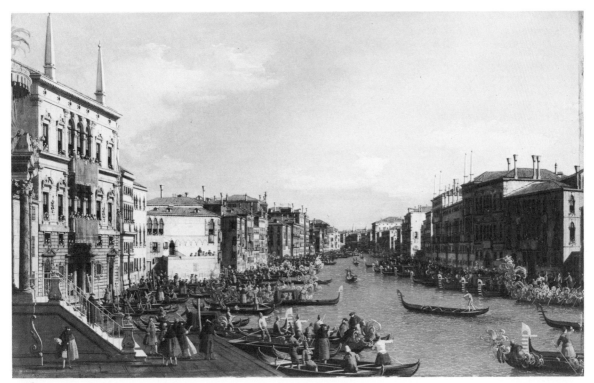

P496

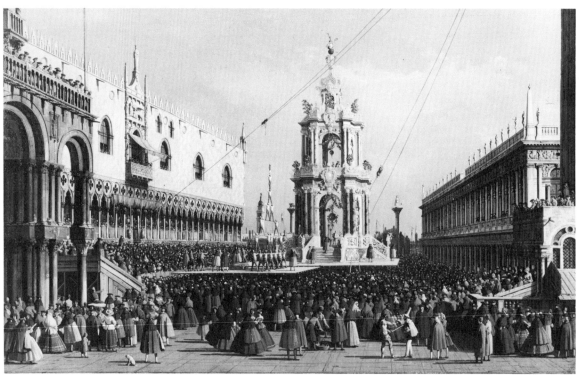

P500

P500 *Venice: the Giovedi Grasso Festival in the Piazzetta*

Looking south; on the left the south-west corner of the portico of S. Marco and the Doge's Palace which displays a red and silver striped awning over the centre bays of the first-floor *loggia*; on the right the Library and the edge of the Campanile (which has hoarding as in P505). In the centre the elaborate temporary *macchina* with blue and white pillars, displaying the arms of Alvise Pisani (Doge 1735–41)[1] above those of Pietro Grimani (Doge 1741–52).[2] On a raised platform in front of it a team of twenty-one acrobats form a human pyramid. Beyond the *macchina* from the left, the campanile of S. Giorgio Maggiore, the columns of S. Marco and S. Todaro, and the campanile of S. Giovanni Battista (now pulled down). The foreground figures are in carnival dress, some wearing the *bauta* (the domino of white mask and black cape).

Canvas, relined 58.5 × 92.7

The surface has been heavily ironed and there are old damages in the sky, centre right, and in the centre of the Library.

As part of the Maundy Thursday festival, the Doge (seated in the *loggia* beneath the awning) received a messenger who 'flew' down from the top of the Campanile to recite verses and present flowers (the *volo del Turco* or *della Columbina*). The messenger was pulled up by the right-hand rope and slid down the left.[3] Rival factions of acrobats (the Castellani and Nicolotti) would compete in forming the pyramid (the *Forza d'Ercole*).[4]

P500, together with P513 (After Canaletto, see below), relates to a set of twelve Ducal Ceremonies and Festivals (the *Solennità Dogali*) engraved by G. B. Brustoloni after Canaletto and published c.1763–6. Ten of Canaletto's drawings for this series survive (C/L630–9), but no exactly corresponding paintings by him (as opposed to his studio or followers) are recorded. A set of twelve paintings by F. Guardi was based on the engravings.[5]

P500 differs considerably from the corresponding Canaletto drawing[6] and Brustoloni print.[7] It takes a wider view from a higher vantage point; the *macchina* and figures differ considerably in detail, and the lighting is stronger. Although Constable attributed P500 to Canaletto, it is possibly rather a studio production, like its pendant P496, perhaps dating from the 1750s (i.e. during or after the Grimani dogate). Waagen (IV, p.80) found it 'somewhat crude'.

Versions
Constable lists five versions (C/L 330 VII 2–6), variously attributed to Borsato, Carlevaris and the school of Canaletto.

Provenance
Acquired by the 1st Marquess of Hertford (1719–94); Hertford House inventory 1834, see Appendix II.

Exhibition
Bethnal Green 1872–5 (283).

Reference General
C/L330 VIII, as attributed to Canaletto, and p.531.

[1] *Per fesse azure and argent, a lion rampant counterchanged*; the arms have no crest. The blue pillars on the *macchina* do not necessarily imply a Pisani allegiance, cf. the regatta paintings in the National Gallery, London, nos.938 and 4454 (c/L348a and 350) in which the *macchine* bear the Pisani arms but have, respectively, blue and pink columns.

[2] *Arg., 3 pallets gu.*, with the ducal crest. The awning on the Palace deliberately echoes these colours. The juxtaposition of the Pisani and Grimani arms makes no obvious sense. In a note on file Watson points out that there was no intermarriage of these families in the eighteenth century, but that both furnished ambassadors to London at this time so that an English patron might have been familiar with both coats of arms. Constable, pp.119, 354, emphasised how unreliable the evidence of coats of arms can be for dating, and examples of Canaletto's paintings with blank shields (cf. Levey, *The Burlington Magazine*, xcv, 1953, p.366) emphasise his point.

[3] This mechanism is seen more clearly in a painting by Guardi (Morassi, *Guardi*, 1973, no.280).

[4] The factions were drawn from the parishes of S. Pietro di Castello and S. Nicolò dei Mendicoli. The *Forze d'Ercole* came to replace the earlier battles between the factions which took place on the Ponte dei Pugni over the Rio S. Barnaba (as painted, for example, by Heintzius in 1673, see c/L, pl.2c). For an account of the *Forze d'Ercole*, see Watson, *Canaletto*, 1949, p.20, and c/L, p.530.

[5] The *Solennità Dogali* are discussed by Links, c/I, pp.525–7; see also Morassi, *Guardi*, 1973, nos.243–54.

[6] c/L 636 (private collection, USA); it shows the arms of Alvise IV Mocenigo (Doge 1763–79). Constable, p.354, incorrectly states that these arms (*coupé d'azur sur arg., à deux roses à quatre feuilles de 'un à l'autre, bout d'or*, see Rietstap, *Armorial Général*) appear on P500 with those of Grimani, but see note 1. A Canaletto drawing at Windsor (Parker, no.8; c/L 546) shows an almost identical view but without the festivities.

[7] No.7 in the set of *Solennità Dogali*, showing the Mocenigo arms, see note 6.

P505 *Venice: the Piazza S. Marco*

Looking west from just south of the central line, towards the church of S. Geminiano (demolished in 1807); the Loggetta, fancifully reduced to a single arch, casts a curious jagged shadow; the hoarding recurs in P500.

Canvas, relined 58.2 × 126

Some retouching in the sky and a general discolouration from old varnish.

The unusual overdoor proportions of P505 may indicate that it has been cut down, but this cannot be verified; the closely related composition at Woburn (47 × 80, c/L 27) might suggest that c.10 cm. have been cut from the top edge. By no means of prime quality, although Constable considered the execution 'too skilful for a pupil'.

Versions

See above. Constable lists three other versions of the Woburn picture (under c/L27–8), one by Canaletto, one school piece and another 'perhaps by the same hand or hands as P505' in the collection of Michael Hornby, 61.5 × 128 (c/L27a).

Provenance

Marked in the 1870 inventory as '*Beckford's*', but not identifiable in any of the Beckford sales; the 4th Marquess of Hertford; Hertford House inventory 1870, see Appendix II.

Exhibition

Bethnal Green 1872–5 (286).

References General

c/L30, as Canaletto; Puppi, no.136B.

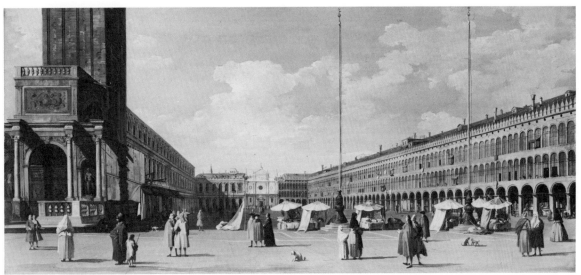

P505

After Canaletto

P492 *Venice: the Grand Canal from the Palazzo Foscari to the Carità*

As in P510, but showing less of the Palazzo Moro-Lin on the left, no gable on the Palazzo Contarini dagli Scrigni,[1] and the boats differently disposed (see P510 for further discussion).

Canvas, relined 47 × 78.5

Slightly discoloured by old varnish, and the surface is a little rubbed.

P492, P495 and P512 (and see P515) are copied from Canalettos at Windsor Castle, part of the series of twelve views of the Grand Canal painted c.1728–c.1734 for Joseph Smith and engraved by Visentini in 1735. The Wallace Collection copies appear to be by the same hand[2] and to derive from Canaletto's paintings, rather than Visentini's plates, since the colours are closely imitated. They may possibly date from before c.1762 when Smith's Canalettos were purchased by George III; they have been attributed to Bellotto by Camesasca, but the attribution is not accepted by Kozakiewicz.

P492 alone was attributed to Bellotto by Fritzsche. It differs from the Windsor picture in the omission of two figures from the boat in the right foreground.

Versions

WINDSOR CASTLE 47.9 × 80.3, probably late 1720s, the original view (C/L203).[3]
Constable lists five school versions (C/L203a–e), one of which, in the collection of D. Tziracopoulo 1939, 48.5 × 75, he considered possibly to be by the same hand as P492 (C/L203b).
A closely related composition by Canaletto is in the National Museum, Stockholm (C/L204), attributed to Bellotto by Levey (*The Burlington Magazine*, CXV, 1973, p.616).

Provenance

Acquired by the 4th Marquess of Hertford before 1859; Hertford House inventory 1870, see Appendix II.

Exhibition

Bethnal Green 1872–5 (either 270, 279, 287, 311 or 323, all *On the Grand Canal* or *View on the Grand Canal*).

References General

C/L203a, as studio of Canaletto, and p.260; H.A. Fritzsche, *Bernardo Bellotto*, 1936, p.108, VG38; S. Kozakiewicz, *Bernardo Bellotto*, 1972, II, pp.419–20 and z166; E. Camesasca, *L'opera completa di Bellotto*, 1974, no.273A.

[1] This seems incorrect, cf. P510; an etching by Carlevaris of the *Palazzo Moro-Lin a Samuele*, dated 1703, shows the gable (illus. F. Mauroner, *Carlevaris*, 1945, p.86) as do Canaletto's drawings at Windsor (Parker, no.19; C/L586), in the collection of T. Miotti (C/L587), and in the Accademia sketchbook, ff.16v and 17r (C/L, p.632, with 16v called the Palazzo Mocenigo Gambara).
[2] Kozakiewicz thought that two or more hands were perhaps involved; Watson considered that Canaletto himself may have worked on P492.
[3] M. Levey, *Later Italian Pictures in the Royal Collection*, 1964, no.385; O. Millar, *Canaletto*, The Queen's Gallery, 1980–1, no.8. It differs from Visentini I, 2, in showing gables on the Palazzo Moro-Lin and chimneys on the Palazzo Michiel Malpaga beyond the Rezzonico.

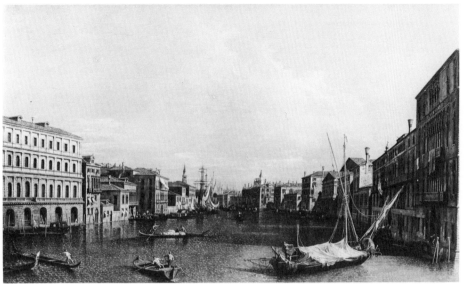

P492

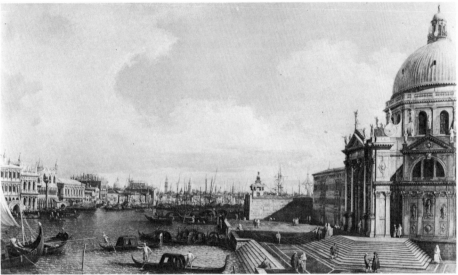

P495

P495 *Venice: the Grand Canal with S. Maria della Salute towards the Riva degli Schiavoni*

Looking east; in the right foreground the church of S. Maria della Salute; on the left the Molo and the Riva degli Schiavoni with the Zecca, the Doge's Palace and the Prisons.

Canvas, relined 47 × 78.3

The surface is a little rubbed and the varnish is generally discoloured.

See P492. The view may be compared with that in the Guardi P503.

Versions

WINDSOR CASTLE 47.6 × 80, probably early 1730s, the original view (C/L170).[1] Constable lists seven other versions attributed to Canaletto (C/L170a1–3, 170b1–4) and another school piece (C/L170c2).

Provenance

Acquired by the 4th Marquess of Hertford before 1859; Hertford House inventory 1870, see Appendix II.

Exhibition

Bethnal Green 1872–5 (either 270, 279, 287, 311 or 323, all *On the Grand Canal* or *View on the Grand Canal*).

References General

C/L170C1, as studio of Canaletto, and p.260; S. Kozakiewicz, *Bernardo Bellotto*, 1972, Z139; E. Camesasca, *L'opera completa di Bellotto*, 1974, no.276c.

[1] M. Levey. *Later Italian Pictures in the Royal Collection*, 1964, no.388; O. Millar, *Canaletto*, The Queen's Gallery, 1980–1, no.11. The composition agrees closely with Visentini I, 5. J. Byam Shaw, *Drawings of Francesco Guardi*, 1951, no.21, reproduces a Guardi drawing of an identical composition.

P501 *London: Northumberland House*

Looking east towards Northumberland House (as reconstructed in 1752) which is surmounted by a lion cast in lead (now at Syon House); the Strand in the mid-distance; to the right Le Sueur's equestrian Charles I; to the left the Golden Cross and other inns.

Canvas, relined[1] 71.5 × 111.7

The surface is a little rubbed; there is a run of varnish lower right.

Northumberland House was demolished in 1874 to make room for Northumberland Avenue.

P501 is a pedestrian version, possibly by an English eighteenth-century hand, of the Canaletto at Alnwick Castle (C/L419) which was engraved in 1753 by T. Bowles with minor variations in the figure groups. P501 differs from both, principally in the figure groups and exaggerated light effects.

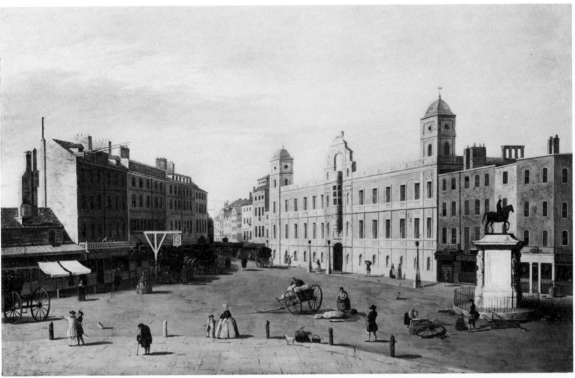

P501

Versions

See above. Constable lists thirteen other versions, none attributable to Canaletto (c/L419a and 419c–o).[2] He considered three possibly to be by the same English hand as P501:

LONDON art market 1929, 71 × 112 (c/L419c). Sotheby's, 30 October 1929 (87), 71 × 112 (c/L419d). Tooth 1947, 63.5 × 112 (c/L419e).

Provenance

Durlacher, 17 April 1873, bt. Sir Richard Wallace, £120;[3] Hertford House inventory 1890.

Reference General

c/L419b, as after Canaletto.

[1] The stretcher is stamped: F.LEEDHAM/LINER; he is recorded in London 1844–56 and 1866–71.
[2] To which may be added, for example, versions sold Sotheby's, 26 March 1975 (106), attributed to William James; Sotheby's, 14 July 1976 (58), attributed to Joseph Paul, and Christie's, 30 July 1982 (57), attributed to Joseph Paul.
[3] Invoice in Wallace Collection archives.

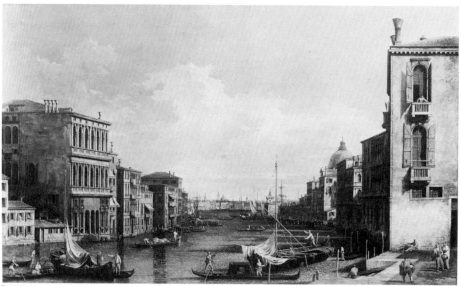

P512

P512 *Venice: the Grand Canal from Campo S. Vio towards the Bacino*

Looking east; on the extreme right the Palazzo Barbarigo; on the left the Palazzo Corner della Ca' Grande.

Canvas, relined 47 × 78.5

The varnish is discoloured and the surface is somewhat rubbed.

See P492. Pendant to P515.

Versions

WINDSOR CASTLE 47 × 79.1, probably c.1729, the original version (C/L184).[1] Constable lists two other school pieces (C/L184b, c) and ten closely related compositions by Canaletto (C/L182–3, 185–92).

Provenance

Casimir Périer (1811–76); his sale, Christie's 5 May 1848 (24, 'A view on the Grand Canal . . . with boats and figures . . .'), bt. by the 4th Marquess of Hertford, 110 gn.;[2] Hertford House inventory 1870.

Exhibition

Bethnal Green 1872–5 (either 270, 279, 287, 311 or 323, all *On the Grand Canal* or *View on the Grand Canal*).

References General

C/L184a, as school of Canaletto, and p.260; S. Kozakiewicz, *Bernardo Bellotto*, 1972, Z150; E. Camesasca, *L'opera completa di Bellotto*, 1974, no. 266A.

[1] M. Levey, *Later Italian Pictures in the Royal Collection*, 1964, no.387; O. Millar, *Canaletto*, The Queen's Gallery, 1980–81, no.10. The composition agrees closely with Visentini I, 4.

[2] The lot number remains faintly legible in chalk, *verso*.

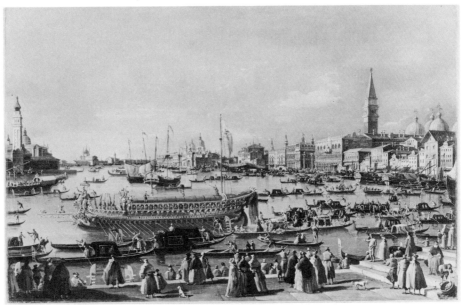

P513

P513 *Venice: the Bacino di S. Marco on Ascension Day*

Looking west from the Riva degli Schiavoni; to the right S. Giorgio Maggiore with S. Maria della Salute beyond; in the centre the Doge's state barge, the Bucintoro;[1] on the extreme right the half-completed façade of the Pietà (S. Maria della Visitazione).[2]

Canvas, relined 52.8 × 81.3

There are some discoloured retouchings in the sky, upper left, and the varnish is generally discoloured.

The Doge sets out in the Bucintoro for the Lido where he will perform the *Sposalizio del Mare*, the marriage of Venice with the Adriatic Sea, by casting a ring into the water with the words *Desponsamus te mare, in signi veri perpetuique dominii*.[3] The ceremony marked the anniversary of the Venetian victory over the Dalmatians on Ascension Day 1000.

P513 is based on the engraving after Canaletto by G. B. Brustoloni (no.5 of the *Solennità Dogali*, see P500). While the topography is quite accurately copied in P513, the boats and figures are differently disposed. The execution is both mannered and weak.

253

Versions

See above. The related drawing by Canaletto (see p500) is c/L634. Constable records three Canaletto school pieces (c/L330v4b–d), and versions attributed to Canaletto (c/L330v1) and Borsato (c/L330v3), and by Guardi (c/L330v2; Morassi, *Guardi*, 1973, no.247).

Provenance

Probably the Guardi bt. from Nieuwenhuys by Wallace in February 1872; Hertford House inventory 1890 as Guardi.

Exhibition

Bethnal Green 1872–5 (273, as Guardi).

Reference General

c/L330v4a, as school of Canaletto, and pp.529–30.

[1] p513 shows the last Bucintoro, designed by Stefano Conti and decorated by Antonio Corradini in 1727. The coat of arms shown at the front of the cabin is illegible.
[2] The façade was being reconstructed in 1745, cf. p509.
[3] For a fuller account, see M. Levey, *National Gallery Catalogues, Seventeenth and Eighteenth Century Italian Schools*, 1971, pp.33–4.

P514 *Venice: the Molo from the Bacino di S. Marco*

Looking north from opposite the Campanile; from the left, the Zecca, the Library, the incomplete Torre dell' Orologio (completed c.1755), the columns of S. Todaro and S. Marco, the Doge's Palace and the Prisons,[1] lit from the right.

Canvas, relined[2] 52 × 69.2

The surface is rather rubbed and discoloured by old varnish.

A heavy handed but accurate copy of the Canaletto in the Brera, Milan (c/L107). It has been suggested that the Library was painted by a superior hand.[3]

Versions

See above. Constable lists two other versions (c/L107b and c) and six closely related compositions by Canaletto (c/L101–6). This view also furnished the setting for the Ceremony of the Bucintoro returning to the Molo (c/L335–9).

Provenance

Thomas Farrant sale, Christie's, 2 June 1855 (54), bt. by the 4th Marquess of Hertford, £104; Hertford House inventory 1870.

Exhibition

Bethnal Green 1872–5 (312).

Reference General

c/L107a, as a studio repetition, probably in part by Canaletto.

[1] The windows are incorrectly detailed, see p497 note 1, as in the Brera painting.
[2] The stretcher is stamped: J. SPENDER/LINER; he is recorded in London between 1842 and 1874.
[3] F. J. B. Watson, *Canaletto*, 1949, p.14 n.61, and in the 1968 catalogue.

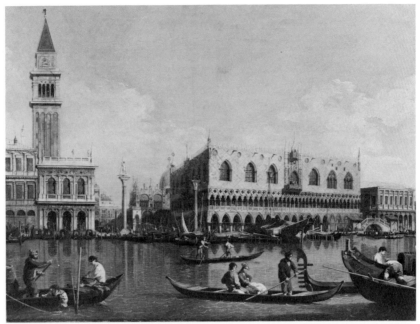

P514

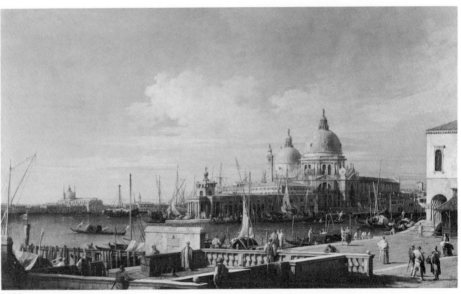

P515

P515 *Venice: the Molo towards the Dogana and S. Maria della Salute*

Looking south-west; on the extreme right the Fonteghetto della Farina, in the centre the Dogana and the church of S. Maria della Salute.

Canvas, relined 47 × 78.2

The surface is rather rubbed and discoloured by old varnish.

Apparently by the same hand as P492, P495, and P512 (its pendant), P515 is a copy of the picture at Windsor (C/L153), until recently attributed to Canaletto.[1] The original composition (which was not engraved by Visentini) remains untraced. P515 was attributed to Bellotto by Camesasca, but this is not accepted by Kozakiewicz (as with P492, P495 and P515). The subject may be compared with that in the Guardi P518.

Versions

See above. Constable lists another studio version (C/L153b) and a related composition in the National Gallery, Washington (C/L154).

Provenance

Casimir Périer (1811–76); his sale, Christie's, 5 May 1848 (25, 'The Dogana and the church of Santa Maria della Salute – the companion [to lot 24, see P512]', 78.7 × 45.7), bt. Grisell, 156 gn.;[2] the 4th Marquess of Hertford; Hertford House inventory 1870.

Exhibition

Bethnal Green 1872–5 (285).

References General

C/L153a, as studio of Canaletto, and p.260; S. Kozakiewicz, *Bernardo Bellotto*, 1972, Z112; E. Camesasca, *L'opera completa di Bellotto*, 1974, no.275A.

[1] M. Levey, *Later Italian Pictures in the Royal Collection*, 1964, no.400, as Canaletto (though with some qualification); O. Millar, *Canaletto*, The Queen's Gallery, 1980–1, p.5, as 'thought not to be by Canaletto'.
[2] The lot number remains faintly visible on the *verso*.

Manner of Canaletto

P498 *Venice: the Grand Canal from S. Simeone Piccolo*

Looking north-east towards the Cannaregio; on the right the Fondamenta and church of S. Simeone Piccolo; on the extreme left the church of S. Lucia (demolished in 1861 when the railway station was built) and beyond it the church of the Scalzi (S. Maria di Nazareth) and the campanile of S. Geremia.

Canvas, relined[1] 96.4 × 148

There are some paint losses round the edges and the surface is discoloured by old varnish with accumulated dirt in the hollows.

The steps leading up to the church, as seen in P498, were completed in 1738.

A unique view, but crudely painted and not by Canaletto. In 1900 Phillips considered it, nonetheless, as the most authentic of the Wallace Collection Canalettos.[2] An attribution to Canaletto was recently, but unconvincingly revived by Puppi.

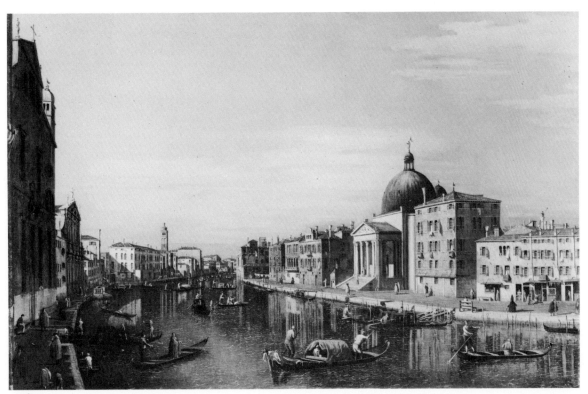

P498

Provenance

Loveden Pryse, Buscot Park; his sale, Christie's, 12 March 1859 (172, '... a very important and capital work, in a very pure state'), bt. by the 4th Marquess of Hertford, 275 gn.; Hertford House inventory 1870.

Exhibition

Bethnal Green 1872–5 (267).

References General

c/L261, as school of Canaletto; Puppi, no.169, as Canaletto.

[1] The stretcher is stamped: W. MORRILL/LINER; he is recorded in London from 1866.
[2] In the earliest editions of the catalogue, and in the *Art Journal*, 1901, p.106. See also 'Note on previous attributions', p.223 above.

Giovanni Battista Cima da Conegliano (1459/60–1517/8)

Born in Conegliano where he is first documented in 1475 aged fourteen. He probably first studied there, but he was in Venice by 1486 where Giovanni Bellini and, to a lesser extent, Antonello da Messina greatly influenced his style which changed little subsequently. His first dated altarpiece, for the church of S. Bartolomeo, Vicenza, is of 1489, and his work continued to be devotional in character; some thirty of his altarpieces survive, the commissions equally divided between Venice and the Venetian *terraferma*. Most of his working life was spent in Venice, though he returned frequently to Conegliano where he was buried on 3 September, probably in 1517; he was certainly dead by November 1518.

Abbreviation

Humfrey P. Humfrey, *Cima da Conegliano*, 1983.

P1 *S. Catherine of Alexandria*

Fair-haired, wearing a jewelled crown, white chemisette and sash, gold breast-plate with silver floral ornament, slashed sleeves of gold with blue floral pattern, green skirt with red and gold hem and a maroon drape with blue and gold rings in the borders. The stone pedestal, decorated with a lion's and rams' heads, is inscribed: IOÃNIS BABTISTE[1]/CONEGLANẼSIS/OPVS.

Poplar panel 152.2 × 77.8 × 0.4

The panel was planed down and cradled c.1896 when thin edging strips were added (not included in the measurements above).[2] The constriction has caused three vertical splits, one 40 cm. long starting 9 cm. from the bottom right-hand corner, and two smaller ones running down from the top edge each side of the head. The paint surface is buckling along the vertical grain. There is retouching in the flesh areas (noted in 1871[3]), the costume (particularly beneath each shoulder) and the sky. A strip 11 mm. wide along the bottom edge is dead coloured. P1 was 'slightly' cleaned by Vallance in 1962.

For the subject, see Sassoferrato P646 (and Attributed to Marinari P562). Coletti, inexplicably, calls the saint Justina.

P1 was originally the centre panel of Cima's triptych painted for the high altar of the church of S. Rocco, Mestre, near Venice. For the lunette panel see P1a below; the two wings, showing the whole-length figures of S. Sebastian (left wing) and S. Roch (each panel 114 × 46; Humfrey, no.155), are now in the Musée des Beaux-Arts, Strasbourg.[4] There is no justification for the claim that Cima's *SS. Christopher and Peter* (Humfrey, no.47) was also part of the altar-piece.[5] Later-sixteenth- and eighteenth-century documents published by Sartori (1962), and elucidated by Humfrey, would indicate that the triptych was commissioned by the Scuola di S. Rocco, Mestre, which had custody of the high altar of the Franciscan Conventual church of S. Rocco;[6] the Franciscan Saints,

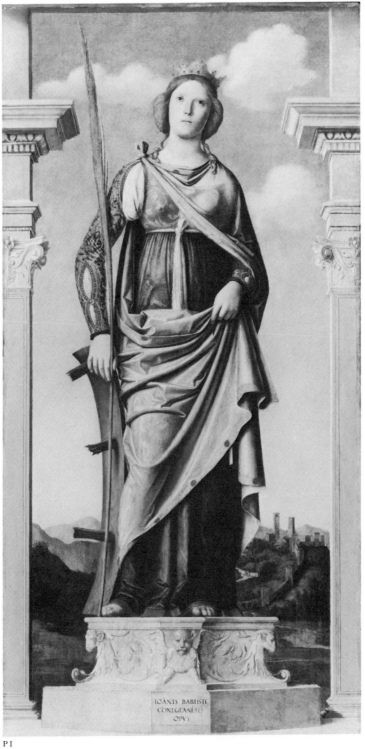

IOANIS BABTISTE
CONEGIANESIS
OPVS

PI

Francis and Anthony of Padua, in the lunette, and the plague Saints, Sebastian and Roch, on the wings, suggest the Confraternity's concern to protect its members from plague. Baratti's engraving, and a photograph taken in 1857,[7] show that P1 originally had an architrave bridging the flanking columns, making it some 15 cm. higher; it had been removed by 1900 when the Wallace Collection was first catalogued. It is also possible that the width of the panel has been reduced; it is now 7 cm. narrower than the lunette, a difference shown in Baratti's engraving which, however, shows the triptych in a delicately carved frame (in detail not unlike that provided for Cima's Miglionico polyptych in 1782[8]) conceivably made after 1726, or 1769 (see Provenance). Humfrey has suggested that, given that there were administrative links between the Mestre church of S. Rocco and the church of S. Maria dei Frari in Venice, and bearing in mind the rarity of the triptych format in Cima's work, the Mestre triptych may have been painted in emulation of Giovanni Bellini's Frari triptych of 1488 – in which case the original, surviving, Bellini frame[9] may be taken to indicate how the columns of P1 would have continued the architectural motif of their surround, an illusion preserved neither in the Baratti engraving, nor (altogether) in the present frame (which was made in 1933). The comparison also suggests that P1 might have been the same width as the lunette panel.

Crowe and Cavalcaselle (1871) dated the Mestre triptych c.1502,[10] and there has since been a general agreement that it was contemporary with the S. Giovanni in Bragora altarpiece which is documented between 1501 and 1503 (Humfrey, no.155).[11] What Venturi termed 'il gigantismo della figura statuaria' finds close parallels in the figures of Constantine and S. Helena in the Giovanni in Bragora altarpiece, and in the *Virgin and Child* in the Miglionico polyptych of 1499 (Humfrey, no.79). The figure of S. Catherine may derive, in part, from Giovanni Bellini's *S. Justina* of c.1471 (Milan, Bagatti Valsecchi collection), as first proposed by Cook,[12] and Phillips first drew attention to the influence of contemporary Venetian sculpture upon it, instancing Alessandro Leopardi (catalogue 1905) and Tullio Lombardo (1907). Humfrey points out that the landscape motif on the right recurs in Cima's *Virgin and Child with Donor* of c.1492–4 (Humfrey, no.13; Berlin-Dahlem).

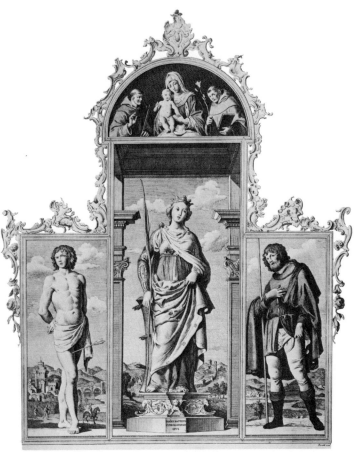

A. Baratti after Cima: the S. Rocco altarpiece.

Engraving

A. Baratti (1724–87), showing the complete triptych (see above); probably commissioned by John Strange (see Provenance).

Copy

MESTRE S. Lorenzo (formerly); a copy of the complete triptych, probably made when the original was sold in the eighteenth century (see Provenance); both Botteon and Aliprandi (1893) and Sartori (1962) confused it with the original,[13] but it is described as 'inadequate' by both Burckhardt and Humfrey.

Provenance

S. Rocco, Mestre; the commission is discussed above; recorded at S. Rocco in 1584 and 1590;[14] in 1726 the friars of the Frari in Venice granted permission for it to be removed to a back wall while a new stone altar was built in S. Rocco;[15] by 1769 it was on a side wall and it was decided to restore it to its original position,[16] but it was acquired soon after by John Strange (1732–99), British Resident in Venice 1773–86; exhibited for sale after his death at the European Museum, London, from 27 May 1799, no.172 ('A superb altar piece richly ornamented, with St. Sebastian, St. Catharine and St. Rocco, the Virgin and Child with two friars, form the semicircular top, the chef d'oeuvre of Cima du Conegliano, engraved'); anon. sale, London, Stanley, 1st day, 12 June 1832 (101, 'Conegliano. An Altar piece in four compartments, representing Saints Catherine, Sebastian, Roche, Madonna and Infant'). The triptych was then split up. By 1846 P1 had been acquired by the 2nd Baron Northwick (1769–1859);[17] his sale, Thirlestane House, Cheltenham, Phillips, 6th day, 3 August 1859 (555), bt. Mawson for the 4th Marquess of Hertford, 800 gn.;[18] Hertford House inventory 1870.

Exhibitions

Manchester, *Art Treasures*, 1857 (120) lent
Northwick; Bethnal Green 1872–5 (265).

References General

Humfrey, no.73, and pp.9, 36, 40–1;
R. Burckhardt, *Cima da Conegliano*, 1905,
pp.39–42; L. Coletti, *Cima da Conegliano*, 1959,
pp.82–3, no.64, as *S. Giustina*;
L. L. Menegazzi, *Cima da Conegliano*, exh.
catalogue, Treviso, 1962, p.33.

[1] Although Baratti's engraving, the 1859 sale catalogue and Cook (1902, see note 11) transcribe this as BAPTISTE, the BABTISTE spelling is authentic and is legible in the 1857 photograph (see note 7).

[2] The cradle, comprising nine vertical members and fifteen cross battens and stamped W MORRILL, is similar to that provided by Morrill for Ruben's *Rainbow Landscape* (P63) in 1896; the cradles bear similar labels.

[3] J. A. Crowe and G. B. Cavalcaselle, *History of Painting in North Italy*, 1871, I, p.240.

[4] Purchased from Sir Anthony Stirling (see P1a, Provenance) in 1890.

[5] 1968 Catalogue. See also F. Heinemann, *Arte Veneta*, XX, 1966, p.236.

[6] A. Sartori, 'Giovanni Battista Cima e i suoi Sant'Antonio di Padova', *Il Santo*, II, 1962, pp.275–87, and Humfrey, p.115: in 1584 an apostolic visitor to the church recorded '*altare maius . . . habet pallam in qua est depicta imago Sancto Rochi . . . In eo est erecta Schola noncupata de S. Rocho . . .*'; in 1590 a receipt from a Friar of S. Rocco records '*la Palla de S. Catterina posta all'altar maggior nella nostra chiesa*'; see also Provenance above. Humfrey further suggests that the inclusion of the Franciscan Saints in the triptych may indicate that 'the prior of the convent was also concerned with the commission'; from 1497 this was Fra Germanno da Casale, later involved, when Prior at the Frari, with the commissioning of Titian's *Assunta*.

[7] Taken by Caldesi and Montecchi at the Manchester *Art Treasures* exhibition and published by Colnaghi, December 1857 (print in Witt Library).

[8] See Coletti, pl.40; Humfrey, pl.70.

[9] See G. Robertson, *Giovanni Bellini*, 1968, pl.LXVIII.

[10] See note 3.

[11] See References General, and H. Cook, *Gazette des Beaux-Arts*, 3e, XXVII, 1902, p.442; A. Venturi, *Storia dell'Arte Italiana*, VII, iv, 1915, p.514; B. Berenson, *Venetian Painting in America*, 1916, p.201; R. van Marle, *Italian Schools of Painting*, XVII, 1935, p.431; R. Pallucchini, *Arte Veneta*, XVI, 1962, p.224. Different dates were proposed by A. Girodie, *La Revue de l'Art ancien et moderne*, XXII, 1907, pp.183–4 (c.1495), and G. Fogolari, *Enciclopedia Italiana Treccani*, 1931, *ad vocem* (after 1509).

[12] See note 11; the Bellini was then attributed to Alvise Vivarini (and illus. as such, p.444).

[13] V. Botteon and A. Aliprandi, *Intorno alla vita e alle opere di G.B. Cima*, 1893, p.107, and Sartori, *loc. cit.*, (see note 6).

[14] See note 6.

[15] Sartori, p.284, quoted in Humfrey, p.115; Botteon and Aliprandi, p.107, and Burckhardt, p.39 n.1, say the new marble altar was agreed in 1630, but give no source.

[16] Sartori, p.284, quoted in Humfrey, p.115; it was perhaps at this time that a new frame was made for the triptych, as shown in Baratti's engraving.

[17] Listed in *Hours in the Picture Gallery of Thirlestane House*, 1846, p.58, no.CCCX.

[18] Bought in competition with the National Gallery who bid up to £600 (see D. Robertson, *Sir Charles Eastlake*, 1978, p.188).

P1a *The Virgin and Child with SS. Francis and Anthony of Padua*[1]

The Virgin in white head-dress, pink dress and blue cloak with gold trimming; S. Francis (left) with the marks of the *stigmata* on his hands, S. Anthony with a white lily and a red book.

Poplar panel 41 × 84.9 × 0.4 lunette

The panel has been planed down and cradled.[2] The constriction has caused a number of horizontal splits, and the paint surface is buckling along the top of the book, on S. Francis's right shoulder and in the Virgin's head-dress. There is a filling above the book, and the Virgin's cloak has been retouched.

See P1 above for discussion of the Mestre triptych of which P1a was originally a part.

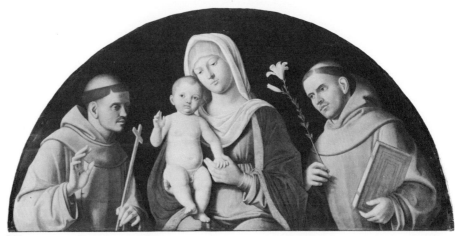

PIa

PIa shows less quality than PI and the Strasbourg wings; the draperies are stiff and the drawing is generally hard. Berenson (1916) first proposed that, while following a Cima design, perhaps only the Virgin's head and throat were executed by him, the remainder being by an assistant.[3] Humfrey has suggested the same assistant worked on the Miglionico polyptych (Humfrey, no.79) and was probably Andrea Busati.

Engraving/Copy

See PI.

Provenance

For pre-1832 provenance, see PI. Sir Anthony Stirling,[4] from whom acquired by John Edward Taylor (1830–1905); Mrs. J. E. Taylor; Taylor sale, Christie's, 1st day, 5 July 1912 (17), bt. Langton Douglas, 2,000 gn.; George and Florence Blumenthal, New York, by 1916;[5] offered to the Trustees of the Wallace Collection by Mr. and Mrs. Blumenthal in 1929 and accepted, on the grounds that PIa was part of a work of art in the Wallace Collection, in 1933.

References General

See PI.

[1] S. Anthony was described in error as S. Dominic in the 1928 and 1968 editions of this catalogue.
[2] Probably between 1912 and 1916 in which period PIa was reframed (as photographs in the Taylor sale catalogue and in Berenson, *Venetian Painting in America*, 1916, fig.82, f.p.200, indicate). The cradle has seven horizontal members and ten vertical battens.
[3] Berenson, *op. cit.*, pp.200–1.
[4] J. A. Crowe and G. B. Cavalcaselle, *History of Painting in North Italy*, I, 1871, p.240 n.5, seem to imply that PIa was with the *S. Sebastian* and *S. Roch* in Stirling's collection.
[5] Berenson, *loc. cit.*

Cremonese School last quarter 15th century

P536 *The Annunciation*

The Virgin in a dark blue cloak with gold trimming over a plum coloured dress; the fair-haired angel in a white robe with a maroon girdle has red wings and bears a white lily.

Tempera on two oak panels, each $44 \times 14 \times 0.8$
maximum sizes of paint surfaces 43.5×14 (the Virgin) 43.4×13.5 (the angel)

The oak panels are not contemporary with the paintings and it is apparent that the paintings with their gesso priming were transferred from another panel or panels. The paint surfaces show extensive losses in the lower areas, and there are smaller damages in the Virgin's cloak, the angel's robe, and elsewhere. There has been extensive retouching and the surfaces have been scratched by the lectern and below the angel.

The subject is taken from Luke I, 26–38 (see Murillo P68).

Though the shape and size of the panels may suggest that they were once the wings of a triptych, it is more probable that they were both part of a larger panel, the centre section of which (at least completing the classical doorway and centre arch) is lost. P536 may be compared in this respect with the two panels by the Master of the Louvre Life of the Virgin in the Kress Collection (K521, each 31.5×10.3, Columbia Museum of Art) which must also have formed originally a single panel. The solemn, full-lipped faces and the obtrusive, somewhat eccentric architectural detail, suggest a follower of Cosmè Tura. P536 was catalogued as Veronese in 1900, Ferrarese in 1907, and as by a Follower of Cossa by Berenson (*Lists* 1932). Hendy (1930) proposed it was a 'youthful work' by Antonio Cicognara (active 1486–1500), a Cremonese master possibly trained in Ferrara.[1] The figure of the Virgin and the head and drapery of the angel may be paralleled in the works of the *Maestro degli occhi spalancati*[2] who, according to Ruhmer,[3] may be identifiable with Cicognara. Volpe convincingly associated P536 with an anonymous Cremonese *Virgin and Child* of c.1480 in the Pinacoteca, Cremona.[4]

Provenance

The vicomte Both de Tauzia (1823–88), from whom purchased by Sir Richard Wallace in 1872, see Appendix IV; Hertford House inventory 1890 as Girolamo Bonaglio.

[1] P. Hendy, *Art in America*, XIX, 1930, p.56.
[2] Cf. the *Virgin and Child* in the Pinacoteca, Bologna, and the fresco *Marriage scene from the month of July* in the Palazzo Schifanoia, Ferrara (both illus. *Pantheon*, XVIII, 1960, pp.254, 257).
[3] E. Ruhmer, *Pantheon, loc. cit.*, pp.258–9.
[4] C. Volpe, letter on file dated 18 March 1955; cf. A. Puerari, *La Pinacoteca di Cremona*, 1951, p.53, nl.75.

P536

P536

Carlo Crivelli (1430/5–1495)

Born in Venice, son of the painter Jacopo and brother of the painter Vittorio; he frequently signed himself *Crivellus Venetus*. First recorded in Venice in 1457 as having abducted a sailor's wife. By 1465 he was a citizen of Zadar (Zara) on the Dalmatian coast; by 1468 he was back in Italy in the Marches south of Ancona, where by 1469 he was a citizen of Ascoli Piceno. He was knighted in 1490 by Ferdinand II of Naples and he incorporated *miles* in his signature thereafter. There are dated works from 1468 to 1493. His rich colouring and mannered style probably derived from the Vivarini in Venice and Squarcione and his school in Padua.

P527 *S. Roch*

Fair-haired, wearing a red tunic and leggings, a turquoise coat and lavender coloured cape, with a brown pilgrim's hat strung round his neck; a rich black and gold brocade hangs behind him.

Egg and oil on limewood panel 40 × 12.1 × 1.7 painted area 38.7 × 11.1

Cleaned by Buttery in 1884, Haines in 1901 and Lank in 1984. The panel had been attacked by worm and there are many fillings in worm holes; there are larger damages top right, above the staff, and top left, and a scratch runs across S. Roch's right leg. The panel has a slight convex warp.

S. Roch, from Montpellier, gave away his rich patrimony and undertook a pilgrimage to Rome; on his way he healed plague victims in Christ's name, but became a victim himself, and sustained a sore on his thigh;[1] he died in France in 1337. His cult became established in the later fifteenth century when he was invoked against plague (often with S. Sebastian); in 1485 his relics were smuggled to Venice where the Scuola di S. Rocco was built. P527, showing the young pilgrim displaying his sore, is one of the earlier representations of the Saint.

The mannered drawing and fine cross-hatching used in the modelling suggest that P527 is a late work.[2] A comparable brocade appears in his *Coronation of the Virgin*, dated 1493 (Brera, Milan), and in the little, late *S. Francis receiving the Precious Blood* (Poldi Pezzoli Museum, Milan). Although the attribution is beyond reasonable doubt, both Geiger (1913) and Testi (1915) considered it a studio production (perhaps without having seen it).[3] The measurements and proportion of P527 indicate that it was probably part of a polyptych, and it has been associated with the *S. Sebastian* (commonly Roch's pendant Saint) in the Poldi Pezzoli Museum, which is the same size, but has sometimes been dated a little before P527.[4] The two panels do not exactly balance each other compositionally, but may have formed part of a series, like that of twelve Saints (possibly from Crivelli's altarpiece in the Duomo, Camerino) now dispersed between Denver, Florence, Lille and Portland;[5] Zeri, however, has suggested (orally 1983) that they originally flanked the *Virgin and Child* now in the Victoria and Albert Museum.[6]

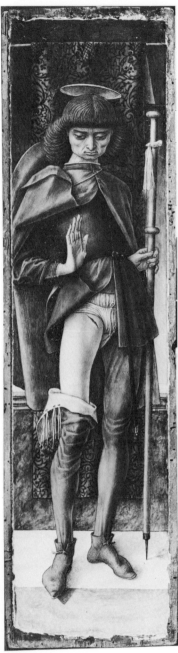

P527

Provenance

The panel bears a Barberini seal, *verso*, but it is not identifiable in the seventeenth-century Barberini inventories;[7] the vicomte Both de Tauzia (1823–88), from whom purchased by Sir Richard Wallace in 1872, see Appendix IV; Hertford House inventory 1890.

References General

F. Drey, *Carlo Crivelli und seine Schule*, 1927, pp.52, 124; P. Zampetti, *Carlo Crivelli*, 1952, p.63, no.58, and *Crivelli e I Crivelleschi*, 1961, under no.26; A. Bovero, *L'opera completa del Crivelli*, 1975, no.147.

[1] The earliest lives of the Saint say the sore was on his left leg (cf. Mrs. Jameson, *The Poetry of Sacred and Legendary Art*, 1850, pp.251–3), but this was not invariably followed by artists, cf.p527.

[2] See References General, and R. van Marle, *Italian Schools of Painting*, XVIII, 1936, p.47, and Index, 1938, as 'after 1490'; S. Y. Legouix, *Apollo*, CI, 1975, p.78.

[3] B. Geiger in *Thieme-Becker*, XIII, 1913, p.132, and L. Testi, *La Storia della Pittura Veneziana*, II, 1915, p.686.

[4] First of all by C. Phillips in the 1904 catalogue, though he pointed out that the backgrounds did not agree. Acquired by G. G. Poldi Pezzoli (d.1878); for the earlier dating, see van Marle, *loc. cit.*, and cf. Zampetti 1961, no.26, and Bovero, no.146.

[5] Each panel 51 × 13; Bovero, nos.166–77, and see Zampetti 1961, no.35 (recording Zeri's dating of c.1490 for the series).

[6] Panel 48.5 × 33.6, Jones Bequest 492–1882; see C. M. Kauffmann, *Victoria and Albert Museum, Catalogue of Foreign Paintings*, I, 1973, pp.78–9, and Bovero, no.116.

[7] M. A. Lavin, *Seventeenth-century Barberini Documents and Inventories of Art*, 1975, records no painting by Crivelli. Prince Barberini sold some paintings in the nineteenth century, cf. the Ferrarese panel, no.1745 in the National Gallery of Scotland, said to have been bought from him in Rome in 1896.

Bernardo Daddi (active 1327 died 1348)

The leading Florentine painter of his day, whose work was influenced by Giotto and the S. Cecilia Master. He had an active workshop in which many of his designs, and doubtless many of the pictures attributed to him, were completed.

Workshop of Daddi mid 14th century

P549 *The Nativity*

The Virgin in blue cloak with gold pattern and pink dress with gold trimming on the collar; the Child swathed; a red ox and black ass; two angels in red, top right; kneeling angels in green (left) and red, bottom right. *Verso*: the truncated figure of a martyr saint in a light brown habit, bearing a palm.

Tempera on poplar panel 14.1 × 12.1 × 1
painted area, *recto*: 14 × 10.3 *verso*: 11.3 × 8 (maximum)

The *recto* was cleaned by Lank in 1983. The surface is pitted in several places due to worm, and the edges of the panel are damaged. The *verso* shows extensive paint losses retouched in terracotta, and the surrounding area shows a canvas impress. Vertical grain; the panel has a slight convex warp.

The subject is taken from Luke II, 6–7 and Isaiah I, 3.

P549 is a fragment apparently from the left wing of a triptych. Catalogued as Florentine in 1900, given to Daddi by Sirén (1917),[1] MacColl (1924),[2] van Marle (1925)[3] and Berenson (*Lists* 1932); attributed to Daddi by Offner (1930)[4] and then to his workshop (1958);[5] catalogued as Daddi in 1928 and 1968. P549 imitates a Daddi formula as seen, for example, in the left wing of the triptych in the National Gallery of Scotland (no.1904),[6] a predella panel from the

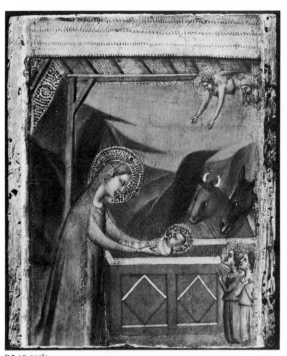

P549 *recto*

P549 *verso*

S. Pancrazio polyptych in the Uffizi, and in a panel from the Ventura collection, with Knoedler, Paris, in 1957–8.[7] Each of these examples shows the subject extended above and below; where they show angels' gilded haloes top left, P549 shows curiously pointless gold tooling on the stable roof. The figure on the *verso* (which could have been comfortably accommodated before the panel was reduced) is crudely painted.

Provenance
The vicomte Both de Tauzia (1823–88), from whom purchased by Sir Richard Wallace in 1872, see Appendix IV; Hertford House inventory 1890 unattributed.

[1] O. Sirén, *Giotto and some of his Followers*, 1917, I, p.217, as fragment of a small wing.
[2] D. S. MacColl, *The Burlington Magazine*, XLIV, 1924, p.228, 'a mutilated example . . . [with] not a great deal to say for itself'.
[3] R. van Marle, *Italian Schools of Painting*, V, 1925, p.475.
[4] R. Offner, *Corpus of Florentine Painting*, III, iii, 1930, p.8.
[5] *Ibid.*, III, viii, 1958, pp.20 n.3, 91.
[6] Mentioned by MacColl, *loc. cit.*, when with Julius Böhler, Munich.
[7] Mentioned by Offner 1958 as 'a stereotyped formula of Daddi's workshop', like P549.

Domenichino (1581–1641)

Domenico Zampieri, called Domenichino, was born in October 1581 in Bologna where he first studied under Denis Calvaert before entering the Carracci Academy in, or after, 1595. In 1602 he went to Rome where he assisted Annibale Carracci in the decoration of the Galleria Farnese (1603–5). In 1612 he received two important commissions: the S. Cecilia frescoes in S. Luigi dei Francesi (1612–5), and an altarpiece for S. Girolamo della Carità (*The Last Communion of S. Jerome*, 1614). In 1617 he returned to Bologna, but with the election of a Bolognese Pope, Gregory XV, in 1621, Domenichino returned to Rome where he was made Papal Architect and received an increasing number of commissions, notably for the decoration of the New Theatine church of S. Andrea della Valle (1622–7). In 1631 he undertook to supply frescoes and five altarpieces for the Duomo at Naples and, apart from a visit to Rome in 1634–5, this commission occupied him until his death in Naples on 6 April 1641.

Abbreviations

Pope-Hennessy J. Pope-Hennessy, *The Drawings of Domenichino at Windsor Castle*, 1948
Spear R. Spear, *Domenichino*, 2 vols., 1982

P131 *A Sibyl*

Beige turban with a hat jewel (*enseigne*) of gold set in pearls enamelled in red and green with a standing figure;[1] rock crystal ear-ring; white chemisette; light beige shawl; maroon overdress with an emerald set in gold on the right shoulder; a deep blue drape over the left arm; the book is bottle-green.

Canvas, relined 77.4 × 68.2

Cleaned and relined by Vallance in 1966. The surface is somewhat rubbed, as is particularly apparent in the fingers and the hair-line which, in both the studio drawing and the 1786 engraving (see below), was wavier. The flesh areas have been retouched, most noticeably on the forehead. There is a filling in the top right background area.

The Sibyls were prophetesses of antiquity who, on the evidence of the apocryphal *Sibylline Oracles*, were thought to have foretold the coming of Christ to the pagan world (and hence, for example, their inclusion in Michelangelo's Sistine Chapel ceiling).[2] Their number varied between four and twelve, and each was identified with an eastern location (as Delphos, Samos, Persia, Erythraea or Libya, while the Cumaean Sibyl, see Rosa P116, had come to Rome from the east). Their iconography is confused and only an inscription (as used by Michelangelo and Guercino,[3] for example) identifies them with certainty. Domenichino painted three; apart from P131, one with the attribute of music (Pinacoteca Capitolina, Rome; Spear, no.80), the other holding a Greek scroll (Borghese Gallery, Rome; Spear, no.51); all three have similar exotic head-dresses and rich drapes, suggestive of their eastern origin. The earliest references to each describe them

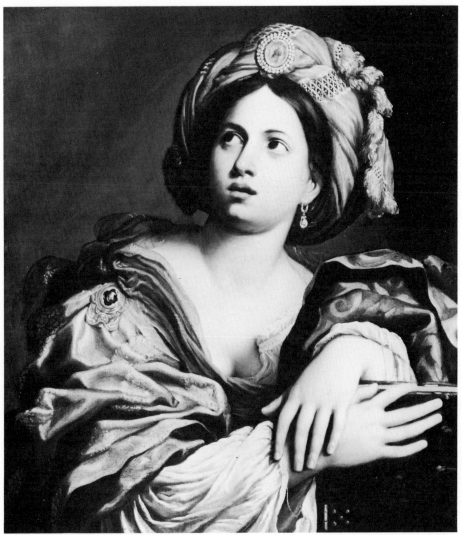

PI3I

simply as *A Sibyl*. PI3I was so described throughout the eighteenth century, but it appeared in the Stowe sale in 1848 as the *Sibylla Persica*, a title revived in the 1913 edition of this catalogue and hitherto retained.

PI3I has been dated in the early 1620s by Borea, and c.1623–5 by Spear, who compares it with the Capitoline *Sibyl*, which he dates c.1620–3, and the two *Mary Magdalene* compositions, in the Mahon collection of c.1625–7 (Spear, no.92) and in the Palazzo Pitti of c.1626–8 (Spear, no.94). Two sketches for the composition at Windsor (see below) show a younger, prettier model who seems to recur in the Borghese *Sibyl* of 1616–7 and in the Louvre *S. Cecilia* of 1617–8

271

Domenichino: Studies for P131 (Pope-Hennessy 213, *recto* and *verso*). Windsor Castle
(Reproduced by gracious permission of Her Majesty The Queen)

(Spear, nos.51, 53); on the same sheet is a study for *The Last Communion of S. Jerome* of 1614. P131 was, accordingly, dated 1613–4 by Pope-Hennessy but, as Spear demonstrates, the import may rather be that Domenichino was contemplating the composition long before the execution of P131.

Drawings

WINDSOR CASTLE three sheets containing studies relating to P131. Pope-Hennessy 211: two studies in black chalk of a half-length female figure with a turban, her clasped hands resting on an upright book (see discussion above). Pope-Hennessy 212: red chalk, a finished study for the head of P131, differing in detail in the head-dress and without the ear-ring; considered by Spear to be a studio copy.[4] Pope-Hennessy 213: black chalk with white heightening; *recto*, three studies for the hands and a general sketch of the composition; *verso*, sketch for the turban without the hat jewel.

Engravings

Foseilleux (J.-B. Fosseyeux) 1793;[5] E. Lingée 1803.[6]

Copies/Versions[7]

AMIENS Musée de Picardie, copy in Beauvais tapestry.
HAGLEY HALL copy in enamel attributed to Henry Bone.
HELSINKI private collection, 81 × 66.3.
LENINGRAD Hermitage, 86 × 66, from the Coesvelt collection.
ORLEANS Musée des Beaux-Arts, 96 × 75.
PARIS Musée des Arts Décoratifs, copy in Gobelins tapestry by Cozette, 1782.

Provenance

Etienne Texier d'Hautefeuille (d. 1703),[8] from whose sale in 1703 P131 was bt. by Philippe, duc d'Orléans (1674–1723);[9] by descent to Louis-Philippe-Joseph ('Egalité'), duc d'Orléans (1747–93),[10] who sold his Italian and French pictures to Walchiers in 1791 (see Titian P11 for a more detailed account); L. de Méréville; J. Harman; bt. Bryan 1798; exhibited for sale at the Lyceum, London, from 26 December 1798, no.120, and bt. by Lord Temple (1776–1839, later Duke of Buckingham), 400 gn.;[11] 2nd Duke of Buckingham (1797–1861) sale, Stowe, Christie's, 23rd day, 14 September 1848 (432, *Sybilla Persica*), bt. Mawson for the 4th Marquess of Hertford, 690 gn.;[12] Hertford House inventory 1870.

Exhibition

Bethnal Green 1872–5 (252).

References General

Spear, no.85; E. Borea, *Domenichino*, 1965, no.77.

[1] Now illegible, but clearly shown in the engravings.
[2] For a discussion of the Sibyls and their iconography, see E. Wind, 'Michelangelo's Prophets and Sibyls', *Proceedings of the British Academy*, LI, 1960, pp.58–75, and Spear, under nos.51, 80 and 85.
[3] Guercino's *Samian Sibyl* at Althorp and *Cumaean Sibyl* in the Mahon collection.

[4] Spear, p.238 n.2.
[5] For J. Couché, *La Galerie du Palais Royal*, 1786–1808, I, (Domenichino, no.6); see E. Pagnon and Y. Bruand, *Inventaire du fonds français, Graveurs du XVIIIe siècle*, IX, 1962, p.266. The plate was exhibited at the Salon 1793 (451).
[6] For G. P. Landon, *Vies et Oeuvres des Peintres les plus célèbres*, 1803, pl.85 *(Dominiquin)*.
[7] Of the versions listed by Spear, those in the Liechtenstein collection, Vienna, and at Knole Park, show different compositions.
[8] For whom, see E. Bonnaffé, *Dictionnaire des Amateurs français au XVIIe siècle*, 1884, p.136.
[9] As stated by C. Stryienski, *La Galerie du Régent*, 1913, p.85.
[10] While in the Orléans collection P131 was listed by L.-F. Dubois de Saint-Gelais, *Description des Tableaux du Palais Royal*, 1727, p.122 (as *Une sibylle ... sa coëfure est bizare*), and it appeared in the Orléans inventories with the following valuations: 1724 800 fr.; 1752 1,400 fr.; 1785 3,600 fr. (see Stryienski, *op. cit.*, p.173, no.287); see also Titian P11, note 57.
[11] W. Buchanan, *Memoirs of Painting*, 1824, I, p.101.
[12] Hertford had urged Mawson to buy P131 'as much for the frame as for the picture' (*Letters*, nos.2 and 3, pp.21–2). The frame, described by H. R. Forster, *The Stowe Catalogue priced and annotated*, 1848, p.194, as finely carved and from the Doge's Palace, is now untraced. Hertford reframed P131 in 1859 (Evans invoice). In 1872 '*A large gilt frame of wood carved, labelled Domenichino, with one piece of carving at top loose*' was sent from Paris to Bethnal Green (*Bethnal Green Museum Van Book*, 25 April 1872). Previous editions of this catalogue have followed MacColl (*The Burlington Magazine*, XXII, 1913, p.325) in supposing the Stowe frame may be that now seen on North Italian School P541 (q.v., note 1) but this is a larger picture and its frame has been reduced.

Ferrarese School (?) third quarter 15th century

P539 *Portrait of a Man in Red*

Black hair, brown eyes, wearing a red hat and a fur-trimmed red cape over a red tunic; black background.

Poplar panel 40.7 × 27.5 × 2 painted area 39.5 × 25.7

Cleaned by Haines in 1901; cleaned, but not restored, by Lee in 1983 when overpainting was removed from the shoulder and in smaller areas on the breast and collar, and along vertical splits running through the shoulder, neck and ear. The surface is worn and pitted in several places by worm holes; there are score marks in the hair and in front of the hat. *Pentimenti* may be seen on the nose, chin and collar. Three vertical cuts were made, *verso*, to counteract a slight convex warp and at the same time a horizontal batten was dovetailed into the panel; it was removed in 1978.

Costume suggests the sitter was a courtier of c.1450–70. There seems no evidence, beyond the colour red, for calling him a Cardinal (as in the 1890 inventory),

P539 unrestored

and a pencil inscription recorded in 1890, but now illegible: '*Leonello Duca d'Urbino figlio di Guido Baldo* [1472–1508]' – may be disregarded on grounds of date.

P539 derives from Mantegna's profile portraits of c.1460. Catalogued as Ferrarese in 1900, it was attributed to Bonsignori by Frizzoni (1904 catalogue) and catalogued as such in 1928 and 1968. P539 appears to be too early, however, for Bonsignori and the attribution was rejected by Schmitt (1961)[1] who preferred Ferrarese school 1460–70; it may also be compared with the *Head of a Man* at Hampton Court which Shearman has catalogued as Ferrarese c.1470–80.[2]

Provenance

Probably the vicomte Both de Tauzia (1823–88), see Appendix IV; acquired by Sir Richard Wallace in or after 1872; Hertford House inventory 1890 as '*portrait of a Cardinal by Giuliano Pesello*'.

[1] U. B. Schmitt, *München Jahrbuch der Bildenden Kunst*, 1961, p.131, no.72.
[2] J. Shearman, *The Early Italian Pictures in the Collection of Her Majesty the Queen*, 1983, no.89.

P553

Florentine School third quarter 16th century (?)

P553 *The Holy Family*

The Virgin has fair hair, a grey head-dress, a white shawl and a light purple dress with a pale green overskirt; Joseph wears a grey tunic and a light brown robe.

Poplar panel 44.2 × 31.3 × 2 two vertical members, the left 12 wide

There are retouchings in Joseph's head and hair, and there is an old damage to the right of the Virgin's left shoulder. Two vertical splits in the central area and another, bottom right, have been retouched.

Previously catalogued as Roman school, P553 would appear rather to be Florentine. It shows a distinct Sartesque influence and may be loosely associated with Giovanni Balducci (c. 1560–c. 1603) as Pouncey (orally) has suggested.

275

Provenance

Inscribed verso: *M[r] A. Magni*(?)/*1844*; exported from Italy after 1861;[1] the vicomte Both de Tauzia (1823–88), from whom purchased by Sir Richard Wallace in 1872, see Appendix IV; Hertford House inventory 1890 unattributed.

[1] The panel bears four seals, verso: i) inscribed *Vittorio Emmanuele re … alia* (King of Italy 1861–78) *Direzione del Museo Nazionale* ii) the arms of Amadeus of Vicenza iii) a customs seal of the Papal States iv) two seals bearing a five-leafed rose *en chef* above a paly of seven with a Cardinal's hat for crest.

Florentine School (?) last quarter 15th century

P768 *The Virgin and Child*

The Virgin has chestnut hair, a turquoise mantle and red dress; the Child holds a red pomegranate; light blue background.

Maple panel 14.8 diameter, with engaged frame 36.7 diameter

Cleaned, but not restored, by Lee in 1983, revealing many retouchings and confirming the apparent age of the painting. The picture surface is convex. The panel has been badly attacked by worm and the outer edges of the engaged frame have been replaced with five nineteenth-century inserts.

Van Marle considered P768 to be from the school of Domenico Ghirlandaio[1] and compared it with the two small *tondi* in Dresden of the Archangels Michael and Raphael (nos. 17–18; Berenson *Lists* 1963, as Bartolommeo di Giovanni); MacColl believed it to be a late fifteenth-century work.[2]

Provenance

The vicomte Both de Tauzia (1823–88), from whom purchased by Sir Richard Wallace in 1872, see Appendix IV; Hertford House inventory 1890 as Ghirlandaio (whose name is written on the *verso* in a nineteenth-century hand).

[1] R. van Marle, *Italian Schools of Painting*, XIII, 1931, p.247.
[2] D. S. MacColl, *The Burlington Magazine*, XLIV, 1924, p.228.

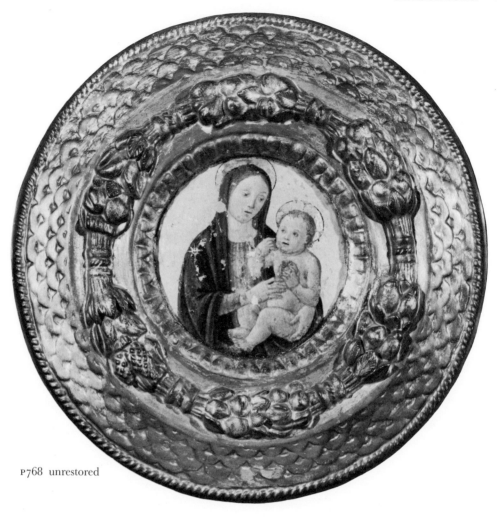

P768 unrestored

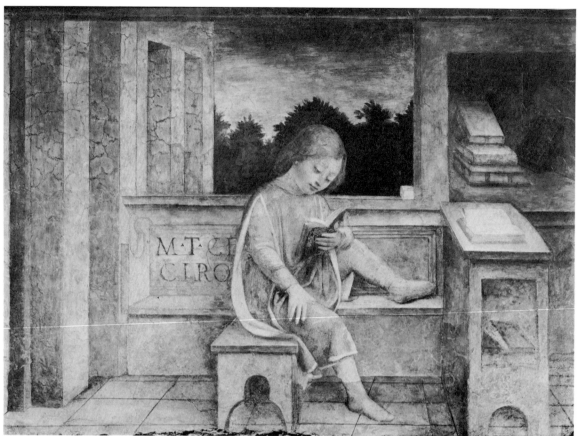

P538

Vincenzo Foppa (1427/30–1515/6)

Born in Brescia, the son of Giovanni da Sandrina da Bagnolo, a tailor. He may have studied with Squarcione in Padua, and his earlier work also suggests the influences of Mantegna and Jacopo Bellini. From 1456 to 1490 he was based in Pavia, though he frequently worked in Genoa and Milan, for example, in that period. He returned to Brescia in 1490 and his later work reflects an awareness of both Bramante and Leonardo. There are documented works from 1458 to 1514. Foppa was the principal Lombard master of the *quattrocento*.

P538 *The Young Cicero Reading*

Fair-haired, wearing a pink fur-trimmed coat over a light blue tunic and hose with pink socks. Behind him on the parapet is inscribed: M.T. CI/CERO which restoration has indistinctly turned into: M.T. CE/CIRO.

Fresco 101.6 × 143.7 × 1.9

Set in an open courtyard for four hundred years[1] P538 was cut from the wall and framed c.1863 (see below). It is, understandably, extensively retouched throughout.[2] It was repaired by Buttery in 1885, but a photograph published in 1898[3] suggests that the right-hand side (from the left edge of the lectern) was still in poor condition. Inconsistencies now apparent in the composition may be put down to subsequent restoration, viz. the lip of the parapet gives out on the right, the white box on the window ledge does not sit correctly, and the fore-edge of the book Cicero reads is confused. The alcove on the right was originally more clearly defined (scored lines remain visible). The surface now has an overall convex warp and is generally uneven. A supporting canvas, devised by Buttery in 1885, was removed in 1984 when the fresco was remounted by Bobak.

P538 is the only surviving fresco from the Palazzo Mediceo (also known as the Banco Mediceo), Milan, which had been given by Francesco Sforza in 1455 to Cosimo de' Medici, who restyled it lavishly. The subject of P538 was described as Pico della Mirandola in 1862,[4] and the young Gian Galeazzo Sforza in 1885;[5] the first because of his well-known precocity, the second because of his parents' association with the Palazzo. Both, however, were too young to have provided the subject (see dating below). It became more generally known as *A Boy reading Cicero*, until Waterhouse in 1950 made the persuasive suggestion that it showed Cicero himself.[6] Plutarch wrote: 'as soon as [Cicero] was of an age to begin to have lessons, he became so distinguished for his talent, and got such a reputation amongst the boys, that their fathers would often visit the school [to witness] the quickness and readiness in learning for which he was renowned'.[7] It remains unclear how this subject fitted into the decorative scheme of the Palazzo. By 1808 P538 was the only surviving fresco, on the parapet of the upper loggia round the *cortile*.[8] Filarete, writing between c.1460 and 1464, said this loggia was decorated with the story of Susanna, while the parapet was going to be painted with the Cardinal Virtues.[9] Doubtless P538

accompanied these Virtues, perhaps as an emblem of rhetoric for, as Waterhouse observed, the Liberal Arts frequently accompanied the Virtues. A late nineteenth-century reconstruction of the *cortile*[10] suggests that there could have been twelve scenes the size of P538 along the parapet.

Filarete said Foppa had begun the decoration of the lower *loggia*,[11] but he did not give an artist's name for the decorations of the upper *loggia* (as described above). The attribution of P538 to Foppa seems, nevertheless, reasonably secure. It was proposed by Müntz in 1885[12] and 1898,[13] and repeated by Berenson (*Lists* 1907) Ffoulkes and Maiocchi (1909), Borenius (1912),[14] Wittgens (1949), Waterhouse (1950 and 1973),[15] and E. Arslan (1963).[16] P538 relates convincingly, with its careful perspective, to the frescoes he painted c.1464–8 in a chapel in S. Eustorgio, Milan, for Pigello Portinari (who was also Cosimo de' Medici's agent for the restyling of the Palazzo Mediceo). A date of c.1464 (i.e. immediately after Filarete's *Trattato*) would seem appropriate for P538; Wittgens proposed between 1462–4, Waterhouse the mid-1460s. Ffoulkes and Maiocchi, unaccountably, proposed c.1485. P538 was first catalogued as Bramante until 1908 when it was given to Foppa.

Provenance

Palazzo Mediceo, Milan (see above), whence removed c.1863 by Bertini;[17] acquired, possibly from Bertini in Milan in 1867, by the vicomte Both de Tauzia (1823–88),[18] from whom purchased by Sir Richard Wallace in 1872 (see Appendix IV); Hertford House inventory 1890, as '*Fresco Boy reading*'.

References General

C. J. Ffoulkes and R. Maiocchi, *Vincenzo Foppa*, 1909, pp.51–6, 288; F. Wittgens, *Vincenzo Foppa*, 1949, pp.25–6, 93–4.

[1] In which time the Palazzo was restored at least once, in 1688, and the frescoes were whitewashed in 1776 (Ffoulkes and Maiocchi, pp.50, 53).
[2] A report on the condition of P538, made by Mrs. Herringham, is given by Ffoulkes and Maiocchi, p.288: she remarked upon distemper or watercolour restoration, particularly over the many cracks, and on the many fine cracks which had not been restored. They have since been touched in.
[3] E. Müntz, *Leonardo da Vinci*, 1898, I, p.132.
[4] Pico della Mirandola (1463–94), proposed by G. Mongeri in *La Perseveranza*, 5 December 1862 (quoted in Ffoulkes and Maiocchi, p.50, and Wittgens, p.93).
[5] Gian Galeazzo Sforza (1468–94), Duke of Milan, proposed by Müntz, *La Renaissance en Italie et en France à l'époque de Charles VIII*, 1885, p.261, and repeated, with various qualifications, in earlier editions of this catalogue 1900–28. See also note 11.
[6] E. K. Waterhouse, *The Burlington Magazine*, XCII, 1950, p.177.

[7] Plutarch's *Lives*, trans. Dryden and Clough, 1910, III, p.187.
[8] Cf. De Pagave's note in Vasari's *Vite*, Siena, 1808, IV, p.331, describing P538 as 'a business man in his office sitting astride and apparently reading, though whether a book or a letter is not clear' (quoted in Ffoulkes and Maiocchi, p.50). F. Cassina, *Fabbriche di Milano*, I, 1840, text to pl.13, gave a similar account. A note in Vasari's *Vite*, Florence, 1848, III, p.284 n.6, recorded that alterations then taking place at the Palazzo had left only '*qualche vestigio*' of the original paintings. P538 was last recorded *in situ* by Mongeri (see note 4), and Bertini (see note 10).
[9] A. Filarete, *Trattato*, ed. W. van Oettingen, *Quellenschriften für Kunstgeschichte und Kunsttechnik*, neue Folge III, 1890, p.685: '*allo entrare della porta, alzando gli occhi, si è una loggia in colonnette di marmo . . . dipinta in verde con la storia di Susanna. Nel parapetto dinanzi vogliono dipignere le virtù cardinali*'. For the dating of the *Trattato*, see Oettingen, pp.40, 67 n.71.
[10] By A. Caravati, '*Il Palazzo del Banco Mediceo di Milano*', *Arte Italiana Decorativa*, 1895, pp.21–31; his drawings illus. by Ffoulkes and Maiocchi, f.p.54 and described p.51 n.2. They were based on drawings made by Bertini c.1863, prior to the destruction of the *cortile*, which showed P538 on the front of the parapet (cf. Ffoulkes and Maiocchi, p.54).
[11] Filarete, *op. cit.*, p.682: '*Foppa . . . à fatto il simulacro di Traiano, . . . con altre figure per hornamento. E cosi l'à dipignere tutta questa partita a figure et inmagine d'imperadori, le quali saronno otto, e la inmagine e simulacro dello illustrissimo Francesco Sforza e della illustrissima sua Madonna e figliuoli*'; and see Vasari-Milanesi, II, p.448. A drawing by Foppa, *The Justice of Trajan*, has been associated with this scheme, though not conclusively (see Wittgens, p.94).
[12] See note 5.
[13] See note 3.
[14] J. A. Crowe and G. B. Cavalcaselle, *History of Painting in North Italy*, ed. T. Borenius, 1912, II, p.320.

[15] See note 6, and 'The Renaissance in Milan before Bramante and Leonardo', *The Journal of the Royal Society of Arts*, CXXI, May 1973, p.387.
[16] E. Arslan, 'Vincenzo Foppa', in *Della Storia di Brescia*, II, 1963, p.932.

[17] Cf. Ffoulkes and Maiocchi, p.54; 'said to have been rescued from the general wreck by the late Professor Bertini'.
[18] Tauzia was negotiating the purchase of some Luini frescoes for the Louvre in Milan in 1867, cf. Ph. de Chennevières, *Souvenirs d'un Directeur des Beaux-Arts*, 1979 ed., v, p.41.

Francesco di Vannuccio (active 1361–1389)

A Sienese master whose single documented work is an altarpiece in Berlin-Dahlem signed FRANCISCHUS DE VANNUCIO DE SENIS PINSIT HOC OPUS MCCCLXXX. Cecchi[1] has reasonably identified him as the Francio di Vannuccio documented as a painter in Siena between 1361 and 1389.[2] The corpus of work attributed to him (first assembled by Brandi[3] and Offner[4]) reflects the influence of Simone Martini, probably transmitted through Andrea Vanni and Bartolo di Fredi; Offner noted his 'child-like and playful fantasy' and his whimsically small figures touched with humour.

[1] A. Cecchi in *Il Gotico a Siena*, Palazzo Pubblico, Siena, 1982, p.282, with bibliography.
[2] See G. Milanesi, *Documenti per la storia dell'arte senese*, 1854, I, pp. 33, 35 and 40.
[3] C. Brandi, *Art in America*, XX, 1931, pp.38–48.
[4] R. Offner, *Art in America*, XX, 1932, pp.89–114.

P550 *The Virgin and Child in Majesty with SS. Peter and John the Baptist*

The Virgin in white and gold with a blue cloak, the fair-haired Child in gold with a coral charm round his neck, holding a scroll inscribed: EGO SVM [VIA] (John XIV, 6);[1] above them red seraphim and blue cherubim. The white-haired S. Peter in a yellow cloak over a blue-grey cassock, holding a red book and the gold and iron keys of Heaven and Hell;[2] the black-haired S. John the Baptist in a blue-lined purple cloak over camel hair, holding a cross and a scroll inscribed: ECCE AGNVS [DEI] (John I, 29). The throne is covered with a rich red and gold pattern; the floor in front is white and gold.

Tempera on poplar panel 54.3 × 24.7 × 0.4

The panel has been severely constricted by a supporting cradle, resulting in a number of convex warps and vertical cracks, the most obvious running the length of the panel from S. Peter's left foot to above the Child's head, and through S. John's right shoulder. There are considerable areas of retouching, both round the cracks, in and around the Child's head, by the Virgin's left foot, and on her cheek and right shoulder. A number of losses on the Virgin's draperies have been filled, and there are a number of surface scratches. The drawing of the pedestals on which the Saints stand has been strengthened. The composition indicates that the panel has been slightly reduced along the bottom edge, and triangular infills in the top corners (approximately 5 × 2 cm.) indicate that the top was originally pointed, perhaps 20 cm. above the present top edge. A black border, 5 mm. wide, runs up each vertical edge, doubtless marking the position of the original gilded frame.

Catalogued as Sienese school in 1900, P550 was attributed to Paolo di Giovanni Fei by Douglas in 1908[3] and catalogued as such in 1928. It was first attributed to Francesco di Vannuccio in 1932 by Offner who thought it probably the left wing of a triptych.[4] He indicated the general influence of Simone Martini in the Madonna and Child group and the resemblance to the Madonna in a polyptych in the Pinacoteca Nazionale, Siena (no.51) by Niccolò di Ser Sozzo Tegliacci and Luca di Tommè, dated 1362. Parallels may also be drawn with the Madonnas given to Francesco di Vannuccio in the triptych, no.183 in the Pinacoteca Nazionale,[5] and in S. Giovanni della Staffa, Siena.[6] The figure of S. John the Baptist in P550 may be compared with the same Saint in no.183 in the Pinacoteca Nazionale. Pope-Hennessy pointed out[7] that the anomalous spatial connection between the upper and lower scenes in P550 (the Saints stand within a separate richly tooled field) finds a parallel in Francesco di Vannuccio's *Annunciation* in Girton College, Cambridge.[8] Cecchi has dated no.183 in the Pinacoteca Nazionale c.1370 and suggests, with Offner, that P550 is a little later.[9]

Provenance
The vicomte Both de Tauzia (1823–88), from whom purchased by Sir Richard Wallace in 1872, see Appendix IV; Hertford House inventory 1890 as Lippo Memmi.

[1] As in Francesco di Vannuccio's *Madonna and Child* in S. Giovanni della Staffa, see note 6.

[2] Cf. Mrs. Jameson, *The Poetry of Sacred and Legendary Art*, 1850, p.112.

[3] J. A. Crowe and G. B. Cavalcaselle, *History of Painting in Italy*, ed. L. Douglas, 1908, III, p.131 n.3. The attribution was accepted by Valentiner (*Early Italian Paintings*, Duveen 1926, under no.28) and, initially, by Berenson (*Lists* 1932) and van Marle (*Italian Schools of Painting*, II, 1924, p.536).

[4] R. Offner, *Art in America*, XX, 1932, pp.90 and 92 ff., the attribution accepted by Berenson (*Lists* 1968) and van Marle (*op cit.*, Index, 1938, *ad vocem*).

[5] See *Il Gotico a Siena*, Palazzo Pubblico, Siena, 1982, no.105.

[6] See *Mostra di Opere d'Arte restaurate nelle Province di Siena e Grosseto*, Siena 1981, no.14.

[7] J. Pope-Hennessy, *The Burlington Magazine*, XC, 1948, p.138.

[8] Exh. RA 1960 (310); Wildenstein, *The Art of Painting in Florence and Siena*, 1965, no.89, and Matthiesen, *Early Italian Paintings*, 1983, no.14.

[9] A. Cecchi in *Il Gotico a Siena*, 1982, p.284.

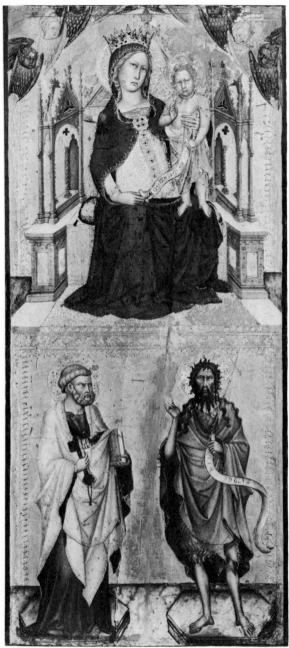

P550

Francesco Guardi (1712–1793)

Baptised on 5 October 1712 in Venice, one of three brothers; his father, Domenico Guardi (1678–1716), was a minor artist and his mother was Viennese. His sister married G. B. Tiepolo in 1719. His earlier work consisted of figure subjects, often produced in collaboration with his older brother Gian Antonio (1699–1760); they have yet to be satisfactorily distinguished. In 1757 he married a painter, Maria Mathea Pagani (1726–69). He had probably turned to painting topographical views in the earlier 1750s;[1] by 1764 he was (doubtfully) described as 'a good pupil of the famous Canaletto'.[2] Certainly Canaletto's works, or engravings from them (cf.P496 and P500 from the studio of Canaletto), influenced his earlier views, but by the 1770s Guardi had evolved a distinctive style in which topography seems to take second place behind the description of light effects made with a nervous brush. Perhaps his *capricci* best embody this poetic concern. He died in Venice on 1 January 1793. The dearth of securely dateable views prevents the establishment of a satisfactory chronology, and the issue is further complicated by the many repetitions he made of his compositions; unlike Canaletto, he appears not to have maintained a studio practice. His son Giacomo (1764–1835) continued less competently in his father's manner.

[1] See D. Mahon, *The Burlington Magazine*, CX, 1968, p.70.
[2] See M. Levey, *Painting in XVIII century Venice*, 1959, p.98.

Abbreviations

Bortolatto	L. R. Bortolatto, *L'opera completa di Francesco Guardi*, 1974
MD	A. Morassi, *Tutti i disegni dei Guardi*, 1975 (numbers refer to the oeuvre catalogue)
MP	A. Morassi, *Antonio e Francesco Guardi*, 2 vols., 1973 (numbers refer to the oeuvre catalogue)
Simonson	G. A. Simonson, *Francesco Guardi*, 1904

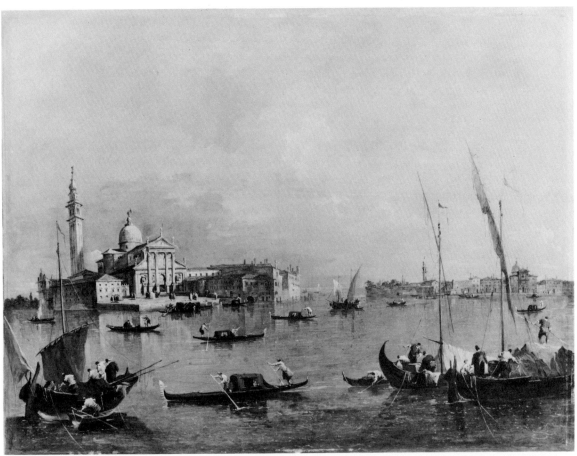

P491

P491 *Venice: S. Giorgio Maggiore with the Giudecca and the Zitelle*

Looking from the north-west across the Bacino; to the left S. Giorgio Maggiore with the campanile (which collapsed in 1774) and the Benedictine monastery (now the Fondazione G. Cini); to the right, across the Canale della Grazia, the Giudecca with the campanile of S. Giovanni Battista (now demolished) on the left and the dome of the Zitelle (S. Maria della Presentazione) on the right; clear evening light.

Canvas, relined 68.5 × 91.5 made up to 70.5 × 93.5

Together with the pendant views P494, P503 and P508, P491 was relined in Paris (probably c.1860), when the paint surface on all four was extended by 1 cm. on each edge.[1] There are several small retouchings in the sky, in the sail of the left-hand boat, in the boatman alongside, and in the small boat with a fisherman in the centre-right foreground. There are small losses to the left of the campanile of S. Giorgio Maggiore, in the centre-right foreground boat (below

285

the sheet hanging over the side) and on the prow of the right-hand foreground boat. The varnish is somewhat discoloured.

The subject of P491 compares closely with that of P517. Curiously, the little south-eastern turret on S. Giorgio Maggiore, seen in P517, is here omitted. The collapse of the campanile of S. Giorgio Maggiore in 1774 does not necessarily furnish a *terminus ante quem*, cf.P517.

With P494, P503 and P508, P491 belongs to a set of four views of fine quality, dating from Guardi's maturity. Göring has dated them 1770–6,[2] although P508 is perhaps a little later; Watson (1968 catalogue) c.1775–80;[3] Bortolatto has dated P491 in the 1760s. When the set was sold in 1865 (see Provenance) there was a fifth view, *La Place Saint-Marc*, 68 × 91, of less quality;[4] it is now untraced.

Drawings

LONDON W. Burns, pen and wash (MD349).
VENICE Fondazione G. Cini, pen and wash, signed, ex-Wallraf collection (MD348).
An attributed pen and wash drawing is in the Wallraf-Richartz Museum, Cologne (MD350), and another, on the London art market 1975, is illustrated by Morassi as a fake (MD, fig.653).

Etching

D. Valesi, c.1778, from the drawing now in the Burns collection (MD, fig.350).[5]

Versions

Of many generally similar views, the following which include the Zitelle, most resemble P491 (see also P517).
LEEDS City Art Galleries (no.16.1/55), 47.6 × 87.6 (MP450).
LONDON Brod Gallery 1977, 34 × 53 (under MP429). Christie's, 10 December 1982 (82), 53.3 × 85 (MP434).
NEW YORK Koetser Gallery 1956, 47 × 81 (MP433).
PENRHYN CASTLE 42.5 × 69.2.
TOLEDO Ohio, Museum of Art (no.52. 62), 46.5 × 76.2 (MP428).
VENICE Accademia (no.709), 72 × 97, signed (MP427).
ZÜRICH Schaffer collection, 32.5 × 52 (MP431). Koetser Gallery c.1972, 34 × 78 (MP430).

Provenance

Together with P494, P503 and P508, acquired in Russia in 1856–7 by Charles-Auguste-Louis-Joseph, duc de Morny (1811–65);[6] his sale, Paris, 2nd day, 2 June 1865 (119), bt. by the 4th Marquess of Hertford, 20,000 fr.; rue Laffitte inventory 1871 (508, '*Guardi, quatre tableaux pendants, vues de Venise*'); Hertford House inventory 1890.

Exhibition

Bethnal Green 1872–5 (282).

References General

Simonson, no.71; MP432; Bortolatto, no.241.

[1] All four stretchers are stamped: MOMPER/A/PARIS; the set was probably relined while in Morny's collection, and in any case before 1870, when the set was in store in Paris before being brought to London in 1872.
[2] M. Göring, *Francesco Guardi*, 1944, p.51; he considered that the set preceded Guardi's view of the Piazza S. Marco during the *Sensa* of 1776 (MP279).
[3] Watson noted that a woman in front of S. Giorgio in P491 has her hair dressed high with feathers, suggestive of this later date.
[4] Lot 120 in the Morny sale, bt. by Lord Orford, 5,100 fr., about a quarter of the average price fetched by the other four. L. Lagrange, *Gazette des Beaux-Arts*, 1ère, XIV, 1863, p.386, remarked that of the five views '*quatre sont surtout sans rivales*'; he described the fifth as '*la Place Saint-Marc assoupie dans une pénombre lumineuse. Seul, le campanile . . . reçoit sur sa flèche de plomb le rayon du soleil*'.
[5] The date of Valesi's etchings is discussed by M. Levey, *National Gallery Catalogues, Seventeenth and Eighteenth century Italian Schools*, 1971, pp.130–1.
[6] Morny visited Moscow and St. Petersburg in 1856–7, representing Napoleon III at the Coronation of Alexander II; he returned to Paris with a wife, the Princess Troubetskoi, and many works of art, including the Guardis, see V. Vernier, *L'Artiste*, ns, XII, 1861, p.12, and Lagrange, *loc. cit.*

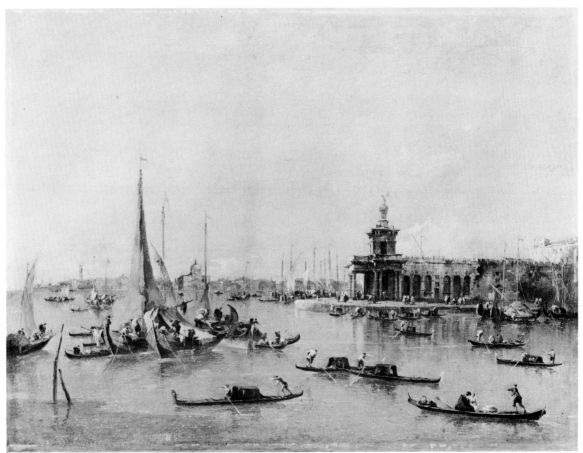

P494

P494 *Venice: the Dogana with the Giudecca*

Looking across the Grand Canal; in the left distance the Giudecca with the dome of the Zitelle (S. Maria della Presentazione) and the campanile of S. Giovanni Battista (now demolished) on the left; clear morning light.

Canvas, relined 68.2 × 91.3 made up to 70.5 × 93.5

See P491. Cleaned by Haines 1904. There are a number of retouchings, most noticeably over the wide craquelure and in the sky to the right (cf.P508). The varnish is unevenly discoloured.

One of a set of four views, see P491. Bortolatto has dated P494 in the 1760s; for further discussion of dating, see P491.

Drawings

COLOGNE Wallraf-Richartz Museum (no.2212), pen and wash, attributed to Guardi (MD359).
DRESDEN pen and wash, on the verso of a drawing of the *Flagellation*.[1]

Versions

Morassi lists a number of versions of this subject (MP497–513), but none is particularly close to P494 which shows the Dogana from a view-point both higher and further away.

Provenance

See P491; Morny sale, lot 118, bt. by the 4th Marquess of Hertford, 20,000 fr.

Exhibition

Bethnal Green 1872–5 (271).

References General

Simonson, no.73; MP505; Bortolatto, no.151.

[1] See *The Burlington Magazine*, XLIX, 1926, pp.30–2, illus.

P502

P502 *Capriccio with the archway of the Torre dell'Orologio*

Beech panel 27.6 × 22.1 × 0.3 oval two vertical members, the left 4.4 wide

The panel surface is roughly finished. The red wood shows through in the thinner passages, noticeably in the sky.

The identification of the archway as that of the Torre dell'Orologio, suggested

by Simonson[1] and Morassi,[2] seems confirmed by comparison with the Guardi no.2523 in the National Gallery, London.[3] Pendant to P504, and probably to be associated with a *capriccio* in the Musée de Lyon (MP799);[4] another *terzetto* of such Guardi views has been proposed by Levey.[5] Both execution and costume suggest that P502 and P504 are late works; Watson (1968 catalogue) suggested late 1780s and Levey 'probably post 1780'.[6]

Drawings

LENINGRAD Hermitage, pen and wash (MD586).
LONDON British Museum (no.1861-8-10-10), pen and wash (MD584). Princes Gate Collection (no.136), pen and wash (MD585).[7]

Versions

BERGAMO Accademia Carrera (no.228), 42 × 29, with commedia dell'arte figures (MP813).
LENINGRAD Hermitage, panel 52 × 38.5 (MP811).[8]
LONDON ex-N. Fischmann collection, 51 × 36 (MP815).
MILAN M. Crespi estate, 54 × 36 (MP, under 813).
MUNICH Alte Pinakothek, 60 × 43 (MP812).[9]
NEW YORK Knoedler 1938, 25.5 × 18 (MP, under 812).
PROVIDENCE Rhode Island School of Design, 40 × 51.5 (*ibid.*).
RINGWOOD Hants., 49.5 × 36.5.
VIENNA G. Nebehay 1927, 76.5 × 57.

Provenance

Acquired by the 4th Marquess of Hertford in Paris; Hertford House inventory 1890.

Exhibition

Bethnal Green 1872–5 (274).

References General

Simonson, no.75; MP814; Bortolatto, no.522.

[1] First recorded in the 1913 catalogue.
[2] Under MD584.
[3] See M. Levey, *National Gallery Catalogues, Seventeenth and Eighteenth century Italian Schools*, 1971, pp.130–2.
[4] Like P502 and P504, the Lyon picture is an oval panel, 26 × 21 (and not a canvas, as MP799 suggests); it is generally similar to no.2523 in the National Gallery; see P. Dissard, *Le Musée de Lyon: Les Peintures*, 1912, p.29 and pl.14. Levey, *loc. cit.*, first pointed out this association; he suggested that the Lyon picture may be inferior in quality to P502 and P504 but at least the composition is that of the third subject.
[5] Levey, *loc. cit.*, the *terzetto* comprising National Gallery no.2523, and the two *capricci* at Ringwood (listed under versions of P502 and P504).
[6] Levey, *op. cit.*, p.132 n.12.
[7] See *Italian Paintings and Drawings at 56 Princes Gate, London S.W.7*, 1959, no.136.
[8] Illus. *The Burlington Magazine*, LXV, 1934, p.70, and M. Göring, *Francesco Guardi*, 1944, fig.95.
[9] Illus. Simonson, f.p.54, when with Dowdeswell in London.

P503 *Venice: S. Maria della Salute and the Dogana*

On the right the monastery of S. Gregorio (which was suppressed in 1775); beyond the Salute the Seminario; to the left in the distance the Molo and the Riva degli Schiavoni and the domes of S. Marco and the Campanile; early evening light.

Canvas, relined 68.5 × 90.5 made up to 70.5 × 93.5

See P491. There are many retouchings, the most apparent being across the sky, top centre left. The varnish is somewhat discoloured.

One of a set of four views, see P491. The inclusion of the Molo seems wilful according to the angle of the Salute; the view may be compared with P495 After Canaletto. P503 has been dated in the early 1770s by Kultzen,[1] and see P491 for further discussion.

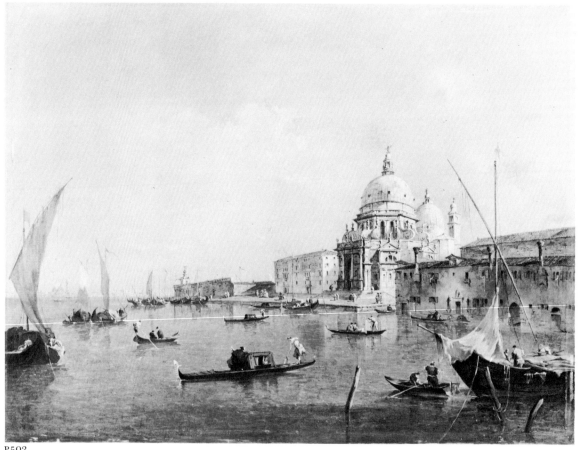

P503

Drawings

ROTTERDAM Boymans-van Beuningen
Museum, chalk, pen and wash (MD353).[2]
An attributed drawing is in the Art Institute,
Chicago (MD, under 358); another was with K.
Rutschi, Brugg, Switzerland 1980, and a
third, on the London art market 1975, is
illustrated by Morassi as a fake (MD, fig.652).

Versions

The following compare quite closely with
P503.
ALBI Musée Toulouse-Lautrec, 55 × 89
(MP489).
BERLIN Lepke sale, 21 October 1910(29),
65 × 92.
LONDON with Leggatt 1951, 28 × 39.3.
LOS ANGELES Norton Simon Foundation,
40.5 × 50 (MP490).

MILAN private gallery, 33 × 45.7 (MP496).
OTTAWA National Gallery of Canada
(no.6188), 71 × 95 (MP488).
PARIS Coty sale, 30 November 1936(22),
34 × 53.

Provenance

See P491; Morny sale, lot 117, bt. by the
4th Marquess of Hertford, 18,000 fr.

Exhibition

Bethnal Green 1872–5 (278).

References General

Simonson, no.72; MP487; Bortolatto, no.377.

[1] R. Kultzen, *Pantheon*, XXV, 1967, p.270.
[2] See also J. Byam Shaw, *The Drawings of Francesco Guardi*,
1951, p.62, no.21.

P504

P504 *Capriccio with the arcade of the Doge's Palace and S. Giorgio Maggiore*

Beech panel 27.6 × 22.1 × 0.3 oval two vertical members, the right 6.1 wide

The panel surface is roughly finished. There are retouchings along the join and in an area lower right. The red wood shows through in the thinner passages, particularly in the sky. *Pentimenti* suggest that the height of the arches has been slightly increased. There is a small loss on the centre pilaster on the left.

See P502, the pendant view. Guardi has slightly exaggerated the height of the arches. Watson (1968 catalogue) observed that the women's hair style would indicate a date of 1780 or a little later.

Drawings

COPENHAGEN Royal Museum of Fine Arts, water-colour (MD533).
MILAN M. Crespi estate, pen and wash (MD534).
Other attributed drawings were with S. Moeller, Budapest (MD534), in the Argoutinsky-Dologoroukow sale, Sotheby's, 4 July 1923(132), and sold Sotheby's, 28 November 1962(32) (MD532).

Etchings

D. Valesi, c.1778 (see P491 note 5), from the Crespi drawing (MD, fig.527); showing a lantern on the right-hand side of the arcade, as in the versions listed below.

Versions

BERLIN formerly B. Richter, 60 × 43, without lantern (MP781).
LISBON Gulbenkian Foundation, panel 24 × 17 (MP774).
NEW YORK formerly Knoedler, 25.5 × 18 (MP780).
PARIS Moratilla collection, 38 × 33 (MP775).
RINGWOOD Hants., 49.5 × 36.5 (MP776).

Provenance[1]

Acquired in Paris by the 4th Marquess of Hertford; Hertford House inventory 1890.

Exhibition

Bethnal Green 1872–5 (275).

References General

Simonson, no.76; MP779; Bortolatto, no.749.

[1] R. Pallucchini, *Francesco Guardi*, Fundação Gulbenkian, 1965, note to pl.xx, implies that P504 was acquired from the collection of Sir Cecil Newman, perhaps confusing P504 with the *capriccio* once in that collection and listed by Morassi as with Knoedler, New York (MP777).

P508 *Venice: the Grand Canal with the Riva del Vin and Rialto Bridge*

On the left the Riva del Vin with the three-bay Palazzo Barbarigo and the Palazzo dei Dieci Savi next to the Rialto; on the right beyond the Rialto the Fondaco dei Tedeschi; clear afternoon light.

Canvas, relined 68.5 × 91.5 made up to 70.5 × 93.7

See P491. There are a number of retouchings, noticeably over the wide craquelure and in the sky (cf.P494). The varnish is somewhat discoloured. The surface was ironed by Morell in 1929.

One of a set of four views, see P491. P508 has a slightly darker tonality than the others and was probably painted a little later; both Morassi and Bortolatto place it in the 1780s, although Göring (see P491) implied a date of 1770–6 in common with the other pictures in the set. The view may be compared with that in P511 by Canaletto.

Drawings

EPINAL Musée des Vosges, pen and wash (MD366).
PARIS Louvre, pen and wash, showing the left side of P508 but differing on the right (MD364).
ZÜRICH Bührle collection, pen and wash (MD367).
Other attributed drawings sold Sotheby's 22 July 1937(24); Christie's, 11 February 1938(8), and with Knoedler, New York 1975 (see MP, under 529).

Versions

Of many versions of this subject the following compare quite closely with P508.
BERGAMO Accademia Carrara (no.232), 24 × 34 (MP538). Lorenzelli gallery, panel 21 × 33 (MP527).
LONDON Sotheby's, 1 November 1978(60), panel 23 × 35 (MP532).
MUNICH S. Lodi gallery, panel 19.5 × 33 (MP526).

NEW YORK Knoedler 1973, 43.3 × 60 (MP531). Metropolitan Museum of Art (no.1982-60-15), panel 17.5 × 32 (MP536).
SAN DIEGO Timken Art Gallery, 57 × 85, signed (MP543).
TOULOUSE Musée des Augustins, 63 × 92.5 (MP544).
WASHINGTON National Gallery of Art (no.623), 68.5 × 91.5 (MP529), and no.1038, panel 19.1 × 30.3.
ZÜRICH Bührle collection, 30 × 45, ?with F. A. Drey 1971 (MP530).

Provenance

See P491; Morny sale, lot 116, bt. by the 4th Marquess of Hertford, 25,000 fr.

Exhibition

Bethnal Green 1872–5 (272).

References General

Simonson, no.74; MP528; Bortolatto, no.405.

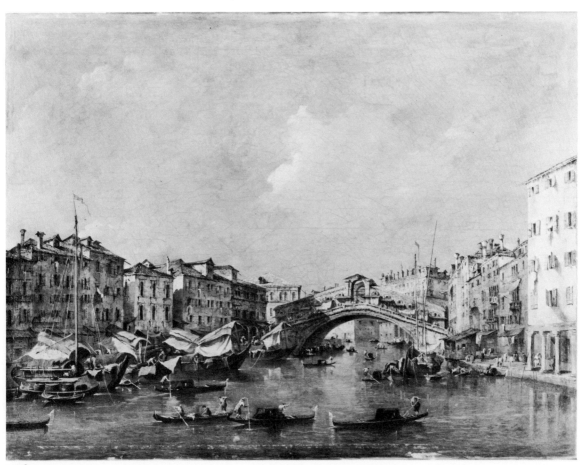

P508

P517 detail

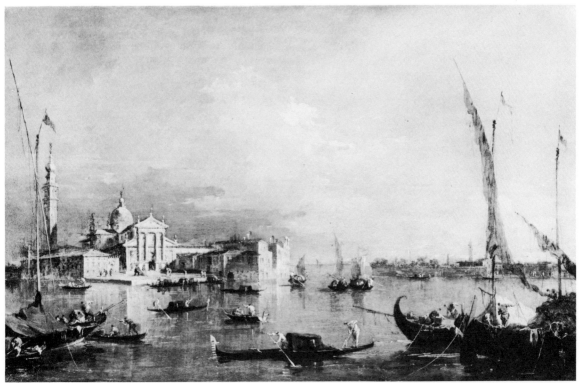

P517

P517 *Venice: S. Giorgio Maggiore with the Giudecca*

Similar to P491, but without the Zitelle on the right, and seen from a slightly lower view-point; strong evening light.

Canvas, relined 35.2 × 54.7

Cleaned by Vallance in 1961. Some minor retouchings in the sky. *Pentimenti* show that S. Giorgio Maggiore was first placed further away and to the left.

Together with its pendant P518, P517 is a work of high quality from Guardi's maturity. The dramatic, silvery light and the nervous brush strokes suggest a date c.1780, i.e. after the campanile of S. Giorgio Maggiore, seen on the left in P517, had collapsed (cf.P491). A comparable pair of views, the same size, are in a private collection in Paris (MP449, 491),[1] and another, smaller pair (18 × 32) were in the Rothan sale, Paris, 29 May 1890, lots 221 and 223.

Drawings

See P491.

Versions

See above, and P491. Of many similar views, the following, which do not include the Zitelle, most resemble P517.

BEL AIR California, Mr. and Mrs. E. W. Carter, 40.5 × 50 (MP425).
LONDON Haywood-Lonsdale sale, Christie's, 4 December 1964(70), 42 × 60 (MP453). Christie's, 7 July 1972(25), ex-Rothermere collection, 46.9 × 64.7 (MP442). Sotheby's, 7 July 1976(62), ex-Bingham collection, 32.5 × 47.5 (MP426). Von Hirsch sale, Sotheby's, 20 June 1978(113), panel 20 × 32 (MP446).

NEW YORK Parke Bernet, 30 November 1950(11), 34.5 × 45 (MP448).
PARIS private collection, 34 × 53 (MP451).

Provenance

Acquired by the 4th Marquess of Hertford in Paris; Hertford House inventory 1890.

Exhibition

Bethnal Green 1872–5 (277).

References General

Simonson, no.78; MP429; Bortolatto, no.249.

[1] Exh. Paris, Orangerie, *Venise au dix-huitième siècle*, 1971, nos.89 and 90.

P518 *Venice: the Dogana with S. Maria della Salute*

Looking across the Grand Canal; the Seminario between the Dogana and the Salute with the monastery of S. Gregorio (see P503) to the right; the Giudecca in the left distance; in morning light.

Canvas, relined 35 × 54.7

Cleaned by Vallance in 1961.

See P517, the pendant view. The subject may be compared with P515 After Canaletto.

Drawings

OXFORD Ashmolean Museum, pen and ink, perhaps drawn on the spot (MD356).[1]
An attributed drawing was with H. Holm, Amsterdam 1946.

Versions

Of many versions of this subject the following compare quite closely with P518.
BIRMINGHAM City Art Gallery (P74.47), 32.5 × 52 (MP482).
HOUSTON Museum of Fine Arts, 49.5 × 90.2 (MP479).
LONDON private collection, 84 × 126 (MP478). Hallsborough Gallery 1955, panel 24.1 × 35.5. Cripps sale, Christie's, 15 July 1955(69), 53.5 × 70 (MP493). Christie's, 29 October 1965(72), ex-Spencer Churchill collection, 42 × 54.5 (MP477). Sotheby's, 7 July 1976(62), 32.5 × 47.5 (MP483).
LUCERNE Fischer, 8 September 1924(94), 47 × 81.5 (MP495).

MILAN art market 1973, 33 × 45.7 (MP496).
A. Gerli collection, 48 × 68 (MP476).
NEW YORK Metropolitan Museum of Art (no.1982-60-14), panel 17 × 32 (MP485).
PARIS comte de B., 53.5 × 85.8 (MP484).
SAN FRANCISCO California, Palace of the Legion of Honor, 48 × 66 (MP492).
ZURICH private collection, 32 × 51.5 (MP494).
See also P517.

Provenance

As P517.

Exhibition

Bethnal Green 1872–5 (281).

References General

Simonson, no.79; MP481; Bortolatto, no.297.

[1] K. T. Parker, *Catalogue of Drawings in the Ashmolean Museum*, 1956, II, pp.508–9, no.1012.

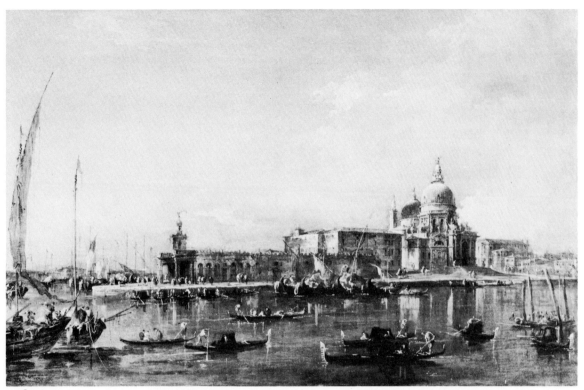

P518

P647

P647 *Capriccio with the courtyard of the Doge's Palace*

From the south looking through an arcade towards the Giants' Staircase on the right and the Foscari Arch on the left; the length of the courtyard has been drastically reduced, the façade beyond the Staircase is somewhat fanciful and a gilded statue of Minerva(?) stands at the top of the Staircase instead of Sansovino's *Neptune and Mars*.

Canvas, relined 38.6 × 28.9

A heavy twill canvas, relined before 1859.[1] There are minor retouchings in the sky and on the left-hand balcony on the Foscari Arch. *Pentimenti* show that the left-hand arch of the arcade has been moved slightly to the left.

Dated in the 1770s by Göring[2] and placed after the National Gallery version (see below) by Bortolatto, implying a date in the later 1770s.

Drawings

Three pen and wash drawings in the Metropolitan Museum, New York (nos.37.165.71, 80 and 87; MD551–3),[3] show a similar view but with the foreground arcade running diagonally across the composition. A similar drawing, with a Minerva statue against the left-hand foreground pillar, was with Tooth 1950. Levey mentions two other related drawings.[4]

Versions

LONDON National Gallery (no.2519), 22.1 × 17.2 (MP790).[5]
PARIS Musée Cognacq-Jay, 14.5 × 11.1.[6]
The following versions show the foreground arcade running diagonally, as in the drawings listed above.
BERGAMO Accademia Carrara (no.229), 39 × 26 (MP791).
PRAGUE National Gallery (no.305), 45 × 32 (MP792); a smaller version of this picture was with Koetser, London 1971.
Attributed versions of this variant composition are listed by Morassi in the Jaffé collection, Berlin c.1930, and with Knoedler, New York (MP, under 792); a late copy is in the Metropolitan Museum, New York (*ibid.*).

Provenance

Acquired by the 2nd Baron Northwick (1769–1859) by 1846;[7] his sale, Thirlestane House, Cheltenham, Phillips, 1st day, 26 July 1859(93), bt. Mawson for the 4th Marquess of Hertford, £54; Hertford House inventory 1890.

Exhibition

Bethnal Green 1872–5 (276).

References General

Simonson, no.77; MP789; Bortolatto, no.469.

[1] The lining canvas still bears the lot number from the 1859 sale.
[2] M. Göring, *Francesco Guardi*, 1944, p.43.
[3] See H. W. Williams, *Art Quarterly*, II, 1939, pp.267, 271 and 274. Illus. Göring, *op. cit.*, figs.72–4.
[4] M. Levey, *National Gallery Catalogues, Seventeenth and Eighteenth century Italian Schools*, 1971, pp.125–6: a drawing once in the collection of Lord Bearsted, and another exh. *Venice in the Eighteenth Century*, Fogg Art Museum, 1948(18), lent by Mr. and Mrs. E. J. Holmes.
[5] *Ibid.*, accepting a date in the 1770s, as proposed by Göring, *loc. cit.* The National Gallery version omits the statue of Minerva.
[6] *Collections léguées à la ville de Paris par Ernest Cognacq, Catalogue*, 1930, p.22, no.55.
[7] Listed in *Hours in the Picture Gallery of Thirlestane House*, 1846, p.50, no.CCL. P647 may also be seen in Thirlestane House in the painting attributed to R. Huskisson, exh. BI 1847 (506), now in the Yale Center for British Art, New Haven (no.1225).

P493

Italian School third quarter 18th century

P493 *Malta: the Grand Harbour of Valletta*

Looking south-east. In the foreground, centre right, Fort S. Elmo with a light-house and a procession of the Grand Master (see below), and the city of Valletta; on the left, from the foreground, on successive headlands, Fort Ricasoli and the towns of Vittoriosa and Senglea. Between these land masses the Grand Harbour. To the right of the composition, Fort Manoel (built in 1724), and behind it the aqueduct of Wignacourt. In the foreground warships and galliasses display the flag of the Knights of Malta (a white cross on a red field).

Canvas, relined[1] 106 × 207.3

The surface is somewhat rubbed. There are areas of loose paint in the left half, and many discoloured retouchings, particularly along a roughly horizontal line 76 cm. long across the centre. Considerably discoloured by old varnish.

Valletta, on the north-east coast of the island of Malta. The island was granted to the catholic Knights of S. John by Charles V in 1530; after they had successfully resisted the Great Siege of Suleiman I in 1565, their Grand Master, J.-P. de La Vallette (1494–1568), built the heavily fortified harbour named after him, which became the island's capital in 1570.[2] The Knights subsequently lost the island to Napoleon in 1798; from 1814 to 1964 it was a British colony, before becoming independent.

P493 derives from an engraving published in Paris c.1730–40, *Malte, Vue de l'Entrée du Port, dessiné sur le lieu et gravé par le S^r Milcent* (P.-N. Milcent),[3] but it is inferior in its draughtsmanship. It was probably painted in Italy, and Constable has noted a similarity with the work of Giuseppe Guerra (active in Rome and Naples, d.1761).

Engraving
See above.

Provenance[4]
Probably acquired by the 4th Marquess of Hertford; Hertford House inventory 1870 as *'Canaletto A Panoramic View of Venice including the Doges Palace'*, see Appendix II.

Reference General
W. G. Constable, *Canaletto*, rev. by J. G. Links, 1976, II, p.473, as possibly by Guerra.

[1] The reliner used a French newspaper, *Le Messager de Toulouse*, 7 September 1867.
[2] In the eighteenth century both the French and English called Valletta 'Malta', cf. Milcent's print as quoted above and the *Encyclopaedia Britannica*, 1771, III, p.22: 'Malta, the capital of a small island of the same name'.
[3] P493 differs only in detail, e.g. in the appearance of the aqueduct (built in 1614). A version of the print was published in London c.1760–70. French interest in Malta in the eighteenth century was not only strategic, for many of the Knights were of French origin.
[4] In the 1928 catalogue it was suggested that P493 may have been in the Giusta sale, Paris, 7–8 February 1809 (17, *'Canaletti, quatre tableaux, une perspective de la ville de Venise'*).

P776

Italian School (?) 18th century (?)

P776 *Two Amorini*

Red chalk on whitened paper 17.9 × 16.5 laid down on two layers of heavier paper

There is a small repair below the left foot of the left-hand *amorino*, and a tiny hole top left.

The degree of finish in some parts combined with the unfilled outlines of others would suggest that P776 is a copy from, rather than a study for, a mythological scene, perhaps a *Triumph of Love*. Previously catalogued as School of Parma (1920) and School of Boucher (1928).

Provenance
Probably the vicomte Both de Tauzia
(1823–88), see Appendix IV; acquired by Sir
Richard Wallace in or after 1872; Hertford
House inventory 1890 unattributed.

Bernardino Luini (active 1512, died 1532)

Probably born in Luini, by Lake Maggiore. Possibly by 1499 (when Leonardo left) he had come to Milan where he was influenced by Bramantino, Andrea Solario and, increasingly, by Leonardo whose manner he superficially adapted to a conservative taste. At least three of his compositions appear to derive from Leonardo designs (*The Virgin and S. Anne* in the Ambrosiana; *Christ among the Doctors* in the National Gallery, London; and *Christ carrying the Cross* in the Poldi Pezzoli Museum, Milan), and many of his works have borne attributions to Leonardo (cf. P10 below). Because of a dearth of dated works, and his stylistic consistency, there is no satisfactory chronology for his easel paintings. More is known concerning his many commissions for decorations in churches and villas in the Milanese, from the earliest in 1512 for frescoes in the *abbazia* at Chiaravalle, to the last of 1529–32 for frescoes in S. Maria degli Angeli, Lugano. Luini received payment in 1531 for frescoes executed at Saronno, but a payment of 1 July 1532 for work at Lugano was made to his heirs. It is assumed he died in 1532, probably in Milan.

Abbreviation

Chiesa A. O. della Chiesa, *Bernardino Luini*, 1956

P8 *The Virgin and Child in a Landscape*

The Virgin is fair-haired with a white head-dress, a light purple dress and a yellow-lined blue cloak; the Child is fair-haired. On the red brecciated marble ledge lie a red book, an ivory teething stick with black ribbons,[1] and a white cloth (doubtless to be read as emblems of wisdom, innocence and death).

Poplar panel 73.2 × 54.4 × 1.9

The paint surface was relaid by Buttery in 1879; it is now lifting in the central area, including the right side of the Virgin's face. Retouchings on the Virgin's skirt, her left eye and hair, and the shadow above the Child's left leg is bituminous.

The composition suggests the influence of Andrea Solario. Cook thought P8 an early work[2] and Chiesa places it earlier than P10, perhaps contemporary with the similar composition in the Litta Modignani collection, Milan (Chiesa, no.168).

Provenance

Stated by Waagen to have come from the Fesch collection,[3] but not identified in the 1841 Fesch catalogue or the 1845 Fesch sale of Italian pictures; acquired by the 4th Marquess of Hertford in London before 1854 when it was seen in Hertford House by Waagen; Hertford House inventory 1870.

Exhibition

Bethnal Green 1872–5 (262).

Reference General

Chiesa, no.87.[4]

P8

[1] I am grateful to Miss N. C. Marshall of the Bethnal Green Museum and to D. W. Wright of the Wellcome Museum of the History of Medicine, for their assistance in identifying this object. Mr. Wright also points out that, in England at least, black silk was thought to be effective against teething troubles.

[2] H. Cook, *Gazette des Beaux-Arts*, 3e, XXVII, 1902, p.448.

[3] Waagen, IV, p.79; since he saw the picture in Hertford House in 1854 the provenance previously proposed for P8 (lot 1079 in the Northwick sale, 1859) is clearly mistaken. Perhaps P8 was the *Virgin and Child* by Luini in Sir William Forbes' sale, 2 June 1842, 76.2 × 56, 110gn.

[4] Chiesa, pl.93, shows P8 cropped along the lower edge, omitting the marble ledge.

Two Fresco Fragments from the Villa Pelucca

P526 *Putto picking Grapes*

Fair-haired with pink drapery.

Fresco transferred to canvas and mounted on panel
original painted area 49.2 × 64 (maximum) with arched top

The surface is worn and has been retouched throughout. Three horizontal cracks, above and below his left arm and 22 cm. above the bottom left corner, have penetrated from the supporting panel. The spandrels have been painted gold and are not part of the original fresco.

P537 *Head of a Girl*

Fair-haired with white dress and red girdle.

Fresco transferred to canvas and mounted on panel
original painted area 48.4 × 35.6 (maximum)

The surface is very rubbed and little remains of the drapery folds. Some incipient vertical cracks, to the left of her ear and to the left of her face, have penetrated from the supporting panel. Cleaned by Ruhemann in 1937.

P526 and P537 formed part of the fresco decorations in a *gabinetto* of the Villa Pelucca, near Milan. Luini decorated three rooms and the chapel of the Villa, with mythological, genre and religious scenes, for Gerolamo Rabia[1] between c.1520 and c.1523. Their history was first published by Beltrami in 1911.

The frescoes had been badly restored in 1806, when the Villa belonged to Eugène de Beauharnais. In 1816 it reverted to the Austrian government who proposed using it as a farm house and stables, whereupon the Accademia di Belle Arti of Milan obtained leave to remove thirty-seven fragments of Luini's frescoes. Between the spring of 1821 and June 1822 Stefano Barezzi (1789–1859) removed twenty-five fragments for the Accademia (the original number having been adjusted), of which ten went to the Brera and fifteen to the Palazzo Reale (these were transferred to the Brera in 1906). Since a further ten fragments are preserved in other collections (see below) it seems clear that Barezzi also worked on his own account. His *strappo* technique for removing the frescoes,[2] unusual in that the frescoes were laid down on a fine gauze canvas before being glued to wooden panels, was not invariably successful.[3]

In 1821 the frescoes in the *gabinetto* (which measured 2.5 × 4.5 m.) were described as a '*Bagni di ninfe e giuochi famigliari, oltre le 8 lunette*'.[4] The *Nymphs bathing* (135 × 250) is now in the Brera (no.749). Of the *giuochi famigliari* (girls playing *il gioco del guancialino d'oro*, in which one hides her face and guesses who touches her) seven fragments survive; three in the Brera (nos.71, 75 and 750), and one each in the musée Condé at Chantilly, the Civica Pinacoteca at Pisa, and in the Borromeo collection at Isola Bella, besides P537. Apart from no.71 in the Brera,

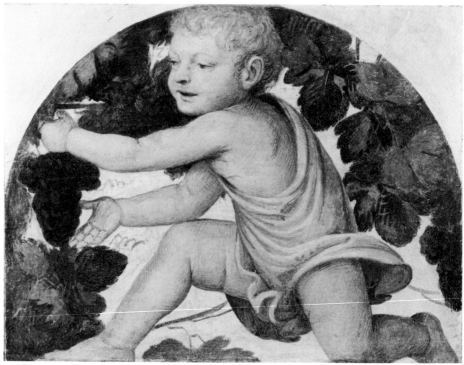

P526

which measures 140 × 100, these fragments are comparable in size. Seven of the lunette panels survive; three in the Brera (nos.16, 746 and 747), two in the Louvre (MI343–4), one in the musée Condé and P526.

Between 1900 and 1905 P537 was catalogued as by Bramantino, to whom no.71 in the Brera was also once attributed.

Provenance

Removed from the Villa Pelucca, Milan, in 1821–2;[5] the Duca Antonio Litta-Arese-Visconti, from whom acquired by the vicomte Both de Tauzia (1823–88) in 1867;[6] purchased from him by Sir Richard Wallace in 1872, see Appendix IV; Hertford House inventory 1890.

References General

Chiesa, nos.120/22 and 25, pp.27–9, 98–101; L. Beltrami, *I Dipinti di Bernardino Luini alla Villa Rabia detta 'La Pelucca'*, 1911, pp.51, 80, and *Luini*, 1911, pp.199–267.

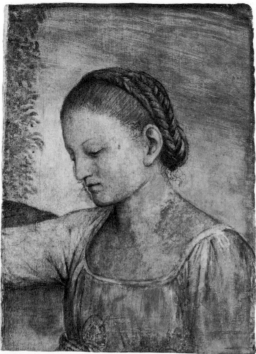

P537

[1] Luini had decorated his house in Milan (cf. Vasari-Milanesi, VI, p.519; Chiesa, no.154).

[2] Orthodox *strappo* technique is described, for example, in *Frescoes from Florence*, Arts Council, 1969, pp.34–43.

[3] There seem no grounds for the statement of Williamson (*Luini*, 1899, p.247) that some of the frescoes were reversed in the process of removal.

[4] In the report of the Commissione Accademica, quoted by Beltrami, *Luini*, p.247; he supposes that originally there must have been ten lunettes, but the Villa was modified early in the nineteenth century.

[5] On the *verso* of P526 is written: *Questo Puttino rappresentante Bacco è stato dipinto a fresco / da Bernardino Luini / in una Casa di Campagna vicina a Milano, / denominata La Pelucca. / Il Signore Stefano Barezzi con somma bravura e finissimo / artifizio ha trasportato questo Dipinto dal muro su questa tavola / il Mese di Giugno dell'Anno 182(1?) / Raffaelo Tosoni.* The date has been read as 1824, but 1821 seems more likely and accords with the official dates of Barezzi's activity at the Villa. A separate label on the verso of P526 is inscribed: *A Fresco / Di Bernardino Luini / Da Cassani Maggio 1835 / Castelburchi-Fraganeschi / Castelbarco Litta Albani.*

[6] In 1867 Tauzia negotiated the purchase of Luini frescoes for the Louvre with the estate of the Duca Antonio Litta-Arese-Visconti (cf. Ph. de Chennevières, *Souvenirs d'un Directeur des Beaux-Arts*, 1979 ed., v, p.41).

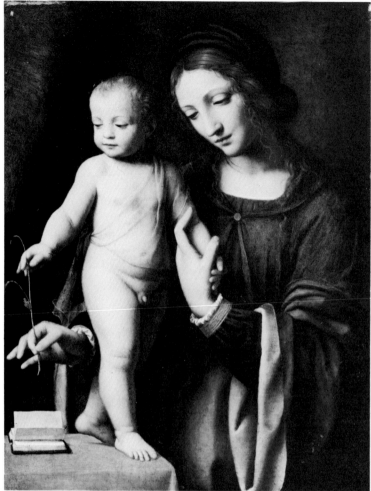

PIO

Ascribed to Luini

PIO *The Virgin and Child with a Columbine*

The Virgin is fair-haired with a purple head-dress, white chemisette, dark maroon bodice with wide yellow-lined sleeves, golden-brown skirt, turquoise-blue under-sleeves with gold-banded cuffs, and a grey-blue cloak clasped at the neck; the Child is fair-haired; a green book lies on the red table-cloth; the background is a rich, dark green.

Poplar panel 73.4 × 55.2 × 1.1
a strip 7 mm. wide has been added round the edges

The panel is cradled and the constriction is probably the cause of the lifting paint in the central area, particularly apparent in the Child's hair and legs. Cleaned by Holder in 1938. There are a number of retouchings, e.g. in the Virgin's left hand and wrist, the Child's breast and right hip and above and below the book. The shadow below the Child's chin has been strengthened. The varnish is discoloured.

The columbine, held by the Virgin and Child with their right hands, was commonly used as a symbol of the Holy Ghost.[1]

P10 which shows one of Luini's popular Leonardesque compositions is probably later than P8. P10 has previously been given to Luini himself but it appears not to be of prime quality, although condition prevents a definitive assessment. The Apsley House version (see below), formerly in the Palacio Real, Madrid, has been called by Chiesa and Kauffmann[2] a replica of P10, but the reverse is possibly the case.

Versions

BASLE Kunstmuseum, panel 44 × 33 (Chiesa, no.4).
COLOGNE Lempertz sale, 5–7 May 1960(61), panel 71 × 62, attributed to Luini.
LENINGRAD Hermitage, panel 66 × 51, attributed to Luini (Chiesa, no.77).
LONDON Apsley House (see above), panel 74 × 51.5, engraved in 1784 as Leonardo (Chiesa, no.92).
Private collection, panel 84 × 50, a copy, ex-Czernin collection, sold Christie's, 24 May 1963(74) (Chiesa, no.246).
MILAN Gallaratti Scotti collection, panel 75.5 × 52, workshop copy (Chiesa, no.165).
MUNICH Julius Böhler, 67 × 50, attributed.
NEW YORK Parke Bernet, 15 January 1944(40), panel 68.5 × 52, attributed, ex-Thompson collection (Chiesa, no.32).

Provenance

Nieuwenhuys; the comte de Pourtalès-Gorgier (1776–1855) by 1841, as Leonardo and from the Palacio Real, Madrid;[3] his sale, Paris, 10th day, 1 April 1865 (76, as Leonardo, '*longtemps [dans] le palais des rois d'Espagne . . . Provient de la collection Nieuwenhuys*'), bt. by the 4th Marquess of Hertford, 83,500 fr.; possibly rue Laffitte inventory 1871 (98, '*Italien, Vierge et Jésus*'); Hertford House inventory 1890 as Leonardo.

Exhibition

Bethnal Green, 1872–5 (258, as Leonardo).

Reference General

Chiesa, no.88, as Luini.

[1] Discussed by C. M. Kauffmann, *Catalogue of Paintings in the Wellington Museum*, 1982, pp.89–90, no.100.
[2] Chiesa, no.92; Kauffmann, *loc. cit.*
[3] J. J. Dubois, *Description des Tableaux . . . de M. le comte de Pourtalès-Gorgier*, 1841, p.5, no.7. The mistaken Madrid provenance was possibly based upon the 1784 engraving by J. G. de Navia, which in fact was of the Apsley House version; Dubois wrote that P10 '*n'est sorti [du Palais Royal] que depuis peu d'années*', which may indicate that Nieuwenhuys sold it to Pourtalès in the 1830s.

Carlo Maratta (1625–1713)

Baptised on 15 May 1625 at Camerano (Ancona). In 1636 he went to Rome where he studied, as a boy, under Andrea Sacchi, and became influenced by Correggio and Cortona. In 1650 he established his reputation with the *Adoration of the Shepherds*, painted for the church of S. Giuseppe dei Falegnami. Thereafter he became the principal master of late Baroque painting in Rome. He died in Rome on 15 December 1713.

P774 *The Virgin of Mercy with SS. Bonaventure and Eulalia*

S. Bonaventure kneels on the left, S. Eulalia on the right; above the Virgin an angel holds a rosary; inscribed below: *ma esté donne par le Prince. Dom Livio/Carlo Marato*, and numbered *58* bottom right. Inscribed *verso: Vient du P Dom Livio*.

Red chalk and brown wash on whitened paper 23.3 × 15.9/16.4

A stain runs down the centre of the sheet and there is a small repair on S. Bonaventure's right elbow.

P774 was identified by Manuela Mena as a study for the *Virgin of Mercy* commissioned from Maratta in 1656 by the *Cofradía del Gonfalón* for their church of S. Eulalia in Palma, Majorca. This Order was descended from the *Raccomandati di Madonna Santa María* which counted S. Bonaventure among its founders; it was established in Palma in the late fifteenth century as the *Cofradía de Nuestra Señora de Santa Eulalia* which, in 1590, became the *Cofradía del Gonfalón*. Mena comments that the composition is unusual in that it combines the Virgin of Mercy (the protectress of Christendom) with the Virgin of the Rosary (whose feast was decreed in 1583).[1]

P774 reflects the influence of Sacchi, and Mena further suggests that the pose of the Virgin may have been influenced by Duquesnoy's figure of *S. Susanna* in S. Maria di Loreto, Rome. Another study for the Palma altarpiece, of various hands and S. Bonaventure's feet, is in the Academia S. Fernando, Madrid.[2]

Related Painting

PALMA Majorca, S. Eulalia; 310 × 230, the composition differs in details (e.g. S. Eulalia kneels on a cross and the angel holding a book in the foreground is omitted).[3]

Provenance

The inscription on P774 has been identified as in the hand of Pierre Crozat (1665–1740).[4] It indicates that P774 was given him from the collection of Prince Livio Odescalchi (1652–1713) who in 1692 had purchased the collections of Queen Christina of Sweden (1626–89) from Pompeo Azzolino, nephew of her legatee, Cardinal Decio Azzolino (d. 1689); P774 must have been amongst those drawings given to Crozat after he had completed the purchase of Odescalchi's collection for the duc d'Orléans in 1721.[5] Probably acquired by the vicomte Both de Tauzia (1823–88), see Appendix IV; acquired by Sir Richard Wallace in or after 1872; Hertford House inventory 1890.

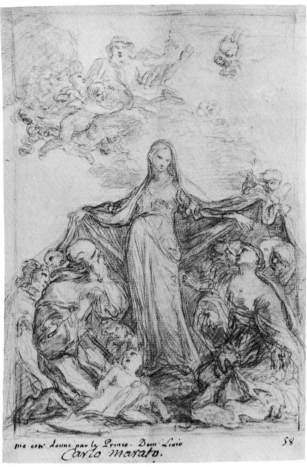

P774

Reference General

Manuela Mena, *'La Obra de Carlo Maratta en la década de 1650', Antologia di Belle Arti*, II, 1978, 7–8, pp.184–6, 190 nn.26–40.

[1] Both, as Mena indicates, may be related to the Battle of Lepanto (1571), a Christian victory over Islam, which caused Gregory XIII to decree the feast of the Rosary of the Blessed Virgin Mary in 1583.
[2] Illus. Mena, *op. cit.*, p.187.
[3] Illus. (reversed) Mena, *op. cit.*, p.185.

[4] By D. Mahon in his catalogue *Omaggio al Guercino*, Cento, 1967, pp.63–4. See also Polidoro da Caravaggio P775, note 12.
[5] Cf. C. Stryienski, *La Galerie du Régent*, 1913, pp.18–31; Crozat was negotiating the purchase of Odescalchi's famous collection for the duc d'Orléans between 1714 and 1721; he had admired particularly the drawings it contained and, in the end, he received seven cases of drawings from the collection for himself. See also P.-J. Mariette, *Description ... du cabinet de feu M. Crozat*, 1741, p.x; J. Q. Regteren van Altena in *Christina Queen of Sweden*, Nationalmuseum, Stockholm, 1966, pp.459–60 under no.1129; M. Mahoney, *Master Drawings*, III, 1965, pp.383–9, and W. Vitzthum, *Master Drawings*, IV, 1966, p.300.

Onorio Marinari (1627–1715)

Born in Florence on 3 October 1627, the son of a minor painter, Sigismondo di Pietro Marinari, from whom he received his first tuition, and the cousin of Carlo Dolci, whose best pupil he became. Baldinucci mentions him assisting Dolci in the later 1650s. While he remained capable of imitating closely his master's style, he was later influenced by Pignone and Furini. He executed a number of altarpieces for Florentine churches and his fresco in the Palazzo Capponi, Florence, is dated 1707. In 1674 he published his illustrated *Fabbrica ed uso dell' Annulo Astronomico*. A self-portrait in the Uffizi shows him aged eighty-two in 1709. He died in Florence on 5 January 1715. There are few signed or documented works, and Marinari's oeuvre has still to be clearly defined.[1]

[1] See G. Cantelli, *Antichità Viva*, IX, 1971, 4, pp.9–16, and XIII, 1975, 2, pp.22–3, and *Repertorio della Pittura Fiorentina*, 1983, pp.105–6 (list of 58 attributed works, not including P562), pls.524–42.

Attributed to Marinari

P562 *S. Catherine of Alexandria*

Light auburn hair in an elaborate coiffure set with pearls; light blue silk dress with a lilac sheen,[1] and a golden yellow drape; the dove-grey book rests on a rich blue velvet cushion and the gold crown on a pink cloth; the table is covered with a deep red velvet cloth; the chair back is of leather figured in silver and red;[2] there is a bottle-green curtain in the background and, to the left, a spiked and broken wheel, the emblem of S. Catherine's martyrdom.

Canvas, relined 75.2 × 106.4

Slight abrasion on the neck and a small loss in the upper part of the chair back. There is a distinctive wide craquelure in the darker areas. The canvas has probably been cut along the top and right-hand edges, as is suggested by comparison with the version at Salzburg (see below) which presents a more satisfactory composition.

For the subject, see Sassoferrato P646. S. Catherine is here shown, rather unusually, as the studious Queen in her palace and the obscurity of the broken wheel led to inaccurate titles in the past (see Provenance); the present title first appeared in the 14th edition of this catalogue in 1920.

Attributed to Dolci in the eighteenth and nineteenth centuries (see Provenance), P562 was catalogued as school or style of Dolci until 1968 when it was attributed to Dolci himself; Cantelli (1983) maintains this opinion.[3] While P562 evidently relates to Dolci's more decorative works of the 1660s, such as the *Salome* and *S. Cecilia* (dated 1671) at Dresden, nevertheless the combination of S. Catherine's informal and attractive figure with the loose and fluent painting of her rich costume suggests an attribution to another Florentine hand, perhaps c.1670.[4] Both Gregori[5] and McCorquodale[6] attribute P562 to Marinari, and it compares

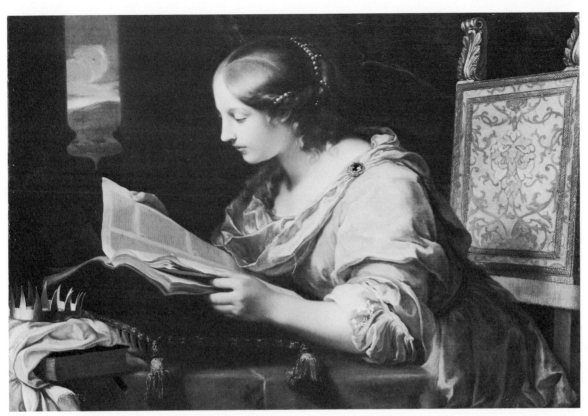

P562

quite closely with the oval half-length S. Catherine in the Palazzo Pitti, formerly attributed to Lorenzo Lippi but given by Gregori and Cantelli to Marinari,[7] which shows a similarly rich handling and, apparently, the same model.

Version

SALZBURG Residenzgalerie; 92.5 × 119, a seventeenth-century version but by another, slightly heavier hand (as is particularly evident in the painting of the sleeve); the composition is more satisfactory than that of P562 and shows more space above and the second finial on her chair to the right; from the collection of Friedrich Karl, Count Schönborn (1674–1746), at the Schönborn Gartenpalast, Vienna.[8]

Provenance

César-Gabriel de Choiseul, duc de Praslin (1712–85); his sale, Paris, 18–25 February 1793 (1, Dolci, '*S.Clothilde . . . assise sur une chaise de tapisserie, inclinée sur une table, et lisant dans un grand livre qui repose sur un coussin de velours bleu . . . Haut. 38 pouc. [sic,* presumably in error] *larg. 39*'), 3,900 fr. (bt. in?); Antoine-

César de Choiseul, duc de Choiseul et de Praslin (1756–1808), who inherited much of his grandfather's collection;[9] his sale, Paris, 9–10 May 1808 (2, Dolci, '*S.Clothilde . . . assise sur une chaise de tapisserie, lisant dans un livre posé sur un coussin de velours bleu. Vingt-huit pouces sur trente-neuf*'), bt. Desmarest, 3,405 fr.; the comte de Pourtalès-Gorgier (1776–1855) by 1841;[10] his sale, Paris, 1 April 1865 (46, Dolci, '*S. Catherine [avec] la roue dentée qui fut l'instrument de son martyre . . . collection du duc de Choiseul-Praslin,* 76 × 115'), bt. by the 4th Marquess of Hertford, 27,000 fr.; rue Laffitte inventory 1871 (434, '*Dolci, une Sainte*'); Hertford House inventory 1890, as '*Dolci, Sacred Studies*'.

Exhibition

Bethnal Green 1872–5 (254, as Dolci, *Sacred Studies*).

[1] *'une robe de soie à reflets changeants qui enlèvera tous les suffrages des dames'* (E. Galichon, *Gazette des Beaux-Arts*, 1ère, XVIII, 1865, p.19).

[2] A comparable chair is illus. by F. Schottmüller, *Wohnungskultur und Möbel der Italienischen Renaissance*, 1921, pl.442.

[3] G. Cantelli, *Repertorio della Pittura Fiorentina del seicento*, 1983, p.72.

[4] Dolci's interest in decorative detail and rich materials in the 1660s is described by G. Heinz, *Jahrbuch der Kunsthistorischen Sammlungen in Wien*, 56, 1960, pp.229–31. Doubts concerning the attribution of P562 to Dolci have been expressed by Waterhouse (letter of 1 May 1983), and by Mahon and Pepper (orally 1983, Mahon changing his earlier opinion quoted in the 1968 catalogue).

[5] Letter on file dated 29 September 1983.

[6] Letter on file dated 15 May 1983; McCorquodale, who had earlier accepted P562 as a work of Dolci's middle period (see *Apollo*, C, 1974, pp.208–9), justly compared it with the Glasgow *Salome* (exh. *Painting in Florence 1600–1700*, RA 1979, no.23 as Dolci) which he now also attributes to Marinari.

[7] *Gli Uffizi, Catalogo Generale*, 1980, p.366 (P1002), and G. Cantelli, *Repertorio*, (see note 3), pl.528.

[8] *Salzburger Landessammlungen, Residenzgalerie mit Sammlung Czernin und Sammlung Schönborn-Buchheim*, 1980, p.54 and pl.71, as Dolci. Both Gregori and McCorquodale (see notes 5 and 6) attribute the Salzburg picture to Marinari.

[9] See C. Blanc, *Le Trésor de la Curiosité*, 1858, II, p.242.

[10] Cf. J. J. Dubois, *Description des tableaux . . . de M. le comte de Pourtalès-Gorgier*, 1841, p.11, no.25 Pourtalès probably bought P562 direct from Desmarest in 1808.

Master of Santo Spirito late 15th–early 16th century

A Florentine artist identified by three altarpieces in the church of S. Spirito, Florence. Fahy[1] has listed forty-three paintings attributable to this hand which is perhaps identifiable as Giovanni di Michele da Larciano, called Graffione (c.1455–1521/7).[2] His works have previously been attributed, for example, to Davide Ghirlandajo, Jacopo del Sellajo, Filippino Lippi, and Raffaellino del Garbo; and see P556 below.

[1] E. Fahy, *Some Followers of Domenico Ghirlandajo*, 1976, pp.192–5.
[2] For whom, see H. Horne, *The Burlington Magazine*, VIII, 1905, pp.189–96; Fahy suggests this identification, *op. cit.*, p.192.

P556 *An Allegory of Love*

On a wheeled car, Venus with a green drape, looking upwards, her fair hair billowing behind her, sits on a brown urn which is decorated with a faun's head, holding out Cupid's broken bow in her left hand, her right hand resting on a red vase upright in her lap; facing her, on a burning altar, kneels Cupid, his hands bound behind his back; an *amorino* blows on the fire, goaded by Venus; the car is drawn by a grey (nearest) and a brown horse, each mounted by an *amorino*.

Pearwood panel 61.9 × 77.5 × 3.2 two horizontal members, the bottom 24.1 wide

The panel has suffered from worm tunnelling and has a marked convex warp. The paint surface has risen along a number of horizontal cracks, and sunk in hollows (e.g. between the horses and the right-hand rock, below the nearer horse's barrel, and by Venus's right hand). The varnish is much discoloured.

The subject, as identified by Chastel, derives from the Platonic commentaries of the Florentine Academy.[1] Earthly love (the bound Cupid, *amor vulgaris*, the imagination) is purified by the fires of celestial love (the *Venus coelestis*, *amor divinis*, the intellect). Chastel supposes that the urn in P556 is to receive the passions and vices, while the small vase is a cleansing vessel. Two other depictions of the same subject add significant details. A medal in Berlin attributed to

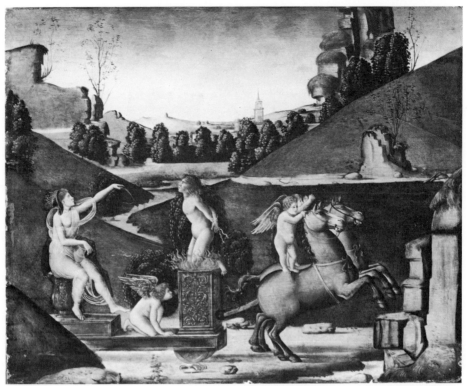

P556

Bertoldo di Giovanni (d.1491) shows in the exergue Cupid's wings, quiver, arrows and part of his bow lying discarded.[2] The illuminated title page of S. Didymus Alexandrinus, *De Spirito Sancto*, painted by Gherardo and Monte del Fora c.1488, in the Pierpont Morgan Library, New York,[3] shows a man checking the horses, holding their reins and turning towards them; this figure recurs, less authoritatively (running with the horses), in the Bertoldo medal. Chastel interprets his action as the restraint of natural instincts, the horse-drawn car being emblematic of the human soul. The subject has previously been described as *The Triumph of Love* or *The Triumph of Chastity*, in the tradition of Petrarch[4] but, as Chastel observes, the absence of any cortège goes against such identifications.

Catalogued as Florentine from 1900, Phillips compared P556 in later editions with the work of Bartolommeo di Giovanni (1905) and then placed it half-way between Piero di Cosimo and Cosimo di Roselli (1908). Berenson attributed P556 to Piero di Cosimo (*Lists* 1909), as did Schubring.[5] The convincing attribution to the Master of Santo Spirito was first made by Fahy in 1970.[6] A comparable landscape, with similar blobbed trees, architectural detail and straight-edged folds, appears in the *Portrait of a Boy*, no.405 in the National Gallery, Washington, attributed to the Master c.1505, while the distinctive

315

facial types of Venus and Cupid in P556 may also be recognised in the kneeling S. Catherine in the Master's S. Spirito altarpiece, *The Trinity with SS. Mary of Egypt and Catherine*. P556, with its close relationship to Bertoldo's medal of c.1490 and the illuminated MS. of c.1488, could perhaps be dated c.1490–5. It may be relevant that the motif of the bound Cupid being burnt on an altar recurs in the ceiling decoration of the sacristy vestibule of S. Spirito.[7]

Schubring[8] and Zeri[9] consider P556 comes from a *cassone*, of which Zeri suggests that a panel formerly in the Fabbri collection, Rome, 65 × 178 and since cut up,[10] was once the frontal. Fahy accepts this connection[11] but believes the panels may originally have been set in a wainscot, together with a third, a *Rape of Lucretia*(?), 60 × 92, lot 6 in the Castiglioni sale, Ball and Graupe, Vienna, 28–9 November 1930, as Lorenzo Leonbruno.

Provenance

The vicomte Both de Tauzia (1823–88),[9] from whom purchased by Sir Richard Wallace in 1872, see Appendix IV; Hertford House inventory 1890 as *Venus in a Chariot* by Piero di Cosimo.

[1] A. Chastel, *Art et Humanisme à Florence*, 1959, pp.269–72; and generally, see E. Panofsky, *Studies in Iconology*, 1962, ed., pp.129–48, and R. Pfeiffer, *Classical Scholarship*, 1976, pp.57–8.
[2] Illus. Chastel, *op. cit.*, pl.lxia; G. F. Hill, *A Corpus of Italian Medals of the Renaissance before Cellini*, 1930, p.242, no.919, pl.149.
[3] Illus. Chastel, *op. cit.*, pl.lx; Hill, *op. cit.*, f.p.242, and M. Harrsin and G. K. Boyce, *Italian MS. in the Pierpont Morgan Library, New York*, 1953, no.71, pl.49.
[4] Berenson *Lists* 1909, 1932 and 1963 as *Triumph of Love*; P. Schubring, *Cassoni*, 1923, p.318, no.414, and E. Fahy,

Some Followers of Domenico Ghirlandajo, 1976, p.193, as *Triumph of Chastity*. For a useful résumé of fifteenth-century Florentine paintings of Petrarch's *Trionfi*, see C. M. Kauffmann, *Victoria and Albert Museum, Catalogue of Foreign Paintings*, 1973, I, pp.109–11.
[5] Schubring, *loc cit.*, see note 4.
[6] E. Fahy, letter on file dated 4 February 1970; published in *Some Followers of Domenico Ghirlandajo*, 1976, p.193.
[7] Illus. Chastel, *op. cit.*, see note 1, pl.lxib. The altar bears a bas-relief showing Orpheus tormented by Bacchantes, a motif Chastel interprets (p.271) as illustrating the conflict between pure love and the baser instincts.
[8] Schubring, *loc. cit.*, see note 4.
[9] F. Zeri, letter on file dated 10 December 1983.
[10] Photograph in Witt Library under School of Botticelli; an interior to the left with a woman stabbed, and a landscape to the right. The landscape is now detached and was published by L. Grassi, *Arte Antica e Moderna*, XXV, 1964, p.59, illus. f.p.64, as Jacopo Ripanda.
[11] E. Fahy, letter on file dated 14 January 1984.

P544

Milanese School first quarter 16th century

P544 *Head of a Girl*

Fresco 29.9 × 24.8 × 3.2

Heavily retouched and probably made up from 23.5 × 17, according to irregularities in the surface. A crack runs down through the chin and another through the left eye. P544 was 'refixed' by Buttery in 1884 and repaired by Holder in 1939.

Although P544 is too slight and in too poor a condition for any certain assessment, it might be associated with the Luini frescoes from the Casa Rabia, Piazza San Sepulcro, Milan, which were sawn off on blocks of plaster in the early nineteenth century.[1] Phillips (1904 catalogue) recorded attributions to both Luini and Sodoma, of whom he preferred the latter.

Provenance

The vicomte Both de Tauzia (1823–88), from whom purchased by Sir Richard Wallace in 1872, see Appendix IV; Hertford House inventory 1890 as Luini.

[1] Now principally dispersed between East Berlin and Washington, see Chiesa, *Luini*, 1956, pp.113–16, no.154; F. R. Shapley, *Samuel H. Kress Collection, Italian Schools XV–XVI century*, 1968, p.141, and *National Gallery, Washington, Catalogue of Italian Paintings*, 1979, pp.286–7.

317

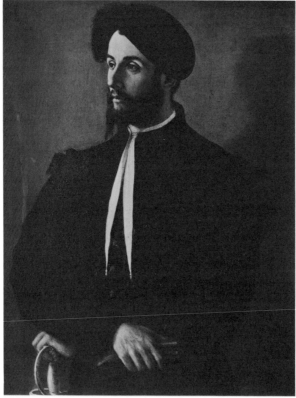

P541

North Italian School second quarter 16th century

P541 *Portrait of a Man in Black*

Dark brown hair, brown eyes, wearing a black tunic with wide sleeves and gold buttons; he holds his kid gloves in his right hand and his left rests on his rapier.

Walnut panel $85.3 \times 64.4 \times 1.5$ two irregular vertical members, the right 21.7 wide at the bottom and 17.5 at the top

Considerably retouched; there are traces of bitumen in the tunic which is abraded in some areas. The varnish is discoloured.

Costume suggests a date of c.1530–40; the carved gilt frame bearing the date 1543 has been adapted to fit P541 and is not evidence for dating.[1] Previously attributed to Paolo Cavazzola of Verona (catalogue 1905), Giulio Campi of Cremona (Berenson, *Lists* 1907), the Brescian school (L.Venturi, 1926[2]), Bartolommeo Veneto (Hendy, 1928 catalogue; Berenson, *Lists* 1932), and Niccolò dell'Abate (A.Venturi 1933;[3] Bodmer 1943[4]). Bartolommeo remains perhaps the most likely candidate, but he is a shadowy figure[5] and, meanwhile, the condition of P541 aggravates the difficulties of attribution.

Provenance

The seal of Adolphe Seiglière de Boisfranc (d. 1738 in Venice) appears on the *verso* (semy of fleurs de lys, on a bend three heads of rye, with Ducal coronet); probably acquired by the vicomte Both de Tauzia (1823–88), see Appendix IV, and purchased from him by Sir Richard Wallace in 1872; Hertford House inventory 1890.

[1] It has been reduced in width by 2 cm., and the carving has been re-applied to a softwood support, perhaps in the nineteenth century. Previously thought to have come from the Domenichino P131, q.v. note 12.
[2] L. Venturi, letter on file dated 30 October 1926.
[3] *Storia dell'Arte Italiana*, IX, vi, 1933, pp.597, 600.
[4] H. Bodmer, *Pantheon*, XXXII, 1943, p.158.
[5] Cf. *National Gallery Catalogues, The Sixteenth-century Italian Schools*, 1975, pp.15–16.

North Italian School last quarter 16th century

P552 *The Holy Family*

The Virgin has fair hair, a white head-dress and shawl, a pink dress and green drape; she holds a blue-grey book; Joseph is grey haired and has a light brown cloak; the Child is fair; a bottle-green curtain hangs behind.

Walnut panel 26.4 × 18.7 including arched top
painted surface 21.2 × 13.8 including arched top 8.5 diameter

A vertical split, running down from the top edge through the Virgin's right eye to the Child's right arm, has been repaired by three cleats, *verso*.

A work of some quality, P552 has previously been catalogued as School of Parma. Phillips (1900) suggested Girolamo Mazzola, and the composition also recalls Alessandro Mazzola,[1] but Volpe has pointed out that the tight execution (and the somewhat Michelangelesque quality of the Virgin's hands) may preclude a Parmesan attribution; he suggests a date of c.1570.[2] Pouncey (orally 1983) suggested P552 may be Cremonese; Zeri (orally 1983) suggested Cremonese or Milanese, indicating a date of c.1580; Bora has tentatively suggested Bolognese.[3]

Provenance

Acquired by the 4th Marquess of Hertford; Bagatelle inventory 1871 (952, '*Jules Romain, Ste. Famille*'); Hertford House inventory 1890 as Giulio Romano.

Exhibition

Bethnal Green 1872–5 (290, as Giulio Romano).

[1] Cf. *The Virgin and Child*, attributed to Alessandro, sold Sotheby's, 17 November 1982 (38).
[2] C. Volpe, letter on file dated 18 January 1983.
[3] G. Bora, letter on file dated 19 November 1983.

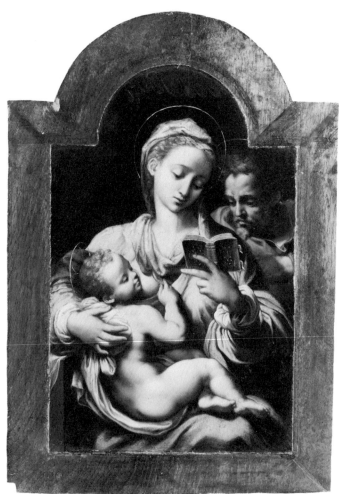

P552

Polidoro da Caravaggio (1490/1500–1535/43)

Polidoro Caldara, born in Caravaggio, Lombardy. From c.1517 he was one of Raphael's assistants in the Vatican *Logge* (see below). Subsequently, in collaboration with the Florentine, Maturino (d.1528), he painted many grisaille friezes on the façades of buildings in Rome, displaying a great knowledge of antiquity. After the Sack of Rome in 1527, he worked in Naples and Messina where, it is said, he was murdered by his servant on the eve of his departure for Rome.

P775 *Study of Four Draped Figures*

Inscribed bottom right: RAFAELLE and, in a later hand: *106. Verso*, two studies of sofas, inscribed top left: *raffaelle*; down left-hand edge: *di Raffaelle d'Urb°.*, and below: *di rafael de urbino.*

Red chalk on paper 10.8 × 15.6

The sheet is stained in several places and there are small damages round the edges. The *verso* was revealed in remounting in 1984.

P775 was first attributed to Polidoro by Pouncey in 1959,[1] and his attribution was accepted by Popham.[2] It was first published in the 1968 catalogue and subsequently by Dacos and Ravelli (but was not noticed by Marabottini).[3] Pouncey identified the subject as an original study for part of the composition engraved by Bartoli (c.1635–1700) as *Joseph before Pharaoh* (Genesis XLI), since recognised by Oberhuber as one of the wainscot grisailles in the twelfth bay of the Vatican *Logge* (now destroyed by a doorway).[4] The surviving frescoes in this bay describe episodes from the life of Solomon, and Oberhuber suggests the correct subject of Bartoli's print is *Adonijah before Solomon* (1 Kings i, 53); Dacos has also suggested *Bathsheba before Solomon* (1 Kings i, 16). Polidoro was listed by Vasari as one of Raphael's assistants in the *Logge* in 1517–19,[5] and Dacos supposes that P775 may have been based on a Raphael sketch. Compared with Bartoli's (reversed) print, and with other contemporary copies (see Related Drawings below), P775 shows the figures further apart and with minor variations in pose and drapery.

Related Drawings

Unless otherwise stated the following show the complete composition.
BERLIN KUPFERSTICHKABINETT, pen and ink copy in Marten van Heemskerck's Roman sketchbook.[6]
CHATSWORTH (no.150), pen and wash, attributed to Perino del Vaga, called after F. G. Penni by Oberhuber.[7]
LONDON British Museum (no.1950-8-16-6, *recto*), pen and ink omitting the central group, by a follower of Girolamo da Carpi.[8]
LULWORTH MANOR pen and brown wash, attributed to Polidoro.

NEW YORK Pierpont Morgan Library (no.118A).
OXFORD Ashmolean Museum (no.650), black chalk, attributed to G. F. Penni.[9]
PARIS Louvre (no.3908).
PHILADELPHIA Rosenbach Foundation, pen and ink copy by Girolamo da Carpi, identical with the British Museum drawing.[10]
STOCKHOLM (no.96), pen and wash, attributed to Perino del Vaga, from the Crozat collection.[11]

P775 *recto*

P775 *verso*

P. S. Bartoli (after Polidoro): *Joseph before Pharaoh*. The British Museum

Provenance

Possibly in the collection of Pierre Crozat (1665–1740); the inscribed *106* is in a hand which seems to recur on other Crozat drawings.[12] Probably from the collection of the vicomte Both de Tauzia (1823–88), see Appendix IV; acquired by Sir Richard Wallace in or after 1872; Hertford House inventory 1890 as Raphael.

References General

N. Dacos, *Le Logge di Raffaello*, 1977, pp.301–2; L. Ravelli, *Polidoro Caldara da Caravaggio*, 1978, no.139, the subject unidentified, dated 1527–35, and said to be in an English private collection.

[1] Note on file dated 13 April 1959.

[2] Note on file dated 5 February 1960.

[3] A. Marabottini, *Polidoro da Caravaggio*, 1969.

[4] K. Oberhuber, *Raphaels Zeichnungen*, IX, 1972, p.180, the identification made from a sixteenth-century copy of the *Logge* decorations in the Nationalbibliothek, Vienna (Cod.min.33). The composition had previously been associated with the *Stanza d'Eliodoro*, cf. J. D. Passavant, *Raphael d'Urbin*, 1860, no.103a (the Stockholm drawing), and K. T. Parker, *Catalogue of Drawings*, Ashmolean Museum, II, 1956, no.650. Passavant associated the Oxford drawing of the same composition with the *Logge* (*op. cit.*, no.465).

[5] Vasari-Milanesi, IV, pp.362–3, and V, p.142.

[6] C. Hülsen and H. Egger, *Die Römischen Skizzenbücher von Marten van Heemskerck*, 1916, II, pp.37–8, pl.84.

[7] Oberhuber, *loc. cit.*, fig.194.

[8] J. A. Gere and P. Pouncey, *Italian Drawings, artists working in Rome c.1550 to c.1640*, British Museum, 1983, pp.105–6, pl.170.

[9] Oberhuber, *op. cit.*, pp.179–80, no.472a, fig.193. Parker, *loc. cit.*, as a sixteenth-century Italian copy.

[10] Gere and Pouncey, *op. cit.*, pp.96, 106.

[11] O. Sirén, *Dessins et tableaux italiens dans les collections de Suède*, 1902, p.129, no.98.

[12] As first indicated by Shearman (note on file dated 1 February 1960). The suggestion made in the 1968 catalogue that 106 may have been the lot number in the Crozat sale (Paris, 10 April–13 May 1741) is not borne out by comparison with other inscribed Crozat drawings. Both P775 and Maratta P774 had similar mounts (watermarked *T Dupuy/Auvergne*, c.1750), perhaps indicating that they passed from Crozat into the same French collection.

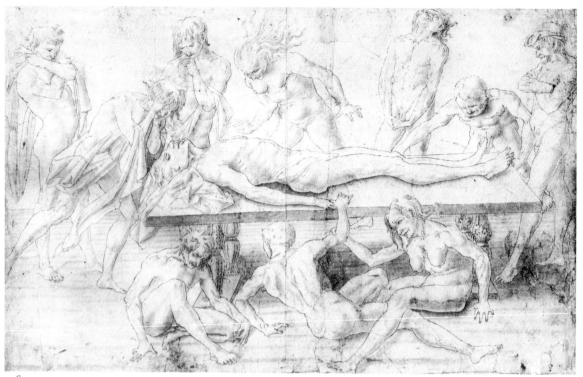

P762

Antonio del Pollaiuolo (1431/2–98)

Born in Florence, where he practised as goldsmith, metal-worker, designer, engraver, painter and sculptor. His painting, in which it seems he was often assisted by his younger brother Piero (1443–96), was much influenced by Castagno and, with his drawings and engravings, shows a careful study of the nude figure. He died in Rome on 4 February 1498.

After Antonio del Pollaiuolo

P762 *Lamentation over a Dead Hero*

Brown ink and wash on paper 27.3 × 43.8 (maximum) laid down on a heavier paper.

In poor condition. The sheet is rubbed, the washes are very faded and the ink lines have been reinforced in many places. The bottom and right-hand edges are very uneven, and there are several repairs, many small tears and two central vertical fold marks. The paper bears the watermark of a hunting horn similar to Briquet 7682[1] and the Esterhazy collector's stamp (Lugt 1966)[2] in the bottom right-hand corner. The backing sheet is inscribed in pencil in a late-eighteenth/early-nineteenth-century hand: *Pr/Mantegna/104*, and in brown ink: *198*.

The interpretation of the subject seems to have been bound up with the question of attribution. It is now generally accepted that P762 is a copy of a lost design by Antonio del Pollaiuolo, whose interest in the representation of the nude in violent action may be sufficient explanation of the extraordinary scene.[3] Alternatively Panofsky suggested the subject is the lamentation of Pallas, from Virgil, *The Aeneid* XI, 29–41: Pallas, son of Evander, King of Arcadia, was killed by Turnus, King of the Rutulians, while fighting for Aeneas in Italy; his body was laid out before his tent, watched by the ageing Acoetes and a crowd of Trojans, including 'ladies of Ilium, their hair thrown free'; when Aeneas came to see the corpse, 'all struck their breasts and loud was the lamentation'. This suggests that the calm standing figure on the right might be Aeneas, with Acoetes next to him, but P762 does not show the 'gaping wound' in Pallas's breast.

P762 was engraved in 1777 as by Mantegna, the subject described as '*Gattamelata de Narni, célèbre Général des Vénitiens, mort en 1440, est pleuré par le peuple*', i.e. Erasmo de Narni, known as Gattamelata (c.1373–1443), a Captain General of the Republic of Venice, who died in Padua (where Donatello made his equestrian monument). This identification and attribution were repeated by Bartsch, Brulliot and Passavant (see notes 9 and 10). In 1888 Tauzia tentatively identified the dead hero as '*Gattamelata, fils du célèbre condottiere*', i.e. Giovanni Antonio de Narni, also known as Gattamelata, who died in Padua in 1455, and this was repeated by Erica Tietze-Conrat in 1935. The Gattamelata identification doubtless depended upon the attribution to Mantegna, for it was known that he had painted the story of Gattamelata (*historia Gatamelatae*) in a house in

Padua (destroyed in 1760);[4] the subsequent rejection of the attribution may also invalidate the interpretation although, exceptionally, Ortolani (1948) has suggested that Pollaiuolo may have helped Mantegna with his designs.

Although Fiocco (1937)[5] supported – and Tietze-Conrat (1935) and Garaviglia (1967) entertained – an attribution to Mantegna, it has generally been rejected since 1879 when Courajod first associated P762 with Antonio del Pollaiuolo. His opinion was shared by Tauzia (1888), who had owned the drawing. Berenson (1903) first pronounced P762 a copy after Pollaiuolo, a view since repeated by van Marle (1929), Cecchi (1941), Sabatini (1944), Panofsky (1945), Ortolani (1948), Popham and Pouncey (1950) and Busignani (1970). Panofsky suggested that Pollaiuolo's original design was one of a cycle of five subjects drawn from ancient Roman history,[6] and Berenson, Ortolani and Busignani have suggested it may have dated from c.1465–70. P762 is perhaps a contemporary copy from Pollaiuolo's workshop.

Engraving
M.C. Prestel 1777, reversed.[7]

Copies/Versions:
MUNICH Staatlichen Graphischen Sammlungen (no.109); pen and wash drawing, in poor condition, of the nine central figures.[8]
An engraving by AC (Alaert Claesz, active 1530–55) shows a similar composition, reversed, against an architectural background.[9] Brulliot recorded an earlier version of this print, signed IF (Jacopo Francia, c.1487–1557), which has not been seen since.[10]

Provenance
P762 was engraved in 1777 as in the von Praun collection at Nuremberg (see note 7); this collection had been formed by Baron Paul von Praun (1548–1616) of Nuremberg and was sold c.1797 to Frauenholz, from whom it was acquired by Prince Miklos Esterhazy (1765–1833), whose mark appears on P762. From 1814 the Esterhazy collection was housed in the Mariahilf Palace, Vienna, whence in 1855 some items, possibly including P762,[11] were stolen by the Keeper, Joseph Altenkopf (the remainder of the collection is now in the Museum of Fine Arts, Budapest).[12] P762 was acquired in 1868 by the vicomte Both de Tauzia (1823–88),[13] from whom it was purchased by Sir Richard Wallace in 1872, see Appendix IV; Hertford House inventory 1890.

References General
L. Courajod, *L'Art*, 5ᵉ, 1879, IV, pp.162–4; Both de Tauzia, *Musée du Louvre, Dessins, 2ᵉ notice supplémentaire*, 1888, pp.71–2; B. Berenson, *Drawings of the Florentine Painters*, 1903 and 1938, I, p.30, II, no.1945; R. van Marle, *Italian Schools of Painting*, XI, 1929, p.356; E. Tietze-Conrat, *The Burlington Magazine*, LXVII, 1935, pp.217–9; E. Cecchi, 'Pitture e disegni di Antonio Pollaiolo', *Civiltà*, II, 1941, 4, p.31; A. Sabatini, *Antonio e Piero Pollaiolo*, 1944, p.90; E. Panofsky, *Albrecht Dürer*, 1945, II, p.96; S. Ortolani, *Il Pollaiuolo*, 1948, pp.171, 201–2 (pl.65); A. E. Popham and P. Pouncey, *Italian Drawings, XIVth and XVth centuries*, The British Museum, 1950, p.137; N. Garaviglia, *L'opera completa del Mantegna*, 1967, no.25; A. Busignani, *Pollaiolo*, 1970, p.lxxx (with the Munich version illus. in error on p.lxxxi).

[1] C. M. Briquet, *Les Filigranes*, 1907, II, p.421.
[2] F. Lugt, *Les Marques de Collections*, 1921, p.359.
[3] Cf. Popham and Pouncey 1950, *loc. cit.*
[4] See Tietze-Conrat 1935, *loc. cit.*; Scardeone, *De antiquitatibus urbis Patavii*, 1560, p.372, mentioned Mantegna's *historia Gatamelatae* in a house in Padua, and Paolo Giovio, *Elogia Virorum bellica virtute illustrium*, Basle, 1561, mentioned that Gattamelata's death was honoured by '*il pennel del Mantegna/Colorite del pianto e della/Consternazione del popolo*'.
[5] G. Fiocco, *Mantegna*, 1937, p.86.
[6] Panofsky 1945, *loc. cit.*; the other four subjects being *The Rape of the Sabines* (known from a copy by Dürer), *Titus Manlius Torquatus taking the necklace from the Gallic chieftain* (engraved by Pollaiuolo), *Tullius Hostilius rescinding the death sentence against one of the Horatii* (British Museum; but see Popham and Pouncey 1950, *loc. cit.*), and the *Battle between the Romans and the Carthaginians* (versions in the Fogg Art Museum and at Turin).

[7] For the title, see main text above; numbered *27* and additionally inscribed: *Gravé d'après le Dessin de même grandeur d'André Mantegna / E Museo Prauniano Norimbergae / M.C. Prestel sculp. 1777;* the image measures 27.8 × 43.7; published in *Dessins des meilleurs peintres d'Italie, d'Allemagne et des Pays-Bas, du cabinet de M. Paul de Praun à Nuremberg, gravés par Prestel,* 1780. An example was presented to the Wallace Collection Library by E. C. Washington Evans in 1922.

[8] Illus. Sabatini 1944, pl.ix; Busignani 1970, p.lxxxi.

[9] Illus. Tietze-Conrat 1935, p.220; G. Fiocco, *Mantegna,* 1937, pl.174. Bartsch, IX, 1808, p.130, no.30, where he records evidence of a date 1555; J. D. Passavant, *Le Peintre-Graveur,* III, 1862, p.36, also referring to the earlier engraving by IF, see note 10. The image measures 29 × 41.8.

[10] F. Brulliot, *Dictionnaire des monogrammes,* II, 1820, p.912, no.2134: '*nous avons aussi trouvé les initiales IF sur une pièce … qui représente le même sujet qui a été gravé par le maître au monogramme AC … nous ne sommes plus en état de donner une explication exacte, car elle n'est plus entre nos mains*'. Passavant, *op. cit.,* V, p.225, says that this print '*n'a jamais été vue par personne*'.

[11] But a few unspecified drawings from the Esterhazy collection 'removed from Chandos House' were sold by Phillips, 26 May 1843; lot 15 included an 'engraving of the Dead Soldier'.

[12] This account of the Esterhazy collection is drawn from Lugt, see note 2.

[13] Tauzia 1888, *loc. cit.,* described P762 as having been purchased in 1868 by '*un amateur de Paris*'; there was a 'fine drawing by Pollaiuolo' in Tauzia's collection, see Appendix IV.

Guido Reni (1575–1642)

Baptised on 7 November 1575 in Bologna where, like Domenichino, he first studied under Denis Calvaert before entering the Carracci Academy c.1594. He worked principally in Bologna and Rome, but also undertook commissions in Mantua, Ravenna and Modena, for example. He died in Bologna on 18 August 1642.

Manner of Reni

P644 *The Virgin and Child with the Infant Baptist*

The Virgin in blue with white head-dress, the Child in yellow, sitting on red cushions; lilac-coloured drapes and a red-covered table.

Copper, tinned on the *recto* 21.9 × 28.1

There is a heavy craquelure in the Virgin's mantle, and a number of small losses, e.g. below the Child's left foot, in the Virgin's hair and neck, and in S. John's upper arm. Traces of bitumen in the darker areas. The edges have been retouched and extended, the original format being a purer oval. The spandrels are painted gold.

P644 is a close adaptation of the larger oval canvas by Reni formerly in the Orléans collection (see below) which differs from P644 principally in that the Child's left hand rests on the Virgin's right, S. John's staff is held against his left shoulder, and the figure composition is more tightly enclosed. The models are similar, and some passages, e.g. the Virgin's head and drapery and the Child's right hand, appear identical. While thus depending upon a Reni design, P644 lacks the master's quality and the heightened domestic sweetness of the composition may indicate a date in the early eighteenth century.[1]

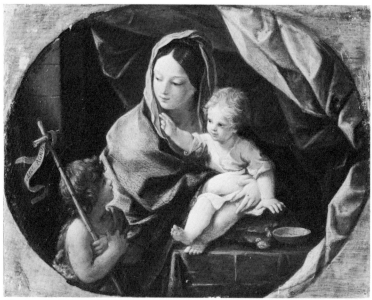

P644

Version

Formerly Orléans collection; 66×81.3, known only from the reversed engraving by F. Guibert of 1786.[2]

Provenance

Alexandre Aguado (1785–1842), Marqués de las Marismas; his sale, Paris, 1st day, 20 March 1843 (322, as Reni), 5,880 fr.; the 4th Marquess of Hertford; reframed in 1859 when in Hertford House;[3] Hertford House inventory 1870 as Reni.

Exhibition

Bethnal Green 1872–5 (261, as Reni).

[1] Suggested by Mahon and Pepper, orally, in 1983.
[2] Guibert's engraving, made for J. Couché, *La Galerie du Palais Royal*, 1786–1808, I (Reni, no.6), shows Christ blessing with his left hand, and is thus clearly reversed. The painting was listed by L.-F. Dubois de Saint-Gelais, *Description des Tableaux du Palais Royal*, 1727, p.189, and by C. Stryienski, *La Galerie du Régent*, 1913, p.171 (as untraced); W. Buchanan, *Memoirs of Paintings*, 1824, I, p.94, no.6, lists it amongst Bryan's purchases, but adds that it did not come to London.
[3] Evans invoice.

Salvator Rosa (1615–73)

Born on 21 July 1615 in Naples where he studied under his uncle, Domenico Greco, his brother-in-law, Francesco Francanzano (a follower of Ribera), and the Neapolitan battle-painter, Aniello Falcone. In 1635 he went to Rome where he also developed literary interests. In Florence, between 1640 and 1649, he formed a literary society, the *percossi*, and met the scholar G. B. Ricciardi (much of their lively correspondence survives). He returned in 1649 to Rome, where he died on 15 March 1673. An original figure, he was known, despite his self-confessed stoicism, for his excitable and arrogant temper; he refused invitations to the Courts of Spain (1652) and France (1665).

Abbreviations

Salerno 1963 L. Salerno 1963, *Salvator Rosa*, 1963
Salerno 1975 L. Salerno, *L'opera completa di Salvator Rosa*, 1975

P116 *River Landscape with Apollo and the Cumaean Sibyl*

The Sibyl, centre left, in white with a light blue shawl and golden yellow drape; the fair-haired Apollo with a golden lyre has a light red drape; the two left-hand foreground figures, probably attendants of the Sibyl, are in green (left) and grey; the seven male and female figures in the mid-distance wear, or are being given, wreaths of bay, and are also, doubtless, part of the Sibyl's retinue.

Canvas, relined 173.7 × 259.5

Cleaned by Vallance in 1963. The paint surface was heavily ironed in the earlier relining and is thin in places, e.g. the trees upper right. An old damage, top centre, which includes three tears, has been retouched and there are minor retouchings elsewhere in the sky; there are a number of fillings round the edges. *Pentimenti* show that the branch reaching out from the left to the centre of the composition had far more foliage, as had the small tree growing out of the centre of the right-hand rock; in the bottom left-hand corner the tree stump behind the Sibyl was originally the root of the second tree from the left.

The subject is taken from Ovid, *Metamorphoses* XIV, 129–53: Apollo, in love with the Cumaean Sibyl, offered her anything she desired; she pointed to a pile of dust (seen here in her hands) and asked for as many years of life as there were grains; her wish was granted but, since she refused Apollo her favours, she was denied perpetual youth, and lived over seven hundred years in increasing misery. Rosa probably knew Cumae (on the Gulf of Gaeta, near Naples); his fanciful landscape shows the Sibyl's cave to the right, but the distant fortified hill may be a deliberate evocation of the Acropolis at Cumae, once crowned with a great temple to Apollo. For the various Sibyls, see Domenichino P131.

One of Rosa's finest works, in which the eerie calm of the wild landscape grandly harmonises with the Sibyl's mysteries and the melancholy story.[1] It may be compared, in grandeur, size and quality, with the *Baptism of Christ* and

S. John the Baptist pointing out Christ (both in Glasgow Art Gallery and Museum)[2] which Rosa painted for the Marchese Guadagni. All three pictures have been dated in the mid-1650s by Salerno.[3] Wallace also believes that P116 'can most reasonably date to the 1650s', and he has pointed out that the Sibyl derives from the same figure in the Tempesta etching of *Apollo and the Cumaean Sibyl*.[4]

Drawing

PARIS Louvre (no.9747), pen and wash study for the Sibyl, in reverse and relating more closely, in the head-dress and angle of the head, to Rosa's etching, see below.[5]

Etching[6]

S. Rosa, *Apollo and the Cumaean Sibyl*, c.1661; a re-working of the two figures from P116 which are seen closer together, with Apollo's right hand on his knee and his lyre resting on the ground. The first state shows a wreathed attendant behind the Sibyl, not unlike the equivalent figure in P116; the second state has this figure replaced by a tree, a progression which suggests the etchings followed P116, as is now generally accepted.[7] Rosa's etching was copied by J. Wolff (c.1663/73–1724), J. M. Beylbrouck (1635–1733), J. Sandrart 1773, and C. Antonini 1780.

Engraving

J. Brown 1781 (as in the Ashburnham collection).[8]

Copies

DUBLIN formerly T. Bodkin collection, 49 × 36, Apollo and the Sibyl only, apparently a copy from the etching.[9]
LONDON British Museum (no.286–36/20), pen and wash drawing.
Waagen (IV, p.270) listed an Apollo with a kneeling Sibyl by Rosa at Osterley Park; it is now untraced. Carl Emmanuel II, Duke of Savoy, included *Apollo and the Cumaean Sibyl* in a list of subjects he proposed to Rosa in 1666, but his commission was not fulfilled.[10]

Provenance

P116 may be identified in Cardinal Mazarin's *inventaire après décès*, 1661, as no. 1240: '*Salvator Rosa, sur toille, représentant un Grand Paysage ou est Apollon assis et appuyé sur sa lyre avecq une femme près de luy et deux aultres plus loing, hault de cinq piedz quatre poulces et large de huict piedz* (i.e. 170.5 × 260), *garny de sa bordure de bois couleur gris clair avecq un fillet d'or, prisé, la somme de sept cent cinquante livres*'.[11] It was later acquired by Jean de Jullienne (1686–1767) and is illustrated in a MS. catalogue of his collection c.1756;[12] his sale, Paris, 30 March–22 May 1767,[13] no.78 ('... *Apollon, la Sibylle de Cumes, qui a du sable dans ses deux mains, & deux autres Sibylles...*, *5 pieds 4 pouces × 7 pieds 11 pouces*'), bt. by the 2nd Earl of Ashburnham (1724–1812), 12,012 fr.; by descent to the 4th Earl (1797–1878);[14] his sale, Christie's, 20 July 1850 (45, '... presumed to be the finest landscape known of this master; it was bought by the Earl of Ashburnham at the sale of Monsieur Julien's collection against the agent of the Empress Catherine of Russia, who afterwards sent an offer of double the amount at which it was purchased'), bt. Mawson for the 4th Marquess of Hertford, 1,700 gn.; Hertford House inventory 1870.

Exhibitions

Manchester, *Art Treasures*, 1857 (saloon H, no.25); Bethnal Green 1872–5 (269).

References General

Salerno 1963, no.83a; Salerno 1975, no.128; R. A. Cecil, *Apollo*, LXXXI, 1965, pp. 464–9; R. W. Wallace, *The Etchings of Salvator Rosa*, 1979, no.102.

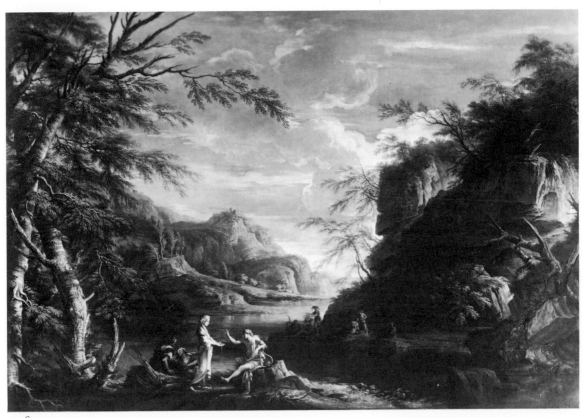

P116

[1] Although M. Mahoney, *The Drawings of Salvator Rosa*, 1977, p.110, sees 'no notable correspondence between subject and setting'.

[2] Salerno 1975, nos.120–1; exh. *Rosa*, Hayward Gallery, 1973, nos.30–1. No other known work of Rosa's matches the size of these three pictures.

[3] Salerno 1975, nos.120–1 and 128; Salerno 1963, no.83a, had previously dated P116 after the Rosa etching, in his '*ultima fase*'.

[4] Bartsch, XVII, p.151, nos. 638–787 (Wallace, *op.cit.*, p.48, and *Art Bulletin*, XLVII, 1965, p.471 n.2).

[5] Salerno 1975, no. 128a; Wallace, no.102b; Mahoney, *op. cit.*, pp.607–8, no.68.8; illus. Cecil, p.468.

[6] For a full discussion of Rosa's etching, and of later derivations, see Wallace, *loc. cit.*.

[7] E.g. by Salerno 1975 and Wallace; see also note 3.

[8] Illus. *Antique Collector*, December 1973, p.316; the plate is reversed and was made from a drawing by George Robertson.

[9] See T. Bodkin, *The Burlington Magazine*, LVIII, 1931, pp. 92–7, illus..

[10] See Salerno 1963, p.134.

[11] Le comte de Cosnac, *Les richesses du Palais Mazarin*, 1884, p.338; this identification was first proposed by Salerno 1963, p.134.

[12] See E. Dacier and H. Vuaflart, *Jean de Jullienne et les graveurs de Watteau*, I, 1929, p.240, and II, 1922, p.108 n.1. The (anonymous) illustration showing P116 is reproduced by Cecil, p.466, and in *Connaissance des Arts*, I, April 1956, p.69.

[13] The order of the sale is not recorded; an annotated copy of the sale catalogue in the Wallace Collection library is inscribed '*la vente a ete faitte en Avril et May 1767*'.

[14] Lady Morgan, *The Life and Times of Salvator Rosa*, 1824, II, p.368, lists P116 in the Ashburnham collection as *Landscape and Figures*, with five other Rosas.

Andrea del Sarto (1486–1530)

Andrea d'Agnolo,[1] called Sarto (his father was a tailor), born on 16 July 1486 in Florence, where he studied probably with Rafaellino del Garbo (though Vasari said Piero di Cosimo), before sharing a studio with Franciabigio from c.1506. In 1508 they were joined by the sculptor Jacopo Sansovino, and on 8 December that year Sarto was admitted to the *Arte de' Medici e Speziali*. He married c.1517 a widow, Lucrezia del Fede (d. 1570), who survives in romantic literature as a demanding, unattractive partner. Between May 1518 and October 1519 he was in Fontainebleau at the command of François Ier who was displeased by Sarto's premature return to Florence. He died in Florence where he was buried on 29 September 1530.

[1] Owing to the misreading of a document by Cinelli (*Bellezze di Firenze*, 1677), Sarto was known as Andrea Vannucchi until Milanesi first demonstrated the error in 1882 (Vasari-Milanesi, v, p.64). Sarto's monogram ☒, which doubtless encouraged the reading of his name as Andrea Vannucchi, was read by Milanesi as two interlaced As, for *Andrea* and *Agnolo* (*ibid.*, p.65).

Abbreviations

Freedberg S. J. Freedberg, *Andrea del Sarto*, 1963
Shearman J. Shearman, *Andrea del Sarto*, 1965

P9 *The Virgin and Child with the Infant Baptist*

The Virgin, seated on a narrow ledge of rock, has red hair and a blue-grey head-dress; she wears a light red smock with bronze-green undersleeves, a deep blue skirt with a gold border and lilac lining, and a purple drape; the Child is fair-haired. Behind the ledge, on lower ground, the red-haired S. John, wearing a pelt, stretches out his right hand towards the Virgin's right arm; behind him two red-haired angels, the left in bright green the other in deep blue, clasp each other. The angel in the sky wears a flame-coloured dress and has blue wings. Signed, upper left: ANDREA DEL SAR/TO FLORENTINO/FACIEBAT over the mono-gram ☒ (for which see note to Biography).

Poplar panel 106.5 × 81.3 × 3.8 two equal vertical members, the left with a slight convex warp, the right with a slight concave warp.

Cleaned by Lank in 1978–9, when original paint losses were found to be minor. Several small cracks and hollows in the paint surface reflect imperfections in the panel, e.g. in and below the music-making angel, to the right of the Virgin's head, in her drapery behind the Child, on her left wrist, below the hem of her skirt, and to the left of the Child's right eye. A split runs down between the two angels' heads, and another is visible on the *verso*, 16 cm. from the bottom right-hand corner. The paint in the angels' hair and in the shadows of their faces has deteriorated, and there are areas of perished glazes on the Virgin's skirt. There are many *pentimenti*: on the Virgin's profile, left sleeve and left cuff, on the back of the Child's head, the front of his torso, in his left leg and hand, and on S. John's right shoulder; the most radical show a right hand (the green angel's?) on S. John's back, the Virgin's left hand with the fingers wider spread and the

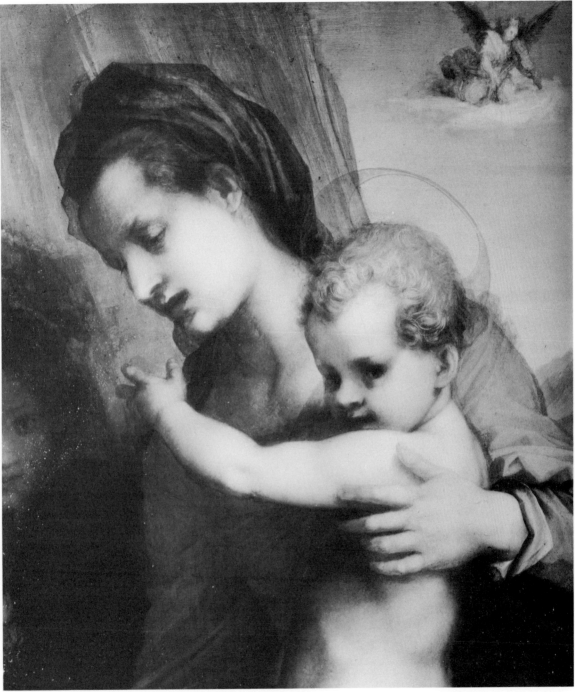

P9 detail

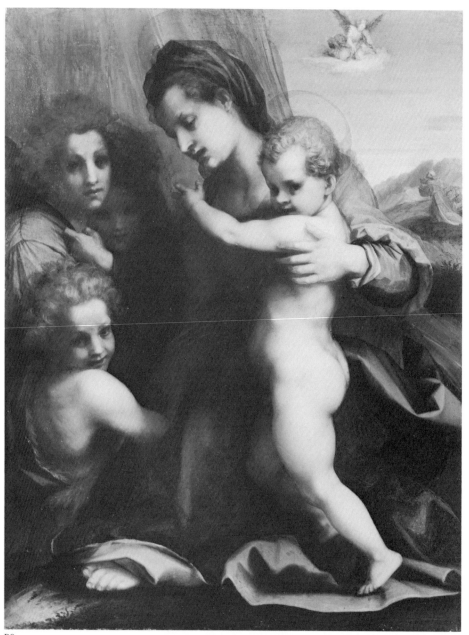

P9

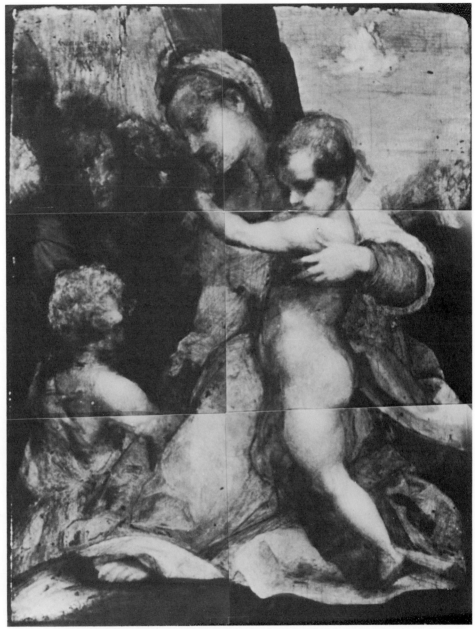

Infra-red vidicon mosaic of P9, showing *pentimenti*
(Hamilton Kerr Institute)

thumb further forward, and the two angels' hair redrawn. Infra-red photography also shows the Child's right leg was redrawn. Analysis of the paint[1] suggests that the sky originally continued behind the outcrop of rock on the left.

In the right background appears an episode from the *Fioretti*. S. Francis, fasting on Mount Alverna during the Feast of the Assumption, saw an angel of 'great splendour, that held a viol in his left hand and a bow in his right' and 'heard such sweet melody that it ravished his soul'.[2] Although Borenius identified S. Francis,[3] the kneeling Friar has otherwise generally been called S. Anthony of Padua, whence P9 was called *La Vierge de Pade* in the nineteenth century (see Provenance). Freedberg thought the two left-hand angels might be children,[4] but they appear with haloes in another autograph version of the composition (see Versions, Paris).

Although Shearman has indicated that P9 was not, perhaps, Sarto's first version of the composition,[5] the quality and *pentimenti* confirm its autograph status and the attribution has never been doubted. Dated between 1517 and 1519 by Knapp,[6] Monti, Freedberg and Shearman. Freedberg and Monti prefer c.1519, after Sarto's return from France, seeing P9 as directly anticipating works of c.1520 such as the Vienna *Pietà* (Kunsthistorisches Museum, no. 651). Shearman prefers c.1517, before Sarto's French visit; he considers P9 to be inseparable from the dated *Madonna of the Harpies* of 1517 (Uffizi, no.1577). Cook[7] and Fraenckl, exceptionally, dated P9 1528–30, the latter supposing it may have been left unfinished and completed by assistants;[8] he may have been misled by the condition of the panel. Shearman has pointed out that the complex (and ingenious) composition may have derived, in part, from Donatello's marble relief *The Madonna in the Clouds* (Boston, Museum of Fine Arts). The earlier version of the Virgin's left hand in P9 appears to have been identical with the left hand of S. Elizabeth in the Louvre *Holy Family* of 1517–18 (no.1516).

Drawings

LONDON British Museum (no. 1896-8-10-1, *recto*), two red chalk studies for the S. John; Shearman and Freedberg point out that a third study on the *recto*, and the six studies on the *verso* recount the invention of this figure in P9 and may be read as a progression.[9]
PARIS Louvre (no. 1686), red chalk, life study for the head of the Virgin; the attribution, accepted by Freedberg and Shearman,[10] was doubted by Fraenckl.[11]

Engraving

F. C. Lewis, mezzotint c.1820.[12]

Copies/Versions

Note: the suffix (A) *indicates a version without the figures of S. Francis and the music-making angel.*

The following appear to be early versions.
PARIS private collection (A), panel, with more foreground and with radical *pentimenti*, considered by Shearman probably earlier than P9.[13]
MADRID Prado (no.338), panel 106 × 79, and no.339, panel 108 × 81 (on loan to the Museo de Bellas Artes, Seville).
NAPLES S. Giacomo degli Spagnoli, canvas on panel, and Galleria Nazionale (no.739), panel 115 × 87.
ROME Galleria Borghese (no.6) (A), panel 94 × 77, from the Aldobrandini collection (see note 16).

Other copies/versions include:

AREZZO Pinacoteca.

BERLIN Lepke sale, 30 May 1911.
Achenbach sale, 23 February 1938(85), panel
111 × 87 (A).

CHATSWORTH (A and only one angel behind
S. John), 95 × 73, acquired by 1761.

DIJON Musée des Beaux-Arts (A), panel
64 × 50, ex-Campana collection, the upper
part of the composition only and with a
different landscape.

EXETER Col. H. M. L. Hutchinson 1901,
acquired from a Mr. Sobey in the mid-
nineteenth century.

FLORENCE Galleria Corsini (no.166) (A), panel.
Uffizi, deposit from the Poggio Imperiale.
S. Salvi, no.2159, no.6062 (A), 109 × 83, and
no.8311 (A), panel 121 × 94.
S. Maria del Carmine, sacristy.
Private collection, as Chatsworth version
above, in poor condition.
Art market 1963.

LE HAVRE Musée Municipal (A), 117 × 89,
with temple to the right and cross in
foreground.

LENZBURG private collection, panel 110 × 84.

LONDON Sotheby's, 24 January 1973 (23),
88.5 × 70, ex-Apethorpe Hall (A).
Sotheby's, 2 February 1977 (12), 122 × 92 (A).

LONGFORD CASTLE 1914, panel.

LOS ANGELES private collection (A), panel
84 × 63.5, ex-Wentworth Woodhouse sale,
Christie's, 11 June 1948 (51).

MADRID Prado (no.333) panel, 107 × 81.

MUNICH Alte Pinakothek (no.509), 127 × 97.
Goeschl sale, 29 March 1897 (898), panel
86 × 72 (A).

NEW YORK American Art Association,
21–2 March 1922 (114), panel 88 × 63 (A),
ex-Marchese Marignoli collection.

PARIS Louvre (no.1745), drawing.

PHILADELPHIA Julius Sachs.

RHODE ST GENÈSE Belgium, private collection,
said to be ex-Esterhazy collection (A).

RICHMOND Canada, private collection (A).

SAINT-EUGÈNE Algeria, R. Rouby 1907.

SIBIU Romania, Muzeul Brukenthal.

SIENA Opera del Duomo.

SYDNEY R. Smith c.1920, with extended
foreground.

TOLEDO Cathedral sacristy (A), canvas, with
Joseph and other figures in a different
architectural background.

WELLS L. Irwin Scott 1925, panel, S. John
holding a cross.

WILTON acquired by 1766.

Provenance

Probably the *Holy Family* by Sarto listed in the
Palazzo Mari, Genoa, in 1766, 1768 and
1781;[14] Arthur Champernowne of
Dartington, Devon; his sale, Christie's,
30 June 1820 (88, 'A Holy Family with a
group of Young Angels, a legendary subject in
the distance, from the Mari Palace at Genoa'),
bt. Piazetta (*sic*), 410 gn.; Féréol-
Bonnemaison (d.1827), from whom acquired
by Nieuwenhuys and sold to William II of
Holland (1792–1849) by 1843. P9 was not in
Bonnemaison's sale (Paris, 17–21 April 1827).
In 1843 Nieuwenhuys described P9 as having
been bought in Rome during Napoleon's
Italian campaign from the Aldobrandini
collection and acquired by Champernowne in
England;[15] although P9 has been associated
with entries in the Aldobrandini inventories,[16]
Nieuwenhuys's account seems dubious in the
light of Champernowne's sale catalogue.
William II sale, The Hague, 5th day,
16 August 1850 (181, *'La Vierge de Pade'*), bt.
Mawson for the 4th Marquess of Hertford,
30,350 fl. (2,410 gn.);[17] Hertford House
inventory 1870.

Exhibitions

Probably BI 1816 (25, Sarto, *Holy Family*) lent
Champernowne. Manchester, *Art Treasures*,
1857 (saloon H, no.26); Bethnal Green 1872–5
(255); RA 1892 (121).

References General

Freedberg, no.43; Shearman, no.48;
R. Monti, *Andrea del Sarto*, 2nd. ed., 1981,
pp.75, 151 n.122.

[1] By Pamela England of the Hamilton Kerr Institute,
Cambridge.
[2] *The Little Flowers of Saint Francis*, trans. T. Okey,
Everyman ed., 1910, pp.110–1, and the *Life of Saint Francis*,
ibid., p.383. There is an indecipherable shape alongside
S. Francis in P9 which may be another Friar turning away
with his hands over his face; in which case he is doubtless
intended to be Friar Leo who visited S. Francis on the
mountain.
[3] J. A. Crowe and G. B. Cavalcaselle, *History of Painting in
Italy*, VI, 1914, ed. T. Borenius, p.200.
[4] Freedberg, catalogue, p.90 n.2; he refers to them as angels
in text, p.52.
[5] Letter on file dated 17 October 1978, see note 13.
[6] F. Knapp, *Andrea del Sarto*, 1907, p.71.
[7] H. Cook, *Gazette des Beaux-Arts*, 3e, XXVII, 1902, p.448.
[8] I. Fraenckl, *Andrea del Sarto*, 1935, pp.86, 157 and 232–3.
[9] Freedberg, catalogue, p.88; Shearman, p.362.
[10] Freedberg, catalogue, p.88; Shearman, pp.374–5.
[11] Fraenckl, *op. cit.*, p.200.

[12] Not seen, but described by C. J. Nieuwenhuys, *La Galerie des tableaux de S. M. Le Roi des Pays-Bas*, 1843, p.197: '*il est dit au bas de cette estampe que ce tableau fut acheté pour la nation française. Le fait est qu'il fut acquis par M. Bonnemaison, alors directeur de la restauration des tableaux du Musée royal du Louvre: mais il l'acheta pour son propre compte*'.

[13] See note 5; '*another autograph version which I believe to be earlier* (than P9). *Its condition is much less good; but its pentimenti are radical*'.

[14] C. G. Ratti, *Istruzione di quanto può vedersi di più bello in Genova*, 1766, pp. 298–9; G. Brusco, *Description des beautés de Gênes et de ses environs*, 1768, p.103, and 1781, p.112.

[15] No.94 in Nieuwenhuys's catalogue, see note 12. Champernowne, it may be noted, acquired several pictures from Genoa in 1805, cf. Murillo P34, P46 and P97 and Rubens P63. Waagen (II, p.155) repeated the Nieuwenhuys provenance.

[16] '*Una Madonna che tiene il Putto in braccio et S.Gio. da un lato ... del Sarto*', 1603, no.181 (C. Onofrio, *Palatino*, VIII, 1964, p.203); the pre-1665 inventory adds to this '*alto p. tre. e mezo*' (*ibid*); '*una donna che tiene il putto braccio et S.Gio. da un lato ... del Sarto*', 1626, no.86 (P. della Pergola, *Arte Antica e Moderna*, XII, 1960, p.431); '*una Madonna con il putto in braccio e S.Gio. da un lato ... del Sarto ... alto palmi tre e mezzo*', 1682, no.532 (*ibid.*, XXII, 1963, p.178). Each of these inventories also records a similar but smaller composition, 3 *palmi* high, by Sarto, conceivably the version listed above in the Borghese gallery (1603, no.47; pre-1665, no.47; 1626, no.35, and 1682, no.609). Shearman accepts the identification of P9 with the first set of entries, but Freedberg, while mentioning that an (illegible) seal on the *verso* of P9 might invite comparison with the *stemma* of the Aldobrandini, is more cautious; Monti identifies the Borghese version as one of the Aldobrandini versions, and notes the discrepancy in the provenance of P9.

[17] *The Times*, 20 August 1850, described Mawson bidding for P9 against the agents of 'all the continental Courts ... for full half an hour'.

Sassoferrato (1609–1685)

Giovanni Battista Salvi, called Sassoferrato after the town where he was born on 29 August 1609[1] and where he first studied with his father, Tarquinio. Lanzi said he studied in Rome and Naples, but that the artist's MS. memoirs (now untraced) named only one Domenico as his master. It has often been assumed, without documentary evidence – but with stylistic encouragement, that this refers to Domenichino,[2] who left Rome in 1631 to work in Naples. Sassoferrato developed an archaizing Baroque classicism while remaining determinedly eclectic, copying or adapting compositions dating from the fourteenth century (see P646) to the contemporary (see P126). His favourite masters were Raphael, Titian and Guido Reni, but he also took from works by Joos van Cleve, Dürer, Mignard,[3] and many others (see P646). Sixty of his carefully finished drawings are preserved at Windsor Castle.[4] The dependent quality of his work makes it impossible to define any stylistic evolution and as yet only two of his works can be dated: the *S. Francis de Paula kneeling before the Madonna and Child* of 1641 in the church of S. Francesco da Paola, Rome, and the *Madonna del Rosario* of 1643 which was given that year to the church of S. Sabina, Rome, by the Princess Rossano.[5] Together with P646 and a *S. Michael slaying the Dragon* (Camp Lejeune, North Carolina), these appear to be his most important surviving works; an altarpiece in the cathedral of Montefiascone, said by Lanzi to be his largest work, is now untraced. He executed a series of fifteen paintings for the church of S. Pietro, Perugia,[6] probably in the 1640s, but the body of his work is comprised of many repetitions of a few half-length *Virgin* and *Madonna and Child* compositions (see P565). He also painted some clerical portraits (and, according to Lanzi, some landscapes). De Lépinay records that a son, Francisco, was baptised in Rome in 1649.[7] Sassoferrato died on 8 August 1685 probably in Florence.[8] In the eighteenth century Sassoferrato was sometimes considered to have been a pupil, or follower, of Raphael.[9]

[1] G. Vitaletti, *Il Sassoferrato*, 1911, p.41.

[2] See R. Spear, *Domenichino*, 1982, I, p.100.

[3] J.-C. Boyer and F. M. de Lépinay, *The Burlington Magazine*, CXXIII, 1981, pp.68–76.

[4] A. F. Blunt and H. L. Cooke, *Roman Drawings at Windsor Castle*, 1960, pp.102ff.

[5] F. Haskell, *Patrons and Painters*, 1971, p.131.

[6] F. M. de Lépinay, *Revue de l'Art*, XXXI, 1976, pp.38–56, and F. Russell, *The Burlington Magazine*, CXIX, 1977, pp.694–700.

[7] De Lépinay, *op. cit.*, 1976, p.53, annexe 2.

[8] Vitaletti, *op. cit.*, p.28.

[9] See, for example, Pilkington's *Dictionary of Painters*, 1805, pp.490–1, where Sassoferrato's dates are given as 1504–90.

P126 *The Virgin and Child*

The Virgin has chestnut hair, and wears a white chemisette and head-dress, a red dress and a blue drape.

Canvas, relined 46 × 43.2 oval

Heavily ironed in relining, when the canvas was roughly cut at the edges. There are many prominent retouchings in the background area, round the edges, and on the Virgin's right cheek, right shoulder and head-dress; the lock of hair on her shoulder is abraded. The paint is tending to lift on the Child's right leg, and the varnish is considerably discoloured. Inscribed verso: *No.290*, on the lining paper in an early nineteenth-century hand.

A composition repeated many times by Sassoferrato (see P565), closely based on an oval etching, in the reverse sense, by Guido Reni.[1] P126 appears to be Sassoferrato's only circular version, but it is possible that it was cut from a larger composition; the present stretcher appears to date from the early nineteenth century.

Versions
See P565.

Provenance
Louis, marquis de Montcalm (1786–1862);
his sale, Christie's, 2nd day, 5 May 1849 (122,
'an exquisite work of this favourite painter'),
bt. by the 4th Marquess of Hertford, 205 gn.;
Hertford House inventory 1870.

Exhibition
Bethnal Green 1872–5 (289).

[1] Bartsch, XVIII, p.279, no.2. This derivation was first pointed out by K. Woermann, *Katalog der Königlichen Gemäldegalerie zu Dresden*, 1908, p.161, no.430.

P126

P565

P565 *The Virgin and Child*

The Virgin with fair hair, white chemisette and head-dress, red dress and blue drape.

Canvas, relined 85.4 × 72.6

Heavily ironed in relining. There are traces of a vertical tear, approximately 40 cm. long, running down through the Virgin's right shoulder, and several retouchings, e.g. on the Child's left hand, the blue skirt round the knee, the head-dress behind the neck, and generally round the edges of the canvas. Slight *pentimenti* round the head-dress and, more prominently, on the Virgin's neck. The varnish is discoloured.

For the source of the composition, see P126 above. In detail P565 differs from P126 in the colour and disposition of the Virgin's hair, but the figure compositions are otherwise practically identical, down to the folds of the draperies. Phillips, in the earliest editions of this catalogue, found P565 'less certainly from the painter's own hand' than P126, but his misgivings seem groundless.

Versions

Sassoferrato used this composition in three basic formats: as in P126 and P565 (type A); with an angel's head on each side in clouds (type B); and with several angel's heads on each side in clouds (type C). The following have some claim to be by Sassoferrato.

Type A

AVIGNON Musée Calvet, 50 × 39.

BERLIN Wismar sale, 30 November 1920(129), 48 × 38.

BURGHLEY HOUSE 42.6 × 34.

CAMBRIDGE, MASS. Fogg Art Museum, 58.7 × 71.4.

GOODWOOD 68.5 × 61 oval.

THE HAGUE Cramer 1961, 49.5 × 37.

INDIANAPOLIS Museum of Art, 63.8 × 47.8 (the Virgin's right eye is raised).

KASSEL Staatliche Kunstsammlungen, 58 × 73 oval.

LONDON Yorke sale, Christie's, 6 May 1927(95), 57.1 × 71.1 oval.

Sotheby's, 13 July 1977(55), 48.5 × 38 oval.

MILAN Meazza sale, 15–23 April 1884(47), 48 × 38.

MUNICH (formerly), Duke of Leuchtenberg, 30.5 × 38.1 oval.

PARIS Drouot sale, 8 November 1928(78), 33 × 25.

ST. LOUIS Art Museum (no.10.1961), 76 × 63.

STELLENBOSCH private collection, oval.

STOCKHOLM private collection, 50 × 42.

VIENNA Kunsthistorisches Museum (no.539), 75 × 60.

Type B

DRESDEN Gemäldegalerie (no.430), 75.5 × 99.

LONDON Sotheby's, 13 December 1978 (118), 59 × 74 oval.

MILAN Brera (no.583), 100 × 75.

Type C

Czartoriski collection (formerly), 74 × 61.

LONDON art market 1947, 74 × 61, ex-Lowther collection.

Christie's, 26 November 1965 (62), 70 × 58.

Christie's, 25 March 1977 (85), 72 × 56.

Sotheby's, 11 July 1979 (252) and 20 February 1980 (27), 75 × 99.

NEW YORK Anderson sale, 15 April 1926 (49), 74 × 61.

PARIS Louvre (inv.599), 77 × 61.

ROSSIE PRIORY 75 × 61.

WASHINGTON Hays collection (formerly), 76 × 63.

Provenance

Acquired by the 4th Marquess of Hertford, probably in Paris after 1849;[1] rue Laffitte inventory 1871 (409); Hertford House inventory 1890.

Exhibition

Bethnal Green 1872–5 (259).

[1] On the assumption that P565 was bought as a superior version of P126, which had been purchased in 1849.

P646 *The Mystic Marriage of S. Catherine*

The Virgin in purple with a blue drape and beige shawl; S. Catherine in a red dress with a yoke set with pearls and garnets, a golden yellow drape and a white head-dress; she receives the gold ring on the second finger of her right hand.

Canvas, relined 231.5 × 137

Revarnished in 1856; cleaned and relined by Buttery in 1880; cleaned by Vallance in 1960. The edges are heavily retouched and there are old losses on the Virgin's blue drape behind her knee, on the cloud below her right foot and on S. Catherine's drape by her left hip. An old tear runs vertically down to Catherine's left thumb.

The subject is recounted in the Golden Legend:[1] the learned Catherine succeeded to the pagan kingdom of Cyprus as a young girl; urged to marry, she defined a noble, rich, beautiful and forgiving husband such as could not be found; baptised by the hermit Adrian, she was taken to a temple in the desert where the Virgin appeared to her with Christ[2] who placed a ring on her finger, making her his bride; subsequently in Alexandria she criticised the idolatry of the Emperor Maxentius who first condemned her to death on spiked wheels ('Catherine wheels'), which were miraculously broken before inflicting harm, and then had her executed by the sword. The emblems of her martyrdom appear in P646. See also Cima P1 and Attributed to Marinari P562.

P646 was almost certainly painted for S. Maria della Cima, Genzano, a church completed in 1650[3] and decorated through the patronage of Duke Giuliano Cesarini (1618–65).[4] The size agrees exactly with the recessed stone frame in a chapel (dedicated to S. Anne in 1870) where there now hangs a later and comparatively crude copy, doubtless installed when P646 was removed probably in the earlier nineteenth century (see Provenance). This provenance would suggest a date in the 1650s for P646, and it seems quite feasible that, with its dramatic lighting and life-sized figures, it is later than the two comparatively staid Roman altarpieces dated in the early 1640s (see Biography above).

The composition of P646 is characteristically eclectic. The pose of the Virgin and the intricate placing of her hands in relation to those of Christ and S. Catherine are echoed in a triptych with the Marriage of S. Catherine, formerly in the convent of S. Dominic, Perugia, where Sassoferrato had been working in the 1640s,[5] and now in the Galleria Nazionale, Perugia, attributed to Bartolo di Fredi.[6] De Lépinay and Russell have recorded other instances of Sassoferrato adapting fourteenth-century works.[7] The Child seems to derive from Catena's *Warrior adoring the Virgin and Child*, no.234 in the National Gallery, London. The figure of S. Catherine may ultimately have derived from Raimondi engravings.[8] The lower half of the left-hand angel recurs in Sassoferrato's *Annunciation* in S. Maria Novella, Casperia.[9] The sword in P646, a hatchet-pointed falchion, is a seventeenth-century type made in imitation of a supposed classical pattern.[10] Curiously, Phillips expressed some reserve concerning the attribution of P646 in the earliest editions of this catalogue.

343

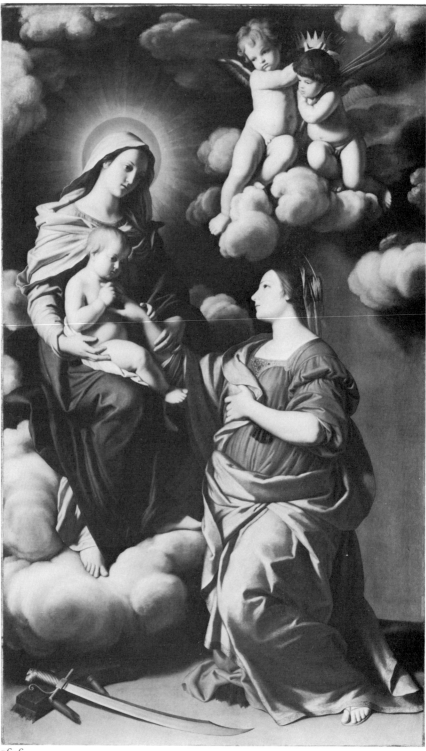

P646

Sassoferrato: Study for P646. Windsor Castle
(Reproduced by gracious permission of Her Majesty
The Queen)

Drawing

WINDSOR CASTLE A squared preparatory study
42.2 × 27.4, showing minor differences, e.g.
the Child's eyes are lowered and the sword
and clouds below the Virgin are less
elaborate.[11]

Copy

GENZANO S. Maria della Cima; 229 × 135, in
poor condition (see above).[12]

Provenance

See above. Commissioned for S. Maria della
Cima, Genzano, c.1650–60, whence removed
probably in the early nineteenth century;
acquired by Horatio Walpole (1783–1858),
3rd Earl of Orford, of Wolterton, where it was
not listed in 1829,[13] but seen by Waagen (III,
p.434) in 1854;[14] his sale, Christie's, 28 June
1856 (279, 'a grand chef d'oeuvre, of the very
highest importance; the figures being of life
size & whole length, so rarely seen in the
works of this elegant master'), bt. Mawson for
the 4th Marquess of Hertford, 1,025 gn.;
Hertford House inventory 1870.

Exhibitions

Manchester, *Art Treasures*, 1857 (saloon H,
no.38); Bethnal Green 1872–5 (260).

[1] Jacobus de Voragine, *The Golden Legend*, trans. Caxton,
1900 ed., VII, pp.10–16; see also Mrs. Jameson, *Sacred and
Legendary Art*, 1850 ed., pp.277–80.
[2] Although not specifically described as a Child, Christ was
almost invariably shown as one, but see Jameson, *op.cit.*,
p.289.
[3] For this date, see G. Spagnesi, *Giovanni Antonio de' Rossi*,
1964, p.18.
[4] See N. Ratti, *Storia di Genzano*, 1797, p.49 and n.1. Ratti
mentions only the picture on the high altar, by Cozza,
which he noted was '*non benissimo conservata*', an indication
perhaps that P646 was not looking at its best when it was
removed. The Cozza has recently been restored.
[5] F. M. de Lépinay, *Revue de l'Art*, XXXI, 1976, pp.38–56;
the dating is probable.
[6] F. Santi, *Galleria Nazionale dell'Umbria, Dipinti . . .*, 1969,
p.99, no.79.
[7] De Lépinay, *op. cit.*, p.50, and F. Russell, *The Burlington
Magazine*, CXIX, 1977, pp.695, 697.
[8] See I. H. Shoemaker, *The Engravings of Marcantonio
Raimondi*, University of Kansas, Lawrence, 1981,
pp.112–13 and 180–1, nos.28 and 60 (Bartsch XIV, pp.87,
100, nos.100 and 113), which jointly reflect the dress, pose
and lighting of the figure in P646.
[9] Illus. de Lépinay, *op. cit.*, p.50.
[10] I am grateful to Mr. A. V. B. Norman for this
identification.
[11] A. F. Blunt and H. L. Cooke, *Roman Drawings at Windsor
Castle*, 1960, p.103, no.879, pl.29.
[12] Listed in E. K. Waterhouse, *Roman Baroque Painting*,
1976, p.114. Zeri has confirmed (orally) that the Genzano
picture is a copy. I must acknowledge the valuable help
given me by Dr. Jeffrey Blanchard in Rome, enabling me to
inspect the Chapel in S. Maria della Cima.
[13] *A General History of the County of Norfolk*, 1829, I,
pp.216–17, lists Orford's collection at that time, without
P646.
[14] Orford may have acquired P646 in Genzano since he
was collecting pictures in Italy, cf. M. Davies, *National
Gallery Catalogues, The Earlier Italian Schools*, 1961, pp.234,
235 n.6, 236 n.18.

Lo Spagna (active 1504, died 1532)

Giovanni di Pietro, a Spaniard, called Lo Spagna. Probably already active in Perugia in 1470 where he is first certainly recorded in 1504. A pupil and follower of Perugino, he was also influenced by Raphael. He worked in Perugia, Assisi and Spoleto where he was made *capitano dell'Arte dei Pittori* on 31 August 1517. There are dated works from 1511 to 1532.

Ascribed to Lo Spagna

P545 *The Ecstasy of S. Mary Magdalene*

The Magdalene has fair hair; the angels above are fair-haired and each carries a white lily (apparently indicating they are Virtues from the second hierarchy of angels[1]), the left-hand figure in a brown dress with green sleeves, the other in a red dress with yellow sleeves; the cherubim below have black and gold wings (left and right) and red wings (centre).

Tempera on paper on beech panel 35.3 × 27.5 made up to 37.5 × 29.7 by edging strips which have been painted over, probably in the nineteenth century

The panel has been badly attacked by worm; it was successfully treated in 1917. The paper has adhered to the now uneven surface and is cracked in places; there is a noticeable hollow to the left of the Magdalene. The paint surface is in poor condition and has been extensively retouched. There are four hinge fixings cut out of the panel on the *verso* of the left-hand side, indicating P545 was once part of a polyptych.

S. Mary Magdalene, a sinner redeemed by Christ whose crucifixion she witnessed, as told in the gospels; medieval legend added, amongst other episodes, an account of her thirty-year penance in a desert where, without food or clothing, she was spiritually sustained by angels who 'every day at every hour canonical' lifted her up in the air to witness the glory and joy prepared for the repentant sinner.[2] This is presumably the subject of P545 (the golden crown symbolising her ultimate victory over sin and death), although it has also been described as S. Mary of Egypt,[3] another *bienheureuse pécheresse* who survived a long penance in a desert where, however, her levitations were unaccompanied and did not exceed 'well nigh a foot and a half'.[4]

The poor condition of P545 makes assessment difficult, but the traditional attribution to Lo Spagna is probably correct; it was accepted by Borenius (1914),[5] Berenson (*Lists* 1932, 1968) and van Marle (1933).[6] The supporting angels are closely paralleled in Lo Spagna's *Assumption* in S. Martino, Trevi, dated 1512, and in his *Coronation of the Virgin* in the Pinacoteca, Todi, dated 1511, in which the landscape and cherubim are also comparable.

P545

Provenance

The vicomte Both de Tauzia (1823–88), from whom purchased by Sir Richard Wallace in 1872, see Appendix IV; Hertford House inventory 1890.

[1] Cf. G. Ferguson, *Signs and Symbols in Christian Art*, 1961, p.97.

[2] See Jacobus de Voragine, *The Golden Legend*, trans. Caxton, 1900 ed., IV, pp.83–4, and Mrs. Jameson, *Sacred and Legendary Art*, 1850, p.205.

[3] By R. van Marle, *Italian Schools of Painting*, XIV, 1933, p.465, and Berenson, *Lists* 1932 and 1968.

[4] For S. Mary of Egypt, see Voragine, *op. cit.*, III, pp.106–10, and Jameson, *op. cit.*, pp.227–8.

[5] J. A. Crowe and G. B. Cavalcaselle, *History of Painting in Italy*, V, 1914, ed. T. Borenius, p.448.

[6] Van Marle, *loc. cit.*, see note 3.

Titian (c.1473/82–1576)

Tiziano Vecellio, born in Cadore in the Dolomites. The earliest sources do not agree on his age; the alleged register of his death in August 1576 gave his age as 103.[1] He studied in Venice with the Bellini and Giorgione (d.1510). His *Assunta*, painted for the church of S. Maria dei Frari, Venice, in 1516–18 established his reputation and thereafter he worked in Venice not only for the princely families of the Veneto, but for the most eminent patrons of Europe, notably the Spanish Habsburgs. In the course of his long life his style evolved from a Giorgionesque idiom (cf. P19 below) to an extraordinarily rich, imaginative vision which has remained without compare in the history of art. He died in Venice on 27 August 1576, perhaps of the plague.

[1] For a discussion of the evidence, see C. Gould, *National Gallery Catalogues, The Sixteenth-Century Italian Schools*, 1975, pp.264–5.

Abbreviation

Wethey III H. E. Wethey, *Titian*, III, *The Mythological and Historical Paintings*, 1975.

J.-L. Delignon after Titian: *Perseus and Andromeda*, 1786.

P I I *Perseus and Andromeda*

Andromeda wears a garnet ear-ring; by her feet lie growths of coral and the skull of a large bird with a crab; Perseus wears a red cloak, crimson cuirass, yellow tunic and lilac-coloured leggings.

Canvas, relined 175/173 × 189.5/186.8 roughly cut

Relined c.1800,[1] when additional strips were added on each side bringing the stretcher size to 183 × 199. The sight size is now 175 × 192. The original canvas seems to have been cut down along each edge. P I I has suffered in the past, though its condition compares not unfavourably with other Titians of this period. By the mid-seventeenth century it was already *'effacé en quelques endroits'*;[2] in 1771 it was probably amongst those pictures from the Orléans collection which had been cleaned and heavily varnished;[3] the figure of Perseus was damaged in 1785;[4] a rock in the foreground, centre-right, had been repainted to conceal a damage by 1786;[5] between 1842 and 1899 P I I was neglected, spending the last twenty-five of these years hanging unglazed over a bath in Hertford House. Cleaned by Haines 1899–1900,[6] and Lank 1980–2 when all additions were removed before making up the present sight size (to accommodate Andromeda's right elbow and Perseus's left foot). There are two major losses dating at least from the eighteenth century: to the left of Andromeda's right foot, and in the foreground, centre-right (as described above). Areas of flaking, causing many small losses, were generally confined to the lower half of the canvas, around Perseus, and in the top left-hand corner. The sky between the two figures has darkened where the brown canvas appears through the white gesso preparation;[7] where the gesso survives, as in the area immediately above the monster's back because of a *pentimento*, the sky has a lighter tone.

The composition evolved through several stages. *Pentimenti* are clearly visible, showing alternative positions for Perseus's cloak, right arm and sword, his shield, Andromeda's right thigh, the right-hand edge of the rock to which she is bound, and the monster's back. Earlier changes are visible only through X-ray or infra-red photography. The evolution of the composition may be summarised as follows:

1 On the right-hand side of the composition there was a full-length female figure, swaying to the left, her raised right arm bound at the wrist. The right arm, at least, was taken to an advanced stage, and evidence of the flesh tone may be observed below Perseus's right knee, on the edge of the cloud. From the 1962 X-radiograph this figure was sometimes supposed to show Perseus in the act of rescuing Andromeda,[8] but the 1982 X-radiograph, taken when the canvas had been removed from its stretcher, suggests more convincingly that the figure was female, and that the right wrist was bound. The figure must have looked into the composition, and the pose probably corresponded quite closely to that recorded in the drawing by van Dyck in his Italian sketch-book (see Drawing below). No evidence survives for the position of Perseus at this stage.

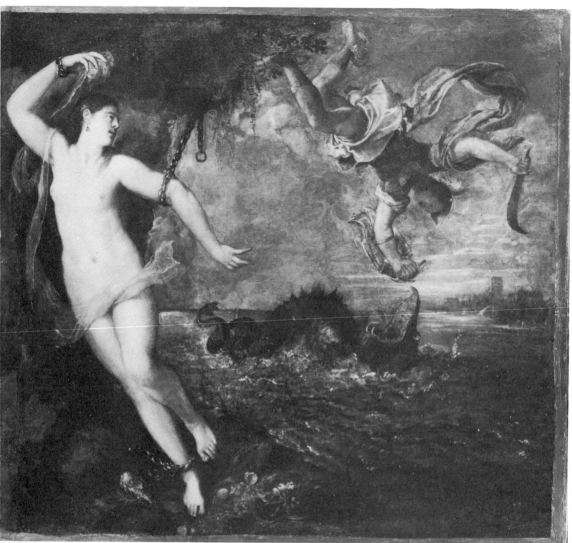

P II

X-radiograph of P I I
(Hamilton Kerr Institute, 1982)

Van Dyck after Titian:
Study for the first version of Andromeda in P I I.
The British Museum

2 When Andromeda was first painted on the left-hand side, both her arms were raised and chained to the rock, her left leg drew away from her right and, while her hips were in approximately the position now seen, her body and head swayed further to the left; the pose appears to correspond with that of the earlier Andromeda described above. The rock extended further to the right, offsetting the complete figure. Keller's proposal that Titian left Andromeda in this position, and that subsequent modifications took place in the seventeenth century,[9] founded on the belief that an anonymous bas-relief on the Procuratie Nuove, Venice, of 1586–1610 derived from Titian's original composition, may be discounted following Lank's recent investigation of the picture.

3 Infra-red reflectography has revealed underdrawing which appears to be for a bent arm parallel to, and above, Andromeda's present left arm, and a bent leg going up out of the composition, to the right of Perseus's present right leg. Together, these suggest that Perseus may once have been swooping in towards Andromeda (in a pose reminiscent of earlier sixteenth-century illustrations of the story, see below, or of Titian's restraining angel in *The Sacrifice of Abraham* of 1543–4, now in S. Maria della Salute, Venice).

Infra-red photograph detail of P 11,
showing the drawing of an earlier position for Perseus's left foot,
top centre right of the canvas.

(Hamilton Kerr Institute)

Infra-red photograph detail of P 11,
showing the drawing of an earlier position of Perseus's
arm above Andromeda's left forearm.

(Hamilton Kerr Institute)

Diagram showing positions of the two infra-red photograph
details reproduced on this page.

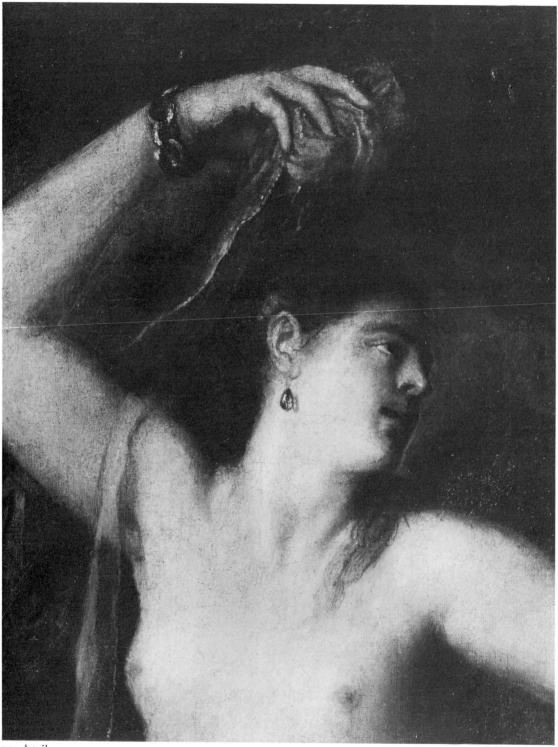

P 1 1 detail

4 The monster rose higher out of the water; the earlier line of its back remains legible as a *pentimento*.

5 The present figure of Perseus at first had both arms further to the left, resulting in the shield being higher and sword lower. Three positions for both sword and shield may be read as *pentimenti*.

The subject is taken from Ovid, *Metamorphoses* IV, 663–752: Andromeda, daughter of Cassiopeia and Cepheus, King of Joppa, is offered, on the advice of Jupiter Ammon, as a sacrifice to a sea monster, sent by Poseidon together with a flood, to destroy Cepheus's kingdom; his attack was made to revenge Cassiopeia's boast that she and her daughter were more beautiful than the Nereids, the sea-nymphs under Poseidon's protection; Perseus, returning from his victory over the Gorgon Medusa (whose petrifying head he had kept with him), slays the monster and marries Andromeda. Titian's account differs from Ovid's in two respects: Andromeda's parents are on a different shore, where Ovid had them close by (691–4); and the coral which Titian shows by Andromeda's feet, was formed by the Gorgon's head after Perseus had slain the monster (741–52). Elsewhere Titian adheres closely to Ovid's text: Andromeda has the air of a marble statue (675), and her eyes are tear-stained (680); Perseus carries a curved sword (666, 726) and has attacked the monster's right shoulder (720). Ginsburg has suggested that Titian could not read Latin and would have relied upon an Italian *volgarizzamento* of Ovid, probably either the *Metamorphoseos vulgare* by Bonsignori (first published Venice, 1497), or *Le Metamorphosi … in volgar verso* by Agostini (first published Venice, 1538).[10] These texts relate closely to each other, presenting the coral-making as a separately titled episode, *De Coralli*, while clearly preserving Ovid's chronology. Agostini implied that Andromeda's parents were in their palace. It would be mistaken, however, to seek a complete textual justification for Titian's composition; his sense of *invenzione* was profound.

A similar caution might be exercised in seeking visual sources for Titian's composition. He could have seen the crude woodcuts of *Perseus and Andromeda* illustrating Bonsignori and Agostini,[11] and conceivably Cellini's wax model, executed c.1545, now in the Bargello, Florence, for the base of his Perseus statue.[12] These possible prototypes all show a general (and inevitable) similarity to Titian's composition; Andromeda stands bound to a rock, or tree, while Perseus swoops (not dives) above the monster to one side. All show Perseus wearing a winged helmet like Mercury,[13] for which there is no textual justification, and carrying a small baroque parade shield, features which Titian may later have remembered. Several sources have been suggested for the figure of Andromeda: Suida proposed Michelangelo's drawing of the Risen Christ of c.1532–3 in the British Museum (Wilde 54);[14] Brendel, a figure in the frieze of a Roman sarcophagus in the Museo Archeologico, Venice,[15] and Panofsky a figure in a relief in the Camposanto, Pisa.[16] The validity of such comparisons is partially undermined by the tortuous evolution of Andromeda's figure, as described above.

P I I may be dated 1554–6, as demonstrated by Wethey and Roskill.[17] Titian told Philip II in a letter dateable 10 September 1554 '*Tosto le manderò la Poesia di Perseo e Andromeda*',[18] and in 1557 Dolce mentions an Andromeda by Titian amongst those pictures painted for the Emperor and the King of England, i.e. Philip II.[19] P I I may, consequently, be identified amongst those pictures which Philip was pressing him to complete in December 1554,[20] which were completed by March 1556,[21] and which were safely received by Philip at Ghent in September 1556.[22] Lank has confirmed that P I I could have taken two years to paint. Previously incorrectly dated between 1562 and 1568,[23] generally through three misreadings: that a related engraving by Fontana was dated 1562;[24] that an engraving by Cort, dated 1565, was after P I I;[25] and that Vasari in 1568 had seen P I I in Titian's studio (when he actually said it already belonged to Philip II).[26]

P I I was one of six *poesie* devised by Titian for Philip II, King of Spain, completed between 1553 and 1562, each subject being taken from Ovid's *Metamorphoses*. The other five (with dates of completion and present locations) are: *Venus and Adonis* and *Danaë with Nursemaid* (1553–4; Prado, Madrid); *Diana and Actaeon* and *Diana and Callisto* (1559; Sutherland loan to the National Gallery of Scotland, Edinburgh), and *The Rape of Europa* (1562; Isabella Stewart Gardner Museum, Boston, Mass.). It is very probable that all six *poesie* were in the Aranjuez Palace c.1584, but Wethey has shown that they could hardly have been received into a predetermined room before that date.[27] There has been much discussion as to how far Titian saw the *poesie* as a decorative scheme. From his letters we learn that he regarded the *Venus and Adonis* and *Danaë with Nursemaid* as a pair; P I I was to display a deliberate contrast to them, but a *Jason and Medea*, announced in the same letter as P I I, was abandoned.[28] *Diana and Actaeon* and *Diana and Callisto* were finished together and are evidently companion pieces.[29] The *Rape of Europa* was started in 1559, together with the *Death of Actaeon* (National Gallery, London)[30] which was probably completed in the early 1570s and appears never to have been sent to Philip II.[31] This schedule, spread over ten years and involving two false starts, suggests that at best Titian had in mind certain pairings, but never a complete scheme. The equivalence of the compositions of P I I and the *Rape of Europa*[32] – seascapes of vast extent with counterbalancing rhythms – need not have been deliberate, and is belied by their stylistic differences (a graceful, sensuous classicism as against a certain *terribilità*). Fehl has attempted the reconstruction of a hypothetical *camerino* containing the six *poesie*;[33] Hope has plausibly insisted that it is unjustified to seek any complex iconographical programme.[34]

Drawing

LONDON British Museum; a pencil drawing by van Dyck in his Italian sketch-book (f.110v), showing two figure studies which agree closely with the first position of Andromeda as described above, was presumably taken from a (now lost) Titian drawing.[35]

Engravings

G. B. Fontana (see note 24); F. Bertelli c.1565–70; J.-L. Delignon.[36]

Copies

GERONA Museo de Bellas Artes, 175 × 207, a late-sixteenth-century Spanish copy, recorded in the Alcázar from 1626 (see Provenance below), in the Buen Retiro from 1746 (already '*maltrata*'), and sent to Gerona in 1882.
LENINGRAD Hermitage, 192.5 × 197.5, probably the version recorded in the collection of Prince Eugen of Savoy (1663–1736)[37] and probably bought by Prince Alexander Kurakin, Russian Ambassador to Vienna 1807–8, before passing to the Hermitage in 1831 from the Naryaschin collection.[38]
MONTAUBAN Musée Ingres, 194 × 236, a seventeenth-century copy, recorded at Versailles in 1683, transferred to the Louvre in 1785, and sent to Montauban in 1872.[39]
PERUGIA Penni Gallery.[40]

Related Painting

KASSEL Gemäldegalerie; a *Perseus and Andromeda* by Palma Giovane repeats the dragon and distant town seen in P II, and the figure of Andromeda is comparable.[41]

Provenance

Sent to Philip II (1527–98) at Ghent in September 1556 and listed by Titian in 1574 amongst those pictures sent to the King for which he had not been paid.[42] There is no documentation of P II in the Spanish Royal collection, but Wethey has shown that the *poesie* were probably in the Aranjuez Palace c.1584; they were all recorded in the Alcázar Palace, Madrid, by Cassiano dal Pozzo in 1626 except P II which had been replaced (?) by a careful copy ('*Andromeda copᵃ diligᵐᵃ che viene da Titiano*').[43] It is not clear how P II left the Royal collection. Philip II had probably given pictures by Correggio to his *quondam* favourite Antonio Pérez before 1579 and to his sculptor Pompeo Leoni before 1582.[44] Pérez owned a '*quadro Grande de Andronida encadenada y Preseo* (sic) *volando*';[45] his collection was dispersed in 1585–6. Dr. Leon Bautista Leoni

(1564–1605), eldest son of Pompeo Leoni, owned on his death in Milan '*una Andrómeda de Tiziano deshecha*' (i.e. damaged).[46] Pompeo Leoni (1533–1608) owned on his death in Madrid '*Una tabla grande de la Andrómeda con Mercurio que mata a un dragón que viene, del Ticiano*'.[47] It is just possible that all three references are to P II.[48] The next certain owner of P II, van Dyck, may have acquired it from the Leoni home in Milan in the course of his Italian visit between 1621 and 1627. P II was listed among the pictures owned by van Dyck on his death, in Blackfriars, London, in 1641 as '*Andromeda con Perseo et il monstro*' by Titian.[49] Bought from van Dyck's executors by the 10th Earl of Northumberland in the year ending 17 January 1646, together with Titian's *Vendramin Family* (now in the National Gallery, London), for £200; in November 1656 Northumberland paid a further £80 to van Dyck's executors to establish his legal claim to both pictures.[50] P II appears in none of the Northumberland inventories (the *Vendramin Family* was listed at Suffolk House in 1652), and is next certainly recorded in Paris by Sauval. It was possibly the *Perseus* by Titian seen by Constantin Huygens in the collection of Louis Hesselin in Paris on 14 June 1649[51] and which appeared in Hesselin's *inventaire après décès*, 30 August 1662 ('*un tableau d'une Andromède qui se dit du Titien-100 livres*').[52] P II was certainly in the collection of Louis-Phélypeaux, seigneur de la Vrillière (1598–1681), and was described hanging in his new Paris hôtel by Sauval: '*L'Andromede du Titien, qu'il avoit fait pour le Roi d'Espagne, & qui a été long-tems l'admiration de Vandick & la merveille de son cabinet*'.[53] If the generally proposed date of c.1654 is accepted for Sauval's text, then P II could not have been in the Hesselin collection, but there remains some uncertainty (see note 2). P II passed to La Vrillière's son, Balthazar, marquis de Châteauneuf (1630–1700), who died in debt. The hôtel was sold in 1705 to Louis Raulin-Rouillé (d.1712), the deed of sale itemising a '*grand tableau sur bois* (sic) *representant andromede au rocher original du titien*'.[54] Mme. Raulin-Rouillé sold the hôtel in 1713 to the comte de Toulouse, but reserved the *Andromeda* which was listed in the hôtel until 1717.[55] Acquired by Philippe, duc d'Orléans (1674–1723), who already owned four other *poesie* (*Diana and Actaeon, Diana and Callisto, The Rape of Europa* and *The Death of Actaeon*).[56] By descent to Louis-Philippe-

Joseph ('*Egalité*'), duc d'Orléans (1747–93), who sold his Italian and French pictures to the Brussels banker Walchiers in 1791.[57] They were bought from him by Laborde de Méréville (d.1801) who brought them to London c.1795 and sold them, with a three-year option, to the banker Jeremiah Harman. Sold by Harman in 1798 to the dealer Michael Bryan acting for a syndicate comprised of the Duke of Bridgewater and the Earls of Carlisle and Gower (later Duke of Sutherland). Exhibited for sale by Bryan at the Lyceum, London, from 26 December 1798, no.205, described as from the collection of Charles I, valued at 700 gn., but not sold. Sold by Coxe, Burrell & Foster, 14 February 1800 (65), bt. Bryan, 310 gn., and again, 27 March 1805 (58), again described as from the collection of Charles I, buyer and price unknown. Acquired by Sir Gregory Page Turner (1785–1843) and in his sale of pictures from Portland Place, Phillips, 20 April 1815 (204), bt. by the 3rd Marquess of Hertford, £362. Dorchester House inventory 1842; stored in the Pantechnicon, Motcomb Street, London, between 1842 and c.1854 when seen by Waagen (IV, p.79) in Hertford House (and attributed to Veronese). Hertford House inventory 1870, in the Lumber Room as Domenichino; between 1876 and 1897 hung unglazed over a bath in Sir Richard Wallace's dressing room in Hertford House. Identified by Phillips in 1897.[58]

Exhibition

BI 1819 (126).

References General

Wethey III, no.30; C. Gould, *The Burlington Magazine*, CV, 1963, pp.112–7; J. Ingamells and H. Lank, *The Burlington Magazine*, CXXIV, 1982, pp.396–406.

[1] P11 had been relined before it was restored by Haines in 1899–1900 and it is most unlikely that it was restored while in the Hertfords' possession (see Provenance). S. Kennedy North, describing the condition of the *Diana and Callisto* and *Diana and Actaeon*, which were with P11 in the Orléans collection, considered that both may have been relined on their arrival in London, see Provenance (*The Burlington Magazine*, LXII, 1933, p.10).

[2] H. Sauval, *Histoire et recherches des antiquités de Paris*, 1724, II, p.233. The exact dating of this account is uncertain. Henri Sauval (c.1620–79) sought permission to publish his work in 1654, but on his death he left nine MS. volumes '*qui contenaient le résultat de ses recherches pendant vingt années*' (Weiss, in *Biographie Universelle*, XXXVIII, 1858, p.88), which were not published until 1724. Vitzthum suggests (*The Burlington Magazine*, CV, 1963, p.216) Sauval's account of the hôtel de la Vrillière should be dated c.1654; it does not mention pictures by Cortona and Maratta which completed the hang of the picture gallery c.1660. But the paragraph concerning P11 has a separate heading, *L'Andromède du Titien*, and could have been written at a different time.

[3] H. Walpole to the Earl of Strafford, Paris, 25 August 1771 (*Correspondence*, XXXV, 1973, pp.344–5), described the Orléans pictures as having been cleaned 'and varnished so thick that you may see your face in them'.

[4] V. Champier and G.-R. Sandoz, *Le Palais Royal*, 1900, I, p.515, quote the 1788 inventory of the Orléans pictures: '*Persée (abîmé en 1785) délivrant Andromède*'.

[5] As shown in the Delignon engraving of 1786, made for J. Couché, *Galerie du Palais Royal*, II (Titian no.5).

[6] Haines removed all the old varnish, and added no new paint except in one 'unimportant' area (by Andromeda's left foot, as described in text above); he had just cleaned the *Diana and Callisto* and *Diana and Actaeon* for the Duke of Sutherland, see C. Phillips, *The Nineteenth Century and After*, May 1900, p.799.

[7] Cf. J. Plesters, *National Gallery Technical Bulletin*, 2, 1978, p.38, and Ingamells and Lank 1982, p.405 and n.4.

[8] When Gould published the X-radiograph in 1963 he canvassed the possibilities of a Perseus and of an Andromeda, but preferred the latter. E. Panofsky, *Problems in Titian: mostly iconographic*, 1969, p.166, preferred the former, as did the 1968 catalogue. A 'rescuing' Perseus is seen in Rubens's composition in the Prado (no.1663).

[9] H. Keller, *Tizians Poesie für König Philipp II von Spanien*, 1969, pp.146–7, but see Ingamells and Lank, 1982, p.405 n.7.

[10] C. Ginsburg, '*Tiziano, Ovidio e i codici della figurazione erotica nel cinquecento*', *Paragone*, 339, 1978, pp.11–17, reprinted in *Tiziano e Venezia*, 1980, pp.129–34.

[11] Illustrated in *Paragone, loc. cit.*, figs. 2a and 2b. Panofsky, *op. cit.*, illustrates the Bonsignori woodcut, fig.181. The 1522 edition of Bonsignori shows a reversed composition.

[12] See Gould, 1963, p.114 and fig.22. It is not absolutely established that Cellini's model was completed before Titian's visit to Florence in 1546.

[13] According to Apollodorus, Perseus had been given by the Stygian nymphs a dark helmet which rendered the wearer invisible (*Bibliotheke* II, 4). The *Perseus and Andromeda* in the Museo di Palazzo Davanzati, attributed (by Bacci, *Piero di Cosimo*, 1966, p.119) to the *Maestro di Serumido*, shows the hero bare-headed, while Peruzzi's *Perseus* of c.1511 in the Villa Farnesina, Rome, and that of the *Maestro del Perseo* (cf. Bacci, no.55) in the Uffizi of c.1520, show him with a winged helmet. It is understandable why Titian's composition was described in 1608 as *Andromeda and Mercury* (see Provenance). The various accounts of the Perseus legend are collected by R. Graves, *The Greek Myths*, 1960, I, pp.237–45.

[14] W. Suida, *Titien*, 1935, p.121.

[15] O. J. Brendel, *The Art Bulletin*, XXXVII, 1955, p.122.

[16] Panofsky, *op.cit.*, p.167 n.72.

[17] M. W. Roskill, *Dolce's Aretino and Venetian Art Theory of the cinquecento*, 1968, p.336.

[18] A. Cloulas, '*Documents concernant Titien conservés aux Archives de Simancas*', *Mélanges de la Casa de Velázquez*, III, 1967, p.227 n.2, the letter dated '*très probablement le 10 septembre 1554*'.

[19] Roskill, *op. cit.*, pp.192–3, '... *delle molte pitture da lui* [Titian] *fatti a Cesare, & al Re d'Inghilterra: come del quadro ... di Andromeda* ...'.

[20] Philip II to Don Francisco de Vargas, London, 6 December 1554: '... *los otros quadros que me haze le dad prissa que los acabe* ...'. Cloulas, *op. cit.*, p.227; J. A. Crowe and G. B. Cavalcaselle, *Titian*, 1877, II, p.509.

[21] Philip II to Titian, Brussels, 4 May 1556, '*Vuestra carta de 7 março he recibido y visto por ella como teneys acabadas algunas pinturas de las que os he mandado hazer* ...', Cloulas, *op. cit.*, p.230; Crowe and Cavalcaselle, *op. cit.*, p.511.

[22] Philip II to Vargas, Ghent, 7 September 1556, '*El que traya los retratos y pinturas que acabó Ticiano llegó con ellos y los truxo muy bien tratados* ...', Cloulas, *op. cit.*, p.231.

[23] 1900 catalogue, and thereafter; Panofsky, *op. cit.*, p.164 and n.66; Keller, *op. cit.*, 1969, pp.142–9. R. Pallucchini, *Tiziano*, 1969, I, pp.309–10, dated PII 1553–62 on stylistic grounds, also believing that Dolce had seen it unfinished. C. Ricketts, *Titian*, 1910, p.132, thought that PII was probably a later variant, to be dated c.1565.

[24] A Fontana print of *Perseus and Andromeda*, only loosely connected with PII (Bartsch XVI, p.235, no.57) is dated 1560; another (*idem.*, no.56), undated, is closer to PII, e.g. in the figures and the dragon, without reproducing it exactly.

[25] But see Wethey III, no.25, pl.224. Several writers mistook this composition for PII, e.g. Ridolfi, *Le Maraviglie dell'Arte*, 1648, ed. von Hadeln, I, 1914, p.202; Sauval, 1724, see note 2; A. Hume, *Notices of the Life and Times of Titian*, 1829, p.95; Waagen, IV, p.79, describing Perseus in PII as mounted on a horse, suggesting he had confused the Cort engraving; Suida, *op. cit.*, p.178.

[26] Vasari-Milanesi, VII, p.452.

[27] Wethey III, pp. 78–84.

[28] See note 18. In that letter, which accompanied the *Venus and Adonis* to Philip II, Titian wrote that because in the *Danaë with Nursemaid* (which he had already sent to the King), '*si vedeva tutta dalla parte dinanzi, ho voluto in quest' altra poesia variare, e farle mostrare la contraria parte, acciochè riesca il camerino dove hanno da stare, più gratioso alla vista. ...Perseo e Andromeda ... avrà un' altra vista diversa da queste; e cosi Medea e Iasone ...*'.

[29] Cf. H. Brigstocke, *Italian and Spanish Paintings in the National Gallery of Scotland*, 1978, pp.162–70. Titian to Philip II, Venice, 19 June 1559; Cloulas, *op. cit.*, pp.235–5; Crowe and Cavalcaselle, *op. cit.*, p.512.

[30] *Ibid.*

[31] Wethey III, no.8; C. Gould, *National Gallery Catalogues, The Sixteenth-Century Italian Schools*, 1975, p.294, does not completely deny the possibility that the *Death of Actaeon* may have reached Philip II in Spain.

[32] Panofsky, *op. cit.*, pp.163–4, refers to 'the third and final pair of mythologies ... two tales ending happily', but M. L. Shapiro, *Gazette des Beaux-Arts*, 6e, LXXVII, 1971, p.109, paired them off as allegories of salvation (PII) and death (*Europa*). P. Fehl, *Fenway Court*, Isabella Stewart Gardner Museum, Boston, Mass., 1980, p.12, and in *Tiziano e Venezia*, 1980, p.146, and C. Hope, *Titian*, 1980, p.134, see them as pendants. S. J. Freedberg, *Painting in Italy 1500–1600*, 1979, p.704 n.7, sees the *Europa* as complementary to the *Death of Actaeon*.

[33] P. Fehl, *Fenway Court*, pp.3–19, and in *Tiziano e Venezia*, pp.139–47.

[34] Hope, *op. cit.*, p.135.

[35] G. Adriani, *Anton Van Dyck: Italienische Skizzenbuch*, 1940, p.73, no. 110v; Wethey III, pl.206.

[36] See note 5. Delignon's engraving shows the composition extended by the equivalent of approximately 18 cm. on each side, despite the fact that the canvas size is given as 178 × 200 ('*5 pieds 6 pouces sur 6 pieds 2 pouces*') in the caption beneath. On the general inaccuracy of Couché's prints, see Gould 1975, *op. cit.*, p.297 n.11. Delignon's print was conceivably based, in part, upon the Montauban version (see Copies above).

[37] It appears in the *Parade und Audienz-Zimmer* of the Upper Belvedere, Vienna, in an engraving by S. Kleinen, published between 1730 and 1741. Eugen's collection was sold to Charles Emmanuel III of Savoy, King of Sardinia, in 1740, but at least one Titian was sold privately before this sale (cf. *Catalogo della Regia Pinacoteca di Torino*, 1909, p.11).

[38] It was attributed to Tintoretto by Waagen in 1861, but catalogued as Titian in 1891 (cf. Hermitage, *Ecoles d'Italie et d'Espagne*, 1891, p.164).

[39] See C. Constans, *La Revue du Louvre*, XXVI, 1976, pp.162, 171. Another *Perseus and Andromeda*, attributed to Veronese and now at Rennes, was also at Versailles (*ibid.*, p.165), and the two pictures have been confused, e.g. by Wethey III, p.172, and Ingamells and Lank 1982, p.399 n.45.

[40] Crowe and Cavalcaselle, *History of Painting in North Italy*, 1871, II, p.288 n.1. and 1912 ed., III, p.540.

[41] See J. M. Lehmann, *Italienische, französische und spanische Gemälde des 16. bis 18. Jahrhunderts*, Staatliche Kunstsammlungen, Kassel, 1980, p.186, no.GK500.

[42] Titian to A. Pérez, Venice, 22 December 1574, '... *le pitture mandate a sua Mᵗᵃ in diversi tempi da anni vinticinque ... Andromeda ligada al saso* ...'; Crowe and Cavalcaselle, 1877, II, p.540.

[43] Quoted in *The Burlington Magazine*, CXXIII, 1981, p.526, by M. Crawford Volk who supposes (p.520) that Pozzo had nonetheless seen PII.

[44] C. Gould, *Correggio*, 1976, pp.164, 270, 275. A. Delaforce, *The Burlington Magazine*, CXXIV, 1982, p.750 n.56, considers that gifts by Philip II would have been quite out of character, and prefers to leave the provenances of the Correggios as uncertain.

[45] Delaforce, *op. cit.*, and n.60, quoting the inventory of Pérez's estate made in 1585. Since this painting was in the garden it is perhaps unlikely to have been PII. Wethey III, p.172, also quotes the Pérez inventory but gives a variant reading.

[46] The Marqués del Saltillo, '*La Herencia de Pompeyo Leoni*', *Boletín de la Sociedad Española de Excursiones*, XLIII, 1934, p.103.

[47] *Ibid.*, p.110.

[48] But see note 44. Conversely, none of these references needs apply to PII.

[49] J. Müller-Rostock, *Zeitschrift für bildende Kunst*, XXXIII, 1922, p.22.

[50] O. Millar, *The Burlington Magazine*, XCVII, 1955, p.255; Gould 1975, p.287; Ingamells and Lank 1982, p.397; see also C. Brown in *Essays on Van Dyck*, National Gallery of Canada, 1983, pp.69–72.

[51] C. Huygens, Journal 14 June 1649, *Werken*, XLVI, 1888, p.98. This reference was pointed out by E. S. de Beer (letter on file dated 14 September 1948).

[52] *Gazette des Beaux-Arts*, 6e, XLIX, 1957, p.60. Only three pictures (by Titian, Tintoretto and Cortona) were more highly valued, at 200 livres each.

[53] Sauval, *loc. cit.*, see note 2.

[54] Archives Nationales, Min. Cent. XCVI, 189; dated *4 septembre 1705*. PII listed as no.62 in the *Cabinet aux tableaux*.

[55] See G. Brice, *Description de la ville de Paris*, 1713, I, p.275; 1717, I, p.333; M.L.R., *Les Curiositez de Paris*, 1716 (1883 ed., p.61). Mme. Rouillé sold '*tous les tableaux ... sans en réserver ny excepter aucuns, sinon seulement l'andromède et un autre tableau représentant Notre Seigneur sortant du temple que lad. dame Rouillé a retenus*' (Arch. Nat., Min. Cent. CXIII, 249, quoted by J.-D. Ludmann and B. Pons, *Bulletin de la Société de l'Histoire de l'Art Français*, année 1979, 1981, p.125 n.42; the authors identified, p.122, *l'andromède* as no. 6 in the *Cabinet aux tableaux: 'coppie d'andromede d'apres le Carache*', but see note 54).

[56] While in the Orléans collection PII was listed by L.-F. Dubois de Saint-Gelais, *Description des Tableaux du Palais Royal*, 1727, p.475, and it appeared in the Orléans inventories with the following valuations: 1724 4,000 fr.; 1752 4,000 fr.; 1785 1,000 fr. (cf. C. Stryienski, *La Galerie du Régent*, 1913, p.150 no.13, where it was also supposed that PII had come to the Regent directly from La Vrillière, and had been in the collection of Charles I); see also note 4.

[57] For the dispersal of the French and Italian pictures from the Orléans collection, see Croze-Magnan, '*Notice historique sur la Galerie du Palais Royal*', in Couché, *La Galerie du Palais Royal*, I, 1786, pp.1–4 (though dated 1786 on the title-page this volume was published in 1808); W. Buchanan, *Memoirs of Painting*, 1824, I, pp.1–147 (PII is listed on p.112); C. Blanc, *Le Trésor de la Curiosité*, 1858, II, pp.147–59; Champier and Sandoz, *op. cit.*, pp.446–8; Ingamells and Lank 1982, p.398, and D. Sutton, *Apollo*, CXIX, 1984, pp.357–72.

[58] C. Phillips, *The Later Work of Titian*, 1898, p.95 n.1, and *The Nineteenth Century and After*, May 1900, p.798.

Ascribed to Titian

P19 *Venus and Cupid*

Venus has chestnut hair and wears a crimson shift over a white blouse; the quiver is blue-grey.

Canvas, relined[1] 110.5 × 138.4

There is a horizontal seam, 60/61 cm. above the bottom edge. In 1786 it was observed that *'le tems et les prétendues restaurations ont beaucoup endomagé ce tableau'*,[2] and P19 has been heavily retouched since then, according to the Couché engraving, see below. The surface is badly worn and there has been considerable flaking. The best preserved passage appears to be Venus's bodice. *Pentimenti* show that Venus's left thigh was originally higher, and Cupid's right shoulder more hunched. X-radiography shows that Venus first had her right arm round Cupid's head, and her right shoulder was lower; Cupid's right foot has been moved to the right, and the solitary tree on the right was painted over the completed landscape.

In 1727 the subject was described as *L'Amour piqué*, from Anacreon, *Odes* xl: Cupid, stung on the hand by a bee while trying to steal honey, complains to Venus who tells him his arrows cause even greater pain.[3] In 1859 the subject was described as 'Cupid wounded by his own arrow, preferring his complaint to Venus'[4] and this has since been generally retained, though Suida suggested that it was not the wounded Cupid, but Cupid wounding a nymph with his arrow.[5] The oldest title, however, appears to be the correct one. The extreme left-hand tree has been partially stripped of its bark, with the implication that Cupid scratched it off with his arrow in his attempt to extract honey;[6] Cupid wears a pained expression, and the 1786 engraving suggests that there was once the mark of a sting on the back of his right hand. It is in any case doubtful that he intends to wound with an arrow held in the left hand, and the discarded bow and quiver indicate that he is off duty.

The traditional attribution to Giorgione[7] was first doubted by Waagen (III, p.202) who proposed Catena. Crowe and Cavalcaselle (1871) considered it to be in the style of Varotari,[8] while Phillips catalogued it in 1900 under Venetian School. An attribution to Titian, proposed by Stryienski in 1913,[9] found wide acceptance,[10] but has been rejected by Wethey. Holmes (1925) proposed a follower of Palma Vecchio.[11] The condition of P19 makes discussion of the attribution hazardous, but it is evidently an original Venetian composition, closely allied to Titian's Giorgionesque phase, c.1510–15.

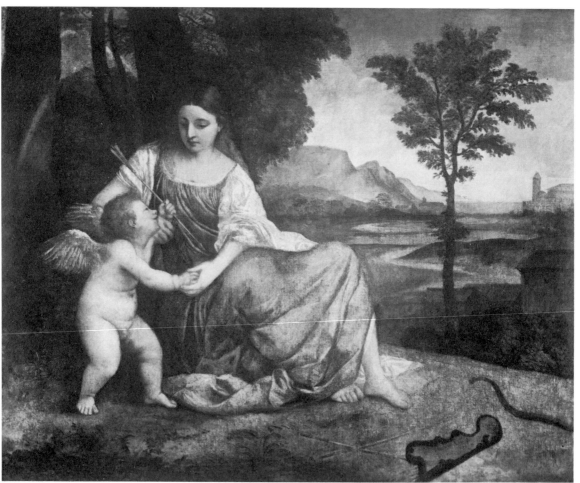

PI9

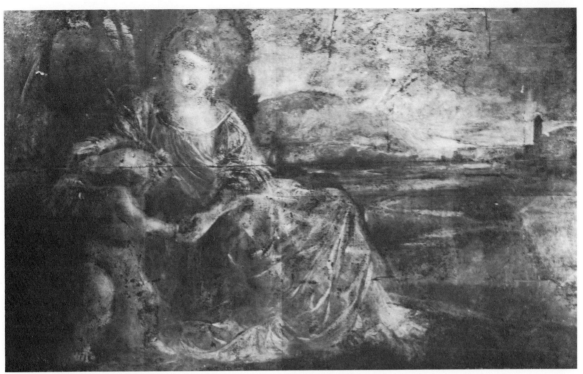

X-radiograph of P 19 (detail)

(The Courtauld Institute)

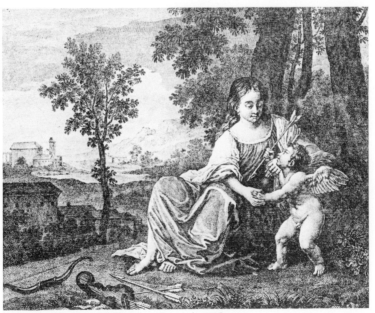

De Longueil and L.-M. Halbou after P 19, 1786.

Drawing

LONDON British Museum, a pencil drawing by van Dyck in his Italian sketch-book (f.117) records a comparable Titian composition, with Cupid holding the bow in his right hand and a broken arrow in his left.[12]

Engraving

De Longueil and L.-M. Halbou 1786.[13]

Version

FOLLINA Treviso, private collection, 104 × 142, apparently a later copy of P19 differing in detail, e.g. the right-hand tree is omitted, the foreground buildings are differently arranged, three figures appear in the mid-distance, and there is a triangular box lying by the quiver in the foreground; other variations, in the draperies and the distant landscape, may be due to the restoration of P19; said to have been in the Brandolini collection and to have remained in Treviso since being painted.[14]

Provenance

M. Forest, presumably J.-B. Forest (1635–1712),[15] from whom acquired by Philippe, duc d'Orléans (1674–1723); by descent to Louis-Joseph-Philippe, ('Egalité'), duc d'Orléans (1747–93), who sold his Italian and French pictures to Walchiers in 1791 (see Titian P11 for a more detailed account);[16] L. de Méréville; J. Harman; bt. Bryan 1798; exhibited for sale at the Lyceum, London, from 26 December 1798, no.206, valued at 400 gn., but not sold; sold by Coxe, Burrell and Foster, 14 February 1800 (62), 175 gn.; Sir Simon Clarke and G. Hibbert sale, Christie's, 14 May 1802 (42), bt. by the 15th Earl of Suffolk (d.1820), 90 gn; Walsh Porter (d.1810) sale, Christie's 14 April 1810 (23), bt. Webster, £336; ibid., 6 May 1826 (5), bt. Davidson, 101 gn.; Sir G. J. Pringle, Manchester;[17] Charles O'Neil sale, Foster's, 24 May 1834 (85), bt. by the 2nd Baron Northwick (1769–1859), 90 gn.;[18] his sale, Thirlestane House, Cheltenham, Phillips, 10th day, 10 August 1859 (996), bt. Mawson for the 4th Marquess of Hertford, 1,250 gn.;[19] Hertford House inventory 1870 as Giorgione.

Exhibitions

As Giorgione: London, Maddox Street, *Paintings in Fresco by Paul Veronese...*, 1826 (1); Manchester, *Royal Institution*, 1831 (36), lent Pringle; Bethnal Green 1872–5 (263).

References General

Wethey III, p.244, no.x-44, as Venetian School, c.1520.

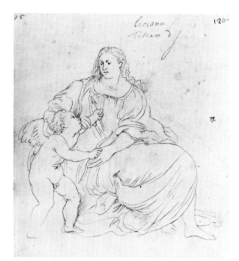

Van Dyck after Titian: Study for Venus and Cupid in P19. The British Museum

[1] The stretcher is similar to that of the Titian P11, and P19 was probably relined by Bryan in 1798.

[2] Text by the abbé de Fontenai beneath the engraving by De Longueil and Halbou in J. Couché, *La Galerie du Palais Royal*, 1786–1808, I (Giorgione no. 6). For the treatment of the Orléans pictures in the eighteenth century, see also Titian P11, note 3.

[3] L.-F. Dubois de Saint-Gelais, *Description des Tableaux du Palais Royal*, 1727, p.167. Saint-Gelais was possibly referring to *Les odes d'Anacréon et de Sapho en vers français*, 1712, p.254, ode XL, '*L'Amour piqué*'. The theme was also treated by Theocritus, *Idylls*, XIX, and illustrated by, for example, Dürer in 1514 (Winkler, no.665) and Cranach, whose composition (repeated several times between 1530 and 1545) is inscribed with a Latin text based on the Theocritan idyll. Lord Northwick (see Provenance) also owned a version of this Cranach.

[4] Northwick sale catalogue.

[5] W. Suida, *Titien*, 1935, p.184.

[6] Cf. Alciati, *Emblemata*, 1574 ed., p.128: '*Amor, fere simile a Theocrito*', which shows the tree partly stripped of its bark, and the end of Cupid's fingers stung; and cf. Poussin's *Nurture of Jupiter* at Dulwich (Blunt, no.161).

[7] Used in the Orléans inventories (see note 16) and in each of the sales recorded in the Provenance; last maintained by H. Cook, *Giorgione*, 1907, pp.93–4, 151, and L. Fröhlich-Bum, *Belvedere*, VIII, 1929, pp.8–13.

[8] J. A. Crowe and G. B. Cavalcaselle, *History of Painting in North Italy*, 1871, II, p.168; their description of the picture is, however, confused.

[9] C. Stryienski, *La Galerie du Régent*, 1913, p.39.

[10] Cf. D. S. MacColl, *The Burlington Magazine*, XLIV, 1924, p.228; P.Hendy, *ibid*, XLVI, 1925, pp.236–40; catalogue 1928, 1968; Berenson, *Lists* 1932, 1957; Suida, *loc. cit.*, see note 5; L. Valcanover, *Tutta la pittura di Tiziano*, 1960, no.62 (attributed); A. Morassi, *Encyclopedia of World Art*, 1967, p.135.

[11] C. Holmes, *The Burlington Magazine*, XLVII, 1925, p.272.

[12] Cf. G. Adriani, *Anton Van Dyck: Italienische Skizzenbuch*, 1940, p.78, no.117.

[13] See note 2; the engraving shows the composition extended by the equivalent of approximately 6.5 cm. above and to the right, but Couché's plates were not always accurate, cf. Titian P11 note 36. The canvas size is given as 113 × 143 ('3 pieds 6 pouces sur 4 pieds 5 pouces') in the caption.

[14] Both G. Fiocco in 1933 and Morassi in 1956 attributed this picture to Titian (letters in possession of the owner). Van Dyck was supposed to have painted a Brandolini (Saratoga, Ringling Museum of Art; Larsen no. 983) and to have copied the Titian, but the drawing listed above does not exactly agree with the picture, and the portrait appears to belong to his English period.

[15] For whom see Dézallier d'Argenville, *Abrégé de la vie des plus fameux peintres*, 1745, II, p.337, and *Gazette des Beaux-Arts*, 6e, LI, 1958, pp.243–54.

[16] While in the Orléans collection P19 was listed by Saint-Gelais, see note 3, and it appeared in the Orléans inventories with the following valuations: 1724 3,200 or 3,000 fr.; 1752 3,200 or 400 fr.; 1785 3,200 fr. (the 3,200fr. quoted by V. Champier and G.-R. Sandoz, *Le Palais Royal*, 1900, I, p.509, the other valuations by Stryienski, *op. cit.*, p.148). P19 was listed in St. Cloud in 1783 in the *chambre d'Henriette d'Angleterre*, no.9 (*l'Amour Blessé, se plaignant à Vénus par il Gorgion*), see *Curiosités du château de St. Cloud*, 1783. The subsequent sale of P19 is described by W. Buchanan, *Memoirs of Paintings*, 1824, I, p.126, and C. Blanc, *Le Trésor de la Curiosité*, 1858, II, p.157, and see Titian P11 note 57.

[17] Sir John Pringle (1784–1869), 4th Bt. of Stichill; see J. D. Passavant, *Tour of a German Artist in England*, 1836, II, pp. 20–1, 189.

[18] Listed in *Hours in the Picture Gallery of Thirlestane House*, 1846, p.51, no.CCLXI. P19 may also be seen in Thirlestane House in the painting attributed to R. Huskisson, exh. BI 1847 (506), now in the Yale Center for British Art, New Haven (no.1225).

[19] See *Letters*, no.96, p.123.

After Titian

P5 *The Rape of Europa*

Canvas, relined[1] 57.5 × 71.5

Cleaned by Allden in 1982.

The subject is taken from Ovid, *Metamorphoses* II, 843–75: Jupiter, in the form of a bull, carries off Europa, daughter of Agenor, king of Tyre.

A reduced, spirited copy of the Titian now in the Isabella Stewart Gardner Museum, Boston, Mass., one of the six *poesie* painted for Philip II of Spain (for which, see Titian P11). In the nineteenth century P5 was generally considered Titian's 'original sketch',[2] and Mawson told Lord Hertford that 'it is much finer than the finished picture'.[3] Crowe and Cavalcaselle in 1877 thought it possibly a seventeenth-century Spanish copy by Mazo,[4] but it could equally be an eighteenth-century French copy, made after the original had left Spain to enter the Orléans collection c.1706.

Versions

Of many recorded copies from Titian's original composition,[5] two particularly concern P5.

DULWICH College Picture Gallery (no.273), 45.7 × 55.5, bequeathed by Sir F. Bourgeois 1811; possibly dating from the early eighteenth century, smaller and weaker [6] than P5, this was probably the sketch of Europa in the Reynolds sale, 3rd day, Christie's, 16 March 1795(57), bt. Bryan, 16 gn.; Bryan sale, 27 April 1795(48), 16 gn.; anon. sale ('from the Continent'), Christie's, 7 February 1807(28), bt. Sir F. Baring, 32 gn.; these sales have also been associated with P5.

A drawing by F. W. Wilkin, sold Phillips, 30 April 1813 (55), 'from the Sketch of Titian, which formerly belonged to Gavin Hamilton, of Rome, afterwards to George Hibbert, Esq., the large picture is now in the possession of the Earl of Darnley...';[7] this substantiates the provenance for P5, see below.

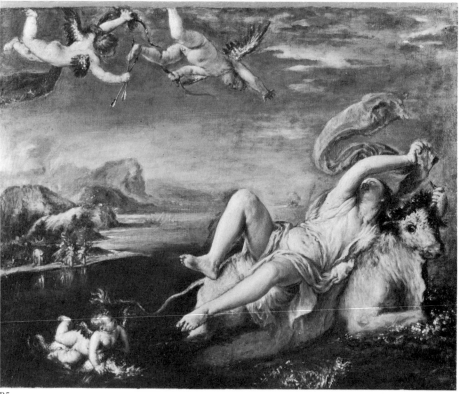

P5

Provenance

Gavin Hamilton (1730–97); Bryan's Gallery
1801–2, 'Robit's Collection and pictures from
other distinguished cabinets', no.41, 'Titian –
Europa'[8] (it was not in the Robit sale, Paris,
16–18 May 1801); G. Hibbert;[9] William
Champion sale, Phillips, 21 March 1810(28),
bt. Buchanan, 295 gn.; W. Y. Ottley
(1771–1836); his sales, Christie's, 25 May
1811(42), bt. in ('Fraser', 270 gn.), and
4 March 1837(78), bt. Buchanan, 148 gn.;
Dawson Turner (1775–1858), Yarmouth, by
1850;[10] his sale, Christie's, 14 May 1852 (77,
as 'imported into England with the Collection
of M. Robit, from which it successively passed
into those of Mr. George Hibbert, and Mr.
Ottley'), bt. Gritten, 275 gn.; G. T. Braine
sale, Christie's 6 April 1857(49), bt. Mawson
for the 4th Marquess of Hertford, 325 gn.;[11]
Hertford House inventory 1870, '*Titian Rape
of Europa*'.

Exhibition

RA 1872(126); Bethnal Green 1872–5(313).

Reference General

Wethey III, p.174, as a copy of uncertain date.

[1] The stretcher bears the chalk marks of the 1857 sale and
is stamped: F. LEEDHAM/LINER; he is recorded in London
1844–56 and 1866–71.
[2] It was so described in all the nineteenth-century sales and
exhibitions. Lord Leighton believed it to be a Titian sketch
(*Nineteenth Century and After*, May 1900, p.801).
[3] *Letters*, no.87, p.110.
[4] J. A. Crowe and G. B. Cavalcaselle, *Titian*, 1877, II,
p.324n.; repeated by C. Stryienski, *La Galerie du Régent*,
1913, p.46.
[5] Wethey, *loc. cit.*, lists nine, to which may be added the
Wilkin drawing here discussed and a canvas, 100 × 140, in
a French private collection.
[6] So described by Crowe and Cavalcaselle, *loc. cit.*
[7] The sale contained a series of drawings by Wilkin
(d.1843) 'executed after Pictures of the Old Masters made
under the immediate Inspection of an Amateur of refined
Taste'.

[8] W. Buchanan, *Memoirs of Painting*, 1824, II, p.67. Though Bryan also owned at this time Titian's original *Europa*, the 1852 sale description of P5 would seem to indicate that it was the *Europa* then exhibited.

[9] Hibbert, with Sir Simon Clarke, had given Bryan the credit to buy at the Robit sale – which may further explain the 1852 sale reference.

[10] When Waagen (III, p.18) saw 'the admirable sketch'.

[11] Hertford had written to him 'the Titian is only a study but I dare say very desirable' (*Letters*, no.73, p.92).

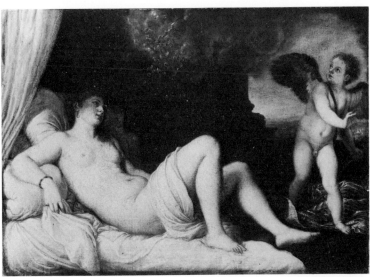

P546

P546 *Danaë with Cupid*

Canvas 32 × 44

The varnish is much discoloured.

The subject is mentioned by Ovid, *Metamorphoses* IV, 697–8: Jupiter makes Danaë, daughter of Acrisius, King of Argos, pregnant with his fertile gold, though she was imprisoned in a tower since her father had been warned that he would be killed by her son. Danaë gave birth to Perseus (see Titian P11) who accidentally killed Acrisius while throwing a discus.

A late eighteenth-century copy[1] of the painting by Titian in the Gallerie Nazionale, Capodimonte, Naples, painted in 1545–6, which hung in the Palazzo Farnese, Rome, before being taken to Naples c.1759. P546 was described as a copy by 'Rosa' in 1804[2] and by 'Rossi' in 1856 (see Provenance below); it was doubtless painted in Naples, and is by a competent copyist.[3]

Versions

Wethey lists more than twelve other copies of Titian's original composition.

Provenance

Commissioned by Sir Richard Worsley (1751–1805), who died intestate and whose collection passed to the Yarboroughs of Brocklesby Park, Lincolnshire; Col. C. de W. Sibthorp (1783–1855), MP for Lincoln; his sale, Christie's, 4th day, 12 April 1856 (555, 'Rossi – A beautiful small copy from Titian, painted for Sir R. Worsley, Bart., when Minister at Naples'),[4] bt. Mawson for the 4th Marquess of Hertford, £15;[5] Hertford House inventory 1870, 'Titian Danae'.[6]

Exhibition

Bethnal Green 1872–5 (316, as Titian, a sketch for the larger picture at Naples).[7]

Reference General

Wethey III, under no.30, as an eighteenth-century(?) copy.

[1] The condition of the unlined canvas is consistent with such a date. In the 1900 catalogue Phillips proposed P546 might be a seventeenth-century Bolognese copy.
[2] *A Catalogue of the principal Paintings, Sculptures, Drawings, &c., &c., at Appuldurcombe House* (Isle of Wight), *the seat of the Rt. Hon. Sir Richard Worsley, Bart., taken June 1 1804*, p.39.
[3] Of recorded artists, only G. B. Rossi of Naples, a history painter active between 1749 and 1782, would seem to qualify.
[4] Worsley was never Minister at Naples; he was the British Resident in Venice 1793–7, and travelled much in Italy and the Levant.
[5] Hertford had asked Mawson to buy it at the Sibthorp sale, 'I am sure I sh^d like to have … it'; after the sale he told Mawson, 'I am sure it is pretty as you say so' (*Letters*, nos.61 and 63, pp.72, 77).
[6] Lord Hertford apparently owned a second copy, cf. Bagatelle inventory 1871 (1010, '*d'après le Titien, Danaë*').
[7] J. A. Crowe and G. B. Cavalcaselle, *Titian*, 1877, II, p.123n., then pointed out that P546 was clearly not by Titian, but a later copy.

Tuscan School(?) mid 16th century

P542 *Portrait of a Young Man with a Lute*

Brownish hair, brown eyes, dressed in a black tunic with wide sleeves and gold buttons; the lower part of his soft black hat is studded; he wears a gold ring of two and a half turns on the little finger of his left hand; the walls are hung with a fringed green tapestry of a floral pattern; the sword, hanging by a red bow from a black hook, has a red scabbard; on the cornice shelf are an oval box with a lid, some manuscripts, two antique torsos and a large lemon (a *cedro*).[1]

Poplar panel 92.7 × 67.6 × 2.2 two irregular vertical members, the right 22.5 wide at the bottom and 23.8 at the top, joined by three cleats; there is an inset 11.1 × 10.8 in the bottom left corner

Considerably retouched throughout, as is particularly apparent in the flesh areas. The damage, bottom left, reflects the repair in the panel. The panel has a marked convex warp.

The sitter's attributes appear to be those of the *cortegiano*. MacColl thought the *cedro* might be a rebus for the sitter, perhaps a Cedrini;[2] he also suggested, more doubtfully, that P542 might be a self portrait.[3] Costume suggests a date in the mid-sixteenth century. Previously catalogued as North Italian school, but the echoes of Pontormo and the clarity of design may rather point to a Tuscan origin, as Zeri (orally) has suggested. Shearman has associated P542 with a group of portraits which he attributes to a mid-sixteenth-century Bolognese hand, provisionally called the Master of the Jacquemart-André Lutanist;[4] P542

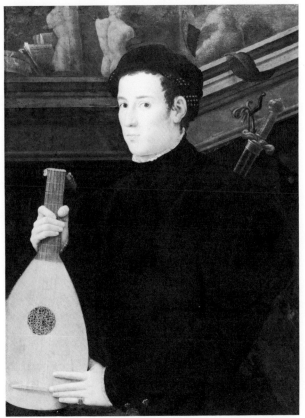

P542

is perhaps flattered in this company, but it certainly shows 'a chronic inability to relate objects and persons in satisfactory stereometry' and a love of still life, which Shearman cites as characteristic of the Master.

Provenance

Acquired by Sir Richard Wallace between 1870 and 1872, probably as part of the Nieuwerkerke collection (*'un portrait italien sur bois'*, bt. by Nieuwerkerke from Malinet, Paris, 10 March 1866, 290 fr.);[5] Hertford House inventory 1890 as Italian sixteenth century.

Exhibition

Bethnal Green 1872–5 (266, as School of Raphael).

[1] Precisely, a variety of *citrus medica vulgaris*, perhaps the *lima oblonga sive scabiosa et monstruosa*, a Chinese plant grown in Italy (cf. A. Rosso and A. Poiteau, *Histoire naturelle des Orangers*, 1818, pp.96–8).

[2] D. S. MacColl, *The Burlington Magazine*, XXII, 1913, pp.325–6; he proposed a descendant of the North Italian sculptor, Marino di Marco Cedrini.

[3] *Ibid.*; he thought it significant that the lute was held in the left hand.

[4] J. Shearman, *The Early Italian Pictures in the Collection of Her Majesty the Queen*, 1983, p.157; the six portraits otherwise forming the group are: Paris, Musée Jacquemart-André, *The Lutanist*, exh. Grand Palais 1965 (349); Amsterdam, Rijksmuseum (2740), *The Harpsichord Player*; Cambridge, Fitzwilliam Museum (1653), *Francesco de Pisia*; Hampton Court, *Lady with a Dog* (Shearman, no.152); Gosford House, *A Girl reading*, exh. RA 1960 (105), and London Art Market 1962, *Caterina Bercighelli*.

[5] Invoice preserved in the Wallace Collection archives.

P540

Umbrian School first quarter 16th century

P540 *The Virgin of the Annunciation*

Fair-haired with a white head-dress, wearing a red dress with a black-lined collar and white girdle, and a grey cloak with a green lining. Inscribed A.DN (possibly part of *ecce ancilla dni*, Luke I, 38, or part of a date, *anno domini*).

Fresco transferred to canvas and mounted on panel of four vertical members original painted area 58.4 × 55.9 with irregular arched top

Retouched throughout. There is a vertical crack, bottom centre; loose paint top and bottom left, and a general heavy craquelure.

For the subject, see Murillo. P68.

The right arm and the cloak over the right shoulder are ineptly drawn, and the blessing gesture of the left hand is unusual in the Annunciation. The condition suggests P540 may have been transferred by Barezzi (see Luini P526 and P537), but it seems to be Peruginesque rather than Milanese, as Phillips pointed out in the 1900 catalogue, instancing the influences of Perugino and Pinturricchio. The latter was also cited by van Marle.[1]

Provenance
The vicomte Both de Tauzia (1823–88), from whom purchased by Sir Richard Wallace in 1872, see Appendix IV; Hertford House inventory 1890 unattributed.

[1] R. van Marle, *Italian Schools of Painting*, XIV, 1933, p.293.

Spanish School

Alonso Cano (1601–1667)

Painter, sculptor and architect, baptised on 19 March 1601 in Granada, the son of an architect and retable designer. In 1614 the family moved to Seville where Alonso studied painting with Pacheco from 1616 (thus briefly overlapping with Velázquez), but probably did not complete his five-year apprenticeship. He studied sculpture under Martínez Montáñes, and architecture and retable design with his father. Licensed as a Master Painter in 1626. After a successful period in Seville he moved in 1638 to Madrid where, under Olivares's patronage, he became a Court painter and Gentleman of the Bedchamber. In 1644 his second wife was murdered and he was tortured as a suspect, but acquitted. In 1652 he retired to Granada to work in the Cathedral where many of his finest works remain, in sculpture, painting and architecture. He took Orders in 1658, and was appointed Cathedral architect shortly before he died, in Granada, on 3 September 1667.

P15 *S. John the Evangelist's Vision of Jerusalem*

S. John in white with a deep scarlet drape;[1] the angel in golden brown with a light green drapery.

Canvas, relined 82.6 × 43.8

Cleaned by Lank in 1983 when overpainting, dating from the early nineteenth century, was removed from the spandrels. There is a small vertical tear by S. John's right leg, and small damages on the inner edge of the angel's drapery (by his left wing) and in the sky below the visionary city. Both vertical edges have been retouched within a band approximately 2 cm. wide. There are *pentimenti* in the positions of the angel's wings, the drapery above his head and right leg, and in the drapery hanging over S. John's left arm.

The subject is taken from Revelation xxi, 9–27: an angel shows S. John the heavenly Jerusalem, part of his vision of a new heaven and a new earth with which the Bible ends. The city walls were of jasper and the city of pure gold; three gates stood on each side, each named after a tribe of Judah, and it was lit by the glory of God, without sun or moon.

P15 was painted in 1636–7, one of eight canvases forming part of the retable of S. John the Evangelist in the Convent of S. Paula, Seville. On 23 November 1635 Cano contracted to make for the Hieronymite nuns a carved retable with ten paintings (subsequently modified to eight paintings and two carvings).[2] When he left Seville in January 1638 Cano had completed the retable and possibly six of the paintings (*'yo tengo ... pintado la mayor parte de los lienços de pintura'*).[3] The commission was completed by Juan del Castillo, and Martínez Montáñes made the two central carvings (*S. John on Patmos*, dateable 1637,[4] and the *Martyrdom of S. John*, a bas-relief). The retable and carvings survive *in situ* today, but the eight paintings were removed by Marshal Soult in 1810 during the Peninsular Wars.[5] They were subsequently replaced by anonymous pictures of Saints.[6]

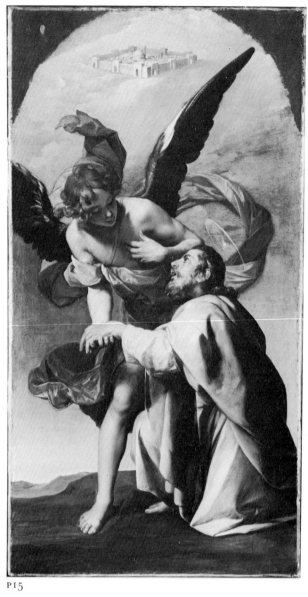

PL 5

Cano's eight paintings were dispersed in the Soult sale of 1852, as was first established by Baticle, who also traced the present locations of six of them; they are numbered below in accordance with the accompanying diagram:

1 *S. John the Evangelist with the poisoned Cup*, 53.5 × 35.6; Soult sale, lot 46, bt. Galliera, 2,800 fr. (Louvre, RF1977–2)

2 *S. James the Greater*, 53.5 × 36; Soult sale, lot 47, bt. Galliera, 2,100 fr. (Louvre, RF1977–3)

3 P15.

4 *S. John giving Communion to the Virgin Mary*, 87 × 43; Soult sale, lot 42, bt. Roux, 7,000 fr. (Genoa, Palazzo Bianco). The attribution has been doubted; Wethey suggests it is a copy, Baticle a much-overpainted original.[7]

5 *S. John's Vision of God*, 73 × 40; Soult sale, lot 45, bt. Galliera, 3,700 fr. (John and Mable Ringling Museum of Art, Sarasota). Attributed to Juan del Castillo by Wethey in 1955; in 1983 he considered it perhaps completed by Castillo.[8] Baticle and Suida accept it as by Cano.[9]

6 *S. John's Vision of the Lamb*, 73 × 40; Soult sale, lot 44, bt. Galliera, 2,990 fr. (John and Mable Ringling Museum of Art, Sarasota). Attribution as 5 above.[10]

7 *Charity*, 36 × 48; Soult sale, lot 49, as *Ecole de Cano*, 'La Charité [qui] allaite un enfant; deux autres l'enlacent dans leurs bras', bt. Laneuville, 136 fr. (Present location unknown)

8 *Faith*, 36 × 48; Soult sale, lot 50, as *Ecole de Cano*, 'La Foi [qui] tient une croix d'une main, et de l'autre un calice surmonté d'une hostie', bt. Townend, 180 fr. (Present location unknown)

Wethey (1955) surmised that the arched frames now seen in the retable in positions 3 and 4 were nineteenth-century additions, and he assumed that the original frames were rectangular.[11] P15 was engraved in 1830 as a rectangular composition. But since it is now clear that nos. 3 and 4 in the above list have arched tops (see above), it follows that the original frames were also arched.

Engraving

A. Réveil 1830.[12]

Provenance

The Convent of S. Paula, Seville;[13] removed by Soult in 1810 (see above); his sale, Paris, 1st day, 19 May 1852 (43), bt. by the 4th Marquess of Hertford, 12,100 fr.;[14] rue Laffitte inventory 1871 (99, 'école espagnole, Saint soutenu par un ange'); Hertford House inventory 1890.

Exhibition

Bethnal Green 1872–5 (325).

References General

H. E. Wethey, *Alonso Cano*, 1955, pp. 35, 41, 146–7, 168–9, and *Alonso Cano*, 1983, pp. 43, 113–15; J. Baticle, 'Deux tableaux d'Alonso Cano. Essai de reconstitution d'un retable', *La Revue du Louvre*, XXIX, 1979, pp. 123–34.

[1] Baticle, p.130, suggested that the same model was used by Zurbarán in his *Crucifixion with S. Luke* (Prado, no.2594).
[2] The contract is quoted by Wethey 1955, p.209, and 1983, p.191; Baticle, p.133.
[3] Document dated 3 January 1638, a statement by Cano of work completed, quoted by Baticle, p.134.
[4] See Wethey 1955, p.146, and 1983, p.42.
[5] A fact first established by Baticle, who located a receipt, dated *31 novembre* [sic] *1810*, given by Soult's representative to Doña Isabel de Molina, bursar of the Convent; described by Baticle, p.129.
[6] Seen in illustrations of the retable in Wethey 1955, fig.31, and 1983, fig.28; Baticle, p.126.
[7] Wethey 1955, p.186, and 1983, pp.43, 113–15; Baticle, p.130. Another canvas of the same subject, attributed to Cano, 81 × 45.7, in the Museo de S. Carlos, Mexico City, with a pendant *S. John with the Poisoned Cup*, was perhaps an earlier version for the S. Paula retable (both illus. Baticle, pp.130–1, Wethey 1983, figs. 33–4).

[8] Wethey 1955, p.169, and 1983, p.114. The picture was engraved by Réveil, *Musée de peinture*, III, 1830, no.196.
[9] W. E. Suida, *Catalogue of Paintings in the ... Ringling Museum of Art*, 1949, p.284, no.344.
[10] Ibid., p.286, no.345.
[11] Wethey 1955, p.147.
[12] *Musée de peinture*, II, 1830, no.123, as *dans le cabinet de travail de M. le maréchal Soult*; illus. I. H. Lipschutz, *Spanish Painting and the French Romantics*, 1972, p.87.
[13] Where recorded by A. Ponz, *Viage de España*, IX, 1786 ed., p.121; '*ocho excelentes quadritos relativos a su* [i.e. S. John's] *historia*', and Ceán Bermúdez, *Diccionario*, 1800, I, p.218: '*ocho pinturas relativas a la vida del santo*'.
[14] *The Times*, 22 May 1852, recorded a fierce competition between Hertford and Galliera for P15, and attributed the high price in part to the fame the picture had acquired through Réveil's engraving.

Juan Simón Gutiérrez (c.1645–1724)

Born in Medina Sidonia, near Cádiz. He was a member of the Seville Academy 1664–72, and was probably taught by Murillo whose style he faithfully imitated. He married in 1677 and was buried in the church of S. Pedro, Seville, in 1724. A large lunette canvas, *The Death of S. Dominic*, dated 1711, in the Seville Museum, provides the basis for attributions;[1] there is a *Virgin and Child with Augustinian Saints* by him in the Convent of the Trinidad de Carmona, Seville, and an attributed *S. Francis in Ecstasy* is in the Walker Art Gallery, Liverpool. Curtis listed further works.[2]

[1] Three other lunettes in the Seville Museum showing other scenes from the life of S. Dominic, formerly attributed to Gutiérrez, are not now considered to be by him, cf. D. Angulo, *Murillo y su Escuela*, 1975, p.8 (a brief biography of Gutiérrez on which this account has been based).
[2] C. B. Curtis, *Velázquez and Murillo*, 1883, pp.349–50.

Attributed to Gutiérrez

P105 *The Assumption of the Virgin*

The Virgin in white with a blue drape; S. John, in the right foreground, with a red drape; in the left foreground a Saint in blue with a beige drape; there are twelve Apostles and three Holy women by the empty tomb which is covered by a white shroud bearing pink roses.

Canvas, relined 65.1 × 39.8

Heavily ironed in relining,[1] with a fine overall craquelure; some discolouration of varnish.

The subject has no Biblical source, but is described in the Golden Legend:[2] at the time of the Virgin's death the twelve Apostles came to her and, with three Holy women who had been living with her, they witnessed her Assumption.

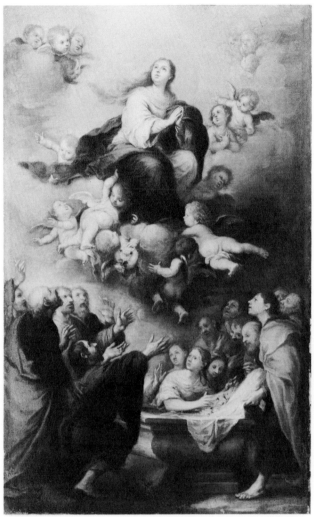

PI05

Although the legend declared Mary was sixty (or seventy-two) years old, she is generally portrayed as ageless. The roses on the shroud are doubtless symbolic of heavenly joy and purity.

The attribution of P105 to Murillo, given in previous editions of this catalogue, is no longer tenable. Milicua (1958) attributed it to an *anónimo murillesco*,[3] and Angulo has since attributed it 'almost certainly' to Gutiérrez.[4] The figure of the Virgin in P105 appears, in reverse, in an *Immaculate Conception* in a private collection, Houston;[5] Milicua pointed out that the composition derives in part from engravings of two *Assumptions* by Rubens, in Buckingham Palace[6] and Düsseldorf.[7]

Provenance

The 2nd Duke of Buckingham (1797–1861); his sale, Stowe, Christie's, 24th day, 15 September 1848 (390),[8] bt. Mawson for the 4th Marquess of Hertford, 56 gn.;[9] Hertford House inventory 1870 as Murillo.

Exhibition

Bethnal Green 1872–5 (317, as Murillo).

References General

C. B. Curtis, *Velázquez and Murillo*, 1883, Murillo no.53; J. A. Gaya Nuño, *L'opera completa di Murillo*, 1978, no.298, as Murillo; D. Angulo, *Murillo*, 1981, no.915.

[1] Relined in France, the stretcher labelled: '*chassis2/No 29/Murillo/Ascension de la Vierge*'.
[2] Jacobus de Voragine, *The Golden Legend*, trans. Caxton, 1900 ed., IV, pp.234–70. See also E. Mâle, *L'art religieux après le Concile de Trente*, 1932, pp.361–3, and M. Warner, *Alone of all Her Sex*, 1978, ch. VI *passim*.

[3] J. Milicua, *Archivo Español de Arte*, XXXI, 1958, p.11
[4] See ref. gen. above and *Murillo y su Escuela*, 1975, p.8 and no.197a.
[5] Angulo 1981, no.728.
[6] M. Rooses, *Rubens*, 1904, no.356, engraved in reverse by Bolswert c.1650, showing the angel to the right of the Virgin's feet in P105 (which recurs in the *Assumption* attributed to Murillo in the Ringling Museum of Art, Sarasota, cf. Angulo 1981, no.974).
[7] Rooses, no.358, engraved in reverse by Pontius, showing the group of S. John and the Holy women in P105. Milicua drew attention to an *Assumption* attributed to Rubens in the Strachan collection (illus. *The Connoisseur*, LXXXV, 1930, p.384), but this would appear to be another derivation from the Pontius engraving.
[8] Lot 391, *The Glorification of the youthful Christ* by Murillo, bt. Ryman, 29 gn., was catalogued as the pendant (cf. Angulo 1981, no.1326).
[9] Lord Hertford was not very enthusiastic about this purchase, see *Letters*, no.2, p.21. In the 1968 catalogue a second letter was mistakenly related to P105, see Meneses P7.

Francisco Meneses Osorio (c.1640–1721)

A member of the Seville Academy 1666–73 and *mayordomo* 1668–9 when he presented an *Immaculate Conception* (now lost). He was very probably taught by Murillo whose style he closely imitated into the eighteenth century. In 1681 he assisted Murillo with the retable for the Capuchin Church, Cádiz, and after Murillo's death in 1682 Meneses completed the central *Marriage of S. Catherine* (adding the cherubim) and executed the four lateral panels from Murillo's designs. Other works by him are in Seville (Hospital de la Caridad and Museo de Bellas Artes), Osuna (a *Mater Dolorosa* dated 1703 in the Church of The Incarnation) and Greenville, Carolina (Bob Jones University). Curtis compiled a list of works by him, few of which can now be identified.[1] Stirling-Maxwell stated that Juan Garzon (d.1729) was his assistant.[2] He was buried in the church of S. Miguel, Seville, on 20 January 1721, aged eighty.[3]

[1] C. B. Curtis, *Velázquez and Murillo*, 1883, pp.331–3.
[2] W. Stirling, *Annals of the Artists of Spain*, 1848, III, p.1103.
[3] See E. Valdivieso, *Goya, Revista de Arte*, 169–71, 1982, pp.75–6 and 81 n.3.

P7 *The Virgin of the Assumption*

The Virgin in white with blue drapery and a beige scarf; an orange-brown light behind her.

Canvas, relined 167 × 109.5

Heavily ironed in relining. There are many retouchings, noticeably in the corners and on the Virgin's blue drape to the right. The foreground angels and the Virgin's chin and neck show signs of abrasion. The varnish is discoloured.

For the subject, see P105 Attributed to Gutiérrez. The Virgin ascending attended by angels without the Apostles below or God the Father above was not a common subject in the seventeenth century.

Previously catalogued as School of Murillo, P7 was attributed to Meneses by Troutman in 1956 on the basis of the drawing described below.[1] The attribution was repeated by Harris (1978),[2] Harris and Troutman (1980)[3] and Valdivieso (1983) who proposed a date of c.1700;[4] it was not accepted by Angulo who considers P7 to be by an unidentified pupil of Murillo. The vigorous handling (reminiscent of Strozzi) recalls Murillo's work of the 1650s, and particularly the *S. Catherine* (London art market 1983) which shows a similar model with long-fingered hands.[5] The *Vision of S. Peter Nolasco* (Seville Museum), now attributed to Meneses, shows angels similar to those in P7.[6]

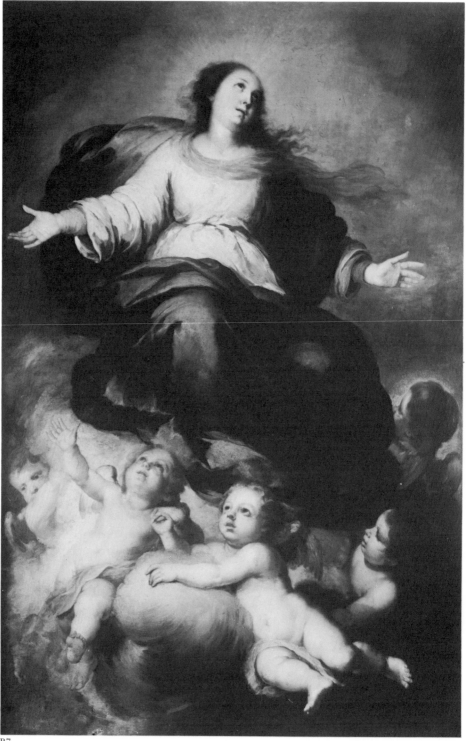

P7

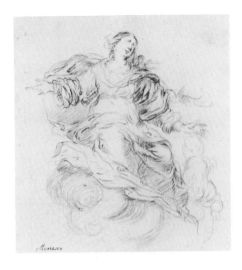

Meneses: Study for P7.
Courtauld Institute Galleries
(Witt Collection)

Drawing

LONDON Courtauld Institute Galleries, Witt Collection (no. 169); pencil and black chalk, showing the Virgin and one angel, inscribed *Meneses*, possibly in an eighteenth-century hand; ex-Stirling-Maxwell collection.[7]

Provenance

Casanova, a picture dealer in Cádiz;[8] bt. before 1835 by Sir John Brackenbury (1778–1847) of Aglesby and Raithby, Lincs., Consul at Cádiz 1825–45; his sale, Christie's, 26 May 1848 (58, 'one of Murillo's finest pictures, not surpassed by that in the possession of Marshal Soult.[9] It was exhibited in the British Gallery in . . . 1835'), bt. by the 4th Marquess of Hertford, 850 gn.;[10] Hertford House inventory 1870 as Murillo.

Exhibition

BI 1835 (161, *Virgin of the Conception* by Murillo) lent T. B. Brackenbury.[11]

References General

C. B. Curtis, *Velázquez and Murillo*, 1883, Murillo, no.50p; D. Angulo, *Murillo*, 1981. no.916.

[1] P. Troutman, *Apollo*, LXIII, 1956, p.179, and *Archivo Español de Arte*, XXIX, 1956, p.326.

[2] E. Harris, *The Burlington Magazine*, CXX, 1978, p.337.

[3] *Golden Age of Spanish Art*, Nottingham University, 1980, no.62.

[4] F. Valdivieso, letter on file dated 15 February 1983.

[5] The attribution to Murillo was doubted by Curtis 1883, no.267a.

[6] Angulo 1981, no.2343, as a late work by Murillo, but see Valdivieso, *Archivo Hispalense*, 195, 1982, pp.189–90, where given to Meneses, and letter, see note 4.

[7] Exh. Nottingham 1980, see note 3. Erroneously associated with P105 (Attributed to Gutiérrez) in the 1968 catalogue.

[8] Cf. W. Stirling, *Annals of the Artists of Spain*, 1848, III, p.1420.

[9] The Soult *Immaculate Conception* now in the Prado, no.2809 (Angulo 1981, no.110).

[10] Probably the 'Murillo' referred to by Hertford in his letter to Mawson of May 1848(?), see *Letters*, no.1, p.21.

[11] J. M. Brackenbury exhibited a *Virgin of the Assumption* BI 1836 (94), and a *Virgin of the Conception* BI 1844 (80).

Bartolomé Esteban Murillo (1617–1682)

Born in Seville, where he was baptised Juan Bartolomé Esteban on 1 January 1618. Ford said he was born and baptised on the same day,[1] but it was customary to baptise on the day after birth.[2] Murillo was his mother's name, Esteban his father's. He studied in Seville c.1633–8 with Juan del Castillo. In 1645 he married Beatriz Cabrera (d.1663) by whom he had nine children. His first decorative cycle, eleven canvases for the *claustro chico* in the monastery of S. Francisco, Seville, was completed in 1646, and his first works for Seville Cathedral were delivered in 1655. Between April and December 1658 he visited Madrid, where his townsmen Velázquez, Zurbarán and Cano were then working. In 1660 he was a co-founder of the Seville Academy, but his interest in it was not sustained. In 1662 he was made a Tertiary of the Franciscan Order. His greatest activity occurred in the decade 1665–75 when he completed commissions for the Church of S. Maria la Blanca, the Capuchin Church (see P3), the Hospital de la Caridad and the Cathedral, all in Seville. He died in Seville on 3 April 1682 after a fall while painting the large *Marriage of S. Catherine* for the high altar of the Capuchin Church in Cádiz. Though he hardly ever left Seville Murillo's work reflects an admiration for sixteenth-century Venetian painting, and for the great seventeenth-century masters, particularly the Flemish and Genoese. The international merchant communities in Seville facilitated this awareness. The development of Murillo's style was divided into three phases by Ford, the *frío, cálido* and *vaporoso*.[3] Murillo probably kept a small studio practice; works attributed to his assistants Juan Simon Gutiérrez and Francisco Meneses Osorio are separately catalogued.

[1] R. Ford, *Hand-Book for Travellers in Spain*, 1845, 1966 ed., I, p.397.
[2] C. B. Curtis, *Velázquez and Murillo*, 1883, p.305, following F. M. Turbino, *Murillo*, 1864, p.40. W. Stirling, *Annals of the Artists of Spain*, 1848, II, p.825, said Murillo was born 'near the close of the year 1617'.
[3] Ford, *loc. cit.*

Abbreviations

Angulo	D. Angulo Iñiguez, *Murillo*, 3 vols., 1981
Curtis	C. B. Curtis, *Velázquez and Murillo*, 1883 (numbers refer to the catalogue of Murillo's works)
Gaya Nuño	J. A. Gaya Nuño, *L'opera completa di Murillo*, 1978
Mayer	A. L. Mayer, *Murillo, Klassiker der Kunst*, 1923

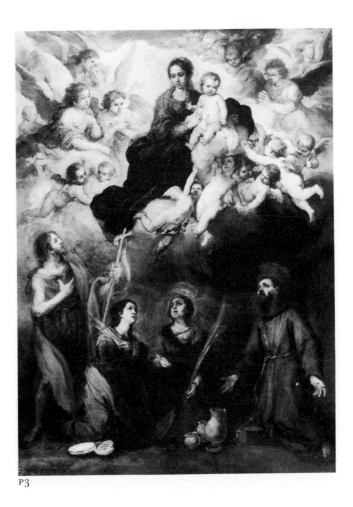

P3

P3 *The Virgin and Child with Saints*

The Virgin in red with a bottle-green drape; S. John the Baptist, on the left, in a red drape; SS. Justa and Rufina in green with a blue drape (centre left) and yellow with a purple drape (centre right).[1] Inscribed bottom left: *133* (see Provenance).

Canvas, relined 70.5 × 51.1

Cleaned in 1959 by Vallance who found P3 to have been previously overcleaned. The edges have been retouched, and there is a small loss by S. Francis's left foot. Traces of bitumen in dark areas. *Pentimenti* show that SS. Justa and Rufina were originally holding a tower (*La Giralda*, see below), S. Francis's right hand has been redrawn, the Virgin's right hip has been lowered, and there was a drapery (?) floating above S. John the Baptist.

SS. Justa and Rufina, patron Saints of Seville, were the daughters of a potter whose pots they refused to sell for pagan rituals; they were martyred in 304. In 1504 they miraculously prevented the collapse of *La Giralda*, the tower of Seville Cathedral, during a thunderstorm.[2] S. Francis is identified by the *stigmata*.[3]

The attribution of P3 had been doubted[4] before the publication of the drawing described below. Angulo has since compared it with the smaller *Immaculate Conception* in the Louvre (Angulo, no.116). The combination of Saints seen in P3 suggests a Capuchin commission; in 1665–8 Murillo painted all four for the Capuchin Church in Seville (Angulo, nos.59, 62, 64) which stood on the site of the martyrdom of SS. Justa and Rufina.[5] Angulo has tentatively suggested that P3 may have been a first idea for the large altarpiece of the Capuchin Church, Seville, for which Murillo painted the *S. Francis in the Porziuncola Chapel* c.1660 (now in Cologne; Angulo, no.59); this would indicate a date in the late 1650s for P3.

Drawing

NEW YORK private collection; pen and brown ink, by Murillo, showing only the four Saints, similarly grouped but in variant poses, SS. Justa and Rufina supporting the tower; dated by Brown 'provisionally in the later 1670s', but probably earlier, see above.[6]

Engravings

Nargeot 1839;[7] M.A.W. (detail of SS. Justa and Rufina) 1848.[8]

Provenance

Escorial, 1788 inventory, no.133: '*Nuestra Señora con el Niño en gloria con muchedumbre de ángeles en la parte superior y debajo San Juan Bautista, San Francisco de Asís, y Santa Justa y Rufina de tres cuartas de alto y dos tercios de ancho* [63 × 56] *su autor Murillo*';[9] the inventory number remains on the picture. Alexandre Aguado (1785–1842), Marqués de las Marismas, by 1839; his sale, Paris, 7th day, 27 March 1843 (39), bt. by the 4th Marquess of Hertford, 17,900 fr.; rue Laffitte inventory 1871 (254); Hertford House inventory 1890.

Exhibition

Bethnal Green 1872–5 (310).

References General

Curtis, no.116; Mayer, p.293;[10] Gaya Nuño, no.275, as c.1675; Angulo, no.182, and under no.59.

[1] The Saints are indistinguishable. Murillo painted them in various costumes and with identical attributes both separately (Angulo, nos.51–2, 346–7) and together (no.64).
[2] See R. Ford, *Handbook for Travellers in Spain*, 1845, 1966 ed., I, p.376, and Angulo, I, pp.351–2, 360–2.
[3] But called S. Felix of Cantalice by Brown, see note 6.
[4] Angulo, *Archivo Español de Arte*, XXXIV, 1961, p.19.
[5] Angulo, I, p.360.
[6] J. Brown, *Murillo and his Drawings*, 1976, no.77; the drawing had previously been in the collections of W. Stirling-Maxwell and the Royal Institute of Cornwall, Truro, whence it was sold in 1965.
[7] For the *Galerie Aguado*, 1839–41, no.8. The same plate was used in W. B. Scott, *Murillo*, 1873, f.p.72, and in the *Art Journal*, 1875, f.p.208.
[8] In Mrs. Jameson's *Sacred and Legendary Art*, 1848 (1850 ed., p.399), where she described P3 as 'a magnificent sketch … painted, I presume, for the Capuchins of Seville'. The block was re-used in C. E. Clement's *Hand-book of Legendary and Mythological Art*, 1871.
[9] Quoted by Angulo, *loc. cit.*, and see J. Zarco Cuevas, *Cuadros reunidos por Carlos IV, siendo príncipe en su Casa de Campa, de El Escorial*, 1934, p.25.
[10] Mayer mistakenly said there was a copy of P3 at Leigh Court, but this is identified by Angulo as a copy of the *Martyrdom of S. Andrew* (Angulo, no.277).

P14 *The Marriage of the Virgin*

The Virgin in white with a blue drape, Joseph in light blue with a light brown drape; the left-hand woman in yellow with a red drape and beige underskirt, the right-hand man in light green with a scarlet drape; a deep red curtain above.[1]

Mahogany panel 76.2 × 56.5 × 3 painted area 72.2 × 55.4

Cleaned by Allden in 1983. There are minor losses on the right-hand pillar, around the dove, by Joseph's rod, on the under-skirt of the left-hand woman and on the green cloak of the right-hand man.

The subject has no Biblical source, but is found in The Golden Legend and in the Apocryphal New Testament.[2] When Mary was fourteen she refused to leave the temple (where she had been serving many years) to find a husband, as the high priest, Zacharias, directed. The Lord then directed that suitors from the tribe of Judah should come to the temple, each bearing a rod; that of the successful suitor would flower and the Holy Spirit would alight upon it. Joseph was described as an old widower with sons, but Murillo, in accordance with Counter-Reformation teaching, makes him young and handsome.[3] The disappointed suitor breaking his rod in anger (on the extreme right) echoes a motif common in fourteenth- and fifteenth-century illustrations of the Marriage.[4]

Dated by Angulo c.1660–70, and probably nearer 1670. The figure of Zacharias is similar to that of the father in the Washington *Prodigal Son* of 1668 (Angulo, no.83); the model for the Virgin may recur in the *Virgin and Child with S. Rose* of c.1670 (Angulo, no.373; and see P104 below). The architectural setting and the rich, subtle colours of P14 recall the much larger *Marriage at Cana* (Barber Institute, Birmingham; Angulo, no.237), dated c.1665–75 by Angulo, and reflect Murillo's knowledge of Rubens and Veronese. Angulo points out the resemblance between the head of the older woman behind the Virgin in P14 and that of S. Anne in Herrera the Elder's *Holy Family* in the Bilbao Museum.

Drawings

HAMBURG Kunsthalle; pencil, a variant composition attributed to Murillo by Angulo.[5]

MADRID Biblioteca Nacional; pencil with white heightening, half-length figures, probably copied from P14; attributed to Núñes de Villavicencio by Barcia.[6]

Copies/Versions

AMSTERDAM private collection, 72 × 52.

BILBAO private collection, c.100 × 80.

LISBON private collection, 105 × 143, a later variant.[7]

MEXICO CITY private collection, a variant, attributed to Arteaga, relating closely to the Hamburg drawing.[8]

A version in the Convent of Carmen, Seville, was removed during the Peninsular War.[9]

Provenance

Madrid, Palacio Real, 1772 inventory, no.93: '*Quelli. Otro en tabla que representa los Desposorios de Ntra. Sra. de vara de alto y tres quartas de ancho* [83 × 63] *original de Murillo*'.[10] '*Quelli*' implies that it was acquired from Florencio Kelly of Madrid, but P14 does not figure in the Kelly inventory of 1732.[11] Given by Joseph Bonaparte, King of Spain 1808–13, to the duc de Bellune (1766–1841); his sale, Paris, 4th day, 27 May 1841 ('*par Murillo, jolie esquisse... représentant le Mariage de la Vierge*'), bt. Reiset who sold it to Laneuville, from whom bt. by the 4th Marquess of Hertford in London, 5 October 1848. 25,000 fr.;[12] Hertford House inventory 1870.

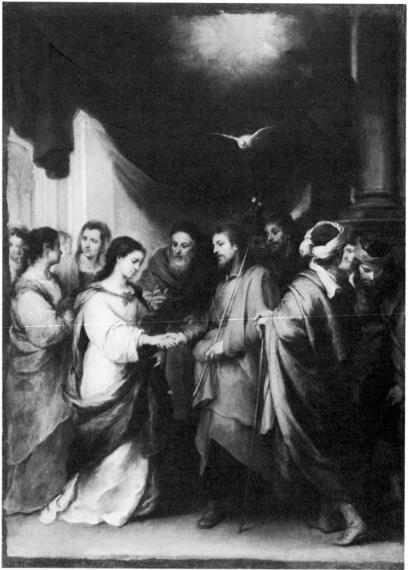

PI4

Exhibitions

Bethnal Green 1872–5 (318); RA 1888 (128).

References General

Curtis, no.59; Mayer, p.186, as 1675–82; Gaya Nuño, no.285, as 1675–80; Angulo, no.132.

[1] The traces of a signature at the foot of the right-hand column, noted in earlier editions of this catalogue, are no longer identifiable.

[2] See Jacobus de Voragine, *The Golden Legend*, trans. Caxton, 1900 ed., V, p.103, and M. R. James, *The Apocryphal New Testament*, 1953, pp.42, 73 (The book of James and the Gospel of Pseudo-Matthew).

[3] See M. Warner, *Alone of all Her Sex*, 1978, p.189, and E. Mâle, *L'art religieux après le Concile de Trente*, 1932, pp.355–6.

[4] Mâle *op. cit.*, p.356, and *The Gothic Image*, 1961, p.242.

[5] *Archivo Español de Arte*, XLVII, 1974, p.107, fig.26, f.p.104.

[6] A. M. Barcia, *Catálogo de la colección de dibujos originales de la Biblioteca Nacional de Madrid*, 1906, no.441, as from a picture by Murillo. Lafuente (*Archivo Español de Arte*, XIII, 1937, p.56) attributed it to Murillo himself, but Angulo, no.132, considers it probably a copy.

[7] *Archivo Español de Arte*, XLVII, 1974, fig.10, f.p.104.

[8] *Ibid.*, p.107, fig.27, f.p.104.

[9] Angulo, no.876, quoting M. Asencio, *Sevilla Mariana*, II, 1882, pp.295–6.

[10] Quoted by Angulo, no.132. A. R. Mengs, in a letter to A. Ponz (*Viage de España*, VI, 1782 ed., p.199), singled out P14 in the King's dressing room in the Palacio Real, as an outstanding example of Murillo's '*dulzura*', characteristic of his 'second' style. P14 was listed by Ponz, *op. cit.*, p.31, and Ceán Bermúdez, *Diccionario*, 1800, II, p.63. Angulo, no.132, makes slight reservations concerning the identification of P14 with the Murillo in the Palacio Real, but, given Laneuville's certificate, see note 12, there seems little reasonable doubt.

[11] According to Angulo, no.132.

[12] Laneuville's receipt to Lord Hertford (Wallace Collection archives) is inscribed: '*je certifie que le dit tableau vient de la collection du Palais de Madrid. Il en a été tiré par le roi Joseph, et donné par lui au Duc de Bellune. M^r. Reiset duquel je le tiens l'a acheté aux héritiers du Duc*'.

P34 *The Adoration of the Shepherds*

The Virgin in a cherry red dress and blue cloak; Joseph in a light brown cloak; the left-hand standing girl in an umber dress with a red underskirt; the fore-ground kneeling shepherd in black; the Child looks up at a cross formed by the ruinous rafters of the stable roof. Signed bottom right: *Bar.^me Murillo.f.*

Canvas, relined 146.7 × 218.4

Relined before 1857.[1] Cleaned by Vallance in 1956. There is a tear below the right elbow of the left-hand girl, and small fillings above the sheep's head and above the ox's head. Traces of bitumen in the dark areas. An angel holding a scroll,[2] on the extreme left of the present group, was painted out.

The iconography follows a Counter-Reformation pattern.[3] The scene is illumin-ated by the Child who, in regarding a cross, thinks already of His death;[4] the Virgin displays the Child, allowing the shepherds to be the first to recognise the Son of Man; they bring gifts (from the poor to One still poorer) of a lamb and doves (a traditional offering for purification after birth).

Dated c.1665 or a little later by Angulo, who points out similarities with the *Adoration* painted for the Capuchin Church, Seville, c.1668 (Angulo, no.73) in which the visitors similarly represent the cycle of life, from youth to old age. The horizontal format of P34, together with its softer colouring, render it perhaps more intimate. The model for Joseph seems to recur in the extreme right-hand figure of the Washington *Prodigal Son* of 1668 (Angulo, no.83), and the Virgin is comparable, in feature and mood, with P58.

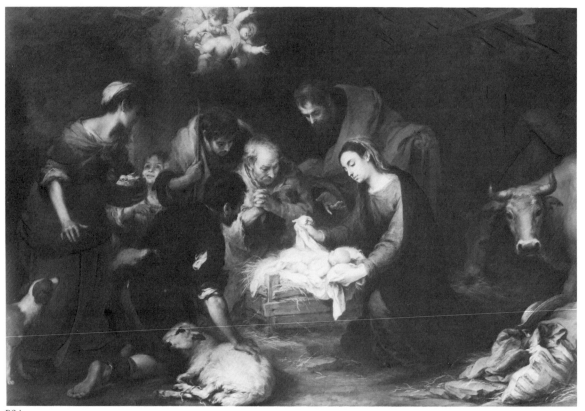

P34

P34 detail

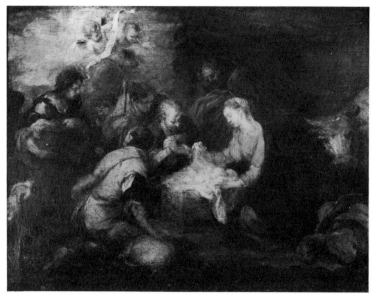

Murillo. *The Adoration of the Shepherds.* Musée Grobet-Labadié, Marseille

Copies

GENOA Capuchin Convent, 149 × 216, by
P. Venancio (d.1840), painted before 1823[5] to
replace P34 (see Provenance).
LENINGRAD Hermitage, 41 × 59, without the
dog (see note 13).
LONDON Christie's, 27 March 1925 (109),
126 × 100.
MADRID art market 1968; without the ox.
VERSAILLES Blanche sale, 8 March 1970 (66),
68 × 55.

Version

MARSEILLE Musée Grobet-Labadié (no.254),
27 × 35, by Murillo; a preparatory sketch for
P34, showing the angel with a scroll (painted
out in P34), the kneeling shepherd in yellow,
and strongly lit from the left.[6]

Provenance

Together with P46 and P97, and four other
Murillos,[7] P34 belonged to the Genoese
merchant Giovanni Beilato (d.1681) who had
resided in Cádiz. In his Will, made in Genoa
on 12 August 1674, he left these seven pictures
to the Capuchin Convent in Genoa, to be
hung in the choir,[8] where they were received
in 1681. They were described as hanging in
the choir in 1743, 1766 and 1780.[9] In May(?)
1805 six of the pictures, including P34, P46
and P97, were bought by James Irvine for
William Buchanan.[10] P34 was assigned at
£800 to Arthur Champernowne of
Dartington, Devon; his sale, Christie's 30 June
1820 (81), bt. Piazzetta, 410 gn.; Féréol-
Bonnemaison (d.1827),[11] his sale, Paris, 17–21
April 1827 (42), bt. J.-F. Boursault
(c.1760–1842), 20,800 fr.; his sale, Paris, 7
May 1832 (83), bt.
Edmund Higginson (*né* Barneby, 1802–71) of
Saltmarsh Castle, Herefordshire;[12] his sale,
Christie's, 3rd day, 6 June 1846 (228), bt.
Theobald for the 4th Marquess of Hertford,
2,875 gn.; Hertford House inventory 1870.

Exhibitions

BI 1819 (87) lent Champernowne;
Manchester, *Art Treasures*, 1857 (saloon H,
no.1); Bethnal Green 1872–5 (294).

References General

Curtis, nos.123, 124c; Mayer, p.187, as
1672–82;[13] Gaya Nuño, no.226, as c.1670;
Angulo, no.220.

[1] The 1857 Manchester exhibition labels are attached to the nineteenth-century stretcher.

[2] Doubtless intended to bear the text *gloria in excelsis Deo et in terra pax hominibus* (Luke II, 14).

[3] See E. Mâle, *L'art religieux après le Concile de Trente*, 1932, pp.242–9.

[4] Angulo, I, p.418, recalls the text of S. Thomas, that the first thoughts of the Infant Christ concerned His Passion, and see Mâle, *op. cit.*, pp.329–30.

[5] When recorded, with copies of the six other Murillos formerly in the Convent, in the *Nouvelle description des beautés de Gênes*, 1823, p.194. Presumably Venancio painted all the copies in 1803–5, see note 10.

[6] Angulo, under no. 220, pl.320a, and see C. Ressort, *Murillo dans les musées français*, 1983, no.50.

[7] The seven Beilato Murillos for the Capuchin Convent in Genoa were as follows:

No. Title Location	size	Valuations 1681[a] lire	1806[b] £	Angulo no./pl.
P34	147 × 218	760	800	220/319–20
P46	152 × 226	760	800	93/297
P97	150 × 152	600	1000	377/342
Flight into Egypt (Wrotham Park)	172 × 160	350	800	228/137
Immaculate Conception (Kansas City, Nelson-Atkins Museum of Art)	135 × 117	300	800	107/362
S. Mary Magdalene (Cologne, Wallraf-Richartz Museum)	140 × 189	250	500	356/349–50
S. John (USA, private collection)	85 × 73	150	600[c]	338/354

[a] Valuation made by Domenico Piola (1627–1703) in Genoa after Beilato's death.

[b] Valuation made by Buchanan (*Memoirs of Painting*, 1824, II, p.171).

[c] Taken from Genoa by Andrew Wilson in 1805; the valuation given here is the price paid by Wilson (Brigstocke, *William Buchanan and the 19th-century Art Trade*, 1982, p.447).

[8] Beilato would seem to have collected these pictures singly, without a total decorative scheme in mind; P34 and P46 may at first seem pendants (as Curtis, p.122, supposed), but they are not exactly the same size and differ widely in mood. Beilato also left a large sum of money and twelve more paintings by Murillo (now unidentifiable) to the Capuchins of Cádiz (Angulo, II, p.95). Murillo's final commission, for the altarpiece of the Capuchin Church in Cádiz, seems to have been a consequence of Beilato's gift (Angulo, no.88).

[9] *Saggi cronologici, o sia Genova nelle sue antichità ricercata*, 1743 ed., p.233, and C. G. Ratti, *Istruzione di quanto può vedersi di più bello in Genova*, 1766, p.328, and 1780, p.349.

[10] W. Buchanan, *Memoirs of Painting*, 1824, II, pp.133, 144, 171; H. N. A. Brigstocke, *William Buchanan and the 19th-century Art Trade*, 1982, pp.80, 98, 182, 243, 414, 423, 428, 434, prints letters from Buchanan to Irvine concerning these Murillos dated between 3 June 1803 and 4 October 1805 when three were about to leave Genoa. On 12 July 1805 Buchanan acknowledges their purchase (p.414) which probably, therefore, took place in May.

[11] For whom, see I. Julia in *French Painting 1774–1830*, Detroit–New York 1975, pp.327–8, and C. M. Kauffmann, *Catalogue of Paintings in the Wellington Museum*, 1982, p.32. Before the Bonnemaison sale Forbin selected several pictures, including P34, as suitable purchases for the Louvre (Forbin to La Rochefoucauld, 10 April 1827; Arch. Nat. o³ 1417, see Julia, p.328), but none was bought.

[12] For Higginson's purchase of the Boursault collection, see H. Artaria, *Descriptive catalogue of the Gallery of Edmund Higginson*, 1841, pp.211–12; *Le Cabinet de l'amateur et de l'antiquaire*, IV, 1845–6, p.425; J. Smith, *Supplement to the Catalogue raisonné*, 1842, p.500, and Curtis, nos. 123 and 124c.

[13] Mayer seems to illustrate the copy in the Hermitage, as Angulo indicates.

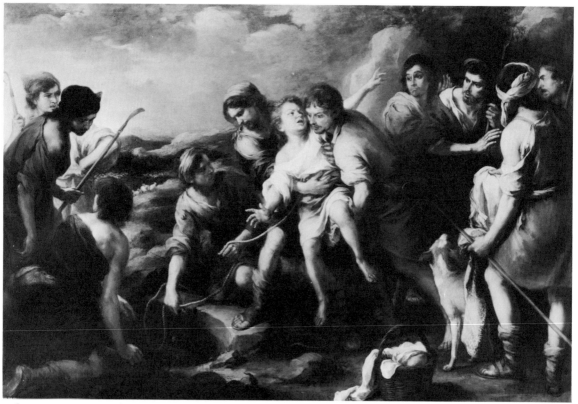

P46

P46 *Joseph and his Brethren*

Joseph in a white tunic; his coat, held by one of his brothers on the right, is pastel blue with rich yellow and pink figuring; from the left, his brothers are dressed in yellow with a pink hat, red with a black hat, blue, purple, blue, yellow, pale purple, blue and pale green. Signed on a stone by the well: *B,*[us] *Murillo, f.*

Canvas, relined 151.9 × 225.6

Relined by F. Leedham in 1854.[1] The surface is slightly rubbed and there are traces of bitumen in the dark areas. Cleaned by Vallance in 1958. There are small discoloured retouchings in the central part of the sky and on the left cheek of the central brother in yellow (whose left eyebrow is also restored). Some retouching on Joseph's tunic near his left shoulder, and an old filling in the dark hair of the right-hand figure (behind the neck). There are several *pentimenti*: in Joseph's left hand, the outline of the distant hills, the left knee of the standing right-hand figure, and the left shoulder of the kneeling left-hand figure. There is an unexplained shadow by the side of the face of the brother in blue supporting Joseph, which has become apparent through the wearing of the overlying paint.[2]

The subject is taken from Genesis XXXVII, 12–24: Joseph, favoured by his father Jacob who had given him a richly coloured coat, excited his brothers' jealousy; when Jacob sent him to find his brothers minding their flocks they first resolved to kill him, but Reuben (presumably third from the right in P46) urged that they should put Joseph down an empty well. Joseph was seventeen at this time (Genesis XXXVII, 2), the second youngest of Jacob's twelve sons. It is presumably Benjamin, the youngest, who is absent in P46. The episode was not a common subject in seventeenth-century painting;[3] S. Isidore, whom Murillo had twice represented in Seville Cathedral, had explained in his *Allegoriae* that it foreshadowed Christ's passion.[4]

Angulo dates P46 c.1670. The models for the fourth figure from the right and the extreme right-hand figure recur in the *Prodigal Son* series (Angulo, nos. 18–23)[5] which, with P46, provides a rare example of violent emotion in Murillo's work. The extreme right-hand figure seems to recur in the Washington *Prodigal Son* of 1668 (Angulo, no.83), and the figure to his left is very similar to one on the extreme right of the *Moses striking the Rock* of c.1668 in the Hospital de la Caridad (where the dog in P46 also appears; Angulo, no.81).[6] The compositions of P46, the *Moses* and the *Miracle of the Loaves and Fishes* (also in the Caridad; Angulo, no.80), are comparable in their concern with figures spread across a landscape.

Copy

GENOA Capuchin Convent; 149 × 216, by
P. Venancio (d. 1840), painted before 1823
(see P34, note 5).

Provenance

See P34. Bought from Buchanan by William
Cave of Brentry House, near Bristol; his sale,
Christie's, 6 May 1843 (63), bt. in at £1,417;
ibid., 29 June 1854 (79), bt. Mawson for the
4th Marquess of Hertford, 1,680 gn.;[7]
Hertford House inventory 1870.

Exhibitions

Manchester, *Art Treasures*, 1857 (saloon H,
no.3); Bethnal Green 1872–5 (298).

References General

Curtis, no.13; Mayer, pp.113, 291, as
1660–70; Gaya Nuño, no.224, as c.1670;
Angulo, no.93.

[1] See *Letters*, no.48, p.60; Leedham's stamp is on the
stretcher.
[2] It appears less obtrusive in a photograph taken in 1859 by
Caldesi and Montecchi (example in Wallace Collection
library).
[3] Antonio Castillo painted Joseph meeting his brothers
(Prado, no.951), including all twelve, and Joseph being
pulled out of the well (Prado, no.952). Zurbarán painted
Jacob's twelve sons separately, numbering each in order of
age (Bishop Auckland and Grimsthorpe Castle).
[4] See E. Mâle, *The Gothic Image*, 1961, p.156, and Angulo,
II, p.30; Joseph, like Christ, was betrayed by his friends; the
coat that was taken from him was the humanity which
clothed the Saviour, and of which He was deprived in
dying on the Cross; the pit into which Joseph was thrown
was Hades, where Christ descended after his death.
[5] The fourth figure from the right in P46 appears
throughout the series as the Prodigal Son; the extreme
right-hand figure appears in Angulo, no. 19, only. The
series is dated c.1660–70 by Angulo.
[6] A comparison made by W. Stirling, noted in his copy of
the Cave sale catalogue (Wallace Collection library); I am
grateful to Hugh Brigstocke for identifying Stirling's
handwriting for me.
[7] Mawson rather insisted on the purchase, the subject not
being entirely to Hertford's taste (see *Letters*, nos. 44–8,
pp.57–60). P46 was much admired in Hertford House by
George Jones RA (*ibid.*, no. 70, p.89).

P58 *The Holy Family with the Infant Baptist*

The Virgin in purple with a blue drape and olive shawl; Joseph in dark brown
with a light brown cloak; the scroll is inscribed: ECCE AGN [US DEI] (John I, 29).

Canvas, relined 168.6 × 130

Painted on a heavy canvas with an elaborate weave, similar to that of P68. First
relined (probably in France)[1] in the early nineteenth century (formerly a
vertical mark, 10.5 cm. from the left-hand edge, reflected a seam in this lining
canvas, cf. P68). Cleaned by Allden in 1983/4 when P58 also received a new
lining canvas. There are several losses: in the Virgin's chin, forehead and skirt,
by S. John's left leg, to the right of Joseph's head and in his cloak above the
Child's head, and in the sky to the left. The paint surface appears rubbed in
places and is particularly thin in the landscape area to the left.

The subject has no Biblical source, but derives from the Franciscan *Meditationes
Vitae Christi* IX.[2]

Angulo dated P58 c.1670 or a little earlier. Murillo also used the model for
Joseph in the *Adoration* painted for the Capuchin Church, Seville, c.1668
(Angulo, no.73), the *Miracle of the Loaves and Fishes* of c.1670 in the Hospital de
la Caridad, Seville (Angulo, no. 80), and the *Rest on the Flight into Egypt* of
c.1665–70 in the Hermitage (Angulo, no.232), in which the Virgin also seems to
be taken from the same model as in P58 and, possibly, in P34.

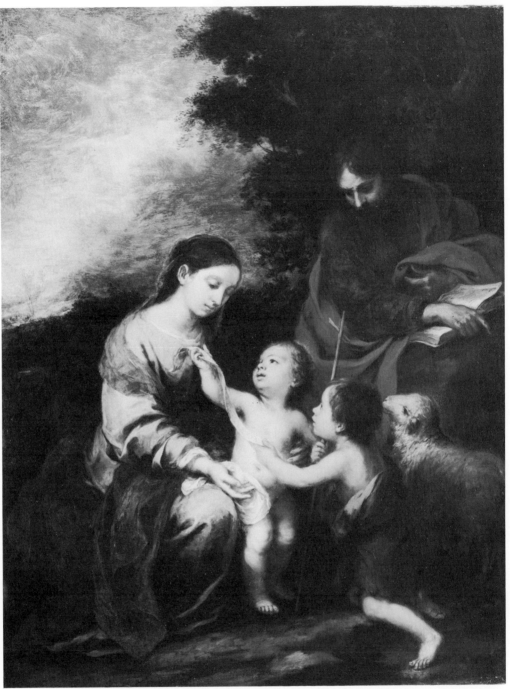

P58

Versions

CAMBRIDGE, MASS. Fogg Art Museum;
119 × 109, showing a comparable
composition but with the figures closer
together; there is no sheep and Joseph has no
book (Angulo, no. 198).
IASI Muzeul de Arta; the same composition
with the addition of an elderly couple,
presumably Elizabeth and Zacharias;
probably a later derivation.
Mayer (p.290) recorded a replica with
E. Forster, Clewer Manor, Berks.

Provenance[3]

Almost certainly the painting in the sacristy of
the Capilla de la Antigua, Seville Cathedral,
described in 1844 as: '*Virgen con el Niño en los
brazos, San José y el Bautista niño arrodillado
presentandole a Jesús el Ecce Agnus Dei*',[4]
and previously listed in 1780,[5] 1800,[6] 1804,[7]
and 1806.[8] Removed by Marshal Soult
c.1810.[9] W. Williams Hope (1802–55) of
Rushton Hall, Northants.; his sale, Christie's
3rd day, 16 June 1849 (125), bt. by the 4th
Marquess of Hertford, 780 gn.; Hertford
House inventory 1870.

Exhibitions

Manchester, *Art Treasures*, 1857 (saloon H,
no.5); Bethnal Green 1872–5 (302).

References General

Curtis, nos.152, 154a; Mayer, p.67, as
1660–70; Gaya Nuño, no.185; Angulo,
no.200.

[1] Fragments of a French newspaper were found within the lining in 1984.
[2] Cf. E. Mâle, *L'art religieux de la fin du moyen âge*, 1908, p.10. The *Meditationes* describe how the Holy Family call on Elizabeth on their way from Bethlehem to Nazareth: '*the childre Jesu and John when they weren brougt to gedere thei kisseden othere lovely and with lawthynge chere and maden moche merthe to gidre; but John as undirstondynge his lorde had hym alwey in countenaunce as with reverence to hym*' (trans. N. Love; 1908 ed., p.63). According to Luke I, 37, John was six months older than Jesus.

[3] Waagen, IV, p.83, said P58 came from the Casimir Périer collection, but it did not appear in his various sales; he seems to have confused the Hope and C. Périer sales (see P133, and Waagen, II, p.156, where he mentions two Murillos from the Hope sale which he thought Hertford had in Paris).
[4] González de León, *Noticia artística y curiosa de todos los edificios ... de Sevilla*, 1844, II, p.92; he did not know where the picture was when he wrote.
[5] A. Ponz, *Viage de España*, IX, 1780, p.40: '*Nuestra Señora, San Juan y el Niño Dios*'.
[6] J. A. Ceán Bermúdez, *Diccionario*, 1800, II, p.58: '*descanso de la Virgen con el Niño. San Josef y San Juanito*'; he was mistaken, perhaps, to call it a '*descanso*', for there is no ass and S. John does not appear in the Rest on the Flight.
[7] Ceán Bermúdez, *Descripción artística de la Catedral de Sevilla*, 1804, p.89.
[8] Ceán Bermúdez, *Carta ... sobre ... la pintura de la Escuela de Sevilla y ... Murillo*, 1806, p.73: '*Murillo pinto entonces* [1668] *el famoso quadro del descanso de la Virgen con el niño, san Josef y san Juanito, que está en la sacristia de la Antigua, executado con brochas y valentía, según el primer estilo del claustro chico de San Francisco* [see Angulo nos. 1–11]. *Es de presumir que lo pintase así por agradar al mayordomo de fábrica de aquel año, pues nunca han faltado en esta iglesia capitulares de gusto e inteligencia en las bellas artes*'. As Angulo observes, if this picture really was in Murillo's style of 1645–6 it is hardly likely to be P58; but Ceán Bermúdez was probably mistaken in his judgment of the picture.
[9] See R. Ford, *Handbook for Travellers in Spain*, 1845, 1966 ed., I, p.382: he recounts that in a small room in Seville Cathedral "hung two superb Murillos – the 'Birth of the Virgin' [Angulo no.130] and the 'Repose in Egypt' [see note 6 above], which, on M. Soult's arrival, were concealed by the chapter; a traitor informed him, and he sent to *beg* them as a present, hinting that if refused he would take them by force". See also I. H. Lipschutz, *Spanish Painting and the French Romantics*, 1972, p.33, and the Conde de Toreno, *Historia del levantamiento, guerra y revolución en España*, 1872, p.424, quoted by Angulo, under no.130. W. Stirling, *Annals of the Artists of Spain*, 1848, II, p.852, supposed that the 'infants Christ and St John, and the Repose of the Virgin' from the sacristy of the Capilla de la Antigua in Seville Cathedral had been taken 'probably by French agency'. Curtis, no. 154a, corrected Stirling, pointing out that his two titles were in fact one painting.

P68 *The Annunciation*

The Virgin in red with a blue drape and white shawl; the Angel Gabriel in light blue with a purple drape and bottle-green girdle; a green curtain to the left and in the foreground a work basket with scissors and a pinkish cushion.

Canvas, relined 187 × 134 the edges are uneven

Painted on a heavy canvas with an elaborate weave, similar to that of P58. First relined (probably in France) in the early nineteenth century (formerly a vertical mark, 13.3 cm. from the right-hand edge, reflected a seam in this lining canvas, cf. P58). Cleaned by Lank in 1984 when P68 also received a new lining canvas. There are three significant losses (previously repaired with canvas inserts): on the right-hand side of the lectern and in two areas below the angel; there are further losses in the Virgin's skirt, on the angel's right arm, by his face and left wing, and along the top edge. Waagen (IV, p.81) had thought, surprisingly, that P68 was 'very well preserved'.

The subject is taken from Luke I, 26–38: the Angel Gabriel is sent by God to tell Mary that she will bear by the Holy Ghost (symbolised by the white dove) a child who would be called Jesus, the Son of God. P68 largely follows the Jesuit formula described by Pacheco in the *Arte de la Pintura*, 1622:[1] the Virgin kneels by a writing table or lectern, with an open book; her hands are clasped and her arms crossed; Gabriel holds the lily in his left hand; the Dove, more angels and seraphim appear above. Pacheco also specified that Gabriel should kneel on the ground, and an oil lamp should burn on the desk, but Murillo has transformed the scene of a domestic miracle into one of celestial glory.

Angulo dates P68 c.1665–70; it is noticeably more highly finished than P58 and perhaps precedes it. Angulo has noted the recurrence of two of the angels in P68 in the *Two Trinities* in the National Gallery, London (no.13; Angulo, no.192). The composition closely resembles the *Annunciation* painted for the Capuchin Church, Seville c.1668 (Angulo, no.70) which, however, shows the Virgin with her hands raised and, instead of the curtain, more clouds and angels; these increasingly Baroque characteristics suggest that it may have been painted after P68. The work basket, prominently placed in P68, recurs in most of Murillo's *Annunciations* (cf. Angulo, nos.70, 133, 135–8, 140).

Engravings[2]

A. Lefevre 1839 (for the *Galerie Aguado*); anon. line engraving; Lafosse 1843; Blümer; W. Hulland (arch-topped variant).

Versions

MUNICH Pickert sale, 17 October 1913 (685), 63 × 85 (Angulo, no. 898).
PARIS with P. Valade in 1955.
VERGARA private collection, 158 × 108, showing minor variations.

Provenance

F.-M.-G. Rayneval (1776–1836), French Ambassador to Spain 1832–6; his sale, Paris, 16 April 1838 (1), 15,000 fr.; Alexandre Aguado (1785–1842), Marqués de las Marismas, by 1839; his sale, Paris, 7th day, 27 March 1843 (37), bt. by the 4th Marquess of Hertford, 27,000 fr.; Hertford House inventory 1870.

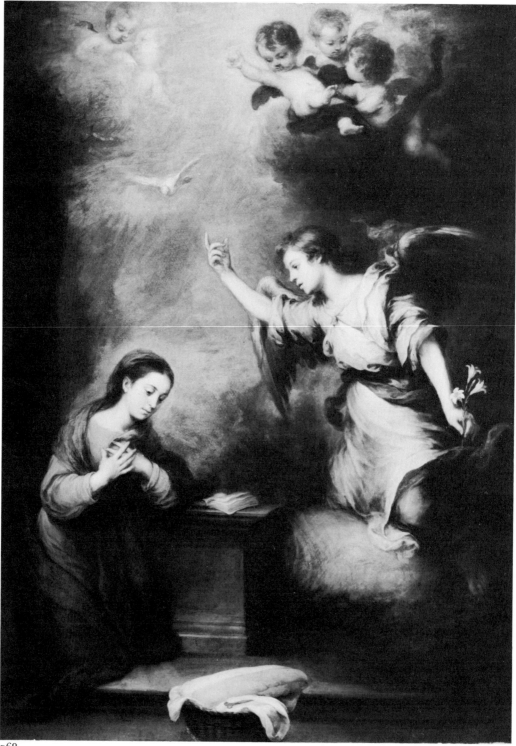

P68

Exhibitions

Manchester, *Art Treasures*, 1857 (saloon H, no.4); Bethnal Green 1872–5 (295).

References General

Curtis, no.68; Mayer, p.175, as 1668–75; Gaya Nuño, no.272, as c.1675; Angulo, no.136.

[1] Cf. J. Brown, *Images and Ideas in seventeenth-century Spanish Painting*, 1978, pp.66–8, and E. Mâle, *L'art religieux après le Concile de Trente*, 1932, pp. 239–42. For a note on the development of the Annunciation theme in Murillo's work, see E. Young, *The Burlington Magazine*, CXV, 1973, pp.604–7.

[2] As listed by W. Stirling-Maxwell, *Essay towards a Catalogue of Prints...from... Velázquez and Murillo*, 1873, p.53; photographs of each are in the Warburg Institute Library (Stirling-Maxwell, Murillo 39–43). Curtis, *loc. cit.*, lists further engravings by J. Rogers and 'André'.

P97 *The Charity of S. Thomas of Villanueva*

S. Thomas in black; the old man in light brown; the standing woman in a white blouse, bottle green dress and red underskirt; her son in a grey-green shirt.

Canvas, relined 150.2 × 152.1

The double lining probably dates from the early nineteenth century and traces of bitumen in the darks suggest it was restored at that time. Cleaned by Vallance in 1956 when bitumen was removed from the green dress of the right-hand woman and from the hat of S. Thomas. A *pentimento* shows the background pilaster was moved slighly to the right.

S. Thomas of Villanueva (1488–1555) was canonised in 1658. An Augustinian friar, he was a prior at Salamanca before becoming Archbishop of Valencia in 1544. Like S. Carlo Borromeo he was canonised for his good works, in whose efficacy the Counter-Reformation strongly believed.[1] Murillo painted six scenes from the life of S. Thomas, four for the Convent of S. Augustine, Seville (Angulo, nos.55–8), one for the Capuchin Church, Seville (Angulo, no.76), and P97.

Dated c.1670 by Angulo. The model for the standing right-hand woman seems to recur in the *Adoration* painted for the Capuchin Church, Seville, c.1668 (Angulo, no.73), and in the *Moses striking the Rock* in the Hospital de la Caridad of c.1668 (Angulo, no.81). Elements of the composition (the cast of figures, the architectural setting, and the overall tonality) recall the *S. Thomas* painted c.1668 for the Capuchin Church, Seville (Angulo, no.76), in which the same model was used for the Saint.

Copies/Versions

CANNES private collection, 146 × 151.
CORDOBA Museum.
GENOA Capuchin Convent, 149 × 150, by P. Venancio (d.1840), painted before 1823 (see P34, note 5).
MADRID Duque del Infantado, 35 × 45, a later copy.
MAURON private collection, 150 × 150.
NEW YORK with Wildenstein, probably an eighteenth-century version.
PARIS private collection 1930, panel 56.5 × 42, a study for the woman on the right holding the child with the boy by her side.

Provenance

See P34. Bought from Buchanan before 1823 by William Wells (c.1768–1847) of Redleaf, £1,000; his sale, Christie's, 12 May 1848 (125), bt. by the 4th Marquess of Hertford, 2,850 gn.; Hertford House inventory 1870.

Exhibitions

BI 1823 (145, *Monks relieving the Poor*) lent Wells; BI 1835 (47, *Mendicants receiving Alms at a Convent*); Manchester, *Art Treasures*, 1857 (saloon H, no. 2); RA 1872 (98); Bethnal Green 1872–5 (305).

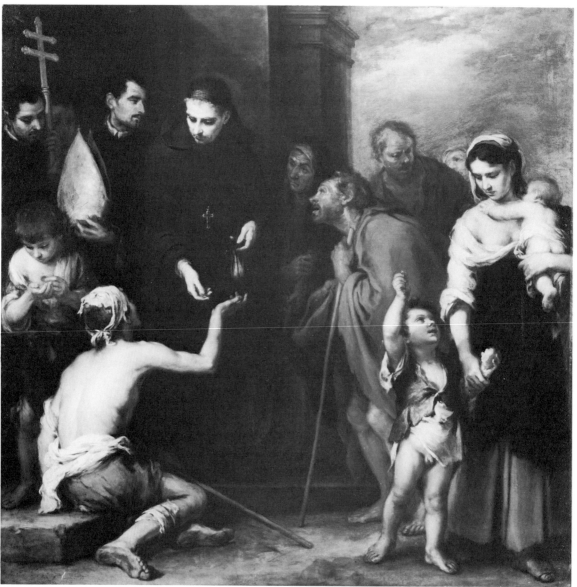

P97

References General

Curtis, no.399; Mayer, p.167, as 1670–82;
Gaya Nuño, no.225; Angulo, no.377.

[1] Cf. E. Mâle, *L'art religieux après le Concile de Trente*, 1932,
pp.86–96, especially pp.91–2.

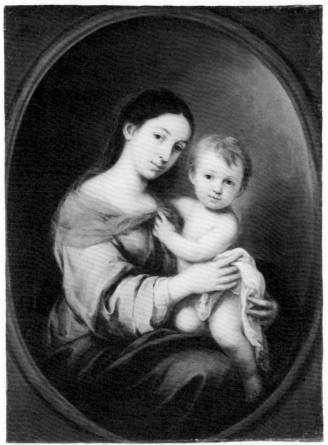

P133

P133 *The Virgin and Child*

The Virgin wears a lilac-coloured dress with a blue drape and beige shawl.

Canvas, relined 106.7 × 78,9

Relined (probably in France) in the early nineteenth century.[1] There are retouchings on the Virgin's left cheek and right hand, the Child's eyes, and in the background area. The varnish is somewhat discoloured and there is a fine overall craquelure.

The attribution was doubted by Mayer,[2] but is accepted by Angulo who dates P133 c.1665–70. He points out that the model for the Virgin recurs in the *Annunciation* painted for the Capuchin Church, Seville, c.1668 (Angulo, no.70), and that for the Child recurs in the smaller *Immaculate Conception* in the same Church, c.1668 (Angulo, no.78). The composition relates quite closely to the *Virgin and Child* in the Norton Simon Foundation, Los Angeles (Angulo, no.158), and ultimately derives from Raphael's *Madonna della Sedia* and *Mackintosh Madonna*. The oval format is unusual in Murillo's work.

401

Version

SEVILLE private collection, 104 × 85, showing the Virgin whole-length with S. Dominic who receives a rosary from Her; attributed by Angulo to Domingo Martínez (d.1756).[3]

Provenance[4]

W. Williams Hope (1802–55) of Rushton Hall, Northants.; his sale, Christie's 3rd day, 16 June 1849 (102, 'The Virgin in pink and blue drapery, holding the Infant in her lap – a lovely work, of the highest quality – oval'), bt. Mawson for the 4th Marquess of Hertford, 580 gn.; Hertford House inventory 1870.

Exhibition

Bethnal Green 1872–5 (300 or 308, see P136).

References General

Curtis, no.109; Gaya Nuño, no. 330, as an attributed work; Angulo, no.154.

[1] The stretcher is roughly cut, the lining canvas is coarse, and fragments of a French newspaper adhere to its edges.
[2] P133 was excluded from his 1923 catalogue. In previous editions of this catalogue P133 was called School of Murillo.
[3] *Archivo Español de Arte*, XLVIII, 1975, p.409.
[4] Waagen, IV, p.82, said P133 had come from the Casimir Périer collection, but it did not appear in his various sales; he seems to have confused the Hope and C. Périer sales (see P58, and Waagen, II, p.156, where he mentions two Murillos from the Hope sale which he thought Hertford had in Paris). Curtis, *loc. cit.*, also said P133 was from the Périer collection.

Attributed to Murillo

P136 *The Virgin and Child with a Rosary*

The Virgin in red with a blue drape and a beige shawl.

Canvas, relined 109.2 × 79.7

Cleaned by Vallance in 1959. Retouchings in the Virgin's sleeves and skirt, and fillings in the dark area, top right. The flesh tones are somewhat raw and contrast strongly with the dark background.

The attribution has been doubted,[1] but Angulo accepts P136 as by Murillo, c.1660–5. The existence of a number of versions of the composition, of which P136 appears to be the best, may support the attribution. Mayer, after hesitating between a copy of a lost original and a worn original, also accepted P136 as by Murillo, but dated it c.1675.[2] The later date is supported by the fact that the same models recur in the Liverpool *Virgin and Child in Glory*, dateable 1673 (Angulo, no.151). It is conceivable, as Angulo has suggested, that P136 has been cut from a whole-length composition, but after relining no evidence survives to support this suggestion.

Versions

AMSTERDAM private collection, 184 × 144, with whole-length Virgin.
LEIPZIG Museum der Bildenden Künste (no.154), 124.5 × 105 (Angulo, no.1011).
MADRID art market 1976.
NEW YORK Ehrich sale, 18–19 April 1934 (75), 91 × 79.5, as ex-Soult collection, but probably a later copy.
SEVILLE private collection, oval 38 × 30 (Angulo, no.1039).

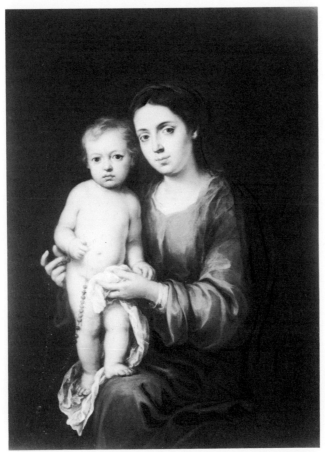

P136

Provenance[3]

Angulo identifies P136 as probably the picture listed in the Palacio Real, Madrid, in 1772: '*Profesa. Nuestra Señora con el Niño que tiene un Rosario en la mano. Sentada y el Niño en pie sobre sus rodillas. Más de medio cuerpo de vara y quarta de alto y una vara escasa de ancho* [104 × 83]. *Original de Murillo*';[4] also listed in 1776, 1794 and 1800.[5] Possibly Louis, marquis de Montcalm (1786–1862); his sale, Christie's 1st day, 4 May 1849 (83, 'The Virgin in a red dress, with a white & blue drapery holding the Infant in her arms; he is playing with a rosary...'), bt. Fuller, 51 gn.[6] The 4th Marquess of Hertford; possibly rue Laffitte inventory 1871 (674); Hertford House inventory 1890.

Exhibition

Bethnal Green 1872–5 (300 or 308, see P133).

References General

Curtis, no.88; Gaya Nuño, no.332, as an attributed work; Angulo, no.153, and see no.1087.

[1] P136 was called School of Murillo in earlier editions of this catalogue, 1900–28, and was excluded by Mayer from his 1923 catalogue.
[2] *Boletín de la Sociedad Española de Excursiones*, XLIII, 1934, p.17.
[3] Curtis, *loc. cit.*, thought P136 may have come from the Hope sale of 1849, but he was confusing it with P133. Angulo mistakenly gives the provenance as Baillie sale 1858, confusing it with P13.
[4] In quoting this entry Angulo (no.1087) indicates that '*Profesa*' (i.e. *Casa Profesa*) may imply the picture came from a Jesuit foundation in Madrid.
[5] Respectively: A. Ponz, *Viage de España*, VI (1782 ed., p.31); the 1794 inventory of the Palacio Real (indicated by Angulo); Ceán Bermúdez, *Diccionario*, 1800, II, p.64.
[6] Hertford purchased four paintings at this sale, cf. Studio of Albani P642 and Sassoferrato P126 (in this volume), and Champaigne P129 and Dou P168.

403

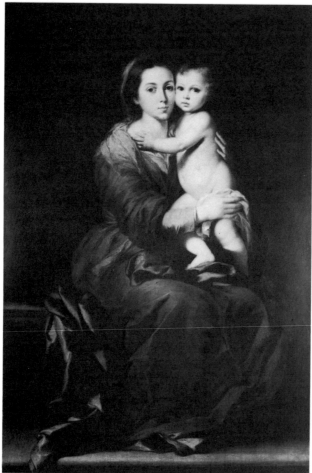

PI3

After Murillo

PI3 *The Virgin and Child*

The Virgin in red with a turquoise blue drape and a white shawl.

Canvas, relined 166.4 × 109.5

Cleaned and relined by Buttery in 1879. There are retouchings in the figure of Christ and in the draperies, and small losses in the background area. Traces of bitumen in the shadows and the craquelure is noticeable in the flesh areas. The varnish is much discoloured.

PI3 is a full-sized copy, probably of the seventeenth century, of the *Virgin of the Rosary* painted by Murillo c.1650–5, acquired by Charles IV of Spain before 1788 and now in the Prado (no.975); the rosary is omitted and the drapery somewhat simplified.

Engraving

Esteban Boix (b.1774).[1]

Provenance

The Condes de Altamira, Madrid; according to Boix's engraving (see above and note 1) P13 once belonged to the Conde de Trastamara, i.e. Vicente Osorio de Moscoso who sucdeeded as 12th Conde de Altamira in 1816 and began to disperse the Altamira collection c.1820;[2] acquired by Col. H. D. Baillie (1777–1866) of Redcastle and Tarradale, before 1823;[3] his sale, Christie's, 15 May 1858 (37, '...formerly an important feature in the celebrated Altamira gallery'), bt. Burgess for the 4th Marquess of Hertford, 1,500 gn.; Hertford House inventory 1870.

Exhibitions

BI 1823 (169) lent Baillie; BI 1854 (41); Bethnal Green 1872–5 (303).

References General

Curtis, no.92, as Murillo; Gaya Nuño, no.297, as Murillo; Angulo, under no.159, as a copy.

[1] Listed by Curtis, no.92, as either from P13 'or a similar picture', inscribed as belonging to the *Senor Conde Trastamara*; photograph in the Warburg Institute Library (Stirling-Maxwell, Murillo 127).
[2] Cf. N. Glendinning, *Apollo*, CXIV, 1981, p.247 n. 10.
[3] While in Baillie's collection P13 was included in the imaginary composition *Patrons and Lovers of Art*, painted in 1829 by P. C. Wonder for Sir John Murray (now in a private English collection). Baillie owned several pictures which were said to have come from the Altamira gallery.

P104 *The Virgin and Child with S. Rose of Viterbo*

The Virgin in a pink-red dress with a blue drape and lilac-tinted shawl; S. Rose, with long chestnut hair, in a white shawl, holding two pink roses.

Canvas, relined 62 × 82.9 with an additional strip 7.2 wide along the top edge

Much discoloured by old varnish and considerably restored. There are many small losses throughout; an L-shaped tear above the Virgin's left shoulder, and a vertical tear across her right upper arm. The lower area, within a strip 3.5 cm. wide from the bottom edge, has been heavily retouched. There are *pentimenti* on S. Rose's left thumb and on the second finger of her right hand. It is evident from the composition that the original canvas has been cut at the bottom and sides, while the additional strip along the top suggests it was cut all round.[1]

There has been some doubt concerning the identity of the Saint. In the related drawing and the similar, but reversed, painting (see below) she is shown as a Franciscan, with a brown habit, white shawl, knotted girdle and bare feet. Together with the roses in her hand, this identifies her as S. Rose of Viterbo, a Franciscan of the thirteenth century. In P104 the Saint's right sleeve should be brown, but it appears in a restored area. Previously identified as S. Rose of Palermo.[2]

Mayer and Angulo agree that P104 is either a school piece or an uninspired studio copy of a lost Murillo whose composition seems preserved in a drawing at Turin; this shows whole-length figures attended by Saints and angels with a distant view of a preacher[3] in a town (see below). Since there is no sign of overpainting in the flat greyish background of P104 it must have been a simplified composition, confined to the three figures.

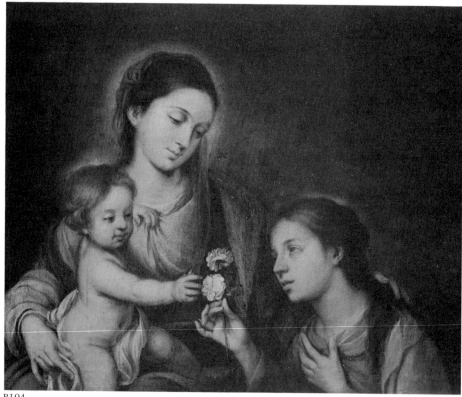

P104

Drawing

TURIN Biblioteca Reale, a copy after Murillo, according to Angulo (see above).[4]

Version

LUGANO Thyssen-Bornemisza collection, 190 × 147, by Murillo c.1670, the composition broadly similar to the Turin drawing, but reversed (Angulo, no.373).

Provenance

Acquired by the 4th Marquess of Hertford, probably after 1856, since it was not seen by Waagen, and before 1859, when it was cleaned in London;[5] Hertford House inventory 1870.

References General

Curtis, no.115; Mayer, pp.257, 294; Gaya Nuño, no.331, as attributed to Murillo; Angulo, no. 374.

[1] I. H. Lipschutz, *Spanish Painting and the French Romantics*, 1972, pp.37–8, 290–1, comments on the frequency with which Spanish paintings were cut up during the Peninsular Wars.

[2] By Angulo, cf. *Murillo*, RA 1983, no.72 (the Lugano picture); S. Rose of Palermo, a twelfth-century Sicilian whose cult was popularised during the Counter-Reformation, was also shown holding roses.

[3] Probably S. Rose preaching in Viterbo, as suggested by A. Rosenbaum, *Old Master paintings from the Thyssen-Bornemisza Collection*, Washington catalogue 1979, no.56.

[4] G. C. Sciolla, *I disegni . . . di Torino*, 1974, p.265, no.318; Angulo, *Archivo Español de Arte*, XLVII, 1974, p.108, fig.21, f.p.104, and Angulo, III, pl.617.

[5] Evans invoice: '*Murillo Virgin & Child & Saint*'.

Diego Velázquez (1599–1660)

Baptised on 6 June 1599 in Seville where he studied briefly under Francisco Herrera the Elder in 1610 and with Francisco Pacheco 1611–17. In 1618 he married Pacheco's daughter, Juana de Miranda, by whom he had two daughters, born in 1619 and 1621. In 1623 he was summoned by the King's First Minister, Olivares (see P109), to Madrid, and in October was appointed painter to the King. He remained attached to the Court of Philip IV (see P106) for the rest of his life, engaged principally in portraiture, and holding a succession of Court appointments: Gentleman Usher 1627, Gentleman of the Wardrobe 1636, Gentleman of the Bedchamber 1643, and Palace Chamberlain 1652. In 1628/9 he met Rubens in Madrid. He travelled twice in Italy, in 1629–31 when he copied works by Tintoretto, Raphael and Michelangelo, and in 1649–51 when he was mainly engaged in collecting works of art for the King. On both visits he spent time in Venice and Rome. In 1659 he was made a Knight of Santiago and in 1660 he went to Irún to supervise the marriage ceremonials of the Infanta María Teresa with Louis XIV of France. He died in Madrid on 6 August 1660.

Little is known concerning the organisation of Velázquez's studio, but the many contemporary copies of his royal portraits suggest that he employed a number of assistants. In the 1630s and 1640s his pupils are known to have included Juan Bautista del Mazo who became his son-in-law in 1633, and Juan de Pareja.

Abbreviations

Allende-Salazar	J. Allende-Salazar, *Velázquez, Klassiker der Kunst*, 1925
Curtis	C. B. Curtis, *Velázquez and Murillo*, 1883 (numbers refer to the catalogue of Velázquez's works)
López-Rey 1963	J. López-Rey, *Velázquez, a catalogue raisonné of his oeuvre*, 1963
López-Rey 1979	J. López-Rey, *Velázquez, the artist as a maker, with a catalogue raisonné of his extant works*, 1979
Mayer	A. L. Mayer, *Velázquez*, 1936

P12 *Prince Baltasar Carlos in Silver*

Fair hair, dark grey-brown eyes; dressed in grey silk brocaded with silver and with silver braid, lace collar and steel gorget edged with gold, with the baton and purple sash of a Captain-General; the cushion and curtains are a deep red, the hat black with white plumes.

Canvas, relined 117.8 × 95.9

Heavily ironed in relining in 1880. The figure, though slightly rubbed, is in a reasonably good state; a *pentimento* shows that the collar was first placed a little higher, but it is otherwise remarkably free from alteration, probably because the pose was copied from an earlier portrait (see below). The surrounding area has suffered from extensive retouching and restoration. P12 was cleaned in 1879 and

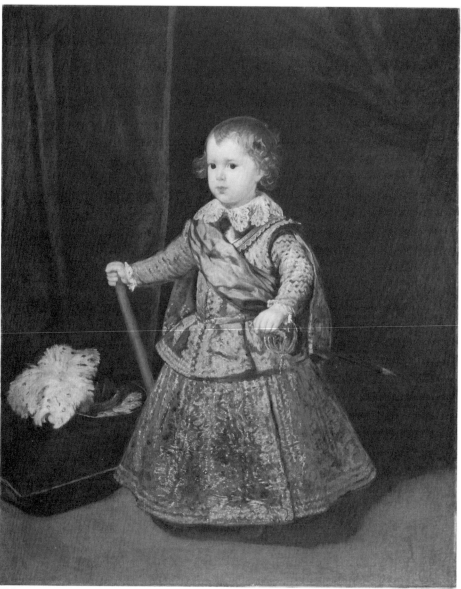

P12

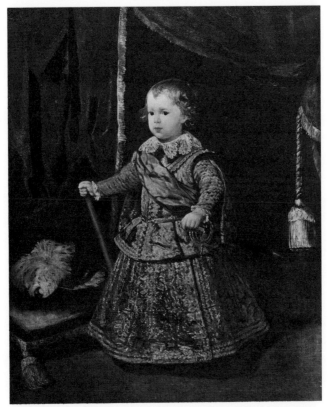

P I 2 before cleaning

1880 by Buttery, and by Holder in 1937 when green overpaint was removed from the curtains, together with gold fringes and tassels on the curtains and cushion.[1] The red curtains then revealed were found to have been extensively restored; the positions of the tassels are now visible as discoloured retouchings. Already in 1857 Scharf had commented upon the 'coarse painting' of the right-hand tassel,[2] and in 1936 Mayer remarked that the 'piece of curtain and the tassel on the right are certainly later additions', but it may be observed that the tasselled cushion recurs in the Boston portrait (see below), and in the Abercorn portrait of the Prince from Velázquez's studio.[3] There are several minor damages, the most noticeable being a horizontal tear running through the Prince's right hand, a vertical damage on the cushion near the left-hand edge, an uneven tear in the bottom right-hand corner, and a small damage across the edge of the left-hand curtain, just above the Prince's head. The suggestion that the portrait was left unfinished by Velázquez cannot be substantiated.[4]

Prince Baltasar Carlos, son of Philip IV of Spain by his first Queen, Isabel of Bourbon, was born in Madrid on 17 October 1629;[5] idolised by his parents, his promising career was cut short when he died of fever at Saragossa on 9 October

1646. The previous July he had been betrothed to his cousin, the Archduchess Mariana of Austria (1634–96), whom Philip IV took as his second wife in 1649. For other portraits of the Prince, see P4 and P6 below.

The pose of the Prince in P12 almost repeats that used by Velázquez in his portrait of the Prince with a dwarf in the Museum of Fine Arts, Boston,[6] although in P12 he appears taller and his hair is longer and more curly. P12 has, accordingly, always been dated a year later than the Boston portrait which Brown and Elliott have recently convincingly identified as that made to mark his investiture at the Buen Retiro on 7 March 1632.[7] P12, therefore, may be dated 1633, as first proposed by Goldscheider;[8] the portraits were otherwise generally dated 1631 and 1632.[9] The simplicity of the composition and the shimmering dress recall Velázquez's contemporary portrait of Philip IV in brown and silver (National Gallery, London, no.1129),[10] the background of which, though not in pristine condition, may convey something of the lost tonality of P12.

Engravings

J. Gauchard 1852;[11] anon. woodcut, *Art Journal*, 1852, p.361.

Provenance

Possibly the portrait listed in the Leganés inventory 1655: '*un retrato del principe nro. señor Don Balthasar Carlos, con faldas, de hedad de 2 años*', '*un retrato de un niño con un baston en la mano ... el principe nro. sr.*'.[12] López-Rey has suggested P12 might possibly be the portrait recorded in the Buen Retiro between 1701 and 1814,[13] but P12 more probably passed, with the rest of the Leganés collection, to the Counts of Altamira in 1712 and might be identifiable with the Velázquez in the Altamira sale, Stanley's, 1 June 1827 (48, 'Don Baltasar, son of Philip IV, from the Altamira collection'), 11 gn.[14] Acquired by F. H. Standish (1798–1839),[15] and bequeathed (with the rest of his collection) to Louis-Philippe of France; exhibited in the Louvre (Musée Standish), 1842–8, no.156. Louis-Philippe's pictures were principally dispersed in two sales at Christie's in 1853, P12 appearing in the Musée Standish sale, 2nd day, 30 May 1853 (222), bt. Mawson for the 4th Marquess of Hertford, 1,600 gn.;[16] Hertford House inventory 1870.

Exhibitions

Manchester, *Art Treasures*, 1857 (saloon H, no.10); RA 1872 (142, as *An Infanta*); Bethnal Green 1872–5 (299); RA 1890 (134).

References General

Curtis, no.135; Allende-Salazar, pp.50, 276; Mayer, no.270; López-Rey 1963, no.303, and 1979, no.60.

[1] As described in *The Times* and *Daily Telegraph*, 1 March 1938.
[2] G. Scharf, *Handbook to the Paintings by Ancient Masters in the Art Treasures Exhibition*, 1857, p.80.
[3] López-Rey 1963, no.309.
[4] The accounts of the 1937 cleaning (see note 1) suggested that the state of the red curtains, as revealed by the removal of overpainting, and the lack of the lighter parts of the silvery ornament on the right-hand side of the skirt, provided evidence that the portrait had not been finished. This would seem to be a misreading of Velázquez's technique. E. Trapier, *Velázquez*, 1948, p.182, suggested that the head was unfinished, but this would seem a misinterpretation of its slightly rubbed condition.
[5] Both Mayer and López-Rey give December as the month of the Prince's birth and death, but October is otherwise generally given.
[6] López-Rey 1963, no.302, and 1979, no.51.
[7] J. Brown and J. H. Elliott, *A Palace for a King*, 1980, pp.253–4; and cf. E. Harris, *Velázquez*, 1982, pp.88, 228. J. Camón Aznar, *Velázquez*, 1964, I, pp.437–40, and J. Gudiol, *Velázquez*, 1974, p.142, suggested that P12 might be identified with the 1632 ceremony, and López-Rey, *Apollo*, CXVIII, 1983, p.193, accepts this interpretation as more plausible than a date of 1633.
[8] L. Goldscheider in Justi, *Velázquez und sein Jahrhundert*, 1933, pl.45.
[9] Cf. Allende-Salazar, pp.49, 50; Mayer, nos.270, 271; Trapier, *op. cit.*, p.182; López-Rey 1963, nos.302, 303, and 1979, nos.51, 60. The Boston picture was dated 1631 by A. de Beruete, *Velázquez*, 1898, p.77; P12 was dated 1632 by Curtis, no.135. See also note 7.

[10] López-Rey 1963, no.245, and 1979, no.52; A. Braham and N. MacLaren, *National Gallery Catalogues, The Spanish School*, 1970, pp.114–19, as 1631/2–5.

[11] It appears in C. Blanc, *Histoire des peintres de toutes les écoles, Ecole Espagnole*, 1869, 'Velásquez', p.11.

[12] *Analecta Calasanctiana*, IV, p.275, no.123, p.326 n.21. Poleró, who first published the 1655 Leganés inventory in the *Boletín de la Sociedad Española de Excursiones*, VI, 1899, said that the portrait was by Velázquez. The possible Leganés connection was first pointed out by Allende-Salazar, p.276. Curtis, no.135, suggested that P12 might have been the portrait of Baltasar Carlos which was one of eighteen pictures for which Velázquez was paid 1,000 ducats in 1634 (accounts of F. de Rioja, see *Colección de documentos inéditos para la historia de España*, LV, 1870, p.621), but López-Rey 1963, pp.47–9, suggests this may have been the Boston portrait or a copy.

[13] López-Rey 1979, no.60; Buen Retiro Palace inventories of 1701 (f.556), and 1716 (no.672), as 2 *varas* high and 1½ wide (c.167 × 125) in a black frame; the inventories of July and September 1789, 1794 and 1814 describe it as in a gilded frame, '*dos varas menos media quarta de alto, y vara y tercia de ancho*' (c.155 × 111); a note in the September 1789 inventory says the portrait had been transferred to the Office of the Secretary of State at the Palacio Real on 3 April 1791.

[14] I am grateful to M. Crawford Volk for suggesting this provenance.

[15] For whom see Curtis, p.5, and A. Braham, *El Greco to Goya*, National Gallery, 1981, pp.27–8.

[16] Mawson was bidding against the National Gallery who had 600 gn. for the picture (cf. D. Robertson, *Sir Charles Eastlake*, 1978, p.132). Mawson had warmly recommended P12, but Hertford could not recollect it in the Musée Standish; when he eventually saw it in Hertford House in 1855 he thought it 'beautiful' (*Letters*, nos.25–8, 51, pp.40–2, 63).

P88 *The Lady with a Fan*

Chestnut hair, brown eyes; wearing an olive-brown dress with a farthingale skirt and cape, white kid gloves, a black shawl, and a gold rosary which terminates in a silver-blue bow and a filigree(?) pendant attached with a red ribbon;[1] she opens a vellum fan.

Canvas, relined 95 × 70

Heavily ironed in relining, probably in the earlier nineteenth century. Cleaned by Brealey in 1974–5 when discoloured retouchings were removed (particularly from the eyes, the rosary and the flesh and background areas) and the left edge of the fan (previously concealed by lining paper) and the filigree pendant were revealed. The pendant, which now appears amorphous, was engraved in 1812 as a cross, but did not appear in the engraving of 1839 (see below); both plates show the fan cut by the left edge of the composition. *Pentimenti* show that the outer loops of the rosary were repainted, the fan was originally more open, and the left side of the figure was slightly further to the left (particularly noticeable on the right forearm).

The sitter is unidentified. The same model seems to recur in the unfinished *Needlewoman* in Washington[2] and in the Chatsworth portrait (whose face mask, however, seems to have been copied from P88, see below). It has therefore been supposed that she belonged to the artist's immediate circle and may have been his wife, Juana de Miranda (the daughter of Francisco Pacheco) whom he married in 1618 and who died in 1660;[3] there is, however, no substantive evidence to support this attractive theory. The sitter, as Harris has observed, is a lady of quality (and not the *femme fatale* which some nineteenth-century critics inferred, see note 12).

The dating of P88 remains problematical. It can be related, as Harris has observed, in the firm modelling of the face and the free treatment of draperies and accessories, to Velázquez's Francesco II d'Este, Duke of Modena, which is securely dated 1638.[4] Dating by costume alone is particularly difficult. Harris suggested that Royal decrees, published in April 1639 (and partly drafted in 1636), forbidding the farthingale (*guardainfante*), the low-necked bodice and the veiling of the face,[5] almost certainly provide a *terminus ante quem* – but such decrees proved largely ineffectual.[6] More recently Carmen Bernis has suggested that the most useful evidence for dating is provided by the hair style and the cut of the bodice, which may indicate a date in the early 1640s; she considers the décolleté to be unexceptional and points out that the black shawl was standard outdoor wear, and was not for veiling the face.[7] Goldscheider dated P88 c.1640,[8] López-Rey in the mid 1630s; it has otherwise been dated between 1644–8, either 'somewhat arbitrarily' or through a misreading of Palomino.[9] The attribution was questioned, quite unnecessarily, by Armstrong[10] and Gensel.[11] This apart, P88 has always been highly regarded; *'il n'y a guère de peinture'*, wrote Bürger, *'qui représente mieux à la fois l'Espagne et Velasquez'*.[12]

Engravings

Pistrucci 1812;[13] Leroux 1839.[14]

Copy

PARIS Bibliothèque Nationale; pencil drawing by Degas in a sketchbook of 1858–60, probably copied from an engraving of P88.[15]

Version

CHATSWORTH Trustees of the Chatsworth Settlement; 98 × 48 (almost certainly cut down); from Velázquez's studio, possibly by Mazo.[16] Although listed in the Carpio collection, Madrid, 1677, as an original by Velázquez, the face mask is a very careful copy from P88 and elsewhere the execution is inferior, as was apparent when the two paintings were placed side by side in 1981. A pen and wash drawing at Chatsworth, attributed to Lady Burlington (1699–1758), shows the portrait fancifully extended to a whole-length in a landscape.

Provenance

Prince Lucien Bonaparte (1775–1840), who probably acquired it in the course of his diplomatic mission to Madrid in 1801 when he was advised on the purchase of pictures by Guillon Lethière;[17] his sale, London, Stanley, 3rd day, 16 May 1816 (141, '. . . painted with great truth of expression, with a broad pencil and a rich tone of colour . . .'), £31; Alexandre Aguado (1785–1842), Marqués de las Marismas, by 1839; his sale, Paris 7th day, 27 March 1843 (140, '. . . *en marche pour aller à ses dévotions* . . .'),[18] bt. Moran for Baron James de Rothschild (1792–1868), 12,750 fr.; bt. from Rothschild in 1847 by Laneuville who sold it to the 4th Marquess of Hertford, 7 October 1847, 15,000 fr.;[19] Hertford House inventory 1870.[20]

Exhibitions

Manchester, *Art Treasures*, 1857 (saloon H, no.12); Bethnal Green 1872–5 (321); RA 1888 (132).

References General

Curtis, no.265; Allende-Salazar, pp.126, 281; Mayer, no.559; López-Rey 1963, no.599, and 1979, no.79; E. Harris, *The Burlington Magazine*, CXVII, 1975, pp.316–19, and *Velázquez*, 1982, p.115.

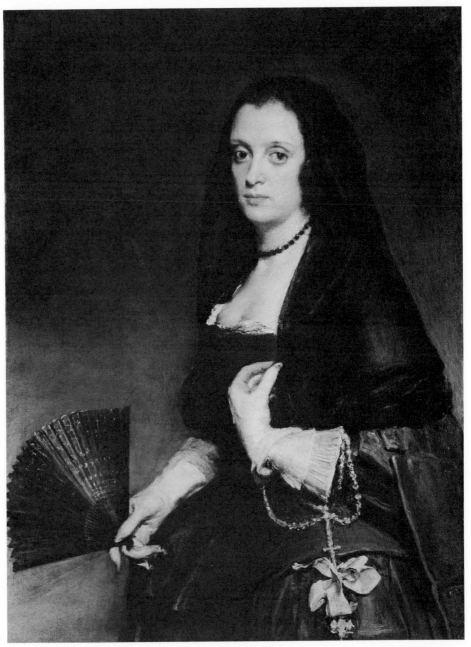

P88

[1] Harris 1975, p.316, suggests the pendant resembles the *paloma* (dove of the Holy Spirit). Dr. P. E. Muller (letter on file dated 6 January 1982) says she knows of no seventeenth-century examples of the *paloma* pendant, and that those recorded in the eighteenth century are not known to have hung from rosaries; she suggests the pendant in P88 might possibly be the upper section of a silver filigree crucifix, or a *medalla* (cf. Muller, *Jewels in Spain*, 1972, p.129).

[2] López-Rey 1963, no.605, and 1979, no.81.

[3] E.g. by López-Rey, *loc. cit.*, and J. Gudiol, *Velázquez*, 1974, p.148. The sitter has also been associated with the artist's daughter (Francisca, 1619–54, who m. Mazo in 1633), e.g. by A. de Beruete, *Velázquez*, 1906, p.71, Mayer, *loc. cit.*, and in *Velázquez y lo Velazqueño*, 1960, no.129.

[4] Modena, Galleria Estense; López-Rey 1963, no.337, and 1979, no.89.

[5] Cf. J. Ortiz y Sanz, *Compendio cronológico de La Historia de España*, VI, 1801, pp.398–9; A. Rodríguez Villa, *La Corte y Monarquía de España*, 1886, p.51 (quoting letter of 18 October 1636); M. Hume, *The Court of Philip IV*, 1928, p.309. The decrees are also described by Curtis, *loc. cit.*, and Harris 1975, p.316.

[6] Cf. Hume, *op. cit.*, pp.299, 445.

[7] Carmen Bernis in two letters to Enriqueta Harris (to whom I am most grateful for allowing me to share these opinions); the hair falling over the ears suggests the French influence of the 1630s; the skirt panels of the bodice are larger than those given in, for example, Martín de Andúxar, *Geometría y trazas pertenecientes al oficio de sastres*, 1640, but become common in the 1640s.

[8] L. Goldscheider in Justi, *Velázquez und sein Jahrhundert*, 1933, pl.68.

[9] Cf. E. Trapier, *Velázquez*, 1948, p.286; Palomino (*El Museo Pictórico*, 1715–24, III, p.334; trans. E. Harris, *Velázquez*, 1982, p.207) described a female portrait by Velázquez as '*Una Dama de singular perfección*' and related it to an epigram by Bocángel (who did not mention, however, Velázquez's name) published in 1627 – clearly too early for P88 – while the date of c.1647, deduced, for example, by Curtis, *loc. cit.*, was due to a misreading.

[10] W. Armstrong, *The Life of Velázquez*, 1896, p.66.

[11] W. Gensel, *Velázquez, Klassiker der Kunst*, 1905, p 125.

[12] W. Bürger, quoted by W. Stirling-Maxwell, *Velázquez*, 1865, p.236: '*où va-t-elle? au sermon? Mais d'où vient-elle? n'a-t-elle point un billet doux caché dans son gant? Oh! la bonne dévote Espagnole, avec ce feu dans le regard et tant de volupté dans les traits! Oh! qu'elle est attrayante, quoiqu'elle ne soit véritablement pas jolie! Mais elle a la beauté espagnole: le désir et la passion*'. Like Curtis and Justi (*Velázquez and his Times*, 1889, pp.266–8) Bürger overdoes the *coquetterie*.

[13] For the *Galerie Lucien Bonaparte*, 1812, no.36.

[14] For the *Galerie Aguado*, 1839–41, no.4, and *Art Journal*, 1864, p.34.

[15] T. Reff, *The Notebooks of Edgar Degas*, 1976, I, p.81; since P88 was in London from 1857 (whence it was lent to the Manchester exhibition that year) it is unlikely that Degas copied the original.

[16] López-Rey 1963, no.600, and 1979, no.35; as Velázquez; A. Braham, *El Greco to Goya*, National Gallery, 1981, no.27, as Circle of Velázquez.

[17] Cf. F. Haskell, *Rediscoveries in Art*, 1976, p.34.

[18] The preface to the Aguado sale catalogue described P88 as '*un portrait . . . que chacun admire depuis long-temps et dont la célébrité est devenue proverbiale*'. Lot 140 was sold immediately before lots 39 and 37, the Murillos Hertford also bought, now P3 and P68.

[19] Receipt in Wallace Collection archives. According to Murray Scott (note in Wallace Collection archives) Rothschild sold P88 because his wife did not like the look of the sitter.

[20] The Spanish frame now seen on P88 was presented by Sir Alec Martin in 1950.

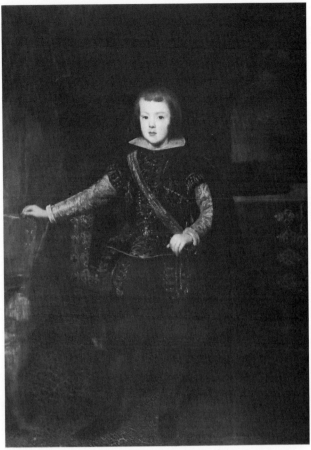

P4

Studio of Velázquez

P4 *Prince Baltasar Carlos in Black and Silver*

Wearing the Order of the Golden Fleece, his black hat on a red-covered table;[1] the chair and left-hand curtain are red with gold trimmings.

Canvas, relined[2] 154 × 108.3

In poor condition; heavily ironed in relining, extensively retouched, and the varnish greatly discoloured. X-radiography shows a large T-shaped tear above the table, and a damage running vertically from immediately to the right of the Prince's left eye up to his hair, together with several other smaller losses. In 1865 Leslie and Taylor recorded that Reynolds had purchased P4 in a ruined state 'and cleaned and retouched it to such purpose that few by Velasquez now look better. Northcote says he painted the face; it is evident that he did much to the sky, and admirably, and it is probable that he enriched the colour of the entire picture'.[3] Traces of bituminous paint round the legs and head show where some

of these retouchings took place; the right hand seems to have been reworked, and in the upper right area the hat, sky and curtain are not satisfactorily resolved; the best surviving version of Velázquez's portrait shows a light coloured wall behind the table, no curtain, and a plain, black, broad-brimmed hat. The face, apart from the repaired damage, does not seem to have been extensively retouched. The darkening of the varnish was already noticeable by 1857.[4] The bottom edge has been made up, adding 1.3 cm. to the height.

For the sitter, see P12 above. The Prince received the Golden Fleece on 24 October 1638, just after his ninth birthday.

The condition of P4 makes assessment difficult, but X-radiographs of the head suggest that it had some quality and may have been from Velázquez's studio, as López-Rey suggested. The image (see versions below) has been dated c.1641–2 by Mayer and c.1639 by López-Rey; comparison with the portrait of the Prince in armour from Velázquez's studio (examples in Hampton Court and the Mauritshuis),[5] which is dateable 1639, suggests that the Prince is older in P4 and that the later date is correct. It was Velázquez's last portrait of the Prince, unless that of 1645–6 in the Prado (no.1221),[6] generally attributed to Mazo, is after a lost Velázquez original.

Versions

VIENNA Kunsthistorisches Museum (no.312); 128.5 × 99.5, by Velázquez with studio assistance; compared with P4 it is reduced along the top and right-hand edges and the Prince's stockings are silver (and see further comparison above).[7]
Half-length versions are in the Metropolitan Museum, New York (no.89.15.31), 53 × 41,[8] and in a private collection, Bilbao, 58 × 43.[9]

Provenance[10]

Sir Joshua Reynolds by 1770–6, when Northcote was his pupil; his sale, Christie's, 3rd day, 16 March 1795 (89, 'Valasques, Baltazar, Infanto of Spain, a capital small whole length portrait of this scarce master'); William Wells (c.1768–1847) of Redleaf by 1828; his sale, Christie's, 2nd day, 13 May 1848 (123), bt. by the 4th Marquess of Hertford, 650 gn.; Hertford House inventory 1870.

Exhibitions

BI 1828 (10) lent Wells; BI 1837 (25); Manchester, Art Treasures, 1857 (saloon H, no.13); RA 1872 (75);[11] Bethnal Green 1872–5 (291); RA 1896 (115).

References General

Curtis, nos.136 and 267; Mayer, no.289; López-Rey 1963, no.321.

[1] W. Stirling, Annals of the Artists of Spain, 1848, II, p.633, thought the table a casket covered with red velvet, exactly like a dressing case presented by Philip IV to the Prince of Wales. His misreading of the picture was repeated by Curtis and Justi, Velázquez and his Times, 1889, p.326.
[2] Probably relined in Reynolds's time, given the condition in which he is said to have received it.
[3] C. R. Leslie and T. Taylor, Life and Times of Sir Joshua Reynolds, 1865, II, pp.139–40. Northcote (Life of Reynolds, 1819 ed., II, pp.189–90) related that when Reynolds had first shown him P4 he had remarked 'with much simplicity' how it was exactly in Sir Joshua's own manner. Reynolds was also once thought to have painted over the landscape background of the Abercorn portrait of Baltasar Carlos from Velázquez's studio (López-Rey 1963, no.309), see Justi, op. cit., p.325.
[4] G. Scharf, Handbook to the Paintings by Ancient Masters in the Art Treasures Exhibition, 1857, p.80; he remarked that P4 was highly esteemed and had a richer, more golden tone than other works by Velázquez in the exhibition, which made it 'quite Titianesque', but the overall appearance 'has been much affected by the darkening of the varnish'.
[5] López-Rey 1963, nos.315–6.
[6] López-Rey 1963, no.324, as probably by Mazo.
[7] López-Rey 1963, no.319, and 1979, no.90.
[8] López-Rey 1963, no.320.
[9] López-Rey 1963, no.323.
[10] Waagen, IV, p.81, described P4 as an Infanta, 152 × 107, acquired from the Higginson collection.
[11] Curtis, no.267, quotes Waagen's description (see note 10), but gives the measurements as 93 × 68 and says the picture was shown at the RA in 1872. The RA catalogue had continued to call P4 An Infanta and to give the size as 93 × 68.

P6 *Prince Baltasar Carlos in the Riding School*

Fair-haired, wearing a black suit with a silver tunic, silver-grey boots and gloves, and the purple sash of a Captain-General; his cloak has a white lining, and his black hat has white plumes. On a black pony he executes the difficult exercise known as the *levade*. In the centre a dwarf proffers a lance, indicating that the Prince will practise tilting in the runs seen on the right. In the background the east wing of the Buen Retiro Palace, Madrid, which contained the Prince's quarters; behind the fence on the extreme left lay the Prince's garden.[1] Against the Palace wall, centre, stands a carriage surrounded by a group of figures; on the right-hand balcony stand two female figures and a small child.

Canvas, relined 130 × 102

Relined in 1879 and revarnished in 1937. The Prince and pony are much more highly finished than the rest of the picture. There are *pentimenti* round his shoulders and his hair has been lengthened, the addition on the left having since worn thin allowing his original shorter hair and the back of his collar to reappear. There are small losses in the pony's rearmost leg and on the Prince's right cheek. The remainder of the picture is very thin and sketchy. *Pentimenti* show that the right shoulder and face of the central standing figure were altered; it is also clear, from the way in which his cape has been painted round the pony's left foreleg, that this figure was added after the equestrian group was completed. Immediately to the right (and to the left of the lance held by the dwarf) a faint black line runs diagonally up to the right (see discussion below). X-radiography reveals that the left-hand edge of the Palace was first drawn further to the left.[2] Infra-red examination has revealed no further changes. There are some minor losses within the Palace wall, and in the bottom right area. The bottom edge has been made up, adding 1.5 cm. to the height.

For the sitter, see P12 above. The Prince, like his father Philip IV, was a keen horseman and an enthusiast for the tilt (*las lanzas*),[3] but P6 is also, as Levey first demonstrated, a representation of the good Prince who, in mastering his horse, shows he will master himself and his kingdom.[4] The attitude of the pony is comparable with that of the horse in Tacca's equestrian statue of Philip IV (now in the Plaza de Oriente, Madrid) commissioned by Olivares who, in August 1636, had instructed Tacca to modify the horse's pose to that which we now see; the statue was first installed in the Buen Retiro Palace in 1642 on a spot very near that occupied by the Prince in P6.[5]

P6 appears to be a contemporary version of the *Prince Baltasar Carlos in the Riding School* painted by Velázquez c.1636, almost certainly for Olivares, and now belonging to the Grosvenor Estate. Until the Grosvenor picture was cleaned in 1973, allowing Harris to attribute it convincingly to Velázquez himself, it had often been assumed that both pictures were copies of a lost Velázquez original.[6] That P6 followed the Grosvenor picture seems adequately demonstrated by the absence of the radical *pentimenti* which appear in the Palace buildings of the

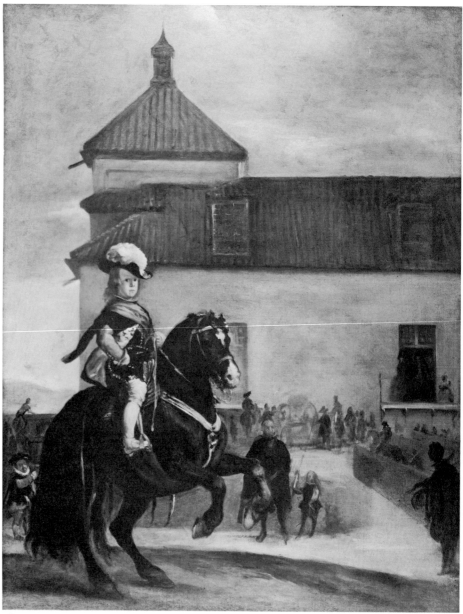

P6

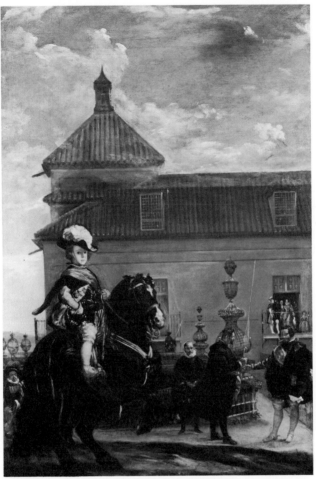

Velázquez: *Don Baltasar Carlos in the Riding School.*
The Grosvenor Estate
(By kind permission of the Duke of Westminster)

latter, as well as by its inferior overall quality, though this is not to deny that p6 is a distinguished studio production. Close comparison with the Grosvenor picture suggests that p6 may have been painted immediately after it; some areas show the closest similarities, while others, though different, contain significant echoes of the Grosvenor composition.

The equestrian group in p6 was closely copied (the Prince's hair was altered subsequently) and the turquoise touches in the foreground shadow occur in both pictures;[7] p6 preserves the outline of the Palace and the figures of a small child standing on the right-hand balcony and a dwarf on the extreme left. Elsewhere the Grosvenor picture shows a much fuller, and more coherent composition: to the right of the Prince stand (according to Harris's convincing identifications) Juan de Mateos (Master of the Hunt); on his left Martín de

Espinar (the King's Keeper of Arms) who turns, proffering a lance, to Olivares on the right of the picture; behind them, on the right-hand balcony, stand the King and Queen with the Duchess of Olivares and the Infanta, María Antonia (15 January 1635 – 6 December 1636);[8] behind the Prince elaborate wicker-work structures decorate an enclosure, and comparable ornaments stand on the wall on the extreme left; the Palace has ornamental balconies and a moulding runs below the eaves; there is more sky, proportionately, above the Palace.[9] In P6 most of the Courtiers have been removed, and the setting and secondary figures are very thin and sketchy, but the anonymous standing central figure and the distant horseman behind him echo the Grosvenor composition; the diagonal line to the right of this central figure (see description above) coincides with the back of Martín de Espinar in the Grosvenor picture; the enclosure behind the Prince has been blocked in, and the tilt runs on the right, set before the Royal balcony, are similarly positioned (though more exposed with the removal of Olivares).

It is not clear under what circumstances P6 was produced, but with the omission of Olivares and the Royal family much of the ceremonial point of the original composition has been lost. Perhaps Olivares would not permit the subtle descrip-tion of his Courtly functions to be copied, necessitating the removal of himself, Martín de Espinar (who offered him the lance) and the King. The evanescence and curious scale of the secondary figures seen in P6 recall the work of Mazo, who worked in Velázquez's studio from c.1633 (and who became the Prince's Painter in 1646), but no works by him of such an early date are known.[10] Harris suggested that the omission of Olivares (who was disgraced in 1643) and the Queen (who died in 1644) might indicate that P6 was painted c.1644–5, making the attribution to Mazo easier to accept. Subsequently, however, she has agreed (orally) that it is doubtful whether there would have been any call for a portrait of the growing Prince as he appeared eight years before, without the Golden Fleece he received in 1638, and with the Infanta (long since dead) on the balcony; there were several later Velázquez portraits of him to be copied (cf. P4 above), though none was equestrian.

Copy

A nineteenth-century (?) water-colour by W. Simson, evidently based on P6, was in the Stirling-Maxwell albums.[11]

Version

LONDON the Grosvenor Estate; 144 × 91, by Velázquez, see above.[12]

Provenance

Amongst Velázquez's possessions at his death was an unattributed picture of '*El Principe Nro. Sr. a cavallo, en bosquejo*',[13] and '*un niño a caballo, borrón original de Velázquez de vara de alto*' was listed in the collection of the Duchess of Huescar on her death in 1784;[14] both or neither of these entries may refer to P6. In the collection of José de Madrazo (1781–1859) in Madrid, as described by David Wilkie in a letter to Robert Peel, dated Madrid, 28 January 1828: 'a duplicate of the Velasquez at Earl Grosvenor's of the little Infante Don Balthazar on Horseback in the Court-yard of the Palace';[15] purchased by Woodburn, on Wilkie's recommendation, for Samuel Rogers (1763–1855); his sale, Christie's, 6th day, 3 May 1856 (710, as 'Don Balthazar Carlos, son of Charles IV. of Spain . . . in the tennis court at Madrid . . . the royal mews are seen in the background. This noble work was purchased in Spain, by Mr. Woodburn, for Mr. Rogers, at the recommendation of Sir David Wilkie'), bt. Mawson for the 4th Marquess of Hertford, 1,210 gns.;[16] Hertford House inventory 1870.

Exhibitions

BI 1838 (2) lent Rogers; BI 1855 (91); Manchester, *Art Treasures*, 1857 (saloon H, no.11); Bethnal Green 1872–5 (307); RA 1890 (136).

References General

Curtis, no.133; Allende-Salazar, pp.180, 284, as Mazo; Mayer, no.268, as perhaps by Carreño; López-Rey 1963, no.207, as by a hand inferior to Velázquez and Mazo, and 1979, under no.78, as a school variant; E. Harris, *The Burlington Magazine*, CXVIII, 1976, pp.266–75.

[1] The identification of the setting was first made by M. Levey, *Painting at Court*, 1971, p.142. See also J. Brown and J. H. Elliott, *A Palace for a King*, 1980, pp.72–3, 255. Though there can be no reasonable doubt concerning the identity, an engraving by Meunier shows two rows of windows in the wing of the Palace and detailed differences in the roofing (cf. Levey, *loc. cit.*, Brown and Elliott, *op. cit.*, p.113, fig.60).

[2] The same alteration may be detected on the Grosvenor picture.

[3] Cf. M. Hume, *The Court of Philip IV*, 1928, p.284, and Harris, *op. cit.*, p.271 n.20.

[4] Levey, *loc. cit.*, and see W. A. Liedtke and J. F. Moffitt, 'Velázquez, Olivares, and the Baroque equestrian portrait', *The Burlington Magazine*, CXXIII, 1981, pp.529–37.

[5] See Brown and Elliott, *op. cit.*, pp.111–14, and J. Pope-Hennessy, *Italian High Renaissance and Baroque Sculpture*, 1970 ed., pp.104–6.

[6] E.g. by W. Armstrong, *The Art of Velázquez*, 1896, pp.48–51; A. de Bereute, *Velázquez*, 1898, p.110; L. Goldscheider in Justi, *Velázquez und sein Jahrhundert*, 1933, pl.132; Mayer, nos.267–8; J. A. Gaya Nuño, *Varia Velazqueña*, I, 1960, pp.475–6; López-Rey 1963, nos.206–7. Others attributed both pictures to Velázquez, e.g. Curtis, nos.133–4 (the Prince described as 'about 4' in P6 and 'about twelve' in the Grosvenor picture); C. Justi, *Velázquez and his Times*, 1889, pp.322–4 (the Grosvenor picture called 'a few years later' than P6); C. Phillips in the earliest editions of this catalogue; J. Camón Aznar, *Velázquez*, 1964, II, pp.570–5; J. Gudiol, *Velázquez*, 1974, p.148.

[7] Armstrong, *loc. cit.*, first noted the very close resemblance of the execution of the equestrian figures.

[8] The child first identified by Allende-Salazar, p.284. Harris 1976, p.271 n.26, notes that the child might, less plausibly, be 'one of the many children that the Princess of Carignano brought with her to Spain in November 1636' (cf. M. de Novoa, *Historia de Felipe IV*, 1881, II, p.218).

[9] The Grosvenor picture was once folded, reducing the height by c.14.5 cm. (see Harris 1976, p.266), which would have made it almost the same proportion as P6. If, as is here argued, P6 was a contemporary version it is hardly likely that the Grosvenor picture was immediately folded over; has P6 been cut, or was the Grosvenor picture folded in imitation of P6? It seems impossible to say.

[10] Mazo's date of birth is assumed to have been c.1612/16; his earliest certain works date from the 1640s, cf. A. Braham and N. MacLaren, *National Gallery Catalogues, The Spanish School*, 1970, pp.51–2.

[11] Photograph in the Warburg Institute Library (Stirling-Maxwell, following Velázquez 125).

[12] López-Rey 1963, no.206, and 1979, no.78; A. Braham, *El Greco to Goya*, National Gallery, 1981, no.24; E. Harris, *Velázquez*, 1982, p.100. The measurements were wrongly given by Mayer, no.267, as 207.5 × 142.5 (recently repeated in *The Burlington Magazine*, CXXIII, 1981, p.533, fig.44).

[13] Quoted by López-Rey 1963, no.200.

[14] *Ibid.*; a *vara* is approximately 84 cm.

[15] A. Cunningham, *Life of Wilkie*, 1843, II, p.496. W. Stirling, *Annals of the Artists of Spain*, 1848, II, p.630, described P6 as with Madrazo in 1827, 'but I did not see it in his collection in 1845'.

[16] For Mawson's commendation of P6, and Hertford's laconic response, see *Letters*, nos.62, 65, pp.74, 78.

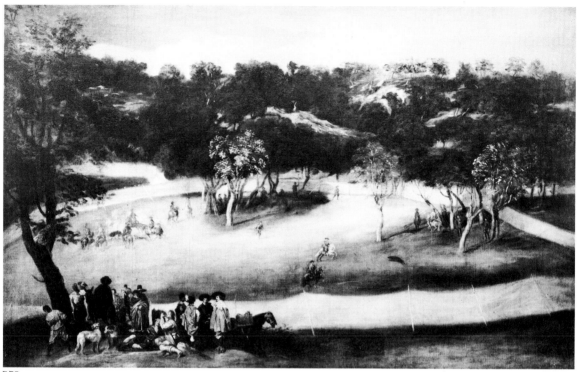

P70

After Velázquez

P70 *A Royal Boar Hunt*

Canvas, relined 69.5 × 121.1

The dark areas have been reinforced with bituminous paint,[1] and the whole is much discoloured by old varnish.

The subject is *la tela real*, the Royal Enclosure, into which wild boar were led to be baited by the King and his gentlemen before being killed by hounds and huntsmen, as seen in the left distance.[2]

P70 is an incomplete, possibly seventeenth-century version of the larger canvas painted by Velázquez c.1635–7, in the National Gallery, London (no.197).[3] It lacks the extreme left-hand and right-hand groups of the foreground figures and many of the hunting party (including the King and Olivares); the enclosure is differently shaped on the right-hand side, as is the path in the left mid-distance, and the tree in the left foreground has much less foliage. A version in a Swedish private collection, the same size as P70, shows the same variations but is a finished composition.[4] A full-sized copy of the National Gallery picture is in the Prado (no.1230).[5]

Provenance

According to Curtis, P70 was brought to England from Spain by Lionel Hervey (Minister in Spain 1820–2) in 1826; lent by him to the BI in 1835. By 1846 P70 had been acquired by the 2nd Baron Northwick (1769–1859);[6] his sale, Thirlestane House, Cheltenham, Phillips, 11th day, 11 August 1859 (1096), bt. Mawson for the 4th Marquess of Hertford, 310 gn.;[7] Hertford House inventory 1870.

Exhibitions

BI 1835 (137) lent Hervey; Bethnal Green 1872–5 (322).

References General

Curtis, no.38; Mayer, no.132; López-Rey 1963, no.141.

[1] First noticed by Waagen, III, p.204, who otherwise thought P70 'very masterly'.
[2] For a fuller account, see A. Braham and N. MacLaren, *National Gallery Catalogues, The Spanish School*, 1970, pp.102–3.

[3] *Ibid.*, pp.101–8; López-Rey 1963, no.138. Though the attribution has been much discussed it is now generally accepted as a work by Velázquez (cf. E. Harris, *Velázquez*, 1982, p.131). At the time of its purchase the picture was not in good condition, having been crudely restored.
[4] López-Rey 1963, no.140; *Velázquez y lo Velazqueño*, 1960, no.108.
[5] López-Rey 1963, no.139.
[6] Listed in *Hours in the Picture Gallery of Thirlestane House*, 1846, p.66, no.CCCLXXV: 'said to be the original of a large picture just purchased from Lord Cowley's collection for the National Gallery'. This statement was misread by the compiler of the Northwick sale catalogue, who described lot 1096 as 'said to be the original sketch of the large picture now in the National Gallery. From Lord Cowley's collection' (and see 1968 catalogue, p.337).
[7] Mawson recommended P70 to Lord Hertford as 'a first rate sketch of the grand picture in the National Gallery & desireable' (*Letters*, no.96, p.123). Curtis, *loc. cit.*, and Justi (*Velázquez and his Times*, 1889, p.217) thought P70 was probably a sketch for the National Gallery picture, but this was rejected by Phillips in the earliest editions of this catalogue.

P100 *The Infanta Margarita*

Fair hair, dark blue eyes; wearing a silver dress with slashed sleeves, fur-trimmed collar and cuffs, and red bows; there is a pale pink bow in her hair.

Canvas, relined 70.8 × 55.5

Cleaned by Buttery in 1879. The varnish is now discoloured and a fine overall craquelure is tending to lift. Old fillings along the top and bottom edges, and traces of an old fold and nail holes showing the height was once reduced to 63.8 cm.

Margarita, daughter of Philip IV of Spain by his second Queen (and niece), Mariana, was born in Madrid on 12 July 1651; she married the Emperor Leopold I of Germany in 1666 and died on 12 March 1673.

P100, which probably dates from the seventeenth century, is taken from the whole-length portrait by Velázquez of c.1656, now in the Kunsthistorisches Museum, Vienna (no.3691).[1] The old fold mark on P100, described above, would have placed the head in the same relation to the top of the canvas as in the Vienna portrait. Other whole-length versions are in the Städelsches Kunstinstitut, Frankfurt,[2] and Nelahozeves Castle, Prague, and a half-length is with the Fine Arts Society, San Diego.[3]

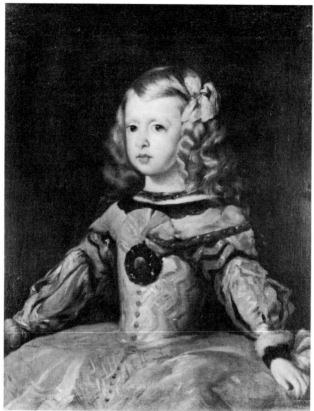

P100

Provenance

Probably from the collection of Gen. the Hon.
John Meade (1775–1849), many years Consul
at Madrid, where he died;[4] his sale, Christie's,
6 March 1851 (120, 'Portrait of Margarita of
Austria . . .'), bt. Nieuwenhuys, 66 gn. Bought
from Nieuwenhuys, 27 May 1852, by the 4th
Marquess of Hertford, £200 ('*un portrait de
l'infante d'espagne peint par Velasquez*');[5] rue
Laffitte inventory 1871 (641); Hertford House
inventory 1890.

Exhibition

Bethnal Green 1872–5 (314).

References General

Curtis, no.258;[6] Allende-Salazar, p.221, as
studio or copy; Mayer, no.533, as probably
Mazo; López-Rey 1963, no.404, as lesser
school work.

[1] López-Rey 1963, no.402, and 1979, no.123; 105 × 88.
[2] López-Rey 1963, no.403; 136.5 × 105.
[3] López-Rey 1963, no.405; 53.4 × 45.8.
[4] Cf. *The Gentleman's Magazine*, 33, 1849, ii, pp.420–1, and
Curtis, p.9.
[5] Receipt in Wallace Collection archives.
[6] As an Infanta 'about 36 × 36 inches' (91.5 × 91.5).

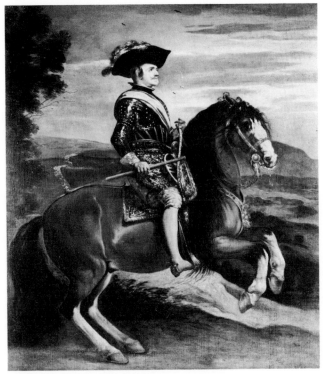

P106

P106 *Philip IV on Horseback*

Canvas, relined 67.3 × 59.7

Philip IV (1605–65) succeeded as King of Spain in 1621.

P106 is an indifferent late copy from the much larger portrait painted by Velázquez in 1634–5 for the Buen Retiro Palace (now no. 1178 in the Prado),[1] or from a version of it (López-Rey lists eight).[2] There are some minor differences: P106 is slightly narrower, black birds have been introduced in the sky and the shapes of, for example, the left-hand tree and the billowing sash differ slightly. For the pendant, see P109 below.

Provenance
Purchased from Nieuwenhuys in March 1872 by Sir Richard Wallace;[3] Hertford House inventory 1890.

Exhibition
Bethnal Green 1872–5 (320).

References General
Curtis, no.102; Mayer, no.191, as an old copy; López-Rey 1963, no.194, as probably a nineteenth-century copy.

[1] López-Rey 1963, no.187, and 1979, no.71; 301 × 308.
[2] López-Rey 1963, nos.188–93 and 195–6; there are examples in the Courtauld Institute Galleries, London (61 × 44), the Palazzo Pitti, Florence (126 × 91), and the Museo Cerralbo, Madrid (46 × 40).
[3] Information from Murray Scott in Wallace Collection archives.

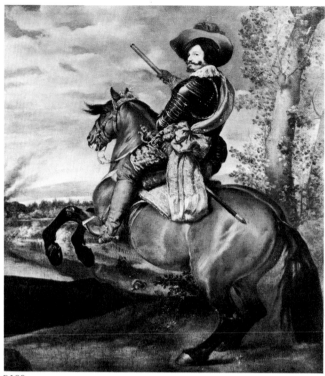

P109

P109 *The Conde Duque de Olivares on a Chestnut Horse*

Canvas, relined 67.3 × 59.4

Don Gaspar de Guzmán (1587–1645), Conde de Olivares and Duque de San Lúcar La Mayor, Chief Minister to Philip IV from 1621 until his disgrace in 1643; Velázquez had first come to Madrid at his bidding and remained loyal to him after his fall.

P109 is an indifferent late copy of the much larger portrait painted by Velázquez in 1638 (Prado, no.1181),[1] or from a version of it (López-Rey lists three other reduced copies).[2] Though apparently painted on a different type of canvas from P106, the two pictures have probably always been pendants (and were possibly painted after the originals had been brought together by Charles III in 1769).

Provenance

Purchased from Nieuwenhuys in March 1872 by Sir Richard Wallace;[3] Hertford House inventory 1890.

Exhibition

Bethnal Green 1872–5 (324).

References General

Curtis, no.169; Mayer, no.311, as probably an eighteenth-century copy; López-Rey 1963, no.213, as probably a nineteenth-century copy.

[1] López-Rey 1963, no.211, and 1979, no.66; 313 × 239. See also E. Harris, *Velázquez*, 1982, pp.100–01.
[2] López-Rey 1963, nos.212, 214–5.
[3] Information from Murray Scott in Wallace Collection archives.

Appendices

Chronology of Acquisitions

Listing only those pictures catalogued in this volume.
In some cases the dates assigned are those of the last sale recorded.

First Marquess of Hertford
1719–1794

1781–3
Downman p751–4(?)

1784
Reynolds p31, p33

dates unknown
Canaletto p497, p499, p507, p511
Studio of Canaletto p496, p500
Studio of Ramsay p560(?)

Second Marquess of Hertford
1743–1822

1810
Reynolds p38
Romney p37

1818
Gainsborough p42

date unknown
S. Harding p770(?)

Third Marquess of Hertford
1777–1842

1810
Hoppner p563
Reynolds p561

1813
Reynolds p48

1815
Titian p11

dates unknown
Eworth p535
German School(?) p533
After Holbein p547, p554
Attributed to van der Meulen p534
Westall p757

Fourth Marquess of Hertford
1800–1870

1843
Bonington p273(?), p656, p684, p696, p700,
 p704, p727, p732, p750
Dietrich p153
Murillo p3, p68
Manner of Reni p644
Stanfield p667, p712(?)

1845
Bonington p733

1846
Bonington p674, p726, p734, p749
Murillo p34

1847
Velázquez p88

1848
Canaletto p509, p516
After Canaletto p512, p515
Denning p765
Domenichino p131
Attributed to Gutiérrez p105
Meneses p7
Murillo p14, p97
Studio of Velázquez p4

1849
Studio of Albani p642
Landseer p589
Lawrence p558
Murillo p58, p133
Sassoferrato p126

1850
Reynolds p36
Rosa p116
Andrea del Sarto p9

1852
Bonington p362, p375
Cano p15
After Velázquez p100

1853
Bonington p333, p341
Velázquez p12
Wilkie p352

1854
Hilton P633
Murillo P46
Reynolds P47

by 1854
Luini P8

1855
Canaletto P506, P510
After Canaletto P514
Cooper P309
Sant P602
Sully P564

1856
Reynolds P40
Sassoferrato P646
After Titian P546
Studio of Velázquez P6

1857
After Titian P5

1858
After Murillo P13

1859
Bonington P270
Manner of Canaletto P498
Cima P1
Gainsborough P44
Guardi P647
Landseer P373
Morton P632
Newton P617
Reynolds P32, P43, P45
Ascribed to Titian P19
After Velázquez P70
Wilkie P357

by 1859
After Canaletto P492, P495
After Murillo P104

1860
Bonington P323, P339, P675, P676,
 P678, P679
After Bonington P319

1861
Reynolds P35

1863
Bonington P672, P698, P701, P708, P714
Derby P709, P713, P725
Fielding P690, P691, P715, P716, P718
J. D. Harding P658
Landseer P257
Lawrence P39
Nesfield P703
Pettenkofen P338
Roberts P258, P587, P659, P680, P689, P697
Stanfield P343
Turner P651, P654, P661, P664

1864
Bonington P688

1865
After Cagnacci P643
Guardi P491, P494, P503, P508
Ascribed to Luini P10
Attributed to Marinari P562

by 1867
Lawrence P41

1868
Studio of Bronzino P555

1869
Bonington P322

1870
Bonington P351

dates unknown
Achenbach P618
Bonington P657, P668
Callow P746
Studio of Canaletto P505
Guardi P502, P504, P517, P518
Italian School P493(?)
Attributed to Murillo P136
North Italian School P552
Manner of Pettenkofen P621
Sassoferrato P565
Westall P566
Winterhalter P669

Sir Richard Wallace
1818–1890

1871
Tuscan School(?) P542(?)

1872
Follower of Beccafumi P525
Benvenuto di Giovanni P543
Attributed to Bertucci P2
After Canaletto P513(?)
Cremonese School P536
Crivelli P527
Workshop of Daddi P549
Ferrarese School(?) P539(?)
Florentine School P553
Florentine School(?) P768
Foppa P538
Francesco di Vannuccio P550
Italian School(?) P776(?)
Luini P526, P537
Maratta P774(?)
Master of Santo Spirito P556
Milanese School P544
North Italian School P541(?)
Platzer P634
Polidoro da Caravaggio P775(?)
After Pollaiuolo P762
Ascribed to Lo Spagna P545
Umbrian School P540
After Velázquez P106, P109

1873
After Canaletto P501
Morland P574

1874
Harper P694, P695

1875
Stanfield P354

by 1879
Landseer P376

1882
Von Angeli P557

1883
Lawrence P559

1886
Symonds P578

APPENDIX II

Canaletto in the Collections of the Marquesses of Hertford

Extracts from inventories and archives preserved in the Wallace Collection library and from Waagen. Note: Manchester House is Hertford House (both names were used in the nineteenth century).

1832

Memorandum by the third Marquess of Hertford[1]

To please my Father [the second Marquess of Hertford, 1743–1822] against my own wish I entailed the settled Estates (which I might have awaited to possess in Fee) on the Title – but I did not renew my entail of the Grosvenor Street House[2] or its furniture, that of Ragley or Sudbourne, or of the plate &c – Vide my Grandfathers [the first Marquess of Hertford, 1719–94] will . . . *Ergo* – all the glasses, pictures, plate, diamond China &c. removed from Grosvenor Street to Manchester House are *now* my property . . . Exempli gratia: in Manchester House the Canalettis in the Blue room are *mine*,[3] M.[rs] Robinson and the S.[r] Joshua being my Fathers private property follow *his* Entailed testamentary dispo.

[1] '*Memorandum in Lord Hertford's pocketbook as to entailed Furniture / 21 July Cholera time / Marlborough*', ms. copy on paper water-marked 1869; the cholera epidemic of 1832 was recorded, for example, in Raikes's *Journal*, 22 July 1832: 'when will this scourge end? Each succeeding day increases the list of victims!'.
[2] The residence of the first Marquess of Hertford; in his Will, dated 8 October 1790, he refers to his 'house in Grosvenor Street wherein I reside for the remainder of a term of years'.
[3] P497, P499, P496, P500 and probably P507 and P511, see 1834 below. The implication seems to be that the first Marquess had acquired these six Canalettos.

1834

Hertford House Inventory (ff.46–7)

A Panorama View of Venice embracing the Doge's Palace St Marck's Place Custom House and the other principal Buildings from the Opposite side of the Adriatic enlivened by numerous vessels & figures – Canaletti – a splendid Picture of the Master[1]

A View of ditto taken from the Custom House. The Companion to the preceding[2] (£300 the pair)

A View of the Grand Canal at Venice taken during the Carnival with variety of Gondolas & figures by Canaletto not in the Deed[3] (£60)

A View of St Marks Place also during the Carnival with many figures not in the Deed[4] (£60)

A View of the Rialto Ditto Ditto[5] (£60)

Another View of the Grand Canal[6] (£60)

[1] P497.
[2] P499.
[3] P496. The annotation on this and the following picture 'not in the Deed' are probably contemporary; according to the 1832 Memorandum quoted above, all these pictures were unentailed (i.e. 'not in the Deed').
[4] P500, see note 3.
[5] Presumably P511, the only Canaletto in the Collection which includes the Rialto.
[6] Presumably P507, the pendant to P511.

1842

Inventory of the China &c. removed after the death of the late Marquis of Hertford by order of his Executors from the Regents Park Villa [St. Dunstan's] to Dorchester House Park Lane

Two Canaletti pictures[1]

[1] P497 and P499, see 1842 below.

1842

Dorchester House Inventory (f.216)

Canaletto A Splendid View in Venice large – ditto – A Ditto – large[1]

[1] P497, P499.

1843

Hertford House Inventory (f.70)

Canaletto A Panoramic View of Venice[1]
Canaletto another View from the Custom House[2]
Canaletto View of the Grand Canal[3]
Canaletto View of St Marks Place[4]
Canaletto View of the Rialto[5]
Canaletto another View of the Grand Canal[6]

[1] P497. [4] P500.
[2] P499. [5] P511(?), see 1834 above.
[3] P500. [6] P507(?), see 1834 above.

1854
Waagen, II, p.155 (Hertford House)

Antonio Canale. – Four very admirable pictures inherited from the late Marquis [not seen]

1857
Waagen, IV, p.80 (Hertford House)

1. A view of the Piazzetta, with a festivity going on.

2. The Bridge of the Rialto.

3 and 4. Two Venetian views. These are the four pictures already mentioned [see 1854 above] as inherited by Lord Hertford. They are remarkable for great power and freshness. The first only is somewhat crude.[1]

5 and 6. Two other pictures by Canaletto, about 4½ ft. high by 6 ft. wide [c.137 × 183], belong for choice of subject and admirable keeping to his chefs-d'oeuvre.[2]

7 and 8. Two other views of Venice, by the same master, may finally be mentioned, in which buildings and figures are on an unusually small scale. These are of a delicacy of keeping and precision of rendering seldom observed in his pictures.[3]

[1] Nos. 1 and 2 are P500 and P496, nos. 3 and 4 are probably P507 and P511, see 1834 above.
[2] P497 and P499.
[3] Presumably P512 and P515, both purchased in 1848.

1859
Evans Invoice

to Making 75 fluted frames for Pictures at Manchester House[1]

A. Canaletto. View in Venice 5 in. wide Measure 11 ft 6 in.
Ditto. View in Venice. the Companion 5 in. wide Measure 11 ft 6 in.
Canaletto. View in Venice 5½ in. wide Measure 13 ft 6 in.
Ditto Ditto 5½ in. wide Measure 13 ft 6 in.
Ditto Ditto 5½ in. wide Measure 13 ft 6 in.
Ditto Ditto 5½ in. wide Measure 13 ft 6 in.
Canaletto. View in Venice 8 in. wide Measure 26 feet
Ditto Ditto the Companion Picture 8 in. wide Measure 26 feet

[1] Evans's fluted frames remain on P492, P495 (pendants), P507, P511 (pendants) and P496 and P500. Of these P492 and P495 agree in size with the first two entries above, while P507, P511, P496 and P500 agree with the next four. The last two entries must refer to P497 and P499, though their frames have since been changed.

1870
Hertford House Inventory (f.18)

Canaletto a pair the Dogana & Grand Canal (in ornamental frames)[1]
Canaletto A Pair Sta Maria Majore & Grand Canal (over doors)[2]
Canaletto Piazza S Marc (Beckfords)[3]
Canaletto A Pair Views on the Canal[4]
Canaletto A Pair the Place St Marc[5]
Canaletto A Back View of the Gd Canal[6]
Canaletto The Doges Palace[7]
Canaletto A Panoramic View of Venice including the Doges Palace[8]
Canaletto St Marks Place Customs house[9]
Canaletto A View of the Rialto the Companion[10]
Canaletto A View of the Grand Canal at Venice during a Carnival[11]
Canaletto A View of St Marks Place during the Carnival[12]
Canaletto A View of the Rialto[13]
Canaletto Another view of the Grand Canal[14]

[1] P512, P515.
[2] P492, P495.
[3] P505.
[4] P506, P510.
[5] P509, P516.
[6] P498.
[7] P514.
[8] Italian School P493.
[9] P499.
[10] P497.
[11] P496.
[12] P500.
[13] P511.
[14] P507.

The only works in the Collection now associated with Canaletto and not in the above list are P501, acquired in 1873, and P513, acquired as a Guardi, probably in 1872. All the listed pictures except P493, and with the addition of P513, were exhibited at Bethnal Green.

The 4th Marquess of Hertford's pictures in London and Paris

Listing only those pictures catalogued in this volume.
Those pictures acquired by the fourth Marquess which do not appear in the Hertford House inventory of 1870 are assumed to have been in Paris.

London
(62 oils, 1 drawing)

Studio of Albani P642
Bonington P270, P273, P341
Canaletto P506, P509, P510, P516
Studio of Canaletto P505
After Canaletto P492, P495, P512 P514, P515
Manner of Canaletto P498
Cima P1
Cooper P309
Denning P765
Domenichino P131
Gainsborough P44
Attributed to Gutiérrez P105
Hilton P633
Italian School P493
Lawrence P558
Luini P8
Meneses P7
Morton P632
Murillo P14, P34, P46, P58, P68, P97, P133
After Murillo P13, P104
Newton P617
Manner of Reni P644
Reynolds P32, P35, P36, P40, P43, P45, P47
Roberts P587
Rosa P116
Sant P602
Andrea del Sarto P9
Sassoferrato P126, P646
Sully P564
Ascribed to Titian P19
After Titian P5, P546
Velázquez P12, P88
Studio of Velázquez P4, P6
After Velázquez P70
Westall P566
Wilkie P352, P357

Paris
(37 oils, 47 drawings)

Achenbach P618
Bonington P322, P323, P333, P339, P351, P362, P375, P656, P657, P668, P672, P674, P675, P676, P678, P679, P684, P688, P696, P698, P700 P701, P704, P708, P714, P726, P727, P732, P733, P734, P749, P750
After Bonington P319
Studio of Bronzino P555
After Cagnacci P643
Callow P746
Cano P15
Derby P709, P713, P725
Dietrich P153
Fielding P690, P691, P715, P716, P718
Guardi P491, P494, P502, P503, P504, P508, P517, P518, P647
J. D. Harding P658
Landseer P257, P373, P589
Lawrence P39, P41
Ascribed to Luini P10
Attributed to Marinari P562
Murillo P3
Attributed to Murillo P136
Nesfield P703
North Italian School P552
Pettenkofen P338
Manner of Pettenkofen P621
Roberts P258, P659, P689, P697,
Sassoferrato P565
Stanfield P343, P667, P712
Turner P651, P654, P661, P664
After Velázquez P100
Winterhalter P669

Sir Richard Wallace and the Tauzia Collection

Amongst the new rooms created by Wallace when he extended Hertford House between 1872 and 1875 were the tiled Smoking Room (now Gallery 4) and the adjoining Sixteenth Century Room (now the northern half of Gallery 3). They were both evidently for his private pleasure, the most remote of the living rooms and the furthest from Lady Wallace's private rooms (now galleries 21–23). The Sixteenth Century Room was the most isolated part of the collection and the only room (excepting the Armouries) completely devoted to 'primitive' art of the fourteenth-sixteenth centuries, a period studiously neglected by the fourth Marquess of Hertford, but appreciated by Wallace. In 1871 he had purchased *en bloc* the huge Nieuwerkerke collection of European arms and armour and medieval and renaissance *objets d'art*, but only one of Nieuwerkerke's surviving invoices refers to a picture (see Tuscan School(?) P542).

There were twenty-three paintings in the Sixteenth Century Room according to the Hertford House inventory of 1890, here quoted with added numbering and present identifications:

1 *An oil painting of a Saint by Andrea del ~~Tagno~~ Castagno in a carved frame* (Benvenuto di Giovanni P543)

2 *Another portrait of a Divine with inscription 1543* (After Ph. de Champaigne P645)

3 *A small oil painting Virgin and Child on panel* (After the Master of the Magdalen Legend P548)

4 *An oil painting on panel Virgin and Child and 2 saints by ~~Lippo Memmi~~* (Francesco di Vannuccio P550)

5 *Another Venus in a Chariot by ~~Piero di Cosimo~~ in a carved and gilded frame* (Master of Santo Spirito P556)

6 *An oil painting Crowning of the Virgin by Lo Spagna* (Ascribed to Lo Spagna P545)

7 *A small oil painting the Nativity in ebony frame and metal mounts* (Workshop of Daddi P549)

8 *An oil painting Judith with the head of Holofernes by Beggafumi* (Follower of Beccafumi P525)

9 *Another portrait of a Cardinal by Giuliano Pesello carved frame* (Ferrarese School(?) P539)

10 *Infant Bacchus by Bernardino Luini* (Luini P526)

11 *The Virgin in a red dress in a Black & gilt frame* (Umbrian School P540)

12 *Holy Family no name* (Florentine School P553)

13 *A Fresco Boy reading ~~Sforza Visconti~~ in a black and gilt frame* (Foppa P538)

14 *A Landscape two nude figures 1 asleep by Ercole Grandi* (Attributed to Bertucci P2)

15 *A Head of a Woman by B. Luini* (Luini P537)

16 *A diptich an oil painting by Girolamo Bonaglio* (Cremonese School P536)

17 *An oil painting half length Portrait of a man in black dress – Venetian school* (North Italian School P541)

18 *Oil painting head of a girl B. Luini* (Milanese School P544)

19 *Portrait of a man Holbein School in a gilt frame* (Flemish School P529)

20 *Portrait of a Saint by Carlo Crivelli in gilt frame* (Crivelli P527)

21 *An oil painting portrait of Francis Ist* (After Joos van Cleve P551)

22 *A saint with a drawn sword by T. Stuerbout* (Memlinc P528)

23 *A circular painting Virgin and Child by Ghirlandaio in circular gilt frame* (Florentine School(?) P768)

Sir Richard Wallace's Sixteenth Century Room in Hertford House, c.1890, looking north (now gallery 3 in the Wallace Collection).

Key: nos. refer to the 1890 inventory as quoted on the facing page.

Three stylistic groups of paintings may be distinguished: three North European portraits (nos.2, 19 and 21), two Netherlandish primitives (nos.3 and 22) and eighteen fourteenth-sixteenth-century Italian paintings, five of which are fresco fragments (nos.10, 11, 13, 15 and 18). No.21 may be identified as *'Holbein A Portrait of Francis Ist'* in the Dorchester House inventory of 1842, and previous editions of this catalogue record that no.8 was bought from the vicomte Both de Tauzia by Wallace in 1872. Nos.5 and 13 were also recorded as having once formed part of the Tauzia collection, together with the drawing after Antonio del Pollaiuolo (P762) which hung in Wallace's study alongside drawings by Courtois (P769), Hondius (P771), Maratta (P774), Polidoro da Caravaggio (P775) and of the Italian School (P776), whose provenances have remained unestablished. Another drawing, by Ingres after Raphael (P767), hung in the Sixteenth Century Room.

The vicomte Both de Tauzia (1823–88) was, like Nieuwerkerke, of Dutch descent, an ardent Royalist, a museum official and a collector. Unlike Nieuwerkerke he was a withdrawn and diffident scholar, beginning his career at the Louvre in 1858 as *expéditionnaire* and ending it as *conservateur* of paintings and drawings from 1874 until his death. He was noted for his connoisseurship of old master drawings and between 1879 and 1888 he published three *suppléments* to the Louvre catalogue of drawings, having previously compiled two *suppléments* to the catalogue of paintings in 1877–8. Under the guidance of his close friend Louis, comte d'Armaillé (1823–82), he had first formed a private collection of chinoiserie, terra-cottas, bronzes and eighteenth-century porcelain figures, but he subsequently turned to Italian renaissance paintings and miniatures (i.e. illuminated manuscript cuttings). This change may have been induced by two surveys he undertook for the Louvre of fourteenth- and fifteenth-century Italian paintings in Germany and Italy.[1] Tauzia travelled frequently in Italy, buying modestly for himself and concluding purchases for the Louvre – such as that of six fresco fragments by Luini from the estate of the Duca Litta-Arese-Visconti in Milan in 1867. His private collection was later described by Chennevières[2] as being housed

> 'in the rue Jean-Goujon … the walls were covered with works which the richest amateur would have envied. At this distance of time I can only recall a stucco fragment from Prato showing a group of children by Donatello, a very fine early-sixteenth-century Italian fresco of a seated child writing, some cassone panels of the Florentine and Ferrarese schools, the vigorous little figure of a Saint by Crivelli, some charming fragments of the Sienese school, a fine drawing by Pollaiuolo, some enchanting little frescoes by Luini, some fine Florentine bronzes and, above all, some exceedingly fine and rich pages by the best Italian and French miniaturists in their finest manner.'

Chennevières then added that this collection, having grown too large for Tauzia's private enjoyment, was sold to Sir Richard Wallace through the agency of the comte d'Armaillé 'who had it sent to London in cases which were feared lost in the crossing'.

From this description no.13 in the 1890 inventory may be identified as the 'very fine early-sixteenth-century Italian fresco of a seated child writing', nos.5, 14(?) and 23(?) as 'cassone panels of the Florentine and Ferrarese schools', no.20 as 'the vigorous little figure of a Saint by Crivelli', nos.1 and 4 as 'charming fragments of the Sienese school', nos.10, 15 and 18 as 'enchanting little frescoes by Luini', while the Pollaiuolo drawing (P762) in Wallace's study was evidently that described as 'fine'. Several of these paintings are marked on the *verso* with a cursive *Nº* followed by an arabic numeral, and so are nos.6, 11 and 12 in the 1890 list. No.8 was already known to have been bought from Tauzia in 1872, and thus fourteen of Wallace's eighteen Italian primitives may

reasonably be associated with Tauzia. Given the consistently modest character of the remaining four (nos. 7, 9, 16 and 17) it would seem highly probable that they came from the same source, together with those other old master drawings in Wallace's study. Of the other items described by Chennevières, the stucco fragment by Donatello is now either s4 or s5 (currently catalogued as squeezes from his *Pulpito della Madonna della Cintola*), while the 'fine and rich pages by the best Italian and French miniaturists' are those cuttings now displayed in gallery 3 and recently catalogued by Dr. J. J. G. Alexander.

There seems no reason to dispute the date of 1872 previously given for the purchase of the 'Beccafumi' P525 by Wallace from Tauzia, and this was, it may be supposed, the date when he purchased the Tauzia collection. Between September 1870 and September 1871 Tauzia had been in Brest tending the Louvre's evacuated pictures during the political upheaval in Paris; in the course of that chaotic year he was exiled, dismissed, re-instated and promoted, and it would be understandable if, after such an experience, he had then decided to realize some of his fixed assets. Wallace must have bought the collection in Paris where he lived until March 1872 when he moved to London and began the modification of Hertford House (and the creation of his Sixteenth Century Room, already described). Although he kept up his residences in the rue Laffitte and Bagatelle in the Bois de Boulogne, it would seem likely that he had made the purchase before settling in London. In May 1872 he made a payment of £360 to d'Armaillé, conceivably in connection with the sale.[3] None of the Tauzia pictures was exhibited at Bethnal Green, but that does not necessarily mean that they were acquired after that date; a number of cases containing works of art arrived at the Bethnal Green Museum from Paris in April and May 1872 which were sent on to Wallace unopened.[4]

[1] MSS. preserved in the archives du Louvre. A survey dated December 1863 lists fourteenth- and fifteenth-century Italian paintings in Milan, Parma, Ferrara, Ravenna, Rimini, Urbino, Gubbio, Assisi and Rome; another (undated) lists early German and Italian paintings in Stuttgart, Augsburg, Nuremberg, Dresden, Prague, Vienna, Venice, Treviso, Padua, Brescia and Florence. I am grateful to Suzanne Gaynor for this information.
[2] Ph. de Chennevières, *Souvenirs d'un Directeur des Beaux-Arts*, 1979 ed., v, p.40 n.1; pp.34–83 contain an essay on Tauzia. The *Souvenirs* originally appeared in *L'Artiste*, November/December 1888, immediately after Tauzia's death. For Tauzia see also C. Euphrussi, *Gazette des Beaux-Arts*, 2e, XXXIII, 1888, pp.158–60, and J. J. Marquet de Vasselot, *Répertoire des catalogues du musée du Louvre*, 1917, p.151.

[3] Extracts from Wallace's London bank account are copied in the Wallace Collection archives. D'Armaillé had been a close friend of the fourth Marquess of Hertford, as well as of Tauzia and Wallace (with whom he stayed at Sudbourne in the 1870s).
[4] The 1872 Bethnal Green Museum Van Book, preserved at the Museum, records eleven cases arriving from Paris on 27 April and returned to Wallace on 31 May (identified as 'Furniture' on arrival); two boxes of miniatures from Paris, marked 'not to be opened', arrived on 27 May. I am grateful to Anthony Burton for allowing me to inspect this register.

British, German, Italian and Spanish Pictures formerly in the Hertford-Wallace Collections

Compiled from the inventories of Hertford House, St. Dunstan's Villa, Dorchester House, Bagatelle and 2 rue Laffitte and from sale records, listing those pictures which may be usefully identified and which did not form part of Lady Wallace's bequest to the Nation in 1897 (see Introduction). The majority were left to her residuary legatee, Sir John Murray Scott (1843-1912), who also received the Paris properties, 2 rue Laffitte and Bagatelle. Pictures in the Murray Scott sale 1913 not identifiable in earlier inventories have been omitted. Dates are given only for those artists not represented in the preceding catalogue.

Abbreviations

In addition to the Abbreviations on pp. 13–15.

rue Laffitte 1912	*inventaire après décès* of the possessions of Sir John Murray Scott found at 2 rue Laffitte, Paris, 16 February 1912 ff., P. Robineau *notaire* (typescript in Wallace Collection archives)
Murray Scott 1903	inventory of 5 Connaught Place, London, W1, 1903; the London residence of Sir John Murray Scott (Wallace Collection archives)
Murray Scott sale 1913	Christie's, 27 June 1913, 153 lots; following his death, Murray Scott's Executors sold a number of his pictures from Connaught Place
Scott sale 1933	By direction of Miss M. K. T. Scott, sister of the late Sir John Murray Scott; Nether Swell Manor, Stow-in-the-Wold, Gloucestershire; Willis's, 15 April 1933
Scott sale 1942	By direction of Miss M. K. T. Scott (see above); Willis's, 27 August 1942, lots 101–32
Scott sale 1943	By direction of the Executors of the late Miss M. K. T. Scott (see above); Willis's, 15 April 1943, lots 91–100

1 ALBANI — *Diana and Actaeon*, 99 × 86; Hope sale, Christie's, 29 June 1816(72), bt. by the 3rd Marquess of Hertford; Dorchester House 1842; Hertford House 1870, 1890; Murray Scott 1903

2 ALBANI — *A Woman and Cupid*; Hertford House 1870

3 ALBANI — *A Landscape and Figures*; Hertford House 1870

4 ANDREWS, H. (d. 1868) — *A Fête Champêtre*, 60 × 146; Hertford House 1890; Murray Scott sale, Christie's, 27 June 1913(46), bt. Agnew, 70 gn.

5 BAXTER, C. (1809–79) — *Lucy Locket/Girl with clasped hands*, 53 × 41; Hertford House 1870, 1890; Bethnal Green 1872–5(37); Ipswich 1880(47). Murray Scott 1903

6 BEAUMONT, SIR G. (1753–1827) — *Conway Castle*, the figures by Wilkie, 51 × 65; Rogers sale, Christie's, 3 May 1856(526), bt. for the 4th Marquess of Hertford; Hertford House 1870, 1890; exh. Bethnal Green 1872–5(25, or no.7 below); Ipswich 1880(20). Murray Scott sale, Christie's, 27 June 1913(47), bt. Newton, 20 gn.

7 BEAUMONT — *Conway Castle*, 27 × 20; Christie's, 5 July 1849(16), bt. by the 4th Marquess of Hertford; Hertford House 1870, 1890; exh. Ipswich 1880(23). Murray Scott sale, Christie's, 27 June 1913(48), bt. Ross, 8 gn.

8 BLAKE, B. (1788–c.1830) — *Dead Hare*, panel 18 × 13; probably the *Dead Hare* attributed to Elmer in Dorchester House 1842; Hertford House 1870, 1890; Murray Scott sale, Christie's, 27 June 1913(49), bt. Newton 8 gn.

9 BLAKE — *Tigress and Cubs*, panel 18 × 13; probably the *Lioness and Cubs* attributed to Stubbs in Dorchester House 1842; Hertford House 1870, 1890; Murray Scott sale, Christie's, 27 June 1913(49), bt. Newton, 8 gn.

10 BONINGTON — *Self-portrait*, water-colour 19 × 12; Villot sale, Paris, 25 January 1864(60), bt. by the 4th Marquess of Hertford and given to Sir Richard Wallace
National Portrait Gallery, London (no.1729)

11 BONINGTON — *The Doge's Palace from the Piazzetta*, water-colour 19 × 24; exh. Bethnal Green 1874–5 (708); Belfast 1876 (64, 74 or 103). Murray Scott 1903; Murray Scott sale, Christie's, 27 June 1913(1), bt. Agnew, 400 gn.
City Art Gallery, Manchester

12 BONINGTON — *The Staircase*, water-colour 20 × 15; Hertford House 1890; Murray Scott sale, Christie's, 27 June 1913(2), bt. Arnold & Tripp, 70 gn.
Whitworth Art Gallery, University of Manchester

13 BONINGTON — *Landscape with Figures returning from the Vintage; sunset*, water-colour 15 × 20; exh. Bethnal Green 1872–5(605). Murray Scott sale, Christie's, 27 June 1913(3), bt. Agnew, 160 gn.

14 BUCKNER, R. (fl.1820–77) — *Mrs. Thistlethwaite*, 211 × 119; Hertford House 1870, 1890; Murray Scott sale, Christie's, 27 June 1913(52), bt. F. C. Harper (son of H. A. Harper), 55 gn.

15 BUCKNER — *Portrait of a Lady*, water-colour; Bagatelle 1871; rue Laffitte 1912

16 CALLOW — *A Dutch River Scene*, water-colour 17.8 × 25.4; Hertford House 1890; Murray Scott sale, Christie's, 27 June 1913(4), bt. Worsley, 32 gn.

17 CAMPIDOGLIO, M.di (1610–70) — *Italian Girl with fruit*, 119 × 160; Hertford House 1890; Murray Scott sale, Christie's, 27 June 1913(54), bt. Leggatt, 40 gn.

18 CARRACCI, ANNIBALE (1560–1609) — *Clytie*, 46 diameter; Wells sale, Christie's, 12 May 1848(48), bt. by the 4th Marquess of Hertford; Hertford House 1870
Cincinnati Art Museum, Ohio (no.1952.199)

CARRIERA, see ROSALBA
19 DENNING — *The Topers*, after Ostade; Hertford House 1890; Murray Scott 1903

20 DENNING — *Venus and Cupid*, after Rubens; Hertford House 1890; Murray Scott 1903

21 DRUMMOND, S. (?1770–1844) — *Battle Piece*; probably the unattributed *Battle Piece* in Hertford House 1834 and 1846; Hertford House 1870

22 ETTY, W. (1787–1849) — *The Bath*, panel 66 × 51; Dorchester House 1842; Hertford House 1890; exh. Ipswich 1880(42). Murray Scott 1903

23 FOWLES, A. W. (fl.1850–78) — *HMS Thunderer/The Old and New Navy*, 91 × 51, dated 1878; Hertford House 1890; exh. Ipswich 1880(43); Murray Scott 1903

24 FOWLES — eight *marines*; rue Laffitte 1912

25 FRITH, W. P. (1819–1909) — *Anne Page carrying a tray with wine*, 46 × 38; possibly RA 1854(270) and Christie's, 30 March 1855(58); Hertford House 1870, 1890; exh. Bethnal Green 1872–5(36); Ipswich 1880(53). Presented by Lady Wallace to the Duke of York

26 GAINSBOROUGH — *Charity relieving Distress*, 102 × 76 (originally 127 × 101); Christie's, 22 March 1803(29), bt. by the 2nd Marquess of Hertford; Hertford House 1834, 1843, 1846, 1870
Private collection (Waterhouse 1958, no.988)

27 GIORGIONE (fl.1506–10) — *Musical Party*; Christie's, 28 March 1819(90), bt. by the 3rd Marquess of Hertford; Dorchester House 1842; probably *The Song*, a group of four figures, 31 × 25, attributed to Titian in Hertford House 1870, 1890; Murray Scott 1903

28 GIORGIONE — *Gentleman with a flute*; Dorchester House 1842; Hertford House 1870

29 GRANT, F. (1810–78) — *Countess Zichy*; St. Dunstan's 1842 and sale, Phillips, 9 July 1855(124); possibly now in the National Gallery of Art Washington (no.2347, as *A Lady* by a follower of Lawrence)

30 GRANT — *Count d'Orsay on horseback*, 31 × 24; Gore House sale, 5th day, 15 May 1849(1014 or 1048), bt. for the 4th Marquess of Hertford; Hertford House 1890; exh. Bethnal Green 1872–5(33); Ipswich 1880(21). Murray Scott sale, Christie's, 27 June 1913(69), bt. Arnold & Tripp, 65 gn.

31 GUARDI — A pair: *Piazza S. Marco* and *The Piazzetta*; rue Laffitte 1912 Probably Musée Camondo, Paris (MP348 or figs.920 and 921, as Giacomo Guardi)

32 GUARDI — A pair: *Views of Venice*; rue Laffitte 1912 Mme. Soucaret, Paris, in 1914

33 HAMILTON, H. D. (c.1739–1808) — *George Selwyn*, crayon 24 × 19 oval; Hertford House 1890; Murray Scott sale, Christie's, 27 June 1913(104), bt. Newton, 10 gn.

34 HARPER — Two water-colours: *Constantinople* and *Smyrna*, dated 1872; bt. by Sir Richard Wallace 1873; Hertford House 1890; Scott sale, 22 March 1933(201)

35 HARPER — Two large water-colours of Jerusalem; bt. by Sir Richard Wallace 1874; Hertford House 1890; Scott sale, 22 March 1933(217)

36 HARPER — *An Eastern Smoker* 1872, water-colour; bt. by Sir Richard Wallace 1878; Murray Scott sale, Christie's 27 June 1913(24), bt. Jones bros., $4\frac{1}{2}$ gn. (shared lot)

37 HAYMAN, F. (1708–76) — *Repose in Egypt;* sold by the 3rd Marquess of Hertford, Christie's, 3 June 1825(27), bt. in

38 HUNT, W. H. (1790–1864) — *Girl sleeping*, water-colour; Christie's, 29 June 1858(20), bt. for the 4th Marquess of Hertford

39 LAWRENCE — *The 3rd Marquess of Hertford*, 127 × 101; Hertford House 1834, 1843, 1870, 1890; Murray Scott sale, Christie's, 27 June 1913(109), bt. Hodgkins, 380 gn. National Gallery of Art, Washington (no.2348)

40 LAWRENCE — *Lady* in yellow dress with red scarf; Hertford House 1834, 1870

41 LAWRENCE — *J. W. Croker*, panel 75 × 63; St Dunstan's 1842 and sale, Phillips, 9 July 1855(123) National Gallery of Ireland, Dublin (no.300)

42 LELY — *Charles II in armour*; presented to the 2nd Marquess of Hertford by the Prince of Wales 1810; Hertford House 1834, 1846; Ragley

43 LEWIS, J. F. (1805–76) — *La Cigarana*, water-colour; Christie's, 29 June 1858(16), bt. for the 4th Marquess of Hertford; rue Laffitte 1912

44 LUCAS, W. (fl. 1840–95) — *Peasant Girl drawing water* 1866: Hertford House 1890; Murray Scott 1903

45 McCLOY, S. (1831–1904) — *The Shelter* and four drawings; Hertford House 1890. *Irish Festival* exh. Belfast 1876(5); *Girl in a pink dress* with Murray Scott 1903

46 MARIESCHI, M. (1696–1743) — *A Scene in Venice*, 61 × 43; Hertford House 1890; Murray Scott 1903

47 MORLAND — A pair of *landscapes with goats*; Hertford House 1834, 1870; Ragley

48 MORLAND — *Coast Scene with Fisherman* 1794; Hertford House 1834, 1843, 1846, 1870; Ragley

49 MORTIMER, J. H. (1740–79) — *Cromwell*; St. Dunstan's 1842

50 MURILLO — *The Assumption of the Virgin*, 51 × 41; Hertford House 1890; Murray Scott sale, Christie's, 27 June 1913(110), bt. Jones bros., 12 gn.

51 NOBLE, J. S. (1848–96) — *Dogs* 1879/*Welcome Rest*; probably RA 1879(217); exh. Ipswich 1880(37). Scott sale, 27 August 1942(106)

OCHIALI, — see VANVITELLI

52 PARET, L.
(1746–99)

A View of Palermo/Fête in a Town 1773, panel 78 × 85; Hertford House 1890; exh. Bethnal Green 1872–5(309a). Murray Scott sale, Christie's, 27 June 1913(111), bt. Hodgkins, 660 gn.

53 POTTER W.

Two nude studies: *Girl at a mirror* 1867 and *Girl with a perroquet* 1867; Hertford House 1890

54 PROUT, S.
(1783–1852)

Scene in Rouen, water-colour 42 × 26; Christie's, 30 April 1863(247), bt. for the 4th Marquess of Hertford; Hertford House 1890; exh. Bethnal Green 1872–5(648). Murray Scott sale, Christie's, 27 June 1913(5, as *Market Place, Ghent*), bt. Agnew, 46 gn.

55 RAMSAY

A pair of whole-length portraits: *George III* and *Queen Charlotte*; Hertford House 1834; St. Dunstan's 1842, 1843; Hertford House 1870; Ragley

56 RAPHAEL, after

Madonna and Child, drawing in red chalk; Bagatelle 1871; Hertford House 1890; Scott sale, 27 August 1942(123)

57 RENI

Virgin and Child; Christie's, 9 March 1811(26), bt. by the 3rd Marquess of Hertford; Dorchester House 1842

58 REYNOLDS

The 1st Marquess of Hertford, 76 × 63; Hertford House 1834, 1870; Ragley

59 REYNOLDS

George Seymour Conway, 61 × 45; Hertford House 1834, 1843, 1846, 1870; Ragley; Christie's, 27 March 1981(150)

60 REYNOLDS

Lord Henry Seymour, 76 × 63; Hertford House 1834; possibly Dorchester House 1842; Hertford House 1843, 1846, 1870; Ragley

61 REYNOLDS

A Son of the 1st Marquess of Hertford in van Dyck dress, 61 × 46; Hertford House 1834, 1843, 1846, 1870; Ragley

62 REYNOLDS

A Son of the 1st Marquess of Hertford in blue, 61 × 46; Hertford House 1834, 1870; Ragley

63 REYNOLDS

The 2nd Marquess of Hertford, 127 × 101; Hertford House 1834, 1846, 1870; Ragley

64 REYNOLDS

Lady William Gordon, 61 × 46; St Dunstan's 1842; Ragley sale, Christie's, 1 July 1921(137)

65 REYNOLDS

Miss Esther Jacobs, 91 × 71; Greenwood's, 15 April 1796(14), bt. by the 2nd Marquess of Hertford; Hertford House 1834, 1843, 1870; exh. RA 1872(50)
Toledo Museum of Art (no.53.42)

66 REYNOLDS

The 2nd Earl of Northington, 125 × 100; Hertford House 1834, 1846, 1870; Christie's, 2 June 1883(98)
National Gallery of Ireland, Dublin (no.217)

67 REYNOLDS

Mrs. Robinson, 76 × 63; Greenwood's, 16 April 1796(9), bt. by the 2nd Marquess of Hertford; Hertford House 1834, 1842, 1843, 1870; Ragley, sold c.1894
Waddesdon Manor

68 REYNOLDS

Mrs. Robinson, 60 × 47; Hertford House 1834, 1843, 1870; exh. Guildhall 1890(105)

69 REYNOLDS

Horace Walpole, 127 × 101; painted for the 1st Marquess of Hertford 1757; Hertford House 1834, 1870; Ragley

70 REYNOLDS

The Snake in the Grass, oval; Phillips, 23 April 1850(81), bt. by the 4th Marquess of Hertford; Hertford House 1870; Scott sale, 15 April 1943(91)

71 ROBERTS

Mosque in Cairo, water-colour 20 × 15; Christie's, 30 April 1863(121), bt. for the 4th Marquess of Hertford; Hertford House 1890; exh. Bethnal Green 1872–5(620); Belfast 1876(92). Murray Scott 1903

72	ROBERTS	*Louvain, hôtel de ville*, water-colour; Christie's, 30 April 1863(119), bt. for the 4th Marquess of Hertford; Hertford House 1890; exh. Bethnal Green 1872–5(606); Belfast 1876(94)
73	ROLFE, W. J. (fl. 1845–89)	*The Signal*, 74 × 61; Hertford House 1890; Murray Scott 1903
74	ROMNEY	*Lady Hamilton as the Tragic Muse* 1792, 122 × 158; given to the 2nd Marquess of Hertford by the Prince of Wales 1810; Christie's, 1 May 1875(92)
75	ROMNEY	*Lady Hamilton as the Comic Muse* 1792, 118 × 147; given to the 2nd Marquess of Hertford by the Prince of Wales 1810; Christie's, 1 May 1875(93)
76	ROSALBA CARRIERA (1675–1757)	A pair: *Cupid* and *Flora*, pastels; Hertford House 1834, 1843, 1846, 1870; Christie's, 1 May 1875(94)
77	SCHIDONE, B. (1578–1615)	*Holy Family*; Phillips, 23 April 1850(51); Hertford House 1870
78	SCHLOESSER, H. J. (1832–94)	*Tourist carriage accident at Sorrento* 1878; bt. by Sir Richard Wallace 1878; Hertford House 1890; exh. Ipswich 1880(51). Murray Scott sale, Christie's, 27 June 1913(84), bt. Sampson, 11 gn.
79	SCOTT, S. (c.1702–72)	*View of Old London Bridge*; St. Dunstan's 1842
80	STANFIELD	*Shipping off a jetty*, water-colour; Christie's, 29 June 1858(27), bt. for the 4th Marquess of Hertford; Murray Scott sale, Christie's, 27 June 1913(6), bt. Bowden, 3gn. (with no.88)
81	STONE, F. (fl. 1837–60)	*After the Masquerade*, 48 × 41; Hertford House 1870, 1890; exh. Bethnal Green 1872–5(39); Ipswich 1880(64). Scott sale, 22 March 1933(222)
82	STONE	*The Mussel Gatherer/Boulogne Fisher Girl*, 51 × 38; Foster's, 4 April 1855(111), bt. by the 4th Marquess of Herford; Hertford House 1870, 1890; exh. Bethnal Green 1872–5(38); Ipswich 1880(60) Scott sale, 15 April 1943(92)
83	TITIAN, after	*Holy Family*; Hertford House 1890
84	TITIAN	*Venus reclining* and *Jupiter and Io*, probably small copies; Dorchester House 1842 see GIORGIONE no.27
85	ULLETT	*Lady* with black hair and a red scarf 1841, water-colour; Hertford House 1890; Murray Scott 1903
86	VANVITELLI, G. (1647–1736)	*Royal Palace at Naples*; St. Dunstan's 1842 and sale, Phillips, 9 July 1855(128)
87	VERONESE, P. (1528–88)	*S. Helena*, 197 × 116; Christie's, 2 March 1816(109), bt. by the 3rd Marquess of Hertford; St. Dunstan's 1842 and sale, Phillips, 9 July 1855(118) National Gallery, London (no.1041)
88	WESTALL	*Il Penserosa*, drawing; Christie's, 26 March 1859(3), bt. for the 4th Marquess of Hertford; possibly Murray Scott sale, Christie's, 27 June 1913(6, as *Ophelia*). see no.80
89	WILKIN, F. W. (d.1843)	*2nd Marquess of Hertford*, drawing; Hertford House 1834, 1870
90	ZURBARAN, F. (1598–1664)	*S. Blaise*, 89 × 30; Soult sale, Christie's, 19–22 May 1852(37), bt. by the 4th Marquess of Hertford Pelesh Castle, Sinai, Romania

Indices

Attributions changed from the 1968 Catalogue and the 1979 Summary Illustrated Catalogue

Previous attribution	no.	Present attribution
ALBANI	P642	Studio of ALBANI
BARTOLOMMEO Veneto	P541	NORTH ITALIAN School
BECCAFUMI	P525	Follower of BECCAFUMI
BIANCHI Ferrari	P2	Attributed to BERTUCCI
After BILIVERT	P643	After CAGNACCI
BONINGTON	P319	After BONINGTON
BONSIGNORI	P539	FERRARESE School (?)
School of BOUCHER	P776	ITALIAN School (?)
BRONZINO	P555	Studio of BRONZINO
CANALETTO	P492	After CANALETTO
CANALETTO	P496	Studio of CANALETTO
CANALETTO	P514	After CANALETTO
Studio of CANALETTO	P506	CANALETTO
Studio of CANALETTO	P510	CANALETTO
DADDI	P549	Workshop of DADDI
DOLCI	P562	Attributed to MARINARI
FERRARESE School	P536	CREMONESE School
FLEMISH School	P534	Attributed to van der MEULEN
FLORENTINE School	P556	MASTER OF SANTO SPIRITO
LUINI	P10	Ascribed to LUINI
MURILLO	P105	Attributed to GUTIERREZ
School of MURILLO	P7	MENESES
School of MURILLO	P104	After MURILLO
School of MURILLO	P133	MURILLO
School of MURILLO	P136	Attributed to MURILLO
NORTH ITALIAN School	P542	TUSCAN School(?)
School of PARMA	P552	NORTH ITALIAN School
RAMSAY	P560	Studio of RAMSAY
ROMAN School	P553	FLORENTINE School
Lo SPAGNA	P545	Ascribed to Lo SPAGNA
TITIAN	P19	Ascribed to TITIAN
VELAZQUEZ	P6	Studio of VELAZQUEZ
After VELAZQUEZ	P4	Studio of VELAZQUEZ
VENETIAN School	P498	Manner of CANALETTO
VENETIAN School	P513	After CANALETTO
F. X. WINTERHALTER	P669	H. WINTERHALTER

Subject Index

Religious

Adoration of the Shepherds:
 Murillo P34

Annunciation:
 Cremonese School P536
 Murillo P68
 Umbrian School P540

Assumption of the Virgin:
 Attributed to Gutiérrez P105

Circumcision:
 Dietrich P153

Holofernes, see Judith

Holy Family:
 Florentine School P553
 Murillo P58
 North Italian School P552

Joseph and his Brethren:
 Murillo P46

Judith and Holofernes:
 Follower of Beccafumi P525

Marriage of the Virgin:
 Murillo P14

Nativity:
 Workshop of Daddi P549

S. Anthony of Padua:
 Cima P1a

S. Bonaventure:
 Maratta P774

S. Catherine of Alexandria:
 Cima P1
 Attributed to Marinari P562
 Sassoferrato P646

S. Eulalia:
 Maratta P774

S. Francis:
 Cima P1a
 Murillo P3
 Andrea del Sarto P9

S. Jerome:
 Benvenuto di Giovanni P543

S. John the Baptist:
 Francesco di Vannuccio P550
 Murillo P3
 Murillo P58
 Manner of Reni P644
 Reynolds P48
 Andrea del Sarto P9

S. John the Evangelist:
 Cano P15
 Attributed to Gutiérrez P105

S. Justa:
 Murillo P3

S. Mary Magdalene:
 Ascribed to Lo Spagna P545

S. Peter:
 Francesco di Vannuccio P550

S. Roch:
 Crivelli P527

S. Rose of Viterbo:
 After Murillo P104

S. Rufina:
 Murillo P3

S. Thomas of Villanueva:
 Murillo P97

Virgin of the Assumption:
 Meneses P7

Virgin of Mercy:
 Maratta P774

Virgin and Child:
 Cima P1a
 Florentine School (?) P768
 Francesco di Vannuccio P550
 Luini P8
 Ascribed to Luini P10
 Murillo P3
 Murillo P133
 Attributed to Murillo P136
 After Murillo P13
 After Murillo P104
 Manner of Reni P644
 Andrea del Sarto P9
 Sassoferrato P126
 Sassoferrato P565
 Sassoferrato P646

NOTE
Literary sources, in author order, are as follows:
Anacreon, *Odes* (Ascribed to Titian P19)
Arabian Nights (Bonington P657)
B., M. L., *Mémorial pittoresque de la France* (Bonington P351, P733)
Boccaccio, *The Decameron* (Westall P566)
Dumesnil, *Histoire de Don Juan d'Autriche* (Bonington P323)
Livy, *The Histories* (After Cagnacci P643)
Longus, *Daphnis and Chloe* (Attributed to Bertucci P2)
Ovid, *Metamorphoses* (Rosa P116, Titian P11, After Titian P5 and P546)
Plutarch, *Lives* (Foppa P538)
Ramsay, *The Gentle Shepherd* (Wilkie P352)
Shakespeare, *The Merry Wives of Windsor* (Bonington P333)
Spenser, *The Faerie Queen* (Hilton P633)
Surrey, *Poems* (Bonington P675)
Virgil, *The Aeneid* (?After Pollaiuolo P762)

Topographical Subjects

Lebanon
Baalbec:
 Roberts P680

Malta
Valletta:
 Italian School P493

Morocco
Tetuan:
 Roberts P697

Scotland
Highland Scene:
 Landseer P373

Kilchurn Castle, Strathclyde:
 Nesfield P703

Loch Awe, Strathclyde:
 Nesfield P703

Loch Katrine, Central Region:
 Fielding P716

Spain
Granada; Cathedral:
 Roberts P587

Madrid; Buen Retiro Palace:
 Studio of Velázquez P6

Santiago; Cathedral:
 Roberts P659

Wales
Traeth Mawr, Gwynedd:
 Fielding P718

Index of previous Owners
Names in quotation marks are those of sale-room agents

Bonington sale, 23–4 May 1834:
Bonington P323, P657(?)

Bonnemaison, F.:
Murillo P34
Andrea del Sarto P9

Boursault, J.-F.:
Murillo P34

Bowles:
Reynolds P36

Brackenbury, Sir John:
Meneses P7

Braddyll:
Reynolds P47

Braine, G. T.:
After Titian P5

Bridgewater, 3rd Duke of:
Domenichino P131
Titian P11
Ascribed to Titian P19

Brown, Lewis, sale 17–18 April 1837:
Bonington P656(?), P668, P672, P688, P698,
P700(?), P708, P714(?), P727, P733, P749,
P750

Brown sale, 12–13 March 1839:
Bonington P322, P674, P684(?), P701, P727

Brown sale, 7 March 1843:
Bonington P656, P684(?), P696, P700, P704,
P726, P727, P732, P750
Stanfield P667, P712(?)

Bryan, M.:
Domenichino P131
Titian P11
Ascribed to Titian P19
After Titian P5

Buchanan, W.:
Murillo P34, P46, P97
After Titian P5

Buckingham, Dukes of:
Denning P765
Domenichino P131
Attributed to Gutiérrez P105

Bucknall, W.:
Reynolds P32

'Burgess':
After Murillo P13

Buscot Park:
Manner of Canaletto P498

Carlisle, 5th Earl of:
Domenichino P131
Titian P11
Ascribed to Titian P19

Carnac, Sir James Rivett:
Reynolds P35

Carpenter, J.:
Bonington P726

Casanova of Madrid:
Meneses P7

Catellan, Mme. de:
After Cagnacci P643

Cave, W.:
Murillo P46

'Caw':
Sully P564

Champernowne, A.:
Murillo P34
Andrea del Sarto P9

Champion, W.:
After Titian P5

Châteauneuf, marquis de:
Titian P11

Chigi-Albani, Prince Sigismondo:
Follower of Beccafumi P525

Choiseul-Praslin, duc de:
Attributed to Marinari P562

Christina of Sweden:
Maratta P774(?)

Clarke, Sir Simon:
Ascribed to Titian P19

Collot, J.-P.:
Bonington P362

Conyngham, Marquesses:
Lawrence P559

'Cottley':
Bonington P375

Coutan, A.-P.:
Bonington P351, P657(?), P733

'Cribb':
Reynolds P45

Crozat, P.:
Maratta P774
Polidoro da Caravaggio P775(?)

'Davidson':
Ascribed to Titian P19

Delessert, baron:
Bonington P322

Demidoff, Anatole, sale 13–16 January 1863:
Bonington P672, P698, P701, P708, P714
Pettenkofen P338
Roberts P689

Demidoff, Anatole, sale, 21 February 1870:
Bonington P351

457

Numerical Index

459

644 Manner of RENI
646 SASSOFERRATO
647 GUARDI
651 TURNER
654 TURNER
656 BONINGTON
657 BONINGTON
658 J. D. HARDING
659 ROBERTS
661 TURNER
664 TURNER
667 STANFIELD
668 BONINGTON
669 WINTERHALTER
672 BONINGTON
674 BONINGTON
675 BONINGTON
676 BONINGTON
678 BONINGTON
679 BONINGTON
680 ROBERTS
684 BONINGTON
688 BONINGTON
689 ROBERTS
690 FIELDING
691 FIELDING
694 HARPER
695 HARPER
696 BONINGTON
697 ROBERTS
698 BONINGTON
700 BONINGTON
701 BONINGTON
703 NESFIELD
704 BONINGTON
708 BONINGTON
709 DERBY
712 STANFIELD
713 DERBY
714 BONINGTON
715 FIELDING
716 FIELDING
718 FIELDING
725 DERBY
726 BONINGTON
727 BONINGTON
732 BONINGTON
733 BONINGTON
734 BONINGTON
746 CALLOW
749 BONINGTON

750 BONINGTON
751 DOWNMAN
752 DOWNMAN
753 DOWNMAN
754 DOWNMAN
757 WESTALL
762 After POLLAIUOLO
765 DENNING
768 FLORENTINE School(?)
770 S. HARDING
774 MARATTA
775 POLIDORO da Caravaggio
776 ITALIAN School(?)

NOTE

These numbers (prefixed by the letter P for picture) were allocated according to the sequence of pictures exhibited when the Wallace Collection opened in 1900. The numbers appearing in this catalogue were then displayed as follows:

Number	Location
1–101	gallery 19
102–42	gallery 20
143–208	gallery 16
257–376	galleries 17 & 18
491–518	galleries 13 & 14
525–56	gallery 3
557–65	gallery 1
566–87	gallery 10
588–9	between galleries 10 & 11
590–622	gallery 11
632–33	entrance hall
634–42	gallery 12
649–85	gallery 25
686–750	gallery 24
751–56	gallery 12
757–76	gallery 9 (then the Board Room)

Index of Artists

Arranged alphabetically by artist, the titles in numerical order
*Asterisk indicates a drawing or water-colour